No. 48 Saloon or ... Drawi...

A Large Steel Stove, iron ...

fender shovel tongs poker & brush ___

a pair of ornamented brass Chandeliers Blyt...

each lines tassells & pulleys ___

a pair of Pier Glasses 87 by 44 in rich gilt

and ornamented frames

a pair of beautiful marble Pier Tables

gilt frames & leather covers

a pair of Candelabras ornamented

carved & gilt & marble tops to d.o

a large & beautiful marble Pier Table

carved & gilt frame & leather Cover

a japanned Table with a set of imaged

Tea & Coffee China 44 pieces ___

6 black and gold japanned Chairs

Twelve Elbow Chairs stuffed & covered with

rich crimson cut velvet. the frames

Noble Households

*Eighteenth-Century Inventories of
Great English Houses*

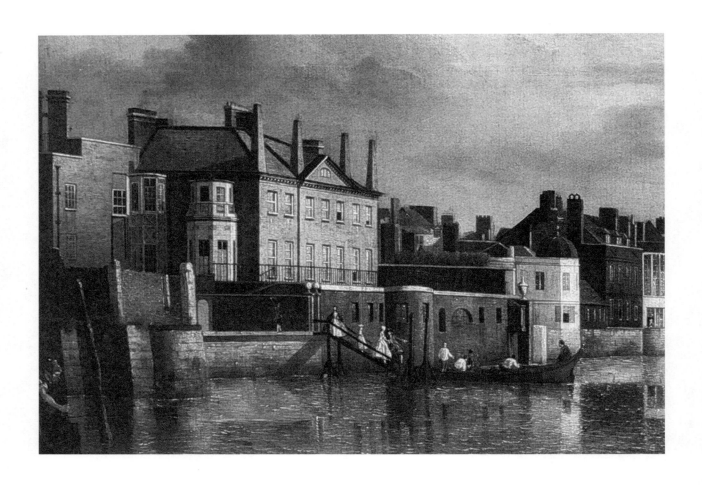

Montagu House, Whitehall (detail), oil on canvas by Samuel Scott (1702–1772), *c.*1749.
Painted for John, 2nd Duke of Montagu, showing the newly built terrace. The house was rebuilt in 1853.
The Duke of Buccleuch and Queensberry, Boughton House, Northamptonshire

Noble Households

*Eighteenth-Century Inventories of
Great English Houses*

A Tribute to John Cornforth

Edited by Tessa Murdoch

Inventories transcribed by
Candace Briggs and Laurie Lindey

John Adamson

CAMBRIDGE

Support for the publication of this book
was provided by
The Marc Fitch Fund

Edited, indexed and produced by John Adamson

British Library Cataloguing in Publication Data
A catalogue record for this book is available from the
British Library.

Published by John Adamson,
90 Hertford Street,
Cambridge CB4 3AQ, England

First published in 2006

ISBN 10: 0 9524322 5 0
ISBN 13: 978-0-9524322-5-8

Designed by James Shurmer

Printed on Munken Premium White
by Cambridge University Press, Cambridge

The endpapers:
'The Salone' from the 'Inventory of Houghton, May the
XXV, MDCCXLV' and 'The Saloon or Principal Drawing
Room' from 'An Inventory of the Elegant Household
Furniture Fixtures Marble Statues, Bustos capital Bronzes
Pictures Tapestry Hangings Linen, China, Glass and
numerous other Effects the Property of the R[t]. Hon[ble].
The Earl of Orford deceased taken at Houghton Hall in
Norfolk June 17th. 1792 & following days'

Contents

Book-plate engraved by Reynolds Stone (1909–1979).
Courtesy of Sarah Medlam

Foreword

JOHN CORNFORTH died at the age of 66 on 3 May 2004. From 1968 until 2001 he was a trustee of the Marc Fitch Fund, the small but far from insignificant charity concerned with funding research and publication in English local history, archaeology and related subjects. In 1977 he had taken over from Sir Anthony Wagner the chairmanship of the Fund, a position he held until 2001, and the present council of management, in gratitude for his long and influential period of service, has sponsored the preparation of this volume. The Fund owes John Cornforth a great debt for his leadership, not least in seeing to the smooth reorganisation of its council business in his early years as Chairman, as well as for his genial but decisive supervision of the twice-yearly meetings of its council over a long period. Throughout his period of office he worked in close cooperation with its Secretary and Director, Roy Stephens, whose own long service with the Fund came to an end soon after John demitted office as Chairman.

The council's members, anxious to commemorate John's long period of voluntary service, asked his views on a number of possible standard tributes: perhaps a conference, or a Festschrift? Each was modestly refused, but the departing Chairman was not unmindful of a gap in published historical documentation that might usefully be filled. He characteristically proposed a selection of the historic inventories, hitherto known only to specialists, of the furnishings of a number of major country houses, accurately transcribed but not overburdened with editorial matter. The Marc Fitch Fund eagerly accepted this suggestion, and the present volume, which was in active preparation at the time of his sudden, severe illness, is the result. What had been intended as a tribute must serve, alas, as a memorial.

John was keen to emphasise the utility to other practitioners of inventory evidence in a subject that has grown rapidly over the last thirty years and more. He could not disguise the part that he himself had played in such developments. As a *Country Life* contributor of very long standing (his first article, on Woodperry in Oxfordshire, dates from 1961), and later as its architectural editor, he had seen gradual changes in approach to the history of the country houses of the British Isles, and had himself been closely associated with many of them. The books he wrote, some of them in collaboration, had been prepared in parallel with the long, and to his regret now much changed, programme of country-house coverage for which the magazine has long been famous. *English Country Houses: Caroline, 1625 to 1685*, written with Oliver Hill and published in 1966, was a major addition to the well-known *Country Life* series. In 1974 it was followed by a very different kind of study, this time in collaboration with John Fowler (a prickly character with whom John said he had only one serious disagreement). *English Decoration in the Eighteenth Century* (1976) moved into territory that had been rather neglected by writers such as John's former *Country Life* colleagues

Arthur Oswald and Christopher Hussey, with their more traditionally architectural approach.

John's interest in the architecture and furnishing of country houses was lifelong, starting during a wartime childhood at Hayward Abbey, a small country house in mid-Staffordshire, with the Trent dividing his parents' home from the neighbouring property of Shugborough, a house which from its variety of buildings gave him an early sense of style and sequence. Even before he could read he developed a taste for the illustrations in *Country Life*, though not for any other aspect of life in the country. Indeed the magazine was part of his upbringing, and the receptive childhood perusal of piles of back issues led to other reading as well as to country-house and museum expeditions that encouraged his taste. Though his schooldays at Repton afforded little visual stimulation, his years at Cambridge (where he read History at Corpus Christi College) also provided an education in art history under Michael Jaffé's tutelage

This might have taken him into a curatorial position in a museum or gallery, but he was fortunate in being taken onto the *Country Life* staff in 1961 as an architectural writer, where he joined Christopher Hussey, Arthur Oswald and Mark Girouard in an established team working on the magazine's famous series on country-house architecture. It kept him very busy with researching and writing on a wide variety of properties – 'like stoking an Aga' he once described it in a remark worthy of the accomplished amateur chef that he soon became. His own interests gradually became more than architectural, however, a significant difference in the days when 'mere' decoration was rather looked down upon by the old guard of *Country Life* contributors.

He took on further tasks in the main stream of architectural history, in addition to his collaboration with Oliver Hill in the 1960s on the volume on English country houses of the Caroline period. A long association with the Historic Buildings Committee of the National Trust had begun in 1965, and in 1970 he followed Christopher Hussey as a member of the Historic Buildings Council for England. But he had also for long had a sense of the importance of the English tradition in the decorative arts, a subject that had been more or less dormant since the death of its early exponent Margaret Jourdain in 1951. In the early 1970s his interest in this neglected subject began to be reflected in his *Country Life* contributions and, as mentioned, there was the collaboration with John Fowler in *English Decoration in the Eighteenth Century* (1976). Working with Fowler had also introduced John to Mario Praz's *History of Decoration* (1964), which was a major influence on his own *The Quest for Comfort* (1978), a work long out of print. It is now a rare and expensive book, but one that has undoubtedly been very influential on a whole generation of younger designers. Among other publications of that period John compiled an influential report on *The Country Houses of Britain – Can They Survive?* (1974), and was much involved with the landmark exhibition entitled 'The Destruction of the Country House, 1875–1975' at the Victoria and Albert Museum. He also became a valued consultant to the Foreign Office on the care of historic embassies abroad – a major task which introduced him to practical details of management and maintenance that he had previously managed to avoid.

Retirement from *Country Life* in 1993 (though he remained an occasional contributor up to the time of his last illness) gave him the opportunity for continuing his research towards a major study of the history of English interiors in the first half of the eighteenth century. He did not, alas, live to see this published. There were many diversions, including a study

of the architecture and decoration of Clarence House in the time of HM Queen Elizabeth the Queen Mother, and work connected with the golden jubilee of the Historic Houses Association founded in 1948. His involvement in upper committee work (though in fact he had limited taste for committees and preferred to do good in his own way, more stealthily) and in the preparation of major exhibitions was recognised by the award of a CBE, but an underlying concern with the history of English decoration had been increasingly apparent in recent years. His major project, *Early Georgian Interiors*, was being prepared for publication by Yale University Press at the time of his death, and this selection of inventories of town and country houses now forms a documentary complement to John's general study of the subject.

It is also a very suitable acknowledgement by the Marc Fitch Fund of John's sustained work as Chairman of its council. In 1956 the Fund's founder, a prosperous wholesale grocer with a lifelong interest in genealogy and related subjects, started a small charity, bearing his own name and increased by further endowments. Its aim was to assist projects in archive publication, local history and archaeology, architectural history and similar subjects, and in nearly fifty years of quietly useful activity the Fund has made a significant contribution to the development of historical and antiquarian studies. John Cornforth's membership of its council of management for over thirty years, and his long tenure of the chairmanship, ensured its steady development. It is in tribute to this work for the Fund that its managing council has dedicated a volume that reflects the special interests of their former colleague.

Alan Bell
Chairman
Marc Fitch Fund

Acknowledgements

John Cornforth has inspired several generations of historians of interiors. His request that his thirty years as Chairman of the Marc Fitch Fund should be marked by the publication of transcripts of inventories of a number of the most important eighteenth-century English interiors will serve to inspire future generations of historians of the domestic interior. I am grateful to John for asking me to oversee this project and for the opportunity to work more closely with such a remarkable series of documents.

We would like to thank the following for permission to publish the transcriptions of the inventories in their possession: the Duke of Buccleuch and Queensberry for the Montagu inventories of Boughton, Ditton, Montagu House, Bloomsbury and Montagu House, Whitehall; Charles Stopford Sackville for the Drayton inventories; the Marquess of Cholmondeley for the Houghton inventories; the Earl of Leicester for the Holkham inventories, the Directors of the Pelican and Coronet Company for the Ditchley inventories, the Trustees of the British Library for the Blenheim and Marlborough House inventories and the Trustees of the Victoria and Albert Museum for the inventories of Kiveton and Thorp Salvin in the National Art Library.

Candace Briggs, a former post-graduate student recommended by David Jones, her supervisor at the University of St Andrews, undertook the lion's share of the transcriptions, a formidable task. She had to return to the United States before completing the work. The challenge was ably taken up by Laurie Lindey, a post-graduate on the V&A/RCA MA in the History of Design. Without Laurie's energy and attention to detail this project would have taken far longer to complete.

In addition we would like to thank the following for their help and hospitality: Bruce Bailey, archivist at Drayton; Susan Cleaver at Houghton; Alec Cobbe; Gareth Fitzpatrick at Boughton; Christine Hiskey at Holkham; Sarah Bridges and Crispin Powell at the Northampton County Record Office; Andrew Moore at Norwich Castle Museum, and Leon Leigh and Victoria Worsfold at the Victoria and Albert Museum. We would also like to thank Adam Bowett, Clare Browne, Nancy Cox, Wendy Hefford, Frances Collard, Laurie Lindey, Michael Legg, David Mitchell and David Moulson for their help with the glossary. Finally we would like to thank Roy Stephens, Alan Bell and Elaine Paintin of the Marc Fitch Fund for their patience, James Shurmer for his elegant design and John Adamson for providing the comprehensive index and publishing this book.

Tessa Murdoch
Victoria and Albert Museum
August 2006

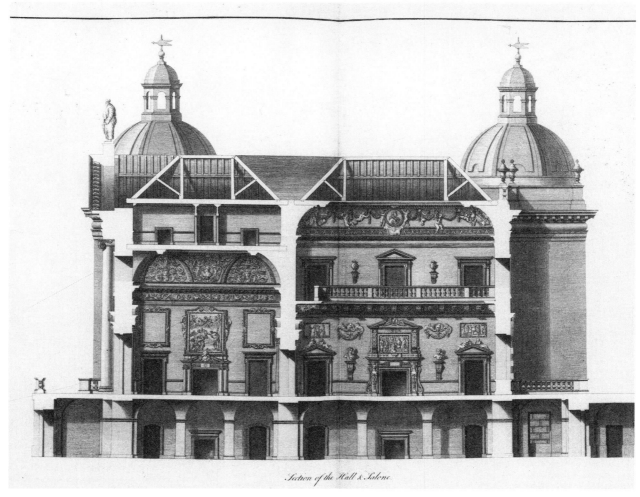

Section of the Hall & Salone.

(Fig. 1) 'Section of the Hall & Salone', Houghton, Norfolk, engraved in 1735 by P. Fourdrinier (1698–1758) for Isaac Ware and Thomas Ripley's *Plans, Elevations and Sections: Chimney-pieces and Ceilings of Houghton in Norfolk. The British Library*

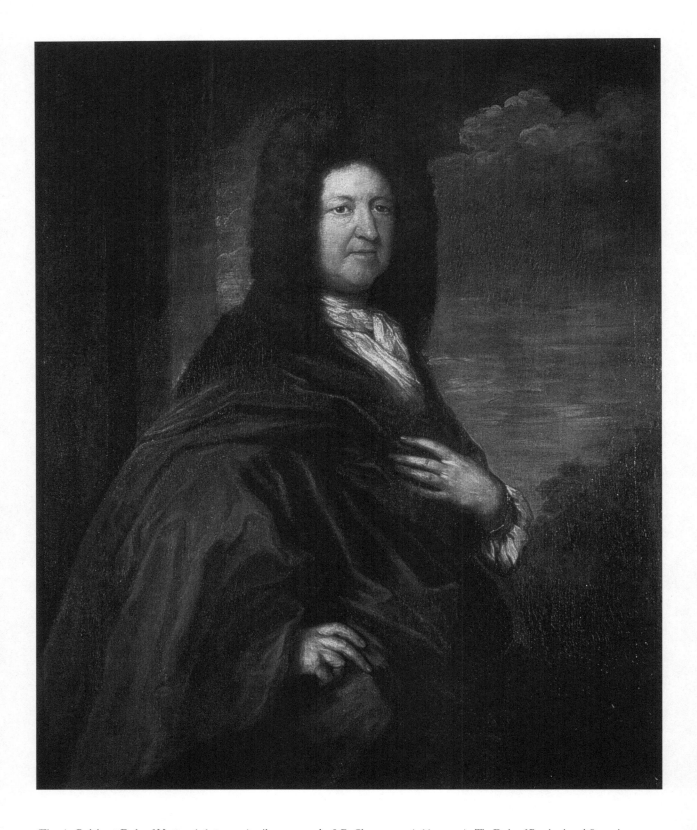

(Fig. 2) *Ralph, 1st Duke of Montagu* (1638–1709), oil on canvas by J. B. Closterman (1660–1711). *The Duke of Buccleuch and Queensberry, Boughton House, Northamptonshire*

Introduction

For a deeper understanding of daily life at great houses in eighteenth-century England, the listings of their contents provide a vital source of information. At times compiled for probate, at others to settle disputes of ownership, the inventories chosen by John Cornforth record in astonishing detail and with great immediacy the goods and chattels accumulated, inherited, or simply acquired over the years for everyday use or enjoyment at nine great country houses and four London townhouses. The grandeur of the upholstery, the tapestries and the silver of the owners are counterbalanced with the practicalities of pots and pans in the kitchen and the 'shovel, tongs and poker' in the hearth of almost every room.

In all these inventories it is eighteenth-century voices that speak. Usually written by professional appraisers, they were compiled swiftly on the spot, room by room, with meticulous care, almost certainly in consultation with family members or their stewards. High degrees of accuracy were required for often these deeds were of legal importance. The breadth of knowledge of artists, makers and materials reflects the pride and awareness with which some objects were regarded.

The inventories chosen include those of Boughton, Houghton and Holkham, where John Cornforth had made a special contribution, advising the current owners on the presentation of the houses to the public by reference to the original eighteenth-century listing of contents. At Boughton, he paved the way as a trustee for the return of the State Bed, on loan from the Victoria and Albert Museum, to its original setting, ensuring that the original bedroom furniture was appropriately displayed to provide an accurate context. At Houghton (fig. 1), it was largely his vision that ultimately secured the most outstanding furniture and tapestries for the nation. The great green velvet and embroidered beds, the suites of giltwood furniture, the Mortlake tapestries, have been taken on by the Victoria and Albert Museum, which will ensure their preservation through appropriate conservation, but they will remain in situ, so they can be properly understood. At Holkham, he guided the hanging of the paintings so that the sumptuous effect of the Landscape Room can be seen as originally intended.

Now that there is such fascination with the history of food and life below stairs, the contents of the kitchen and scullery assume as much interest as the grand rooms of entertainment. The lists of equipment required to service the household, for cleaning, medical treatment, brewing, baking and distilling, garden tools and furniture reflect the community of servants, stewards, housekeepers, cooks and gardeners that worked and lived there permanently whether the owner was in residence or not. The language with which this equipment is described often seems startlingly modern. One house was equipped with a 'washing machine', another refers to the latrine as 'the boghouse'. Kitchen equipment with French names may reflect the presence of a French cook and the adoption

of French cooking methods. The problems of an unoccupied house are manifest in the 1733 inventory of the contents of Montagu House, Bloomsbury, where much of the servants' bedding is described as 'full of buggs'.

These inventories supply an opportunity to compare the arrangements of the interiors of the great country houses and town houses of the same noble families in different generations. The contrast in life style between the 1st and 2nd Dukes of Montagu is revealed in the earlier town palace in Bloomsbury and the river-side Palladian residence at Whitehall (see frontispiece). The contents reflect their professional interests. The quality of furnishings at Montagu House, Bloomsbury, demonstrates the influence of the 1st Duke's role as Charles II's ambassador to Versailles and his subsequent services as Master of the Wardrobe to William III (see fig. 2). The presence of arms and armour at Montagu House, Whitehall, reflects the 2nd Duke's role as Master of the Ordnance (see fig. 3). Like his father-in-law, the great Duke of Marlborough, the 2nd Duke's military career accounts for the campaign furniture listed.

There is an opportunity to contrast the role of gender. The collections at Holkham reflect the gentleman's experience of the European Grand Tour. Thomas Coke, later 1st Earl of Leicester, was a lifelong collector of classical sculpture and landscape painting that focussed on Italy alone, as is borne out by the art collections at Holkham and at Thanet House, London. At Houghton, Sir Robert Walpole (fig. 4) amassed an eclectic array of paintings and large suites of furniture to cater for the scale of his entertaining. The indefatigable Duchess of Marlborough personally dictated the inventories of Blenheim Palace and Marlborough House, giving these documents a very different flavour and reminding us of her proprietorial attitude towards those belongings which she had herself bought and which did not form part of the Marlborough inheritance (fig. 5). The Drayton inventories record Lady Betty Germaine's passionate collecting of oriental porcelain (fig. 6). The Marlborough and the later Montagu inventories demonstrate ladies' accomplishments; Sarah Marlborough was herself a needlewoman and Mary, Countess of Cardigan, younger daughter of the 2nd Duke and Duchess of Montagu, emerges as an amateur artist.

Contemporary annotations attributed to family members throw additional light on the houses and their contents. These include Horace Walpole's annotations on the 1792 inventory of Houghton, Lady Betty Germaine's comments on the Drayton inventory and Mary, Countess of Cardigan's occasional comment on the 1733 and 1746 Montagu House inventories.

The inventories' vocabulary and turn of phrase capture the flavour of contemporary daily life. The present transcriptions have been faithful to the often quirky spelling of the original documents as well as to the abbreviations used. While every attention was focused on recording the contents, less heed was paid to accuracy of spelling. Sometimes the spelling reflects regional accents; 'slob' and 'plod' for slab and plaid echo eighteenth-century Northamptonshire pronunciation. An appraiser's education would not have been on a par with that of the rising professionals. It is unlikely that they would have consulted Nathan Bayley's dictionary published in the first quarter of the eighteenth century (Dr Johnson's *Dictionary* was only published in 1755). On the other hand, the inventories dictated by Sarah, Duchess of Marlborough are redolent of the elevated writing style of the patron.

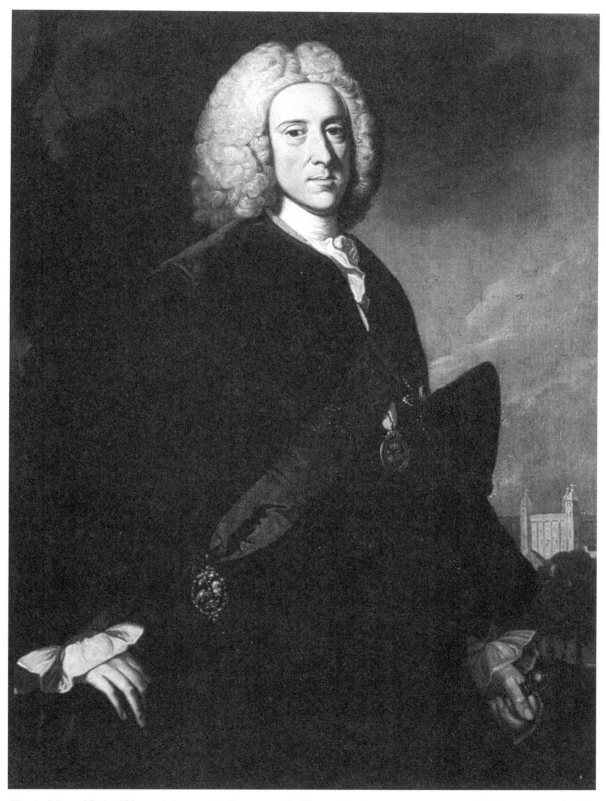

(Fig. 3) *John, 2nd Duke of Montagu* (1690–1749), oil on canvas by Thomas Hudson (1701–1779), 1749. *The Duke of Buccleuch and Queensberry, Boughton House, Northamptonshire*

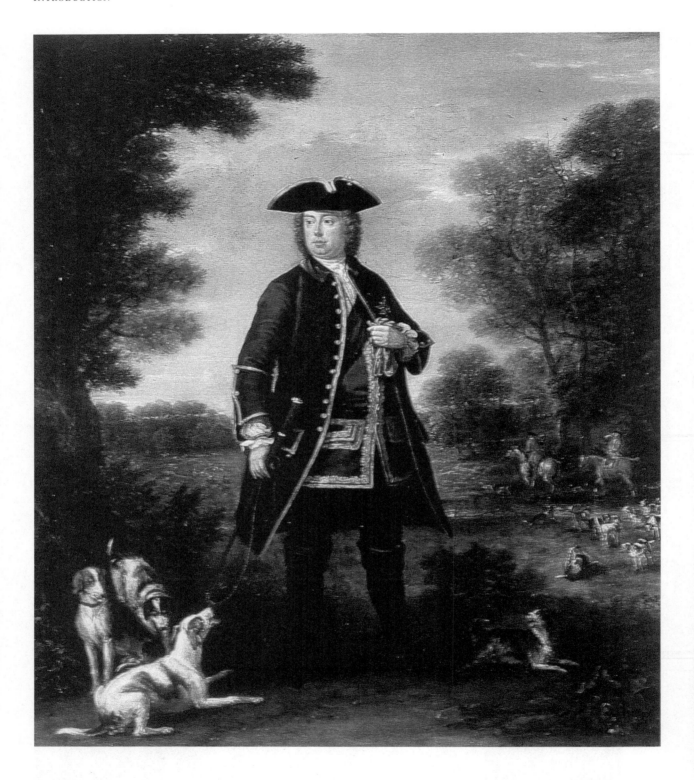

(Fig. 4) *Sir Robert Walpole (1676–1745), oil on canvas by John Wootton (d. 1764), c.1725. The Marquess of Cholmondeley, Houghton Hall, Norfolk*

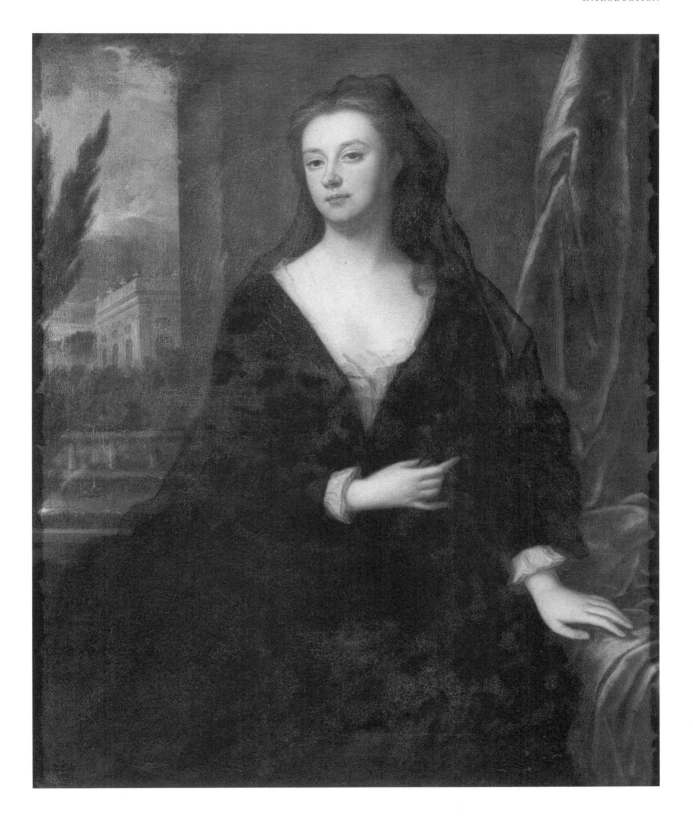

(Fig. 5) *Sarah, Duchess of Marlborough* (1660–1744), oil on canvas by Michael Dahl (d. 1726), 1722. *National Portrait Gallery, London*

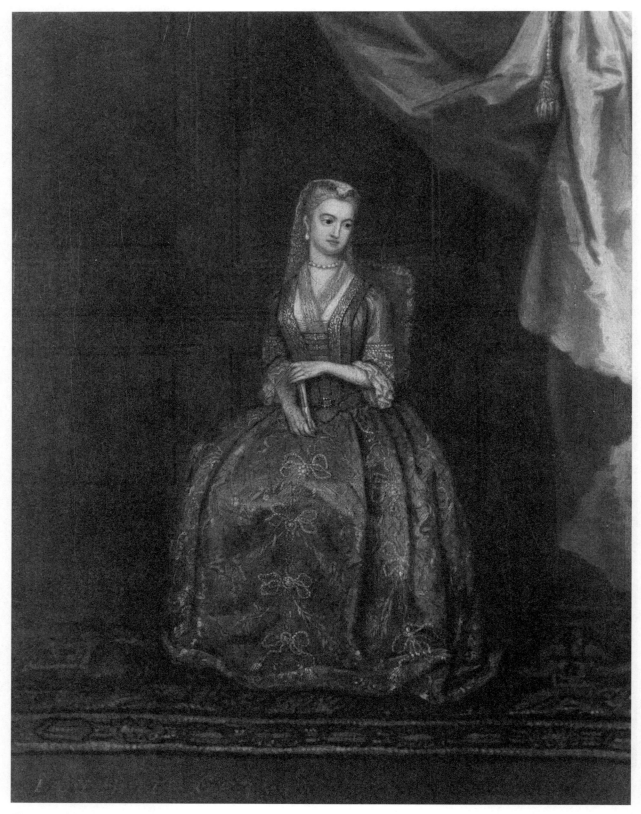

(Fig. 6) *Lady Betty Germaine* (1680–1769), oil on canvas by Charles Phillips (1708–1747), 1731. *Trustees of the Sackville Family*

If the spelling is imperfect, the exquisite quality of handwriting on the neat copies of the inventories demonstrates the awareness of the importance of a clear hand and the growing influence of the writing master in raising clerical standards.

The compilation of the inventories reflects the extended role of the upholsterer and auctioneer. James Gronouse and William Bradshaw are recorded elsewhere as working upholsterers and furniture makers but their duties included appraisal. The auctioneer James Christie also appears in this capacity at the end of the century at Houghton in 1792. The care and detail with which chattels are recorded indicates the diligence with which everything was described, although Sarah, Duchess of Marlborough dictated that the china and glass in her households were not worth bothering about. In several cases the inventories are working copies, annotated with changes for probate, and these have been transcribed in preference to a finished neat copy where this survives, as the working copies provide more contemporary evidence.

Each inventory needs to be considered in the light of the occasion for which it was compiled. Thus the earliest Boughton, Ditchley and Montagu House, Bloomsbury inventories are a once-in-a-lifetime record, produced for probate and provide the additional information of the monetary value of the contents. The 1733 inventory of the contents of Montagu House, Bloomsbury, documents the contents of the house prior to the move to Whitehall. The Drayton inventories were evidence in a battle for the legal ownership of the house. The Marlborough inventories must have been compiled at the Duchess's request principally to record her ownership of some of the contents.

John's hope was that this publication would inspire and revitalize the study of the great house in the eighteenth century. As we leaf through this book on a journey of discovery it is as if he is still present, at our elbow.

Tessa Murdoch

Note on the Transcriptions

While the transcriptions are faithful to original spelling and punctuation and use of superscripts, they are not facsimiles. There has been no revision of spelling to conform to modern usage or any attempt to make either spelling or punctuation consistent. Striking through is also faithful to deletions in the original documents. Inserted words are shown in superscript.

Contemporary signatures are shown in italic whereas later undated annotations and commentaries are differentiated by being shown in Eric Gill's Joanna typeface. Very minor annotations deemed to be ephemeral have been omitted.

Editorial annotations have been kept to a minimum and are shown in square brackets. A contextual interpretation has been given for the few indecipherable words occurring.

Layout has been slightly modified to fit within a two-column grid and the original page breaks could not be respected. Where appropriate, therefore, such headings as 'continued' have been moved to head an entry continuing on a new page.

PART I
The Montagu Inventories

Montagu House, Bloomsbury, London
1709 and 1733

Boughton House, Northamptonshire
1709, 1718 and 1730

Ditton, Buckinghamshire
1709

Montagu House, Whitehall, London
1746

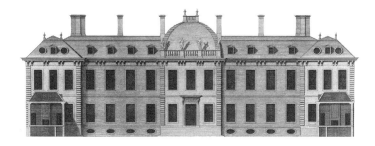

Montagu House, Bloomsbury, London
1709 and 1733

The earlier inventory was taken after the death of Ralph, 1st Duke of Montagu (1638–1709), and the contents reflect his cosmopolitan taste. As former ambassador to the court of Louis XIV at Versailles and Master of the Royal Wardrobe to Charles II and William and Mary, Montagu was aware of sophisticated French patronage and cultivated the highest quality of interior decoration at the English court. William III was inspired by the interiors of Montagu House when he visited in 1689 and contemporaries regarded Montagu's London home as a palace. It was rebuilt after a fire in 1686 to the designs of a French architect said to be a Monsieur Pouget.

The walls of the principal rooms were decorated with mythological scenes by the leading French painter Charles de Lafosse and over fifty flower paintings by Louis XIV's renowned flower painter, Jean-Baptiste Monnoyer, referred to as 'Baptist'. Ralph Montagu owned the Mortlake Tapestry Manufactory which explains the profusion of tapestries hanging in the principal rooms and stored in the wardrobe. The portrait of Hortense Mancini, Duchess of Mazarin, in the Duke's bedchamber records a close personal friendship with this former royal mistress. Large looking-glasses in glass or silver frames, and marble tables with gilt frames and accompanying candlestands, reflect French influence; the several 'Indian' pieces of furniture and textiles demonstrate Montagu's fascination with the Far East. Furniture listed in 1709 can still be identified with pieces that survive today at Boughton House, Northamptonshire, the home of Montagu's direct descendant, the Duke of Buccleuch and Queensberry.

The inventory also records the members of Montagu's household including the Huguenots, Mr. Portal, Mr. Falaizeau, Mr. Mirande and his doctor, Silvestre. Details such as the prints in the Bathing Room and the list of plants in the garden provide insight into aspects of daily life in the greatest private London house of the early eighteenth century, which was inherited by Duke Ralph's son John, 2nd Duke of Montagu.

The 1733 inventory was taken after the 2nd Duke and his Duchess Mary, a daughter of the great Duke of Marlborough, had moved from Bloomsbury to their new house in Whitehall. It documents the items dispersed to the Montagu's other houses: Beaulieu, Hampshire; Boughton, Northamptonshire; Ditton, Buckinghamshire; to the new London house and the cockpit at Whitehall, and to their villa at Blackheath. Ralph Montagu was entitled as Master of the Wardrobe to the cockpit lodgings which stood on the site of Henry VIII's cockpit at Whitehall Palace, built in 1533–4. Some furniture was sent to their younger daughter Lady Cardigan. The items in storage include an amazing collection of saddle furniture including two sets of Turkish origin. The extensive armoury reflects the 2nd Duke's role as Master of the Ordnance. Paintings were taken away by the cabinet-maker Benjamin Goodison for reframing; looking-glass was sent to the new house for reuse or sold to Goodison for his own stock.

The inventory records the two large tapestry cartoons in gilt frames, two Indian cabinets with gilt stands, and thirty-six pictures by Van Dyck now at Boughton. Some of the comments in the margin bring to life the enormity of the task of moving the contents of this great London palace. The comment: 'Doubtful if not infested with Buggs' beside the item 'a Feather Bed and Bolster' hints at the housekeeping problems of an empty mansion. The lists of silver and linen indicate the scale of entertainment the house had seen in its heyday.

These inventories are in the collection of the Duke of Buccleuch and Queensberry and deposited in the Northampton County Record Office. The 1709 inventory is transcribed from the working copy signed off by the duke's steward, Mark Antonie, which explains the crossings out as furniture was moved elsewhere. For the transcription of the 1709 Ditton inventory which forms part of the same document, see pages 79–84.

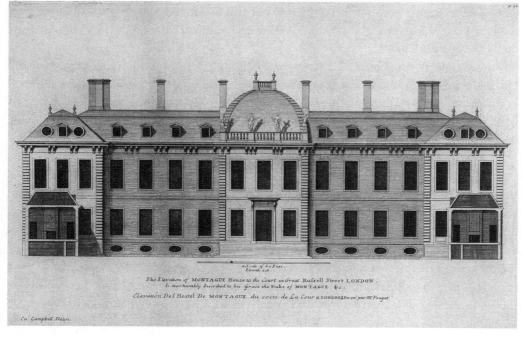

(Fig. 7) 'The Elevation of Montague House to the Court in Great Russell Street London', from Colen Campbell, *Vitruvius Britannicus*, vol. 1, 1715. *Victoria and Albert Museum*

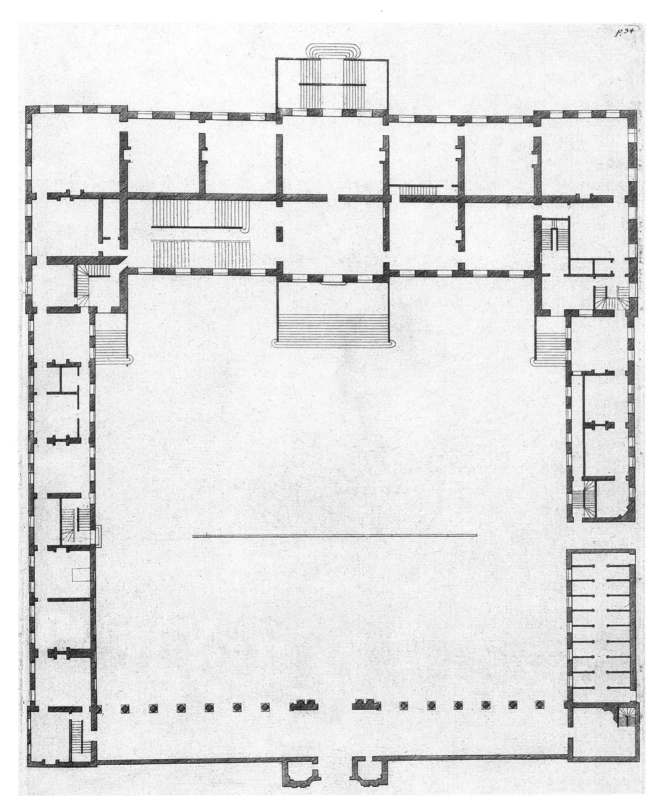

(Fig. 8) 'The Plan of the Principal Floor of Montagu House', Bloomsbury, from Colen Campbell, *Vitruvius Britannicus*, vol. I, 1715.
Victoria and Albert Museum

N⁰. 2 1709 Inventory

An Inventory of the goods & Chattells of the most noble Ralph Late Duke of Montagu deced being at Montagu house in the County of Middx and at Ditton Park in the County of Bucks with a seperate account of the said late Duke wine Syder and Strong Beere at Montagu house aforesaid And also an Inventory or account of the said late Duke's goods & chattels at the said late Duke's lodgings at the Cockpitt in or near her Majes^ties. Palace at Whitehall and at M^r Antonie's house together with the particulars and values of the said severall goods chattells Wine Syder & Beer as the same were severally valued and appraised.

Writn the 6 July 1710
of M^r Antonie this acct
T Pitts

An Inventory of the Household Goods of his Grace the Late Duke of Mountagu Deceased, taken the 18^th of July 1709 at Mountagu house & Ditton Parke & M^r Antonie's house

Imp^is:

In y^e Upper Roomes at the West End

M^r: Portalls Roome

A Bedstead, & Crimson Damask furniture, a fether bed, bolst^r: 1 pillow, a Mattress, & holland: Quilt, 3 blanketts, a Walnut=tree Screutore, 2 Wainscot tables, & Deske, 2 Cloath=presses, 7 Caine Chaires, one Dressing Glass; a Stove, fier Shovle, tongues, poker & fender a brush & 4 p^cs: of Tapestry Hangings

21=18=00

In the Corner Roome

A Beadstead w^th: a sacking bottom & Mohair furniture Compleat, a fether Bed & boulster, 2 Check Quilts, 4 blankets, a small Wainscott Cup board, a Cloath's press,

a Wainscott Table, 10 Mohair Chaires, 2 Caine Chaires, one Caine Stoole. a Stove grate fier Shovle, tongs, poker fender, bellowes & brush; one p^ce: of Tapestry, one Stand & one Bell

15=04=00

37=22
M: Antonie

In the Darke Roome

A Beadstead, mat & Corde & printed furniture, 4 Window Curtains, 2 Rods, 2 Elbow Chaires, a Stove grate fier Shovle tongs, poker fender & bellows.

01=10=00

In M^r: Ellingtons Roome

A Beadstead w^th: a Sacking bottom, a printed Stuf furniture a fether bed & bolster, a Rug 2 blankets & 2 old Chaires

2=18=00

In the Closet Joyneing to y^e Nurcery's

A Table bedstead, a fether bed & boulster, 2 blankets, a Callicoe Quilt, a Check Curtaine a Cloathes press, a chest=with=Drawers, 2 Small Tables, 3 Cane Chaires, 2 Matted Chairs one Needle Worke Chaire hangings to the Roome a Window Curtaine, Valion'd & Rod, 27 small paper=printes, a peice over the Chimny: a Chimny Glass a Stove, fender, tong's & Poker

18=17=00

23=05=00
M: Antonie

In the Nurceries

A beadstead w^th: a Lath bottom. a Sky couler Camblet furniture Compleat, a fether bed & boulster, a check Mattress, a Holland Quilt 4 blankets, 6 black caine Chaires. w^th: Quilted Camblet Cushiones 3 Stuft Chaires Covered w^th. Camblet & fether Cushions, 2 mated Chairs 4 Camblet Window Curtaines 2 Valions & Rods, a Skreene Covered, w^th: Serge, a Table Standes & Glass, a Watch Cloke a Chimny Iron, a pair of Doggs fender fier shovle, tong's belows & brush. 4 peices of Tapestry Containing 88 Ells a Cradle Lined w^th: Curtains &c & Quilt of the Same & thre Quilts of Holland.

69=16=6

A Beadstead w^th: a Lath bottom a Velvett furniture Embroyder'd Lined w^th: Sattin Compleat a fether bed & boulster, a cheek Matress & holland Quilt 4 blanketts. A Beadstead w^th: a Sacking bottom a

Wrought furniture Lined w^th: Callicoe, a feather bed, boulster & 2 pillowes 2 Check Quilts 4 blankets & a Callico Quilt, a Wainscott chest of Drawers, a Table & Standes, a Guilt Leather Skrene 6 Velvet Chaires 3 Stooles Ditt^o: 2 matted chaires w^th: Velvet Embroydered Cushions a Child's Easy Chaire cover'd w^th: Sky Damask, 2 matted Chaires 5 Green Serge Windo^e: Curtains & Valions & Rods

69=16=6

M: Antonie

Nurcery Continued

One Doore Curtaine & Valion, 1 Leather Skreene 6 Leaves, a Stove grate a brass fender fier Shovle, tonges, poker & brush a chimny Iron three p^cs: of Tapestry hangings containin^g 78 Ells, a small Dutch Table & two Matts

73=01=00

In the Roome Adjoyning

9 Velvet Stooles, 3 D^o: Chaires, 4 p^cs: of Tapestry Hangings

15=18=00

In the Roome next y^e Sallone

3 Velvet Chaires, 1 Stoole D^o: 5 Matted Chaires, 3 peices of Tapestry Hangings

14=11=00

In the Sallone

12 Damask Stooles, 6 Curtaines Rods, a Stove grate fier Shovle tong's Poker & fender

06=16=6=

110=06=6

M: Antonie

In my Lady's Womans Roome

A Bedstead w^th: a Lath bottom a Greene Serge furniture Compleate, a fether bed, boulster & 2 pillows, 3 blankits, a Matt & a holland Quilt, 3 Wainscot Tables & one Stone Ditt^o: a Wainscot Cupboard, 2 Caine Chaires, & 2 Matted chaires, 1 Covered Elbow Chaire, a Large Looking Glass & Dressing Glass a Stove grate, fender fier Shovle, tong's, poker & brush printed hangings, 8 Window Curtains & 4 Rods

13=00=00

In Dorothy's Roome

A bedstead w^th: a Sacking bottom, camblett curtains head Cloth & Teaster, a feth^r: bed, boulster & pillow, a check mattress, 3 blankitts, 1 Rug, 2 matted chaires one press &

2 cupboards y^e: printed hangings. a fier grate, fender, shovle, tong's & poker, a Trivett a cheese Toster, a coper fryeing pan & Drinking pott a Coffee & a chocolate pott a Tea Kettle, a Coffee mill 2 Sauce Pans a paire of below's & a Lamp

06=10=00

19=10=

M: Antonie

In the Lady^s: Dressing Roome

one Dressing Chaire Covered w^th: Damask, 3 Chaires Ditt^o: a Cou^tch frame, w^th: a Quilted Cushion & 3 pillows. hanging^s: to y^e Roome of Damaske 2 paire of persian Window Curtains & Valions; a Looking Glass in a Gilt frame a Chimny Glass; a pickture over y^e Chimny, a Japand Carde Table, a paire of Doggs, fier Shovle, tongu's, brush & bell=s a pair of Stands. 2 Wainscott Square Tables & 1 old fier Skreene

61=19=00

In the Lord^s: Dressing Roome

Three Elbow Chaires, Covered w^th: Needle Worke 2 Stooles Ditt^o: 5 Chairs w^th: List Seates a Wallnut=Tree Cabinett a Dutch Table, a Wainscot Table, a Marble Table, one Dressing Glass, 1 Chimny Glass a pickture over y^e: Chimny, hangings of the Roome, 4 Window Curtains, 2 Valions & 2 Rods. a Stove, a fender fier Shovle, Tong's, poker & Brush & below's

33=18=0

95=17=0

M: Antonie

In the Waiteing Roome

A Table bedstead w^th: Serge Curtains & Rod. a fether bed & boulster. a Callicoe Quilt 3 blankets, 2 Wainscot Ovill Tables, 3 List bottom Chaires 1 Square Caine Stoole, a Bloeing Grate, fender, tong^s, poker & brush an Old Green Carpitt

06=18=00

In the Dutches Dowager's Appartment

A Lath bottom bedstead & Damask furniture. one fether bed, & boulster, two Mattresses & 1 holland Quilt 1 Elbow Chaire 4 Mated chaires. 1 Wainscot Table 2 Serge Window Curtains Valions & Rods, a Blowe Stove fier Shovle tonges belows, brush & hooks the Camblot Hangings

12=11 6

In the Next Roome

A Caine Squab Cushion and boulster. 2 Easy Chaires two Square Stooles. 2 Stuft Chaires, 2 Caine Chaires. one Ovall Wainscot Table. 1 Square Dito: 1 Marble Table: one Chest of Drawers, one Looking Glass. 2 Serge Window Cur=taines. Valions & Rods a Stove grate. fire Shovle, tong's poker & fender. Camblott Hanings to ye: Roome

12=11=0

32=00=06

M: Antonie

In the Dineing Roome

Three Caine Elbow Chaires one black Table, 2 Marble Tables. a paire of tong's a pair of Doggs a brass fender & brush. Camblett hangings of the Roome. 4 Window Curtains 2 Vallions & rods. Line & Tossils a Lookeing Glass & 16 picktures

18=17=0

In the Bed Chamber:

A bedstead wth: Lath bottom a purple Cloth furniture Lined wth: yellow persian Com=pleat. 1 fustian matress one check: mattress. 6 Elbow Chaires & Cloth Cases to them. 5 Small pillows & a Callicoe Quilt a Small Indian Skreene the purple Cloth hangings. 2 pr: of Window Curtains & Valions & Rods. Lines & Tossils a Marble Table a pair of Doggs fier Shovle tonges brass fender, belowes & brush, 2 Fustian Quilts, 1 holland Quilt a Sattin Twie=light a polonia downe quilt & Callico quilt & a feather boulster

In the Clossett

2 Elbow Chaires a Chimny Glass a Grate & Fender

97=17=00

116=14

M: Antonie

In the Maid's Roome

four bedsteads wth: Lath bottoms. wth: Curtains head Cloths & Teasters. 4 fether beds, 4 boulster. 4 Mattresses 13 blankits. 2 Rugs: one Callicoe Quilt. 7 Caine Chaires. 3 Caine Stooles. 3 Stuft Stooles. 2 boarded Squabs one boarded Stoole. 2 Wain=scott Tables. a Close Stoole & panne. a fier Shovle tong's. poker below's & brush a Cloathe's Press

19=13=

In Mrs: Dose's Roome

A Lath bottom bedstead a serge furniture. a fether bed boulster & pillow. 4 blankets. 2 Mattres Quilts 4 Caine Chaires. 1 Stoole Do: one Easy chaire. 2 Stuft Chaires.

one Cloathes press hangings to the Roome 4 Window Curtains & 2 Rods. one Table. a Stove; wth: fender fire Shovle tong's poker & belows

07=15=06

27: 08: 6

M: Antonie

In Dr: Silvester's Roome

A Lath bottom bedstead wth: a green Serge furniture Com=pleat, a fether bed, bolster & pillow. 2 Check Mattrisses 2 blankets, ye printed hangings a Cloathes press

05=19=

In ye: Drs: man's Roome

A Table bedstead. a fether bed & boulster. 2 blankets a Close press

02=00=

In Saml: Jewels Roome

A Table feather beadstead. one fether bed & boulster. 5 blankets & 1 Table.

02=03=

In the Passadge

One Ovil Table one Chest 1 Caine Chaire, Some Drugget Hangings

00=13=0

10=15=0

M: Antonie

In the Garrett over my Lord's Dressing Roome

A Lath bottom bedstead wth: Shalloone furniture Compleat a fether bed & boulster, a Check Mattress. a Holland Quilt. 4 blanketts. 6 Caine Chaires. & a Matted Chair. 3 tables. ye Shallone hangings & 8 Window Curtains. 4 Rods a Stove grate & fender fire Shovle tong's poker belows & brush

10=16=00

The East End

In Mr Whites Roome

a bedstead wth: a Sacking bottom, & an Old Camblett furniture. 2 Check Mattresses 2 Holland Quilts a boulster & pillowe, two blankets. a Callicoe Quilt 3 Wainscot presses. 2 Tables 4 Caine Chaires. 3 Stufe Do: & one Stoole. ye: Hangings of the Roome. Iron Barrs & fender. fier Shovle tong's bellow's, ~~below's~~ & brush a bell & Mopp

12=04=6

23:00 6

M: Antonie

In the Roome Adjoyning

A bedstead mat & Corde a Linnen furniture Lined. a fether bed boulster & pilloe 6 Blankets, a Wallnut=tree Table & 4 Chaires a Grate fender bellows & brush. Tapestry Hangings

3=17 6

In the Presses

26 Backes & Seates: Needle Work: 13 pcs: for Chairs 13 Small peices & Slips. 1 back & Seat Do: 2 backes: 2 Seates 3 Slips of Irish Stitch 19 old backes & Seates & 2 Slips Dito: 13 pcs: backes & Seates Do: one Stoole Seat. 3 Sattine peices Embroydered one Gold Ground Velvet Embroydered 126 yards of 3/qrs: Chince 15 yards. ½ of brown Indian Muslyne 196 yds. of blew Callicoe 2 White Indian Quilts. 2=black twilights. ~~14 Small Picktures~~ 17 small pictures

238=8=

242=05=6

M: Antonie

In the Roomes over my Lord Dukes Appartment

A Wallnut=tree press. a Screw=tore Dito: ye: check hangin's 4 Window Curtains, 2 Rod's 2 Caine Chaires. a Writeing Table. a Strong box, a Chim=ney Glass a Stoole & a Stove grate

11=10 6

In ye: Next Roome

3 Tables. 4 Caine & 2 Stuff Chaires. Irish Stitch hang=ings. a Chimny Glass one Pickture. a blowe Grate a Stove Grate fier Shovle Tong's and Poker

04=13=6

In Mr: Falaizeau. Roome

12 Caine Chaires. a Wallnut=tree Buro. a Carde Table Dito: a Wainscott Table, a Looking Glass & Dressing Glass. a Chimny Glass, a Pickture over the Chimny, 5 Maps. ye: printed hangings 6 Windoe Curtains. Valions & 3 Rods. a Turky Carpet & Cushion. a Stove Grate & fender. a fier Shovle tong's pocker & Brush

falaizeau

14=00=6

39=04 6

M: Antonie

In the Butlers Roome

A bedstead, wth: Sacking bot=tom. printed furniture a fether bed & boulster a Rug, 2 blankets, 3 Chaires 1 Table. a matrs a Deale Press. hangings of ye: Roome a bloweing Grate. fender & poker. a Wainscot Press

08=01=0

In the ffoot mens Roome

a bedstead mat & corde ye: printed furniture. a fether bed & boulster, 4 blankets 1 Rug a checkt Matts: 2 Caine & 3 Wooden Chaires 1 Chest of Drawers. 2 Tables

03=06=6

In Mr: Mirande's Roome

a bedstead wth: a Sacking bot=tom, a checkerd Linnen furniture, a fether bed, boulster & pillow. one holland Quilt 4 blankets. a Callicoe Quilt 5 Caine & 2 Leather Chaires 3 Cloath's Presses. a Table ye: hangings. a Closs Stoole & pan a blowe Grate. fire Shovle tong's poker the Bellowes & Brush

07=10 0

18=17 6

M: Antonie

In the Late Dukes Apparts:

In ye Closet a Dressing Chaire. an Elbow Caine Chaire & 3 Cushions a Green Silke Door. Curtaine Valion & rod. a White Damask Window Curtaine & Valion & pullie rod a Wallnut=tree Chest Lined wth: blew Silke:

In ye chest: a culgee Quilt, a Spriged Sattin Counter=poynt, one Persian Quilt, a Green Silk Twi=Light, a Callicoe Ditto a Grey Silk counterpoynt a Spotted Callicoe Twilight a Sad Couler Silk Quilt a Grey flannel counter poynt a Small Sattin boulster & pillow. a Chimny Glass a Stove Grate. fire Shovle tong's & poker

14=15=00

In his Grace's Bed Chamber

a bedstead wth: Lath bottom Plad ffurniture Lined wth: Gawze. 4 Mattresses Quilts a Sattin boulster filled wth: Downe hangings of Plad & Silk 3 Caine Chaires. & Cushions one Caine Squab & Stoole, 1 Round Stoole. 2 plad Window: Curtaines, Valions & rods, Strings: & tossils. the Dutchess of Massarren's Pickture. a pair of Wallnut=tree Stands. a Stove Grate & fender fier Shovle tong's, poker & brush

18=12:0

33=7

M: Antonie

In the Drawing Roome

A Crimson Cloath Easy Chaire. 6 Caine Chaires and Cushions. y^e Camblett hangings. 2 Window Curtaines Valions, & pullie rodes a fire skreene, a Carde Table a Japan'd Chest, a Chimny Glass. a Stove Grate, fender fire Shovle tong's, poker bellow's & brush, a pair of Standes. an olde serge Curtaine & 4 picktures.

21=05=00

In the Anty Chamber

6 Caine Chaires & 2 Stooles Dit^o: a Cained Table an Indian Skreene a pendulu‾ Clocke. 2 Window Curtains Valion & rod. a Cloathes Press a Peire Glass a Stove Grate & fender a fire Shovle tong's Poker & Brush

21=04=00

In the Vestibulo below Staires

2 Marble Tables, 2 Caine Coutches, 3 Large Lant=hornes

13=10=0

55=19 00

M: Antonie

In the Painted Stone Hall

5 fflower peices P^r: Baptist a p^ce: of Moses. a Hercules M^r Winwoods Pickture Quen Mary by Vandyke a Man & Woman 2 p^cs: p^r: Moro: 2 p^cs: of Burdan a Venetian Woman p^r: Pau=lyn Quen Mary p^r: Holbin a Little p^ce: by Brassan 12 Leather Chaires a Marble Table a Long Walnut=tree Carde Table. a blew Damask Skreene 2: Wain=scott Tables, 2 Matts, 2 Serge Window Curtains & Valions, 2 pully Rodes 3 Caine Stooles, a Chimny Glass. a paire of Doggs fire Shovle tong's. belows & Brush

198=07=

In the Paynted Roome next the Stone Hall

11 Caine Chaires, Damask Cushions & Serge Case's. 4 Elboe Chaires Stuft Damask & Serge Cases. a Walnuttree Scrutore a Dutch Table, a Large Marble Table 5 p^cs of Tapestry Hangings q^t: about 115 Els: 19=6=0 2 pair of White Damask Windoe Curtains Valions & rodes: a Chimny Glass a Large Lookeing Glass. 3 picktures a fire Skreene a pair of Doggs fire shovle tong's below's & brush

181=13=0

399=6

M: Antonie

In the Corner Roome East Warde

3 Large peices p^r Luca Jordana, 2 p^cs: p^r: La Force 2 Doore p^cs: & Chimny p^cs: p^r: Baptist: hangings of the Roome of blew Velvet & Stript Silk. 6 Arm'd Chaires & Seette Ditto. 4 Velvet Round Stooles. a fire Skreene.

a Buro. a Large Looking Glass with a blew Glass frame a Marble Table. a pair of Large Guilt Stands ~~2 Indian Gilt Cabinets~~ a Strong box, a Chimny Glass. 5 pair of Damaske Window Curtains & Valions q^t: 125 yards & rods a Steele Hearth & Doggs. a fender, fir^e Shovle tong's & brush a Madona a peice a Coppy of Burdoe's

250=10

250=10

M: Antonie

In the Roome next y^e Corner East Warde belowe Staires

A Crimson Velvet Bed Lined w^th: Embroydered Sattin Compleat. & a Case of fflorence Sasnett a fether bed & boulster, a Checkt Mattress. a Sattin Quilt Holland fashion 3 blankets. 11 Chaires w^th: Velvet & Shalloon Cases 3 p^cs: of Tapestry Hangings Containing 120 Ells ~~a Scrutore~~: a hanging Glass w^th: an Inliade frame. a Table & Stands Dit^o: w^th: Ben Gall Cases 2 Door peices & Chimny p^cs: p^r: Baptist: 2 pair of Window Curtains & Valions & 2 Pully Rods a Chimny Glass a fire Skreene ~~a Small Indian Table~~ Steele Hearth, Dogg's, ffender, fire Shovle Tonges poker below's & Brush

285:08=

285-8

M: Antonie

In the Roome next y^e Stone Hall

2 p^cs: of Tapestry 90 ells 3 Door p^cs: & Chimny p^cs: p^r: Baptist: an Easy Chaire Cover=ed w^th: Needle worke & a Green Serge Case. a Large hanging Glass w^th: a Gilt frame. a Table & Stands Di^o w^th: bengall Cases, a fier Skreene. ~~a Cabinett Inlaid w^th: Mother of Pearl:~~ 2 p^r: of Greene Silke Window Curt^s: Valions & Rods. a Stove grate fender, fire Shovle, tong's Poker & brush. 6 Greene Velvet, back Stooles. two fier Skreenes. Covered w^th: Sky Damask, a Chimny Glass

170-17

In the Stone Hall

12 Leather Chaires. four Marble Tables. 3 p^cs: of Tapestry q^t: about 90: ^ells of: Hero & Leander 2 Glass Sconces. a fier Skreene a Stove, fender, fier Shovle, Tong^s: Poker & Brush a Pickture of King Charles 2^d: 4 Doore p^cs: p^r: Baptist 2 hanging Glasses, wth Glass frames. 6 Caine Chaires w^th blew Damask Cushions: 3 paire of Window Curtains of Serge

136=8=

307-05=0

M: Antonie

In the Roome next y^e Stone Hall West End belowe

6 p^{cs}: by Reusau. 2 Doore p^{cs}: by Baptist. the Mohair hang=ings. 10 Needle Worke & Velvet Easy Chaires. a Looking Glass in a Silver frame. a White Marble Table, wth: a black border & Gilt frame a fier Skreene. a fier Shovle tonge's Poker below's & brush: a black Japan'd Plate Case wth: Glass Doores. a Chimny Glass a hanging Glass in a Black frame

211=15.0

In the Roome next y^e Corner D^o:

5 Peices of Tapestry; Psyche a Needle Worke bed lined wth: a yellow Damask. a Crimson Shalloone Case & Rod. 6 Arme Chaires Di^o: wth: Loose Cases 2 Easy Chaires Ditto. 2 Door peices p^r: Baptist. a Looking Glass in a Silver frame. a Table & Standes Ditto., 2 p^r: of White Damask Windo Curtains. Valions & Rods &c a paire of Dogg's a p^r: of Smal ones Ditto: a fire Shovle tonges & Poker D^o: bellows & brush a Chimney Glass. a hanging Glass in a black frame: a Table & Stands Ditto: a fether bed & boulster. a Mattress a holland Quilt: 2 blankets a fier Skreene

278=14
16=6

506=15 0
M: Antonie

In the Corner Roome

The Greene figured Velvet hangings. Eight Chaires Ditto fourteene flower p^{cs}: by Baptist a Large Lookeing Glass wth: a Glass frame a Large White Marble Table Edged wth: black 2 Stands Carved & Gilt a fier Skreene Sett wth: pearle 2 Looking Glasses wth: Inlaide frames. 2 Tables Ditto: a Stand of Mother of Pearle an Indian Cabinett; an Indian Skreene. 2 paire of Dogg's a fier Shovle. tonges and Poker. a Long fender. 5 pair of White Damaske Windoe Curtains. Rods & Line &c

283:03=0

283=03
M: Antonie

In the Lady's Bed Chamb^r

A Bedstead wth: Payned Dam=ask furniture. trimed with Gold & Silver fringe. Case & Case Rod. 4 peices of Tapestry Hangings Containing about 142 Ells. 8 Chaires & 2 Round Stooles the Same as the Bed. with false Serge Cases. an Easy Chaire Cover=ed wth: Greene Damaske & Silver Silk and a Shalloone Case. 2 Door peices by Baptist. a fether bed & boulster. a Mattress Quilt a Holland Quilt a Sattin Quilt, Mattress fashione: a Looking Glass wth: an Inlaide frame. a Marble Table 2 White Damask Windo'e

Curtains, Valions, & Cornish's a Stove grate & fender, fier Shovle tong's, poker& brush a Watch Clock

191=09=

In the Darke Closett adjoyning to the Dutches's bed Chamber

Three Wainscott Presses

06=15=

198=04=0
M: Antonie

In the Lady's Closst

3 Square & 2 Round Stooles a Pannell of paynted Glass a Chimny Glass 2 Dogg's fire shovle tong's & brush 1 Dutch Elbow Chaire a paire of White Damask Win=doe Curtains, Valions & pully=rod D. ~~a Tortoise Shell Inlaid Writing Table.~~ a Dutch Table a pair of Small Standes 3 flower p^{cs} p Baptist.

42=16=

At the foot of y^e Great Staires

4 Marble Tables, 2 bayes Curtains & r^ods. 4 old Curtains & 2 rods. ~~3 Large Brass Lights~~

16:05-

In the Roome over y^e Little Stable

2 bedstead's wth: Sacking bottom's, & blew Serge furniture, 2 fether beds, bolsters & pillow's 2 check Mattrisses. 8 blankits 2 Callicoe Quilts, y^e hangings of the Roome of Old Tapestry 5 Caine. 1 Leather Chaire & a Cushion; a Cloathes press. a Stove grate, & fender, a fier Shovle tong's hookes, belows & brush. a Wainscot Table

11:19=

71=00=0
M: Antonie

In the first Roome in the Passadge at y^e East End below Staires

1 Caine Chaire. 2 Tables one Press a parcell of brushes, Sives & hand bowles, 3 Copper pre-Serving panns. 1 bell: Metal Mortar, one boyleing pott & Cover. 1 Coffe boyler y^e top of a Still. 1 Standeing, Candle Stick Some Iron barrs in y^e: Chimny & a fender. a Copper wth: Iron Worke, Lead & Cover. Some Lead Weightes

08=02=6

In the Coffe Roome

2 Caine & 1 Matted Chaire. one Wainscot table. a grate fier Shovle, tong's, poker & 2 pott:hangers. 5 Sauce pans, 1 Stew=pan & cover. a chocolate pot 2 Coffee potts. 1 fier pan, a Tea boyler & Lamp. a paire of brass Scales,

2 Candle Stickes 2 Iron Stoves, a Wafer Iron 1 Large Stew pan 5: Slices a Large Deale press an Iron Oven Lid & a parcel of tinn & Earthen Ware.

<div align="right">05=03 6=</div>

In the House Keepers Roome

A bedstead & Serge furniture a fether bed, boulster & pillow a Check Mattress, 3 blanketts a Callic^{oe} Quilt. 4 Caine Chairs, 1 Stoole 2 Tables. a Grate, fender, fire Shov^{le}: Tong's poker, bellow's & brush. a Glass, y^e Tapestry Hangings & 4 Presses

<div align="right">12:03=</div>

<div align="right">**25:09:**</div>
<div align="right">*M: Antonie*</div>

In Mr Colley's Roome

a bedstead & serge furniture a fether bed, bolster & pillow, 2 Mattresses 3 blankets 1 Callicoe Quilt. 4 caned chaires, 2 armed Chaires. 2 serge Window Curtains & Rod. one Table. 1 bell. one Stove grate fender, fier Shovle tong's poker. bellow's & brush a Wainscott Press

<div align="right">13:18</div>

In the Batheing Roome

4 Dutch Tables, 3 Cane Stooles 18 prints. a Stove Grate. fend^{er}: fire Shovle tonges & poker a Batheing Tub: 2 Cain Sashes

<div align="right">06 09=</div>

In the Gilt Leather Roome & Clossett

7 Dutch Chaires, 2 List bottom Chaires, 3 Cane stooles, a Marble Table, a Wallnuttree Table a Large pannel of Glass. Gilt Leather hangings. a Chimny Glass. 4 peire Glasses. a Stove Grate & fender. fire sho::vle, tonges poker, below's & brush

<div align="right">53=11=</div>

<div align="right">**73:18**</div>
<div align="right">*M: Antonie*</div>

In the Grate Dineing Roome

26 Picktures in Gold fram's 6 Glass Sconces, a Chimny Glass. one Black marble Table. 1 Small ovel Table, a Blew Broachadille Couch. & Cushion. 13 Liste bottom Chair's 1 Red Silke Cushione, 1 Armed Leather Chaire. 2 Needle Worke D^o: 1 Gilt Leather Skreene. a Stove Grate & fender. a fier Shovle tong's poker bellows & brush a Marble Cistron & Stand.

<div align="right">155=17=6</div>

In the Confectioners Office

5 Old Cain Chaires, 1 Old Armed Chaire Stufed, 3 Ovill Tables a Stove Grate, 2 fire Shovles 2 p^r: of tong's. 2 pokers & 2 Trevetts: 23 fruites basketts. a Wainscot Cupboard, a Stuf Curtaine & Rod. a cane Sash a Leaden Cistron, a Copper Stove 2 Copper preserveing pan's, a Marble, Mortar & Pestile, a Square Table, a Copper Stew 19 Chamber potts, an Old fier pan. 12 Sweat meat boxes. a parcel of tyn things

<div align="right">11=18=0</div>

<div align="right">**167=15 6**</div>
<div align="right">*M: Antonie*</div>

In the Pantry

2 Caine Chairs. 1 Leath^{er}: Chair 1 plate Chest. 1 Candle Chest, 1 bread binn. 1 Iron Chest. 1 Hair Safe. 3 Glass basketts 6 Voiders. 1 plate Iron, 2 Wain=Scott Tables, one Cistron, a fire Shovle tonges & pocker a Grate & fender, a fether bed & bolst^{er}: one Mattress one holland Quilt 3 Rug's. 2 blankets. y^e printed Curtains & rod. a Cistren in the Cellar. 2 bottle racks and Stillings

<div align="right">19=6=6</div>

In the Little Roome over against y^e Pantry

One Wainscot press, 1 Marble Table. 1 Leaden Cistron. 2 Large Chestes. a Cupboard Table Covered wth: Greene Cloth 1 Caine & 2 Matted Chairs 4 Wooden Chairs. 3 trunkes 4 boxes & a parcel of hampers a pair of Scailes & beam's, & 49 ^{lb.} in Leaden Weigh^{ts}: an Old brass Kettle. a Knife Whetter, Some tyn things, broken Chares & Lumber

<div align="right">13=11</div>

<div align="right">**32=17 6**</div>
<div align="right">*M: Antonie*</div>

In the Roome next y^e Pantry

12 Dutch Chaires with Dam=ask Cushions & serge Cases 1 caine chaire cushion & Case 1 Easy chaire & case, one Ovall Wainscott Table, one Marble Table. one hanging Glass wth: a Glass frame. a Chimny Glass Ditto. 2 Large Sconces Ditto. a pendulum Clock. a Stove Grate, fend^{er}: fire Shovle tonges & poker another Stove Grate, fend^{er}: fire Shovle tong's and poker Some Wainscott boards & a Dutch Table.

<div align="right">19=6=6</div>
<div align="right">19=05=00</div>

In y^e Ston^e Hall at y^e West End below Staires

a Caine Coutch. 2 Marble Tables. 2 Round hanging Glasses, wth: Gilt frames, 1 Oval table. 1 Carde Table. 3 Elbow Caine Chaires. an ~~Elbow Leather D^o:~~ 14 List

bottom Chaires. 1 caine chair a Pendulum Watch Clock & Stand. a Damaskt Leaer: Skreene 1 square cain stoole a Stove Grate & fender fier Shovle poker tonges, below's & brush a Chimny Glass 2 cushions a Weather Glass a fire Skreene. a Marble Cistron. a Greene Serge Curtaine & rod. 2 peire Glasses in ye Volary the Matt round the Roome

53=16=

92=07 6

M: Antonie

In the GentleWoomans Dineing Roome

12 Prints, an Oval Table a Black table. 12 black Lea=ther Caine Chaires. 1 Leather Skreene. a Stove Grate a Carpitt. a Wooden Cistron

05=17=00

In the Stewards Closett

a paire of Harpsicalls 4 Cain & a Velvett Elbow Chaire, 2 Tables, a Buroe a round Stoole a paire of Windo Curtains, Valions & Rode. 2 White callicoe Curtains Valions & Rod

19=07=

In the Little Marble Roome In the Passadge

2 Large Ovill Tables, a Leaden Cistron

03=05

In the Stewards Roome

A Table. 12 caine chaires a Grate a fender Fire Shovle & tong's

02:4

30=13=0

M: Antonie

In the Scullery

16 Dishes, 6 Dowzen of Plates. 8 pewter Covers 1 Pasty Plate. 1 bed pan 4 Coper Cistrons. 1 Coper wth: an Iron frame. 5 sauce pans. 1 Coper =Drinking=pot, 1 Coper fountaine. 2 Coper Choco=late potts 1 Coffee pot 1 Slice. 1 pair of snufers, a Dish & Extinguishere. 1 pair of Snuffers & pan. 1 Warming pan. 10 hand Candlestickes. 1 Cullinder & Cover 1 Lead Paile 20 Standing Candlesticks a Stove grate. a fender fire Shovle tonges & poker 1 plate heater. 1 Old Skreene 2 plate frames 4 Wooden, 1 Cane & one Stuf Chaire. 2 formes 2 Tables. 3 baskitts Lin'd wth: tyn: Some tyn Ware 3 payles. 1 hand boule & some Wooden Ware a bedstead. a fether bed & boulster & 2 blankits

21=04=6

21=04 6

M: Antonie

In the Greate Landery

6 Wooden & Mated Chaires 1 Long Ironing Table. 2 Small Tables. 1 Large Cupboard 2 Horses. one pr: of Steps, 2 Large Grates. 2 fenders. 2 Pokers. 1 fire shovle one pair of bellows. 2 Iron backs. 1 pottadge pott 3 sauce pan's. 1 fryeing pan. 1 Gridiron. 1 Trivitt 2 box Irons. 27 flatt Irons 2 skillets. 1 Coper pott. 7 Treenchers, 1 Large press for Cloathes, wth: screws 1 Coffee Roaster. 1 press. 1 paile. a piggin & boule 4 standes for Iron's, 1 Iron scuttle. 2 pewter Dishes. 9 Drieing poles a Leaden sinke. 5 cloathes flaskets. a pr: of tong's

11=12=

In the Grate Wash House

2 Copers, Iron Worke & Lead 2 Leaden Cistrons. a rainge an Iron back, tonges fire sho=vle, poker & hanging Iron. 12 Washing tubbs. 2 pailes. 2 small tubbs. 2 barrows: 5 baskets. 1 Horse. 1 Trough. 1 Cuppoard a Table wth: Iron feet one forme

16=01 0

27=13=0

M: Antonie

In The Little Landery

2 Little Tables. 2 Old chaires. 1 horse. a Grate & fender. a fire shovle & poker. a hanging Iron. 1 Gridiron. 2 Iron Back's 1 pr: of bellow's; 1 Iron skutle 1 forme 3 stand's 3 Candle=sticks. 1 pair of snufers & stand. 1 saveall 3 basketts 1 Cane stoole 1 Cupboard

01=18=0

In John Hensons Roome

A Press bed, a fether bed & boulster. a Mattress. 3 blankets. 1 rug. a flock bolster. a Cuppoard 1 Table. 4 Old chaires. 1 Grate a fire shovle. poker & fender

03=13=00

At the Entrance to ye Room

A Large Cistron cased wth: Lead. a Lead sink a Coper & Iron Worke

08=00=00

13=11=00

M: Antonie

In the Kitching

A Large Rainge and Iron back a fender. 2 Large Spitt=rackes 2 fire Shovles 2 pokers, a pr: of tonges & 4 plaine Rackes, 10 Spitts wth: Iron Wheeles. 1 hand Spitt. 2 Larke Spitts 2 Choping Knives 1 Cleaver a Large Jack. Chaine & weitt: & a Large Wheele. a Clock & Case: 9 stoves. 8 Trevitts. 3 Iron Candle stickes. 2 house=wifes & 2 rodes.

a Large Gridiron. 1 beife forke. 2 small shovles. 1 Iron
frey=ing pan. 10 boyleing potts & covers. 1 Ditto. 6 sauce
pans 14 toffe pans. 3 cullinders 5 stew pans. 2 fish pan's
& 1 Cover one Dutch oven & 1 odd Cover. 1 puding
pan 6 patty pan's. 1 fish plate 4 Joynted Kandlesticks.
4 Ladles & 4 Skumers. 1 pestle & Mortar. 1 Large Coper
Drinking pott. 1 Leaden Cistron. 1 Marble Morter &
pestle. a round block & a Large table: a Large Grate &
Cheeckes. an Iron Back. 2 old Rackes. a Coper w^th:
Iron=Worke & Cover, an Old Sauce pan. part of an
Old Dutch Oven, 3 payles & a Coper Dripping pan
2 Iron backs 2 formes

<div align="right">37=12=6</div>

<div align="right">**37=12 6**
M: Antonie</div>

In the Lardery

A Wainscot press & 2 pye Peiles, a parcel of
Earthen & Wooden Ware, a Large Choping block &
a Step Lather

<div align="right">01=10=00</div>

In the Pastery

2 Peiles. 1 Rack. 2 Ovin Lids 1 forme

<div align="right">00=07=00</div>

In M^r: Crosiers Roome

a bedstead w^th. a Doble Sack=ing bottom. a Green
print=ed furniture. a feather bed & boulster a check
Mattress & Rug. a blankitt 6 old chaires. hangings to the
Roome. a Table a Wainscott press a Stove Grate & fire
Shovle

<div align="right">04=15</div>

In the Kitching=Maides Roome

a half headed bedstead, a matt & corde & cloth furni=ture.
a fether bed & bolster 2 blanketts. 1 Rug. a Table bed-
stead. a fether bed & bolster 1 blanket. 1 rug. 1 Skreene,
1 Cupboard. 1 Table 2 Chaires. 1 Stoole. barrs In the
Chimny

<div align="right">04=05=6</div>

<div align="right">**10=17=6**
M: Antonie</div>

In the Landry Maides Roome

2 Bedsteads matts & Cordes, w^th: blew stuf furniture's.
2 feth^r: bed's. 2 boulsters & 1 pillow. 7 Bla^nkets, 2 Rug's.
2 Wooden & 3 Old Stuf Chaires. y^e barrs In the Chimny.
a pair of tonges & 1 Table

<div align="right">05=05=</div>

In the Wett Landery

a pair of scales & beam 1^lb ? of Lead Weights a salting
Trough lined w^th: Lead. a cupboard. a hanging shelf &
Irons. 1 powdering Tub.

<div align="right">03=19=</div>

In the Servants Hall

2 Large tables. 4 formes a Grate & 3 Coper potts

<div align="right">02=10</div>

In the Porters Lodge

2 musketts. 2 fowleing p^es: 5 blunder busses. 1 case of
pistolls. a stove Grate a bedstead, mat & corde: a fether
bed & boulster. a hair mattress. 4 blankets. a rug, a Table
& an Iron pale

<div align="right">06=17=6</div>

<div align="right">**18=11=6**
M: Antonie</div>

In the Servants Lobby

2 Table 2 formes. a Large Rainge. a fir shovle & Trevitt
and ~~easy~~ Chaire case

<div align="right">02=00=00</div>

In the Coatch-mans Roome

3 half headed bedsteads, mats & cordes. 5 fether beds.
5 boulsters. 6 blankets 3 rugs 3 Tables. 1 old table,
bedstead, a grate fire shovle & poker

<div align="right">11=00=00</div>

In my Lady's ffootmens Roome

2 half headed bedsteads 1 Table bed. 4 fether beds
4 boulsters 7 blankets 4 Ruges 2 chaires. 1 Table
1 Cupboard. 1 grate & fend^r:

<div align="right">07=15=</div>

In my Lord's ffootmens Roome

a Press bedstead; a feather bed, boulster & matts.
3 blank=etts 1 rug. 1 half headed bedstead matt & corde.
2 fether beds. 1 boulster. 3 blankets. 1 rug. 2 Tables. 1 cane
chaire & some old broken chair's. Some Iron barrs.
a fender & fire shovle 2 hand=Candlestickes, 3 Deale
Presses

<div align="right">09=11=</div>

<div align="right">**30=06:0**
M: Antonie</div>

Linnen

28 fine Damask Table=cloths 11: Douzen of Napkins D^o:
12 Damask Table Clothes 12 Ditt^o: 11 Doz^n: of Napkins
Ditt^o: 6 Huckaback. Table Cloths: 15 Damask Table

Clothes. 12 Old Ditto 12 Damask Table Cloths 18 Dyaper Side board Cloth's 16 Ditto: 6 Ditto Worse 12: Ditto very bad 30 small Ditto 44 Douzen of ordnary napkins 4 paire of Dimmity sheets 2 Damask Window Curtains 2 pare of holland sheetes 3 paire Ditt°: 4 paire Ditto & 4 pare Di°:, 27 paire of Gentlemens sheets 6 paire Ditto: Worse 62 Gentlemens Towels 22: Caps: 110 corse Towels 6 servants Table cloths 39 Round Towels ~~cloths~~ 4 Douzen of Oyster Clothe's 7 Glass Clothes 33 holland pillow beires 56 corse pillow beires 51 pair of ordinary sheets

<div align="right">163=07=</div>

<div align="right">**163=07=0**</div>

<div align="right">*M: Antonie*</div>

In the Stable yarde

1 Large bottle racke 1 leaden Cisterne

<div align="right">05=10=00</div>

In the Cloysters

84 Leather bucketts 1 Large Glass Light 6 Wainscott Settles 10 Irons for Lanthornes

<div align="right">20=6=00</div>

In yᵉ Staire Case & Passadge

18 Glass Lights 3 Caine Coutches & a press

<div align="right">06=03=0</div>

In the Lumber Roome at yᵉ East End

19 Glass Lamp's. 2 old Chestes. 2 Tables. a Stove=Chimny. a Leafe of a Table a Workeing board and trassel's a frame & poles. a Table frame: a Settle bed: four Umbrelloes & a parcele of Lumber

<div align="right">07=07=</div>

<div align="right">**39=06=0**</div>

<div align="right">*M: Antonie*</div>

In the Warderobe

In the first Roome on yᵉ North East side

12 Dutch Chaires 1 black Caine D°: 8 small caine chaires. 4 paire of brass Dogg's: 1 paire of Iron Dogg's. 3 pair of brass tongs. 2 fire shovles 6 brass sconces. 1 Ovil Table 6 pewter chamber potts. a Close stoole & pan. 4 Lant=horn's. 4 Leather: Portman=tuas, a fruite basket 3 bedsteads. a fire shovle & Tong's

<div align="right">09=17=</div>

In yᵉ: first Roome on the North Side

In yᵉ chest N°. 1

5 peices of fine tapestry with Little Boy's qᵗ
100 ells:

3 peices of Julius Ceesar
5 pˢ: of yᵉ Acts of yᵉ Apostles: 160 Ells
9 pᵉˢ: Julius Ceesar Cont: 235
3 pᵉˢ: of french Boores Cont 125
5 pᵉˢ: of yᵉ Acts of yᵉ Apostles 255
6 pᵉˢ: of yᵉ Grand Pryor Cont: 165

<div align="right">787=10</div>

N°: 2: 7 pᵉˢ: of Landskipe Cont. 144=
5 pᵉˢ: of Sussanah Cont 110 Ells
4 pᵉˢ: of Piramus & Thisbe Cont 110
2 pᵉˢ: of Landskips

<div align="right">50=10</div>

N°. 3:
26 Large & Small Carpets a Velvet side sadle & furniture wᵗʰ: broad rich Gold Lace a Checkt: & a holland Quilt, an Indian Tea Table

<div align="right">£ s</div>
<div align="right">123=8</div>

<div align="right">**971=05=**</div>

<div align="right">*M: Antonie*</div>

Cheste's Continued

N°: 4:
9 old Cushion seats: 14 Greate & small, Cushions.
1 Callicoe Quilt

<div align="right">05=09=00</div>

N°: 5:
a Crimson Damask Bed, a blew Camblet Bed & bed=Stead 2 Mattriss's, a Down bed & boulster 12 yellow Damask backes & seates for chaires: 4 sad coulᵉʳ Damask Window Curtains 4 Plad Window Curtains trim'd wᵗʰ: Blew. 7 Plad Widow Curtains 3 Valions, trimed wᵗʰ. Red

<div align="right">39=10=0</div>

In the Second Roome on the North Side

14 Elbow Chaires Uncover'd 6 stooles & 1 coutch Ditto 1 chest of Drawers. 2 Elbow Leather Dressing chairs. 3 peaʳle chaires a coutch & Cushion: 1 Red Indian box

<div align="right">28=12</div>

<div align="right">**73=11:**</div>

<div align="right">*M: Antonie*</div>

In the third Roome on the North Side

9 Stooles. 1 Wainscott Ovil table

<div align="right">03:12</div>

In the Presse Nᵒ: 1

180 yᵈˢ: of Damaske of severale sortes
284 yᵈˢ: of Dᵒ: small flowers
183 yᵈˢ: of ? Ditto
180 yᵈˢ: Ditto
295 yᵈˢ: Ditto
56 yᵈˢ of green florence
95 yᵈˢ: of cherry & white Damask
10 yᵈˢ: ? of crimson & Gold Velvet
11 yᵈˢ: of Red & yellow Ditto
8 yᵈˢ: ? of green and yellow Ditto
1 Blew Bear skin

232:14
78=15

315=01=
M: Antonie

In the Press Nᵒ: 2

A Greene Velvet Bed stript wᵗʰ: Needle Worke. 6 chair cases Dᵒ: 1 fire screen Ditto: 1 Callicoe Bed. ~~1 Grey Damask Bed trim'd wᵗʰ: Silver. 2 Chairs Dᵒ.~~ 1 Indian ash couler sattin Quilted Counterpoynt: 1 Cherry Dittᵒ. 1 Quilt. a Carpet wᵗʰ: sattin borders. a Callicoe Counterpoynt. 1 very fine Dᵒ: 1 Indian Dᵒ: 1 Large Dᵒ: 4 Sattin Ditto:

280=05

In yᵉ Press Nᵒ: 3

A Gawse head Cloth & Valions the Pearle Hangings 13 Needle worke backes & seats Made up: & 6 stooles Ditto

83=10=0

363=15=0
M: Antonie

In the Truncke

3 pᵉˢ of crimson flowered Velvet qᵗᵒ: 15 yᵈˢ: a blew Sattin quilted Counterpᵗ: boardered wᵗʰ. Silver Lace 1 Ditto: Crimson Ground wᵗʰ. Silver flowers & border Dᵒ: 1 Large Dᵒ: Embroidered wᵗʰ: Gold & cherry flowers 1 Red Velvitt Ditto one White Stitch't Ditto & pillows

58=15

The Gardners Roome

a fether bed & bolster, 3 blankets & 1 Rug

01=10-

~~Piktures in yᵉ wallnuttree Chest~~
~~4 Landskips: 2 peices:~~
~~14 Small peices~~

60=05=00
M: Antonie

In the Roome on the South Side

4 Coach Glasses a Large Ovile Table, 3 Close Stooles & panns. 1 Old Coutch. 4 Steele hearthes & 4 fenders 1 Stove Grate poker & fender 2 Old Tables. 1 Settee & Case 72 brass Lockes 21 Brass Boltes

114:07=

In the Second Roome on yᵉ South Side

an Iron Japan'd Cistron & Table, 2 Salvers Ditto 4 fether bed 7 bolsters 2 Plad curtains an Old long Tapestry Coutch. a Cane'd Settee & Cushion. a greene Serge Skreene. 3 Elbow Cane Chairs 3 back Stooles 2 Matt bottom Chairs. 4 Gilt Pickture frames. 6 Barbary matts. 2 frames of bedstead wᵗʰ: sacking bottom. an India Mat an Umbrello. 2 old blankets a Hooland Quilt. 6 Black Armed Chaires Stuft wᵗʰ: Haire

32=03=

146=10:
M: Antonie

In the Garden

16 millon frames wᵗʰ glasses 2 wier skreens 2 water tubbes a grind=stone 1 small engine a leather pipe 3 hand barrowes 6 wheel barrows 4 Iron bars 6 pr of straps 1 Coper wattering pott 48 trussell & frames 16 small ones 139 square mellon glasses 16 tubes with mirtles in them 81 earthern pots with mirtles in them; 20 Spanish Jessimies 45 money plans in potts 24 empty potts 16 Hollys in tubbes 8 lauratima 60 bayes on standes, 50 without stands 2 ditto 6 leaden flower potts 5 wooden seats 8 leaden figures one marble ditto 2 sund dialls & stands 2 marble pots with box trees in them 7 wooden Roulers 5 stone Roulers with Iron frames 2 with wooden frames one Iron Rowler one water tub in a barrow 4 wooden seats in the wilderness

£
370=00

All the Goodes in mountague house amounts to six thousand three hundred thirty three poundes sixteen shillinges and sixpence

370=00=0
M: Antonie

An Inventory of the Wine Syder and strong beer of the most Noble Ralph late Duke of Montagu in his Cellars at Montagu house on the 9th of March 1708. together with an Accot. of money paid for wine

	£ s d
3 hogsheads of Bordeaux	75:0:0
1 hogshead of Port	16:0:0
2 hogsheads of Syder	16:0:0
1 hogshead of Sack	20:0:0
2 Barrells of Strong Beer	6:0:0

Wine in Bottells & Syder in bottles

Doz: Bottles

Bordeaux		
18: 2	at 20d p bottle	20:3:4
Burgundy		
7:4	2s 6d pr Bottle	11:0:0
Hermitage		
4:0	3s pr B.	7:4:0
White wine		
10:10	2s pr B.	13:0:0
Sack		
34:0 pints	1s pr. P.	19:18:0
Frontinmark		
1:6 pints		1:2:6
Ordinary Clarett		
17:8	at 1s 4d p Bottle	14:2:8
Syder		
22:6	at 6d B.	6:5:0
Rhenish		
13:6	at 2s p B	13:4:0
		85:1:0

Wine which came from holland (towards which was paid by Mr. Antouine as p his book of Accots from Michās 1708 to 9th of March following in page 6) to Mr. Gachon £84:1s:0d in the late Duke's life time which wine the psent Duke of Montagu has taken to his owne use.

323:0:6

Inventories valued & appraised by

~~M: Antonie~~ *M: Antonie*
~~Tho Swales~~ *Tho Swales*

No (3)
An Inventory of the goods of the most Noble Ralph late Duke of Montagu at the Cockpitt

In the Drawing Roome below

2 peices of stript Mohaire hangings 4 Matted Chaires with 3 old Cushions A Couch & Cushion of Mohaire one Elbow Chaire 1 stript muslin Curtaine A stove fire shovell tonges & poker 2 caned sashes a Caned chaire a Caned stoole 1 Needle work stoole 1 Chimney glasse 1 Peer glasse a Card Table

£ s d
8:13:0

In the next Roome

Strip't Mohaire hangings 5 matted Chaires 1 strip't muslin Curtaine 1 square Table 1 Dutch Table A stove fire shovel tongs & poker bellows & brush 1 Chimney Glasse 1 Caned Sash

7:10:0

In the Dining Roome

Guilt Leather hangings & 10 Caned chaires two Caned Sashes a Marble Table A stove fire shovel tongs & Poker A Peer glasse A Chimney glass a Watch Clock

23:10:0

Foot of the staires

2 Caned sashes, 2 Caned stooles

1:5:0

In the Passage

A Cupboard & 3 Caned Stooles A Stone Bason

1:16:0

In the little Kitchen

Barrs in the Chimney Tongs Poker fender and Bellows. Two Chairs & a Table A Cisterne

Carried over **45:16:0**

M: Antonie

No (3)
Brought from the other side —

£ s d
45:16:0

In the Kitchen.

A range fender ffire shovele tonges poker a pair of spit Racks a Crane a Jack Two Brass potts 3 Sauce pans 3 spits 11 Dishes 9 plates a leaden Cistern 2 Copper Cisterns

8 Brasse Candlesticks 1 Chopping block a square table
2 ffish Kettles A Brasse Firepan 2 ffrying pans a Dripping
pan A Lamp Stand

11:8:0

In the Garrett

A Corded Bedstead A Mattress A ffeather Bed & boulster
3 blankets A Callico quilt & stuff furniture hangings to the
Roome 1 Caned Chaire & one Caned stoole

3:5:0

Linnen

2 Damask tablecloths 5 Diaper Tableclothes 3 fflaxen
Pillow bears 4 Dozen & ? of Diaper Napkins one Dozen
& ? of Damask 1 Dozen of huckaback Towells 7 pair of
Coarse sheets

8:0:0

Little Roome at the Staire head

A Corded Bedstead and Stuff furniture A ffeather Bed &
boulster 3 Blanketts & a Rugg

2:5:0

Bed Chamber above

Velvet hangings a Couch a Double chaire covered with
stript silk & a peice of hangings Ditto 2 Muslin window
Curtaines A Steele hearth A pair of Dogs fire shovel
tonges Bellows & brush 2 matted chaires & Cushions a
Chimney glass a peer-glass. A Black card table 4 round
stooles

16:5:0

Carried over **86:19:0**

M: Antonie

Nº (3) Brought over £ s d
86:19:0

Drawing Roome

6 matted Chaires with green Damask Cushions. A Double
Chaire 2 Muslin Curtains A Stove Fire shovel tonges
poker fender bellows & brush A piere glass. A Chimney
glass A Cedar Table

12:2:0

Two Carpetts 6 Worke stooles needle work for an Easy
Chaire for 5 Chaires backs & seates & 1 stoole 11 Brass
lockes

19:3:0

Two Pictures

10:0:0

£128 4 0

All the above menconed goods are valued at one hundred
& twenty eight pounds & four shillings by us.

~~James Gronouse~~ *James Gronouse*
~~Robert Haynes~~ *Robert Haynes*

M: Antonie

Dono Somers eat &
Duc Montagu } 19 July 1711 The Inventory on paper
writeing contained in this and the two precedent sides or
pages was produced and showed to James Gronouse at
the time of his Examinacon before me

Tho: Pitt

And was then also produced and showed to Robert
Haynes at the time of his Examinacon before me

Tho: Pitt

[Inventory of Montagu House, Bloomsbury, London, 1733]

Garrets.

1 South East Corner Garret.
2 Closet on the right hand.
3 South East corner Garret
4
5 North East corner Garret.
6 Next west of 5.
7 Next west of 6.
8 Oposite to 7 South
9 East of 8 And West of 3
10 South west corner Garret
11 1ˢᵗ. Garret on Right hand, on west Stairs
12 South Closet on the West End
13 North Closet on ditto
14 Room next to 12 & 13 East.
15 Room next to 14 East.
16 Room next to 15 East.

2ᵈ Story

17 Little Lumber Room, a Bedstead in it.
18 Great Lumber Room. Floor took up.
19
20 North East corner Room. Surveyers Room.
21 Next to 20 West.
22 Next to the Salon East.
23 Salon.
24 Next Salon South, or Fall of Phaeton.
25 Next to 24 East.
26 Next to 25 East.
27 Next to the Salon West.
28 Next to N.W. corner Room East.
29 North-west Corner Room.
30 Nursery.
31 Mʳˢ. Palmer's Room.
 West Wing 2 pʳ. Stairs.
32 Mʳˢ. Goldstone's Room.
33 Mʳ. Burton's Room.
34 Mʳ. Reason's Room.
35
36 Footmen's Room.
7
38 Caddy's Room.
39 The Cook's Room.
40

East Wing, 2 pʳ. Stairs.

41 Mʳ. John Booth's Bedchamber
42 Jos: Allen's Bedchamber.
43 Mʳ. Sam. Booth's Room, North

44 Ditto Bedchamber
45
46
47
48

Principal Story.

49 Late Duke's Apartmᵗ. next yᵉ. Stables.
50 Dᵒ. next Room North.
51 Ditto next Room North.
52 Dᵒ. next to the corner Stairs.
 Great house.
53 Blue Mohair, or next n:e. Corner, South
54 North East corner Room.
55 Next Room, west.
56 Next to North Hall, East.
57 North Hall.
58 Next North hall, west.
59 Next to N:W. corner Room, East.
60 North west corner Room.
61 Next dᵒ. South or her Gr. Dress: Room
62 Closet next her Grace's Dressing Room (East.
63 His Graces Plugg.
64 South Hall.
65 Next Room East or Stone Hall.
66 2ᵈ. Room East from South hall.
67 Closet between 66 & 53.
68 Gilt Closet So: of her Gr. Dressiug Room
69 Gilt Leather Room, So: of Gilt Closet.
70 Dining Room.
71 Waiting Room.
72 Next to ditto South.
73 2ᵈ. next or his Gr. Dressing Room.
74 3ᵈ next, or Gilt Room.
75 Library.
76 Next Room South.

Ground Floor.

77 Dry Larder.
78 Kitchen.
79 Kitchen Boy's Room.
80 Woodhouse.
81 Wash-house.
82 Mangling Room.
83 Wet Larder.
84 Steward Hall.
85 Landry.
86 Scullery.
87 Next Room North.
88 2ᵈ. Room North.
89 Mʳ. S: Booth's old Office.
90 Late Duke's Dining Room.
91 Evidence Room.

92 Pantry.	1	9¼	5½
93 Small Beer Cellar.	2	7¼	5½
94 Confectionary.	3	6½	5½

Julius Cesar in Triumph.

95 Next to ditto, East.	1	9¼	6¼
96 2ᵈ. Next East, hung wᵗʰ. gilt leathʳ.	2	9¼	6¼
97 Closet East of 96.	3	9	6¼
98 Bathing Room.	4	8¾	6¼
99 Houskeeper's Bedchamber.	5	7½	6¼

Our Saviour & the Apostles.

100 Ditto outer Room.	1	8	5½
101 Store Room.	2	7½	5½
102 Sand Room.	3	6½	5½
103 Clerk of Kitchens Room.	4	5½	5½
104 Oil Room.	5	4¾	5½

Mark Aurelus the Roman Emperor.

105 Ale Cellar.			
106 Old Pantry.	1	4½	5
107 Next Room, west.			
108 Well Room.			

The Apostles course work the remainder of 5 peices in the Room next but one to the Library 73.

Little Room next Mʳˢ. Goldstones.

	1	5½	5
Nº. 1 a Single Plate Chimney Glass	2	5½	5
one hanging Pier Glass Sent to Ditton	3	5½	5
Three Frames of Ditto	4	3¾	5

Susannah.

A pair of old Glass Sconces	1	7¼	6
one Single Plate of Looking Glass without a Frame	2	5¼	6
a corner broke off			

Dutch Boors.

one Ditto a Pier Glass with 4 Plates	1	5¾	5¼
an old Carv'd Chimney piece of Wood	2	5½	5¼
an old Trunk, an old Chest, & a Table	3	5½	5¼
Mʳ. Goodison had some carv'd work out of	4	4½	5¼
the Room	5	3½	5¼

Vintage.

	1	5	4½

Boys & Baskets.

2 Empty

		yds.	yds.
	1	3¾	4
3 A Table Bedstead. 2 old Chests, 2 large brass Fenders,	2	1¾	4
one Large Japan'd copper Cestern, 2 Salvers ditto,	3	6½	4

Sad colour'd Velvet Hangings.

1 Table ditto, 80 Stands with tinn Sockets to illuminate the Great Stair-case, and Salon.

All these put in Chest Nº. 1 at the Newhouse

The Table Bedstead sent to Blackheath but 1 large Brass Fender, 1 sᵈ. to be in his Gʳ Bed Chamʳ but is not there now.

Chest Nº. 2

4 Old Lumber of different sorts.

	1	7¾	5
5 Chest	2	7½	5
Nº. 1	3	5¾	5
	4	5¾	5
	5	4¾	5
	6	4¾	5
	7	4	5
	8	3¾	5
	9	3¾	5

Julius Cesar. Sent to Boughton

Nº of Pieces	Ells wide	Ells deep	Tapestry Hangings.
1	8	6	
2	7	6	
3	6½	6	
4	6½	6	
5	4½	6	
6	4½	6	

Leander & Hero.

1	5½	5½	
2	6½	5½	Landskip out of their Graces
3	4½	5½	Bedchamber.
4	7½	5½	N°. 1 a 5 put in Chest N°. 5 at
5	3½	5½	the Newhouse
6			

1	2¾	4½	Landskip the remainder of 5 peices sent to Ditton
			Sent to Ditton

1	8	5¼	
2	5¼	5¼	
3	5	5¼	Forest of wild Beasts.
4	5	5¼	put in Chest No. 5 at the
5	4	5¼	Newhouse
6	5¼	5¼	

1	3¾	5	Image.

1	4	4	Landskip. Sent to Ditton

1	7	4½	Image.
2	4½	3	put in Chest N°. 5 at the Newhouse

1	4½	3	An old Peice of Grotesque Hangings.

N°. 3. *Carpets*

1	10¾	4½	Persian
2	7½	3½	Ditto
3	7	3	Ditto
4	5¼	5½	Turkey white Ground
5	8½	3¾	Persian
6	2	1½	Turkey
7	6¾	6	Persian
8	3¾	3	Ditto
9	4½	4½	Ditto
10	5¾	3¼	Turkey
11	5	2¾	Ditto
12	6¾	3½	Persian
13	8	3	Ditto
14	3¼	3	Yorkshire
			a Craddle Carpet.
			All these put in Chest N°. 2 at the Newhouse

N°. 5 Chest N°. 4

1. A crimson velvet Bed lin'd with embroider'd Sattin with case Curtains of crimson Persian all compleat. *Good*
2. A blue Mohair Bed compleat. *Good*
3. A small crimson Damask Bed the Cornishes wanting the rest compleat. *Good*

4. A blue Cloth Bed compleat, 2 pair of window Curtains
 All these made into 4 Beds for the Newhouse 3 pieces of Hangings & Covers of 6 Chairs of the same.
5. Four peices of Hangings of India Sattin, and 2 pair of window Curtains ditto. *Indifferent & much Soil'd*
6. A Teaster Cloth of blue India Gauze with inside and-outside Vallens. *Good*
7. An India Sattin Carpet flower'd with Gold. *Good*
8. A head Cloth and inside Vallens of a buff coloured Damask Bed. *Good*
9. Four Covers of Chints for Backs, and 4 ditto for Seats of Chairs. *Good*
 All these things Except N°. 4 & 13 put in the same Chest at the Newhouse
10. Five Counterpains of different sorts. *1 Good 3 Indifferent & 1 Bad*
11. Two Bolsters & two Pillows of white Sattin. *Good*
12. A Needlework'd Bed compleat. *Good*
13. A yellow Damask Bed compleat with a Counterpain. Made use of in Hanging her Graces Dressing Room at Newhouse
14. A blue Camblet Bed from the Cockpit, compleat. *Good*
15. A plad Bed lin'd with Gauze (out of the late Dukes Apartment) compleat. *Good but soil'd*
16. A yellow Mohair Bed compleat.
 Sent to Boughton − not sent
 9 Backs & Seats of Yellow Mohair
 4 Pieces of Green India Damask

5 N°. 5

1. 1 Redstrip'd Silk Couch, & 2 Pillows ditto. *very old*
2. 1 Stript Mohair Couch & 2 Pillows ditto. *very old*
3. 1 Red damask Couch, & 1 Pillow ditto. *Good*
4. 1 Green damask Couch, & 6 Backs & Seats for Chairs ditto. *Good*
5. 6 blue Damask Cushions. *Good*
6. 5 Red damask ditto. *Crimson* *Good*
7. 3 Red velvet Cushions. *Good*
8. 1 Brocaded Silk Cushion. *Good*
9. 1 Green flower'd Velvet Cushion. *Good*
10. 2 Sad colour'd Cushions. *Good*
11. 4 Green damask ditto with yellow Lace. *Indifferent*
12. 5 Covers for Backs & Seats for Chairs of flower'd Silk. *Good*
4. 5 Peices of Stript Camblet Hangings, & 2 window Curtains d°. *Good*
5. 3 Pair of red & white chequer'd Stuff window Curtains and Valans. *Good*

} Made into 3 Beds for the Newhouse

7. 2 Red & white Stript Camblet window Curtains & Vallens. **Good**

8. 2 White Callico window Curtains & Vallens.
 Good

9. 5 Pair of white Camblet window Curtains & Vallens.
 Good

10. 1 Pair of blue Camblet window Curtains & Vallens.
 Good

11. 1 Pair of white damask window Curtains & Vallens.
 Good but Soild

12. 1 Green Taffity window Curtain. **Good**

13 2 Pair of dark grey damask window Curtains.
 Good

14 1 Pair of Ash colour'd damask ditto. **Good**
 All these things except Nº. 4 & 5. are put into Chest Nº. 3 & at the Newhouse

Room 5. Chest 5. *Continued*

15. 1 Pair of blue Serge window Curtains & Vallens.
 Good Moth-eaten & laid upon the Chest

16. 4 Peices of Stript Mohair Hangings. **Bad**

17. 3 Peices of Sad colour & black Velvet Hangings.
 Good

18. 3 Peices of Stript Silk Hangings. only 2 pieces **Good**

19. 8 Small peices of old Mohair Hangings. **Old**

20. 2 Green Cloth Carpets. **Good**
 Moth eaten & laid upon the Chest

21. 1 Red Counterpain. **Serge** **Good**

22. 5 Vallens of Stript Camblet. but 4 **Good**

23 2 Green Serge Cases for Chairs. **3 Cases** old

24. 2 Pair of green Taffity window Curtains. & *Vallens*
 Old

25. 2 Yellow damask window Curtains & Cornishes.
 Good

26. 2 Green Silk window Curtains to draw up.
 very bad

27. 1 Green Mohair Vallens with yellow Lace. **Good**

28. Several Sorts of old Lines for window Curtains.
 Very bad of no value

29. 12 Cushions for Chairs of green damask, and a Couch com=pleat ditto. **Good**

30. 1 Pair of plad window Curtains & Vallens.
 Good but Soild

31. 1 Pair of Stript Camblet window Curtains and Vallens, and a small Cushion of brocaded Silk. **Good**

32. **11 Green Damask Cushions & Cases out of Room 27**
 Good

33. **6 Backs & Seats of Needlework with red Serge Cases out of Room 28 Good In a Press in Nº. 67**

These things were not in this Chest

34 **2 Cushions of Needlework paned with blue Velvet out of Nº. 28 Good**
 ~~Sent to Ditton~~ they are in 55 wᵗʰ the Chairs

35 **4 Covers of Needlework & Cases of red Serge out of Nº. 28**
 Good
 2 are in a Press in Nº. 67, and tis probable that
 2 were sent to Ditton with 2 Chairs 24 May 1734.

1 White Damask Window Curtain & Cornish out of the Great Corner Room

2 Blue Serge Window Curtains & Vallens out of the Library

7 Small pieces of Stript Silk Hangings
 All these things Except 15. 20. 33. 34. 35. are put into Chest Nº. 3 & at the Newhouse

4 Blue Silk vallens

Chest Nº. 6

1. 14 Backs and Seats for Chairs of Needlework. **Good**
 2 ditto out of Room Nº. 96

2. 12 Covers for Stools of ditto. **Good**

3. 12 Peices of unfinish'd ditto **Good**

4. 2 Cradle Quilts of black Silk **very old**

5. 1 Large Quilt of Cherry colour Silk **Good**

6 1 Peice of black Silk **very Bad**

7 1 Cover for a Bed of white Serge. **Good**

8 1 India Ash colour'd Quilt. **Good**

9. Yard of yellow Damask.
 5 Yards us'd in covering the Posts of a Yellow Damask Bed

A Back & a Seat of a chair of Needlework out of Nº. 29.

A callico Quilt

A French Clock
 These thing are put in the same Chest & at the newhouse
 There were likewise in this Chest & put into it again
 3 Base Moldings for a Bed of blue Silk
 1 Counterpain & 3 Base Moldings for a Bed of green Mohair

Room Nº. 6

Seven old Bedsteads of different sorts.
 1 Sent to Ditton

7 A Settee of crimson Velvet embroidered with Gold and 4 Chairs ditto. **Good** Sent to Ditton

The Top of the gilt Phaeton, and the Supporter.

Several Teasters belonging to the Beds in the Wardrobe

8. [blank]

Room Nº. 9 *Bedding.*

No. Ft. In. Ft. In. [spelt out in full]

1 6 9 by 7 6 A Feather Bed. **Good**

2 6 — by 7 — Ditto & a Bolster. Sent to Ditton

No.	Ft. In.		Ft. In.	[spelt out in full]
3	6 6	by	6 6	Ditto & ditto

<div style="margin-left:2em">Made less & sent to Blackheath 17th June 1735</div>

4	3 4	by	6 3	Ditto & D⁰. the Bolster on the Cooks Bed **bad Ticken**
5	2 7	by	6 10	A Feather Bed. *Dimitty very dirty*
6	3 6	by	6	Ditto.
7	3 –	by	6 3	Ditto. **Good but Ticken dirty**
8	5 –	by	7 3	A hair check Mattress.

<div style="margin-left:2em">Sent to Ditton</div>

9	5 9	by	6 4	A Flock check Ditto.

<div style="margin-left:2em">To the Newhouse</div>

10	6 5	by	7 6	A Holland Quilt. To Ditton
11	6 3	by	6 10	Ditto. **Good** ⎫
12	6 4	by	6 11	A Holland Mattress. ⎬ To Ditton
13	3 –	by	5 9	A check Flock ditto.
14	6 4	by	7 6	A dimitty flock ditto. To Ditton
15	6 –	by	7 6	A hair check ditto.1 **Good**
16	4 4	by	6 5	A check Quilt. **Good**
17	3 8	by	6 11	A check flock Mattress.

<div style="margin-left:2em">To the Porter at the Newhouse</div>

18	5 –	by	6 7	A check ditto. **Good** ⎫
19	2 6	by	6 6	A check hair ditto.
				Good ⎬ To Ditton
20				Two holland Cradle Quilts. **Good** ⎭
21				Seven Bolsters of several sorts (there are but 6) **Good**
22				A window Seat. **Good**

An old Chest containing several odd
old window Cur=tains Lynes &c.

An old Chest containing a crimson ⎫
Harrateen Furni=ture for a Field ⎬ Remov'd into the
Bed, & a pair of Blankets. ⎪ Cooks Room
A Field Bedstead to ditto Furniture. ⎭

10 1 Indian Print. ⎫
41 Pictures of different sorts ⎬ In Room 72 & 49
16 Picture Frames of different ⎪
 dimensions. ⎭

11 A Portland Chimneypeice and Slab.
A Fire Stone Hearth and Stone Covings.

Room 12.

A small Dresser & Shelves.

13. An old Parrot Stand.

14. A Portland Chimney peice and Slab.
A Fire Stone Hearth & Stone Covings, and an Iron Back.
 The Back sent to the Newhouse
A Table Bedstead. *Sent to the Cockpit*

15 A Portland Chimney-peice & Slab.
A Fire Stone Hearth & Stone Covings, and an Iron Back.
 The Back sent to the Newhouse
A Dresser in the Closet.

16 A Portland Chimney peice and Slab.
A Fire Stone Hearth and Stone Covings.

17. Several sorts of old Lumber.

18. Sixty Eight old Sashes.
Four new Sashes.
Two old Glass Doors.
Ten rais'd Pannels with Bollection Moldings, 1 small ditto
 taken out of the new painted Room next the Library.
Two wallnuttree Frames for marble Slabs. In N⁰. 20.
Old Lumber of different sorts.
An old wainscott Chest
A broken marble Table with a carved black Frame.

Room N⁰. 19

Old Lumber.

20. A marble Chimney peice and Slab and an Iron Grate
 The Grate to the Newhouse, the Chimneypiece
 in 87

21 Empty.

22 Empty.

23. A marble Chimney peice and Slab.
An Iron Grate, Fire Shovel, Tongs and Poker. & a Fender
Three pair of Cloth Serge window Curtains. **Good**
Six round Stools covered with crimson Damask. **Good**
Six square Stools cover'd with ditto. **Good**
A Landskip over the Chimney by Russeau. at the
 Newhouse
 ~~taken down & put in the late Duke's Apartmᵗ.~~
Three marble Slabs in the Windows.
A Picture of Prince Wᵐ. over the Chimney out of Room 53
A Picture of Prince William over the Chimney out of
 Room 53

24 Three marble Slabs in the Windows.

Room N⁰. 25. Empty

26 A marble Chimney peice, and an old Grate.
 put in Room 87

27. A marble Chimney peice & Slab, and an Iron Back.
 The Back at the Newhouse
Two marble Tables with black Frames.
Two Japan'd Stands. (but 1) **broke**
Eleven cane Chairs with black Frames, and eleven green-
 damask Cushions & Cases to the same.
 the Chairs to the Newhouse **These Cushions in Room**
 N⁰. 5 Chest N⁰. 5
 the Cushions & cases in Chest N⁰. 3 in
 the wardrobe
Two Easy Chairs with Wallnuttree Frames covered with
 crimson ~~Damask~~ Velvit and trim'd with Gold Lace with
 Cushions and Cases to the same.
 Bad ~~Remov'd to 55~~ **To the Cockpit**
 29ᵗʰ. Decʳ 1736

28. A marble Chimney peice and Slab.
A Fine large Iron Grate with Tongs, fire Shovel & Fender.
 In the Salon N⁰. 23
Six arm'd Chairs of needlework with Wallnuttree Frames,
 the same work as the needlework'd Bed in the
 Wardrobe with Covers of red Serge.
 the Chairs in 55. Coverings in a Press in N⁰. 67
 The Chairs to the Cockpit 13ᵗʰ Decr. 1736
 The frames good These Backs & Seats in Room N⁰. 5
Four arm'd Chairs of needlework trim'd with blue Lace
 with wallnuttree Frames & Covers ᵒᶠ red Serge.
 The frames good These Cushions in Room N⁰. 5
2 of the frames to the Cockpit 29ᵗʰ Decʳ 1736
Two Easy Chairs of needlework paned with blue Velvet
 and Trimed with buff colour'd Lace with Cushions of
 the same and Covers of red Serge.
 The frames rotten These Cushions in Room 5
 ~~Sent to Ditton These are in Room 55. the 2ᵈ.~~
 ~~July 1735~~ To the Cockpit 29ᵗʰ Decʳ 1736
One marble Table with a black Frame. **frame rotten**
One Japan'd Table, part of the Frame gilt. **Good**
 To the Cockpit 24ᵗʰ Decʳ. 1736
A pair of Stands ditto. **Good**
 To the Cockpit 13ᵗʰ Decʳ 1736

[The following is written on a small note pinned to the
bottom right-hand corner of the folio.]

2ᵈ. July 1735 Memᵈᵐ. In Room 28.
6 Arm'd Chairs of Needlework &c.
 Chairs are in 55
 Coverings in a Press in 67
4 Arm'd Chairs of Needlework &c
 2 of the Chairs are in 55
 Covering of ditto in 67
2 Easy (or arm'd) Chairs of Needlework &c Chairs &c are
 in 55
 Tho' Mʳ. Reason makes 'em

sent to Ditton 24th May 1734 But it rather seems that 2 of
the 4 Chairs above were sent instead of them, because the
Frames are not to be found; And then the 4 Covers of
Needle=work & cases of red Serge, which were said to be in
Room N⁰. 5 Chest N⁰. 5 but were not, may be accounted
for thus viz
2 sent to Ditton with the Chairs &
2 In a Press in N⁰. 67 as above

[end of note]

Room N⁰. 29

A marble Chimney peice & Slab, and an Iron Back.
 The Iron Back sent to the Newhouse
Three ~~pair~~ of green ~~Cloth~~ Serge window Curtains &
 Vallens. **Bad**
One needlework'd Chair with a black Frame.
 The back & Seat in the Wardrobe Chest N⁰. 6
Six Chairs with black carv'd Frames cover'd with Purple
 Silk and borderd with stript Velvet. **Good**
One Settee with a black carv'd Frame, a cane Back and a
 Cushion
the same as the Chairs **Good**
A large marble Table with a black Frame.

30. A marble Chimney peice and Slab, a fire stone Hearth
 and stone Covings, an Iron Grate & Back wᵗʰ. fire
 Shovel, Tongs, Poker & Fender.
 Sent to the Newhouse
A four post Bedstead with green Velvet Furniture
 embroidered with Gold and lin'd with red Sattin
 embroider'd with ditto with a Counterpain of the same.
 Old & Soild
A Feather Bed Bolster & Pillow, a white holland Quilt
 a Check Mattress, a white sattin Quilt and four
 3 Blankets. **Bed Bolster & Pillow very Good**

Pillow sent to BH. **Holland Quilt & Check Mattress Good**
 The Holland & Satin Quilt to the Newhouse
 Sattin Quilt Bad 4 Blankets wanting
Two pair of window Curtains of stript Stuff with Vallens
 and Rods. **Bad** made into a Bed
Three peices of Tapistry Hangings. Perspective and
 Landskip. **Good**
Eight matted bottom Chairs. **4 of em Bad & 4 pretty good**
 To Cockpit 13ᵗʰ Decʳ. 1736
A six leav'd Screen of Emboss'd Leather. **Bad**
A three leav'd ditto of green Serge. **Bad**
A fire Screen of green Velvet. **Bad. the Velvit gone**
A Wallnuttree Chest of Drawers **Old**
 To the Cockpit- 13ᵗʰ Decʳ 1736
Two Japan'd Stands. **Broke**
A small drawing Desk of Wallnuttree Inlaid. **Wanting**
 To Lady Cardigan

A Harpsicord & Frame **In Room 53** To Lady Cardigan
Four Stools with black Frames cover'd with blue Velvet.
 Frames good. Velvit Bad
A Wallnuttree Scrutore. *Wanting* To Lady Cardigan
A Nest of India Drawers and a Frame. *Wanting*
Two dutch Tables. **Old**
 Two Dutch Tables & an Oval Table sent to the
 newhouse
A Wainscot Press, an oval Table, and a Warmingpan.
 Press & Table good Warming pan wanting
 Press sent to the Newhouse the Warming
 pan remains

Room Nº. 31

A marble Chimney peice and Slab. a fire stone Hearth and
 stone Covings. an Iron Grate & Back with Fire=Shovel
 Tongs, Poker and Fender
 To the newhouse
A Looking Glass over the Chimney & a Picture over yᵉ.
 same.
A Picture of Lady Hinchingbrook. To Mʳˢ. Palmer
 wanting
A four post Bedstead with blue Serge Furniture, A Feather
 ᴮᵉᵈ Bolster & Pillow, a check Quilt a Callicoe
 The Bed & Bolster to the housemᵈ. in the dark
 Room next Mʳˢ. Goldstone
Quilt and three Blankets.
 The Quilts & Blankets to the Newhouse
A pair of green Serge window Curtains, Vallens & Rod.
 Good
Six cane Chairs with black Frames. **Bad**
 1 To the Newhouse 3 Remains bottoms out
One cane Stool, one needleworkt ditto. **Bad** 2
 Needleworkt Stools to the Cockpit
 13th Decʳ 1736
A wainscot Chest of Drawers, & a Bookcase ditto.
 Good To the Cockpit 13th Decʳ1736
A wallnuttree Press. **Good** To Blackheath
A square wainscot Table. ~~Wanting~~ *at the Cockpit*
A Pendulum Clock.
 In the Library from thence to the Newhouse
Four peices of Grotesque Hangings. **Good**

32 A Stove Grate with Fire Shovel, Tongs, Poker, Fender
 Hearth Broom with a pair of Bellows.
 All but the Grate sent to the Newhouse
A Portland Chimney peice, and a marble Hearth.
A Looking Glass over the Chimney.
A Beach Bedstead with green Serge Furniture and a
 Counterpain of the same. **Good**
A Feather Bed Bolster and Pillow, a check Mattress, a
 white holland Quilt and four ² Blankets **Good**
 2 Blankets to the Porter at Montagu house

Four cane Chairs and a Stool. **Chairs good, Stool bad**
 The Chairs to the newhouse
An Easy Chair. **Bad**
Three square Tables. **Old** There are but 2.
A wainscot Nest of Drawers, & a wainscot Cupboard.
 Good
A deal Chest. **Good**
The Room hung with green printed Stuff **Old**

33 A Portland Chimney piece & Marble hearth, an Iron
 Grate with fire Shovel, Tongs, Poker & Fender
 The Shovel Tongs & Poker to the Newhouse
A Beach Bedstead with red Serge Furniture.
 The Serge good but very dirty
A Feather Bed, Bolster & Pillow, a Check Mattress,
 a holland Quilt three Blankets, & a Counterpane of red
 Serge.
 all good but the white Quilt Sent to the Newhouse
The Room hung with red Serge **Good**
A wainscott Chest of Drawers. **Good**
A wainscott Chest. **Good**
Two Deal Chests. **Good**
One Square wainscott Table. **Old**
One Easy Chair covered with red Serge. **Bad**
One wainscott Table covered with green Cloth. **Bad**
One Elbow Chair. **Bad**
Five Cane Chairs. **Bad** To the Newhouse

34. A stone Chimney peice & a tile Hearth and Iron Grate
 and Back with Fire Shovel Tongs, Poker and Fender.
 The Back sent to the Newhouse
A Looking Glass over the Chimney.
A pair of wallnuttree Bellows.
A Beach Bedstead with green Serge Furniture. **Good**
A Feather Bed, Bolster, and Pillow, a check Mattress.
 Good The Bed & Bedding to the Newhouse
Two Blankets and a Callicoe Quilt.
 The Pillow to Blackheath
Three cane Chairs, and an old Easy Chair. **Bad**
 1 To the Newhouse
Two wainscot Presses. **Good** In the Next Room
A cane Table. **Good**
The Room hung with green Stuff. **Bad**
A Crimson Cheney Field Bed
A Feather Bed & Bolster Taken out of the Wardrobe **Good**
2 Blankets & a Rug

35 The Room hung with green Stuff.

36 A halfheaded Bedstead. To Blackheath
A Feather Bed and Bolster, a check Mattress, two
 Blankets, a Rugg, and a Callicoe Quilt.
 doubtful whether Bugs in it or no To the Newhouse
A deal Press, a square Table, and two Chairs. **Bad**

Room Nº. 37.

Six hair Trunks.
A deal Chest.
Two old Bedsteads.
A dog Cushion cover'd with red Leather.

38. A Table Bedstead.
A Feather ^{Bed} Bolster, and two Blankets *Good*

39. A marble Chimney piece and Slab & Stone Covings.
An Iron Grate with Fire Shovel, Poker & Fender.
A pair of Bellows and a Brush.
Three pieces of Plad Hangings. **Bad**
Two pair of window Curtains ditto. **Bad**
One wainscott Press. *Good*
One wallnuttree Scrutore. *Good*
One Square wainscott Table **Bad** } Sent to the
Two Elbow Chairs with black Frames. } Newhouse
Two Cane Chairs
A Field Bed with Crimson Harrateen Furniture & a pair of
 Blankets out of Nº. 9. To the Newhouse

40. One large Deal Press.
One Nest of Drawers ditto.
Two old Chairs.
Two old Stools. **Very bad**
One old writing Table.
The Room hung with green printed Stuff.

41. A Portland Chimney peice, a fire Stone Hearth &
 Stone Co=
=vings, an Iron Grate, Back and Fender.
 The Grate Sent to the Cockpit
A Looking Glass over the Chimney.
 The Back at the newhouse
An elbow cane Chair. *Good*
Two Chairs with black Frames. **Bad**
A wallnuttree Table, a deal Oval ditto. **Bad**
Part of the Room hung with ~~green~~ *checker'd* Stuff. **Bad**

Room Nº. 42.

A Portland Chimney peice, a fire stone Hearth, and stone
Covings, an Iron Grate & Back with Fire Shovel Tongs
 Poker
Fender and Bellows. To the Newhouse *Falasau*
A Looking Glass over the Chimney
A Four post Bedstead, with Stript Linen Furniture.
 Bad the Bedstead / The furniture good
 part of the Hangings to the Newhouse
A Feather Bed & Bolster, an old Sattin Quilt, a white
 holland Quilt three Blankets & an old Callicoe Quilt.
 The Bed the Holland Matress & 2 Blankets to 103.
 All good but the Sattin Quilt

The Sattin Quilt & the Bolster to the Porter at
 Montagu ho. the Calico Quilt wanting
A deal Press. *Good* To the Newhouse
Three ² Chairs. **Bad** 1 Chair to the newhouse
A square cane Table. **Bad** To the Newhouse
The Room hung with Irish Stitch. **Bad**
 **1 Matted Bottom Chair out of this Room to the
 Cockpit 24th Dec�r 1736**

43. A Portland Chimney piece, a fire stone Hearth, &
 stone Covings.
an Iron Grate, with Fire Shovel, Tongs, Poker, an hearth
 Broom. and a pair of Bellows. **Booths Room**
 Shovel Tongs & Poker to the newhouse
Sixteen Pictures of several sorts.
Two pair of red Serge window Curtains and Vallens.
 Good
A Looking Glass over the Chimney, & a hanging Ditto.
 To Mr. Goodison
A nest of Drawers of wallnuttree Inlaid.
 Old at the Cockpit
Six cane Chairs, and a Stool with a black Frame.
 Good the 6 Chairs to the newhouse
A Square writing Table. *Good* To the newhouse

44. A small Stove Grate & a marble Slab, a Poker and
 Fender the Chimney set with Dutch Tiles.
 Booths Room
A two post Bedstead with red Shalloon Furniture. *Good*
A Feather Bed, Bolster and Pillow, a dimity Mattress,
 and a check Quilt, four Blankets & a Callicoe Quilt,
 a Counterpane the same as the Furniture of the Bed.
 Good
Two cane Chairs with black Frames, and an old Easy
 Chair. *Good* The 2 Cane chairs to the Newhouse
A wallnuttree Buroe, a deal Press. *Good*
 The Press to the Newhouse
A Picture of an old mans Head.
Part of the Room hung with sad colour'd painted Stuff.
 Bad
 A Table out the this Room to the newhouse

Room Nº. 45.

A Stove Grate, a wainscot Press.
 The Press to the Newhouse
A wainscot Table. To the Newhouse
The Room hung with sad colour'd printed Stuff.
Two deal Chests containing their Graces Saddle Furniture
 viz.
1 Leather Furniture embroider'd with Gold.
1 Blew Furniture embroider'd with Silver.
1 Red Velvit Furniture embroider'd with Gold.
1 Blew Cloth Furniture with Silver Lace.

1 Red Cloth Furniture with Gold Lace.

1 Blew Velvit Furniture embroider'd with Gold.

1 Yellow Cloth Furniture with Silver Lace.

1 Blew Cloth Furniture with Gold Lace.

1 Green Cloth Furniture with Gold Lace.

1 Red Cloth Furniture with Gold Lace.

2 Turkish Gilt Furnitures.

1 Tissue Furniture with gold wire Fringe.

1 Green Cloth Cover for a Side Saddle with Gold Lace.

1 Yellow ditto with Silver Lace.

1 Blew Velvit ditto.

1 Red Velvit ditto with Silver Lace.

2 Side Saddles & a Silver Turkish Furniture.

6 Lac'd Caparison Cloths.

1 Ditto Embroidered.

2 Leather water Decks.

4 Suits of Furniture for Gentlemen.

3 Sumpter Cloths & a Caparison for a Side Saddle.

2 Silk Netts.

46. A deal Chest containing 99½
pair of Pistols.

Two deal Chests containing 205
pair of Pistols.

} *2 if sent to Ditton*

One deal Chest containing 16 Laced Livery Coats

A deal Press containing 12 pair of Pistols.

The Press to the Newhouse

A deal Press containing 357 Buff Sword Belts, 213 Buff Carbine Belts, and 3 Belts for Drummers.

A deal Chest containing 14 Suits of Indian Dresses, and 13 Caps ditto.

Room Nº. 47.

A wooden Chimney piece, a Stove Grate with Fire Shovel, Fender & Poker To the Newhouse

A deal Chest Nº. 1. Containing 156 Swords, 14 Daggers, 2 Pole Axes, and 79 Bayonets.

Ditto Nº. 2. Containing 159 Carbines, 1 Cartridge Gun.

Ditto Nº. 3. Containing 20 Spanish Guns & Bayonets, 21 Portuguese

Guns and a large Broa'd Sword.

Ditto Nº. 4. Containing 39 best Guns, 7 Traders, & 16 pair of Pistols.

Ditto Nº. 5. Containing 31 Buckaneer Guns and Bayonets, & 13 Traders.

Ditto Nº. 6. Containing 42 Buckaneer Guns and Bayonets.

Eighty four Breast and Back pieces of Armour.

Eighty four Head pieces ditto.

} *to Ditton*

48. Nº. 1. A Case containing 56 Muskets and Bayonets.

2. A Case containing 60 ditto.

3. A Press contª. 139 Sword Belts, & 70 Belts with Frogs & Pouches.

4. A Press contª. 396 Powder Horns.

5. A Press contª. 109 Powder Flasks & Straps.

6. A Press contª. 41 Cartouch Boxes & Formers with Belts & Frogs.

179 Swords.

69 Sword Blades.

194 Scull Caps.

2 Presses out of this Room to the Newhouse

1 Table ditto

2 presses remaining

49. A marble Chimney piece and Slab.

A fire stone Hearth and stone Covings.

An Iron Back. To the New house

A Looking Glass over the Chimney.

24 Pictures different sorts not hung up.

4 of these at the Newhouse

27 Pictures

1 Dº. in a Gilt Frame

1 India Print out of Nº. 10

3 Empty Frames

}

5 Large Pictures of Fruit & Flowers out of Nº. 60

6 Smaller ditto 5 Took away by Mʳ. Goodison

Room Nº. 50

A marble Chimney piece and Slab.

A Fire stone Hearth and stone Covings.

An Iron Grate and Iron Back. To the Newhouse

The Room hung with plad Hangings, paned with green Taffity.

Two Fire Screens of needlework

To the Cockpit 13th Decʳ 1736.

Two ditto of black Silk embroidered

Three Elbow ᶜᵃⁿᵉ Chairs with black Frames

To the Cockpit 24th Decʳ 1736

Three cane Chairs ditto

To the Cockpit 24th Decʳ 1736

Two wallnuttree Elbow Chairs with green Bottoms.

To the Cockpit 24th Decʳ 1736

Two small Chairs with matted Bottoms.

To the Cockpit 24th Decʳ 1736

One wallnuttree Close Stool Chair. at the Cockpit

One wallnuttree Dressing Chair cover'd with crimson Velvet

To the Cockpit as below. 24th Decʳ 1736

One round Stool of needlework

To the Cockpit 24th Decʳ

One Dutch Table.

A wainscot Press, & in it two pieces of gilt Leather.
> The Press to Ditton
> The 2 pieces of Gilt Leather in a Press in Nº. 67
2 Wallnuttree Reading Chairs
> 1 To Bewley & 1 remains
> 1 To the Cockpit 24th Decr 1736 which I believe is
> that call'd a Dressing Chair above
> A Stufft Arm'd Chair out of this Room to the Cockpit
> 24th Decr 1736

51 A marble Chimney piece and Slab.
A Fire stone Hearth and stone Covings.
An Iron Grate and an Iron Back. To the Newhouse
A green Serge window Curtain in the Closet.
A Field Bedstead.
A Feather Bed Bolster and Pillow.
A dimitty Mattress and a holland Quilt.
One Sett of green Mohair Furniture
 to ditto. } at the Cockpit
One Sett of blue Lutestring Furniture
 to ditto.
Twelve matted Chairs with Beech Frames. In the next
 Room To the Cockpit 24th of Decr 1736
Six smaller ditto. at the Cockpit
The Room hung with stript Harrateen.

52. A marble Chimney piece and Slab.
A fire stone Hearth and stone Covings.
An Iron Grate and an Iron Back. To the Newhouse
A large Peer Glass.
A cane Table.
A large China Jarr. To the Newhouse
An eight Leav'd blue damask Screen.
Thirteen matted bottom'd Chairs with beach Frames.
 To Ditton
One Elbow cane Chair To the Cockpit 24th Decr 1736
6 Old Matted Chairs out of the
 Dining Room Nº. 70 } To the Cockpit
2 Arm'd Chairs ditto out of ditto } 24th Decr 1736

Room Nº. 53
A marble Chimney piece and Slab.
A Fire stone Hearth and stone Covings.
An Iron Grate and an Iron Back. To the Newhouse
A Poker and Fender. Dº.
A Looking Glass over the Chimney with a gilt Frame
 Sent to Ditton
The Peer covered with Glass.
 The great Plate to the Newhouse
Two pair of blue Mohair Window
 Curtains and Valens } In a Press
Three pieces of blue Mohair Hangings. } in No. 67.

Six wallnuttree Chairs cover'd with ditto
 In 55 To the Cockpit 29th Decr 1736
 all to be left
One easy Chair with a wallnuttree
 Frame cover'd with red Cloth }
 To the Cockpit 29th Decr 1736 } In 55.
A three Leav'd Screen of blue damask. }
 Sent to Ditton
A marble Table. } Sent to Blackheath
Two wallnuttree Stands. }
A Cabinet of wallnuttree. Sent to Ditton
One ditto of wainscot. Sent to Bewley
A wallnuttreee folding Table.
 In 65. & since to the Cockpit 13th Decr 1736
A Picture over the Chimney called Cleopatra.
Three Flowerpieces over the Doors.
 Sent to the Newhouse
A Picture of Prince William in his Installation Robes.
 put up in Salon
A Harpsicord & frame out of Room 30
 To Lady Cardigan
A large Marble Table on a Walnuttree Frame out of 91

54. A marble Chimney piece and Slab.
A Fire stone Hearth and stone Covings.
An Iron Grate & Back, with Fire Shovel, Tongs, Poker
 and Fender. The Grate sent to Ditton
A Looking Glass over the Chimney.
Six pieces of Tapistry Hangings Landskip and Figure.
 put in Chest No. 1 at the Newhouse
Two round Looking Glasses with carv'd gilt Frames.
 Sent to Ditton
Twelve arm'd Chairs with wallnuttree Frames
 cover'd with crimson Velvet with red Serge Cases
 to ditto.
 The Chairs to the cockpit 13th Decr. 1736 ₅₅
 Coverings to a Press in 67
One easy Chair with a wallnuttree Frame covered with
 Damask and paned with Brocade with a red Serge Case
 to ditto.
 In 55 **To the Cockpit 29th Decr 1736**
One ditto with a black Frame covered with needlework
 and a green Serge Case to ditto.
 In 55 **To the Cockpit 29th Decr 1736**
Two round Stools with gilt Frames cover'd with crimson
 Velvet and trim'd with Gold Lace with red Serge Cases
 to ditto.
 In 55 **To the Cockpit 29th Decr 1736**
Two square ditto with ditto Cases.
 To the Cockpit 29th Decr 1736
Three marble Tables with gilt Frames.
 1 Sent to the Newhouse 2 Sent to Ditton
Two Stands ditto. In 55 **To the Cockpit 13th Decr 1736**

One wallnuttree Scrutore.
One Mahogany writing Table. } At the Cockpit
Two Flower pieces over the Doors.
One ditto over the Chimney.

Room Nᵒ. 55

A marble Chimney piece and Slab.
A fire stone Hearth and stone Covings.
An Iron Grate and Back with Fire Shovel, Tongs.
 Poker & Fender To the Newhouse
A Looking over the Chimney and two wooden Sconces
 The Looking Glass & carv'd work took away by
 Mʳ. Goodison
One ditto with a carv'd gilt Frame. Sent to Ditton
Four Stands ditto.
 The 2 least sent to Ditton
 2 carv'd gilt Stands
 To the Cockpit 13th Decʳ 1736
One Table ditto. Sent to Ditton
One square Table Inlaid. } To the Cockpit
Two Stands ditto } 13th Decʳ 1736
Three peices of Tapistry Hangings of the Elements.
 put in Chest Nᵒ. 1 at the Newhouse
Four arm'd Chairs the black Frames covered with green
 sent to Ditton
Damask and green Serge Cases.
Five arm'd Chairs with black Frames
 cover'd with needlework with
 green Serge Cases. } To the Cockpit
Two round Stools with black Frames } 29th Decʳ 1736
 cover'd with green Velvet with
 green Serge Cases.
One wallnuttree Folding Table. Sent to Ditton
A Pendulum Clock. In the Library
Two Fruit pieces over the Doors.
One Flower piece over the Chimney.

56. A marble Chimney piece and Slab.
A Fire stone Hearth and stone Covings.
An Iron Grate & Back, with Fire Shovel, Tongs,
 Poker & Fender.
 All to the Newhouse except the Back
An oval Looking Glass over the Chimney and two
 wooden Sconces.
 The Looking Glass took away by Mʳ. Goodison
One hanging ditto with an Inlaid Frame.
 Sent to Ditton
Two pieces of Tapistry Hangings of Vulcan at Work.
 put in Chest Nᵒ. 1 at the Newhouse.

Six Chairs wᵗʰ: black Frames cover'd
 wᵗʰ. green Velvet, & green Serge
 Cases to ditto. ~~In ʃʃ~~ } To the Cockpit
Two Stools ditto with green Serge } 29th Decʳ 1736
 Cases to ditto ~~In ʃʃ~~
One marble Table with a gilt Frame. Sent to Ditton
Two flower pieces over the Doors.
One piece of Fruit and Flowers over the Chimney

57. A marble Chimney piece and Slab.
A Fire stone Hearth and Stone Covings
An Iron Grate, & Back, with Fire Shovel Tongs,
 Poker and Fender.
 All but the Back to the Newhouse
Three pair of red Lutstring Window Curtains and Vallens.
 To a Press in Nᵒ. 67.
Four marble Tables with wallnuttree Frame.
 2 Sent to Ditton & 2 to Boughton
Two Stands of wallnuttree.
Nineteen Chairs with wallnuttree Frames, & wove
 cane Bottoms. To Boughton
Three Pictures of our Saviour.
One Picture over the Chimney of King Charles the
 Second.
Two Fruit and one Flour piece over the Door.
Two large Peer Glasses & 2 pair of wallnuttree Sconces.
 the Bottom plate of each taken out for the
 Newhouse and the remainder sold to
 Mʳ. Goodison
Two large Cartoons with gilt Frames, & green Serge
 Curtains to ditto.

Room Nᵒ. 58

A marble Chimney piece and Slab.
A Fire stone Hearth and stone Covings.
An Iron Back.
A pair of Dogs ornamented with
 Silver. } To the Newhouse
Fire Shovel Tongs, and Poker ditto. }
A Looking Glass over the Chimney and two wooden
 Sconces
 The Looking Glass & carv'd work took away by
 Mʳ. Goodison
A Large Hanging ditto with a gilt Frame.
 To the Newhouse
Two pair of window Curtains and Vallens of blue flower'd
 Velvet lined with Persian.
 made use of at the newhouse
Two pair of door Curtains ditto. } made use of at
Three pair of Hangings of blue } the Newhouse
 flower'd Velvet.

One Fire Screen ditto with a gilt Frame.
Two easy Chairs ditto with gilt Frames.
Twelve Chairs ditto with ditto.
A Settee ditto with ditto.
Two Stools ditto with ditto.
Two Indian Cabinets with gilt Frames.
A round Mother of pearl Table on a
 gilt Frame.
A round India Tea Table.
A carv'd Table gilt with Gold.
} Sent to the Newhouse

 To the Cockpit- 13th Dec^r 1736
Two Flower pieces over the Doors.

59. A marble Chimney piece and Slab.
A Fire stone Hearth and stone Covings.
An Iron Back.
A pair of Dogs with silver Images.
A pair of Tongs & a Fire Shovel
 ornamented with Silver.
} To the Newhouse

Two pair of window Curtains,
 Cornishes, & Vallens of yellow
 Damask.
Two pair of door Curtains ditto.
} made use of at the Newhouse

A four post Bedstead with green
 Velvet Furniture paned with
 Needlework & lin'd with a
 buff colour'd Damask with
 embroidery.
A Feather Bed, Bolster and
 two Pillows.
A Mattress.
Two holland Quilts.
} Their Graces Bed &c at the Newhouse except y^e. Bedstead which is in 52

Five pieces of Tapistry Hangings of Sica.
 At the Newhouse
Eleven Chairs with wallnuttreee Frames
 and cover'd with yellow Damask.
Two easy Chairs ditto.
A painted Glass Screen with a wallnuttree
 Frame, the Back yellow Damask.
An India Japan'd Chest inlaid with
 Mother of pearl and gilt Frame.
} To the Newhouse

One India Tea Table. To the Newhouse
A white Teapot and Bason.
A Sugar-dish.
Six Cups, and six Saucers.
Two Flowerpieces over the Doors.
 1 of 'em at the Newhouse & 1 Remains
A Looking glass over the Chimney and two wooden
 Sconces.
 The Looking Glass took by M^r. Goodison for
 the Newhouse
One Hanging ditto with a Gold Frame.

One Japan'd Table with a gilt Frame
 To the Cockpit- 13th Dec^r 1736
A small India Chest of Drawers, and a gilt Frame.
 To the Newhouse
7 Chairs with Walnuttree Frames cover'd with
 Needlework & callico
 To the Cockpit- 24th Dec^r 1736
Cases to ditto out of 69
 A Wicker Chair lin'd with
 crimson Persian & a
 curtain & cushion of ditto
} *to Cockpit 24th Dec^r. 1736*

Room N^o. 60.
A marble Chimney piece and Slab.
A fire stone Hearth and stone Covings.
An Iron Back.
A pair of Iron Dogs with Fire Shovel, and Tongs.
 Fire Shovel & Tongs to the Newhouse
Five pair of white damask window Curtains & Vallans.
 1 in Chest N^o. 3 at Newhouse & 4 p^r. in
 a Press in N^o. 67
Three pieces of Flower'd Velvet Hangings paned with
 green Velvet. To the Newhouse
Eight armed Chairs with black Frames covered with
 The Frames to the Cockpit 13th Dec^r 1736
Flower'd Velvet. The Covering in a Press N^o. 67
One Settee cover'd with brocaded Damask & a
 Wallnuttree Frame. At the Cockpit
A dressing Chair and two Stools ditto.
 Dressing Chair at the Cockpit 2 Stools in 59
One easy Chair with a back Frame cover'd with
 needlework and a white Case to ditto.
 Sent to Blackheath
Two Inlaid Tables.
Two hanging Glasses
 with inlaid Frame.
} Taken away by M^r. Goodison
One Japan'd Cabinet with Glass Doors. Sent to Ditton
One six Leav'd India Screen. In 59
One two Leav'd India fire Screen of leather w^th. India
 Figures. At the Cockpit
One fire Screen with a black Frame and buff colour'd
 damask. Sent to the Newhouse
A small Japan'd Trunk and Frame.
 ~~In 59~~ To the Newhouse
Nine large Pictures of Fruit and Flowers.
 1 at the Newhouse & 5 in N^o. 49 & 3 Remains
Six smaller ditto. 5 To the Newhouse
An India Tea Table and on it. To the Newhouse
Six Chocolate Cups. 1 at the Cockpit & 2 broke
One Sugar Cup and Cover
Two small Basons.
four Cups and six Saucers of different sorts.
Two large Saucers.

One Silver Branch with eight Sockets.
An Inlaid Table
 To the Cockpit 13th Dec^r. 1736
 A long Square Mahogany Folding Table out of this
 Room to the Newhouse
 2 Stools of brocaded Damask & Wallnuttree
 Frames out of this
 Room to the Cockpit 13th Dec^r. 1736

Room N^o. 61.

A marble Chimney piece and Slab.
A Fire stone Hearth and stone Covings.
An Iron Back.
A pair of Iron Dogs with Fire Shovel, and Tongs.
Two pair of yellow Lutestring
 window Curtains with Cornishes } To the Newhouse
 & Vallens.
Two pieces of yellow Damask Hangings.
Ten Chairs with wallnuttree Frames
 cover'd with yellow damask and } Sent to the
 yellow Stuff Cases to ditto. Newhouse
A Settee ditto.
An easy Chair ditto. Sent to Bewley
A Couch and four Pillows ditto. To Ditton
An inlaid Table. To the Newhouse
A hanging Glass with an inlaid Frame.
A strong Box with gilt ornaments and Frame.
 To the Newhouse
One Ebony Cabinet. Sent to Ditton
A china Jarr and Cover. To the Newhouse
A large china Bowl. at the Cockpit
A brown Teapot.
Five white Cups and one Saucer.
Two china Plates.
Three small Beakers. To the Newhouse
A white Teapot.
Three painted Basons.
Two marble Cups.
A Bear of China-ware. To the Newhouse
A six Leav'd India paper Screen. In 59
A small glass Screen with a
 wallnuttree Frame. }
Two Cellars with Shagreen Cases. } To the Newhouse
A square India Box. }
Her Graces Picture at whole Length over the Chimney.
One Fruit and one Flower piece over the Doors.
One damask easy Chair, with Casters with a wallnuttree
 Frame. Sent to Bewley
A Pendulum Clock.
 In the Library from thence to the Newhouse
A Persian Carpet. To the Newhouse

Room N^o. 62.

A wallnuttree Chest and Frame.
A door Curtain of red Shalloon.
A two Leav'd paper Screen.
 A Strong Box out of this Room to Cockpit
 13th Dec^r 1736

63. Three large wainscot Presses. }
One wallnuttree Chest of Drawers. } To the Newhouse
A two Leav'd India Screen.
A six Leav'd ditto.
 To the Newhouse as also a Little Horse
 A Mahogany Leaf & a }
 Frame of Wainscot } out of this Room
 A Night or Bed Table } to newh^o.
 A Square wainscot Folding Table out of this
 Room to the Cockpit 13^th. Dec^r. 1736
 A Wainscot Close Stool Ditto & D^o.
Under the great Staircase and on the Stairs.
Four oval wainscot Tables.
 1 To Blackheath
 1 To Newhouse
 1 To the Cockpit 13th Dec^r 1736
Four pair of green Serge window Curtains.
 1 Curtain to the Newhouse
 1 Manchineal }
 & } Oval Table to Newhouse
 1 Mahogany }
 A Dutch matted Bottom'd Chair
 to the Cockpit 10^th. Jan: 1736/7

64. Two large Glass Lanthorns with ballance
 Balls & Chains. Taken away by M^r. Goodison
Two Door Curtains of green Serge.
Two marble Tables with black Frames.
Two cane Settees.

Room N^o. 65.

A marble Chimney piece and Slab.
A fire stone Hearth and stone Covings.
An Iron Grate and Back. The Back to the Newhouse
A pair of Bellows and hearth Broom. To the Newhouse
Two pair of white Damask window Curtains and Vallens.
 In a Press in N^o. 67
Fourteen fine cane Chairs with wallnuttree Frames.
 To the Newhouse
Two elbow Chairs with wallnuttree Frames, covered with
 crimson and gold colour'd flower'd Velvet & white
 Camblet Cases to ditto. To Bewley
Two small wainscott folding Tables. 1 To the Butler
A marble Slab with Iron work to support it.
 the Slab to the Newhouse
A four Leav'd gilt Leather Screen. To the Newhouse

A Looking Glass over the Chimney and two wooden
 Sconces.
One Fruit and one Flower piece over the Doors.
One Flower piece over the Chimney.
Twenty one Pictures of different sorts.
 2 to his Grace & 15 to the Newhouse
a Walnuttree Folding Table out of 53.
 To the Cockpit- 13th Decr 1736

66. A marble Chimney piece and Slab.
A fire stone Hearth and stone Covings.
An Iron Grate and Back.⎫
A Fire Shovel Tongs and Fender.⎬ To the Newhouse
A large hanging Glass in a ⎭
 Gold Frame.
A marble Table with a gilt Frame. To Ditton
An India Cabinet and Frame. To the Newhouse
Three China Jarrs.⎫
Three china Bottles, two of 'em ⎬ To the Newhouse
 with silver Stoppers.⎭
One brown ditto.
Two yellow damask Chairs wth.⎫
 wallnuttree Frames & yellow ⎬
 Camblet Cases. ⎬ Sent to the Newhouse
Two Stools and one easy Chair ⎭
 ditto.
One elbow Chair with a wallnuttree ⎫
 Frame & a yellow Camblet Case. ⎬ Wanting
Two Stools and one easy Chair Ditto.⎭
One elbow Chair with a wallnuttree Frame cover'd with
 brocaded Silk and a yellow Camblet Case.
 In 55 To the Cockpit- 29th Decr 1736
One Settee ditto Case ditto.
Eight Chairs with wallnuttree Frames cover'd with
 needlework paned with green Velvet and yellow
 Camblet Cases to ditto. To the Newhouse
A Looking Glass over the Chimney and two wooden
 Sconces.
One fruit and Flower piece over the Chimney.
One Landskip over the Door.
 In 49
 Six Arm'd Chairs of Needlework said to come out
 of this Room by Mr. Reason
 To the Cockpit- 13th Decr. 1736
 NB. they Stood in 28

Room No. 67.
Three wainscot Presses. 2 Sent to the Newhouse
A Suit of Armour on a Block. Sent to Ditton

68 A marble Chimney piece and Slab.
A Fire stone Hearth and Stone Covings.
A pair of brass Dogs and an Iron Back.
 The Back to the Newhouse the Dogs to
 B Heath
A Looking Glass over the Chimney.
 Taken away by Mr. Goodison
Two pair of gilt Sconces. 1 pr. taken away by Do.
A large peer Glass.⎫
Two flower Pieces ⎬ Took by ditto for the Newhouse
 over the Doors.⎭
One ditto over the Chimney.
One small Picture with a black Frame.
One India Japan'd Chest inlaid with Mother of pearl.
 Sent to Ditton
One window Curtain and Cornish of white Damask.
 Taken down & put in 55.
Four Chairs with wallnuttree Frames, ⎫
 with Backs & Seats, of white Damask ⎬ Sent to Ditton
 and Covers of white Camblet. ⎭
Two Stools and an easy Chair ditto.
A small India Table **To Blackheath 9th Sept. 1737**

69. A marble Chimney piece and Slab.
A brass Stove Grate with brass Fire Shovel and Tongs,
 The Shovel & Tongs to Blackheath
and an Iron Poker with a brass Knob.
Two pair of white Dimitty window Curtains and Vallens..
 Took down & Sent to the Newhouse
 17th June 1735 no Vallens
A Couch with a wallnuttree Frame, ⎫
 two Squabs cover'd with ⎬
 flower'd Silk, & three Cushions ⎬
 ditto, & a Case of Chints. ⎬ To the Newhouse
Six seven Chairs with wallnuttree ⎬
 Frames cover'd with needlework ⎬
 and Callico Cases to ditto. ⎭
One dressing Chair with a wallnuttree Frame cover'd with
 brocaded Silk. Ditto or the Cockpit
One ditto with a wallnuttree Frame, & a red Leather Seat.
 To Ditton
Three pieces of gilt leather Hangings.
One Looking Glass over the Chimney.
Two pair of wooden Sconces.
 1 pair in the Dining Room
One Peer Glass.
One wallnuttree Chest of Drawers. at the Cockpit
One Japan'd folding Table.
One dressing Glass. at the Cockpit
Five Pictures with gilt Frames.
 3 to Blackheath & 1 to the Newhouse

Room Nº. 70.

A marble Chimney piece and Slab.

An Iron Stove Grate with Fire Shovel Tongs and Poker.
 To Ditton

A Hearth Brome and a pair of Bellows.

A Looking Glass over the Chimney. the corner of it broke

Three pair of wallnuttree Sconces. broke

Three pair of white Dimity window Curtains and Vallens.
 Took down & sent to the Newhouse
 17th June 1735 no vallens

Six matted bottom'd Chairs. In 52

Two elbow Chairs ditto. In 52

Two easy Chairs with black Frames covered with black
 Leather. Sent to Boughton

One marble Table with a wallnuttree Frame.
 Sent to Bewley.

Two wallnuttree folding Tables.

A Pendulum Clock. To the Newhouse

A Strong Box with gilt ornaments and Frame
 To the Cockpit- 13th Decʳ 1736

A china Pot under the marble Table. To the Newhouse

A six Leav'd India Screen.

A four Leav'd paper Screen cover'd with Maps.

A fire Screen embroiderd with gold & silver on Crimson
 Velvet To the Cockpit 13th Decʳ 1736

One India paper fire Screen.

One India dumb Waiter. broke

A Carpet cross the Room. }
One Turkey Carpet. } To the Newhouse

Thirty six Pictures by Vandyke.
 Taken away by Mʳ. Goodison

Thirty nine Pictures of different sorts.
 1 To Ditton
 35 To the Newhouse

71. A marble Chimney piece and Slab.

An Iron Stove Grate with fire Shovel, Tongs, Poker and
 Fender. The Poker at the Cockpit

Two marble Tables with wallnuttree Frames.

One round Table To the Cockpit- 13th Decʳ 1736

Two oval Tables.

One Folding ditto. at the Cockpit

One Mahogany Tea table. To the Newhouse

Three cane Chairs. 2 to the Newhouse

One cane Couch and Leather Cushion.
 1 Round Wainscot Stool out of this Room
 to the Newhouse

72. A Marble Chimney piece and Slab.

A Fire stone Hearth and stone Covings.

An Iron Grate & Back with Fire Shovel, Tongs, Poker
 and Fender. All to the Newhouse except the Back

A Looking Glass over the Chimney.

Four cane Chairs.

One square folding Table.

Room Nº. 73.

A marble Chimney piece and Slab.

A fire stone Hearth and stone Covings.

A pair of Iron Dogs.

A Looking Glass over the Chimney. broke at the corner

A pair of wallnuttree Sconces. (Dº.)

Four pieces of Tapistry Hangings of the Apostles.
 put in Chest Nº. 1 at the Newhouse

A six leav'd Screen of gilt Leather.

A wallnuttree Table with Drawers.

Four Chairs with wallnuttree Frames with Backs and Seats
 of blue Camblet. & 1 Easy Chair dº. from the Cockpit
 Sent to Ditton

One window Curtain of blue Camblet.
 In Chest Nº. 1 At the Newhouse

A Picture over the Chimney of Our Saviour and the
 Virgin Mary. At the Newhouse

Two small Pictures over the Doors.

74. A marble Chimney piece and Slab.

A Fire stone Hearth and stone Covings.

An Iron Grate with Fire Shovel, Tongs. Poker & Fender.
 To the Newhouse

75. A marble Chimney piece and Slab.

An Iron Stove Grate with fire Shovel Tongs, Poker a large
 brass Fender, and a Hearth Broom.
 Sent the Fender to Blackheath

A small wallnuttree Scrutore. Deliver'd his Grace

Three wainscot Tables.
 1 Sent to Ditton & 1 to the Newhouse

Three Chairs and one Stool.

One fire Screen of crimson Velvet.

One large Pendulum Clock.

One green Serge window Curtain.
 In Chest Nº. 3 in the Wardrobe at the Newhouse

One wainscot Scrutore.

One Strong Box.

One small wallnuttree Trunk.

One small wainscot Desk.

One Weather Glass.

Room Nº. 76.

A wooden Chimney piece and marble Slab.

An Iron Stove Grate and Fender.

Two deal Presses. 1 To the Newhouse

One wainscot Table.

One cane Chair.

One Forest Chair.

One old needlework Chair.

One small Flower piece, in a gilt frame.

> M^r. Goodison had a small Flower Piece without a Frame

Two door Curtains & Vallens of green Serge.

Two window Curtains ditto.

77 A hanging Shelf.

5 Shelves supported with Iron. Sent to the Newhouse

2 Cross Barrs with Hooks.

3 Dressers. Sent to the Newhouse

1 Wainscot Press.

1 Tin Box.

A small wainscott Cupboard.

1 Tin Candle Box.

Room N^o. 78.

A large Iron Grate of Six Barrs with Fire Shovel, Tongs, Poker Fender and Bellows.

6 Spits.

A large Jack with a multiplying Wheel.

17 Iron Scuers.

1 Brass dridging Box.

1 Tin Spice Box.

3 Copper Fish Kettles and Covers

3 Copper Gravey-pans.

1 Copper dutch Oven.

3 Copper Cullenders.

3 Copper Soop-pots and Covers.

1 Large copper Boiler and Cover.

6 Sauce-pans great and small.

1 Copper Dish Kettle and Cover.

1 Large copper Dripping-pan.

19 Copper Stewpans and Covers.

1 Copper Preserving Pan.

6 Copper Tart Pans.

2 Chopping Knives.

1 pair of Stake Tongs.

11 Copper Patty-pans

1 Brass Mortar and Pestle.

1 Marble Mortar and Pestle.

3 Copper Frying-pans.

3 Copper Ladles.

2 Scummers.

1 Copper Spoon.

1 Copper drinking Pot.

1 Copper Kettle.

1 Copper Fish Plate.

1 Large copper Boiler and Cover.

1 Cleaver.

2 Brass Candlesticks, and 2 Iron ditto

2 Sallamanders.

1 Iron Trivet.

10 Ditto for the Stoves.

2 Gridirons

2 Pewter Boilers, 1 pair of Stilyards.

1 Tin Grater. 1 Iron Peeler. 1 Baster.

A Clock and Case.

A Baster.

A Leaden Cestern and Sink.

3 Dressers. 1 Chopping Block.

1 Long Table. 1 Oval ditto.

1 Wooden Screen lin'd with Tinn.

1 Old six Leav'd Screen.

2 Leather Chairs.

> The Things in this Room are all took away except
> The Jack
> Range
> Rack
> 2 Tables
> A Leaden Cistern & Sink
> An old 6 Leav'd Screen
> 7 Stoves.

Room N^o. 79.

A five Barr'd Iron Range with Tongs and Fender.

A four post Bedstead with blue printed Stuff Furniture.

> **Good**

A Feather Bed and Bolster.

> **Good doubtful if not infested with Buggs**

A Check Mattress, three Blankets and a Callicoe Quilt.

> **Mattress & Blankets pretty Good, the Quilt bad**
> The Mattress to Blackheath

A wainscot Press.

a Dresser and Drawers. **bad**

Two Chairs.

A large Leaden Cestern going up to this Room.

> Taken away by the Plummer for the Newhouse

80. The Woodhouse.

81. An Iron Grate, and an Iron Back.

> To the Newhouse

Two Coppers. 1 to Ditto

2 Leaden Cesterns and Pump. 1 Cistern to ditto

7 Washing Tubs.⎫

2 Wrenching Tubs⎭ Sent to the Newhouse

1 Dresser.

82. An Iron Grate, and an Iron Back. ⎫

A Mangle with Lead weight. ⎭ To the Newhouse

2 Dressers.

1 Deal Table. To the Newhouse

1 Bathing Tub.

Room Nᵒ. 83.

An Iron Beam with Scales and Weights.
>To the Newhouse

Two Beams with Flesh Hooks.
One Large earthen Pot.
One Chopping Block.
A leaden Cestern and a wooden Frame.
>To the Newhouse

2 Dressers.
1 Hanging Shelf.

84. A stone Chimney piece.

An Iron Grate with fire Shovel, Tongs. Poker and Fender.
10 Cane Chairs.
>*7 Good & 3 Broke* 2 at the Cockpit, 2 at the Lodge
>the rest broke

1 Wainscot oval Table. *Good* To the Newhouse
A six Leav'd Screen cover'd with blue Serge *Bad*
7 Prints with black Frames.
1 Copper drinking Pot. ⎫
10 Horn handle Knives, ⎪
& 14 Forks ditto. ⎬ To the Newhouse
2 Brass Candlesticks. ⎪
A pewter Mustard pot ⎪
and Spoon. ⎭
A three pint white Mugg.

85. Two Iron Ranges, and Cheeks and Iron Backs.
>1 To the Newhouse

A fire Shovel, Tongs, ⎫
Poker and Fender. ⎪
16 Flat Irons. ⎬ All to the Newhouse
3 Box Irons and Heaters. ⎪
& 3 Stands for the Irons. ⎪
A Linen Press. ⎭
Two Horses for Linen
>1 *Bad* the other To the Newhouse

2 Brass Sauce-pans and a Skellet ditto.
>To the Newhouse

3 Tables.
2 Dressers. 1 Step Ladder.
>The Step Ladder to the Newhouse

3 Iron Candlesticks.
>but one & that Sent to the Newhouse

A Leaden Sink.

Room Nᵒ. 86.

An Iron Stove Grate with fire Shovel, Tongs,
Poker & Fender. Tongs & Poker wanting
1 Copper Dish Kettle.
1 Coffee Mill. *Good*
1 Deal Press. *Bad*
A Leaden Sink.

A plate Rack and a deal Cupboard.
Two Tables, and three Chairs. *Bad*
An old Screen. *Bad*
23 Pewter Dishes great and small.
3 Dozen & 7 Pewter Plates.
3 Dozen of new ditto.
4 Pewter Salts.
1 Copper Sauce pan.
3 Copper Chocolate Pots.
2 Copper Tea Kettles.
1 Brass Dish Kettle.
>There is nothing of value left in this Room

87. A Portland Chimney piece and Slab.
An Iron Range.

88. A Portland Chimney piece and stone Covings.
A Stove Grate.
9 Prints with black Frames.
A hanging Looking Glass.
1 Wallnuttree Table. *Good*
>To the Porters Lodge at the Newhouse

1 Wainscot Press. *Good* To Blackheath
4 Chairs and a Stool. *Bad* To the Newhouse
>Another Table out of this Room to the Newhouse

Room Nᵒ. 89.

A wainscot writing Desk. *Good*
5 Cane Chairs and a Stool. *Good*
>2 to Newhouse 1 to 90 & 1 to 103

4 Prints with black Frames.
A pair of white window Curtains and Vallens. *Bad*

Evidence Room

90. A marble Chimneypiece and Slab.
A fire stone Hearth and stone Covings.
A large Iron Grate with fire Shovel Tongs, Poker &
Fender
A wallnuttree Press. *Good* To the Newhouse
A wainscot Press. *Good*
A wallnuttree Chest of Drawers. *Good*
A cane Couch with a wallnuttree Frame *Good*
3 Chairs and 2 Stools. *Bad*
2 Wainscot Tables. *Good*
A wainscot Cupboard. *Good*
A marble Cistern. To the Pantry at the Newhouse
2 Brass Candlesticks and Snuffers.

Evidence Room

91. A marble Chimney piece & Slab, & Stone Covings.
An old iron Grate & Fender, and an iron Back.
>The Back sent to the Newhouse

A large Looking Glass over the Chimney.

Two Glass Sconces.
A large Looking glass in the Door of the Closet.
One large Deal Table covered with green Cloth. *Good*
A large marble Table with a Wallnuttree Frame. In 53
Two oval Wainscott Tables. *Good*
One Writing Table covered with blew Cloth. *Bad*
A Six Leav'd gilt leather Screen. *Good* In 73
A Three Leav'd leather Fire Screen. *Bad*
1 Arm'd Chair covered with green Velvit & a Wallnuttree
 Frame *Bad*
1 Arm'd Cane Chair. *Good*
2 Cane Chairs. 1 Stool covered with Strip'd Velvit.
 2 arm chairs of the same
A Step Ladder. *Good*
A Weather Glass. broke

Room Nº. 92.

A Portland Chimney piece.
A hoop Grate with fire Shovel, Tongs. Poker and Fender.
A press Bed with green printed Stuff Furniture. *Bad*
A Feather Bed Bolster and Pillow *Good*
A check Mattress. *Good*
3 Blankets and a callicoe Quilt.
 Blankets Good / Quilt bad
A Bread Binn.
A large Chest for the Plate.
A Cheese Cupboard.
A marble Mortar and wooden Pestle.
 this was sent to Ditton
4 Chairs and 3 Tables.
A leaden Cistern.

To the
Newhouse

Plate

Thirty nine Dishes small & great.
Eight dozen of Plates.
Five dozen and 5 Forks.
Five dozen & Eight Knives.
Five dozen of Spoons.
One dozen of desert Knives
Eight Salt Sellars.
Ten Salvers.
Two Sallad Dishes.
Two Fountains & two Cisterns.
Two Crewet Frames.
Two Crewet Tops.
Two Pepper Casters.
One Mustard Pot & Spoon.
One small Table Ring.
One large Table Ring for five Plates.
One large Tarreen with a Cover.
Two smaller ditto with Covers.
One Gilt Porringer & Cover.
Eleven small Spits.

One gilt Cup and Cover.
Two Sugar Casters.
Two large Soop Spoons.
Nine Covers for Dishes.
Two large Carving Knives.
Two forks ditto.
One Bread or Lemon Basket.
One Sartood for Knives forks & Spoons.
Two Silver Muggs.
Three Silver Toasters.
A French Knife.
Twelve Knives & twelve forks w^th. agate
Handles.
Three Dishes Good Round.
One pair of Snuffers & Pan.
Eight old plain Salt Sellars.
One dozen of Knives.
One dozen of Forks.
One dozen of Spoons.
Two great Basons Good Round
Two Ewers belonging to them.
Two large gilt Dishes.
Two flaggons belonging to them.
Four Casters.
One Montath.
One Bason Good Round.
One Chamberpot.
Two gilt Cups with Covers for y^e. Sacram^t.
One Crane
One Salver & Cup of Fillegreen work.
Fifteen small gilt Knives in a Case.
Eight old Silver handle Knives.
Four little gilt handle Knives.
Two Tumblers.
Two Casters.
Four Salt Sellars.
One pair of Snuffers & Pan.
Twelve Spoons.
One Mustard Pot & Spoon.
One Small Cup or Tumbler.

93. Two old Bottle Racks.
Stillions round the Cellar. **Remove Part**
 Major part sound all mov'd that were good
One tinn Lamp.
A Cupboard.
A leaden Cestern. Sent to the Newhouse

Room Nº. 94.

1 Copper Stewpan.
3 Preserving Pans ditto. 1 Sent to Ditton
1 Copper Pudding-pan. wanting
1 Copper Squirt.

28 Desert Baskets.
Several Desert Glasses.
12 Tin Cups for Ice Cream.
2 Tin Cake Hoops.
3 Tin Basket Pan.
1 Pewter Box and Cover for Sugar.
1 Dutch Oven.
2 Hair Sieves.
1 Wainscot oval Table.
2 Pewter dish Covers.
1 Leaden Cistern. at the Newhouse
1 Round tinn Grater.
3 Deep china Dishes. and 3 deep china Plates.
9 China Dishes of several sorts.
3 China Basons.
6 China Saucers.
1 Caudle Cup.
1 Delf Bason and Cover.
12 China Plates of different sorts.
1 White china Plate and Saucer.
1 Deal Press. at the Newhouse
5 Trivets.
A fire Shovel, Tongs and Poker, and two Iron Backs.
A Portland Chimney piece.
4 Deal Presses for the Sweetmeats. at the Newhouse
1 Copper Ladle. wanting
1 Chafing dish. worn out
9 Wainscot Boards for Sweetmeats.
1 Wainscot Table.
5 Chairs. 2 The Butler took to the Newhouse

Room Nº. 95.

A marble Chimney piece and Slab.
A fire stone Hearth and stone Covings.
An Iron Grate and Fender. To the Newhouse
A Looking Glass over the Chimney. To Boughton
3 Pair of glass Sconces. **To Boughton**
18 Chairs cover'd with black Leather.
 To the Newhouse
A marble Cistern. In the Monkey Room Nº. 87

96 A marble Chimney piece and Slab. } Taken down &
A fire stone Hearth and stone } put in 87
 Covings. }
An Iron Grate and Back & Fender. To the Newhouse
A Looking Glass over the Chimney.
 Taken down & put in 43.
4 Pieces of gilt leather Hangings.
2 Needlework arm'd Chairs with wallnuttree Frames.
 The Backs & Seats Remov'd into the Wardrobe
 in chest Nº. 6 at the Newhouse
A marble Buffet and Cestern.
marble pavement

97. Three cane Stools.
3 Pieces of gilt Leather Hangings. **Good**
3 Glass Doors.

98. A marble Chimney piece.
A fire stone Hearth and stone Covings.
An Iron Back.
A bathing Tub, lin'd with Lead.
2 Cane Blinds for Windows.
marble pavement

Room Nº. 99.

A Portland Chimney piece and Slab.
A Stove Grate with Fire Shovel, Tongs, Poker and
 Fender. Fire Shovel Tongs & Poker to the Newhouse
1 Wainscot Press and 4 deal Presses. To the Newhouse
A two post Bedstead with blue Harrateen Furniture
 Good
A Feather Bed, Bolster and Pillow. **Good**
A check Mattress. To the Newhouse
3 Blankets and a Callicoe Quilt. **Indifferent**
2 Pair of stript Stuff window Curtains & Vallens. **Bad**
 Made use of for a Bed for the Newhouse
2 Hanging Looking Glasses. 1 At the Newhouse
1 Wainscot Table. **broke**
1 Dutch Table and Tea Board. **Old** At the Newhouse
2 Chairs and a Stool. **Old**
 1 Matted Bottom Chairs to Cockpit 10th January
16 Silver Jarrs and Images with leather Covers.
 In the Drawing Room at Privy Garden
3 Wafer Irons. At the Newhouse
15 Diaper Towels for His Grace's Use
5 dozen & 11 fine damask Table Cloths.
1 dozen of fine Birds-eye ditto.
5 dozen & 10 Napkins ditto.
6 Damask Table Cloths.
5 dozen & 10 damask Napkins.
6 dozen & 9 fine damask Desert Napkins.
3 dozen & 6 Supper Cloths.
18 Tea Napkins.
6 Pair of fine holland Sheets.
9 Dimity Blankets.
3 Fine pillow Cases.
16 Pair of second Sheets.
13 Pair of course Sheets.
12 Steward Table Cloths.
2 Pieces of Tapistry Hangings Grotesque work. **Old**
A Wainscot Chest To the Newhouse

Room Nº. 100.

An Iron Grate set in Brickwork.
A pair of Tongs, Poker and Fender.
A copper Still and a Chafing dish.

A marble Mortar and wooden Pestle.

A small Gridiron. To the Newhouse

A six Leav'd leather Screen. **Good**

An Iron Peel for the Oven.

A leaden Sink.

A copper Chocolat-pot and Cover.

A tinn Funnel. To the Newhouse

A square wainscot Table. **Good**

A high Chafing dish.

A brass Tea-kettle. To the Newhouse

An Iron Trivet.

2 Brass Saucepans.

A small brass Pot and Cover } To the Newhouse

3 Chairs.

A large wallnuttree Press. **Good**

2 Silver preserving Pans. } In the Groom of the

1 Silver Spoon and Ladle } Chambers Inventory

1 Copper Scummer.

1 Silver Skellet and Cover.

1 Copper Warming pan.

1 Tinn Candle Box.

101. An Iron Grate

set in Brickwork. } To the Newhouse

A large Copper.

A brass Mortar.

A Top of a Still.

2 Deal Presses. **Good** To the Porter at the Newhouse

1 Wainscot Chest. **Good**

2 Pewter Close Stool-pans

1 Pewter Bed-pan.

A pair of small Scales and Weights. To the Newhouse

A square wainscot Table. **Bad** In 103.

A Press out of this Room to the Newhouse

Room Nº. 102. Empty.

103. A Portland Chimney-piece and Slab.

A fire Stone Hearth and Stone Covings.

An Iron Grate and Back w^th. fire Shovel Tongs,
Poker & Fender. The Back at the Newhouse

A pair of Bellows and a Hearth Broom.

A four post Bedstead with blue Serge Furniture. **Good**

A feather Bed. Bolster and Pillow. **Good**

A check Mattress. **Good** To the Newhouse

3 Blankets and a Callicoe Quilt. **Good**

A cane Squab with a black Frame, and a red Serge Cushion
and Bolster. **Bad**

2 Pair of blue Serge window Curtains, and Vallens. **Good**

4 Cane Chairs, and 1 Stool. **Bad**

1 Black Japan'd Table. **Good**

1 Wainscot ditto. **Good**

1 Wainscot Scrutore. **Good**

1 Hanging Looking Glass.

1 Large wainscot Press. **Good** To the Newhouse

104. 1 Large Copper set with Brickwork.
Taken up & Sold

8 Large Jarrs for Lamp Oil.

A Case containing several pieces of old Marble.

2 Pieces of Iron Pipe

2 Oval marble Slabs for Tables.

Part of an old marble Slab.

Cellar 105.

Ten Binns for Wine two of 'em with Covers.

Room Nº. 106

One wainscot Press containing Plate

One large Deal Chest.

One large old Chest.

One large iron Chest.

One Plate Chest. } to newhouse

One leaden Cistern }

One large glass Lanthorn.

One wainscott Box.

Several brass Bolts for Doors, brass Sconces,
Brass Locks & Strong Hinges. & several Pieces of
Broken Marble.

The Plate.

Eighteen pair of Candlesticks small & great.

Five pair of Snuffers & their Pans.

Two Branches with five sockets each.

Two Branches with four sockets each.

Four Branches with two sockets each.

One hand Candlestick.

One Bell.

One Coffee pot.

One Chocolate pot and Mill.

Two Tea water Kettles.

Two Lamps ditto belonging to them.

A Plate to carry Coffee.

One Milk-pot.

Two Silver preserving Pans.

One Skellet and Cover.

One Spoon with a fork at the Handle.

Five Tea Spoons and one Strainer.

One large gilt Sartood for Chocolate & Coffee Cups.

Two Small ones ditto gilt

One Standish and Bell gilt.

One Salver gilt.

Two Small Plates.

One small Cup and Cover gilt.

Six Salvers for Chocolate gilt.

One Silver Tea Canister.

One Stand with a Silver top.
A gilt Dish.
A Silver Chamberpot.
A Silver Tea-pot.

107. One large Trunk covered with Leather.
One smaller ditto, cover'd with ditto.
One Bread Binn.
One large Deal Case.
One wainscott Chest covered with Leather.
One hanging Shelf and some old Iron.

108. A leaden Cistern and Pump.
A Bucket and Rope, and Frame to the Well.
The Room set with white dutch Tiles.

In the Little Room next to M^rs. Goldstone's.

A Portland Chimney piece and Slab.
An Iron Grate with Tongs, Poker, Fender,
 Brush & Bellows. To the Newhouse
A two post Bedstead with Ash colour Serge Furniture.
 Bad

A Feather Bed and Bolster.
 Good
A check Mattress and a holland
 Quilt. *Good* } To the Newhouse
3 Blankets and a callicoe
 Quilt. *Good*
A Field Bedstead with callicoe
 Furniture.
A check Mattress, 2 holland } This is said to be
 Quilts and a Bolster. sent to Ditton
 Remov'd into the Wardrobe 21 Feb: 1733/4
1 Blanket and a blue printed
 Stuff Quilt.
2 Presses. *Good*
1 Dresser and Cupboard. *Good*
2 Chairs. *Good*
The Room hung with green printed Stuff. *Bad*

In the Half Story over Lady Mary's Apartment.

Two Rooms.
A Portland Chimney piece & a small Iron Grate.
A half headed Bedstead.
A four post Bedstead with Ash colour Serge Furniture.
 Old & Bad
A feather Bed and Bolster. *Bad* Bolster wanting
An old Blanket and Rugg. Wanting
A wainscot Table and a wainscot Chest
 At the Newhouse
 Another Table out of this Room to the Newhouse

In the Half Story on the East Side.

Two Rooms.
Two Portland Chimney pieces.
1 Iron Back. To the Newhouse
9 Pieces of old Tapistry Hangings. *Bad*
A large wainscot Press. *Good* To the Newhouse
 A Bedstead sent out of 1 of these Rooms to
 Blackheath

In the Passage on the Back Stairs.

4 Iron Fire Hearths. 1 at the Cockpit
An old Iron Grate.
4 Fenders. To the Newhouse
A cane Squab.
Several pieces of old marble.
An old Table.
3 Pair of Iron Dogs.

In the Saddle-horse Stable.

A half headed Bedstead.
A Feather Bed and Bolster. }
 Good } Suspected to have Buggs
1 Blanket. *Bad* }

In the Groom's Room.

A half headed Bedstead.
A feather Bed and Bolster. }
 Good } Suspected to have Buggs
3 Blankets and Rugg. *Bad* }
A Straw Mattress.
A stone Chimney piece.
An Iron Back and Fender.
A wainscot Table and 4 Chairs. *Bad*
The Room hung with old Tapistry. *Bad*

In the Coach-horse Stable.

A Press Bedstead. *Bad* }
A Feather Bed and Bolster. } } *Suspected to have Buggs*
 Indifferent }
2 Blankets and two Ruggs. }
 Bad

In the Lobby.

A large Chimney piece of Derbyshire Marble.
An Iron Range and Back.
 The Iron Back to the Newhouse
2 Brass Pots and an Iron Trivet.

In the Rooms over the Lobby viz^t.
 Coachmens Room.

A half headed Bedstead. *Good*
A feather Bed and Bolster.
2 Blankets a Rugg and a Straw
 Mattress. *Good*
2 Wainscot Tables. *Bad*

} *Suspected to have Buggs*
 To Blackheath

2 Forest Chairs. broke *Bad*
An old Iron Grate.
An old wooden Chest and Form. *Bad*

Footman's Room.

2 Half headed Bedsteads.
2 Feather Beds, and Bolsters.
 1 Bed & Bolster to Blackheath
1 Mattress and a holland Quilt.
5 Blankets and 2 Ruggs.
 3 Blankets & a Rugg to BH.
 NB. there is only 1 Rugg &
 2 Bits of a Blanket left.

} *Good Suspected*
 to have Buggs

2 Square Tables. *Bad*
5 Chairs and a Stool. *Bad*
An Iron Grate with Fire Shovel and Fender.

Footmen's Room.

A Press Bedstead with Folding
 Doors.
A Feather Bed and Bolster.
A Check Mattress, three Blankets
 & green Rugg

} To Blackheath
 Good Suspected to
 have Buggs

Four Deal Presses.
Two wooden Chairs.
A Square Deal Table.

} *Bad*

Over the Porter's Lodge.

A half headed Bedstead. *Bad*
A Feather Bed and Bolster. *Good*
A hair Mattress. *Bad*
3 Blankets and a Rugg.
 1 worn out

} To the Porter at
 the Newhouse

In the Maids Room over the Washhouse.

An Iron Range.
A fire Shovel and Tongs. worn out
2 Half headed Bedsteads.
2 Feather Beds
 and Bolsters.
2 Straw Mattresses.
6 Blankets and
 two Ruggs
2 Square Tables.
 1 To the Newhouse
2 Chairs and two Stools.

} To the
 Newhouse

} **To be moved but**
 not to the House
 at White Hall
 Full of buggs

Ditto.
An Iron Range and Fender.
A half headed Bedstead.
A Feather Bed, Bolster
 and Pillow.
3 Blankets and a Rugg.
1 Straw Mattress.
1 Chair.

} To the
 Newhouse

} **Full of buggs**

Ditto over the Woodhouse
An Iron Stove with fire Shovel,
 Tongs Poker and Fender.
A half headed Bedstead.
A Feather Bed, Bolster,
 and Pillow.
3 Blankets and a Rugg.
A Straw Mattress.

} To the
 Newhouse

} full of Buggs

1 Dutch Table, and a square Table.
1 Wallnuttree Frame for a Chest.
3 Stools and two Chairs.

Closet N^o. 67

Sundries in a Press viz.
2 Cushions belonging to the Phaeton of
 Green Velvit
The Furniture of 2 Beds from Newhall viz
1 of white Camblet Embroider'd & Lin'd
 with a Cherry colour'd Lutestring. &
1 Crimson Velvit spotted with white &
 Lin'd with a crimson Persian
2 Pair of blue Mohair Window Curtains *Out of Room*
 & vallens 53
3 Pieces of blue Mohair Hangings
12 Arm's Chair Cases of Crimson Velvit with
 red Serge Covers 54
The Cases of 2 Needlework Arm'd Chairs
 Trim'd with blueLace & red Serge Covers 55
3 Pieces of Flower'd Velvit } 3 pieces of
 Hangings paned w^th. green } Velvit
 Velvit } to the 60
13 Pieces of Velvit Hangings } Newhouse
 & Cases of ditto for 8 chairs } **not put up**
4 Pair of white Damask Window Curtains with
 Cornishes & Vallens The Cornishes are in
 the Closet by the Press 60
3 Red Lutestring Window Curtains & Vallens 57
2 Pair of Yellow damask Window Curtains &
 Vallens 65
6 Needlework Chair Covers the same of the
 Needlework Bed 66

Boughton House, Northamptonshire, 1709, 1718, 1730

Acquired by Sir Edward Montagu in 1528, Boughton House was extended by Ralph, 1st Duke of Montagu, in the late seventeenth century on the north front in the French manner with two pavilions joined by a series of state apartments in readiness to entertain the monarch. William III is known to have visited Boughton in 1695. The earliest transcribed inventory was taken after the 1st Duke's death in 1709.

The State Rooms were decorated in a series of contrasting colours. The first room or Antechamber was furnished with crimson upholstery and white damask window curtains; the Drawing Room had similar curtains; the State Bedroom with its crimson and gold damask bed, recently returned to Boughton from the Victoria and Albert Museum, was hung with tapestries and white damask window curtains. The Fourth State Room was hung with blue damask with matching curtains. The 1709 inventory demonstrates, despite the grandeur of the State Apartments, how sparsely this country house was furnished by comparison with Montagu's town palace.

The 1718 inventory records the names of members of the Montagu household who had served under the 1st as well as the 2nd Duke including Dr Silvestre, who personally supervised the late seventeenth-century extensions and gardens at Boughton and Mr. Charles Lamotte, who also served as the local parson. Lady Hinchinbrooke was a cousin who lived nearby at Hinchinbrooke, Huntingdon, but often stayed at Boughton in the 1st Duke's time.

Although the contents of the State Apartments had not changed since 1709, the house was extended during the second quarter of the eighteenth century to create the New Gallery now known as the Audit Gallery and the Music Room. The 2nd Duke was particularly interested in family history and the set of 'six hole length Pictures in Gold and Black Frames' in the Great Stone Hall where the family dined on formal occasions are the imaginary portraits of Montagu's ancestors which hang in the New Armoury at Boughton today. The 'Smoking Room', used by the gentlemen of the house for smoking, still survives. The Duchess's Drawing Room demonstrates the welcome female presence of the 2nd Duchess – the 1st Duke's second wife never lived at Boughton. The Armoury, laid out by the gunsmith Lewis Barbar in 1718 formed the nucleus of what is arguably the most important private armoury in the country and reflects the 2nd Duke's growing professional interest in this area of his collections. The 1730 records of twenty-three maps in the Long Gallery refer to the estate plans commissioned by the 2nd Duke. The new pewter and brass domestic equipment indicates that the house was more regularly used at this period as the housekeeping records demonstrate.

These inventories are in the collection of the Duke of Buccleuch and Queensberry and deposited in the Northampton County Record Office. The 1709 inventory is transcribed from the paper version compiled at Boughton for probate.

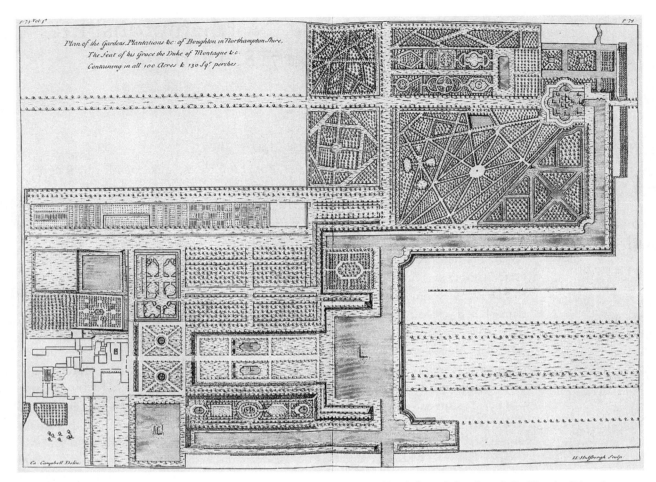

(Fig. 9) 'Plan of the Gardens, Plantations &c: of Boughton in Northampton Shire', from Colen Campbell, *Vitruvius Britannicus,* vol. III, 1725. *Victoria and Albert Museum*

An Inventory of the goods and Chattles late of his Grace Ralph late Duke of Montagu at his late Seat at Boughton in Northamptonshire taken March 25th 1709.

Imprimis in a garret in the east wing of yᵉ House

a Lath bottom'd bedstead with a sad coloured Serge furniture a flag Mat and chequer'd Mattress a feather bed bolster and two blankets one old silk quilt two cain chairs. Two Dogs a pair of Tongs a close stool and a lock and key valued at six pounds three shillings

6. 3. 0

In the next Garrett

a half headed bedstead Cord and Matts a feather bed and bolster two old blankets and one old green Rugg and a lock and key valued at one pound nineteen shillings and six pence

1. 19. 6.

In the gallery where the Billiard Room is in the Maid's garrett

One old sacking bottom'd bedstead with a sad colour'd camlet furniture a feather bed and bolster two down pillows three blankets and Coverled and cane chair a Camp stool a walnut tree chest of Drawers a dressing glass three close baskets a lock and key valued five pounds six shillings

5. 6. 0

In Mʳ. Colley's Room

a Bedstead Matt and Cord a red cloath furniture a feather bed and bolster three blankets a yellow coverlid a sacking bottom'd bedstead a sad colour'd china furniture a feather bed bolster and chequer'd Mattress one pillow two blankets one calico quilt three old stuft chairs one matted chair a spanish Table a dressing glass and a lock and key valued at twelve pounds five shillings

12 5. 0

In the next Room

a halfe headed sacking bottom'd bedstead with a red Serge furniture compleat a feather bed and bolster a chequer'd Matress Two blankets a small square Table a stuft chair a matted chair and lock and key, valued at four pounds eight shillings

4. 8. 0

In the billiard Rooms

a Billiard Table covered with green cloth and a false leather Cover to it with balls and sticks to it. Six valear Chairs The Room hung with Tapestry the floor covered with watled Mat a large Iron stove lock & key valued at sixteen pounds one shilling

16. 1. 0

In the little Room over agᵗ. the Billiard room

A Bedstead Matt and cord with grey Serge Cantoone furniture a feather bed and bolster a Linnen Matress a folding Table two stuft chairs a lock and key vallued four pounds thirteen shillings

4. 13. 0

In the Room at the End of the gallery

A sacking bedstead and a chequer'd India plod furniture a feather bed and bolster a chequer'd Matress one pillow three blankets a calico quilt one Elbow cane chair two back stools Dᵒ. one stuft chair a chimney glass a wainscot Dressing Table a Deal dressing table a pair of Dogs fire shovel Tongs bellows a wig block three locks and keys – valued – ten pounds ten shillings

10. 10. 0

In the Closet of the same Room

A small corded pallat bedstead a feather bed bolster and three blankets one Elbow stuft chair with a false case to it one cane chair a hearth brush a round Table vallued at Two pounds eleven shillings

2. 11. 0

In Mʳ. Cecill's Room

A sacking bedstead and Indian chequer'd furniture a feather bed bolster a chequer'd Mattress two blankets a callico quilt one white holland quilt one elbow cane chair three back stools Dᵒ. a wainscot dressing Table a Dressing glass a close stool and pewter pan one pair of Doggs fire shovell Tongs bellow and brush and one lock and key valued at nine pounds seven shillings and six pence

9. 7. 6

In the Closet of the same Room

A small lath'd bottom'd bedstead feather bed and bolster one blanket vallued at one pound two shillings and six pence

1. 2. 6

In Dʳ. Silvester's Room

a sacking bedstead and Indian plod furniture a feather bed and bolster and pillow a Dimothy Mattress a chequer'd quilt two blankets a callico quilt and elbow chair one back

stool D⁰. one square stool one stuft chair a walnut tree dressing Table a wainscot close stool and pewter pan a pair of Doggs fire shovell Tongs bellows brush two locks and keys valued ten pounds nine shillings

10. 9. 0

In the Closet of the same Room

A small lath'd bottom'd bedstead feather bed bolster two blankets and a Camp stool valued at one pound seven shillings

1. 7. 0

In the room over agt. Dr. Silverster's Room

A Sacking Bedstead with an Indian plodd furniture a feather bed bolster a holland quilt a chequer'd Mattress three blankets a Callico quilt two cane chairs a stuft chair a wainscot dressing Table a close stool and pewter pan a pair of Dogs Tongs bellows and brush a lock and key valued nine pounds eleven shillings

9. 11. 0

In the Room over agt. Mr. Cecill's

A Sacking Bedstead and Indian plodd furniture a feather Bed Bolster one pillow a chequer'd mattress two blankets a callico quilt a walnut tree Dressing Table bellows brush lock and key valued seven pounds fifteen shillings

7. 15. 0

In Mr. White's Room upon the Stair case

A feild Bedstead with an Indian callico furniture compleat Two holland quilts one Dimothy one and two flock ticking quilts two blankets a square Table an elbow chair stuft a back stool D⁰. a matted chair a Turkey wrought cushion a small Dressing glass lock and key valued four pounds seventeen shillings

4 17 0

In the two Chambers over agt. Mr. White's Room.

A sacking bedstead with a cloath furniture lined with gold coloured persian compleat a feather bed bolster a holland quilt three blankets four cane chairs a wainscot Table a pair of bellows two Sconces washed over three locks and keys valued eight pounds fourteen shillings

8. 14. 0

In the little room behind the great apartmt. upon the same Staircase

a feild bedstead with an Indian gause pavilion curtain a small feather bed a matted chair a lock and key on the Door vallued one pound ten shillings

1. 10. 0

In the two Rooms behind the great Apartmt. upon the same Stairs

Fifty six yards of Brockadilla hangings an Elbow cane chair a hearth brush a lock and key – Vallued two pounds twelve shillings

2. 12. 0

In the Bedchamber to the same Room

A sacking bedstead and Mohair ffurniture a feather bed bolster two Dimothy Mattresses Two blankets one callico quilt one Elbow chair three back stools D⁰. as Table and Stands Japan'd the hangings of the Room Mohair containing abt. sixty yards a pair of Doggs lock and key valued twelve pounds four shillings

12. 4. 0

In the Room over my Lord Monthermon's new apartmt. that was

A lath bottom'd bedstead with a Bengall furniture a feather bed bolster two pillows a dimothy Mattress two blankets an Indian callico quilt a cane chair a stuft chair a Table a perriwig block a hearth brush a lock and key to the Door valued at five pounds ten shillings

5. 10. 0

In the next Room

A halfe headed Bedstead Cord and Matt a feather bed bolster a blanket a green Rug a Stool an old chair a Lock and key vallued four pounds

4. 0. 0

In the next Room

A Bedstead Matt and Cord a feather bed bolster a blanket one Rug a Chair a Stool a Lock and key vallued four pounds

4. 0. 0

In the next Room over my Lord Monthermon's apartmt. that was

A Bedstead Cord and Mat a feather bed bolster an old Mattress a blanket green Rug an elbow chair an old Table Lock and key vallued three pounds

3. 0. 0

My Lord Monthermon's now Apartmt.

One Table Bedstead a Dutch Table four English and two Dutch matted chairs three cane chairs two wainscot dressing Tables one glass in a walnut tree frame about eighty Ells of old imagery Tapestry Sixty five Ells of Landskip D⁰. a feild bedstead with a blew and sad coloured damask furniture trim'd with fringe compleat one holland quilt two chequer'd Mattresses a feather

bolster two blankets five holland window curtains vallance and pulley rods two elbow chairs and one back stool one brass lock Two spring bolts Dᵒ. – valued fifty pounds

50. 0. 0

In the first Room going into the great apartmᵗ. over the Cloysters

One large brass lock two square Stools walnut tree frames and cases to them of Needlework a marble chimney peice and Slobb valued five pounds ten shillings

5. 10. 0

In the Blow Room in the great Apartmᵗ.

The Room hung with blew Damask about ninety six yards lined with chequer'd linnen Six walnut Elbow chairs covered with the same Damask trim'd with gold coloured silk fringe two pair of blew Damask window curtains and Vallance qᵗʸ. fifty six yards trim'd with gold colour'd silk fringe silk line and Tassells one large looking glass in a large glass frame An inlaid Table and Stands one large chimney glass in three parts a marble chimney peice and Slobb the furniture of the chimney being Dogs fire shovel Tongs and brush two brass locks box Staples four bolts valued fifty three pounds eleven shillings

53. 11. 0

In the bedchamber

a lath bottom'd bedstead with crimson Damask ffurniture compleat flower'd with gold and trimm'd with gold fringe one feather bed and bolster a chequer'd mattress a holland quilt three blankets a case to the bed of Indian Callico and a case rod six stuff elbow chairs covered with the same Damask trim'd with gold fringe six matted chairs six cushions of the same Damask Twelve Cases of callico to the chairs one large Looking glass in a glass frame and top a walnut tree Table and Stands inlaid with leather Covers to them one large chimney glass in three parts two white indian Damask window curtains qᵗʸ. fifty six yards with vallance and Cornishes the hangings of the room three peices of Tapestry containing one hundred and twenty two Ells being part of the History of the Apostles a marble chimney peice and Slobb furniture of the chimney Doggs fireshovell Tongs and brush a brass lock Staple and two bolts valued three hundred twenty one pounds eleven shillings

321. 11. 0

In the Drawing Room

One large glass in a glass frame and a Top Dᵒ. one inlaid Table and Stands with leather Covers Two white Damask Indian curtains for the window qᵗʸ. fifty six yards vallance and Cornishes trim'd with whole fringe Eight arm'd chairs

of walnut tree stuft covered with velvet and trim'd with gold galoome one large chimney glass in three parts Two glass Sconces the hangings of the Room being two peices of tapestry qᵗʸ. one hundred and two Ells part of the History of the Apostles the furniture of the chimney Doggs fire shovell Tongs Marble chimney peice and Slobb Lock of brass and two long bolts valued one hundred and forty pounds three shillings

140. 3. 0

In the Antic Chamber

Six large glass Sconces two Elbow Dutch matted Chairs Twelve back Stools Dᵒ. fourteen crimson Damask cushions with vallance trim'd with crimson galoome six white serge window curtains three vallance qᵗʸ. seventy five yards with Strings Tossells three pulley Rods a large marble Table with a walnut tree frame a marble chimney peice and Slob Dogs fireshovel Tongs brass lock box Staple two bolts Twenty seven pounds

27. 0. 0

On the great Stair case

Two brass Locks

1. 0. 0

The first Room in the white pavilion above Stairs

One large glass the frame Dᵒ. a walnut tree table and Stands four white serge window curtains two vallance two pully Rods Six Elbow chairs with cases of blew Damask trim'd with gold colour'd fringe Doggs fire shovell Tongs a marble chimney Slobb three brass locks two long bolts vallued fourteen pounds and eighteen shillings

14. 8. 0

In the Bed chamber

One large glass Table and Stands Indian with Cyphers and plate and other work one of them of Silver a bedstead with a gold brokadoed Damask furniture trim'd with a black and gold fringe compleat a feather bed and bolster two chequer'd Mattresses a silk quilt three blankets six Elbow chairs with Cases to them of the same Damask of the bed and trimmed Dᵒ. four square and two round stools Dᵒ. covered and trimmed Dᵒ. a Case to the bed chairs and Stools of red Serge and a case rod three peices of fine Tapestry qᵗʸ. one hundred and thirteen Ells the Story of the Apostles a marble chimney peice and Slob fire shovell Tongs Dogs brush one large brass Lock Two spring bolts Three window curtains white Serge pulley rods Line and Torsell vallued Two hundred five pounds ten shillings

205. 10. 0

The Room behind the great Bedchamber

The Room hung with green striped plodd a feild Bedstead with green plodd furniture trim'd with galoome a feather bed and bolster one canvas Mattress an Indian Callico quilt Two window curtains and vallance of the same pladd pulley rods and line a cane chair a stone chimney peice and hearth one brass spring bolt valued nine pounds eight shillings

9. 8. 0

In the next Room

A feild Bedstead with crimson Damask furniture trim'd with silver and gold fringe a feather bed and bolster chequer'd Mattress one holland Quilt one blanket four Elbow chairs with cases of crimson Damask trimmed with gold and silver fringe two peices of old Tapestry hangings one black Cord Table marble chimney peice Slob Dogs fire shovell valued forty seven pounds and five shillings

47. 5. 0

The old Billiard Room

Six Elbow chairs covered with valure two matted chairs the hangings of the Room of valure a large chimney glass Marble chimney peice Slob a brass lock vallued eleven pounds fifteen shillings

11. 15. 0

Ditton Room

A lath bottom'd bedstead with Tissue furniture lined with sky coloured sattin trim'd with gold and silver fringe compleat feather bed and bolster a Dimothy Mattress a holland Quilt five blankets black Table Stands and glass with chas't work of brass on't one Elbow chair of cane Two back stools Dº. two blew damask brocadoed easy chairs with false cases to them of Indian pladd pair of Dogs a hearth brush three peices of Landskip Tapestry qty. twenty Ells a white serge case and Rod to the bed marble chimney peice Slobb two callico window curtains and Rods two brass locks vallued one hundred thirty seven pounds three shillings

137. 3. 0

In the Closet of the Ditton Room

A feild Bedstead with stuft furniture feather bed down pillow ticking matress a blanket a Coverlid two cane chairs a Brockadillo Stool a close stool the hangings of the Room of Brockadillo a wigg block a brass lock and two Iron ones valued five pounds eighteen shillings

5. 18. 0

The Closet belonging to the Lady Anne Popham's Bedchamber

A feild Bedstead and Indian Callico furniture feather bed bolster two blankets a stuft Stool a cane chair the hangings in the Room of Brockadello a deal press an Iron Lock a small bolt valued seven pounds eleven shillings

7. 11. 0

Lady Anne Popham's Bedchamber

A Bedstead with needle work'd furniture lined with white flowred peeling compleat a feather bed bolster two chequer'd Quilts one blanket six walnut tree Elbow chairs stuf't with false Cases of Needlework and Table Stands and glass two callico window curtains two Rods the hangings of the Room of valeur marble chimney peice Slob a close stool pewter pan an Iron lock Dogs fire shovell and Tongs valued thirty one pounds seven shillings

31. 07. 0

Long gallery

Two walnut tree Scrutores with bottom and top two Elbow cane chairs six Maps one picture two brass spring bolts valued Eight pounds ten shillings

8. 10. 0

Mr. Pavelliere Room

A lath bottom'd Bedstead with sad colour'd serge furniture compleat a feather bed bolster Dimothy Quilt Two blankets an Indian Callico quilt three cane chairs a wainscot Table two Dogs an Iron lock and key valued six pounds four shillings

6. 4. 0

Mr. Palmer's Room and Closet

a Lath bottom'd Bedstead with strip'd silk furniture feather bed bolster pillow two blankets a silk quilt a Damask Elbow chair Card Table a walnut tree table glass three cane chairs pair of Dogs a small corded bedstead a broken cane chair Joint Stool two Iron locks and keys valued seven pounds eight shillings

7. 8. 0

Lady Hinchinbrook's Apartmt.
In the waiting Room

A Table Bedstead three cane chairs two white callico window curtains two Rods Dogs fire shovell Tongs brush a Stone chimney peice and hearth a large brass lock valued three pounds two shillings

3. 2. 0

In the Bedchamber

A black turned Japan'd bedstead with a Bengall furniture lined with yellow persian and trim'd with silver lace feather bed bolster holland Quilt Dimothy Mattress three blankets an Indian persian sticht Quilt the hangings of the Room being five Sumpter cloaths one Elbow cane chair two black stools a large glass in a black frame a Card Table two Indian Callico window curtains and rods a large brass lock and two bolts Stone chimney peice and hearth a matted chair Dogs fireshovel Tongs six blew Damask cushions for the Backs and Seats of three chairs one strip't Sattin cushion valued forty seven pounds ten Shillings

47. 2. 0

The next Room

One Elbow chair and four back stools D⁰. ten blew Damask cushions to the five chairs one Elbow stuft Chair of blew Sattin a cushion of the Same two stuft Stools D⁰. a folding Table Dutch Table three callico window curtains walnut tree Chest of Drawers leather Cover the hangings of the Room of blew Damask qᵗʸ. thirty five yards a Stone chimney peice and hearth brass Spring bolt a large brass lock vallued fourteen pounds twelve shillings

14. 12. 0

In my Lord Duke's own apartmᵗ. below Stairs

In his Grace's Dressing Room
One stuft elbow chair one cane chair D⁰. two cane back stools two stuft square stools with false Cases of Needlework a Dutch Table walnut tree table and Stands the hangings of the Room of Callico qᵗʸ. thirty five yards two large window curtains vallance two large brass locks spring bolt vallue eight pounds ten shillings

8. 10. 0

His Grace's Bedchamber and Closet

A Bedstead and blew genoa Damask furniture compleat a chequer'd and a Dimothy Mattress feather bolster two elbow cane chairs five back stools D⁰. – one Elbow sticht chair cane Swabb a Needlework fire Screen a walnut tree Budore large glass in a black frame small Cedar Table three peices of Vintage Tapestry hangings qᵗʸ. sixty four Ells two window curtains and vallance of white callico two pulley rods Torsell and Line six blew Damask cushions two backs D⁰. Dogs fireshovell Tongs bellows marble chimney peice Slobb large brass lock two spring bolts valued Eighty one pounds four shillings

81. 4. 0

ffootman's Closet

A small halfe headed bedstead feather bed bolster two blankets callico window curtain and Rod a matted chair Close stool pewter pan a flaskett a callico curtain and Rod to draw before the bed valued three pounds four shillings

3. 4. 0

The next Bedchamber

A Bedstead with Irish stich't furniture lined with white pink'd Satten a down bed feather bolster a Dimothy and chequer'd Mattress two elbow chairs six back Stools D⁰. covered with Needle work two Square Stools stuft and covered with blew Damask a large glass in a walnut tree frame black table chimney glass in three parts four persian window curtains lined with red Serge and vallance to them trimmed with silver gold and black fringe two curtain Rods five peices of vintage tapestry qᵗʸ. abᵗ. one hundred four Ells marble chimney peice and Slob Dogs fireshovell Tongs large brass lock spring bolt D⁰. vallued one hundred and thirty pounds eleven shillings and six pence

130. 11. 6

The Drawing Room

ffour Elbow chairs and a Settee stuft and covered with needlework two square Stools D⁰. large glass with Chest work on it a black Table chimney glass in three parts Two blew Damask square Stools two white Indian Damask window curtains and vallance and pulley rods five peices of Tapestry qᵗʸ. one hundred and two Ells Stove grate fire shovell Tongs fender bellows brush a marble chimney peice Slobb feather cushion large brass lock and spring bolt valued one hundred ten pounds nine shillings and six pence

110. 9. 6

Musick Room

Six Elbow chairs with valeur Cases four back Stools D⁰. two marble Tables with walnut tree frames chimney glass in three parts five glass Sconces Doggs fire shovell Tongs a red valeur chair three brass Locks four long bolts two walnut tree Stands marble chimney glass Slob vallued eighteen pounds five shillings

18. 5. 0

The Vestable

Two marbles Tables one elbow cane chair two back Stools D⁰. two stuft elbow chairs covered with Needlework chimney glass in three parts Stove grate fender Shovell Tongs bellows brush marble chimney peice Slob three brass locks and four long bolts vallued Twenty two pounds sixteen shillings

22. 16. 0

The great Stone Hall

Two large marble Tables on walnut tree frames a wainscot folding Table two square ones an eight leaves guilt leather'd Skreen lined with Serge four stuf't arm'd chairs with Needlework Cases Eight walnut tree cane back't Stools one elbow D⁰. large Stove grate fire shovell and Tongs five white linnen Damask curtains for windows and vallance five pulley rods Torsels and line large marble chimney peice and Slobb pair bellows four brass locks two bolts valued sixty four pounds four shillings

64. 4. 0

The side board room

Two marble Tables with walnut tree frames large marble Cisterne and Stand two wooden Stools two Camp Stools valued thirteen pounds five shillings

13. 5. 0

The little painted Hall

Two ovall wainscotted Tables one square D⁰. Ten cane chairs eight callico window curtains and vallans four pulley Rods with line and Torsells stone chimney peice and hearth brass lock and bolt D⁰. valued Six pounds fourteen shillings

6. 14. 0

The side board room to the little painted hall

A Stone Table and Cistern Stand two cane chairs Stone chimney peice and hearth brass lock spring bolt D⁰. valued four pounds five shillings

4. 5. 0

The new Stone hall

Ten Valeur Chairs large marble Cisterne and Stand stone chimney peice hearth two brass spring bolts six holland window curtains three vallance three pulley rods valued thirteen pounds ten shillings

13. 10. 0

The great Stair case

Three large brass locks spring bolt D⁰. Four long bolts valued two pounds five shillings

2. 5. 0

The new Pavilion below Stairs in the Stone parlour

Eight valeur Chairs a Dutch Table marble Table looking glass in a black frame two white Serge window curtains and rods marble chimney peice Slobb large brass lock and spring bolt D⁰. valued nine pounds nine shillings

9. 9. 0

The Bedchamber

A lath'd bottom'd bedstead lined with a purple and white striped Sattin compleat dimothy Mattress and chequer'd Mattress four blankets seven stuft elbow chairs and four back Stools D⁰. covered with the same Damask one Turkey leather'd Elbow chair looking glass with a black frame Table and Stand leather Covers to them a Dutch Table square folding wainscot Table three peices of Landskip Tapestry hangings qty. seventy six Ells large brass lock spring bolt D⁰. marble chimney peice and Slob valued ninety two pounds three shillings

92. 3. 0

The Plugg Room

Twenty four yards of Damask hangings six round Stools covered with the Same two striped Muslin window curtains two Rods valued eleven pounds six shillings

11. 6. 0

The middle Room

A walnut tree Chest of Drawers two Elbow cane chairs one black Stool Room hung with green plad window curtains the Same a Dutch matted chair two brass spring bolts stone chimney peie and Slob valued Six pounds one shilling

6. 1. 0

The little Bedchamber

A Lath'd bottom'd bedstead of poin'd Damask furniture stich'd Quilt feather bed bolster chequer'd Mattress two blankets three Elbow chairs back Stool D⁰. covered with the same Damask walnut tree folding Table three peices of tapestry Landskip qty. abt. fifty Ells marble chimney peice a callico window curtain and Rod a brass spring bolt Doggs fireshovell Tongs vallued fifty two pounds seventeen shillings

52. 17. 0

Closet where the footman lyes

A feild Bedstead Callico furniture compleat feather bed bolster chequer'd quilt cane chair vallued four pounds twelve shillings

4. 12. 0

The passage that goes to the garden

A brass lock two long bolts one Iron Lock two long bolts valued ten shillings

10. 0

The Corner Room at the End of the passage facing the garden

A deal press folding Door two matted Chairs two stuft chairs cane chair some old Tapestry old Trunk and pulley Rod valued Two pounds eleven shillings

2. 11. 0

Mr. Maram's Room

A feild bedstead green Damask furniture feather bed bolster three chequer'd quilts two blankets two cane chairs walnut tree Table press for cloaths and a perriwig block valued five pounds

5. 0. 0

The footman's waiting room

A folding Table six cane chairs two stuft valeur chairs one cloath and one Turkey wrought Chair Two Camp leather Chairs and a wooden chair valued one pound ten shillings

1. 10. 0

Steward's dining Room

An elbow chair stuft three cane chairs a wainscot Table Desk fireshovell Doggs bellows Tongs and brush valued one pounds three shillings

1. 3. 0

Gentleman's Parlour

A folding ovall Table folding square Table a square Dressing Table Deal Stool pair Dogs fire shovell Tongs brush eight cane chairs vallued one pound eleven shillings

1. 11. 0

Confectioner's Office

ffive Baskets lined with Tin seven other baskets glass baskets round Table two square Tables two wooden Cisterns twenty one Trenchers a block four Tin Lanthernss marble Mortar ten glass Decanters ninety five drinking glasses five Cruets thirteen glass Mugs six flint glasses pints each, Thirty six syllabub glasses ninety four sweet meats glasses thirty glass Stands for Sweet meats Sauce pan Dº. glass Salver fifty four delph ware Saucers Eighteen fine delph ware plates five Dishes Dº. nine earthen Salts three earthen plates six china plates two dozen and eleven case knives ordinary thirty seven forks forty nine pewter Dishes ten Mazarines hundred thirty plates eight dish Covers two pasty peels a bottle Cistern four Salts a bason cheese plate twelve sweet meat plates three close stool pans Dº. all weighing five hundred forty seven pounds weight valued seventeen pounds fourteen shillings

17. 14. 0

Copper

Eight Drinking pots Cistern two teakettles Chocolate pot two Coffee pots chaffing dish two stew pans a sweetmeat pan fountain with brass Cock in't all weighing eighty pounds valued four pounds six shillings and eight pence

4. 6. 8

Brass

One kettle a Boyler skellet two Stew pans a Dutch oven two warming pans eleven flat Candlesticks forty nine standing Candlesticks six Stands for snuffers four snuff pans six pair Snuffers seven Extinguishers and two Coffee Roasters weighing gross one hundred twenty one pounds valued four pounds eighteen shillings

4. 18. 0

Iron

A fire pan fire shovell two pair Tongs two round stoves four Trevets a Stand Chaffing dish Stove pan vallued nine shillings

9. 0

The Cupboard of the said Office

Two pair brass Scales six sweetmeat baskets Eleven Seives three hair Seives two wooden pestles tin pudding pan and ffunnell four lead Standishes forty five quire of paper tin cream freezer three pound and a quarter of sweet Almonds four pound halfe bitter Dº. three balls of packthread two of Cotton yarn Tin grater thirty pound of wax lights a pewter pint pott three quarts and two pint bottles of Spirits pair bellows fishing rod wooden Cistern lined with lead two cane chairs twenty four pound of Sugar gross weight vallued five pounds ten shillings

5. 10. 0

Smoking Room

A Table and four cane Chairs Ten Shillings

10. 0

The Pantry

A Binn for bread a Coffee Mill leather Jack folding Table square Table a table bedstead five matted chairs one cane chair pair bellows pair dogs pair fire shovell pot hanger and Chaffing Dish valued one pound fourteen shillings

1. 14. 0

Pantry Chamber

A Bedstead, Matt and Cord with yellow serge furniture
feather bed bolster two blankets Rug a bedstead Matt and
Cord with sad colour'd Serge furniture feather bed bolster
Dimothy Mattress an Indian Callico quilt five old Chairs
two Stools pair brass Dogs and a Table valued six pounds
ten shillings

6. 10. 0

Next Room

Bedstead Matt and Cord two old curtains feather bed
bolster four blankets an old Bays Coverlid and Mattress
old Elbow chair and matted chair three large Spits and a
Dutch oven valued three pounds seven shillings

3. 7. 0

In the passage

A large Cedar Chest and Cupboard Terret Clock and a
large Bell vallued four pounds fourteen shillings

04. 14. 0

In Mr. L'Motte's Room and Closet

A lath bottom'd bedstead with Bengall furniture a
chequer'd Mattress a Dimothy mattress feather bed
bolster four blankets callico quilt one old leather chair and
cushion two Turkey wrought Chairs three Stools wainscot
Table covered with green cloath pair dogs large Chest
Tongs fireshovell bellows two Stands brush Dressing
glass pendilum clock valued eleven pounds six shillings

11. 6. 0

Room over Mr. L'Mott's

ffive brass locks a stock Lock two pistols a bullet gun five
pewter Lanbecks some old Iron two old Trunks severall
old baskets a Close Stool and other Lumber valued four
pounds

4. 0. 0

Water house and yard

Leaden Cistern and Trough Do. large Chest Cupboard a
Stillion two pailes a bottle rack Iron Stand hand bowl two
lead brushes a hair broom thirty two pound weight of
candles valued two pounds twelve shillings

2. 12. 0

Stewards hall

Eleven wooden Chairs four cane elbow Sattees large deal
oval Table stone table pair large brass Andirons pair doggs
tongs bellows wooden Stool Matt under the Table large
wattle mat at the Entrance of the Door Another Table
valued five pounds

5. 0. 0

Servants hall

Long dining Table lesser Table four fforms a press horse
to dry cloaths forty two beer vessels great and small
valued nine pounds one Shilling

9. 1. 0

Great kitchin and Larder

Seven copper porridge pots and Covers two large boyling
brass pots one Cover seven copper flew Sauce pans seven
brass flew Sauce pans four brass Sauce pans one Copper
one three large brass gravy pans two pudding pans one
brass tart pan with three false bottoms two large patty
pans one brass one copper two copper fish pans and
Covers three brass Collenders one copper one a large
brass kettle two brass ladles six small brass petty pans
twelve small copper petty pans four brass Skimmers and
Slice Do. two brass and one copper french Ovens a brass
fishplate and pott Cover bell mettle mortar Iron pestle the
weight of the brass is one hundred fifty four pounds and a
halfe The Copper fourscore and ten
Value of the brass Six pounds four shillings

6. 4. 0

—— of the Copper five pounds ten shillings

5. 10. 0

Two large Iron Dripping pans six Spits Jack and leaden
weight three lark Spits two beef forks three Clevers two
chopping knives four large gridirons two frying pans four
Iron Candlesticks nine Trevets nine Stoves fire shovell
Sifter Tongs and poker range and spit rack a small Copper
and Irons three Tin graters Iron hanger fender three
chairs marble Mortar wooden pestle wooden Mortar two
Rowling pins six pye peels three pudding Dishes and
Covers two blocks chairs a Cruch small Box a Lanthorn
Jugg hour glass earthen bason two earthen pippin pans a
paushion and venison pot two old pales a wheelbarrow a
Table form three salting Tubs hanging Shelfe wooden
Cisterne lined with lead valued Seven pounds eighteen
Shillings

7. 18. 0

The Wine Cellar

Twenty one Bottles of Cyder twenty nine bottles of
Rhenish wine ten pint bottles of Sack sixteen bottles of
Mum seven bottles of elder vinegar thirty six pint bottles
of Spanish wine three bottles florence Oyl one Stillion one
bottle wrack valued four pounds eight shillings six pence

4. 8. 6

Ale Cellar

Eleven Butts full of strong beer qty. four Barrells and a
halfe each Butt one hogshead full eight Stillions Sixty
Dozen of Bottles vallued fifty four pounds ten shillings

54. 10. 0

next Cellar

Five Stillions pair of Iron gates Valluied Two pounds

2 0 0

Small beer Cellar

Six peices full small beer six brass Cocks great and small pair of Iron gates seven stillions one empty Cask four locks and keys valued twelve pounds

12. 0. 0

Scullery

Two Tables four forms one old Cupboard a plate Rack four old stools valued five shillings

5. 0

The yard

A lead Cistern valued one pound thirteen shillings

1. 13. 0

The Dary

An old Table two forms old Cupboard four shillings

4. 0

The yard before the great kitchen

A wooden Cistern lined with lead a bell wheel and Cord vallued four pounds

4. 0. 0

Linnen Chamber

Six large Trunks a Deal box five flaskets two stuft chairs a round cane Stool picture twenty eight white basons twenty seven Chamber pots fifteen hair brooms seven Mops forty pounds of Soap twenty three hard rubbing brushes abt. a yard and halfe kiddermister twenty two pair of holland Sheets fifty eight pair flaxen Sheets ten yards of new flaxen cloath one Ironing Cloath fifty five fine holland pillow beers twenty nine dozen and halfe Damask napkins thirty nine large Damask table cloaths seven small ones Seventy seven diaper and huccaback Table cloaths Eleven dozen and eight flaxen Towells seventeen huccaback and diaper Towells four dozen and two Diaper and damask Do. three dozen holland Towells fourteen oyster cloths vallued one hundred thirty seven pounds three shillings

137. 3. 0

Landry

A large Range and Cheecks hangers and Trevet a copy and Iron work to it pair old Bellows eight washing Tubs one rinsing Tub wooden horse an old cupboard a copper and Iron work two small Ladders vallued eight pounds

8. 0. 0

Drying rooms

a large range fender hanger fireshovell nine smoothing Irons two wooden horses pair Steps large deal press a form three cloaths flaskets a cloath press four Tables a form ten black matted Chairs one Stool large fender two hand pales valued three pounds and ten shillings

3. 10. 0

Garrets over the Laundry

A halfe headed bedstead Matt and Cord feather bed bolster two blankets square Table and chair vallued two pounds ten shillings

2. 10. 0

Two next garrets

Three halfe headed bedsteads matt and Cords two feather beds two bolsters two pillows four blankets an old Coverlid and Quilt a Suit of green serge curtains an old chair valued five pounds ten shillings

5. 10. 0

Pastry

A peel Rake and prong four shillings

4. 0

The Larder where they weigh the meat

A large pair of Scales abt. a hundred and ¾ of lead weight, chopping block clever three salting flatts lined with lead a large Dresser valued four pounds

4. 0. 0

Chamber over the pastry

A halfe headed bedstead Matt and Cord feather bed bolster and pillow two blankets rug red Serge furniture a stuft chair valued three pounds ten shillings

3. 10. 0

Same floor

A Bedstead Matt and Cord with red cloath furniture compleat feather bed bolster two chequer'd Quilts two blankets two cane chairs wooden chair spanish Table pair Dogs and Tongs valued four pounds fifteen shillings

4. 15. 0

Next Chamber

Lath bottom'd bedstead and blew cloath furniture a Dimothy Mattress feather bed bolster three blankets three matted chairs a stuft stool folding Table pair dogs valued five pounds

5. 0. 0

Stable Chamber

Two halfe headed bedsteads mats and Cords two feather beds two bolsters five blankets one old Quilt a green Rugg two stuft chairs a stand perriwig block and frame of a Stool valued five pounds twelve shillings

5 . 12 . 0

Next Room

Two bedsteads mats and Cords two feather beds and bolsters four blankets a rugg an old quilt one chair and boot Jack valued five pounds ten shillings

5 . 10 . 0

Room at the Stair head over the Stairs

Two Bedsteads Matts and Cords two feather beds and bolsters two green Rugs four blankets three matted chairs vallued five pounds nine shillings

5 . 9 . 0

Room over the Stables

A Deal Table matted chair turkey wrought cushion a leather Stool vallued three shillings and six pence

3 . 6

Gardiner's Room

A halfe headed bedstead Matt and Cord feather bolster two blankets rug an old Chair one old green Serge curtain valued two pounds

2 . 0 . 0

Seed Chambers

A Table Chair three Tubs four shillings

4 . 0

Bake house and Chamber

A copper and Irons some old Iron a Copsey Rope and pulleys two chairs a Stand a bedstead and Cord feather bed and bolster two blankets two old Rugs old curtains a Flower Mill and hopper Table eight stock locks one old Chair valued four pounds

4 . 0 . 0

Brewhouse

Two large Coppers and Iron work a mashing flatt three leaden Colours one working flatt and under back pump nine large brass cocks three wooden Spouts two Oars eleven hogsheads fourteen Cellar Tubbs a pair Dogs valued sixty pounds

60 . 0 . 0

The Lodge

A cupboard Table two forms two wooden chairs two Doggs fireshovell Tongs and bellows bedstead and Cord a feather bolster Rug two blankets Deal table a wainscot table Lanthorne two wooden chairs a peel a fork and Scuttle valued four pounds three shillings

4 . 3 . 0

Account of hay cattle and other goods in the yard

About ninety Loads of hay three wagons nine Carts three yoke of oxen one Cow twelve horses at Boughton and Barnwell geers and Collars to the Teems an old Charriot a great watering Cisterne valued one hundred sixty four pounds fifteen shillings

164 . 15 . 0

five marble chimney peices unputup and Slobbs and hewed Stone and other rough Stone abt. the yard valued thirty pounds

30 . 0 . 0

About the house and in the Chase

A parcell of rough Timber felleys and wrought Timber and fire wood vallued sixty four pounds

64 . 0 . 0

In the garden and parts adjacent

fforty nine melon glasses four hot bed glasses fourteen orange Trees in Tubs two hundred and fifteen bays trees in Tubs ten lead Statues seven marble Statues fourteen large lead vawses two small Do. sixty four lead flower pots six covered benches and twenty five tame hen pheasants eleven Cocks Do. some poultry many Ducks valued two hundred seventy eight pounds fifteen shillings

278 . 15 . 0

The fish in the ponds and Canal One hundred pounds & the boats on the Canal

100 . 0 . 0

In the pheasant pen

A halfe headed bedstead cord and Matt feather bed bolster four blankets rug a Table Chair and Stool valued two pounds ten shillings

2 . 10 . 0

Deer in the park

Three hundred forty head of Deer vizt. forty brace of Does a hundred Deer of Antler a hundred and sixty Rascall Deer one hind valued five hundred pounds

500 . 0 . 0

The plate

Eleven silver Spoons twelve forks eighteen knives one
Lemon plate a cup and Cover six Salts four high candle-
sticks two Chamber pots lamp kettle milk pot an old Silver
Bowl all weighing twenty two pound averdupoiz Troy
weight two hundred sixty four ounces sixty nine pounds
six shillings valued

69. 6. 0

In the Wardrobe

A Cedar Chest four Trunks an old wainscot press a
wooden chest round Trunk two long Tables four valees
Six dressing glasses five coach glasses two fire skreens
two peices of old Tapestry hangings a large stitcht Callico
quilt a blew Sattin sticht Toilight an Indian Sattin
Counterpan a valeur Door curtain and vallans lined with
Callico four flanell Iron cloaths two twelve qur· and one
eleven qr. blankets seven odd peices of valeur one yard
and halfe of green cloth seven more blankets a black
sticht quilt lined with Callico eight glass plates two stuff
window curtains four satten cushions flower'd with silver
trim'd with gold lace a white Sasnet Toilight four callico
window curtains a sarge flagg for the boat two Caps a sad
colour'd Serge bed a Coach Seat and Cover a Smyrna side
board carpet and two Turkey wrought ones a long sticht
carpet a bedstead and black posts a small Rugg a parcell
of curtain rods and other old Iron a canvas Cover for the
boat two cloath brushes thirty one pounds one shilling
vallued

31. 1. 0

In the middle Room

A Deal press a wainscot press an Indian persian sticht
Quilt green and red two yards and a halfe of blew
Shaloone two blew false Cases of Do. Shalloone twenty
one small and great Down pillows and bolster Do· four
large feather beds one small one two holland quilts two
chequer'd quilts a Dimothy Mattress a chequer'd
Mattress Seven feather pillows one old Counterpan four
old Blankets two old Ruggs crimson Damask dressing
Chair seven crimson square velvet Stools walnut tree
frames a green figured velvet chair three large Turkey
carpets a small one Do. five Smirna carpets two persian
Carpets one easy chair three Stands one old Turkey
wrought chair twenty two chimney cups sixteen
Saucers Do. four Tea pots Do. a Canister the top of an
Indian Tea table two hand Tea tables and a small one
three pewter Standishes three tin Canisters two matted
chairs a Nest of Drawers covered with hogskin four
boxes to pack up goods the Materialls to the boat a
small parcel of fflocks light warming pans one step
ladder and two others thirty pound of curled hair an old

blew Rug some old lead and brass rings and old grate a
padlock an old stuft chair forty four pounds two shillings
valued

44. 2. 0

The outward Room

A Table bedstead Chest fifteen glass lanthorns part of a
pair of brass Andirons a wooden horse a horse lanthorn
three bolts close Stoole and pewter pan wainscot table
a stuft chair red cloath Tester and curtains a quilting
frame a floor mat two bed matts three brass matts two
chaffing dishes three locks and keys four brooms four
bolts with brasses some old Iron valued five pounds ten
shillings

5. 10. 0

Mr. Warner's Lodge in the Chase

A Room hung with old Tapestry one pound

1. 0. 0

At Barnwell

One hundred thirteen Ewes two hundred thirty seven
whethers two hundred twenty and seven sheer hogs sixty
seven lamb hogs sixteen heifers two bulls fourteen welsh
Runts a parcell of wool some hay a parcell of wool at
Weekley hall valued five hundred ninety one pounds nine
shillings

591. 0. 0

All which Goods and Chattles are appraised to the Sume
of four thousand two hundred ninety six pounds fifteen
shillings and eight pence by us whose hands are hereuto
subscribed

Francis Fox
John Horne

An Inventory of the Goods of His Grace The Duke of Mountague at his Seat at Boughton In Northamptonshire taken Nov[r] the 27. 1718.

Imprimis In the Garrett in the East Wing of the House. A Half head Bedstead Matt and Cord, a Feather Bed Boulster, one Blanket one Rugg two Chairs, a Leathern Close Stool five Locks and Keys, one Latch

The Gallery Where the Billiard Room is – **In the** maids Garrett, A Sacking Bed Stead with Sad Colour Camlet Furniture A Feather Bed, Bolster and Pillow, three Blankets, a Coverlid, a Cain Chair, a Camp Stool Two Rows of Pins a Lock & Key

In M[r]. Collys Room. A Bed Stead matt and Cord, with Redd Cloth Furniture, a Feather Bed Bolster, two Blankets and a Yellow Coverlid, A Sacking Bed Stead with Sad Colour Cheney Furniture, A Feather Bed Bolster, Checkerd Mattris Three Blanketts One Callicoe Quilt two old Stuft Chairs One Cane Chair a Spanish Table a Lock and Key

In the next Room A Halfe headed Sacking Bed Stead with Red Serge furniture Compleat, A Feather Bed, bolster and Pillow A Check'rd Mattriss two Blankets a Stuffd Chair a matted Chair a Table a Lock and Key.

In the Billiard Room. A Billiard Table Covered With Green Cloth and a Leather Cover to it, three Balls Seven Sticks, ~~Six Valere Chairs~~, y[e] Room Hung With Tapestry the Floor Coverd With a matt A Large Iron Stove a Lock and Key.

In a Little Room against the Billiard Table Room. A Bed Stead matt and Cord with Grey Serge Cantoon furniture Feather Bed, Bolster and Pillow, a Linnen Mattris, a Folding Table, three Blankets one Rugg a Stuft Chair a Lock and Key

In the Room at the End of the Gallery, A Sacking Bed Stead and Chequered India Pladd Furniture, A Feather Bed and Down Bolster a Holland Quilt and Chequerd Mattris, two Blanketts, a Callicoe Quilt a Cane Elbow Chair four back Stools Ditto A Chimney Glass and Walnut Tree Table a Dressing Table a Pair of Doggs and Bellows, one Lock and Key two Latches, one Bolt

In the Closet of the Same Room A Corded Pallet Bed Stead, feather Bed, and Bolster, three Blankets two Stuft Chairs One false Case for a Chair a Close Stool and Pewter Pan a Square Table A Lock and Key

In M[r]. Cecills Room, A Sacking Bed Stead and India Chequerd Pladd Furniture, Feather Bed and Bolster a Holland Quilt, a Chequerd Mattris three Blanketts and a Callicoe Quilt One Elbow Cane Chair three Back Stools Ditto a Walnut Tree Dressing Table, a Close Stool and Pewter Pan One Lock and Key.

In the Closet Belonging to the Same Room. A Small lath Bedstead.

In D[r]. Silvesters Room
A Sacking Bed Stead and Indian Pladd Furniture, a Feather Bed, Bolster and Pillow, A Dimitty Mattriss and Holland Quilt, three Blankets and A Callicoe Quilt One Cane Elbow Chair One Back Stool Ditto one Stuft Chair and a Stool Ditto a Wallnut Tree Dressing Table One Camp Stool a Chimney Glass 2 Locks & Keys

In the Room Over against D[r]. Silvesters Room. A Sacking Bed Stead and Indian Plad furniture, a feather Bed a Bolster, and Chequerd Mattris three Blanketts and a Callicoe Quilt One Stuft Chair two Cane Chairs a Wainscot Dressing Table, A Pair of Doggs Tongues, and Brush. Two Locks and Keys.

In the Room against M[r] Cecills Room. A Sacking Bed Stead and Indian Plad furniture a feather Bed and Bolster A Checquer'd Mattris three Blanketts a Callicoe Quilt, One Cane Elbow Chair One Back Stool D[o]. a Stuft Chair a Wainscot Dressing Table a Pair of Doggs, a Lock and Key

In M[r] Whites Room on the Stair Case. A field Bed Stead with Indian Callicoe furniture a feather Bed Bolster and Pillow two ticking Quilts three Blankets a Square Table an Elbow Cane Chair A Back Stool D[o]. one matted Chair a Lock and Key

In the two Chambers against Mr. Whites Room. A Lath Bottomd Bed Stead and Cloath Furniture Lined with Gold Colour'd Persian Compleat a feather Bed Bolster and Holland Quilt three Blankets four Cane Chairs two Brass Sconces a Square Wainscot Table a Pair of Bellows and Brush a Perriwig Block three Locks and Keys

In a little Room behind the Great Appartment on the Same Stair Case. A Field Bed Stead with an India Gause Pavillion Curtains a feather Bed and Bolster a matted Chair a Lock and Key

In the Room behind the Great Apartment on the Same Stairs. Two Pieces of Crockadillo Hangings Containing 56. yards seven matted Chairs two Locks and Keys

In the Bed Chamber to the Apartment, A Sacking Bed Stead and Mohair furniture a feather Bed and Bolster a Dimitty Mattriss three Blanketts a Callicoe Quilt a Japand Table and Stand five matted Chairs four Pieces of Mohair Hangings Containing about 60. yards a Lock and a Key

In the Room over the New Nursery. A Lath Bottom'd Bed Stead with Bengall Furniture A Feather Bed Bolster and Pillow a Dimitty Mattriss three Blanketts a Callicoe Quilt two Cane Chairs A Table a Lock and Key.

In the Next Room A Half headed Bed Stead Matt and Cord, a feather Bed and Bolster One Blanket one Green Rugg A Chair An Old Stool a Lock and A Key

In the next Room A Bed Stead Matt and Cord, a feather Bed and Boulster two Blanketts a Rugg a Table A Stool, a Lock and a Key **In the Nex Room,** A Bed Stead matt and Cord, A feather Bed and Bolster A mattress two Blanketts, a Rugg, a Chare a Lock and Key

In the New Nursery A Table Bed Stead A Dutch Table, four matted Chairs two Pair of White Holland Window Curtains Vallans Lines and Pulley Rodds three Pieces of old Imagary Tapestry one Brass Lock and Key, a Box Staple **In the Bedchamber** In the Said Apartment; A Field Bedstead with Blew and Sad Colour Damask Furniture trimmd with fringe Compleat, a feather Bed and Bolster a Chequerd Mattriss two Pair of Whole Holland Window Curtains Vallons Lines and Pulley Rodds two Stuft Arm Chairs one Back Stool Dᵒ. two False Cases to the Chairs of Blew Serge two matted Chairs two Silk Cushions three Pieces of Landskip Tapestry Hangings Containing about Sixty five Ells A Looking Glass In a Wallnut Tree Frame two Brass Spring Bolts two Latches Ditto

In the Closett. A Small Bed Stead feather Bed and Bolster a White Holland Window Curtain Vallond, Line and Pulley Rodd, three Pieces of old Imagery Tapestry three Cane Chairs

In the First Room going into the great Apartment Over the Cloysters. Five Square Stools Wallnut tree frames and Cases to them of Needle Work, A Grate, a Shovell Tongues and Poker a large Brass Lock and Key and Box Staple

In the Blew Room in the great Apartment. Four Pieces of Blew Damask hangings Lined with Linnen Containing Ninety Six yards two Pair of Window Curtains and Vallons Ditto Trimm'd with Gold Coloured fringe Containing fifty Six yards Silk Lines and Tossells ~~Six~~ 8 Wallnut tree Elbow Chairs & *a Couch* with Cases of *needle work* ~~the same Damask trimmd with fringe Ditto~~, One large Looking Glass with Glass frame and Top, An Inlaid Table and Stands and Leather Covers a large Chimney Glass In three Parts, a Steel Harth, Doggs fire Shovell tongues and Brush a Marble Chimney Piece and Slabb a Brass Lock and Box Staple and two Bolts Dᵒ.

In the Bed Chamber. A Lath Bottom Bedstead with Crimson Damask Furniture Compleat flowerd with Gold and Trimmd with Gold Fringe A Feather Bed and Boulster A Chequerd Mattris A Holland Quilt three Blanketts A Case to the Bed of Indian Callicoe and Case Rod, Six Stuffd Elbow Chairs with Cases of the same Damask trimmd With Gold Fringe Six Matted Chairs and Six Cushions of the Same Damask Twelve Cases of Callicoe for the Chairs A Large Looking Glass in a Glass Frame and Top. A Walnut tree Table and Stands Inlaid and Leathers Covers to them A Chimney Glass in three Parts, two White Damask Window Curtains, Vallans and Cornishes trimmd with White Silk fringe Containing fifty six yards Silk Lines and Tossells, Three Pieces of fine Tapestry Hangings Containing abt. 122 Ells, being Part. of yᵉ History of the Apostles a Marble Chimney Piece and Slabb, a Steel Hearth, Doggs, Shovell Tongues Bellows and Brush A Brass Lock Box Staple and Two Bolts Dᵒ.

In the Drawing Room. A Large Glass in a Glass frame and Top, an Inlaid Table and Stands and Leather Covers Two White Damask Window Curtain Vallons and Cornishes Trimm'd with White Silk fringe Containing fifty Six yards With Silk Lines and Tossells 8. Wallnut tree Arm Chairs Stuffd and Case of Velvet trimmd wth. Gold Gallome, One Chimney Glass In Three Parts two Glass Sconces two Pieces of Tapestry Hangings Containing about 102 Ells being part of the History of the Apostles a Marble Chimney Piece and Slabb A Pair of Doggs, A fire Shovell, Tongues, Bellows and Brush A Brass Lock, a Box Staple, and two Bolts

In the Anti Chamber. Four Large Sconses, two Elbow matted Chairs, twelve Back Stools Ditto fourteen Crimsen Damask Cushions Quilted and Vallons Trimmd with Crimsen Galloom two Crimsen Damask Easy Chairs and Cushions trimmd with Gold Fringe and false Cases of Indian Plad a Crimson Damask fire Screen ~~Six White Large Window Curtains Vallonds~~ Lines Tossells and three Pulley Rodds two marble tables with Walnut Tree frames

a Wallnut tree Scruitore, A Pair of Doggs fire Shovell Tongues and Brush two Brass Locks and Keys and Box Staples, two Bolts. Ditto

On the Great Stair Case, two Brass Locks and Keys, two Box Staples

In the first Room In the White Pavillion above Stairs A Large Glass with a Glass frame and Top Ditto a Wallnut tree Writing Desk two Stands Ditto two pair of White Large Window Curtains, Vallonds Lines and two Pulley Rodds, Six ~~Wallnut tree~~ *valure* Armed Chairs Stuft~~, and Cases of Blew Damask Trimm'd with Gold Colour'd fringe Three matted Chairs~~ a Cane Couch two Cushions, three Pillows of Flowerd Persian An Indian Cabinet on A Black Frame A marble Chimney Piece and Slabb. A Pair of Doggs, Shovell Tongues and Bellows, Two Locks and Keys two Long Bolts

In the Bed Chamber One Large Glass Table and Stands Inlaid with Cyphers and Plates and other Work on them of Silver a BedStead and Damask furniture Lined with Purple and White Stripd Sattin Compleat, a Down Bed and Bolster a Chequered mattriss and a Dimitty mattriss one White Persian Quilt one Shagreen Dº. One Blew and White Dº. Bordered with Silver Brocade, One Green Persian Dº. A Green Persian Cover for a Twilight Seven Elbow Stuff'd Chairs and Damask Covers A Walnut tree Chest of Drawers ~~three pair of White Large Window Curtains Vallons~~ Lines and Pulley Rodds three Pieces of fine Tapestry Hangings Containing abt: 113: Ells being Part of the History of the Apostles a Marble Chimney Piece and Slabb A Pair of Doggs, fire Shovell Tongues Bellows and Brush A Brass Lock and Key two Spring Bolts Dº.

In the Room Behind the Chamber A field Bedstead and Green Plad furniture trim'd with Galoom the Hangings of the Room Dº. two Pair of Window Curtains and Vallonds Dº· Lines, tossells and two Pulley Rodds, A Feather Bed Bolster Canvas mattriss and Callico Quilt two Cane Chairs one Brass Spring Bolt

In the next Room a field BedStead with Crimson Damask furniture trimm'd with Gold and Silver fringe A Feather Bed Bolster Dimitty Mattriss two Blanketts a Crimson Persian Quilt four Arm Chairs with Crimsen Damask Cases trimd with Gold and Silver fringe a Black Card Table A marble Chimney Piece and Slabb. A Pair of Doggs Shovell and Tongues *three matted chairs*

In the Old Billiard Room. Six Armd Chairs Coverd with Valure the Hangings of the Room of Vallure Two

Wainscot Tables a Chimney Glass a Marble Chimney Piece and Slabb. a Brass Lock and Box Staple

In the Same Room A Lath Bottomd BedStead with Tishue furniture Lind with Sky Coloured Sattin with a Blew Brocade Counterpane all trimd with Gold and Silver and Silver fringe and White Large Case Curtains and Case Rodd, a feather Bed and Bolster, a Chequered Mattris a Dimitty mattriss a White Peeling Quilt three Blanketts two Blew Damask Brocaded Easy Chairs and Cushions false Cases of Pladd one Elbow Cane Chair and two back Stools Ditto three Pieces of Landskip Tapestry Containing 74: Ells Two Callico Window Curtains and Rods a Table and Stands with Cast Work in Brass, a Glass, the frame Ditto, a marble Chimney Piece and Slabb a Pair of Doggs, two Locks and Keys. **In the Closet** belonging to Room Two Pieces of Brockadillo Hangings a Square Stool Covered with Ditto a Wallnut Tree Arm Chair Covered with Needle Work and a Square Stool Ditto a Back Stool Covered with Velvet a Dutch Table a Wallnut Tree Chest of Drawers Seven Down Pillows, thirteen Small Holland Pillow beers a Lock and Brass Bolts. **In the Closet** belonging to Lady Ann Pophams Bed Chamber A Field BedStead and India Callicoe furniture, Feather Bed and Bolster two Blankets a Rugg two Pieces of Brockadillo Hangings a Cane Chair a Press one Lock and Key a Small Bolt **In Lady Anne** Pophams Bed Chamber, a BedStead with Needle Work furniture Lined with White flowerd Peeling Compleat a feather Bed and Bolster two Chequer'd Quilts two Blankets Six Walnut tree Stuft Arm Chairs and Needle Work Cases to them two White Callicoe Window Curtains and Rodds three Pieces of Vallure hangings a Wallnut tree Table and Stands A Chest of Drawers Dº. a Hanging Glass a marble Chimney Piece and Slab a Leather Close Stool and Peuter Pan A Pair of Doggs fire Shovell tongues and Brush a Lock and Key **In the Long Gallery**, Three Arm Chairs and Eight Back Stools Covered with Needle Work an Iron Back A Piece of Stone that Came from Barnwell two Spring Bolts.

In Mr. Pavilleros Room, A BedStead and Sad Coloured Large furniture a feather Bed and Bolster A Dimitty mattriss three Blankets a Callicoe Quilt a Stufft Arm Chair a Cane Back Stool a Wainscot Table, two Locks and Keys **In Mr Palmers Room** and Closet A BedStead Striped Silk furniture, Feather Bed and Bolster two Holland Quilts three Blankets An Indian Callico Quilt two White Callico Window Curtains and Rods an Elbow Chair Covered with Crimson Damask Three matted Chairs a Card Table a Walnut Tree Table and Glass a Corded BedStead two Locks and Keys, **In Lady Hinchinbrooks** Apartment; Two India Callicoe Window Curtains and Rodds one Elbow Cane Chair

four Back Stools Ditto a Dutch Table a Pair of Doggs a Brass Lock and Latch.

In the Bedchamber, A Black Turnd Japand BedStead with Bengall Furniture Lined with Yellow Persian trimmd with Silver Lace a Yellow Persian Quilt, a feather Bed and Bolster A Dimitty Mattriss a Holland Quilt and three Blankets, the Hangings of the Room being fine sumpter Cloths of Tapestry an Armed Chair Covered with Leather four Dutch matted Chairs and four Blew Damask Cushions two White Callico Window Curtains and Rods a Glass in a Black Frame a Card Table A Brass Lock two Spring Bolts Ditto

In the next Room Three Pieces of Blew Damask Hangings Containing 35. Yards a Cane Elbow Chair four Back Stools Ditto Eight Blew Damask Cushions for the Backs and Seats of the four Back Stools a Wallnut tree Dressing Chair the Seat Covered with Crimson Damask three White Callico Window Curtains and Rods A Wainscot Table an Old Cushion A Pair of Doggs, Shovell tongues Bellows and Brush. A Brass Spring Bolt

In my Lord Dukes Apartment Below Stairs **In** the first BedChamber a BedStead and Blew Ginoway Damask Furniture trimmd with Gold Colour Fringe Compleat a feather Bed and Bolster, a Dimitty Mattriss a Chequer'd mattriss Two Elbow Cane Chairs four Back Stools Ditto twelve Blew Damask Cushions for the Six Chairs Four Wallnut Tree Square Stools Covered With Blew Damask two White Callicoe Window Curtains Vallons Lines and Rodds A Glass A Wallnut tree Desk a Needle Work fire Screen three Pieces of Vintage Tapestry Hangings Qty. Sixty four Ells a marble Chimney Piece and Slabb, A Grate, Shovell, Tongues and Fender, Bellows and Brush a Brass Lock and Spring Bolt Do.

In the Next BedChamber, A Bedstead and Irish Stich furniture Lined with White Pinked Sattin Imbroidered Compleat a Down feather Bed and Bolster a Dimitty mattriss and Check Do. two Elbow Chairs Six Back Stools Do. Covered with Irish Stitch two White Damask Window Curtains, Vallonds, Silk Lines Tossels and Pulley Rodds, five Pieces of Tapestry Hangings. Containing One Hundred and one Ells, A Glass in a Wallnut tree frame a Black Table a Chimney ~~Piece~~ *Glass* A Pair of Doggs fire Shovell and Tongues A marble Chimney Piece and Slabb A Brass Lock and Spring Bolt Do.

In the new Gallery Three Arm Chairs Cover'd with Velvet Nine Square Stools Do. ~~A Cedar Card Table~~ a Chimney Glass A marble Chimney Piece and Slabb. two Brass Locks and two Bolts Do. **12** *red plush* **Arm Chairs**

In the Drawing Room, ~~Four~~ 14 Elbow Chairs Stufft and Covered with ~~Needle Work Two Arm Chairs Covered with~~ Blew Damask four Persian Window Curtains Lin'd with Serge and Vallonds trimmd with Gold Silver and Black Fringe Silk Lines and two Pulley Rodds Six Pieces of LandSkip Tapestry Hangings Qty. One Hundred and forty six Ells a Glass with Cast Work on it a Black Table a Chimney Glass a Marble Chimney Piece a Stove Grate, Fender Shovell Poker Tongues and Brush. A Brass Lock and Spring Bolt *a cedar card table*

In the musick Room Six Elbow Chairs with Vallure Cases ~~ten~~ twelve Back Stools Do. a Large Marble Table wth. a Black Frame a Chimney Glass In three Parts five Glass Sconces An Eight Day Clock in a Walnut tree Case a Map a marble Chimney Piece and Slabb. A Pair of Doggs, Shovell Tongues and Brush two Brass Locks two Bolts Do. *3 pairs of white Holand window curtains*

In the new Stable Two Marble Tables and Wallnut tree frames two Wainscot Tables and two Wallnut tree Stands fourteen Cain Chairs a Pair of **long** Brass Doggs three Brass Locks and four Bolts

In the great stone Hall Two Large marble marbles and Wallnut tree frames an Eight Leaf Gilt Leather Screen Lined with Serge five White Linnen Damask Window Curtains Vallons Lines Tossels and Pulley Rodds, four Elbow Cane Chairs Sixteen Back Stools Ditto Six hole Length Pictures in Gold and Black frames a Large Marble Chimney Piece and Slabb A Large Stove Grate, Shovell Tongs Poker and Bellows four Brass Locks and four Long Bolts

In the side Board Room Two marble Tables with Wallnut tree frames marble Cistern and Stand a Wooden Forme, **The little Painted Hall** Two Ovall Wainscot Tables two Elbow Cane Chairs four Back Stools Ditto, 4. Pair White Callico Window Curtains Vallons Lines and Pulley Rodds a Marble Chimney Piece and Slabb a Brass Lock and Spring Bolt, **The Side Board to the Little Painted Hall** A Stone Table, Cistern and Stand a Stone Chimney Piece and Hearth two Brass Spring Bolts **The New Stone Hall** Tenn Valure Chairs a marble Cistern and Stand ~~Three pair of White Holland Window Curtains Vallons Lines and Pulley Rodds~~. A Stone Chimney Piece and Slab. A Stove Grate, Shovell and Tongues A Brass Spring a Bolt and Latch

The Great Stair Case, five Glass Sconces three Brass Locks One Spring Bolt and four Long Bolts Do.

The new Pavillion Below Stairs In the Stone Parlour,
Thirteen Cane Chairs two Pair of White Holland Window
Curtains Vallons Lines and Pulley Rods a Glass In a Black
frame, A marble Table a Dutch Table a Pair of Stands one
large Stand and two Glass Arms a Pair of Doggs Shovell
and Tongues a marble Chimney Piece and Slabb a Brass
Lock and Spring Bolt

In the Lady Dutchess's Drawing Room, Three White
Damask Window Curtains Vallonds Lines Tossels and
Pulley Rodds Two Arm Chairs with Damask Cases and
Six Back Stools Ditto two Wallnuttree Dressing Chairs
Covered with Silver Brocade a Couch Quilt, and three
Pillows Covered with Scarlet Velvet and Silver Brocade
four White Damask Cushions flowered with Gold and
Silver and Bound with Gold Lace a Small Stool Cover'd
with Brockedello a Cane Stool a Black Table Stands and
Glass and Leather Covers a Black Ebony Cabinet on A
frame 4 Pieces of Vintage Tapestry Containing Eighty
Ells, two Glass Arms a Wallnut tree Card Table a marble
Chimney Piece and Slab A Pair of Doggs Shovell Tongues
Bellows and Brush. A Brass Lock and Spring Bolt D°.
In the Plugg Room Two Pieces of Damask hangings qty.
twenty four Yards Six Stuft Round Stools Covered with
D°. Two Striped Window Curtains and Rodds a Wainscot
Corner Cubbards A Pair of Back Gammon Tables Boxes
Dice and men. **The middle Room** The Room hung with
Pladd a Pair of Window Curtains D°. Lines Tossells and
Pulley Rodd two Wallnut tree Square Stools Stuft and
Covered with Velvet a Wallnut tree Writing Table
A Stone Chimney Piece and Slabb A Pair of Doggs and
two Brass Spring Bolts **In the Little BedChamber** A
BedStead and Pained Damask furniture A featherd Bed
Bolster and Chequered Mattris two Blankets and Stitcht
Quilt three stuft Elbow Chairs damask Cases five Wallnut
tree Square Stools Stuft and Cover'd with Velvet *a red
mouhaire hanging* a Callicoe Window Curtain Vallons and
Rodd A Pair of Glass Arms A marble Chimney Piece
and Slabb, A Pair of Doggs Shovell and Tongues a Brass
Spring Bolt. **In the Servants Closet** A field BedStead
and Callicoe furniture Compleat a feather Bed and
Bolster, A Dimitty Quilt two Blankets A Cane Chair and a
Dressing Glass.

The Passage that goes to the Garden. A Brass Spring
Bolt a Bell a Lanthorn a Iron Lock

Mr Marins Room A Callicoe Window Curtain and Rodd
a Square Table Cain Chair a Lock and Key

Mr Anthonys Room and Closet A Sacking BedStead
and Serge furniture a feather Bed Bolster and Pillow a
Checkquered mattriss a Holland Quilt 3, Blankets, an old

Silk Quilt two pair of White Callico Window Curtains
Vallons Lines and Pulley Rodds a Wallnut tree Scruitore
four Cane Chairs a Square Table a Wainscot Table One
Stuft Square Stool two Pieces of old Tapestry a Pair of
Doggs a Lock and Key

In Mr Balgays Room Two Wainscot Tables a Writing
Desk an Arm Chair Covered with Blew Serge two Cane
Back Stools Doggs Shovell Tongues and Bellows and
Brush, Lock and Key

Mr Lamots Study, Two Elbow Chain Chairs Six Back
Stools Ditto a Leather Camp Chair an Old Leather
Cushion two Oval Table a mapp and a Weather Glass
a Pair of Doggs Shovell Tongues and Bellows and Brush
a Brass Lock

Gentlemans Parlour ~~two Back Stools Stuft and Covered
with Vallure~~ *These belong to the musik Room* Eight Cane
Chairs one Oval Table a Square Ditto a Dutch Table
a Pair of Doggs Tongues and Brush a Brass Spring Bolt an
Iron Lock and Key

The Confectioners Office and Yard belonging to it:
Two Tables, a Leaden Cistern a Cain Chair a Wooden
Ditto a Pewter Limbeck two Hundred and thirty
Sweetmeat and Drinking Glasses four India Tea Boards
three Green Card Cloths Ten Seives a marble morter
and Wooden Pestle two Lanthorns Shovell Tongs and
Bellows

China Six Chocolate Cups with handles Six White D°.
without handles Nine Blew and White Chiney Tea Cups
and Eight Saucers Eleven Brown China Tea Dishes two
Tea Potts Ditto a Blew Cheney Tea Pot a Slop Bason
a Suggar Dish and Earthen milk mug *a Slop Bason* three
Chamber Potts a mugg a Sillibub Cup Six Basons Ten
Dishes thirty Nine plates Eighteen Deep Ditto Eight
Sweetmeat Ditto

Pewter: Eleven Doz Plates Twenty four Dishes Eight
mazerreens Eight Dish Covers twenty four Spoons Six
Salts a Bottle Cistern fourteen Ordinary Knives and forks
Twelve Square Plates **2** *Pastry Peels* five Lanthorns and
a Closestool Pan.

Copper. a fountain and Cistern Eight Drinking Potts three
Sweetmeat Panns Two Coffee Potts a Chocolate Pott one
Tea Water Kettle & Lamp a Coffee Roaster **Brass** fourty
two Candlesticks tenn snuffer Pans and four pair of
Snuffers three Extinguishers a Bell mettle Pott

In yᵉ Steward's Hall EIeven Wooden Chairs four Cane Elbow Settees a large Deale Oval Table a Stone Table on a Wallnut tree frame A mat to Lay under the Table A Pair of Doggs

The Smoaking Room A Table a Lock and Key Eight Dutch matted Chairs

The Pantry A Bread Binn a Coffee mill two Square Tables a table Bedstead four matted Chairs two Wooden Ditto a Camp Stool two Pott hangers a Grate, a fender, Shovell Tongs Poker and Bellows four Locks and Keys

In the Pantry Chamber A BedStead, matt, and Cord a sett of old Curtains, a feather Bed Bolster, two Dimitty Quilts four Blankets and a Rugg, A Table Bedstead a feather Bed Bolster and two Blankets a Callico Window Curtain two Tables three Chairs an old Trunk three Guns a Blunder Buss five hangers and Belts a Close Stool and a Pewter Pan Pʳ. Dogs

In the Passage A Wainscot Cupboard Turet-clock a Large Bell and Small Dᵒ.

Mʳ L'Motts Room and Closet A Lath Bottom'd BedStead with Bengall Furniture featherbed and Bolster a Chequered Mattriss a Dimitty Mattriss and five Blankets a Callicoe Quilt a Leather Chair and Cushion two Turkey Work Chairs A Large Chest a Wallnut Tree Chest of Drawers two Square Tables a Dressing Glass two old Stools a Close Stool and Pewter Pan A Pair of Doggs Shovel Tongues and Bellows and Brush three Locks and Keys.

The Room over Mʳ L'motts, five Pewter Limbecks Some old Iron and Some Lumber

The Water House and yᵈ. A Lead Cistern and Trough Ditto a Large Chest a Cupboard two Beer Stillions

The Stone Stair Case and Passage. A Deal Press a Lanthorn a Lock and Key

The New Pantrys, A Table Bedstead two CupBoards four Deal Leaves for Tables one Hundred and Ten Drinking Glasses Six Decanters Eight Crewets Ten Water Bottles Eight Glass Bottles an old Glass Basket three Bottle Baskets and a Lanthorn four side Board Basketts and A Perriwig Block Seven Locks and Keys

In the Servants Hall, A Large Table and Ditto Less four forms an Old Cupboard 30. Leathʳ Buckets A Lock and

Key **In the Great Kitchin** and Dry Larder, A Range, Fender, Cheeks, Tongs, Poker and Shovell 2 Spitts Racks and a Large Jack and Lead Weights, two Chains Six Spitts two Iron Driping Pans and four GridIrons three Cleavers two Choping Knives four Iron Candlesticks Nine Stoves Eleven Trivetts and two Beaf forks a hanger an Iron Morter and Pestle two Squares and two Lark Spitts. *Copper* Ten Porridge Pots and Covers twenty one Stew Saucepans four Covers four Scimors four Ladles five Deep Saucepans two fish Kettles and Covers three large Pans and Part of A Dutch Oven two frying Pans and three Cullenders, A Copper and Iron Work five Pudding Pans a Pasty Pan and Six Small Dᵒ. A marble morter and Wooden Pestle A Kitchin Knive three Long Tables two Dressers two Choping Blocks a Salt Tubb and a flower Ditto a WheelBarrow a Tray four Pails an hour Glass two forms three Chairs two Cupboards two Locks and Keys two Bolts and Latches **The Wett Larder** and Pastry Yard, A Pair of Scailes four Lead Weights about one hundred ? a Chopping Block a Dresser three Salting fatts Lined with Lead a Dresser a Table a Cistern Lined with lead two Iron Shovells two Dressers four Locks and Keys

The Room over the Wett Larder, A BedStead and Blew Cloath Furniture a feather Bed and Bolster and Pillow three Blanketts a Dimitty Mattriss and Holland Quilt two Quare Tables a Stuft Chair three matted Ditto a Dressing Glass a Perriwigg Block A Wainscot Close Stool three Locks and Keys

The Room over the Pastry. A BedStead and Red Cloth Furniture Compleat, feather Bed and Bolster One Blanket and a Chequered Mattriss a BedStead and Red Cloth furniture feather Bed Bolster and two Blankᵗs a Rugg a Chair and A Table A Pair of Doggs a Lock and Key

In the Landry A Range Cheeks Hanger and Trivet two Coppers and Iron Work Seven Washing Tubbs one Rencing Tubb two Wooden Horses and an old Cupboard ywo Small Leeders two Locks and Keys.

Drying Rooms, A Range Cheeks fender Shovel and Poker a Hanging Iron Six Smoothing Irons four Iron Stands and four Wooden Horses a Pair of Steps a Cloaths Press three Dressers three Tables a Pair of Bellows five matted Chairs a hair Line two Locks and Keys

In the Garretts over the Landry, A BedStead, matt and Cord, a feather Bed Bolster and three Blanketts two old Cushionsurtains a Square Table

The next Garrett A Half headed BedStead Green Cloth Furniture A Feather Bed and Bolster a Blankett and Quilt, A Half Headed Bedstead a Feather Bed and Bolster two Blanketts a Rugg an Old Chair two Locks and Keys

In the Dairy, Two Tables two forms four Chairs and an old Cupboard a Long Board and Treessells A Pair of Doggs Shovell Tongs and Bellows A Lock and Key

In the Scullery Three Brass Kettles an Iron Stand a Cupboard two Chairs a form a Table three Dressers A Plate Rack A Lead Trough two Locks and Keys

In the yard before the great Kitchin. A Cistern Lined with Lead A Bell Wheel and Cord

The Stable Chamber, A BedStead three Old Curtains, A feather Bed Bolster and two Blanketts A Rugg and two Old matted Chairs A Stool a Lock and a Key

The Next Room A BedStead matt and Cord a feather Bed Bolster, a Striped mattriss and three Blankets an Old Quilt and an Old Chair a Lock and Key

In the Room. one Pair of Stairs Higher, two Half headed Bedsteads Matt and Cord two feather Beds two Bolsters five Blanketts three Ruggs two Chairs a Wooden Stool a Lock and Key

The next Room two half headed Bedsteads matts and Cord two feather Beds and Bolsters five Blanketts two Ruggs two Old Chairs A Lock and Key

The Next Room A Half headed Bedstead Matt and Cord A feather Bed and Bolster three Blankts and an old Silk Quilt one old Chair A Lock and Key

In the Back house and Chamber, A Copper and Iron Work and Large Brass Cock a Bolting Mill and Appurtenances a Half headed Bedstead Matt and Cord feather Bed and Bolster a Blankett a Rugg an Old Table two Locks and Keys

The Hen House one Large Chicken Coop two Less Ditto a Quail Pen a Dresser two Geese Stages A Lock and Key

The Brewhouse Two Large Coppers and Iron Work a mashing fatt and three Coolers and another Back a Small Cistern Lined with Lead two Working fatts four Spouts a Pump Nine Brass Cocks four Empty Hogsheads four Pales two Locks and Keys

The Porters Lodge A BedStead matt and Cord A feather Bed and Bolster a Blanket a Rugg a Table A Form A Chair two Locks and Keys

The Garden and Parts Adjacent, Fourty two mellon Glasses four Hot Bed Glasses two Hundred and twenty four Bay Trees in Tubbs Ten Lead Statutes Seven marble Ditto fifteen Large Lead Vausees two Small Ditto Seventy one Flower Pots Ditto Six Large Benches Eight Small Ditto Six Copper Watering Potts Nine Pair of Garden Sheers one large Pair Ditto to Cut the Weeds In the Cannells Eight Rowling Stones three frames for Ditto four Boats Six Pair of Oars three Canvass Sales three old Carts four New Ditto four Pair of Geers two Watering Carts

In the Yards Round the House Two Waggons, an Old Lime Cart a Pair of Draught Wheels A Gibb and Appurtenances

At the Lodge In the Chase A Room Hung with old Tapestry

In the Cloysters A fire Engine and Leather Pipe four Caned Sattees

In the Ale Celler and Wine Celler, Fourteen Pieces two Pipes three Hhds Eight Brass Cocks Six Beer Stillions A Pair of Iron Gates three Locks and Keys Twelve Doz of Bottles a Beer Stillion A Bottle Rack

The small Beer Cellar Three Pieces Six Pipes Seven Hogsheads five Screw Hoops Six Stillions two old Iron Gates two Locks and Keys

The Plate. Eleven Silver Spoons Twelve Forks Eighteen Knives one Lemon Plate four High Candlesticks and four hand Candlesticks A mugg and Cover A Cup A milk Pott Seven Gilt Tea Spoons and two Chamber Potts

In the Linnen Chamber, Six Large Trunks A Deal Box Seven old flasketts Two Stuft Chairs a Round Cane Stool Twelve Earthen Basons fifteen Chamber Potts five hair Brushes & five Brooms two Rubbing Brushes Twelve New mopps Seventeen Pair and one Holland sheets fifty six Pair of Flaxen Sheets one Pair of Dimitty Ditto Twenty four Servants Sheets Six Yards of new flaxen Cloth Twenty Eight Holland Pillow Beers Twenty eight Flaxen Ditto Sixty Eight Damask Table Cloths Twenty Six Huckaback Ditto Seventeen Diaper Table Cloaths Nine flaxen Ditto thirty five Doz and five Damask Napkins twenty one Damask Supper Cloaths Thirty two Holland Towells Thirty two Damask and Diaper Ditto

four Huckaback Towells Sixteen Round Towells Eleven Oyster Cloaths

In the Wing of the House: five marble Chimney Pieces and Slabbs some old Packing Cases and some old Lumber

In the Wardrobe Two Large Ceder Chests three Trunks An Old Wainscot Press an old Chest A Portmantle Trunk four Vallees Two long Tables Six Dressing Glasses two Couch Glasses A Fire Screen four Pieces of old Tapestry Hangings a White Stitch Callico Quilt a Black Silk Ditto Lined with Callico One yard and a half of Green Cloth, Seven Odd Pieces of Vallure Eight Glass Plates two Crimson Velvet Cushions A Blew Stripe Sattin Cushion a Blew Stitch Sattin Toylight A Pair of White Holland Window Curtains and Vallond A White Callicoe Ditto a Sad Colour Serge Bed two Green Serge Curtains A Wainscot Bedstead and Crimson Damask furniture flower'd with Gold and trimm'd with Gold and Black fringe Compleat a Case to the Bed of Red Serge and a Case Rodd, Six Elbow Chairs with Large Cases four Square Stools Ditto and two Round Stools Covered With the same Damask of the Bed A Field Box BedStead and Green Damask Furniture two White Serge Window Curtains a Large Stitch Carpet two Small Persian Ditto Eight Smyrna Carpitts three Large Turkey Workt Carpitts and two Small Ditto a Leather Cushion an India Hand Tea Table A half headed Bedstead three Pieces of India Callicoe Hangings and Vallonds Ditto A Piece of Dyed Linnen Seven Yards of White Ditto

In yᵉ Middle Room A Deal Press a Wainscot Press Nine Feather Beds Eleven Bolsters Six Down Pillows Nine feather Ditto Seven Checkerd Linnen mattriss's one Ticking Dᵒ. One Dimitty mattriss three White Holland Quilts a Ticking Bagg with some Feathers in it a field BedStead and Stuff Furniture a Sett of Irons that belong to a Boat and a ticking Tilt for Dᵒ. ~~four Stuft Arm Chairs and Needle Work Cases~~ A Cedar Table An Easy Chair and foot Board two Wallnut Tree Inlaid Tables two Stands Ditto A Nest of Drawers Covered with Hogskin three Umbrellows Nine Old Warming Panns two Pewter Standishes two hand Bells two Lead Inkhorns a Peuter Close Stool Pan two large Brass ~~And~~ Stand Irons five Pulley Rods A House Lanthorn Some old Curtain Rodds and old Iron Six Long Bolts a Brass Spring Bolt a Small Clock

The Out Ward Room A Chest a Square Table two Cane Elbow Chairs two Back Stools Ditto Six old Stuft Chairs, 2 old Cane Chairs twelve Pair of Bowles and two Jacks two old Stands a Pedestall for a Clock a Small Lath Bottom'd BedStead two Plate Warmers two Step Lathers

one single Lather two Large Iron Grates to air the House three Pair of Irons to hang Looking Glasses on four Brass Spring Bolts and Box Staples Ten Lanthorns In the Passage of the House two old Blankets a Callicoe Quilt 2 Setts of old Bed Curtains 4 Rugs an old Counterpain 2 old Red Curtains a Coach Box Cloath 5 Dozen of Trenchers

The old Wardrobe Four Deal Presses Six old Pictures Part of a Perkentine Wainscot floor Two Tressels Some Boards and Boxes an Old Cane Chair a Lock and Key

At Mʳ Hunts at Barnwell a feather Bed and Bolster

In the Armory

530	musketts
530	Bayonets
100	Carbines
282	Case of Pistolls and one Odd one

In the Old Wardrobe

110	Basket Handle Swords
170	Brass Hilted Swords
79	Case of Pistalls
367	musketts
367	Bayonetts
80	Carbines
198	Belts
183	Leather Slings for musketts
213	Powder Horns
6	Pikes
12	Halbirds

In the Granary

		Wanting
126	Saddles	
115	Pair of Cloak Straps	11 Pair
126	Cloth Housings Bound with White Worsted Gallome	
126	Holster Caps Dᵒ	
116	Pair of Holsters	10 Pair
116	Holsters Straps	10 Pair
126	Carbine Buckets and Straps to them	
126	Breast Plates	
126	Cruppers	
124	Pair of Stirrops	2. Pair
123	Pair and one Stirrop Leathers	2 Pair + one
118	Gerths	8 Pair
161.	Bitt Bridles	
500	Buff Belts	
189	Carbine Belts	
425	Cartridge Boxes and Belts to them	
418	Bayonet Belts with Bullet Pouches to them	

499. Leather Power flasks and strings D⁰.
12 Drums and Sticks
428 Coats
11 Drummers Coats
433 Hatts
12 Silver laced Hats
12. Serjeants Worstead Swashes

In a Room Over the Stables Next the Arch

	Wanting
50 Old Saddles	
41 Pair of Cloak Straps	9 Pair
44 Pair of Holsters	6. Pair
35 Pair of Holster Caps	15. Pair
36 Carbine Bucketts	14
36 Straps D⁰.	14
40 Breastplates	10
37 Pair of Stirrups	13 Pair
37 Pair of Stirrop Leathers	13 Pair
45 Cruppers	5

An Inventory of his Grace yᵉ Duke of Mon=ᵗᵃᵍᵘ's Goods at his Seat at Boughton in Northton Shire Taken In 1730

Imprimis

In the Garrett yᵉ: East wing of the House Nᵒ. 1

Four Sad colour'd curtains, three Yellow curtains, one Yellow covelid, & Vallonde for the sad colour'd curtains, an old Quilt, one Red Rugg. two Green Ruggs, five Locks & Keys, one Latch, ten Picture Cases.

In the Gallery where yᵉ: Billiard room is yᵉ: Maids Garret Nᵒ. 2

In Mʳ: Collys Room Nᵒ: 3

A Bedstead matt and cord, with red Cloth furniture, a feather bed Bolster & two blankets and Yellow Coverlid, a Sacking Bedstead wᵗʰ sad colour China Furniture, a feather bed Bolster, a Chequer'd mattris, three Blanketts, one Callicoe Quilt, two old stuff'd Chairs, one Cain Chair, a Spanish Table, a Lock and Key

In the next Room Nᵒ. 4

In the Billiard Room Nᵒ. 5

A Billiard Table Cover'd with Green cloth, a leather Cover to it, five Balls, Eight Sticks, The Room hung with Tapestry, The floor cover'd with a matt, a large iron stove, four Chairs, a lock and Key.

In a little room against the Billiard room Nᵒ. 6

A Bed Stead matt and Cord with Gray Serge Canttoon furniture, Feather bed bolster and a Linnen mattris, three Blanketts, one Rugg, a Stuff'd Chair, a folding Table, a Lock and Key

In the Room at the end of the Gallery Nᵒ. 7

A Sacking BedStead, and Chequer'd India plad furniture, a feather bed, and Down Bolster, a holland Quilt, a Cain Elbow chair, a Chequerd mattris, two Blanketts, a Callicoe Quilt, and two other cain chairs, a Chimney Glass, a wall-nuttree Table, 4 harth Brushes, a lock and Key two Latches and one Bolt.

In the Closset of the Same Room Nᵒ. 8

A Corded pallett bedstead, feather bed, bolster, three Blanketts, two Stuff'd Chairs, one False Case for a chair a Close Stool and Pewter pan, a Square Table a Lock and Key

In Mr: Cecils Room No. 9

A Sacking bedstead and India plad furniture, Feather bed and Bolster, a holld: Quilt, a Chequer'd Mattris, three Blanketts, a Callicoe Quilt, one Elbow Cain Chair, three other Do: an oak Dressing Table, a Close Stool and Pewter pann, a lock & key

In a Closset belonging to the same Room No. 10

A Sacking Bed Stead

In Dr: Silvesters Room No: 11

A Sacking bedstead India plad furniture, a feather bed, bolster & Pillow, a dimity Mattris, a holland Quilt, three Blanketts, a Callicoe Quilt, one Elbow Cain Chair, one black stool do: one Stuff'd chair and Stool, a wallnuttree Dressing Table a Camp Stool, a Chimney Glass, two Locks and Keys

In the Room against Dr. Silvester's No: 12

One Stuff'd Chair, two Cain Chairs, wainscott dressing Table, a Sacking bed Stead, and India Plad furniture, a feather bed and Bolster, a Chequer'd matris, a Callicoe Quilt, two Locks and Keys

In the Room against Mr Secils No: 13

A Sacking bedstead & India Plad furniture, a Feather bed Bolster, a Chequer'd Mattris, two Blanketts, a Callicoe Quilt, an Elbow Cain Chair, one back Stool, a Wainscott dressing table a lock and Key

In Mr Whites Room on the Stair Case No: 14

A Field bedstead with India callicoe furniture, Feather bed bolster and pillow Two Tickin Quilts three Blanketts, a Square table, an Elbow Cain Chair, one back Stool do: one mattd Chair, a Lock and Key

In the two Chambers against Mr: Whites room No 15

A lath bottom bedstead and Cloth ffurniture lin'd with Gold Colour persian Compleat. a Feather bed Bolster, a holland Quilt, three Blanketts, four Cain Chairs, two brass Sconces, a Square Wainscott Table, a pr. of Bellows a brush, a Perriwig Block two Locks and Keys

In a little room behind ye: Great Apartmt: on the same Stairs No: 16

A Field bedstead with an Indian Gauze pavillion Curtain, a feather bed and Bolster, a matted Chair, a Lock and Key

In the next room on the Same Stairs No: 17

Two Pieces of Brocadillo hangings conta: 56 yrds, Seven matted Chairs, two locks & Keys

In the Bed Chamber to ye: Apartment No: 18

A Lath bottom bedstead and Mohair Furniture, a feather bed, bolster, a dimity Mattris three Blanketts, a Callicoe Quilt, a Japann'd Table, and five matted Chairs four pieces of Mohair hangings Contain about 60 yds: a Lock and Key

In the Room over the new Nursery No. 19

A Lath Bottom Bedstead with Bengall furniture, a feather Bed bolster & Pillow, a Dimity mattris, three Blanketts a Callicoe Quilt, a Stuff'd Elbow Chair a Table Lock and Key

In the Next Room No. 20

A half headed Bed Stead matt and cord, a feather bed, Bolster, one Blankett, a Green Rugg, a Stool a lock and Key

In the next Room No 21

A bedstead matt and Cord, a Feather bed, Bolster, two Blanketts, a Rugg, a Stool, a Lock and Key

In the next Room Number 22

A Bedstead matt and Cord, a Feather Bed, bolster, a matris, two Blanketts, a Rugg, a Table, a Chair, a Lock and Key

In the New Nursery Number 23

A Table Bed Stead, a dutch Table, four matted Chairs two pr: of White holland Window Curtains, Valands, Lines, and Pulley rods, three Pieces of old Imegery Tapstery, one Brass Lock and box Staple

In the Bed Chamber, the Same Apartment No. 24

A field Bed Stead with Blew and Sad Colour ffurniture of Damask trim'd with fringe Compleat, a feather bed, Bolster, a Chequer'd matris two pr: white Holland window Curtains, Valands, Lines, and Pulley rods, too Stuff'd arm Chairs, one Back Stool do: two false Cases for the Chairs of Blew Serge, two matted Chairs, two Silk Cushions, two Brass Spring Bolts, two Latches do:

In the Closett No: 25

A small Bed Stead, feather bed, bolster, three Blanketts, a White holland window Curtain Valand Line and Pulley rods, three pieces of Old Imegery Tapestery, Three Cain Chairs

In the first Room going into the Great Apartmt. No: 26

Six Square Stools with Wallnuttree frames and Cases to them of Needlwork, a Grate Shovel, Tongs and Poaker, a Large Brass Lock box, Staple a Square oak Table.

In the Blew Room in the Great Apartm^t: N^o: 27

Four pieces of Blew Damask hangings, Lin'd with Linnen Conta. 96 yards, two p^r: of Window Curtains & Vallands d^o: trim'd with Gold Colour fringe Cont^a 56 yrd: Silk lines and Tossels, Eight Wallnuttree Elbow Chairs of Needlework, one Couch d^o: one Large looking Glass with Glass Frames and Top, an Inlaid Table and Stands, a large Chimney Glass in three parts, a Steel harth, doggs, Tongs, fire Shovel and Brush, a Marble Chimney piece and Slab, a brass Lock & box Staple, two Bolts d^o:

In the Bed Chamber N^o. 28

A lath bottom bedstead, with Crimson damask furniture Compleat, flower'd with Gold and Trimd with Gold fringe, a feather bed, Bolster, a Chequer'd Matris, a Holl^d: Quilt three Blanketts, a Case to the Bed of India Callicoe and Case rod, Six Stuff'd Elbow Chairs with Cases of the Same Damask Trim'd with Gold fringe, Six matted Chairs and Six cushions of the Same damask, Twelve Cases of Callicoe for the Chairs and a Large looking Glass in a Glass frame & Top, a wallnuttree Table and Stands Inlaid, a Chimney Glass in three parts, two White damask window Curtains Vallonds and Cornishes trim'd with White Silk fring cont^a. 56 y^{rds}: Silk Lines and Tosells, three pieces of fine Tapestrey hangings cont^a: about 122 Ells being part of the History of the Appostles, a marble Chimney piece and Slob, a Steel harth, doggs, Shovell Tongs, Bellows and Brush, a Brass lock, box Staple two Boltts

In the Drawing Room N^o 29

A Large Glass in a Glass frame and top, an Inlaid Table, & Stands, two White damask Winder Curtains Vallands and Cornishes Trimd with With silk fringe, cont^a: 56 y^{ds}: with Silk lines and Tossells, Eight Wallnuttree Arm'd Chairs, Stuff'd, and Cases of Velvett, trim'd with Gold Galloom, one Chimney Glass in three parts, two Glass Sconces, two pieces of tapstrey hangings cont^a: 102 Ells, being part of the history of the Appostles, a marble Chimney Piece & Slob, a p^r: of Dogs, fire Shovell, Tongs, Bellows and brush, a brass lock box staple, two boltts

In the Antichamber N^o. 30

Four large Sconces, two Elbow matted Chairs, twelve Back Stools d^o: fourteen Crimson Damask Cushions, Quilted Vallonds trim'd with Crimson Galloon, two crimson damask Easey Chairs and Cushions trim'd with Gold ffringe and fa^lse cases of India Plad, a Crimson damask Fire Screen, six large white window Curtains, Vallonds lines Tossells and three Pully rods, two Marble Tables with Wallnuttree frames, a Wallnuttree Escritoire, a p^r: of Dogs, Fire Shovell Tongs and Brush two brass locks, a box staples, two Bolts do.

In the Great Stair Case N^o 31

Two Brass locks, box Staples

In the white Pavillion, above Sta^{irs} y^e first room N^o. 32

A Glass frame and Top d^o. a Wallnuttree Writing desk, two Stands d^o. two p^r: of Large white window Curtains Vallonds lines pully Rods, Six Wallnuttree arm'd Chairs, Cover'd with Vallure two matted Chairs a Cain Couch and two Cushions, three Pillows of Flower'd Persian, an India Cabinet upon a Black frame, a marble Chimney Piece and Slob, a p^r: of dogs, Fire Shovel, Tongs Bellows and brush, a twylight Table, two locks and two long boltts

In the Bed Chamber N^o. 33

One large Glass, Table and Stands, India, with Cyphers and Plates & other Work on them of Silver, a bedstead and Damask furniture lin'd with purple and White Sattin Compleat, a down bed and bolster, a Chequer'd mattris, a Dimity d^o. one White persian Quilt, one Shagreen d^o: one Blew and White d^o. Border'd with Silver brocade, on Green Persian d^o. a Green Persian cover for a Twillett, Seven Elbow Stuff'd Chairs and Damask Covers, a Wallnuttree Chest of Drawers, three pair of White Serge window Curtains, Valonds lines and Pully rods, Three Peices of fine Tapestrey hangings Contain about 113 Ells, being part of the History of the Apostles, a marble Chimney piece and Slob, a p^r. of dogs fire Shovell, Tongs Bellows and Brush, a brass Lock, Two Spring Boltts ditto

In the Room behind the Bed Chamber N^o 34

The hangings of the Room Green plad Trim'd Galloon, two p^r: of window Curtains and Vallonds d^o: Lines Tossells and pully rods, two Cain Chairs, a Black Card Table, one Spring Bolt.

In the next room N^o 35

In the old Billiard Room N^o 36

Eighteen Chairs Cover'd with Vallure, the hangings d^o. a Chimney peice of Marble and Slob d^o. A Chimney Glass, a brass lock and Box Staple

In the Ditton Room N^o: 37

A Bedstead with needlework furniture lin'd with white flower'd peiling Compleat, a feather bed bolster, two Chequer'd Quilts, two Blanketts, Six Wallnuttree Stuff'd Elbow Chairs, and needlework Cases to them, two white Callicoe window Curtains and rods, two Peices of Imegery Tapestry, A Square oak Table, a wallnuttree Table and Stands, a pair of Dogs fire Shovel Tongs and Brush, a Lock and Key.

In the Closset belonging to y^e Ditton Room N^o. 38

Two Peices of Brocadelle hangings, a Square Stool Cover'd with D^o. a Dutch Table, A Field Bedstead and India Calicoe furniture, feather bed Bolster, two Blanketts, one Coverlid, a leathern Close Stool and pewter pan, a Chest of drawers, a Cain Chair, two Pictures, one matted Chair, a lock & brass Bolt.

In the Library Number 39

A Mohougany Writing desk, Eigh matted Chairs, two Stuff'd Chairs Cover'd with leather, two Calicoe window Curtains and Rods, a Chimney peice of Marble and Slob d^o: two brass locks.

In the Clossett next the Library N^o 40

A Fild Bedstead with Stript Stuff furniture, a plad mattris, feather bed Bolster and three Blanketts, a Sqare oak Table, one Cain Chair, two Brass locks.

In the Long Gallery N^o 41.

Two Mohougany Tables, twenty three mapps, Eleven old needlework Chairs, four Cain Elbow Chairs, four black round Stools Cover'd with Velvett, one Cain Elbow Chair with a Velvett Cushion, a long black stool d^o. a Square Stoole cover'd with Velvett, a back Stool d^o: a brass lock & bplt do.

In the Dressing room in y^e: new Apart==ment Number 42

Six Stuff'd Elbow Chairs with Cases to them of Linnen plad, one Couch d^o: a Square wallnuttree Table, a Chimney peice of Marble & Slob d^o. a Chimney Glass in three parts, one Square oak Table, Three pieces of Landskip Tapestry, two Brass locks.

In the next room the same Apartm^t. N^o. 43

A Field bed Stead with Crimson damask Furniture trimd with Gold and Silver fringe, a feather bed bolster, Chequer'd mattris a Dimity Quilt, one Red Persian Quilt, four Arm'd Chairs with crimson Damask Cases trim'd with Gold and Silver fringe, a wallnuttree arm'd Chair Cover'd with needlework with a Case to it of Linnen plad, one Card Table, a marble Chimney peice and Slob d^o. a Chimney Glass in three parts, a wallnuttree Chest drawers, a look^ing Glass & wallnuttree frame, two peices of Landskip hangings, two Calicoe window curta=ins and Rods two Brass locks.

In the Plugg Clossett N^o. 44.

A Press, a lock and key, one Brass Latch.

In the Passage belonging to y^e: new Apart:^mt N^o 45.

A Brass lock and Key.

In the Lady Hinchingbrooks apart^mt. N^o 46

Two India Calicoe window Curtains and rods, one Elbow cain chair, four back Stools d^o. a dutch Table, a brass lock and latch.

In the Bed Chamber N^o 47.

A Black turnd Japan bed Stead with Bengall furniture lin'd with Yellow persian trim'd with Silver lace, a Yellow persian Quilt, feather bed Bolster, dimity mattris, a holl^d: Quilt, three Quilt, three Blanketts, The Hangings of the room being Sumpter Cloths of Tapestry, an Elbow Chair Covered with leather, four dutch matted Chairs & four blew damask cushions, two white Calicoe window Curtains & rods, a Glass in a black frame, a Card Table, one arm'd Cain Chair, a p^r: of Dogs, Shovel Tongs Bellows and Brush, a brass lock and two Spring Bolts.

In the next room N^o. 48

Three peices of blew damask hangings Contain 35 yrd: four back Stools eight Blew damask Cushions for the Back and Seats, a Wallnuttree dressing Chair y^e: Seat Covr'd with Crimson damask, three white Calicoe window Curtains and rods, a wainscott Table, a Brass Spring Bolt.

In the late Dukes Apartment below Stairs
In the First Bed Chamber N^o 49.

A Bed Stead and Blew Jeneva damask furniture trim'd with gold Colour fringe Compleat, a feather bed bolster, a holland Quilt, a Chequer'd mattris, two Elbow Cain Chairs, four back Stools d^o. twelve blew damask Cushions for the Six Chairs, two white Calicoe window Curtains, Vallonds lines and Pulley rods. a Glass, a wallnuttree desk, three pieces vintage Tapestry hangings cont.^a 64 Ells, a marble Chimney piece and Slob, a Grate Shovel Tongs bellows and Brush, a Brass lock and Spring Bolt d^o: four Square wallnuttree Stools Cover'd with Blew Damask trim'd with Gold Colour fringe, a Square oak Table.

In the next Bed Chamber N^o. 50

A Bed Stead and Irish Stich furniture, lind with white pink'd Sattin, Embroider'd Compleat, feather bed bolster, dimity mattris and a Chequer'd d^o: two Elbow Cheairs & Six back stools Cover'd with Irish Stich, two white damask window Curtains, Vallonds Silk Lines, Tossells and pully rods, five pieces of Tapestry hangings Cont^a: 101 Ells, a Glass in a wallnuttree frame, A Black Table, A Chimney Glass, a Square oak Table, a p^r. of dogs, fire Shovel & Tongs, a marble Chimney piece & Slob, a brass lock & Spring bolt.

In the new Gallery N⁰. 51.

Five arm'd Chairs Covr'd with velvett, nine Square Stools d⁰· Twelve arm'd Chairs Covr'd with red Vallure, twenty Pictures in Gold and Black frames, a Chimny Glass in three parts, a marble Chimney piece and Slob d⁰. a piece of hearldry in a Gold and Black frame, two Brass locks, two bolts d⁰.

In the drawing Room N⁰. 52

Fourteen Elbow Chairs Stuffd and Covr'd with blew Damask & Yellow fringe the window Curtains of persian lin'd with Red Serge trimed with Gold and Silver & Black fringe, Silk lines and Pulley rods, Six pieces of Landskip Tapestry hangings Conta: 146 Ells, a Glass with Cast work on it, a black Table, a Cedar Card Table, a Chimney Glass in three parts, a Marble Chimney piece & Slob d⁰. a Stove Grate Shovel Tongs and poker One picture in a Gold and Black frame, a Brush a brass lock & Spring bolt.

In the Musick Room N⁰. 53

Three pr. of White holland window Curtains, Vallonds lines and pully rods, Six arm'd Chairs Covr'd with Vallure, Twelve back Stools d⁰. a large marble Table and Black frame, four Glass Sconces, an Eigh day Clock in a wallnut-tree Case a stone Chimney piece and Slob d⁰., a dutch Table, an Eight leaf Gilt Leather Screen lin'd with Serge, a large Mohougemy Table, one picture, a pr. of dogs, Shovel Tongs and Brush, one Brass lock.

In the Vestabule N⁰. 54.

Two marble Tables and wallnuttree frames, two wainscot Tables Two wallnuttree Stands fourtteen Cain Chairs, a pr. of long brass dogs Three Brass locks and four bolts.

In the Great Stone Hall N⁰ 55

Two large marble Tables, and wallnuttree frames, ffive white linnen damask window Curtains, Vallond lines Tossells and pulley rods four Elbow Cain Chairs, Sixteen back Stools d⁰., Six whole length pictures in Gold and Black Frames a large marble Chimney piece and Slob d⁰., a large Stove Grate, Shovel Tongs and poker four brass locks and Long Bolts.

In the Side Board Room N⁰. 56

Two marble Tables with wallnuttree frames, a marble Cistern and Stand, a wood frame

In the little Painted Hall N⁰ 57

Two Oval wainscot Tables, two Elbow Cain Chairs, four back Stools ditto four pr. of white Calicoe window Curtains Vallonds lines & pully rods, a marble Chimney-piece, a large Stone Table, a brass Lock and Spring Bolt.

In the Side Board room to the little painted Hall N⁰. 58.

A Stone table Cistern and Stand, a long Wainscott Table, two Brass Spring Bolts

In the new Stone Hall N⁰. 59

A Marble Cistern and Stand, a Stove Grate, two furdale Tables, One oval ditto, a large wainscot Table, one wainscot Cupboard a lock & Key, one map, Shovel Tongs and poker, a Brass Spring bolt & Latch.

In the Great Stair Case below Stairs N⁰. 60

Two Glass Sconces, three Brass locks, one Spring bolt, four long bolts.

In the white Pavillion below Stairs The Stone Parlour N⁰. ~~59~~61

Thirteen Cain Chairs, two pr. of White holland window Curtains Vallonds lines and Pully rods, a Glass in a Black frame, a marble Table a pr. of Stands, one large Stand, two Glass armes, a pr. of Dogs, Shovel & Tongs, a marble Chimney piece and Slob, a brass lock and Spring bolt.

In my Lady Dutches's drawing room N⁰. 62

Three White damask window Curtains Vallonds lines Tossells & pully Rods, two Elbow Chairs with damask Cases, and Six back Stools d⁰. two Wallnuttree dressing Chairs, Cover'd with Silver brocade bound with red with cases to them, a Couch Edged with Silver brocade with a Calicoe case, two Quilts one Cover'd with Linnen and bound with Silver brocade the other Cover'd with Silver and bound Scarlet Vellvett four white damask Cushions flowr'd with Gold Silver and bound with Gold lace, three pillows of Silver Brocade bound Red with Calicoe Cases to them, a Cain Stool a black Table Stands and Glass, A Black Ebony Cabinett on a frame, four pieces of Vintage Tapestry Conta. 80 Ells, Two Glass arms, a wallnuttree Card Table, a marble Chimney piece and Slab, a pr: of Doggs, Shovel, Tongs, Bellows, and Brush.

In the Plugg room N⁰. 63

Two pieces of damask hangings, Six Stuff'd round Stools Covrd d⁰. two Strp'd window Curtains and Rods, a Corner Cupboard of wainscot.

In the Middle Room 64

The room hung with plad, one Calicoe window Curtain line and pully rod three wallnuttree Square Stools Stuff'd and Covr'd with Velvett, a wallnuttree writing Table, a Stone Chimney piece and Slab, two Brass Spring bolt.

In the little Bed Chamber Nᵒ. 65

A Lath Bottom bedstead and wrought damask furniture a feather bed bolster, a Chequer'd mattris, a holland Quilt, three Stuff'd Elbow Chairs with Covers the same to the Bed, three pieces of Crimson Burdett hangings, four wall-nuttree Square Stools, Stuff'd and Cover'd with velvet a Square oak Table, one Calicoe window Curtains Vallonds and rod, a marble Chimney piece and Slab, a Brass Spring Latch.

In the Servants Closett Nᵒ. 66

A Field bedstead and calicoe furniture Compleat, a feather bed bolster a dimity ~~mattris~~ Quilt, two blanketts a Cain Chair, a Small Stool Cover'd with Brocadello, a brass Spring Bolt, an Iron Latch.

In the Passage that goes to y Gardens Nᵒ. 67

A Brass Spring bolt a Small Bell two Glass Lanthorns, a Iron lock.

In the room next yᵉ: new Gallery Nᵒ: 68.

A Calicoe window Curtain and rod, two Cain Chairs, A bedstead with Sad Colour Sarge furniture, a feather bed bolster, a dimity mattris, three Blanketts, a Square oak Table, a lock and Key.

In Mʳ. Lamotts bedroom and Closset Nᵒ 69

A Sacking bedstead and Serge furniture. a feather bed bolster & pillow, a Chequer'd mattris, a holland Quilt, three Blanketts two pʳ: of white Calicoe window Curtains Vallonds lines and pully rods, a wallnuttree Escritoire, three Cain Chairs and a Square Table, a wainscot Table, A Dressing Glass, two pieces of old Tapestry hangings, a leather Camp chair Stuff'd and Cushion, a Chest of drawers, a pʳ. of doggs, a Stand, a lock and Key.

In the Counting room Nᵒ: 70.

In the little Stone Room. Nᵒ: 71.

One oval Table, four Cain Chairs, a matt, one Brass lock.

In the Gentlemens Parlour Nᵒ: 72

Six black Leather Chairs, two wainscot Tables, a dutch Table, a pʳ: of doggs fire Shovel: Tongs bellows and Brush, a Brass Spring Bolt.

In the Conffectioners Office & Yard Nᵒ. 73

One Table, two Cain Chairs, four India tea boards, three green Card Cloths Seven Seives, a marble mortar & wood Pestle, three Lanthorns a Shovel and Tongs, one fire fork. two doz. and one Round Trenchers, one doz. of Square ditto, a dutch oven. Two tin'd basketts a lead Cistern & brass Cock.

Pewter Nᵒ. 74.

Fourty Seven new pewter Dishes, five doz. and Eleven new plates, four doz. and five old dᵒ. two Salts, one Limbeck, Seven Gilt Spoons

Copper Nᵒ 75.

A fountain and Cistern, Eigh Drinking potts, three Sweetmeat stew panns, two Coffee potts, one Chocolate pott, one water Kettle a lamp and Coffee roaster, one Tea Kettle and Lamp.

Brass Nᵒ: 76

Thirty Eigh Candlesticks, Six pʳ. of Snuffers, and panns, three Extinguishers, one Bell mettle pott.

China Nᵒ: 77

Thirty one Dishes, Six dozen of Plates, fifteen Chocolate Cups with handles, Six dᵒ: without handles, Eight Saucers, Ten brown Tea dishes, two Tea potts dᵒ. a blew Teapott and Slop Bason, three Chamber potts a mug Eigh blew and white Tea cups, one doz. of blew and White Basons, Ten Larger dᵒ: a large brown China Bason.

In the Smoaking room Nᵒ: 78

A Table an Iron lock and Key.

In the old Pantry Nᵒ: 79

A Bread bing a Coffee mill, Two Square Tables, a Table bedstead, two matted Chairs, three wooden dᵒ: a Camp Stool, a pʳ. of doggs, Shovel Tongs and Bellows, four locks and Keys.

In the Pantry chamber yᵉ: first room Nᵒ: 80

A bedstead matt and Cord, a Sett of old Curtains feather bed bolster two dimity Quilts three Blanketts, a Rugg, A half headed bedstead feather bed bolster, and two blanketts, two Tables three Chairs, a blunder bush a Sword a map, a pʳ: of Drawers, a pʳ: of doggs, a lock and Key.

In the Passage Nᵒ: 81

A Turrett Clock and Large bell, a Small bell, a Table bedstead a perry=wgg. bloc.

In the Second room Nᵒ: 82

A Lath bottom bedstead, feather bed bolster, two Chequer'd mattris, four Blanketts, an old Silk Quilt, a large Chest, two Square Tables, a dressing Glass, a Close Stool and pewter pann, two Leather Camp Chairs, two wooden dᵒ: a pʳ: of old doggs, a lock and Key.

In the room over the Second room Nᵒ. 83

Some old Iron and other Lumber.

In the waterhouse and Yard Nᵒ: 84.

A Lead Cistern, a Large Chest and Cupboard, two beer Stillions a lock and Key.

At the Celler head Nᵒ: 84

One Cain Elbow Settee a Square oak Table

In the new Pantrys Nᵒ: 85

Three Cupboads one Cain Elbow Settee, Six wooden Chairs, one matted dᵒ: two Oval Tables, one Square oak Table a pʳ. of doggs fire Shovel Tongs Six locks and five Keys.

In the wing of The house Nᵒ 87

five marble Chimney pieces and Slabs, two Charcole Grates upon Small wheels Six Vazas's, one Iron dutch Stove, Some Lumber.

Glass &c Nᵒ 88

Fourteen water Bottles, fourty two wine beer and Water Glasses two Crewetts, five decanters, five Salts, one oak Kimble.

In the Lobby Nᵒ 89.

Two Elbow Cain Settees, two brass Spring bolts one Iron Lock & two bolts. dᵒ.

In the Servants Hall Nᵒ. 90

One Long Table, four forms, an old Cupboard, thirty bucketts, a lock & key

In the Yard before yᵉ: Great Kittchin Nᵒ: 91

A Cistern lind with Lead, a bell and wheel.

In the Great Kittchin Nᵒ: 92.

A Range fender, Cheeks, Tongs, and Shovel, two Spitt Racks, a large Jack and lead weights, two Chains, five Spits, two Iron driping panns, four Gridirons, three Cleavers, two Choping knives four Iron candlesticks, nine Stoves, Eleven Trevitts, two beef forks, two hangers, a brass morter & Iron Pestle a marble morter and wood pestle, a Kittchen Knife, Six Iron Squers, two long Tables, three dressers, Two Chopping blocks, a Salt tub, a flour Tub, Three pasty peals, two Cupboards & locks to them six lark Spits, one Larg boᵒwl, a drudge box, a Copper pan, for Spice & a Gratter.

The Copper & Brass

Nine poridge potts, Seventeen Covers, Nineteen Stew Sauce pans, four Skimmers, Two Iron Ladles, one brass dᵒ: two fish kettles, and Covers two large pans, part of a dutch oven, two frying panns three Cullinders, a Copper and Iron work, five pudding pans, Six Small patty pans, a Small Slice, five deep Sauce panns, a large brass Spoon.

In the dry Larder Nᵒ 93.

Three dressers, three Shelves a lock and Key.

In the Pastry Nᵒ: 94.

A Dressour, a pʳ: of Small Scales and weights, an Iron pasty peal & cole Rake, a Grate, a Rolling pinn, Two locks and Keys two Iron Latches.

In the Wett Larder Nᵒ. 95

A pʳ. of large Scales and weights, a Choping block, a dresser, two Square Tables, Three Salting fatts lin'd with Lead, one pʳ: of Stilliards three Locks and Keys.

In the Pastry Yard Nᵒ: 96

A Lead Cistern and Brass Cock, a lock and Key.

In the Room over the pastry Nᵒ. 97

A Bedstead matt and cord with purple Cloth furniture a feather bed bolster and one pillow, a dimity mattris, three blanketts, a Calicoe Quilt, Two Cain Chairs, a Square oak Table, a lock and Key.

In the next room Nᵒ: 98.

A Bedstead and Chequer'd mattris, with old red Cloth furniture Three Blanketts, one old Rugg, a feather bed bolster, one old red Cloth Chair an old Leather Stool, a lock and Key.

In the room over the wett Larder Nᵒ: 99.

A Lath bottom bedstead ~~matt~~ and dimity mattris with blew Cloth furniture a feather bed bolster Three old blanketts, a Counterpin, one pillow a Close Stool and Pewter pan, Three Cain Chairs, a perriwigg block in the Closset.

In the Garrett over yᵉ: pastry Nᵒ. 100

Two Square Tables, two old matted Chairs, a lock and Key.

In the Scullery Nᵒ: 101.

One Stove Copper, two Kettles, an old cupboard a Table Three dresser a Lead Trough & brass Cock, one form, a plate rack, a Grate two locks & Keys.

In the dairy ye: first room No. 102

A Square Table, a Cupboard, a pr: of dogs, a form, a fire Shovel a lock & Key.

In the Second room No: 103

One large board upon Tressels, Three old Tables, a Chest, an old Stool one form a lock and Key.

In the hen house No: 104

One Large Chickin Coop, Two less do: one Quail pen, two Geese Stages, A dresser, a lock and Key.

In the Bake house & Chamber No: 105

In the Brew house No: 106

Two large Coppers and Ironwork, a mashing fatt, and Three Coolers a Small Cistern lin'd with Lead Two large working fatts, four Spouts a pump with Two bucketts to it, Nine Brass Cocks, two little mashing fatts, five Tubbs, two Covers, three payles, two mashing Rules a malt mill and other Lumber.

In the Stable Chamber one pr: of Stairs
In the first room No: 107.

Two Yoaks and four bucketts, a lock and Key.

In the next Room No: 108.

Some brass adjects and old Iron, some other Lumber, a lock and key.

In the next room No: 109.

A bedstead matt and Cord Three old Curtains, a feather bed bolster Three blanketts, a Rugg, two old matted Chairs, one old Stuff'd do: a Cupboard frame with a drawer in it a leather Stool a dale Table a lock and Key.

In the First two pr: of Stairs No: 110.

In the next Room No: 111.

Two half headed bedsteads, matts and Cords, two feather beds two bolsters three old blanketts, two old Rugs, on old Stuff'd Chair an old Bathing Tub a lock and Key.

In the next Room No: 112

Two half headed bedsteads matts and Cords four old Blanketts two feather beds, Thwo Rugs one old Stuff'd Chair a lock and Key.

In the next Room No: 113.

Two half headed bedsteads matts and Cords, two feather beds two bolsters, Three blanketts, Two old Quilts, one old Stuff'd Chair, an old Stool, one old Lanthorn, a lock and Key.

In the Wash house ye: first room No: 114

A Copper and Ironwork, and Three brass Cocks A wrenching Tub. Eight washing Tubs, a draining horse, a dresser, an old Cupboard, a Lade payle, a form, a lock and Key.

In the Second room No: 115.

A Range Cheeks and hanger, a Copper, two brass cocks, two dressers Two mashing fatts, a Thrall, a Table, one box some other Lumber, a lock and key.

In the Landry's ye: first room No: 116

A Range, Cheeks, fire Shovel, Tongs poker, and fender, a pr: of bellows Two dressers, two Tables, a pr: Steps, a Linnen press, and Six leaves, an old Stuff'd Chair, and Stool, a lock and Key, four Smoothing Irons,

In the Second Room No: 117.

a Range and fender and Cheeks, a dresser four wooden horses, a Spanish Table a lock and Key.

In the Garretts Over ye: Landrys the First Room No. 118.

A half headed bedstead matt and Cord, feather bed bolster two Blanketts, a lock and Key.

In the Second room No: 119.

A half headed bedstead matt and cord, and Green Cloth furniture a feather bed bolster and two Blanketts, a half headed bedstead matt and Cord, feather bed bolster, and Three blanketts, a Close Stool, and pewter pan, a broken Cain Chair, a lock and Key.

In the Small Beer Celler No: 120

Ditton, Buckinghamshire, 1709

This property was inherited by Ralph, 1st Duke of Montagu, in 1688 from his mother's family, the Winwoods. Ralph Montagu's grandfather, Sir Ralph Winwood, was principal Secretary to King James I. In the late seventeenth century, the oldest part of the house was a tower said to have been built by Sir John de Molines in the reign of Edward III or Richard II. The house was rebuilt by Sir Ralph Winwood in the early seventeenth century.

The inventory records the contents of Ditton after the 1st Duke's death. The paintings in the Gallery indicate Montagu's taste for Venetian masters including Bassano, Tintoretto, Veronese, and the French artists Gaspard Dughet called Gaspard Poussin, Pierre Mignard and Sébastien Bourdon. In addition the decorative painters Jacques Rousseau, who painted landscapes, and Jean-Baptiste Monnoyer, the flower specialist whose work is named here, were employed by Louis XIV of France before Montagu encouraged them to settle in England. The gallery of paintings and plaster figures and other sumptuous contents indicates that Ditton was more lavishly furnished than Boughton at this date. Ditton was closer to London and thus more often used for entertaining from London than Boughton, which was a long day's journey from the metropolis and at its best in the summer months. As at Montagu House, Bloomsbury, this inventory records the rare use of prints as decoration in the Stone Dining Room. The presence of the Duke's young family is recorded in the 'Young Lords Dineing Room' and the 'Young Ladys Nursery', a reference to the Duke's eldest granddaughter Isabella.

The inventory includes the contents of Mr. Anthony's house. Mark Anthony was Steward to the 1st and 2nd Dukes of Montagu and this provides an interesting record of his furnishings.

The contents of the garden, thirty-four orange trees, one hundred and ten bay trees and twenty hollies, suggest that this was laid out in the then fashionable formal manner favoured by the Dutch and French.

The earlier house was destroyed by fire in April 1812 and rebuilt for Elzabeth, Dowager Duchess of Buccleuch, to the designs of the architect William Atkinson (c.1773–1839). This inventory is in the collection of the Duke of Buccleuch and Queensberry and is deposited in the Northampton County Record Office. The original forms part of the same paper document as the 1709 inventory of Montagu House, Bloomsbury. Each page is signed off by Mr 'Antonie'. It is labelled 'Inventory No 2 Montagu House and Ditton'.

[Ditton House]

In the Lady's Wooman's Roome

A bedstead w^th: a Lath bottom a Mohair furniture
complet: a feather bed boulster & pillow 4 blankets.
a mattress, a holla^d: Quilt, 4 Chaires, 1 Stoole. a Table.
a Cloathes Press. a Close Stoolee & 2 panns a brush a bell
& Stoole.

<div align="right">11=04</div>

In the Roome Over the Kitching

A Bedstead, matt & corde. a camblett furniture, a feth^er:
bed & boulster. 3 blanketts a Callicoe Quilt. 2 Chairs a
Table & a Velvet cushion

<div align="right">04=07=0</div>

In the Next Roome

A half headed bedstead matt & corde a fether bed &
boulster; rug & blankett one Chaire. one Table

<div align="right">02=00=00</div>

<div align="right">**17=11=00**</div>
<div align="right">*M: Antonie*</div>

In the Room over the Ladys Womans

one Table 3 Chaires. a boarded Pickture. a Grate below's
& Tonges

<div align="right">01=02=</div>

In the 1^st: Roome in Maiden Ro^we

A bedstead, with a Lath bottom. a Serge furniture
Compleat. a fether bed & bolster a check Mattress, a
Holland Quilt, & 2 blanketts a Wainscott table & 5 caine
Chaires. a Chimny Glass. a bedstead & table in y^e
Clossets

<div align="right">10=12=</div>

In the Second Roome

a bedstead with Lath bot=tom. a Serge furniture
Com=pleate a feather bed & bolst^er: a mattresses a
holland Quilt 2 blankets. 2 Chaires 1 Table.

<div align="right">07=4</div>

<div align="right">**18=18=00**</div>
<div align="right">*M: Antonie*</div>

In the 3 Roome

A bedstead & Lathe bottom w^th: a greene printed
furniture a fether bed, boulster & pillow 4 blankets,
a Callicoe Quilt a Mattress. a Holland Quilt a Table &
2 Chairs

In the 4^th: Roome

A bedstead & Stuf furniture a fether bed, boulster &
pillow a mattress & holland Quilt 3 blankets, 2 Chaires &
a Table

<div align="right">13=12=0</div>

<div align="right">*[the sum above is for both 3rd and 4th rooms]*</div>

In the 5^th Roome

a bedstead & Stuf furniture a fether bed & boulster.
A Mattress & holland Quilt. 3 blankets 2 Chaires &
a Table

<div align="right">06=9</div>

In the 6^th: Room

a bedstead & Serge furniture a fether bed, bolster & pillow
a Mattress & holland Quilt a Chimny Glass. 2 blankets 2
Chaires & a Table.

<div align="right">09=15 6</div>

<div align="right">**29=16=6**</div>
<div align="right">*M: Antonie*</div>

In y^e Clossett against y^e: 6^th: Roome

a bedstead & 3 rods

<div align="right">00=6=6=</div>

In the Bylliard Roome

a Large Bylliard Table & Sticks. an old Trunke. a Chair a
tycken cover to y^e Table.

<div align="right">09=14</div>

In the ffootmens 2 Roome

4 half headed bedsteads, mats & cordes. 4 fether beds
4 boulsters. 8 blanketts 4 Rugs 3 Chaires. one Table.
one Old Napkine press

<div align="right">12:01</div>

In the Maides 2 Roomes adjoyning

One bedstead a Sett of blew printed Curtains. & 2
half=headed bedsteads, 2 fether beds 2 boulsters, &
1 pillow 4 blankets 2 rugs. 3 Chaires 4 old heads. 1 old
pickture a parcel of pickture frames

<div align="right">11=6=</div>

<div align="right">**33=07=06**</div>
<div align="right">*M: Antonie*</div>

In the Nursery

a bedstead and Lath bottom a Cloth furniture Lined
Compleat a fether bed bolster & pillow a Mattress.
3 blankets. 6 Dutch Chaires. a Table 2 p^r: of curtains.
Valions & rods 4 p^es: of Tapestry q^t 100 ^Ells a paire of
Doggs, fier Shovle Tong's below's & brush

<div align="right">28=8=</div>

In the young Lord's Dineing Roome

9 Chaires w^th: List bottom's one Table

02:04

In the Darke Roome

a bedstead & Sacking bottom w^th: Drugget furniture.
a fether bed, bolster & pilloe 3 blankets. a Callicoe Quilt
a Mattress & Tapestry hangeing^s

08=05

In the Dineing Roome

14 Crimson Velvet Chaires a Coutch Cushion & fether
boulster. 4 p^cs: of Tapestry hangings q^t: 104 Ells, 3 pair of
Camblet Windo Curtains 3 Valions 3 Rods Tossils &
String. 2 Glasses in Gilt oval frames, 2 Carde tables.
2 Doggs & brush

69=13=

108=10=0

M: Antonie

In the Young Lady's Nurcery

a bedstead w^th: a Lath=bottom, a Chints ffurniture Lined
with yellow Indian Silk & Callicoe. 3 Mattresses a fether
boulster. 3 blankets a White tufted Counterpoynte 5 p^es
of Tapestry hangings q^t 160 Ells. 9 Caine Chaires 3 Caine
Stooles. 2 pair of White Damask Window Curtains.
2 Rods. Line & Tossils a pair of Doggs fire Sho=vle, tong's
bellows & brush

38=10

In the next Room

8 Velvet Chaires w^th: false Cases. 4 P^es of Tapestry q^t:
96 ^Ells a paire of White Callicoe Window Curtains.
Valions & Rods. a Chimny Glass a pair of Doggs.
a Wainscott Table

63:4

In my Lady's Dressing Roome

6 Square Stooles. w^th: fether Cushions. one Dressing
Chaire. y^e Gilt Leather hanging 2 pair of Window Curtains
& Valions & Rods. of Camblet a Table a Chimny Glass a
pair of Dogg's

11:00

112=14=0

M: Antonie

In my Lady's Bed Chamber

A Bedstead w^th a Lath bottom a Chints ffurniture a fether
bed & boulster, a Mattress. & 2 holland Quilts 10 Chaires
& Cushions. y^e: h:angings of the Room &Window

Curtains of Callicoe a Chimny Glass, a pair of Dogg's a
Carde Table a black Cab=binnett

63=9

In my Lords Dressing Roome

5 Velvet Cushions & 5 Dutch Chairs. 2 Wainscott Tables.
1 black Dressing Glass. a Chimny Glass. a paire of Iron
Dogg's & brush y^e: Dam=ask hangings bordered w^th:
Velvet: 1 pa^r: of Serge Windoe Curtains & Valions. y^e
pulley Rod & String

15=16=

In y^e Roome next my Lords Dressing Roome

a bedstead & a Blew Damask furniture w^th: Scarlet
Mantua Silk Compleat. a fether bed & bolster.
2 Mattresses. a hol=land Quilt. y^e Blew Velvitt hangings.
2 Serge Windowe Cur^s: & rods. 2 Caine & 2 Dutch Chair's
4 blew Velvet Cushions & a Chimny Glass

45=6=

124=11=0

M: Antonie

In my Lord's Closet

A Table & Stoole & 2 Maps

01-3

In y^e: Next Roome

3 p^es: of Tapestry hangings 1 Looking Glass belows &
brush

2=3

In the Gallery & Closet

5 Camblet Windoe Curtains 5 Valions Tossils & String 1
Chimny Glass. a Stove grate & poker. 2 Plasture figures,
a bedstead frame & 2 Stands

17=00

In the next Roome

A White India Cabinett a Chimny Glass. a Stove grate fier
Shovle Tong's Poker & brush. 1 Dutch Chaire, an India
Japaned Table & Case

19=04

39=10

M: Antonie

In the Draweing Roome

An India Cabinett one Chimny Glass. a Stove grate fier
Shovle tonges, poker & fender. a Dutch matted Chaire.
old Green ~~Linen~~ Silk Cases & 50 y^ds of green mohaire

26=16=

In the Stone Dineing Roome

54 prints. 2 Marble Tables 1 Wainscott Table a Stove grate fire Shovle tong's & poker 11 Dutch Chaires, a Wainscott Table.

30=01-

In the Grate Roome ye Corner of the new Appartment

10 Neidleworke Chaires & a Saffoy. 2 India Plate Cases, an Inlaye'd Table wth: Drawers an Indian Stand=Dish, a Watch Clocke. a Tea Table a Stove. fier Shovle Tonges & poker. ~~3 pickturs 2 heads~~ a Round Wallnuttree Table

66=13=

In the Hall

4 Needle Worke Stooles 2 Marble Tables 2 plaister figures

15=10

139=00:00

M: Antonie

In the New Bed Chamber & Dressing Roome

2 Chimny Glass,s a White Indian Cabinett: a Damask Bedd & 12 Chaires. an Indian Chest Inlayed wth: Mother of pearle. an Inlayed Table wth. Drawers one tea table a fier screen

207=05

In the Gentlemens Halle

18 boarded Chaires, 3 Tables 2 Chimny Glass & a paire of bellows

- - -

In the Servants Hall

a Table and 2 fformes

- - -

In ye Parlour

8 Square Stooles & Sattin Cu=shions. 2 Needle Work Stools 6 Stuft Chaires. 8 Caine Chaires wth. List bottom. one Dutch Chaire. one Mohaire Easy Chaire. one Leather Skreene 1 Small Table. 1 Glass. four Blankets. 2 Rug's. 9 Large Prints 2 stone basons

16=12=

223=17=00

M: Antonie

In the Maides Roome

a bedstead & Sacking bottom wth. a Stuf furniture. a fether bed 2 bolsters. a Mattress. 3 blanketts. a small fether bed & boulster. 2 blanketts, 1 Table, 2 Chaires. ye hangings to ye Roome. a Wainscott Press, 8 blew Velvett Cushions 6 blanketts. a fether bolster & 2 Downe pillowes. a Sute of Serge Curtains & Valions. 7 pair of Camblet Curts: & Camblett hangings to ye Roome. a pce of Tapestry. 3 pes: of Old hangin's a Smyrna Carpet: Deale Chest 1 old Carpet

44=8=

Linnen

17 Table's & Side=board Cloth's 6 Huckaback Table Cloths 8 Douzn: of Napkins: 28 paire of Sheetes. 3 Dozn: of Dyaper. Napkins. 3 Dozn. & ? of Towels 10 pillow beires. 6 Coarse Table Clothes: 3 Dozn: & one Pantry Towels: 7 Round Towels: 3 ps: of Damask Table Clothes: 5 paire of Holland Sheets

37=14=6

In ye: Nursery

A bedstead wth: a Sacking bottom & Plad ffurniture Compleat. a fether bed bolster & pillow 3 blankets. 1 Callicoe Quilt 2 Mattresses. 6 Chaires & Cushios: 1 Ovil Table. a pair of Dogg's, fier, Shovle & tonges Camblet hangings. a press bed a fether bolster. 3 blankets a Callicoe Quilt Camblet hangings to ye Closett a Large Glass in a Glass frame

38=19

121=01=06

M: Antonie

In the Pantry

8 pare of brass Candlesticks 8 pair of Snuffer's & pan's 8 brass hand Candlesticks 4 Iron Candle=sticks: 3 Coper potts: 1 Coper Lamp. & tea Kettle: 5 Lant=horns 5 Lamps. 6 pewter Dishes 3 Dozn: of plates: 3 Salts: Do: 7 Basketts: 11 Knives: 1 Dozn: of forkes: 1 Marble Mortar. & pestle. 4 Drinking hornes one Table. 1 Chair: a bread binn 2 Glass Lights: an Iron a Raspe, a Coffee Mill & a Coper Cistron

12=4=6

406 ounces of plate & 12 knives

107=05

In the Kitching

6 Brighte Saucepans: 2 fier pan's. 2 brass Skimers 2 ladle's, 2 Iron Dripeing panns: 4 Spits 2 Jack's. an Iron back a fire Shovle. a rainge a paire of Tong's a poker & below's 2 frying pan's. 2 Iron Spit Racks one Copper, wth. Iron

and Leaden Work a Craine & hooks. 6 brass Sauce pans.
3 potts & pott lyds: a Cleaver. 2 Choping knives a Dutch
Stove. 2 Grid Iron's & a fier Shovel: 2 Tables & Step's.
5 Chaires. one Stone Morter & Pestle. 1 brass pan.
1 Nutmeg Grater. a beife forke 4 Trivetts & hanging
Iron's. a fish plate. a Cullender. a Warming Pann

<div align="right">17=10</div>

<div align="right">**136=19=6**</div>

<div align="right">*M: Antonie*</div>

Belonging to yᵉ Cellar

16 Hogsheads: 4 Barrils 1 brewing vessel, 2 Covers
2 beareing Tubs a Stove Grate & Trivett: 6 Stillings
1 batheing Tub

<div align="right">06=00=00</div>

In the Chapple House

One bedstead, matt & corde 1 fether bed 3: blankits a Rug.
a bedstead wᵗʰ: Old Cloath Curtains & Valions a fether
bed & boulster. a blankit & Counter=point 3 Chaires & a
Table a pare. of Dogg's. a paire of tonges a Deale Press

<div align="right">05-01-</div>

In the Kitching's

A Rainge, a fender; hanging Iron's. fire Shovle, tonges
Poker. 2 Dressers, 2 Tables 2 horses

<div align="right">02=13=0</div>

In the Wash House

one Coper Iron Worke & Lead 2 great Tables. 9 Washing
Tubbes. 2 buckets: 2 piggings a pʳ: of bellowes: 10
Cloathes baskets: 2 box Iron's 4 heaters 12 other Irons.
3 Stands 2 Skillits. a horse. 2 barrows

<div align="right">4=07=</div>

<div align="right">**18=01:00**</div>

<div align="right">*M: Antonie*</div>

In the Grdners Roome

a halfe headed bedstead matt & corde; 1 fether bed 2
boulsters. a Mattrice 3 blankitts: 1 Rug: 1 pᶜᵉ: of Tapestry.
2 presses & one Cupboard

<div align="right">6=2=</div>

In the 4 Roomes over the Stables

4 bedsteads matts & cordes 4 feather beds, 4 boulsters
8 blankitts 4 Rug's. a Table a fforme. 2 Chaires 2 Stooles.
a Large Corn Binn. a House Clocke a large Copper & a
water Cart

<div align="right">35=10=</div>

In the Yarde & Bake House

A Bottle Rack, a Plate Dreiner a forme 6 Tubs a brass
kettle a scimer a Dough Trough. 2 Iron Ovin Lids. 1 peile
3 brushes wᵗʰ: Lead, a Hand Bell

<div align="right">4=06=</div>

<div align="right">**45=18=0**</div>

<div align="right">*M: Antonie*</div>

At the Farme House

3 Tubs, 2 Milk=Leads: 2 brass pans. 1 Chorme a Coper &
Iron Worke a Table, 2 fformes, 1 Chaire 2 Beare Stands.
a barril a Hogshead: & 3 formes

<div align="right">- - -</div>

3 bedsteads; matts & cordes 2 feather beds, 3 boulsters 2
flocke boulsters, 2 Rugs 2 blankitts

<div align="right">- - -</div>

1 bedstead. 1 fether bed & boulster: a flock bed a Table

<div align="right">- - -</div>

A feather bed & boulster 2 Tables, 2 Chaires. 1 forme

<div align="right">11=09=</div>

44 brass Lockes and 24 bolts

<div align="right">79=00=0</div>

<div align="right">**90=09=0**</div>

<div align="right">*M: Antonie*</div>

In the Garden

34 orrange trees 110 bayes trees 20 holly 4 stone Rowlers
3 wooden Rowlers 5 hoes a Reele 3 pʳ of sheers 5 rakes
a drag nett a Casting nett 9 bell glasses 5 millon frames,
a boat and Skulls 1 Iron Rouler 2 turfing Irons 2 edging
Irons 2 leaden figures and standes 4 wooden seats

<div align="right">189=06</div>

<div align="right">**189=00=6**</div>

<div align="right">*M: Antonie*</div>

Pictures at Ditton

In the Gallery

A flower pcs pr Baptist over the Chimney the na=tivity of
our Lᵈ by Bassant St Peters martyr'dom after Stisian
a large Landskip by Gapard Pousin one flower pce of
Baptist Abraham going to Egypt with his family by
Bassant a Cattle pce by Rosa Tivolide a Landskip by
Fouker one Ditto a large Landskip by Ruseau Tarquin
and Lucretia of Tintoret a foule pce by Snyder a flower
pce by Baptist Noahs flood after Alexander Veronois the
Nativity a Dutch pce a Cattell pce by Rosa Tivolide a
Landskip by Pousin a Childs picture by Mignard a

<div align="right"></div>

Madona by Bourdona flower pce by Baptist over the Doore

£
228=05

A Chimney pce three phylosophers heads by an Italian hand

06=00 00

In the Corner Roome

four family Pictures one half length by Vandyke the Queens picture a Childs picture by Mingard an Ovall Landskip by Ruseau 2 flower pcs by Bourdon

81=00=0

315=05=00

M: Antonie

A Landskip in the manner of Brugall a flower pce by Baptist our Saviour taken downe from the Cross by Bassant two Italian pictures by bernin two small Landskips by Ruseau a Landskip by Mauler, a small picture after Ruben a small picture of Shepards by Bourdona small Landskip Fouker another small Picture 4 pictures of Different sorts 8 more

89=15=

Up Staires

A Large Landskip over the Chimney a flower pce by Baptist Bourdonover another Chimney the Late L^d Dukes Picture 8 small pictures 5 large pannells painted by Louvoir a Chimney pce painted by Cheron

76=00

In the Nursery

ten Pictures

05=00=

170=15=0

M: Antonie

In the Wardrobe

50 pictures

10=00=

All the Goods of Ditton house & Mountague house mentioned in this Inventory amounts to eight thousand two hundred seaventy nine poundes, one shilling as appraised by us

James Gronous
Robert Haynes

8279=01=00

M: Antonie

Goods at Boughton val 4296:15:0

nº (2)
In Mr Anthony's House

A bedstead & serge furniture a feather bed and boulster & a pr of pillowes a pelong mattress & a Holland quilt 2 blanketts one old silk quilt 15 Caned Chaires and 2 Caned ~~chaires~~ stooles 2 wainscot tables 2 stove grates fier shovels tonges pokers fenders bellowes and brushes 5 pr of white Cheny windo Curtaines vallens & Rodes a glass & a wallnuttree table

15=08

Appraised by us

James Gronouse
Robert Haynes

M: Antonie

Dono Somers ad Duc Montagu

19 July 1711 The Inventory's on paper writeing's contained in this and the 32 precedont folios were produced and showed to James Gronouse at the time of his Examination before me

Tho: Pitt

And was also then produced and showed to Robert Haynes at the time of this Examination before me

Tho: Pitt.

Montagu House, Whitehall, London, 1746

Between 1731 and 1733 John, 2nd Duke of Montagu (see fig. 3), commissioned the architect Henry Flitcroft (1697–1769) to design a new house in the neo-Palladian style on part of the site of Old Whitehall Palace. The reference P.G. which recurs in this inventory stands for Privy Garden. Montagu House, Whitehall overlooked the Thames and in the next ten years the site was extended to include the adjacent Thames foreshore and a terrace was constructed overlooking the river, as recorded in contemporary paintings (see frontispiece). New furniture was made for the house to Flitcroft's designs including the mahogany bookcases and settees now at Boughton, Northamptonshire. The Duchess's bedroom and dressing room were decorated and furnished in the 'chinoiserie' style, most fashionable for ladies' apartments.

The full listing of silver includes new additions made the year after the inventory was taken. The case with the Dresden tea and coffee service decorated with landscapes is of particular interest.

Montagu House, Whitehall, was demolished in the mid-nineteenth century and rebuilt to the designs of the Scottish architect William Burn (1789–1870) for the 5th Duke of Buccleuch.

This document is in the collection of the Duke of Buccleuch and Queensberry and deposited in the Northampton County Record Office.

TESSA MURDOCH

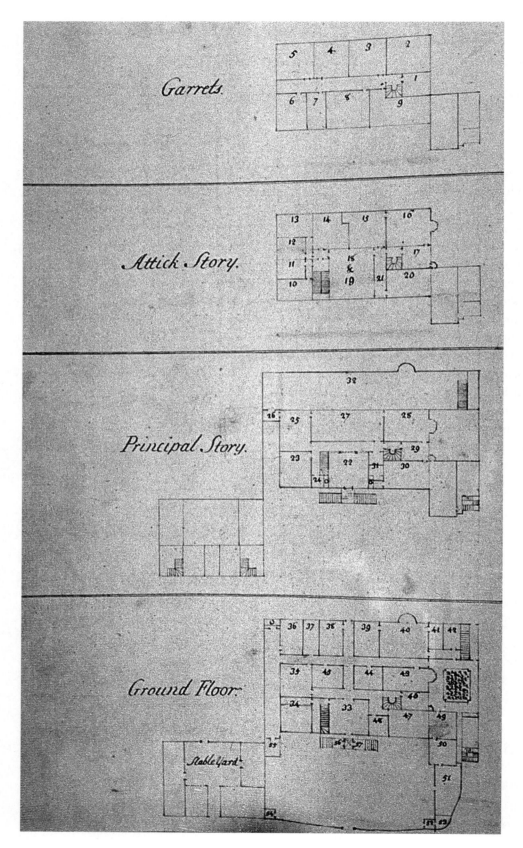

(Fig. 10)
Frontispiece to the
1746 inventory
for Montagu House,
Whitehall.
*The Duke of Buccleuch
and Queensberry*

[Whitehall 1746]
Plans of Garrets, Attic Story, Principal Story and Ground Floor

Index

N⁰. of Rooms Contin^d.	a Description of them Continued in full.	Pages.
51.	The Court between the Landry and the Porters Lodges	74.
52	The Porters Outer Lodge	75
53.	The Porters Inner Lodge	75.
54 & 55	The Lodge on the north west Corner of the Court and	76
56 & 57	Coal holes	76
58.	The Court before the house	76
	Divers Things under the Grooms Care	81 82 83 84.
	Divers Things under the Coachmans Care	85.
	On the Gate	76

$\frac{15}{26}$ } June 1746, An Inventory of the Things in the ward Robe.

Tapestry in a Deal Chest N⁰. 1.

Chest N⁰. 1

N⁰. of Piece	Ells wide	Ells Deep	
1.	9¼	5½	Julius Cæsar in Triumph.
2	7¼	5½	
3	6½	5½	
1	5½	5.	Susannah.
2.	5½	5.	
3.	5½	5.	
4.	3:¾	5.	
1.	8.	6.	Leander and hero.
2.	7.	6.	
3.	6½	6.	
4.	6½	6.	
5.	4½	6	
6.	4:½	6.	
1.	8	5	The Apostles Course Work.
2.	4	5	
3	5¾	5	
4	5½	5	
5.	7.	5.	
1.	9¼	6¼	Our Saviour and the Apostles fine work. **These 5 pieces were sent to the Wardrobe**
2.	9¼	6¼	
3.	9.	6¼	
4	8¾	6¼	
5.	7½.	6¼	

N⁰. of Piece	Ells wide	Ells Deep	
1.	8.	5½	Mark Aurelius the Roman Emperor. to be fitted to the Bedchamber Three are returnd & two remain there
2.	7½	5½	
3.	6½	5½	There are two at M^r. Bushels y^e Tapestry Weavers at the Work House in Poland Street
4	5½	5½	
5.	4¾	5½	
1.	7¼.	6	Dutch Boars.
2.	5¼	6.	
1	5	4½	Boys and Basketts. —
1.	5¾	5¼	Vintage.
2.	5½	5.¼	
3.	5½	5.¼	
4.	4½	5.¼	
5.	3½.	5.¼	
1.	8¼	5¼	The Elements
2.	8¼	5.¼	
3.	8.	5¼	
1.	7	5½	Vulcan at Work.
2.	11.	5½	
1.	3¾	4.	Sad Coloured. Velvet hangings.
2.	1¾	4.	
3.	6½	4.	

Chest N⁰. 1 Continued.

Chest N⁰. 1	N⁰. of piece	Ells wide	Ells Deep	
Joyn'd	1 2 3	3 6¾	4½	Cupid and Psyche.
Joyn'd	4 5	9.	4½.	
Deliver'd *Nov. ye 10th. 1752.*	1	7¾	5	Landskip and Figures,

N B. There were 5 pieces more of this Tapistry w^{ch}. were sent to L^d. Cardigan's, 1740

his Graces Furnitures in this Chest. viz^t.

a housing and Bags of blue velvet with Gold Lace and Fringe.

a housing and Bags of Crimson Velvet with Gold Lace and Fringe.

a housing and Bags of Leather Embroider'd with Gold and Silver.

a housing and Bags of Gold Tissue with Goldffringe to Ditto.

a Housing and Bags of Gold Tissue with Gold ffringe to Ditto Sent to Mr Spencers 17 Feb^{ry} 1747

Chest Nº. 1 *Continued.*

A housing and Bags of Crimson velvet Embroider'd
with Gold.
> Return:d 1st Aprill 1748

her Graces Furnitures in this Chest viz^t.
a Covering for a Side Saddle of Green Cloth with a Gold
Lace and a Stirrop to Ditto.
a Covering for a Side Saddle of Crimson velvet with a
Silver Lace and a Stirrop to ditto.

Chest Nº. 2. Carpets in Chest Nº. 2.

Carpet Nº.	Long ft.	In.	Wide ft.	In.	
1	23	10	9	7	Persia The Drawing Room Carpet
2	15	6	8	0	Persia
3	16	0	6	7	Persia
4	12	0	8	3	Persia
5	19	0	8	4.	Persia
6	5	1	3	7	Turky In his Graces yellow dressing Room
7	14	10	13	6	Persia
8	8	5	7	2	Persia
9	15	5	8	9	Turky The Dining Room Carpet
10	13	0	7	9	Turky
11	11	0	6	6	Turky
12	15	1	7	5	Persia
13	18	4	7	1	Persia
14	7	2	7	0	yorkshire In her Graces dressing Room
15.	5	9	4	0	Turky } in his Graces
	5	7	4	1.	Turky } dressing Room
16	6	2	4	2	Musketue
17	6	6	4	0	Turky -
18	5	5	3	10	Turky -
19	6	3	4	1.	Persia **from Boughton**
20	7	8	4	4.	Persia **from Ditto**
21.	13.	2	6	6	Persia In her Graces dressing Room

a Thread Net hammock.

Sundry Things in Chest Nº. 3.

Chest Nº. 3.
One Red Strip'd Silk Couch & 2. pillow ditto
Six Backs & Seats for Chairs Green Damask.
ffive Crimson Damask Cushion.
One Brocaded Silk Cushion
One Green fflowered velvet Cushions
Two sad Coloured Cushions
Four Green Damask Cushions with Yellow Lace

5. Covers for Backs and Seats for Chairs of flowred Silk
2. white Callico Window Curtains and Vallens
1. pair of White Damask window curtains and vallens
1. Green Taffity Window Curtain
2. Pair of dark Grey Damask Window Curtains
1. Pair of Ash Coloured Damask Ditto with Silver ffringe
and vallens to ditto.
1. Crimson Damask pillow to a Couch
NB. the Couch is at Montague house part of the Bottom
being Moth Eaten
3. pieces of Sad Coloured and black velvet hangings
2. pieces of stript Silk hangings.
2. pair of Green Taffety window Curtains & vallens
2. Yellow Damask window curtains & Cornishes
2. Green Silk Curtains to draw up.
1. Green Mohair Vallens with Yellow Lace
Severall Sorts of Old Lines &c. for window curtains of no
value in a Baskett by this Chest.
One Small Cushion of brocaded Silk.
Eleven Green Damask Cushions and Cases.
One White damask Window Curtain & Cornish
NB. there are 4 other Cornishes belonging to 4. Curtains
her Grace had to clean &c.
6. Small pieces of Stript Silk hangings.
4. blue Silk vallens
Two Crimson velvit Cushions
Three Red LuteString window Curtains and Vallens to
them
2. yellow Damask window Curtains Lined with Yellow
Stuff.
6. Needle work Chair Covers the Same of the Needle
work bed & red Serge Covers to Dº.
12. Armed Chair Cases of Crimson Velvit with red Serge
Covers to Ditto.
9. Backs and 8. Seats of Chairs of Green flowr'd velvet and
8. yellow Camblet Cases to Dº.
Furniture to a Bed of Green Velvit Embroidred with Gold
and Lined with red Satin Embroider'd with Dº. and a
Counterpane of the same.
Furniture of a Crimson velvit Bed Spotted with white and
Lined with a Crimson persian from Newhall
From New Hall
No Teaster
Furniture of a Bed of White Camblet Embroidered with
Grapes and Lined with a Cherry Coloured Lute string
Changed white from Newhall.
The Cases of Two Needle work Arm'd Chairs trimm'd
with blue Lace and 2. red Serge Covers to Ditto.
Two pair of blue Mohair window curtains & vallens &
Three pieces of blue Mohair hangings,

Sundry Thing in Chest Nº. 4.

Chest Nº. 4

A Crimson Velvit Bed lin'd with Embroider'd Satin with
2. Case Curtains of Crimson Persian all Compleat.
the Teaster pull'd to peices

a blue Mohair Bed Compleat.　*no Teaster.*

A Small Crimson Damask Bed the Cornishes wanting,
the rest Compleat.　*no Teaster Cloth*

Four pieces of hangings of India Sattin and
Two Window Curtains Ditto

A Teaster Cloth of blue India Gauze with Inside and
Outside Vallens.
N B. there are 2. pieces more of India Gauze of
a Different Sort. tied up with the Teaster Cloth
Above.

An India Sattin Carpet flowered with Gold. An head
Cloth and Inside Vallens of a Buff Coloured Damask
Bed.

4. Covers of Chints for Backs and 4. Ditto for Seats of
Chairs.

5. Counterpanes of Different Sorts.

2. Bolsters and 2. pillows of White Sattin

A Needle work Bed no Teaster or Headcloth

Continued

Chest Nº. 4. *Continued.*

Chest Nº. 4.　*Sent to Black heath*

A Plad Bed Lin'd with Gauze Compleat

A yellow mohair Bed Compleat

9. Backs and Seats of yellow Mohair same of the Bed

4. Pieces of Green India Damask.
*These were the lining to the curtains of the Needle
work Bed*

14. Backs of Chairs of Yellow Damask with purple
and white fringe.

16. Seats of Ditto.

6. Covers for Stools of Buff Colour'd Damask with
black Fringe.

2. Backs & Seats for Chairs of Ditto.
From New Hall

a Buff Coloured Damask Bed with black Fringe.
no Teaster nor Headcloth

a Counterpane Ditto.

6. Backs for Chairs of pink Coloured Sattin
Embroider'd with Silver Changed white

7. Seats　Ditto and Ditto.

An Octogan Mahogana Leaf for a Table.

Tapestry in Chests Nº. 5. and 7.

Chests Nº. 5 & 7

Nº. of Piece	Ells wide	Ells Deep		
1.	5.½	5½	} Landskip.	
2.	6.½	5½		
3.	4.½	5½		
4.	7.½	5½		
5.	3.½	5½		
1	3¾	5.	Image.	
1.	7.	4½	} Image.	
2.	6	4½		
1	4½	3.	Grotesque.	
1	6.	5		} Tapestry from Newhall.
2.	4.½	5.	Julius Cesar.	
1	5.	4¼	Imagery in 2. pieces.	
1.	3¾	5.	Imagery.	
1.	4½	5	} Landskip & Figures.	
2.	3.¾	5		
1.	7¼	4.	} Imagery a Sacrifice.	
2.	6.½	4.		
3.	5.	4.		
1.	5½	5	} Imagery Achilles.	
2.	3¾	4¾		
1.	4½	5½.	Imagery	

Tapestry from Montagu House.

1	6¼	4.	} Landskip & Figures.	
2.	5½	4.		
3.	3½	4.		
4.	4½.	4.		
1	3½	4½	} Verdure.	
2	7.	4½		
3	4¾	4½		
4.	2¼.	4½		
1	8.	5.	} Imagery	
2.	6½.	5.		
1	5.¾	3¾	} Out of the half Story on the East Side of the house.	
2	4½	3.¾		
3	5½	4¾		
4	4½	4¾		
5	3¾	4½		
6	2.¾	4¼		
7	3.	4½		
8	2.	3.¾		
9.	2½	3:¾.		

Sundrys in Chests N⁰. 5. and 7. *Continued*

Chests N⁰. 5 and 7:

A Cotton hammock.

a blue Camblet Window Curtain

a Stript Mohair Couch and 2. pillows

2. Red & White Stript Window Curtains & vallens

1 pair of blue Camblet Window Curtains & vallens

1. Red Serge Counterpane.

4. Vallens of Strip'd Camblet.

1. pair of plad window Curtains & Vallens

~~4 pair of Strip'd Camblet window curtains~~ These were Sent
 to Blackheath in June 1741 as Pr Old Inventory.

~~and Vallens~~ Inventory and sho^d. not have been Enter'd in this
 Inventory.

4. Pieces of Strip'd Mohair hangings.

8. Small pieces of D⁰. of another Sort

16. Backs and Seats for Chairs of Needle Work

12. Covers of Stools of Ditto.

12. Pieces of Unfinished Ditto.

3. Bases for a Bed of Green Mohair.

a counterpane of Ditto.

a blue Camblet Bed from the Cock pit.

Sundry Things in Chest N⁰. 6.

Chest N⁰. 6.

A Large Quilt of Cherry Coloured Silk

2. Bitts of Black Silk

1. Callicoe Quilt.

1. India Ash Coloured Quilt

2. Cradle Quilts of Black Silk

a Back & Seat of Needle work for a Chair.

3. Base Mouldings for a Bed of blue Silk

3. pieces of Greenflower'd Velvit hangings paned with
 plain Green velvet.

a blue & white Lute String Quilt

a Blue Silk Couch with Some Otter Down in it.

A White Sattin Quilt Embroidered with Gold. *Put in y^e*
 Chest wth. y^e. Velvet Curtains

In Chest N⁰. 8.

Chest N⁰. 8.

A Bed Tent & Markee in a Canvass Vallise

In Chest N⁰. 9.

Chest N⁰. 9.

A Virginia Wallnutt ffield Bedstead & Sacking Bottom

A Mahogany Ditto. and D⁰.

In a Chest N⁰. 10.

Chest N⁰. 10.

A Check Linnen Mattrass for a Field Bed.

4. pieces of Sprig'd Cotton.

5. Blanketts the Remainder of 6. pair from General Tyrrel
 in 1738.

A Carpet belonging to the Tent that Came from
 Boughton.

Of Cherry Colour Linnen Embroidered with Colours and
 Lined with Green Linnen.

In a Chest N⁰. 11.

Chest N⁰. 11.

A Quantity of yellow Silk Fringe & Tossells D⁰.

11. Yellow Silk Damask Vallens.

3. Bases D⁰.

Some Remnants & Bits of Yellow Silk Damask

3. Breadths of yellow Cheney 3½. yards long.

2. White India Damask Curtains & Vallens very Old.

A Yellow Silk Damask Teaster Cloth Lin'd with Linnen.

2. yellow Damask Bags for Bed Posts.

7. peices of Green velvet pain'd with Needlework

Some Old Green & White Fringe.

Sundry Bits of Green flowred Velvet

12. peices of Green Persian Linings Great and Small

51. Yards of Green Silk Line.

2. Tossell's & Bits of yellow Line.

a Bit of old Tapestry 2:½ wide 2½ long Ells.

In the Landry maids Room. N⁰. 1.

Room N⁰. 1.

a wainscott Stump Sacken bottom'd Bedstead on Castors

a ffeather Bed and 2. Bolsters.

3. Blanketts.

a yellow Quilt Silk on one Side & Serge on the other

a Blue Lincey Woolsey Quilt.

2. Caine Chairs.

a Brass Lock on the Door.

In The Footmens Room N⁰. 2.
William Ward &c.

Room N⁰. 2.

1. Wainscott Stump Sacken bottom'd Bedstead on
 Castors.

1. Straw Mattress. and 1. Flock Ditto.

1. ffeather Bed and Bolster.

3. Blanketts and an Old Coverlet

1. Wainscott Stump Sacken bottom'd Bedstead on
 Castors

1. Straw Mattress.

1. Feather Bed & Bolster

Room Nº. 2. *continued*

3. Blanketts & a Coverlet
A Deal press
2. Old Chairs
a Square Wainscot Table. **a Cubard in steed of a Table**
an Iron Back in the Chimney
a Brass Lock in the Door.

Sundry Things in Room Nº. 3.

Room Nº. 3.

A Stone Chimney piece hearth and Slab.
an Iron Back.
a black strong Box with Gilt Ornaments on a Frame.
2 Coach Seats of Wainscott.
a Brass Lock on the Door.
A Gilt Table
a Gilt Stand } from Newhall Old & broke
a Gilt Stand.
a Wallnut Arm'd Chair Cover'd with Brocade and Case.
an Old Armed Chair Covered with Serge.
a Wallnut Settee Covered with Brocade & Case
and a Cushion with the ffeathers taken out
a Small Feather Bed in a Canvass Bag.
an Old black Japan'd Table packt in a Mat.
a Wainscot folding fframe for a Leaf of a Table
some Spanish Ship Colours in a Bagg.
His Graces ffield Bed in a Vallise. **One Blanket belonging to His Graces ffield Bed**
8. wallnut Tree Chairs Stufft in Canvass. **left at Ditton in December 1747**
an Easy Chair Dº.
6 Wallnutt Tree Chairs Stufft in Yellow Linnen
5. Wallnut Chairs Covered with yellow Damask
4. Small Ebony Chairs.
3 Arm'd Ditto.
a Leather Valise
a Speaking Trumpet
Some pieces of Ebony from her Grace.

High Feet	Inchs	Wide Feet	Inchs	Glasses of Several Sorts
1	4	{ 1 / 1	9 / 9 }	Ditto 2. Plates.
1	11½	2	5½	Ditto 1. Plate.
2	2.	3	0.	Ditto 1. Plate.
2.	0	2.	6½.	Ditto 1. Plate.
1	6.	{ 1 / 2 / 1	1 / / 01 }	Dº. 3. Plates
1	10	{ 0 / 2 / 0	10 / 2½ / 10 }	Ditto 3. Plates
2	2	{ 1 / 3 / 1	0 / 4 / 0 }	Ditto 3. Plates.
2	3	{ 2 / 2	3 / 3 }	a Chimney Glass 2. plates
2	0	{ 0 / 2 / 0	11 / 9½ / 11 }	Ditto 2 plates this plate is broke.
2	1.	{ 1 / 2 / 1	0 / 7 / 0 }	Ditto 2 plates this plate broke and gone.
3 / 2 / 1 / 1	0 / 10½ / 9½ / 8.	2	2	a Pier Glass in 4. Plates:
3 / 3 / 2 / 1	0 / 0 / 6 / 3	2	2	Ditto 4. plates.
2 / 2 / 2 / 0	2 / 1 / 4 / 9	3	0	Ditto 4. Plates.
1 / 1 / 2	8½ / 9½ / 11½	1	11.	Ditto 3. Plates.
1 / 1 / 2	8 / 8½ / 11½	1	11.	Ditto 3. Plates.
3	9½	2	5½	a hanging Glass in an Inlaid Frame.
3	10½	2	6½	Ditto in Ditto.
3	0	2	2½	a hanging Glass in a black frame.

High Feet	Inchs	Wide Feet	Inchs	Glasses of Several Sorts
2	5½	3	9.	a Chimney Glass out of Bed Chambr.
2	1	{ 3 / 0 / 0	0½ / 10 / 10: }	Ditto in 3. Plates
1	11	{ 2 / 2	0 / 0 }	Ditto 2. Plates.
1	8	{ 1 / 1	10½ / 10½ }	Ditto 2. Plates.

Room Nº. 3. Continued.

Room Nº. 3

Feet	Inchˢ.	Feet	Inchˢ.	
2	7½.	1	11½.	a hanging Glass in a Carv'd Gilt fframe from Newhall.
3	1	2	2½.	a plate without a fframe.
1	11	1	6.	a hanging Glass in an Ebony Frame
2	4.	1	6.	Dº. broke in a wallnut Frame.
2	2.	1	8½	a Plate.
2	3½	1	5	
2	3½	1	5	Thre Plates with Borders Green and Gold.
2	3½	1	5.	
2	1	2	9½	a Chimney Glass in 1. Plate.
2	10	2	2.	a Plate a Corner broke off.
3	4	2	3½	a Looking Glass in a Carvd Gilt fframe in Room Nº. 8.

2 Glass Sconces.
Severall Glass Borders and Pieces of Glass.
Coach Glass Vizᵗ.
2. fore Glasses.
2. Door Glasses
2. Dº.
2 Do.
1 Door Glass Whole
1. Dº. broke
1 Dº. broke
3. Dº whole
2. pieces of Plate Glass broke

| 1 | 9 | 1 | 4. | An Oval Looking Glass without a fframe. |

Two Iron Frames for Arms which Came out of the Library at P.G. Nº. 18.

In the house Maids Room Nº. 4.

Room Nº. 4.

A stone Chimney Piece hearth & Slab.
an Iron Back in the Chimney
a Wainscott Stump Sacken bottom Bedstead on Castors.
a Feather Bed and Two Bolsters.
3. Blanketts and a Coverlid
a Caine Chair
1. Elbow Dº.

a Square Wainscot Table with a Drawer
a Stove Grate and Fender Shovel & poker
a Brass Lock on the Door.
2. Brass Candlesticks.

In the Room Nº. 5. Wardrobe.

Room Nº. 5.

A Square wainscot Table and on it
Severall Cases of Whited Brown paper for Covering of ffurniture.
a Long wooden Roller and on it
Severall Cases' of paper for Covering of Furniture
a Step Ladder to go to the Top of the house.
3. Deal pannells or window Shutters Nº. 3.
Some other Deal Lumber
a Brass Lock on the Door
a round wainscot Close Stool and an Earthen pan to Dº.
2. Cabinet Frames Carv'd and Gilt
2. large picture Frames Carv'd and partly Gilt.
6. Carv'd Gilt Moldings Small ones
an Architrave to a Door Carv'd and Gilt
2. large Mouldings Dº.
3. Bed waggons.
a Wooden Chandelier, Silver Gilt with 8. Sockets. to it one broke.
An Ebony Bedstead Compleat put in About April 1747
A Wallnut Tree Easy Chair Stuft in Canvas.
a Bedsted in a mat from Ditton
a ffield Bedstead out of the house keepers Room Novʳ. 1746.
Severall old Bedsteads from Montague house
Severall Curtain Rods from Dº.
a Great deal of Carv'd work of severall sorts from Dº.
 14 December
a Pair of Chair Poles for Her Graces Chair

In the Room Nº. 6. Wardrobe.

Room Nº. 6.

a Leather Trunk.
Another Leather Trunk
5. Wallnut Tree Cane Chairs.
The English Atlas 8. vols. in fo:
Cambdens Britania 1. vol: fo.
Le Theatre du Monde by Wᵐ. & John Bleau 1. Vol: Fo.
 Severˡˡ. Sorts of Carv'd work Vizᵗ.
2 Trophies.
2. Cyphers with Earls Coronets. 2 Eagles to one of them.
2 Festoons and Other Ornaments of Roses and Sun Flowers &c.
an Iron rimm'd Lock on the Door
Blue Cloth ffurniture to a Bed Lin'd with Yellow Silk out of the housekeepers Room at P.G. Nº. 19.

In the Room Nᵒ. 6. Wardrobe. *continued*

Room Nᵒ. 6.

3. pieces of Callico hangings lin'd
 with Canvas
Some odd pieces of Green hangings
Green printed stuff ffurniture to a Bed } From the
blue printed Stuff ffurniture to a } Cockpitt
 bed unmade. } Xtmas 1737.
India paper hangings to a Room

[The following is on a small paper inserted into the manuscript.]

Furniture of Beds from Montagu house. vizᵗ.

Sent to Black heath. 25 Jun 1747

a Red Serge ffurniture to a Bed }
Three pair of window Curtains. Dᵒ. } Booth's Room

Sent to B.h. 25ᵗʰ. June 1747

A red Serge ffurniture to a Bed }
The hangings of a Room of Dᵒ } Burton's Room
One window Curtain Dᵒ. }

Sent to B.h. 25ᵗʰ. Jun 1747.

a Blue Serge ffurniture to a Bed }
a Green Serge Window Curtain } Palmer's

a Green Serge ffurniture to a bed Goldstone's

a blue Serge ffurniture to a Bed }
Two blue Serge Window Curtains } Clerk of the Kitchen's

a Gray serge Furniture to a bed }
Green printed Suff hangings to } Mʳˢ. Mary's
 dark Room }

a Gray Serge ffurniture (unmade) }
 to a Bed } Mʳ. Reason.
a Green Serge Furniture to a Bed }

[The small paper insert ends here.]

16 Laced Livery Coats and one more
2. Chairmens Coats Dᵒ.
4. Green Cloth ᶜᵒᵃᶜʰ Seats
4. Cotton hammocks and
1. Thread hammock
15. Swords brass hilts
1 Dᵒ. black hilt

**Furniture of Beds from Montague house – vizᵗ. –
see the Paper put in the Book**

~~1. of Red Serge and … at Blackheath.~~ Sent to Blackheath
 25. June 1747
~~3. pair of Window Curtains Dᵒ.~~
~~1 of red Serge The hangings of a Room at Blackheath~~
 Sent to Blackheath 25ᵗʰ. June 1747
~~1 window Curtain to Ditto~~

~~1 blue Serge ffurniture … Gone to Blackheath~~
 Sent to Blackheath 25ᵗʰ. June 1747
~~1. Green Serge Window Curtain~~
~~1. Green Serge. ffurniture~~
~~1. of blue Serge and~~
~~2. Window Curtains Dᵒ.~~
~~1. of Gray Serge and~~
~~Green printed Stuff hangings to dark Room by Golstones.~~
~~1. of Gray Serge (unmade) out of the dark Room~~
~~1. of Green Serge.~~
The hangings of a Room of Irish Stitch
4. Green Serge Window Curtains vizᵗ. 2 from Salon 2.
 from Iron Doors of the hall.
3½ yards of Livery Furniture Lace.
The Dinner Bell from Montague house.
Iron Bolts and Ropes belonging to the Tapestry Machine.
a Wicker Chair Lin'd with Crimson Persian and a Cushion
 to ditto
a Settee Covered with blue velvet and 2 Cushions Dᵒ.
a Check Case to Dᵒ. and 2. to the Cushions.
2. Arm'd Chairs Dᵒ.
a black Sedan and
~~2. Chairmens Coats Dᵒ. black~~ ordered to be burnt
10. Glass Shades for Candles
2. Cupboards.
8. Green Rummer drinking Glasses
92. pair of Linnen Gueters for the Guards
14. Cockades of different Coloured Ribbons vizᵗ. Red
 black yellow white and Green
7. Dᵒ. white
3. Dᵒ. Green
Two Cockades Red
1. Ditto Yellow and
a Little loose red Ribbon
7. Old black Baggs.
a parcell of Old Paper Books & Book Covers
a Small Strong Box Ornamented with brass no key
40 Books of the Arms of the knights of the Baths
a deal Box full of Small prints with black Frames
12 larger prints with black Frames.
an Easy Chair Covered with Camblet, blue.
1. Deal Case full of ffrench drinking Glasses
another Ditto not full taken by me MMontagu
Another Dᵒ. packt in Canvass not Opened
12. matted Bottomd Chairs Sent 6 of the Chairs to B.H.
 20ᵗʰ July 1747
a Wallnut Tree Arm'd Chair Stufft in Canvass.
26. ffrench Drinking Glasses in a Baskett.
1. Green Serge Curtain
a hook on a Staff to walk in the woods with
a Fowling piece out of Allens Room 30 May 1747.
a wood Ram Rod with a Screw at the End to draw a Gun.
5. hangers for Footmen

Room Nº. 6. *continued*

Room Nº. 6.

5. Belts to Ditto and
6. Belts more.
1. hanger & Belt was Julia's
1. Sword blade in a Scabbard
3. pair of Leather Straps for hammocks
3. Blanketts.
5. Chint Curtains Lin'd with Nankin
1. Check Mattress blue and white
22. yards of broad Silk Lace or Velvet Lace.
A pair of Livery Pistols brass Barrels.
a pair of Gentlemens Pistols
a pair of Spanish Pistols.
a Small Screw Barrell Gun
3 Dº. Butts & Locks but none of the long parts of the
 Barrell's
5. Scotch Turks.
4. Coats Green
4. Green Frocks
3. ffustian Frocks … **one of em new**
3 red Waistcoats … **Livery old Cloaths**
4. Scarlett Breeches
3 Leather Breeches
4 hatts
1. Green Great Coat … **very Old.**
1 New pair of Scarlet Stockings.

In the kitchen maids Room Nº. 7.

Room Nº. 7.

A Wainscott Stump Sacken bottom'd Bedstead on Castors.
a Feather Bed and a Bolster
3. Blanketts
a Rugg.
2 Old Cane Chairs Leathered
an Old Leather Trunk
an Iron Rimm'd Lock on the Door

In the Room Nº. 8. Wardrobe

Room Nº. 8.

A Stone Chimney peice hearth & Slab.
an Iron Lock
a Large China Tub.

Feather Beds and Bolsters.

Feather Beds.	Long feet	Inchˢ.	Broad Feet	Inˢ.	
A Bed	7	6	6	9	& 1 Bolster to Dº.
Ditto	6	7	5	3.	& 1. Bolster to Dº. **Sent to Blackheath 25 June 1747**
at PG.	6	6	4	6.	

Feather Beds.	Long feet	Inchˢ.	Broad Feet	Inˢ.	
Dº. from 103 at M h	6	7	5	3	& 1. Bolster
a Bed.	6	9	5	0	& 1. Bolster
	6		4	6	& 1. Bolster **Sent to Blackheath 25 June 1747**
Dº. Cockpit	6	-	2	6.	
Table bed	6	10	2	7	& 1. Bolster of Fustian
Table Bed	6	3	3	4	1. Bolster of Another Sort 1. Window seat 6½ fᵗ. long

a Tick from Black heath & ffeathers out of Willᵐ.
 Wards Bed.

A Feather Bed from Ditton

Bedding out of the house keepers Room	2 White Mattresses 3 Blanketts The Curtains 1. Quilt. One mattress gone to BH. 25 June 1747

A Feather Bed from B: Heath.

Mattresses

	6	10	6	3	Check on outside and Fustian on the Other filled with Flock.
a hair Check Mattress	7	3	5	0	hair
Ditto	6	2	4	6	hair **Gone to B h. 25 June 1747**
Ditto	6	9	4	6	fflock **Gone to Do. Do. die**
Ditto	6	6	4	8	fflock
Ditto	6	5	4	4	Flock
a white Flock Mattress	6	6	5	3	
Ditto	6	5	3	10	
Ditto	6	2	3.	9.	

Two holland Cradle Quilts Good

Most of the mattresses are very Indifferent Some Good
 for Nothing

a White Mat.	6	4	7	2	not entire
a Check mat.	6	0	3	0.	

There are now six Blanketts of Different Sizes remaining
in the wardrobe **3. Gone to B.h. 25 June 1747**

The Room Nº. 8. *Continued*

Room Nº. 8

a ¾. Length of a Lady – No Frame

a half Length of a Man -

a pair of Small Landkips & Figures in Gilt Frames

a ¾. of a Lady Antique in a Gilt Frame.

a head of a man – No frame

a Small Dº Antique in a Gilt Frame

a Landskip not finished – no Frame

a Picture of Deities – no Frame.

Edward the 6th. – in a Gilt Frame

a Small head of a Lady – in a Gilt Frame.

Cupid – in a Gilt Frame.

a Small picture in a black Frame.

a Scripture piece Inlaid – in a Gilt Frame

a Mandona very Small – on Copper

a Fryar – Dº. – black Frame

a Small Landskip – black Frame.

a map of Barbadoes – black Frame.

20. Pictures Frames – Great & Small

3. Glasses that have Glaz'd prints Originally –

a Glass with Montagu Arms painted on it

a large Glass Frame with Gilt Edges and Glass Borders.

Two Frames carved and Gilt.

One Ditto Carved Another painted belonging to –
 the picture of the Virgin Mary – from Genl. Poultney

13 prints in Colours by Gautier – No Frames

a Large pedigree of the Montagu Family in a Black Frame.

a painting of the hulk of the Gloucester Man-of war in a
 Deal Case. –

1. Copper Still

1. Pewter Ditto – Suppos'd not Compleat. –

4. brass Boxes for Post Chaise Wheels.

6. Brass Canon on Carriages

1. Canon without a Carriage and Sundry Coins

a Small Carriage for a Canon.

Two Iron Cannons bound with wire

48. Scull Caps Great & Small.

7. Cocoa Nut Shells polish'd – in a Baskett

a Bushell, pork, half pork & Quartern Measures.

a Strike and Shovel to Ditto

a Lanthorn for a Post Chaize

a Dark Dº.

a Tin Tinder Box

4 wax Candles for the post Chaise.

Two Old Dutch Tables

a Camp Chair.

a Large Iron Fender

a Canneau pack'd in Canvass directed for Lord Brudenell

3. Cornishes Covered with Green velvett

a Small Pidgeon wood Tea Table broke to pieces

51. Iron Grates that belonged to the Tarrass

9. Sliding Doors for Stoves.

a Small Iron Engine in a Tin Case in a Deal Box

a Chest with 4. Vauses for a Bed

2. Standards One with the half Moon and the
 other a Griffin.

4 Gold Tossells and Gold ffringe taken off
 Ditto.

2. Banners for Kettle Drums **Given to
 Mr. Edgcomb**

Gold Lace & ffringe taken off Ditto

2 Shoulder Belts with Silver Lace

2. Foot Colours with Tossels of Silk

4. Oyl Skin Cases for Ditto

10. of his Graces Coat of Arms painted on
 Canvas in Oyl. **2 Sent to Ditton Feb:ry 9th
 1747 to put on the cart**

11 little red Colours

11 Cases to Ditto

} in a Deal Box

a Green Bays Bagg

10 Bells and some pulleys Lines handles &c. to ditto

a Deal Pole and fire Screen Covered with white Paper.

Two hundred Sacks

a Square Wainscott Close Stool & pewter pan

a wooden Log for a Stocking.

a Suit of Armour Campleat all but the Legs in a Box.

a Suit of Armour.

a Back & Breast of Another } in a Deal Chest

Another Back and Breast

a wainscot model of a house – made by Sturges.

a pair of Globes.

a machine for Diving in a Box.

a wind Gun

a warming Pan

a Strong Box of Rosewood on a black Frame.

an Oval Wainscot Stool

a Wainscott Corner Cupboard

2. Coach Lanthorns.

a Copper pan to Carry fire in with a Wooden handle.

Two travelling Trunks belonging to her Grace.

Another Trunk.

a Glass Lustre

a Chamber horse.

a Camera Obscura

a Pewter Bedpan

a Small Case of Bottles Containing 6.

a Brass Lock.

a hand Bell

Some Old Glass.

a black Strong Box on a black Frame.

an Old 3. Leafe Screen Leather and Green Serge.

a machine's Lanthorn

a Wooden case to put a watch in.

a Drawing of Stuccoe work – done by Mr. Clarke.

Room Nº. 8. *Continued.*

Room Nº. 8

8. Silver Badges for his Graces Watermen. *Daniel
Pamflett's Badge Given in December 4ᵗ 1747*
an Alabaster ᶠⁱᵍᵘʳᵉ without a head – in a Box – 2ᵈ. June
 1747.
Part of an Old Turkey Carpet. in Nº. 5
2. pair of Leather Cantine Bags.
a Large Tent with poles & pins &c. which Came from
 Boughton.
a Deal Chest with 19. Carbines.
a warming Pan. *Qu if this is not a Warming pan too much*
a 4 wheeld Orrery in a Deal Box. one being mention'd before
Kettle Drum's Sent to Ditton 20ᵗʰ December 1747

In the Footmens Room Nº. 9.
John & James Montagu.

Room Nº. 9.

a Wainscott Stump sacken bottomd Bedsted on Castors.
a Linnen Check Flock Mattress.
a Feather Bed and Bolster.
4. Blanketts and a Rugg.
a Deal press.
a Small Wallnut tree Cupboard with 2. Doors to it
a Square wainscott Cupboard with a Drawer in it
2. Cane Chairs.
a Brass Lock on the Door.

In the Passage.

a Leather Close Stool with a pewter pan in it
a wooden Frame of a Chair.

In the Room Nº. 10.

Room Nº. 10.

a Stone Chimney piece hearth and Slab
an Iron back.
an Iron Grate & ffender
a Wainscott Bedstead with a Sacken Bottom and Castors
 and Stuff Check ffurniture to Dº.
a flock Check Mattress
a ffeather Bed
a Bolster
One Blanket
a Callicoe Quilt
a Green Rugg.
1. Arm'd Cane Chair
1. Chair broke
1. Square wainscot Table
1 Deal press.
1. Old fire Shovel
an Old broken Octogan Table.
an Oak Chest and in it

a Stove Grate belonging to the marble hall
 ffire Shovel Tongs and Poker to ditto
a Stand used for Musick Books.
a Brass Lock on the Door.

In Room Nº. 11.

Room Nº. 11.

a Stone Chimney piece hearth and slab.
an Iron back.-
a Grate.
a ffire shovel
a pair of Tongs
a Poker
a ffender
a hearth Broom
a Coal Tub.
a Wainscott Bedstead with a Sacken Bottom and Castors
 to Dº
Blue Cloth ffurniture to Dº.
a Check fflock mattress
a ffeather Bed
2. Bolsters
a Pillow.
3. Blanketts. **1 Ditto More**
1. Rugg
2. Cane Chairs with black Frames.
a Square Deal Table
a Deal press.
a Brass Candlestick
a Brass Lock on the Door

At the head of the Great stairs

2. Brass Locks on 2. Doors.

In Room Nº. 12.

Room Nº. 12.

a Stone Chimney peice hearth and Slab.
an Iron Back
a Grate
a Coal Tub
a ffender
a hearth Broom broke
a ffire Shovel
a Poker
a Wainscot Bedsted with a Sacken Bottom and Castors to
 Ditto.
Furniture of Blue Cloth to Ditto.
a ffeather Bed.
a Bolster
a pillow.
a Check Mattress
3. Blankets.

In Room Nº. 12. *continued*

Room Nº. 12.

a Callicoe Quilt
2. black Cane Chairs.
1. Elbow Cane Chair
a Small Square wainscott fflapp Table
a Wainscott Buroe
a Wainscott press.
an Old Stand.
a brass Lock on the Door.

On the Door of the passage Leading to Rooms 12. and 13.

a Brass Lock.

In the Room Nº. 13.

Room Nº. 13

a Stone Chimney peice hearth & Slab
an Iron Back.
a Grate.
a ffire Shovel
a pair of Tongs
a Poker
a Tin Fender
a hearth Broom
a pair of Bellows
a Coal Tub
2. Cane Chairs with black Frames.
one Leather Cane Chair
an Elbow Cane Chair
a Wainscot writing Desk
a Wainscott press.
another Dº. Less
a Deal Press
a Matt on the Floor.
a Wainscott Bedsted upon Castors and a Sacking Bottom.
Striped Stuff ffurniture to Dº.
a ffustian fflock mattress.
a ffeather Bed
a Bolster
a Pillow.
3. Blanketts.
a Linnen Quilt Shift back
a Steal Screw press for a Seal.
a Square wainscott Table with a Drawer
a Small Wainscott Case for Books
a Square Wainscot Case and in it
Mapps & plans of his Graces Estates.
a month Clock in a Walllnut Tree Inlaid Case
a Wainscott Bureau – and on it
a Small Wainscott Cupboard with Nests for papers
a Wallnut Tree Escrutore.

a Small Wainscott Nest of Drawers.
a Small Square Wainscott Flat Table.
a pair of pistolls.
One brass Candlestick
a pewter Inkstand
2 Rulers.
a Small round wainscott Stand
a Brass Lock on the Door.

In the Room Nº. 14.

Room Nº. 14

a Stone Chimney peice hearth and Slab.
an Iron Back.
a Grate.
a ffire Shovel.
a pair of Tongs.
a Poker
a Fender.
a hearth Broom
a half Bushel Basket Tinn'd
a pair of Bellows.
a Wainscott Bedsted with a Sacken bottom on Castors
check Stuff ffurniture to Dº.
a Feather Bed
a Bolster
a Pillow.
a Check Mattress.
a white holland mattress.
3. Blanketts. **1 Ditto more**
a Red Serge Counterpane.
2. Cane Chairs with matted Bottoms.
1. Arm'd Cane Chair Dº.
1. Square Wainscott Table.
a Wainscott Chest of Drawers.
a Double Wainscott pressing
a Wainscott Chest
a Deal Chest
a large Deal Chest
a wainscott Box
2. Small horses to Air Cloaths on
a Brass Lock on the Door.
a Silver Shaving Bason
a Silver Ewer
a Silver Case for a Wash Ball
a Brass handle Candlestick
his Graces Cloaths & Sundry odd Things.

His Graces Room Nº. 15.

Room Nº. 15.

a Marble Chimney piece and Slab.
a Fire Stone hearth and Stone Covings
an Iron Back

His Graces Room Nº. 15. *continued*

Room Nº. 15.

a Steel Scotch Coal Grate

a ffire Shovel

a pair of Tongs

a Poker

a Round Looking Glass over the Chimney in a Gilt
 Frame.

2. Gilt pedestals viz^t. 1. on Each side the Glass

Carv'd work over the Glass Gilt

a Looking Glass in an Inlaid Frame.

a Walnut Tree Buroe.

a Walnut Tree Nest of Drawers.

12. Wallnut Tree Chairs Covered with yellow Damask.
 and Yellow Camblet Cases to Dº.

2. Wallnut Tree Stools Dº.

2. Wallnut Tree Easy Chairs Dº. with Cushions in them

a Wallnut Tree Settee with 2. Cushions Dº.

2. Mahogany Book Cases in the windows with Books in
 'em.

2. Yellow Silk Window Curtains to draw up

The Room hung with yellow Damask

Pictures in this Room

2. fflower peices over the Doors in Carved Gilt Frames.

4. fflower peices in Gilt Frames

10. Landskips in Gilt Frames.

1. a view of a Town in Dº.

1. a Sea piece in Dº.

40. pictures by Vandike in Dº.

a Womans head in Crayons

1. king of Sweeden

1. The Judgment of Paris

1. king henry the 8th. & his Family

2. king Charles the 1st. & his Queen

2. king Charles the 2^d. and his Queen

3 Pictures Viz^t. One Whole Length.
 & 2. Three Quarters

} In Gilt Frames.

2. Small pictures in black fframes One of them Ariadne.

42. Pictures in miniature in black Frames

15. Ditto in 3. Dº. Frames.

6. Ditto in 2. Ditto Frames.

2. Small Oval Limnings.

Shakespears Monument in Ivory on a black pedestal with
 a Glass over it.

a Plaister Figure of a woman

a Coffee mill to Grind Vipers

a brass Lock on the Door.

In his Graces Green Room Nº. 16

Room Nº. 16

a marble Chimney Peice and Slab.

a ffire Stone hearth and Stone Coveings.

a ffire Shovel

a pair of Tongs } with brass knobs to them

a Poker

an Iron Back.

an Iron Scotch Coal Grate with brass ornaments

an Oval Looking glass in a Carved Gilt Frame over the
 Chimney.

Carved work Gilt about Ditto

a Peer Glass in a Carved Gilt Frame between. the
 windows.

a Chest of Drawers of Pidgeon wood under it

8. Wallnut Tree Arm'd Chairs Covered with Crimson Silk
 Damask – and

8. red Serge Cases to them

a Wallnut Tree Couch with a Cane bottom

1 Squab of fflowered Silk and

3. Pillows Dº.

1. Squab Covered with Linnen the Edges of blue Silk.

Callicoe Cases to the Couch & 3. pillows.

2. fflower peices in Carvd Gilt Frames over the ^{Doors}

2 Small Carpets on } in the Inventory of Carpets in
 the Floor } the wardrobe

2 Brass Locks on the Doors.

The Room hung with Green paper

a Square mahogany Flap Table.

5. Large pieces of ffruit & fflowers in carved & Gilt
 Frames.

an Old head of a Gentleman in a Carved Gilt Frame.

Edward the 6th. in a Gilt Frame.

The Countess of Southton in a Carved Gilt Frame

The Prince & Princess of Orange in Dº.

a Lady in black in Dº.

king henry the 7th. in a carv'd gilt Frame

a Representation of the Emperor Charles. the 5th. making
 a peace with ffrancis the first king of ffrance in 1544 in
 Crayons. _____

The ffigure of a man in a Gilt Frame by Lady Cardigan.

a Spring Clock with Inlaid Case upon a pedestal Dº.

a fforreign ffowling peice

a pair of fine Inlaid wro^{ht} pistols with wheel Locks.

In the waiting Room. Nº. 17.

Room Nº. 17.

a Marble Chimney Peice and Slab.

a Fire Stone hearth and Stone Covings.

an Iron Back.

a Mans head in Crayons.

a picture of Julie Green in Crayons.

In the waiting Room. Nº. 17. *continued*

Room Nº. 17.

a Barometer
a Thermomater with Quick Silver
Another Dº. with Spirits of Wine.
an Iron Convenience Call'd a Footman.
The Room hung with Green paper
a Brass Lock on the Door.

In the Room Nº. 18 } **These Two Rooms are**
 19 } **now laid into One.**

Room Nº. 18. 19.

Two Book Cases with Books in them
a Mahogany writing Table with Drawers in it and Covered
 with black Leather & Castors to Dº.
a Stone Chimney peice Covings hearth & Slab.
Another Dº. Dº. Dº.
an Iron Back & a Grate
another Dº. & Dº.
a ffire Shovel
a poker
One large Deal press
a fframe & Case of Mahogany upon Castors & in it a
 Model of Gibraltar
One Deal Box with Swords in it
Another Deal Box with kitchen Things in it for a Camp.
a 3. Logged Staff for a ffield Jack
a Deal Box and in it }
3 Turkish Bridles } Mr. Burton has the key.
a Mahogany fframe with Glass Door the Ends Dº. with
 the Model of a Vessel in it
a Wind Dyal
3. Brass Lock on three Doors.
9. Matted bottom'd Chairs – at present in the India house
1 *Ditto More*

In the Room Nº. 20.

Room Nº. 20

a Stone Chimney peice hearth & Slab.
an Iron Back
a Grate
a ffire Shovel
a Cyndar Shovel
a pair of Tongs
a Poker
a ffender
a hearth Broom
a pair of Bellows
a half Bushel Basket of white work Tinn'd
a Wainscott Bedstead with a Sacken Bottom & Castors
Blue Cloth ffurniture to Dº.

a ffeather Bed
another Dº.
a Bolster
another Dº.
a pillow
a holland Mattress
3. Blanketts
a Callicoe Quilt
a Small horse to Air Cloaths on
a Block to dress heads on
a Square wainscott Flap Table
4. Cane Chairs with black Frame.
a Walnut Tree Chest of Drawers on a Frame.
a Walnut Tree Cabinet with Drawers
a Chest of Drawers of India wood
a Dutch Oval Table.
an 8. Square Looking Glass in a black fframe.
her Graces's Travelling Trunk for the post Chaise
a Cloaths brush
a Matt to the Floor
a Brass Lock to the Door
a Box Iron }
2. heaters }
a Trivit }

In the Room Nº. 21.

Room Nº. 21.

Two Wainscott presses – her Graces
Another Ditto
a Double press of Deal
a Chest of Cyprus Wood.
a Brass Lock on the Doors.

In the Room Nº. 22. the halls.

Room Nº. 22.

a Portland Chimney piece
an Iron hearth & Stone Covings
4. Mahogany Settees
a Dutch Stove
a ffire Shovel
a Poker
One Square Mahogany fflap Table
a Mahogany Oval Table
a large Square ~~wainscot~~ **Mahogany** Flap Table
a Small wainscott Stool
5. Wooden pedestals or Brackets
a brass Lock on the Outer Door
2. Iron Bolts with brass Ornaments on Dº.
a Brass Lock on the Door going into the Waiting Room
2 brass Lock's to the passage Doors into the hall

In a Little Closet near this Room

a Mahogany Quadrille Table.
2. Stands Ditto
a Little wainscott Cupboard
a Whisk brush with a long handle for the hangings.
a Carved Gilt picture Frame.
a Large round Tin Canaster
an Iron Latch with brass knobbs on the Door

In Room Nº. 23.

Room Nº. 23.

a White marble Chimney piece and Slab
a Fire Stone hearth and Stone Covings
an Iron Back
a Steel Bow Grate
Fire Shovel Tongs and Poker
a Looking Glass over the Chimney in a Carved Gilt
 Frame.
a Piediment with 2. Gilt Eagles over Dº.
a White marble Table with a black Border on a Carv'd Gilt
 Frame.
an Oval Table of Pidgeon wood.
a round Walnut Tree Table with one Foot
10. Walnut Tree Chairs Covered with red Leather and
 Castors to Ditto.
2. Easy Wallnut Tree Chairs on Castors Covered with
 yellow Damask and 2 Cushions Dº. with Check Linnen
 Covers to Dº.
a 4. Leafd' Gilt Leather Screen
a Canvass Fire Screen with a Mahogany Frame
a Table Clock.
a Carv'd Gilt Pedestal to Dº.
a Yellow Silk window Curtain to draw up.
a Canvass Spring Curtain

Pictures in this Room.

Two fflower pieces over the Doors – without Frames.
4 fflower pieces – 2 in Square Gilt frames & 2 in Octogan
 frames Carved & Gilt
6 Landskipps
1. Sr. Ralph Winwood ½ Length
1. Dutchess of Mazarine ½ Length
1. Oliver Cromwell ⎫
1. Mr. hobbs ⎬ ½ Length
3. Men ½ Length
3. Women Ditto
2. heads vizt. Man & Boy
1. the Cartoon
1. a Scripture peice
The holy Family.
a Sepulchre piece
a Landskip in Figures

All in Gilt Frames.

2. Brass Locks on the Doors
a Glass Lanthorn with a Mahogany Frame as One Goes to
 this Room.
a Stick with a brass hook to pull down Spring Curtains.

In Room Nº. 24. – a Closett

Room Nº. 24.

a walnut Tree Quadrille Table
a Book Case of Wainscott with Some Books in it
a picture of the Queen of hungary without a Frame.
2. wallnut Tree Stands
a Dum Waiter of Pidgeon Wood on 3. Castors.
The water Stool Marble & Wainscott
a picture of Monstrous Figures on a board
a Brass Lock on the Door
A Black Picture frame & narrow Gilding

In the Great Dining Room Nº. 25.

Room Nº. 25.

a white marble Chimney peice & Slab.
a Fire Stone hearth and Stone Covings.
an Iron Back
a Steel Stove Bow Grate with brass Ornaments
a Brass fire Shovel
a Brass pair of Tongs.
a Poker Ornamented with Brass.
a Chimney Glass painted with a Garland of Flowers And a
 Carved Gilt Frame to Dº.
a Carv'd Gilt pediment and other Carv'd Gilt Ornaments
 over Dº.
a peer Glass in a Carv'd Gilt Frame.
an Egyptian marble Table on a Carv'd gilt Frame
14. Wallnut Tree Chairs Covered with red Leather on
 Castors.
2. Armed Chairs Dº. & Dº.
a Fire Skreen of blue fflowered velvit and a Gilt Frame
 needle work on the other side.
2. window Curtains of red Damask Lined with red
 Stuff
2 Canvass Spring Curtains.
a White Marble Table with a black Border on Mahogany
 fframe on 6. Castors to Ditto.
a Round India Tea Table with 5 feet and on it
1. Tea pott
1 Saucer to Stand on
1 Sugar Dish & Cover
1. Slop Bason
6. Tea Cups
6. Saucers to Ditto

All White China.

a Two Leaf'd India Skreen
3. pictures of ffruit & fflowers over the 3. Doors in Carved
 and Gilt Frames.

In the Great Dining Room N⁰. 25. *continued*

Room N⁰. 25.

a Landskip over the Peer Glass in an Oval Carv'd Gilt Frame.

5. Large Landskips in Carved Gilt Frames.

6 Trophys Carved & Gilt in the Pannells of the Room

1. Mahogany Stick with a hook to pull Spring Curtains

3. Brass Locks on 3. Doors.

The Room N⁰. 25. Continued.
In the Small Closset going out of N⁰. 25. on the Terras. Room N⁰. 26.

Room N⁰. 26.

An Iron Lock with brass knobbs on the Door going to the Terras.

In the Drawing Room N⁰. 27.

Room N⁰. 27.

a white marble Chimney piece and Slab.

a Fire Stone hearth and Stone Covings.

an Iron Back

a Steel Bow Stove Grate with Silver Ornaments.

the ornaments charg'd in the groom of the Chamb^rs. Inventry

a Fire Shovel.
a pair of Tongs } Ornamented with Silver
a Poker

a Landskip over the Chimney in a Carved Gilt Frame.

2. Landskips over 2 Doors in D⁰. Frames.

2. peer Glasses in Carv'd Gilt Frames.

3. Canvass Spring Curtains.

3. window Curtains of blue flowered velvit

the Room hung with blue flowered velvit.

2. Marble Tables with Gilt Borders and Carved Gilt Frames on Castors.

12 Chairs cover'd w^th. blue flower'd velvet w^th. gilt Frames on Castors & checkt linnen Cases to D⁰

And 4 Arm'd Chairs D⁰. & D⁰

a round Mother of Pearl Table on a Gilt Frame with 5. feet.

2. India Japann'd Cabinets on Carv'd Gilt Frames

1. India Fire Skreen and a Wooden Rod with three Feet.

1 Stick with a hook to pull spring Curtains down with

2. Green Bays Covers for the Tables – {Leather on Top of Bays.

2. Blue D⁰. for the Cabinets.

an Iron Latch on a Door with brass knobbs.

In her Graces Dressing Room N⁰. 28.

Room N⁰. 28.

a White Marble Chimney peice and Slab.

a Fire Stone hearth and Stone Covings.

an Iron Back.

a Steel Bow Grate with brass Gilt Ornaments

a Fire Shovel

a pair of Tongs

a poker

a Chimney Glass in a Carved Gilt Frame

2. Gilt Festoons Viz^t. 1. on Each Side of D⁰.

other Carv'd work and 2. Eagles Gilt over D⁰.

a Picture viz^t. the Marquiss of Blanfords head. in a Carv'd Gilt frame over the Chimney Piece.

a Peer Glass in a Carv'd Gilt Frame

a picture of his Grace in a Oval Carv'd Gilt Frame

2. Landskips over the Doors in Carvd gilt Frames

2. yellow Damask Window Curtains.

7. Canvass Spring Curtains.

The Room hung with yellow Damask

6. yellow Damask Chairs with wallnut Tree fframes with Check Linnen Cases to D⁰. on Castors.

1. Easy Chair D⁰. with D⁰.

4. Stools D⁰. with D⁰.

a Couch with 2. Squabs & 3 pillows D⁰.

an India Cabinet on a Carved Gilt Frame.

an Inlaid writing Table

2. Two Leaf's India paper Skreens with wallnut Tree Frames.

a 4 Leaf'd India Skreen with Wallnut Tree Frame.

a Fire Skreen yellow Damask on one Side and Needle work on the other

a Small Square India Box.

2. Wire Blinds for 2 windows in Mahogany fframes.

a Turkey Carpet on the Floor

1. Black Shagreen Box with a Lock & Key

3. Square Boxes of Different Sorts.

a Large picture of the Virgin Mary with our Saviour in her Arms.

Another D⁰. but of different Sort & Size

2. Boys in a Garland of fflowers – one Sleeping

a Companion to it

1. Landskip & ffigures.

Two Small Landskips.

a Large picture of Child and a Dog.

Queen Catherine ? Length

2. heads under D⁰.

a round Landskip between the 2. last.

a Woman ? Length

a Crucifix with 2 Small pictures 1. on Each Side of it

1. Small piece of ffigures in Disguise.

1. Small round picture of Copper with a Man on one Side and a woman on the other.

4. heads in a Square black Frame.

an English marble Table with Brass round it on a Carved Gilt Frame on Castors.

a Green Bays cover to D⁰. with Leather over the Bays

3. Sides of a Deal Case to D⁰.

Her Graces Dressing Room N⁰. 28. *Continued.*

Room N⁰. 28.

a Square wainscot Dressing Table.

a Quilted Toylet to lay upon D⁰.

7. Japann'd Boxes of Different Sorts & Sizes

a Mahogany powder Box in 3. parts.

2. Round Gilt Boxes.

a hand Mirror of polish'd Metal.

1. India Cabinet with folding Doors.

1 India D⁰. with Drawers.

1. Mother of pearl Cabinet with 18. Drawers.

a Black Frame for D⁰.

~~a Green China Dish with 3. Snails for feet.~~

~~1 Silver Owl~~

1 D⁰. Less

2. Large ffestoons by the Bow window.

a Black Japan'd square Box from BH

In the waiting Room N⁰. 29.

Room N⁰. 29.

a white marble Chimney Peice & Slab.

a ffire Stone hearth & Stone Covings.

a pair of Silver Drops.

a Chimney Glass in a carv'd Gilt Frame.

a fflower piece over that in a Carv'd Gilt Frame

a head & other Carved Gilt Ornaments over ~~with~~ D⁰.

2. ffestoons by the Side of D⁰. Gilt.

4. Mahogany Stools. -

a Square Mahogany Folding Table on Castors

a Brass Lock on the Door

In the Bed Chamber Room N⁰. 30

Room N⁰. 30.

a White Marble Chimney piece and Slab

a Fire Stone hearth and Stone Covings.

an Iron Back.

a Steel Bow Grate with Silver Ornaments.

a Fire Shovel ⎫
a pair of Tongs ⎬ Ornamented with Silver

a Chimney Glass in a Carved Frame.

a Picture of Lady Bridgewater in a round Carved & Gilt fframe over the Chimney 2 Gilt ffestoons over it.

an India Chest Inlaid with Mother of pearl on a Gilt Frame

a Flower piece over the Door in a Carved Gilt Frame.

a Small India Cabinet on a Gilt Frame. -

a Wainscott Bedstead with a boarded Bottom

Needlework Curtains and ffurniture to D⁰ paned with Green velvit and Lined with Buff Coloured Damask.

1. Check Mattress.

2. holland Mattresses.

a ffeather Bed

a Bolster

2. pillows – round ones

1. Square pillow.

3. Blanketts.

1. white Sattin Casting Quilt

a white Dimity Quilt Sprigg'd with Several Colours.

1. India Quilt Stiched with Natural Coloured Silk.

a Small Chince Quilt Red & White &c.

9. Wallnut Tree Chairs Covered with Needle work paned with Green Velvet the Same as the Bed

a Buff Coloured Damask ffire Skreen with a black Japannd fframe.

a large Inlaid Chest on a fframe on Castors.

a Square Leather Trunk or Case.

a Square Cane Baskett.

a Two Leafed India Skreen

2. India Corner Cupboards. -

One Dish ⎫
Two Small Basons ⎬ Blue & White China
Two Basons larger ⎭

a ffishes Shell

3. Walking Sticks

2. Bitts of ffrench Carpeting to lay by the Bed.

a White Marble Slab in a mahogany fframe on the window.

a Brass Lock on One Door

a brass Bolt & a Latch D⁰. on the other Door

In the passage N⁰. 31.

N⁰. 31.

a 6. Leafed India Skreen

another 6. Leafed India Skreen

a Trunk Covered with black Leather

a Wainscott Book Case with Books in it

2 Night Tables of Mahogany upon Castors.

a Large Deal Chest

another D⁰. Less.

a Chest of India Wood.

a Small Oak Box with a Drawer in it

a Deal Box full of papers.

a water Stool Marble & Wainscott &c.

a brass Lock on the Door.

The Terras N⁰. 32.

N⁰. 32

a Brass Dial on a Stone Pedestal

a Lock upon the Water Gate.

Another on the Door in the passage.

a Leaden Case Cistern against the North Side of the house near the Terras

a Brass Cock in the Cistern

an India house upon the Terras. — *The India house at MH*

The hall on the Ground Floor Nᵒ. 33.

Nᵒ. 33

a Portland Chimney Peice
a ffire Stone hearth
an Iron Back
a Grate set in Stone work with a false Bottom
a Poker
a Bow Iron ffender
21. Wainscott Chairs
a Wooden Bench
2. Square Glass Lanthorns with Tin Frames.
an Iron rimm'd Lock ⎫
an Iron Latch ⎪
an Iron Bolt ⎬ on the Outer Door
and Iron Bar ⎭
a Brass Latch on the Inner Door
her Graces Chair with 2. pair of poles.
a Deal Case for Dᵒ.
a Chairmans Lanthorn.
1. Large Oval wainscot Table.
a Small hand Bell to ring for Dinner.

The Evidence Room Nᵒ. 34.

Room Nᵒ. 34

a Portland Chimney peice and a Slab.
a Fire Stone hearth
and Iron Back.
a Stone Grate
a ffire Shovel
a pair of Tongs
a Poker
a Large Oval Flap Table of fforeign wood.
1 step Ladder
a Large high brass ffender
1. Long Square Deal Table Covered with Green Cloth.
Severall Boxes with writings under it
an Oval Table of Manchineal Covered with hair Cloth.
an Oval writing Stool
3. broken ffuzzees. ⎫
 1. Bayonett to one ⎬ These belong to the Officers
 of them ⎭ of the Carabineers.
Presses with Boxes in them for writings round the Room.
a Leather Trunk with Musick ⎫ *Daniel Loude*
 Books that belonged to Julie ⎬ *has* the charge of
 — 2 Cases wᵗʰ. 3 Violins ⎭ *these things*
1 Brass Lock on the Door
an oeld Iron Machine

At the Bottom of the Great Stairs near this Room.

a Square Glass Lanthorn at the Bottom of the Great
 Stairs.

2. Step Ladders.
10 poles belonging to the Tents in Wardrobe
1. Large Copper Skillet in an Iron Frame.
1. Strong Iron Square Chest.
1. Long Square Deal Box with fflambeaus in it.
1. wig Block and Stand.
1. Cobweb Brush with a long handle.

In the Room Nᵒ. 35.

Room Nᵒ. 35

a Portland Chimney Piece
a Fire Stone hearth
an Iron Back
1. Wainscott Press
1. Deal press
1. Other Dᵒ.
a Candle Chest of Oak
an Iron Stove to Air the Rooms with
1 Large Iron Stove Grate with a Back in it
2. Old Iron Stove Grates without Backs
1. Iron Range.
6. Iron Backs with Arms on them
1. plain Iron Back
2. Backs to Stove Grates.
5. Iron ffenders
1 Square Copper upon 4 Iron ffeet ⎫ **In the Confectionary**
a Copper Cover to Dᵒ. ⎭
a Large Deal Chest — and in it
an Iron Stove Grate with a back to it pretty Good
an Iron hearth
4 Square of Iron work for Glass Doors.
1. Small Iron Grate to be set in brick or Stone
Severall Sorts of Old Iron
7. Iron Casements
a pair of Leather Canteens.
Severall Old hampers, Cases, & Lumber of divers Sorts
a Square Wainscot Table with a Tray on it to powder wigs
 in and a wig Block in the Tray.

In the Confectionary Room Nᵒ. 36.

Room Nᵒ. 36.

a Portland Chimney Piece
a Fire Stone hearth
an Iron Back
a Range — a Trivit to Set pots over Dᵒ.
a pair of Bellows
a hearth Broom
a Coal Tub
a Fire Shovel
a Pair of Tongs
a Poker — the Poker broke.
a Stone Fender — broke in the middle

In the Confectionary Room Nº. 36. *continued*

Room Nº. 36.

2. Stoves and 2. Trivetts
a Leaden Cistern
a Leaden Sink.
a Dresser Supported with Iron
Another Dresser Supported with Bracketts
3 Shelves above Ditto
2. Deal Presses
a cold Still
the Bottom of a Still part Copper on an Iron Frame.
a Large Marble Mortar & Wooden Pestle
a Small marble mortar & a Brazil Pestle
2. Tin Cake hoops
2. Tin Boxes – and 8 Tin plates.
12. Small Tin Tart pans.
12. Tin Pans to bake Spunge Bisketts in
 Each Pan holds 6. Biscuits.
84. Small Tin Cake pans.
Severall Tin Molds for Ice Cream. – in a Tin Box
4 Pewter molds for Ice Cream.
1. Still from Lady Norris in 1743 } in the Soap Press.
 in the Soap Press.
1. Brass kettle bo.ᵗ by Mʳˢ. Roe in 1741.
1. Wooden Ice Pail – with a false Bottom to it
1. Large Copper Sauce pan & Cover
2. Small Copper Sauce panns.
a Copper Spoon or Skimmer
a Square Copper Skimmer with an Iron handle.
a Pewter Bed pan.
a Drying Stove for Sweet Meats.
~~a Chafing Dish~~ see further
a Wainscot Oval Table.
a Square Wainscot Table
1. Elbow Cane Chair
a Dutch Copper Oven
2. Copper Preserving Pans.
an Iron Peel, to the Oven
a very large Earthen pan and a Cover to Dº. to make
 punch in.
a Small round Tub to wash her Graces feet in
a high Iron Chafing Dish *Changed for a new one*
a Low Iron Chafing Dish
a Wooden fframe for Jelly Baggs. & a Jelly Bag.
2. Silver preserving pans.
1. Large Silver Spoon with a Fork at the handle.
1. Silver Table Spoon. **in the Butlers Inventory**
3. pair of water Irons.
a Small Flap Wainscot Table

An Iron Rimm'd Lock on the Door

In the Passage by this Room.

a Pump
2 Iron Bolts into the Court
an Iron Bolt & Latch on the Boghouse Door
a Stock Lock on the Door going into the house.
an Iron Latch and Two Bolts Ditto.
a Lamp & Shelf

In the Small Beer Cellar Nº. 37.

Nº. 37.

a Leaden Cistern
a Bottle Rack with Shutters & a Door to Lock up.
Stillions for the Barrells to Stand on
a Stock Lock on the Door.

In the Stewards hall Nº. 38.

Room Nº. 38.

a Portland Chimney peice
a Brick hearth
an Iron Back
a Grate set in Brick work
a Fire Shovel
a pair of Tongs
a Poker
a ffender
a Bushel Basket Tinn'd
2. Oval Wainscot Tables.
12. black Leather Chairs with Stufft Backs and Seats very
 bad not being a whole one among them
a Deal press
an Iron plate warmer
7 knives & Forks with black handles – but 6 & all different
 Coulors
2. brass Candlesticks
2. Tin Extinguishers
a Brass Lock on the Door.
12 Knives & 12 forks new yᵉ 19th Appril 1748

An Iron rimm'd Lock and 2 Bolts on the Door in the
 passage opening to the water
a Glass Lanthorn with brass Socket Ornaments in the
 Crossing of the Passages.
a Ladder to Light this & other Lamps.

In the Scullery Nº. 39.

Room Nº. 39.

a portland Chimney piece -
an Iron Range with 2. Iron Cheeks.
a Leaden Cistern
a Leaden Sink
2. Shelves over Ditto
a Dresser and a Shelf over Dº.

In the Scullery Nᵒ. 39. *continued*

Room Nᵒ. 39.

another Dresser under the window

a brass pan Set in Brick work

a Copper Dish kettle in an Iron Frame and Iron Feet to
 the Frame.

2. Tubbs with 2. Iron hoops Each *one wanting*

a brass water Candlestick **wanting**

a plate Rack

an Iron Latch on the Door

an Oven with an Iron Lid to it

an Iron ffunnell and Grate to the Dish kettle for a
 Charcoal Fire

an Iron Ash pan with three Feet to Stand – under the Dish
 kettle – to receive the Ashes

a plate Baskett Lin'd with Tin

a knife Basket Lin'd with Tin
 a knife Basket lin'd with Tin Wanting novʳ 5

a Grease Tub Lin'd with Tin

Crockery ware of Severall Sorts in Dᵒ.

The Scullery maid has – 6. Rubbers.

In the kitchen Nᵒ. 40.

Room Nᵒ. 40.

Copper Things. vizᵗ.

12. Stew pans and Covers to them
 all Different Sizes Nᵒ. 1 @ 12.
 3 Wanting

6. Soup Pots & Covers to them
 all Diffᵗ. Sizes **All Wanting**

1. Daubing Pan and Cover

1. Ladle

2. Spoons

} New in
December
1746

6. Patty pans for Tarts of different Sizes.

13 Oval patty pans Small & 6 Dᵒ. larger

4. round Dᵒ.

4 Square Dᵒ.

} For Patty
Patties

1. large round Plate

1. Large Square Plate

1. Smaller Square Plate

3. Large Cullendars or Strainers

4. Large Stew pans.

1. Cover to one of them

2. Large boyling pots & Covers to 'em – bright

1. Boyling Pott and Cover to it – Black

2. Large Oval potts

2. Covers to Ditto

2. Loose handles to put the Covers to make
 'em use'd as stew pans on Occasion

} Belonged
to the
Barge

3. ffish kettles with Covers of Different Sizes.
 1 Sauce pan Lin'd with Silver for Breakfast broth
 1 Cover to Dᵒ. not Lined with Silver

8. Sauce pans – bright

4 Covers to 4. of 'em

2. Sauce Pans black

a Cover to one of 'em

2. round Fish Plates.

2. Oval Fish Plates.

another Small Oval Fish plate.

2. Large Spoons – One of 'em has an Iron handle
 one Soop Spoon wanting Novʳ. 5

1. Large Spoon with holes in it

4. Soup Ladles of different Sizes with Iron handles. *2*

1. Basting Ladle – with an Iron handle.

4. Scummers with Iron handles.

1. large Daubing pan and Cover

4. Soup pots with Covers to them of different Sizes.

1. Odd Cover to a Pot

3. Large Gravy pans of different Sizes. **1**

a Cover to one of them

5. Stew pans with Covers to them of Different Sizes.

a Cheese Toaster or Dutch Oven

a Large Copper drinking pot holds about a Gallon

3. Chocolate potts with Covers & Mills to Dᵒ. **2 Covers
 1 Mill**

2 Coffee Potts

a Spine Box with a Cover to Ditto.

a Large popeton and Cover

Un Cote de Melon mould

half a melon mould

Un popetoniere (plain without Cover)

a large pan – on 4. Etages

Un Serringe.

2. molds to Cut Paste for petty Patties *1*

a large Dripping Pan

a Large Fire pan with a wooden handle.

a Grater

a mould to make Pommes d'Amour

a Large Copper Set in Brick work

an Old kettle.

a Small Old Tea kettle.

a Clock in the Kitchen with a wooden case

Iron Things Vizᵗ.

An Iron Back in the Chimney

a Large Iron Range with 5 Barrs and 3 Cheeks to Ditto.

2. Racks.

2. Rods to lay over Ditto to Set Dishes on

2. Pig Irons.

1. ffire Shovel

1. ffire Shovel with a Grate Pan

1 large Poker

1 Small Poker.

The Kitchen Nº. 40. *Continued.*

Room Nº. 40.

Iron Things **Continued** viz^t.

4. Salamanders viz^t. 2 large and 2. Small *1 small*

2. Gridirons and a pair of Bellows

7 Spitts viz^t. 6. with Iron Wheels and 1. with a wooden
 Ditto.

a Jack with Line Pulleys and Weight

2. Jack Chains and 2. Old Jack Chains *2 old*

2. Trivetts to Sett dripping Pans on

2. Old ffire Shovel handles. *1*

2. Iron Skewers or Larke Spitts.

8. Trevets to the Stoves.

1. Iron Skewer with a Weight to it

1. Iron pan to Carry fire in. *W*

1. Beef Fork.

a pair of StakeTongs.

2. Iron Candlesticks. large & 1. Small D^o.

a wooden Skreen Lin'd with Tin.

2. Trevits to Set Pots on over the Fire

2. Chopping knives. *1*

1. Ditto Old.

1. Cleaver.

a Steel to whet knives on

an Iron Dust pan

a Chafing dish

an Iron hoop with 9. hooks to hang meat on

2. Iron peals

1. Iron Rake for the Oven

1. Iron Frying Pan

a pair of Stilliards.

3. Cooks knives. *2 Cooks knives wanting Nov^r. 5*

An Iron Fender

a pair of Tonges

Brass Things – viz^t.

2 Large Larding Pins. *1*

12. Small Larding Pins. *one Larding pin Wanting Nov^r: 5 8*

1. Pepper Box.

1. Dredging Box.

1. Cover for a Pot.

1. Tart Pan without a bottom

2. Lamps.

2. mortars and 2. Iron pestles to 'em *one Mortar & pestle
 wanting Nov^r: 5*

an Old Sauce pan with a hole in it.

a Candlestick for the Cook.

Pewter Things – viz^t.

an Old Pewter Jugging Pott

a Pewter Jugging Pot Lin'd with Silver

2. Pewter Covers for Dishes

11. Dishes of different Sizes – round *10 – 2 Melted*

4 Dishes of 3. different Sizes – Oval *8 good 2 melted*

2 Soup Dishes of different Sizes.

51 plates – or 4 Dozen and three. *Pewter plate Wanting
 Nov^r. 5 1747*

1. Soup Spoon broke *found 38 2 melted*

17. Table Spoons. *12*

2. Salts.

Tin Things – Viz^t.

a Dripping pan

a Cover to an Earthen Pan to bake Kine &c.

2. Cases for Larding Pins. (I think)

a Small Funnell to fill Sausages.

a Tart pan

a Grater

6 Small patty Pans

The kitchen maid has } *4 Dresser Cloaths*
 } *15. Rubbers. 3*

[written on a small piece of paper attached to the main
manuscript]

Belonging to the Kitchen Inventory
a strong Octagon Dresser round the Pillar in the
kitchen with 6 Cubboards & two Drawers
4 of the Cuboards with Locks on Them,
a D^o: Shelf Supported with 4 Iron Brackets
and a Small Iron frame (wants a spindle) to
wind pack thread on fastend to D^o. one found 3 locks
Oaken Dresser with Iron Barrs Cross the 9 march
frame of D^o: to hold Spitts on and a false
bottom, one D^o: with D^o: & D^o a shelf in the
Middle to Lay Stew pans on one Short D^o: with
a Square Sink lined with with Lead and a
Brass Cock to bring water into it, upon it,
and a place to hold Charcoal under it, one Short
D^o: with a false Bottom, a chopping Block,
Six Shelves One arm Cain Chair one Wodden
arm Chair wanting a back, a round wainscot
flap Table

[end of attached note]

In the Dry Larder Nº. 41.

Room Nº. 41.

a marble mortar and wooden Pestle

a Brass mortar and Pestle Ditto

a Tin Candle Box

Dressers round the Room

2. Cupboards

1. Drawer

a hanging Shelf

In the Dry Larder Nᵒ. 41. *continued*

Room Nᵒ. 41.

Shelves round the Room on Bracketts of Iron

a parcell of Crockery ware

2. Rolling pinns.

an Iron rimm'd Lock and a Iron Latch on the Door

The wett Larder a Room under the New Building.

an Iron Beam

a pair of wooden Scales.

4. Rails with Flesh hooks in them./

1. Dresser.

1. pair of Steps.

1. Iron weight ½.lb

1. Iron weight ¼.lb and an Iron 14.lb

1 Leaden weight – 7.lb

1. Iron weight – 4.lb

1. Iron weight – 2.lb.

wire ffly work round the windows.

3. Earthen pans with Covers to them for Salting meat. -
 found 5

an Iron rimm'd Lock on the Door

In the Coal Room Nᵒ. 42.

Room Nᵒ. 42.

In the Pantry Nᵒ. 43.

Room Nᵒ. 43

A Portland Chimney Piece

a Fire Stone hearth

an Iron Back

an Iron Grate set in Fire stone.

a Fire Shovel

a pair of Tongs

a Poker

a Fender

a Wainscot Field Bedstead with a Sacken Bottom and
 striped Camblet Furniture to Dᵒ.

a Check mattress

a Feather Bed.

a Bolster

a Pillow.

3. Blanketts

a Callicoe Quilt -

3. Leather Chairs

1. Arm'd Cane Chair.

1. Square Wainscot Table

1. Square Wainscot ffolding Table.

1. Wainscot Oval Table

1. Long Square Deal Table.

2. Bread Binns – or one Double Binn

2. Wainscot presses – or one Double press.

1. Single Wainscot press.

6. Wainscot Cupboards in the Bow Window Locks on 2.
 of em.

1. white marble Bason with a Cork over it
 and a plug at the Bottom of it
 on a black marble Pedestall

1. Copper Cistern

1. Plate Chest Covered with black Leather

1. Large Chest of Teek Wood.

1. Wainscot voider.

1. Mahogany voider. -

1. Tin Funnel

1. Copper Sauce pan.

1 fflatt brass Candlestick

1. pair of Snuffers. – iron

1. Lamp in the Court Close by the Door

2. Water pitchers.

1. pair of pistols.

1. Tin Grater

1. Wicker voider.

3. plate Basketts 2. Single and 1. Double for Knives fforks
 Spoons &c

Glasses & Decanters of Severall Sorts.

An Iron Lock with brass knobs on the Door

2. Iron Bolts on – Dᵒ.

1. Iron Barr Cross the Door.

1. Brass Latch on the Inner Door of the Passage going
 into the Court.

a Spring on Dᵒ. to make it Shut.

an Iron rimm'd Lock - ⎫
an Iron Latch - ⎬ On the Outer Door of the
2. Iron Bolts - ⎭ passage going into the Court.

a Brass plate warmer

24. Diaper Napkins. – for Glass Cloths

5. Cloths to Cover Glasses.

22. Plate Rubbers of Russia Diaper.

~~a Brass Plate warmer~~

2 Cubards above the press Bed

1 Ditto long by the Side of the Bed

Plate in the Butlers Care.

38. Dishes. Great and Small.

96. plates

2. Fountains 1. of 'em is broke.

2. Cisterns.

1. Large Terrein and Cover

2. Smaller Terreins and Covers.

9 Covers for Dishes of Different Sizes.

1. Bread or Lemon Baskett.

2. Sallet Dishes.

1. Fish Plate.

92. Large knives.

76. Forks to Ditto

In the Pantry Nº. 43. *Continued*

Room Nº. 43.

89. Table Spoons.
2. Carving knives.
2. Forks to Ditto
11. Small Spitts (or Skewers)
2. Soup Spoons.
2. Sugar Castors.
2. Crewit Cases or Frames with a ⎫
 pepper Castor to Each and ⎬ One of the frames
 Two Tops for Crewets Castor ⎪ broke & a bit Lost.
 to Each ⎭
1. Mustard pot & spoon
1. Small Table Ring.
1. Large Table Ring for 5. Plates.
10 Salvers Great & Small – 6 of 'em broke.
1. Gilt Porringer and Cover
1. Gilt Cup and Cover
4. knobs for fire Shovells & Pokers &c.
1. Small Cup or Tumbler
2. Ditto Larger of different Sizes.
2. Muggs – Barrell ffashion
1. Monteth
1. Chamber Pot – in the Plugg Room.
3. Dishes 1. Small and 2. large. Godroned
2. Large Dishes Scolloped and Godroned.
2. Ewers belonging to them
1. Salver and Cup of Filligreen work – Gilt
2. Large Gilt Dishes.
2. Flaggons belonging to them
2. Gilt Cups with Covers for the Sacrament
1. Crane – broke.
1. Toaster
1. Toaster with a wooden handle
1 Truncheon Gilt at the Ends.
1. French knife
1. Clasp knife with a Tortoise Shell handle.
12. Desert knifes
15. Small knives with Gilt handles.
8. Salts
2 Sauce Boats. **Found Two more**
3. knives with agate handles broke ⎫
 ⎬ her Grace has these.
3 Forks Dº whole ⎭
4. Sartout for knives Forks and Spoons.

One New Spoon … the 8th Febbʳy 1736/7
One large Gilt Salver – from Groom of Chambers.

16 Silver Dishes of an Oval Form of five ⎫	2 large
Different Sizes Vizᵗ. 4. of a Size of the - ⎪	2 less.
3. least Sizes and 2. of a Size of the. Two ⎬	4 Less
largest bought by my Lord Waldgrave ⎪	4 Less
about the year 1738 ⎭	4 Less
	16.

4. Octogan Dishes.} Xtmas 1746.

2 Sauce Spoons ⎫
1. Terrine and Cover ⎬ Easter 1747. **Found Two more**
1. Bread Baskett ⎭ **1749 27 March**

A Silver box for a nutmeg Grater
a manchineel waiter to put botles on in a Shagreen Case
a Bason and ewer
a Dram bottle a washball Case
8 Tickets with Chains

In the Cellar Nº. 44

Room Nº. 44

7. Binns.
Stillions to Set Casks on
2. Oak Shelves.
2. Deal Shelves.
an Iron Bolt on the Inner Door
an Iron Rimm'd Lock and a Bolt on the Outer Door
1. Brass Cock to a Leaden pipe.

In Another Cellar Nº. 45

Nº. 45.

7. Binns.
Stillions to Set Casks on.
2. Oak Shelves.
2. Deal Shelves.
a Iron Bolt on the Inner Door
an Iron rimm'd Lock and a Bolt on the Outer Door
1. Brass Cock to a Leaden Pipe.

In the Groom of the Chambers Room Nº. 46

Room Nº. 46

A portland Chimney Peice & Slab.
a Fire Stone hearth
an Old Dutch Stove with a ffunnel burnt out
a ffire Shovel
a pair of Tongs
a pair of Spring Tongs
a short deal Dresser or Shelf in the Corner
a pair of Bellows
a hearth Broom
a Square wainscot Table.
a black Elbow Cane Chair
a wainscott Desk on a Frame.
a voider of white Wicker work
a Copper Tea kettle
an Iron rimm'd Lock on the Door
a wainscot press.
a Square Glass Lanthorn at the Bottom of the stairs going
 to this Room

In the Groom of the Chambers Room N^o. 46
continued

Room N^o. 46

Plate &c in this Room.

7. Pair of Snuffers & their pans. – 2 p^r of em broke.

21. pair of Candlesticks Great & Small.

1. hand Candlestick.

another hand Candlestick with a Socket to D^o.

2. Branches with 3. Socketts Each

2. Branches more with 3. Socketts Each

2. Branches with 2. Socketts Each.

Two new Silver Branches ^{for Candlesticks} with 2. Socketts
 Each. (April 1747)

4. Branches more with 2. Sockets Each

1. Bell

Another Bell Larger

1. Coffee Pott

Another Coffee pott Large

another Coffee Pot

1. Chocolate Pott and a Mill to D^o.

1. Tea water kettle

Another Ditto

1. Lamp.

1. Round Plate to Carry Coffee on

1. milk Pot – the handle broke off

1. Skillet & Cover – broke.

1. Tea Strainer – broke & a piece lost

1. Large Sartood for Chocolate Cups & ⎫
2 Small Ones … D^o … ⎬ Gilt.
1. Standish for Ink &c. … ⎪
1. Bell … ⎪
2. Small plates … ⎪
1. Small Cup And a Cover to D^o. ⎭

6 Salvers for Chocolate ⎫
1. Oval Dish ⎬ Gilt
16. Silver Beakers of ⎪ **Pantry in the Butler's**
 Different Sizes in a Chest ⎪ **care 27 March**
 in the pantry ⎭

3 Tea Spoons

1. Stand with a Silver Top – in the Dressing Room

1. Chamber pott

1. Oval Ditto.

1. Tea pot

1. Tea Canister

2 Candlesticks old fashioned- Bot. 1744 } **are now Gilt & in**
 her Graces Dressing Room 2^d. June 1747

1. Box Silver of ffilligrane work **To her Grace 9th. April**
 1747.

1. pair of Silver Dogs **the Butler has in keeping**

1. pair of Do. in the Drawing Room

1. pair of Do. in the Bed Chamber. -

1. pair Ditto – in the Little waiting Room

3 knobs for Tongs poker the Fire Shovel

2 knobs for Fire Shovel and Tongs.

30 Silver Counters in a Silver Gilt Box.

78. Silver Counters – in a Silver Box.

Things not Silver

4. pair of ffrench Candlesticks.

9. Branches to Ditto. with 2. Socketts Each Gilt

9. Small Sockets or nossells to Ditto

1. Mahogany Tray. -

2. India Japann'd Boards for Chocolate.

1. Back Gamon Table with Dices Boxes & Men.

1. Embroidered Crimson velvet Purse. **36 white**

1. Silk Net with 72. Fishes for Counters. **37 Red**

1. Leather purse with Ivory Counters. **12 Square**

1. blue velvet purse for Counters. but has none in it.
 66 Round School Room

1. Round Crimson Velvet Cover for a Card Table.

1. Green Cloth for a Card table **from the housekeeper.**
 21. June 1747.

1. Ditto of Green Cloth

1. brass Spring Bolt for a Bed Chamber Door

1. Brown Copper Tea kettle & Lamp with an Iron Ring

1. Dutch Copper Coffee pot

Another Ditto – Larger.

a Copper Coal Skuttle.

1 Mettle Coffee pot – from M^r. Swiney.

China Viz^t.

1. Bason – Blue White & Yellow **Two sauce pans in 1748**

1. Bason Blue & White for Breakfast Broth **1 Silver Lamp**
 & a Dutch Case

1. Cup – D^o. for D^o.

Another Cup for D^o. **Want**

9. Coffee Cups of different Sorts – broke & Crackt
 Only 6 – 5

6 pair of Metal Candlesticks bought of M^r. Alexander in
 June 1747.

The housekeepers Room N^o. 47.

Room N^o. 47.

A Portland Chimney peice & Slab

A Fire Stone hearth

an Iron Back.

a Grate Set in Fire Stone.

a ffire Shovel

a Poker –Tongs – ffender – Bellows.

a hearth Broom.

Two pair of Tongs ⎫
One ffire Shovel ⎬ not in use.
a pair of Iron Dogs ⎭

a Trivit – a Toasting Fork – and Another Trivit

a hand brass candlestick – a p^r. of Iron Snuffers

The housekeepers Room N⁰. 47. *continued*

Room N⁰. 47.

2. brass Candlesticks. *but 1 to be found*

a Pewter Ink Stand – Sand Box &c.

a 4 Square looking Glass in a Wallnut tree Frame.

a Spring Clock. – a Chest of Drawers.

4 Cane Chairs with black Frames.

1. other Chair with a Beach Frame.

1. Deal press with 2. Doors

1. Small Deal press with one Door

1. other Deal press with 2 Doors

1. Wainscott press with one Door.

1. Deal drying Stove for Sweat meats.

6. wooden Boxes in Ditto.

a Deal Dresser with a Flap Supported by Iron

a One hand Coffee Mill

1. Coffee Mill fixed upon a post.

a Silver Skillet with a Cover to D⁰.

another Silver Skillet Less with a Cover to D⁰.

a pair of Brass Scales

a pile of Brass Weights. Viz. 2ᴵᵇ. & dᵒ weits 1. Ounce

a pair of Small brass Scales.

a pile of Brass weights to Ditto. Vizᵗ.⎫ **To BH June 1747**
 a pound and down to half an Ounce.⎭

a Large Dutch Oval Table.

1 Knife & a Large knife to break Sugar.

a Mahogany Tea Board.

2. Setts of Glass for French Deserts. – Boᵗ. 1743.

1. Tin Coffee Roaster – 1. Tin Apple Roaster. **1 Ditto new
 24 Feb 1747**

a Machine to Shave or Scrape Cheese Wood & Iron

2. brass Candlestick Enameled Green White &c.

2. Green Candles for Ditto.

**2 Bras Candlesticks Enameled Green white &c.and 2 Green
Candles Sent to BH October 1747**

a large Japann'd India Tub

1. Japann'd India vessel with a handle & Spout to it.

an India Tea Board – Red and Black.

an India Tea waiter – black and Gilt

an India hand Skreen.

2. India Dishes – Black and Inlaid

1. Waiter- D⁰. & D⁰.

an India Box that takes off in 3. parts black & Gilt.

Linnen &c.

5. Damask Table Cloths.

81. Napkins to Ditto

2. Damask Table Cloths.

24. Napkins to Ditto.

35 Damask Table Cloths.

17. Damask Table Cloths.

6. Damask Table Cloths.

14. Old Damask Table Cloths.

24. Diaper Tea Napkins.

10. Diaper Towells.

6. fine Linnen Damask Window Curtains.

1. pair of Vallens to Ditto.

8. peices of Silk Wadden

3. pair of Holland sheets for Country use.

4. pair of Holland sheets for her Graces Bed. *a Pair sent
 to Ditton 20ᵗʰ December 1747*

6. pillow Beers to Ditto. – 2 of 'em past use.

2½ pair of Dimity Sheets – and 1 Sheet at Blackheath

2. pair of Dimity Sheets

2 Dimity Cloths to lye under Table Cloths.

12. pair of Second Sheets – New Febʸ. 1745 -

1½ . pair of Ditto – Old

22 pair of Coarse Sheets. new Feb: 1745 & August.
 1746
 1. pair of D⁰. Good
 2½. pair D⁰. Old. – and
 3 pair of Old Sheets fit for nothing but to be torn in
 pieces **3 pair of Sheets cut up for Dusters Nov:22**

4. pair of Coarse Sheets at Blackheath *1747*

22. pillow Beers. for Servts. Beds. vizt.
 20 Good – and 2 bad … **1 Pillow ber 19 December 1747**

1. Ditto for the house keepers Bed. **1 Ditto 30ᵗʰ October
 1747**

9. huckaback Stewards Table Cloths

12. plain Russia Cloths for Footmen to wait with

35. Round Towells. Vizt – 25 Good & 10. bad.

5. Round Towells at Blackheath

24. Diaper Napkins⎫
5. Cloths to Cover⎪ To the Butler who has them
 Glasses. ⎬ always in keeping
22. plate Rubbers of⎪
 Russia Diaper ⎭

6. Diaper Napkins – For the housekeepers use

17. huckaback Napkins. Ditto

4. Dresser Cloths.⎫
 ⎬ The kitchen Maid has these
18. Rubbers ⎭

4. Diaper Table Cloths. ⎫
 4 Diaper Table Cloths & 48 Napkins ⎪
 to Ditto Sent to Boughton – August 1747 ⎬ Ship Linnen.
 by Thᵒ: Dummer ⎪
48 Napkins to Ditto ⎭

18 Coarse Cloths an Ell long Each

a Yard of red and white Check'd Holland.

a Bundle of white Silk Damask in 20 peices which has
 been Cleaned

24. Birds Eye Table Cloths

86. Napkins to Ditto – Severall past use.

9 Turkish Napkins with Fringe to them

5. huckaback Table Cloths Inda. Lin. bot abt Lady day
 1747

The housekeeper Room Nº. 47. *Continued*

Linnen &c. Continued.

Room Nº. 47

60 Napkins to Ditto … India Linnen bt. Abt. Lady day
 1747 **1 of the Napkins wanting**

2. Rolls of blue Silk Fringe ⎫
9. Bobbins with blue Silk on them ⎪
2. knotting Needles ⎪
2. Skains of Silk (Scarlett & pink) ⎬ Tied up in
6. Small Cases for Jewells of Diff Sizes. ⎪ a Napkin.
1. Leather purse and in it a Botton of ⎪
 brown Silk knotting ⎪
An Alburnus ⎪
a Dimity Cushion or Seat. ⎭

3. Foot Bases which came from her Graces Bed and a
 piece of Green Silk Fringe Ditto.

a Lath and Rod belonging to a Red Damask window
 Curtain.

9 pieces of Chints hangings.

2. pair of holland Sheets – New for Ditton **2 pair of**
Holland Sheets new sent to Ditton 20th Decr:1747

a Chints Counterpane for a bed.

a peice of Chints hangings for a Room from her Grace.

Red India Callicoe – the Lining of a Quilt.

9 Peices of Orange Colour'd Damask the Linngs of her
 Graces bed

a Green Bas Cover for a Cabinet in her Graces Dressing
 Room

Some peices of Glass in a little Ban Box

Some white thread Fringe.

a Lining of a Quilt white Persian – Good for Nothing

6. yard of fine New huckaback.

a Table Cloth of – Ditto – Unmade.

an India Stich'd Quilt for her Graces Bed.

an Artificial Desert on fine plates – Good for Nothing.

2. yellow Damask Curtains from her Graces Dressing
 Room

24. Diaper Napkins – New and not in wear.

6. Cloths to wipe knives for Austin

6. yards of New Second Sheeting Cloth.

8½. yards of new huckaback in 2. peices for housekeepers
 Napkins.

7. yds. of New Russia Diaper for Butlers plate Rubbers.

21. yards of new Cloth for Servants pillow Beers.

Some Bitts of New Cloth belonging to Rio's Shirts.

a Parasol Crimson & white Silk - & white Silk Lace.
 round it.

 A bundle of Some peices of Old sheets.

 A Bundle of Old Tea Napkins.

Glass- vizt.

1. Large mugg with a Cover & 2 handles to it Crackt.

4 fine wrought drinking Glasses.

Severall Sorts of Glasses for the Desert.

Severall Gally pots for Sweet Meats.

White China.

6. Chocolate Cups.

6. Chocolate Cups of Another Sort.

2. Basons – both of them Crackt

1 Sugar Dish with a cover.

9 Coffee Cups – Whole.

2. Ditto – the handles broke off.

Brown China.

17. Custard Cups.

1. Tea pot.

1. Tea pot – broke

Coloured China

1. Cup and Cover with brass Ears

3. Dishes Large

4. Dishes of the same fashion – Small.

Blue and white China.

1. Dish.

3 Dishes { 1 of em broke and Mended.} and 1. plate

3 Dishes – These are all blue.

2. Desert Dishes

2. Small Desert Dishes

2. Dº. of the Same Size but different pattern. One of em
 broke and mended. -

2. Dishes a little Scollop'd

2. Dishes of Another Fashion a little Scolloped.

1. large Dish

2. large Dishes.

2. other large Dishes

4. Dishes.

4. Bassons of the Same Sort.

4. Basons with Covers to them { **one of these Basons is taken**
 for Breakfast Broth

a Large Terreen and Cover

a Large Bowl with 3 Feet

5. Deep Plates.

2. Ditto of Another Sort.

4. plates whole and { 1 Crackt 1 broke

2. plate of Another Sort – whole and – 1 Dº. Crackt.

1. pint Mug – the bottom has been out & put in Again

2. Little Basons.

1. Deep Dish

1. Bason – has been broke and is mended Again

1. Large Oval Dish with 3. Feet.

12. Eight Square Dishes of three Different Sizes Vizt. four
 of Each Size.

The housekeeper Room Nº. 47. *Continued*

Room Nº. 47

Blue and white China. *continued*

16. whole 8 Squared plates to Ditto and { 1. Crackt and a
 piece broke oV the Edge of Another

9. Dozen of blue and white Chocolate Cups. { 4 of em
 Crackt 11 crackt 4 Broke

9. Dozen of Saucers to Ditto – 1 Broke

a Trunk or Case Covered with Red Leather And in it the
 following Landskips Dresden China Vizᵗ.

1. Tea pot
1. Coffee pot
1. Sugar Dish and Cover
1. Milk pot and Top to it *at Blackheath*
1 Slop Bason
1. Tea Cannister
1. Saucer to lay Spoons in
12. Tea Cups
12. Saucers to Ditto
6. Coffee Cups
6. Saucers to Ditto.

Broken China
Severall Dishes plates and Basons.

Room Nº. 48
A Portland Chimney peice and Slab
a Fire Stone hearth
an Iron Back
a Grate set in ffire Stone.
a Brass Lock on the Door
a Deal Dresser
4 deal Shelves viz. 2 Short & 2 long
5. beams with fflesh hooks
Deal steps.
a wyre ffly work to the Window
a Square mahogany Frame Glass'd to Cover Butter &c.
Two Small Shelves
a Chimney Board

Room Nº. 47
The housekeepers Room Nº. 47. *Continued*.

1. Tea Board.
1. Brown Tea Pot
1. Saucer to Ditto - **blue and white.**
1. Sugar Dish.
1. Slop Bason – **blue.**
5 Cups and 7. Saucers. **one of Each Broke**
a milk pot of Different Colours.
1. Blue and White Sugar Dish
5. Coffee Cups 1. of 'em without a handle.
1. Bason Blue and White.

1. Small white China Dish for Sugar Candy
3. Tea Cups 1. Saucer
6. Silver Tea Spoons.
6. Silver Tea Spoons Gilt 1 Strainer Gilt.

Colourd Staffordshire Ware vizᵗ. 1. Tea pot whole
1. Tea pot the End of the Spout broke off.
1. Salver with three ffeet.
1. Milk pot with 3. feet one of 'em broke off
1. Cover of a Sugar Dish
1. Slop Bason a piece broke out of it
1. Small Tea Canister
6. Tea Cups 6. Saucers to Ditto.
1. Saucer for Spoons.
6. Coffee Cups.

Sundry Delft and Earthen Ware Things.
4. Eight Squared Dishes blue & white China or Delft
 at Blackheath
4. Scollopt Shell Salvers Ditto … Delft
2. Blue Dishes **1 Broke Earthen ware**
1. Blue and White Dish Broke **Earthen ware.**
1. Desert plate with 6. Divisions in it **Delft broke and
 mended.**
1. Ditto with 7 Feet **Delft.**

In the Wash house Nº. 49.
Room Nº. 49
a Leaden Cistern
a Brass Cock in it and a brass Cock over it
a Leaden pump with an Iron handle and a wooden Top
 Covering to it
1. Copper Set in Brick work with a Brass Cork over it- a
 wooden Cover to it
1. Ditto Sett in Brick work with a large Cork in it and a
 brass one over it.
2. Dressers by the window Supported with Two Iron Feet
 Each.
2. Shelves
a wooden horse to hang wet Linnen on
a wooden Form for a washing Tub.
a wooden Bench to Set on
a Large oval Rincing Tub
7. Washing Tubs of Different Sizes.
a Piggin
a Bowl Dish
a wooden Bridge over the Coppers to lay wett Linnen on
an Oaken Linnen Press.
9 Oak Leaves belonging to it
an Iron Crow to the press.
A wooden Frame to Set a Tub on
an Iron hoop pail
an Iron rimm'd Lock and iron Latch to the Door.

In the Landry – Nº. 50.

Room Nº. 50

An Iron Back.

a Range.

a Fire Shovel.

a pair of Tongs

a Poker

a Fender.

a hanger to hold the Flatt Irons.

15 flat Irons. 1 wanting

1. Box Iron and 2 heaters.

2. Resters to Set the Irons on

a mangle and 3. Rollers belonging to it

4 Leadean weights – to Ditto

One Deal Dresser with 3. Drawers and Two Cupboards with Locks.

Another Deal Dresser with one Cupboard and three Drawers with Locks.

a Square wainscot Table

a Square Deal Table

3. wooden Chairs.

4. Basketts.

2. Flasketts.

2. horses – 1. large and 1 Small.

2. Brass Candlesticks.

1. pair of Iron Snuffers.

a horse that draws up by pulleys to hang Linnen on

a pair of Bellows – a hair broom – a Dust Brush

a Tea Kettle.

1. large Sauce pan – 1 Smaller

a Copper Frying Pan

Two ffolding Cloaths for the Basketts

4. mangling Cloths ⎫

a horse Cloth wore out ⎬ Linnen

3. Boyling Bags. viz. 1 large 2 Small ⎪

 1 wanting ⎭

4. Cloths to rub Irons on. 1 wanting

Two fflannel Iron Cloths.

a Square Cupboard.

a Stock Lock ⎫

an Iron Bolt ⎬ On the Outer Door

an Iron Latch. ⎭

an Iron Latch to the Inner Door

2 a Coal Basket

gave 4 flat Irons for the Kitchen

In the Court between the Landry and the Porters Lodge- nº. 51.

Nº. 51

A Large Case Cistern with a Ball and Stop Cock in it.

a Cock of Brass to draw water from the Cistern

hair Lines cross the Court.

7. Deal Cases for the India house. Sent to Montague House

an Iron Rimm'd Lock & Latch on the Door

In the Porters outer Lodge. Nº. 52.

Room Nº. 52.

A Portland Chimney peice

2. Benches One of them Inclos'd to the Ground.

The Porters Inner Lodge Nº. 53.

Room Nº. 53.

a Portland Slab.

an Iron Grate.

a Blower with 2. Joints in it to Dº.

a Fire Shovell

a Poker.

a half headed wainscott Bed with Castors to it.

a Feather Bed

a Bolster

2. Blanketts.

1. Rugg.

1. Square wallnut Tree Table.

1. wooden Chair.

1. Cane Chair

1. Deal press.

a fflat brass Candlestick

a pair of Snuffers.

In the Lodge on the North west Corner of the Court Room Nº. 54

Coal hole.

Nº. 55

In the Holes under the Stone Steps.

Nº. 56. Coals in One.

a Stock Lock on the Door.

Nº. 57 Charcoal in the Other

a Stock Lock on the Door

58 In the Court before the house

2. Lamps on Iron Standards.

2. Lamps at the Gate

On the Gate

an Iron rimm'd Lock.

a Long Bolt.

a Short Bolt.

Inventory of Things in the Grooms Care. his Graces Things.

Seven Demi Peak Sadles with 8 pair holsters viz^t. the Sadles – 3 of 'em new and 4. old.

The Inventory of Things under the Grooms care
Continued

1. French post Saddle very bad
2 Small Buff saddles.
1. Sumpter Saddle.
7. Bridles with Gilt Bosses. *3 Wanting*
2. plain Bridles without Bosses.
1 large Bit with Gilt Bosses. *found 4*
3 Small Bitts with Bosses.
5 Bitts without Bosses.
1. Ditto with head Stall and Reins

Furnitures. viz^t.

In the wardrobe
a houseing and Bags of blue velvet & Gold lace and
 ffringe. wardrobe.

Wardrobe
a crimson velvet houseing and Bags with a Gold Lace and
 ffringe wardrobe.

wardrobe
a Leather houseing and Bags Embroidered with Gold and
 Silver wardrobe.

wardrobe
a housing and Bags of Gold velvet Embroidered with
 Gold } wardrobe
a Green velvet housing with Gold Lace.
an Old blue velvet housing and Bags Embroidered with
 Silver
One Green Cloth houseing with Narrow Gold Lace.
a white Thread ffly Nett
a yellow Thread ffly Nett
a Green Silk Bridon
3. Leather Bridons. *found 5*
a Headstall Reins and Crupper of Leather with Gilt Brass
 Ornaments.
a pair of stirrups washed yellow
a pair of Spars Ditto
6. new Caparison Cloths.
5. Old Caparison Cloths.
2. Smaller Caparison Cloths. viz^t { 1 his Grace 1. her
 Grace. in Wardrobe
3. Sumpter Cloths with Surcingles.
a Whip.

Furnitures.
One housing and bags of blue Silver Tissue Embroidered
 with Silver – old.

her Graces Things.
2. Side Saddles with Covering to D^o. viz^t. *taken to the*
 wardrobe

One yellow Cloth with Silver Lace and Reins D^o and
 Stirrup
One Green Cloth and Gold Lace and a Stirrup. } *wardrobe*
One Crimson velvet Covering with Silver Lace and a
 Stirrup to D^o } *wardrobe.*
One blue velvet Covering with a Gold Lace and Silk Reins
 to Ditto.
One Green velvet Covering with Silk Lace and Silk Fringe
 and a Stirrup to D^o.
One Buff Coloured Cloth with a Gold Lace and a Stirrup
 to D^o. *wanting suposed to be in the wardrobe*
One Old Caparison Cloth
One Whip with a Tortoise Shell handle and Silver
 Ornaments to Ditto.
2. Old Whips.
1. Bridle with Silver Bosses.
1. plain Bridle. *wanting supposed to be in the wardrobe*

Things for his Grace &c.

a wattering Saddle for Rio's little horse. *Ditton*
a Small Cub with headstall and Reins to D^o. *Ditton*
a Snaffle Bridle to D^o. *Ditton*
a blue Cloth ffurniture and Gold Lace- his Graces
 found 2
a Green Cloth Saddle Cloth with a narrow
Gold Lace.
One Demi peak Saddle- for Favorite.
One Bridle with plain Bitt for Ditto.
Bleu Saddle Cloth gold Lace

Servants Furnitures
4. housings and Bags of Green Cloth & Silver Lace.
2. Ditto. very bad.
1. housing d^o. for Julia. very bad
12. new Green Cloth housing and Bags with Livery Lace
 on them. – New in 1744.
7 Old Green Cloth housings and Baggs with Livery Lace
 on them.
11 Servants Saddles – old
12. D^o ... New ... 1744 *old but 11*
a Servt^s. Saddle with a furniture to Ditto at Ditton
2. D^o. Mr. Burtons and Julias
9 Servants Bridles Compleat and 3. with the Bitts broke.
 7 Compleat
2. Old Leather water Decks to Throw over Saddles.
not in Order
1. Old housing and baggs yellow
Cloth and Silver Lace. } bad.
1. Ditto of Green Cloth and Gold Lace ... bad.
2. Ditto Green Cloth and Silver Lace ... bad
1 Ditto Blue Cloth and Narrow poor Silver lace ... bad.
One horse Cloth Fillet Cloth and Collar from M^r. Durells.
 Worn out & gone

The Inventory of Things under the Grooms care
Continued

6. horse Cloths and 6. Rollers. **found 10**

a Suit of Cloaths for Bob from the Riding house
 15th June 1747.

3 water Saddles at Blackheath – good for nothing

Two Snaffle Bridles.

Three Girths 4 yards long Each

Three Curry Combs and Brushes.

Two hard Brushes.

Two Oil Brushes.

Two water Brushes

One mane Comb. and a Sponge to Dᵒ.

~~a Sponge.~~

a Large Sponge to wash Saddles.

6. Collars.

6. Rack Reins.

a wainscot Folding Bedstead

a Rush Mattrass.

a Feather Bed

a Bolster

Three Blanketts

a Coverlett.

a wainscot Bedstead

a Rush Mattress

a Feather Bed

a Bolster.

3. Blanketts

1. Coverlet.

2. pair of Servants pistols with brass Barrells to Two
 Grooms. **found 3**

2. hangers – to Ditto **Dᵒ 3**

2. Buff Bolts to them **Dᵒ 3**

3. Turkish Bridles for his Grace. in Mr. Burtons
 Keepings} **One Turkish Bridle Sent to Mr. Spencer Febry
 17: 1747/8**

a Square Iron machine on 4. feet for Airing Rooms.
 Returned 5th Aprill 1748

Inventory of Things in the Coachems Care.

One watering Saddle.

a postillions Saddle. **Says they are at Blackheath**

Two Green Cloths to put over the horses

a Set of harness.

a postillion Coat **say tis at Blackheath**

a postillion Cap

a pair a wheel harness

a Chaise whip

a Second postilions Coat

a Second postillions cap } in 1746

The Great Coach **says tis at Mont house**

The Chariot

The Little Berlin

The Landau

The Old Double Chaise **says 'tis at Mountague house**

The one horse Chaise
 harness and 2. Saddles to Ditto

a Post Chaise
 harness and 2. Saddles to Ditto

Another post chaise
 harness and 2 Saddles to Ditto

and Old Wooden double Chaise
 without a Top.

an Old Chariot – was Mr. Marchants.

a Chaise Marine

The yellow Chaise

The ffore wheels of a Carriage upon
 an Axis

**Says they are at
Montagu House**

a wainscot Bedstead

a Canvass Straw mattrass

a Feather Bed

a Bolster.

3. Blankets

1. Coverlet

a wainscot Bedstead

a Canvass Straw mattrass

a Feather Bed

a Bolster.

3. Blankets

a Coverlet

PART II
The Drayton Inventories

Drayton House, Northamptonshire
1710 and 1724

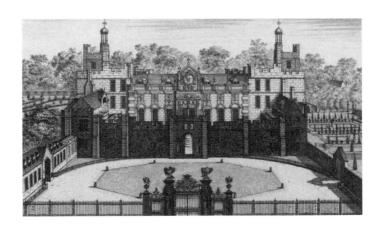

Drayton House, Northamptonshire
1710 and 1724

These inventories were drawn up at the request of Lady Elizabeth (Betty) Germaine (1680–1769). Lady Betty inherited Drayton following the death of her husband, Sir John Germaine, in 1718. He in turn had originally inherited the property from his first wife, Mary Mordaunt, Duchess of Norfolk.

The Mordaunts had owned Drayton since about 1500 and had been raised to the peerage as Earls of Peterborough in 1628. Henry Mordaunt, 2nd Earl, died in 1697, but left only the title to his male heir, his nephew Charles, and the Drayton estate to his daughter Mary. She married in 1671 Henry, Lord Arundel, who became 7th Duke of Norfolk. The marriage foundered and she subsequently formed a liaison with Sir John Germaine, a Dutchman in the train of William of Orange, and by repute William's illegitimate brother. In 1700, following a scandalous divorce from the Duke of Norfolk, Mary married Germaine, but continued to call herself Duchess and sign as 'Mary Norfolke'.

When in 1697 the Duchess and Germaine took possession of Drayton House, Charles Mordaunt as 3rd Earl of Peterborough made claims for the inheritance of the estate, bringing a sequence of cases to the Court of Chancery. These continued into the eighteenth century, and following the duchess's death in 1705, were revived against Germaine and his new wife, Lady Betty. The legal battle continued until about 1710, when the 3rd Earl finally abandoned his case. The 1710 inventory marks the acceptance of Germaine and Lady Betty as the legal owners.

The house had survived almost intact since the Duchess of Norfolk's time and reflected the refurbishment undertaken by her father, the 2nd Earl. He made significant architectural changes in the 1650s, employing the architect John Webb. Through his close involvement with James II he was able to acquire furnishings of high quality. Germaine and the duchess employed the architect William Talman and further embellished the house. They were responsible for the huge quantities of china which decorated almost every available surface.

The 1710 inventory was frequently amended and by 1724 a new version was called for. The later inventory provides evidence for alterations and improvements. Lady Betty continued to refurbish the house during the 1720s. A spending spree in France resulted in the purchase of a fine inlaid desk in the style of A. C. Boulle which is recorded as having been 'bought from the Dauphin for 100 guineas'. This may be the 'inlaid Buroo' which appears as a later addition to the Painted Parlor entry in the 1710 inventory. The 'french Paper' in the Norfolk Dressing Room is further evidence of French purchases. Lengths of French textiles of this period still exist at Drayton, including a woven fabric with rustic scenes in coloured silks and a fragment of crimson damask with a chinoiserie design. The latter may be a remnant of the various crimson damasks which are listed in the 1724 inventory. But the 1724 inventory demonstrates that the

original rooms were left largely intact although some furniture was moved and additional china acquired.

An interesting feature of the house of around 1700 was the Beaufett or Buffet Room, a space where gold or silver plate could be displayed and utensils and glasses used during a meal could be washed. A good deal is known about this room. It had two large marble niches housing marble cisterns and several marble topped tables. The ceiling and heads of the niches, as well as the ceiling in the adjoining eating parlour, were painted by the artist Gerard Lanscroon. A later inventory of 1770 lists the dimensions of the marble items, and the two cisterns as well as the marble tops still exist, the latter mounted on neo-classical frames made *c.*1790. When in 2002 an outbuilding was being cleared several panels of curved marble were found, as well as two lengths of semi-circular carved and moulded cornice, clearly from the same source. A bill in the archive at Drayton makes it clear that all this marble work was fashioned by the carver, William Woodman. The Buffet Room survived until 1789, when the space was cleared to create a new Ante-room, and sadly Lanscroon's painted decoration was swept away at the same time.

Lady Betty spent much of her later years either in London, at her home in St. James's Square or staying with her distant cousins, the Sackvilles, at Knole, where a sequence of rooms still bears her name. When she died in 1769, she left Drayton to the younger son of Lionel Sackville, Duke of Dorset, Lord George. He became Secretary of State for the Colonies shortly after inheriting, living largely in London or at Stoneland, on the Sackville estate in Sussex, and so made few changes at Drayton beyond having two rooms redecorated. On his death in 1785 the estate passed to his son Charles, who, since he outlived the male Sackville line at Knole, eventually inherited the Dorset dukedom. Charles was also very much London based, being a confidant of George IV, so he also only made a few alterations. This means that much of the furniture which is listed in these two inventories still exists and can be readily identified.

In the Drayton Archive there are two versions of both the 1710 and 1724 inventories. One version of each, clearly the earlier, is heavily altered and amended. The versions used here are the second pair, also with later amendments. In both cases the alterations reflect the changes made during Lady Betty's time, and a good many of the alterations are written in her own hand. Both are in foolscap notebooks with contemporary marbled paper covers. They belong to Charles Stopford Sackville and remain at Drayton, and are reproduced with his permission.

BRUCE BAILEY

An Inventory of Goods at Drayton made 14th Sept 1710

In my Ladys Dressing Room over Jerusalem

~~Three piece of blew and white hangings~~ 4 Peeces of
Chints Hangings a **window curtain of y^e. same**

Three sea pieces over the Door

One picture over the Chimney viz^t. Queen Mother

One intyre lookeing glass chimney piece

Two little green Sconce feet or flower potts on each side
y^e Chimney

~~Six Indian pictures with glass before them~~

Two white Chairs of white and purple Damask

One pair of **Chints** ~~white Damask~~ window Curtains bound
with redd

Three Dutch Chairs

One Stoole

One Strong water box

One little velvet box with brass hindges

One long Sweet box

One Chimney back a fire shovel and tongues

One pair of Iron Doggs

One lead coulor'd marble chimney piece

~~One little writing table~~

One flower pott on a black pedistall

One brass lock

One old table

2 low backed Elbow Chairs with Irish Stich Cushions

**In The Bedchamber next adjoyning to the aforesaid
Dressing roome**

One wrought and carved footed table and Two Stands

One large looking glass in a wallnutt tree fraime

One landskip over Each Doore

Four arm'd Chairs with wrought fraims and Silk wrought
Seats Two of them being of one Sort and Two of an
other

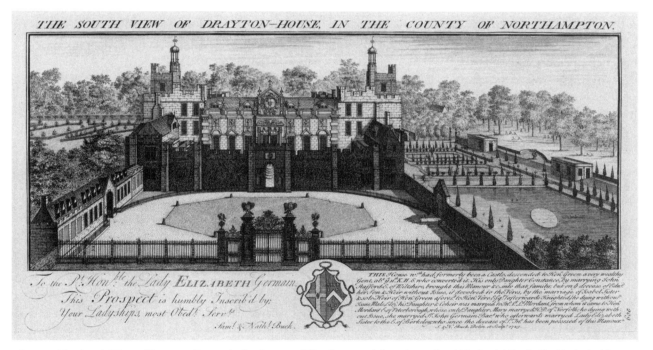

(Fig. 11) 'The South View of Drayton-House, in the County of Northampton' from Samuel and Nathaniel Buck, *Buck's Antiquities*,
1774.

Buck's 1729 view shows the Entrance Front of the house. The Gatehouse leads directly to the main entrance, in the centre of the
facade designed by William Talman in 1702. The right-hand half of the facade fronts the Great Hall.

The tower complex on the right contains the King's Dining Room (1st floor) and Upper Lodgings (2nd floor). The tall tower
contains the Great or Hanging Staircase. The dark wing in front contains Sir John's and My Lady's Bedchambers (1st) and the
Jerusalem rooms (ground), Jerusalem presumably as they are next to the Chapel, hidden behind the dark wall to the right of the
Gatehouse.

The tower complex on the left hides the Kitchen and Service Rooms. This was built as part of the Talman contract and evidence
suggests it was not completed till *c.*1715, hence why it is still called 'new' in the 1724 Inventory. The long wing on the left was Stables.
Victoria and Albert Museum

One Intyre looking glass over the Chimney

One Japan'd chest

Three black wrought Stools with Seats like the chairs

One blew imbrordered bed lined with blew gold colour'd
and white

Damask made up with white fring

Two blankets and one bolster

Two quilts to lye upon and a Callico cover lidd

Blew Silk curtains to both the windows with vallances to
ye Same

One feather bedd

~~Six green~~ 4 Silk covers for the chairs

Two blew and white basons

Six tea cupps and Saucers *6 Coffee cups with Handles* ~~a Bason~~
& cover for y^e Tea Table

One brown tea pott

One round= hand= tea=table

Pieces of tapestry hangings of the History of Diana

One brass lock and one white marble chimney piece

A Stool for coal

1 fender

1 little china Bason on y^e Tea Table

In the Drawing roome next adjoyning to the bedchamber aforesaid

One fine Indian cabinett Standing on a fine wrought and
guilded fraime

Four pieces of tapestry gold colour'd hangings with boys
& flowers

One little Indian Fire Screene

One Cain box Standing upon a redd fraime

~~Six black wrought=fraim'd elbow chairs~~

One chimney back with a pair of white Silver colour'd
lacker'd andirons

And a pair of Doggs with knobbs of the same

One pair of bellows fire shovell and tongues

One intyre looking glass over the chimney

Blew Silk curtains and vallances to y^e windows

One landskip of the hunting the Hair

One landskip over each Doore

One fine large looking glass in a black fraime

One fine marble table upon a guilded fraime

One china Jarr, Four bottles, two whereof has gold tipps,
Two blew

And Gold colour'd rullwagons, Two white, and two little
blew and

White china rullwagons all upon the Indian cabinett
& 2 Bottles

Two blew potts with covers

A blew and white china flatt pott with a Cover

Blew Silk Curtains and vallances to the windows

Six china cupps and a litte tea table

One three footed Japan'd flower pott

One white marble chimney piece

Eight walnuttTree chairs with gold wrought seats

In the 4^th: Roome which adjoyns to the Drawing roome last afores^d:

Two pieces of hangings with larg borders

One picture of the old Dutchess of Richmond over y^e
Chimney

One looking glass in a round=gold=guilt fraime carved

Six chairs with tapestry cushons

Two looking glass Sconces

One picture over each of the three Doors

One little Seader table

One carv'd table cover'd w^th: velvett

One fire Shovell and a pair of tongues

One pair of andirons lacker'd Silver colour

One three branched hearth Iron for wood fires

Two pair of white window curtains

One China Decanter with a Silver tipp or cover, Two blew
and

White bottles, Two Blew and white cruetts, 2 blew and

White Jarrs, Two china Doggs, and two China Ladys

In the 5^th: and last Roome on the Same Line with y^e 4 Last menton'd

One feather bed and one quilt

Four blanketts and a Callico coverlidd

One bolster

The Curtains and furniture for the bed of fine Colour'd
callico

Two arm'd and two plain chairs cover'd with Callico

One Callico Safoy or easy chair with a Cushion on it of ye
Same

One Fire Skreen with a guilt Fraime

2 Dutch chair .and a yellow and black velvett Easy
Chair

Four white Damask window curtains and Muslin
vallence

One fire Shovell and a pair of tongues

One pair of brass inamiled andirons

One pair of bellows

One wrought Iron back

One Marble chimney piece

One picture of my Lord Holland over the Chimney

Three pieces of hangings of tapestry

One picture of S^t: Barbara

One Stone cabinett upon a black fraime & *A Peece of Chany
under*

Two great china white and blew rullwagons

One gold and blew Jarr

Two hand tea tables

One China hansome Ink and Sand box

Three chocolatt cupps

Six chocolatt cupps and 15 other pieces of China over ye
 Chimney
1 *Guilt Table on a Black frame & 2 Stands*
1 *CloseStool in ye closet*
1 *large glass with a wrought Gilt frame*

In the Great als the Kings Dineing roome

One larg looking glass divided into 3 pieces and border'd
 ab^t:
One inlaid table
Two marble tables
Two very larg China Jarrs and Covers
Two china Candlesticks and a china bason broaken at y^e
 edg
Twelve tapestry arm'd chairs with Callico covers to y^m all
Two larg fine Indian Japan'd chists on black fraims and
Green covers to lay over them
One Marble fountaine
One pair of tables to play with
One fine Stone marble like chimney piece
One wrought Iron back
Two pair of brass inamil'd Andirons
~~One pair of iron doggs~~
Three brass locks and a brass lock on y^e Door at ye top of
 y^e Stair
Ten larg pictures of the Peterborow family
Four Lesser pictures over the Doors being Lady Elizabeth
Germains; Her Son Mr James, and Her Daughter Miss
 Bettie
Both being infants in one piece; Mrs Loyds; And an old
Piece of a Child of an Earl of Peterborough
One Eight corner'd inlaid tea table with Eight blew and
White cupps and Saucers a larg bason and a Suggar pott A
Brown tea pott
The Dutchess of Norfolks head in Aliblaster
Eight white worsted window curtains
One pair of bellows
One fine China Bason cracked Standing in a fine Guilt
 And wrought Silver case
An Indian cover for y^e Tea Table

In the Great hanging Stair case and passage below

~~Thirty five~~ **forty Two** picturs of Severall Sorts and Sizes
One Table bed one larg Table

In the yellow bed Chamber in the upper lodgings

One, *olive* 2 yealow bed of damask with a wrought
 bedstead
Curtains and vallance with Cornish of the same Damask
One feather bed One quilt one bolster and two blankets
One Callico coverlidd
~~Ten Japan'd fraim'd chairs with 6 Cushions~~ **Eight Chairs**
 like y^e bed

~~Four~~ Two of them being arm'd Chairs
~~Two Japan'd fraim'd Stools~~
Three pieces of hangings with larg borders
One large glass in a wallnutt tree fraime
One table and two Stands of wallnutt tree wood
~~One~~ 2 Dutch chairs
One fine Indian cabinett upon a black fraime
Two earthen old fashoned bottles being redd ones
Two blew and white china basons & one white bason
One bakeing pott and cover
One large picture over the chimney but cutt
A picture over each of the two doors
One Iron Stove with a wrought back
Five Shovell and tongues and two pair of Doggs
One fine Stone marble like chimney piece filled with
 ~~Three~~ 2 chocolat cups and 14 other pieces of Stone and
 Chinaware & one panther=Stone Cupps
One needle worked Cover lidd
~~Four yellow Silk window curtains and vallances~~
One bed and two blanketts in y^e Closett for footmen
2 Damask window curtains & vallence y^e same of y^e Bed
y^e pretenders picture over y^e Glass

In the Dressing roome adjoyning to y^e last aforesaid Bed chamber

~~Four~~ 2 pieces of yellow ~~paragon~~ & *red Indian silk* hangings
Six Dutch chairs with Stript Silk cushions
One marble table and Stands inlaid with y^e Peterborow
 arms
One Looking glass in a like inlaid fraime
One Marble chimney piece
Two pair of brass doggs and brass fire shovell and tongues
~~Fifteen~~ 13 picture of Several Sorts and Sizes
One brass lock
~~Four~~ Two window curtains with ~~white~~ **Black** fringe *the same*
 as y^e Hangings
One pair of bellows
[line missing that was damaged and unreadable]
A little Table with one foot
1 *Red Indian little Table*

In the Drawing roome on the Same floore and Line

Two pieces of green and white brocadell hangings
Four chairs with ye Same brocadell two of them being
 arm'd Chairs
Two pair of brass doggs and a fire Shovell and tongues
One pair of bellows and a wrought Iron back piece
One black marble chimney piece and Slabb on y^e hearth
One looking glass over the Chimney piece
One black table And a looking glass in a black fraime
Four pictures, A Brass lock, and a Steell firework lock
And a brass lock upon the Staircase doore
One pair of white window curtains

In the next roome on yᵉ Same floore over yᵉ Kings Dineing roome

One Imbrordered Indian bed A feather bed quilt and
 bolster
Two blanketts One Callico quilt bordered ~~with silk~~
Seventeen pieces of China waire over the Chimney
Three pieces of Hero and Leandra hangings one being
Cutt into two pieces
Two white Damask window curtains
One looking glass in a black fraime
One Inlaid table and a pair of Stands of the same
Four arm'd and ~~four~~ 6 other Chairs with yellow damask
Covers to Each of them
One Allibaster bason and ewer
~~Three~~ 2 pair of doggs and one wrought back
One Stone marble like Chimney piece
Four picturs
One Close Stoole in the Closett
One worked quilt to lay over yᵉ Bed
a pair of Tonges fire shovel & Belows
2 Dutch chairs

In the little Dressing roome over yᵉ new Stone Stairs

Three long Indian pictures
One Marble chimney piece and a Slabb
One looking glass over the Chimney
Three pieces of tapestry hangings
One Chest of drawers
Six Japan'd Cain'd Stools
2 Japan'd Elbow Chairs with yellow Damask covers
2 pair of Doggs
a Tea Table upon yᵉ Chest of Drawers
4 Cups & 4 Sawcers
4 Chocolate cups a Bason sugar Dish & Tea pot a Dish for it to
Stand in

In the passage Down the Steps in the Same Line

One wooden Couch with a green and white quilt or
 Cushion
Two old Dutch Chairs & A Chester drawers

In the little roome on yᵉ left hand

One A field bed of Mohaire
One ~~feather bed~~ and a mattress
One feather bed and bolster Two blanketts and
One Callico coverlid and a white Coverlid
One Dutch Chair the place hung with old Cloath

In the next Roome on the Same floore and Line

One bedstead hung with old Cloath Curtains
Old Tapestry hangings
Four Cain Chairs
One little writing table

In the Long Gallery at the top of the Great Stairs

Ten window Curtains
Six tables, three pair of Stands Two black Cabinet fraime
 and Two pair of black Stands, four Cain=
=Couches, ~~Three~~ 4 pair of Iron doggs, Two little brass
 Fire Shovells, One pair of tongues, Two white & black
 Marble Chimney pieces, and 2 Slabbs for the same
Two pair of Scollopt looking glass Sconces, Eight
 Naked Chairs, four naked Chairs with arm's,
 Six Pannells of looking glass, Sixteen picturs of
 Severall Sorts and Sizes, Three brass locks, Two Japan
 Cabinets With guilt frames, one Green blew white and
 red Jarr over ye first Doore, Two blew and white
 basons
Two rullwagons; One Tea table with Six Cupps, one
 Teapott, one blew dish, Two little Japand Dishes, one
 Stone Standish Sand box & all in a fraime, Two blew
 And white Jarrs, one rullwagon upon a Cabinett, one
 Three footed flower pott, Two red and white Japan
 Basons, Two yellow basons with Covers and ~~five~~ 6 blew
 And white China dishes, Two Deff flower potts upon
 black Pedistalls,
5 pair of Green lutestring window curtains lined with green
cheny
10 Couches of yᵉ same lutestring & 4 stools
2 Right Japan scrutores with Black Frames

In the Closett on the Right hand in yᵉ Said Gallery

It is hung with yellow Damask hangings
Two Callico window Curtains and vallance
One Japan Couch with a blew quilt and bolster
One Glass Cubord with China waire in it
Four yealow Damask chairs

In the Bedchamber on the left hand in the Said Gallery

one Holland quilt one old Silk & one worked one
One Bedstead, ~~3 Quilts,~~ One feather bed, one Bolster
A Dutch matt to lay over the floore
Five pieces of blew callico hangings & **Indian Silk**
Five caind elbow chairs
One looking glass chimney piece wᵗʰ: The Lady
 Thomonds picture over it
~~Two~~ One pair of Iron doggs
Three tea potts and Six pieces of other china
Two flower potts and an Red piece

In the Inlaid closett in the Said Gallerey

Two pieces of Crimson hangings mixt wᵗʰ: Gold
Four ~~Two~~ dutch chairs, a little pair of doggs, One marble
 Chimney piece and hearth, a china Jarr over the
 Chimney and 2 long cupps with Covers, Three pieces of

Course serge to cover the floore, ~~Three~~ 4 white Damask window curtains and one over the Doore

Four Indian picturs in the closett within w^th: glass over ym
Three wrecks survive

~~Two green damask Stools with lacker'd fraimes~~

Three Stript musling window cutains and Ivory things
… billiard table

In the first roome towards the Great Stairs in the Middle floore

One lanskipt over the chimney and one over each Doore, one Stove grate a fine Stone marble like Chimney piece, A brass lock, Three pieces of tapestry Hangings, A wallnutt table and Stands, four Clouded Silk window curtains, four doore curtains and vallances

One Indian Japan Skreene four elbow chairs Six Chairs
Three low stools with cushions y^e same as y^e window curtains

In the next roome in the same floore and Line

One lanskip over the chimney and one over each doore

A Stone marble like chimney piece, A pair Irons, One Pair of doggs, a pair of tongues, One brass lock, Six Elbow chairs of flowered velvett, One inlaid table

Two white Silk window curtains and vallance four Pieces of tapestry hangings of Diana

In the little closett within the Said Roome

One bedstead One feather bed, One Silk quillting Of Changable purple and Curtains of the same, Two Pieces of Mohair hangings with tapestry Slips between

Two blew Serge window curtains *A Ceadar Closestool*

Instead of y^e Chaingable Bed A Feild Bed with yelow Damask Curtains one Dutch Chair

One Feather Bed & Boulster one Holland quilt & one silk quilt to cover y^e Bed one Table

In the bed chamber on the same line in the midde floore

One Marble chimney piece, one hearth piece

One very fine needle work bed with Curtains vallance And bases being lined with yellow Silk and y^e bases lin'd With green bukarome, One feather bed one bolster

Three quilts, One fine Needlework'd coverlidd, Four yellow Silk window curtains and vallances

Three pieces of tapestry hangings, Eight Chairs 2 being elbow of red Velvett w^th: gold lace and blew covers for them all, Green base covers for the table and Stands, One Black Ebony Cabinett with guilt hindges or hasps and A green Cover for it, One looking glass with the Frame finely inlaid and Stands & *table* of the same, One Landskip over the Doore

A Glass over the Chimney & y^e Dutchess of Norfolks picture

Green silk covers for y^e Chairs

In the next roome on the same floore

Two Six pain'd looking glasses

Two black fraim'd cain couches with Silk quilts on y^m

A Black and white marble chimney piece with a looking=Glass over it, and a hearth piece of the same marble

A fire Shovell and tongues, Two pair of ~~tongues~~ dogs, One Iron hath=grate for wood, Four gold colour'd Persian Window Curtains, Four pieces of brocad hangings

Six pictures being flower pieces, One black tea table

2 setee chairs with chery & silver covers

6 Tea cups & 6 saucers

6 coffee cups with Handles

1 Teapott a Dish for it to Stand in

1 Sugar Dish a Bason

A cover for y^e Tea Table Indian

In the closett on the right hand of the said roome

One Glass cubord, Two lanskipts, A marble chimney piece With a looking Glass over it, One brass hearth *one pair of Dogs* to burn Wood on, a white and black marble hearth Stone

One Picture of a girl with a lamb Thirty seaven other Pictures of Severall Sorts and Sizes, Two little Indian Cabinetts on black feet, four dutch Chairs w^th: Black fraims, five pieces of Strip't Sattaine hangings

Two window curtains and vallance of the same

One brass lock to the Doore *two Stool y^e same as y^e Hangings*

1 little Black Indian Table

In the Closett and passage on the left hand

Twelve pictures of Severall Sorts and Sizes to Be Disposed of

In the Great Parlor at the foot of the brown Stairs

~~Nineteen~~ Eighteen cain chairs, One skreen, One larg marble Table, One Card table, One round Dutch table, Eight Red Serge window curtains, Nine pieces of China Waire over each doore, Twenty two pieces of China Waire over the Chimney, ~~Six~~ 8 Sconches washed with Silver Colour, Two large China Jarrs, One large flower, pott, one Fine Stone marble like Chimney piece, one tapestry fire Skreene, One larg plaine Iron grate with a brass fender And brass Andirons, a fire shovel and a pair of tongues, A Pair of Bellows, A landskip over each Doore

In the Drawing roome on the same line and Floore

Two pieces of tapestry hangings with great horses and men

Eight blew changable damask chairs, 4 whereof are
Elbow'd, ~~Nine~~ 7 pieces of China ware over one Doore
and Seaven over the other ~~four~~ 6 Handle Coffee cups, ~~and
two tea cups~~ *6 saucers one sugar Dish* With stands on one
of the two tea tables Two Indian Window curtains,
Two blew Sattain imbrordered Stools, One White
marble hearth and Chimney piece with a fine glass
Painted with Flowers above it, A landskip over Each
Doore, One larg looking glass with a fraime laid with
Silver And the table and Stands imbellished in like
manner

One blew and white Jarr upon a table, Two flower potts in
Cases, One Landskip over the Chimney, A Japand
Stand to Sett a teakittle on. *A Hand tea table*

A Cain tea table w^{th} Six old chaney blue & white tea Cups A red
tea Pot & A dish A sugar dish & A Bason, Six Silver tea
Spoons & A little Shovell Blew stuff covers for y^e chairs,
Hearth to Burn wood on 1 wrought Back 2 pair of Dogs 1 pair
of Tongs
1 Fire Shovel 1 Brush

In the Bedchamber in the last menconed floore

One Bed of Work & paine with green velvet lined with yellow
Taby
~~One olive and Lemon coloured Damask bed with Curtains~~

Bases vallance and Cornishes of the same, One white
Sattain under quilt, one white Coverlid wrought with
yellow Silk and a red Silk lining, a yellow quilted cover-
lid, One Bolster ~~Nine~~ 11 pieces of China over the Door
Six Doore Curtains *of Green Damask* ~~the same of the bed~~
and vallances Two *Green Damask* ~~white~~ Window
curtains and vallances Three hand Japan tea Tables
2 Japand baisons under the table Three pieces of Great
hors tapestry Hangings ~~yellow chairs wrought with
Gold Six Chairs two whereof Has elbows,~~ One easy
Chair and Cushion of gold Cloath And a yellow paragan
cover to it Two Dutch Chairs, One looking glass with a
Japan'd fraime with table and Stands one red Japan'd
Box with a black fraime One Indian Cabinett on a gold
+ old. Fraime, One white and black marble hearth
and Chimney Piece with a looking glass over it and a
landskip at the Topp Three other landskips over the
Doors, fire shovell Tongues Iron Andirons and Doggs
and an Iron hearth to Burn wood on, one wrought back
A large white & blew China bason upon a black foot
Two large Jarrs and Covers

An other Jarr under the Cabinett, one blew and gold Jarr

Two white and blew rullwagons, Two China Bottles,
Two Little blew and Gold rullwagons, Two flower
potts with Three feet, One little blew and white Jarr,
~~one Indian Cabinet furnished with China as aforesaid~~,
A Turkey Matt under the bed, a Brass lock to the
Doore

Two Green Damask Stools, saffoy of work & green velvet
6 Elbow chairs ye same work as y^e Bed

In the Closett on the right hand of the last mentond roome

One Cornershelf furnished with Sixty eight pieces of
China

A little Japan'd table and Two Stands, One black writing
Table with a green cover of velvett, Two glass cubords
Both locked up, One being furnished with books, and
the Other having in it An Indian Small cabinett and a
Box Three Japan hand tea tables, Three Japan Bowls
one having a Cover, ~~a red white and Green China Jarr~~
One red hand tea Table Four white Silk Cushions on
four Stoole fraim's, Two Window curtains of the same,
Ten Indian pannells of Wainscott round the roome
2 Door curtains & valence of y^e same as y^e window curtains

In the Closett one the left hand

A marble Chimney piece and Slabb A Glass over the
Chimney 2 Heads w^{ch}: M^r: Germain p^rsented S^r: John
with

The roome wainscotted ~~but hangings to nothing
being yet finished~~

Green white & red Irish stuff Hangings

& window Curtains of the Same a Table Bed fine lanskip
over y^e Chimney a picture over y^e Door 4 Dutch Chairs

In the Nursery formerly called the Chapell Chamber in Jerusalem

One livery bed lined with Stript muslin, One feather bed

One quilt Two Blanketts One Bolster, One blew
Coverlidd

One Other bed of Silk Damask one Quilt one feather bed

Two blanketts One Bolster, One quilted Callico coverlidd

One Chest of Drawers Two turkey Chairs A pair of Doggs
a fire Shovell and a pair of tongues A pair of bellows

One looking glass

In the next Roome in the same line in Jerusalem

A Stuff bed lined with yeallow and black flower'd persian
Curtains and vallance And a quilted Coverlid of the
same

Bases of the same Stuff as the bed Three blanketts Two
Quilts One feather bed and Bolster, One pillow, one
little Table, Four pieces of hangings, One Chimney
piece of The Arms of the house of Peterborow Two old
Camblett window curtains, One pair of doggs with
brass Knobbs A Chest of Drawers Two turkey Chairs

In the roome formerly the Stewards hall in Jerusalem

Four pieces of hangings

Two pictures over the Doors

One Landskip over the Chimney
A pair of Tongues
A pair of Doggs

In the inward roome called Mr Germains Bedchamber in Jerusalem

One stript fustion bed, One feather bed, One under quilt, Two blanketts, One Callico quilted Coverlidd, Two elbow'd And Three other Caine chairs, yellow paragon hangings, Two window Curtains of gray Camlett, One table, A brass Lock, A pair of Iron doggs, One chest of Drawers
One turkey chair

In Sr: John's and my Ladys Bedchamber over Jerusalem

One bed of gold colour'd tabbey imbrordered with purple and White the outside being printed Linnen, One feather bed
One quilt Three blanketts, an uper quilt of yellow Silk
One looking glass, One Chest of Drawers four elbow=Chairs One tapestry cushion Two yellow Cushions, One Dressing glass, One little writeing table, Three cain chairs
Three pictures, an Iron lock Nine pieces of Small China Waire, One hand bell, Three pieces of gold coloured black
And white hangings with Mohair between the Strip or Slipps
1 Steel Hearth a fender fire shovel & Tongues 1 pair of Doggs a Counter pane ye same of ye lining of ye Bed

In the passage over against the aforesaid Bedchamber

Twenty prints of the french Court, One Larg picture over The Doore, One Cubord with two delf foutains upon it One of the topps being lost and one of the Corks

In the closett up the steps over agt: the said Bedchamber

One brass chafing dish in a Stand
Cours callico hangings
Two Stript muslin window curtains
Two glass cubords
Five printed pictures

In Sr: Johns Dressing roome over Jerusalem

One Stove grate and fender
Fifteen Indian pictures
Nine long prints with glasses before them Two whereof are Cracked
~~Three French pictures~~
One head

One Cornershelf ~~wth Fine China baisons on it~~
One Scrutore and Two chist of drawers
~~two~~ little cabinetts and four cain chairs
One Close stoole A box naild up suposed to be things in it For the Necessary house
One box with bolts
A brass warming pann

In the land Stewards apartment in the old Gate house

In the Kitchen

Four wooden chairs and two others
A table A pair of old iron doggs
An old pair of tongues A lock with out a Key

In the roome over agt: ye sd Kitchen

Two tables One Dresser Nine Shelves A hors
A Stone and Stoole for a Cheese press
An Iron lock and Key

In the bedchamber

Two tables five chairs A Serge bed and Curtains Lined with Callico feather bed quilt four blankets
four Cloath window Curtains A bolster and pillow
A Callico quilt Kittermaster hanging an Iron
Back A lock and Key to the roome or a lock and Key to the Closett wherein there is one Stoole And three Shelves

In the next roome

A Stipt Stuff bed Callico quilt and bolster
Kittermaster hanging

In the next roome

A bed and bolster two blanketts a rugg
A press with a lock and Key A lock and Key to the Stair foot Door

In the passage under the Stone Stairs by the Hall

One Large Table

In the out house comonly called the Inn In Mr Goffs roome

Two ruggs Three blankets a bed and bolster a quilt
A bedstead Curtains vallance Three chairs a Table
Three Stools Three formes

In the next roome called Joshua's roome

A feather bed two bolsters three blanketts and a rugg
Curtain and Vallance A table four chairs a long forme And a Short one One old trunk

In the lower roome

A table Some part of a bed stead a long forme or Couch

In Bethelham als Bedlam
In the Gardiners roome or bedchamber

A red Cloath bed with Curtains Counterpain
featherbed bolster Two blankets five Chairs two stools a
 table and a Chest of Drawers

In the next roome

Part of a bedstead a box in yᵉ Closett a table
An old press a table frame a bedstead

Below Stairs

A Chest of drawers a Chair and Stoole
A Dresser and hanging shelf

In the Great Hall itself

One larg marble table on a wallnutt tree fraime
Twelve Cain chairs without and two with Arm's with
 black Leather'd Cushions on them all
One reading desk, One Clock
Six laquer'd Sconsh's Six brass locks
A Grate fender fireshovell and tongues and poker
A fine large white marble chimney piece with black
 veins
Thirteen picturs viz: King Williams the Duke of Norfolks,
 My Lord Dursleys, Prince Eugens, Duke of Savoys,
 Duke of Marlborow's, the black prince, King Henry the
 Seaventh's, King Henry the Eights, King Charles The
 first's, Lord Shrewsbureys, The Elector of Bavaria's
 And Prince George of Denmarks

In ye Room next Adjoyning to yᵉ Great Hall

Four peices of Tapestry Hangings Three pictures
One pair of Brass Andiorns a coper scolop shell For yᵉ Back of yᵉ
 Chimney 16 Turkey work chairs

In the Beaufett Roome adioyning to the Great Hall

Four tables
A marble table for the beaufett
Two Marble nieches
Two Marble Cesterns with marble faced plints
The topp of the Roome the topp of the Neeches and the
 Beaufett painted by Mʳ Lanscroone

In the painted Parlor or Dineing roome adioyning

One Grate with a wrought back, a fire shovell and A pair
 of tongues, A fender and a pair of bellows,
~~Eleven~~ ten Cain chairs ~~One Dutch Chair~~
One Marble table on a wallnutt fraime and a larg looking
 Glass over it

A marble Chimney piece and Slabb with a glass over it
 And a picture over the glass
An inlaid writeing table with a glass over it
Six wooden Sconses with brass Socketts
Four window curtains worked and bordered wth: Callico
A lock to the Closett Doore **an Inlaid Buroo**

In ye Eating Parlour

1 Dozen of Wallnutt Tree Chairs with a Red & white lace
 Bottoms

In the Stewards Hall

Six cain chairs and three turkey work chairs; Two
 pictures
An Ovall table, an other Small table, 2 Iron doggs
A Iron lock with brass knobbs

In the roomes in the passage at the top of the red Stairs Towards the front in the new Buildings

Two blanketts in the roome on the left hand up the
 steps
One feather bed, One bolster, One quilt, a bass mattress
One Bedstead with ordinary Camblett Curtains, one
 Table, ~~one old Chest of Drawers~~
An elbow Cain Chair And one other Chair One rugg

In the next roome

One blew and white bed, One rugg 2 Blanketts, one
 Feather bed One bolster, a bass mattress, an old table
 And an old Chair

In the next roome on the same floore

One bed with red and white Curtains, One rugg,
 2 Blanketts
One feather bed, One bolster, One Chair, an old Chist of
 Drawers, A bass mattress Two Cain chairs

In the apartment over the Counting roome and beaufett roome

Two pieces of gult leather hangings in the Antychamber
Eight green damask Chairs, One pair of white paragon
 Window curtains with vallances **A table bed**

In the bedchamber over the painted parlor formerly Called the Counting roome

One bedstead, one feather bed, One quilt, one bolster
Three blanketts, one green and gold coloured Silk quilt
One under quilt, the bed of green brocadell lined with
 Changable Silk, one looking glass over the Chimney
Four elbow Chairs of green damask, Two window=
 =Curtains of red paragon, one Chest of Drawers, one
 Table, one Stand, Thirteen dutch painted pieces, one
 Dutch Chair, a fire Shovell and a pair of tongues, A pair

of wrought brass andirons, a pair of doggs, a pair of Bellows, a hearth brush, a brass lock a Close Stoole

In the Spangle Roome over ag^t: the aforesaid bedchamber

Dark Cloath hangings with Spangles, the bed of the Same

One under quilt one feather bed, Three blanketts, one Coverpain of Stript Silk, One bolster, four Spangle elbow chairs, four Stools of the same as the bed, four Chairs of the same Without arm's, one Chest of Drawers, One looking glass wth: A black fraime A table and two Spangle Carpetts, Two Guilt hanging shelves, One table bed, One pair of andirons

One wrought back and a hearth, One large Indian skreen

~~Two Stone Baisons one Broke~~

1 pair of Dogs & fire Shovel & Tonges

1 pair of paragon *Window Curtains*

In the wardroble in the passage up the red Stairs

Seven quilts to lye upon, five Dutch pieces and two Other pictures, a black looking glass fraime, Eighteen Wood Sconses with brass Sockets, Six wooden Carved Candlesticks, ~~two blew damask Stools~~

In the roome at the farther End of the aforesaid Passage

Four window curtains of yeallow and red Indian Callico

The bed of the same callico lined with white dimothy

Five pieces of tapestry hangings with Sea fish borders

Two pictures One feather bed One quilt and blankett

One bolster Six elbow cain chairs, A marble Chimney Piece One table bed One old chest of Drawers

One Dressing glass One cain chair without arm's One Closestoole in the Closett 2 *Pair of Iron Dogs*

A calico quilt with a Stiched border

In the landry

Three horses without lines, four tables, two presses to ye Linnen a press to putt linnen in One grate a fire shovell

tongues an old Iron Stovegrate to be sett up, a forme

Hair lines enough four great flasketts One lesser one

Nine flatt Irons 2 Box Irons 3 Grates to Sett Irons

In the roome on the left hand Down the Landry Steps

A field bedstead a rugg 2 Blanketts a Bolster a Chest of Drawers a Dutch Chair

In the roome over the last mentoned

One ordinary bedstead, a featherbed a bolster an an old trunk

In the banketing house

Twenty three pieces of Chinaware in the first there is

Five pieces of hangings four Cain couches, Two Chests of Drawers, 2 Guilt fraim'd wrought looking glasses

Two Marble heads One picture, One Landskip Two window Curtains of Crimson persian

In the bedchamber

One bedstead One Cain couch with a head to it, four pieces of hangings, A Stove grate and fender One Stone marble=Like Chimney piece and hearth Stone, Three picturs

The Mantlepiece filled with the above menconed China ware

A looking glass with an inlaid fraime a table of the same

Four white and red Sattin chairs a white Sattin Cushion For a Couch, Three pillows Callico curtain vallance and bases

Lined with white Indian Sattain Stain'd, 2 Crimson persian Window Curtains

[The following entries were added *c*.1720.]

In the Room before y^e Maids room

One Chester drawers two Great Boxes & A Press

the Maids room

Two Beds two Blankets A featherbed A quilt a rug on the other 2 Blankets A fetherbed A rug

Susanas room y^e Housekeeper

A Coloured Linnen bed & Hangings, window Curtains of Green stuff, two Cain Chairs 2 leather Chairs A Chester drawers

A Table A Press A trunk two Wallnut tree Chests & one other

In y^e Cooks room

A Stuff bed & three old Chairs

In the Land Stewards room

A Green & white druget bed & Hangings & Counterpin

Three Blankets A featherbed & Bolster 2 Chairs A writing desk A Little Box A table A Closet wth Shelves

In y^e Porters Lodge

A bed A table & forms

Valet de Chambers room

An old Camlet Bed 2 Blankets A rug A featherbed Bolster & Pillow A Good trunk A Chester drawers

Stewards room

A Stuf bed A featherbed 3 Blankets A Rug & bolster & matres two Chairs & table

In the Wash House

three tubs upon feet four wth out A Buckin tub
A Horse A Cheese Press A dreser & two forms A triviot

In the Milk House

A tub two Milk Pails it Leaden Cistern upon A wooden table
 some Milk Pans

Kitchen Pewter

two Pewter dishes two foot wide Each Dish
one Pewter dish 22 Inches
2 Pewter dishes being 16½ Inches
1 Pewter Dish 15 Inches
2 dishes 12 Inches Each
1 Masarine 14 Inches ¾
1 Masarine 13 Inches ¼
1 Venison Plate 24 Inches & ½
1 Venison Plate 23 Inches
1 flat Calender Plate 13 Inches
1 Pewter Bason 10 Inches wth in the rim
6 Pewter Covers to dishes
One Pewter dish 22 Inches over
2 dishes 16 Inches & ½ Each
one Masarine 14 Inches
3 dishes 15 Inches & ½
4 dishes 12 Inches Each
1 Soop dish near 18 Inches
1 dish 15 Inches & half
7 dousen of Plates
1 Pewter salt Seller & A rim for Plates
3 Pewter flagons
2 frying Pans Iron & an Amlet Pan 2 Grid Irons 2 drying Pans
 2 beefe Spits 4 others 4 Lark spits 2 new Chafing dishes, old
 one
 2 Beefe forks 2 Mincing knifes & a Clever
A tin Apple roaster
A driping Pan for A Grid Iron
A trevot for a dryping Pan
4 trevots for Stoves & Stove chovell

Copper

2 Large Copper Boat Pans wth Covers
A Large stew Pan & A small one
2 Culenders
3 flat sawce Pans
1 small upright Sawce Pan
1 Large Copper fish kettle
1 Coffee Pot
1 Chocolate Pot
1 fish Plate
1 heart Patty Pan
1 Copper Pot & Cover to it

Brass

one Brass stew Pan 2 Patty Pans 3 flat sawce Pans
2 old flat sawce Pans 6 small deep sawce Pans
2 Small Patty Pans 3 Skimers 3 Soop Laddles
2 Small Laddles 2 Graters
1 Basting Ladle, Large Pot wth A Cover to it
A boyler wth A Copper Cover to it
1 Large deep sawce wth A Cover to it
1 Drudging box 3 Small Pots & but 2 Covers
1 Small Skillet wth 3 legs to it
1 Baking Cover, A brass dish kettle
1 small frying Pan
3 Large Bras Kettles
A deep bras stew Pan
A bras Peper Box
2 Rolling Pins
2 Marble Mortars & two Bras ones 2 tea Kettles

All thees lookt over by E Germain 5 October 1711

A large Copper Patty pann which was forgott to bee Sett Down in
 ye Last inventory

[The following is written on the inside front cover page of
the inventory]

Things brought to Drayton 1722
4 Dressing Glasses with Drawer 2 without
in y^e House 1 before 2 Japan Dressing glasses & 2 large ones with
 Black frame
2 pair of y^e finest Blankits 1722
1 pair of Middle Blankits 1722
5 pair of Servants Blankits 1722
3 pair of Middle Blankits 1723
3 pair of Servants Blankits 1723

An Inventory of Household Goods at Drayton made 22th July 1724.
the best Rooms Look'd over 1738

Nº. 1 In the Bedchamber in the long Gallery

1 Bed compleat of blew & yellow and red chince lined with white sattin

the Room hung wth the same as the Bed

four chairs of the same chince & two stools

5 Elbow cane chairs wth: Irish stitch cushions

1 paire of window curtains *of the same chince* and 1 pair of Door curtains

valence of chince wth both sides alike

a chimney-glass wth the Lady Thomond's picture over it

7 pieces of china over the chimney wth some broken red ware

1 paire of Iron Dogs, and a Back in the chimney

a Dutch matt to lay over the floor

Nº. 2 In the Dressing Room on the right hand of ye same gallery

4 yellow Damask chaires and the Room hung wth ye same Damask

1 Jappan couch with a blew quilt and Bolster

1 glass cupboard with china ware in it

1 paire of stript muslin window curtains & valons of the same

Nº. 3 In the inlaid closet in the same Gallery

2 pieces of crimson Damask hangings paned wth gold stuff

4 Dutch chairs, and a little paire of Iron Dogs

2 large china jarrs wth 4 pieces of other china

37 Indian pictures, 4 large pictures of fish and fowl and two of them covered with glasses

5 white Damask window curtains wth a Door curtain of Ditto

1 little red indian writing table

a piece of green Bays to cover the floor

Looking Glass at the top of the Closet

Nº. 4 In the Gallery

5 paire of green lutstring window curtains and valens lined with green stuff

10 couches and 4 Stools covered wth the Same lutstring

6 inlaid wallnut tree tables

3 paire of wallnut tree Stands

2 paire of black Stands

2 paire of black sconces one of them wth. ye sockett broke

6 pannels of looking glass

17 pictures of several Sorts and Sizes

2 Marble chimney pieces and Slabs

4 paire of Dogs and one paire of tongs

2 brass fire shovles, and one paire of Bellows

2 Fine indian cabinets upon black frames with leather covers to them

2 fine indian cabinets upon gilt black frames with 13 pieces of fine old china & a large jarr upon each of them

5 large china Dishes upon the tables & 1 little china Dish

2 Delph flower potts upon pedistalls

1 inlaid Tea-table wth. 6 blew & white cups and a red Tea-pott wth. a blew and white china old Dish to set it upon

1 paire of black jappan porringers wth. 2 salvers of Ditto

1 Stone Standish for writing

2 old blew and white china Basons

1 large coloured jarr

2 very fine Japan Trunks upon Gilt frames

Nº. 5 In the Bedchamber in the upper Floor formerly called the Dutchess of Norfolk's

a Bed compleat & window curtains & valons of olive & lemon coloured Damask

2 Elbow chairs and 6 other chaires of the Same Damask

1 yellow indian silk **quilt** workt with white

3 pieces of Tapestry hanings with large borders

1 glass in a wallnut tree Frame

1 table and Stand of the same

4 pictures

1 fine indian cabinet upon a black carved frame wth. 11 pieces of fine old china & a large jarr upon it

a marble chimney *piece* and Slab wth. 13 pieces of china, and an Iron herth and back

1 paire of Dogs, 1 paire of tongs a fire shovle with 1 paire of Bellows all tipt with brass

Nº. 6 In the Dressing Room belonging to ye same apartment

1 wallnut tree table-Bedstead

1 chest of Drawrs inlaid of the same

4 Dutch chairs with stript cushions *covered with Blew silk*

4 cushions pictures

4 pieces of Hangings of stript silk with *french Paper*

2 window curtains & valons of ditto lined wth white *Blew silk*

1 large glass a black painted paste frame

1 Dressing table

a marble chimney piece and Slab

2 paire of copper Dogs wth. tongs & fire shovle of ditto

2 Stools cover'd ye same at the chairs

Nº. 7 In the Antichamb[r]. belonging to the same apartment

4 pictures
a square glass over the chimney
2 pieces of Hangings of green and white Brockodel
2 Elbow chairs & 2 others of the same at the Hangings
4 Irish stich Cushions to 2 Cane Chairs
~~2 Elbow chairs & 1 other of black & yellow flowred silk~~
1 black painted paste Table upon a black frame
1 glass over the table in a black wooden frame
2 paire of copper Dogs a fire Shovle and tongs of Ditto
a black marble chimney piece and Slab
a plain writing table, an Iron back

Nº. 8 In the Dutchess of Dorset's appartment in the bedchamber

a bed compleat of white embroidered indian sattin lined wth blew silk
a white Sattin embroidered indian Silk quilt
1 p[r]. of white Damask wind: curtains & valons lined wth white
4 black Elbow chaires and 4 others with the seats and backs of blew and white & gold coloured Silk
3 pieces of Hero and Leander Hangings, 1 being cut
1 loocking glass in a black frame
1 ~~inlaid table~~ *a Pigeon wood table* and 2 stands of the same
17 pieces of fine china over the chimney
4 pictures
2 paire of Iron Dogs, wth. a fire shovle and tongs of Ditto
an Iron back in the chimney
2 Dutch chaires

Nº. 9 In the Dressing Room belonging to y[e] same appartment

3 pieces of Tapestry Hangings 3 pictures
1 paire of blew Damask window curtains and valens
1 Dressing table, and chest of Drawrs
1 fine indian Tea-table with 8 coloured china cups & 4 saucers, a sugar dish, a plate & cover, a small china bason and a red Tea-pott
2 paire of Iron Dogs with fire shovle and tongs and 1 paire of bellows
a marble chimney piece and slab, wth a glass over it

Nº. 10 In the passage down the steps in the same line

1 wooden couch wth a green stuff cusheon & bolster

Nº. 11 In the little Room on the left hand of the passage

a Mohaire field bed
the Room Hung with old cloth
a little black old table

Nº. 12 In the next Room upon the same floor

1 old cloth bed
1 chest of Drawrs
the Room Hung wth old Tapestry
1 calico quilt upon the bed
a fire shovle and Tongs
3 old cane chaires

Nº. 13 In the working Room upon the same floor

Nº. 14 In the first Room next the Staires in the middle floor

3 pieces of fine Tapestry Hangings
3 pictures
1 large 4 pane loocking glass in a glass frame one of the panes being broke
1 inlaid table and 2 stands Ditto
2 paire of window curtains, and 2 paire of Door curtains and valens of clouded silk
13 cusheons of the same silk
7 Elbow and 6 other cane chairs with black frames
1 fine Six leafed indian skreen
an old fashion Iron Stove & fender and Shovle
a marble like chimney piece and Slab

Nº. 15 In the second Room upon the same floor

4 pieces of Diana Tapestry Hangings
3 pictures
1 inlaid table wth. a large glass in a wallnut tree frame over it
6 figured velvet elbow chairs
2 cherry and silver sattée chairs
1 paire of green lutstring window curtains and valens lined with green stuff
a Marble like chimney piece and Slab
2 paire of Iron Dogs
1 paire of Bellows and tongs
1 larg Walnuttree Cabinet upon a Walnuttree Frame

Nº. 16 In the closet within the same room

a yellow Damask field bed wth an old silk quilt
2 Dutch chairs and a little table
2 pieces of old mohair Hangings paned wth Irish Stitch
1 paire of old window curtains

Nº. 17 In the Bedchamb[r]. upon the same floor & line

3 pieces of fine Tapestry hangings
1 fine Bed compleat workt wth. shades of yellow and lined with yellow silk
1 fine quilt & 4 pillows workt wth. coloured silks and gold
2 Elbow & 6 other chairs of red velvet and gold lace

2 paire of ~~green~~ *yellow* lustring wind: curtains and valens lined with ~~green~~ *yellow* stuff

1 black ebony cabinet with gilt hinges

1 large glass in an inlaid frame

1 inlaid table and 2 stands of Ditto

3 pictures

a marble chimney piece and slab w^th. a glass over it and a picture in the chimney

green bays to cover table, stands, and cabinet and green lutstring cases for the chairs

N^o. 18 In the dressing Room upon the same floor & line

2 Six paned loocking glasses

1 whole glass over the chimney

4 pieces of green, white, red, & yellow broccodel hangings

5 cane couches & 2 elbow chaires w^th. cusheons of the same as the hangings

3 white Damask window Curtains

~~4 gold colour persian wind: curtains and valens~~

6 pieces of Flowers

1 Dressing table

a jappan Tea- Table w^th. 6 blew, white, & brown china cups & saucers & sug^r. Dish of the same

6 Blew and white coffee cups

1 Blew and white Slop bason

1 Blew Dish for the Tea-pott to stand in

an indian cover for the table

an Iron herth

4 Dogs a fire shovle and tongs w^th. brass knobs

a marble chimney piece and slab

N^o. 19 In the closet on the right hand upon the same floor

5 pieces of ~~... Sattin~~ *white crimson stripd velvet* Hangings w^th. wind: curtains & valons of Ditto

~~4 jappan chairs, and 2 stools w^th. cusheons of y^e same as y^e hanging~~

4 Mahogany Dresing chairs w^th crimson & white lace bottoms

2 Small indian cabinets upon black frames

1 fine indian table

a brass Herth and a paire of Dogs

a marble chimney piece, and slab w^th a glass over it

a glass cupbord with 6 panes of glass

N^o. 20 In the closet on the left hand of the same floor

5 chests to put up the furniture

N^o. 21 In the Kings Dining-Room

1 large glass in 3 panes w^th. glass borders

1 inlaid table, and 1 marble table

2 large china Jarrs w^th. covers to them

2 china candle-sticks, & 1 Ditto brok at the edge

1 large china bason broke set in silver gilt w^th. a case to it

12 workt Elbow chaires w^th. calico covers to them

2 very fine large jappaned indian chests w^th. green covers to them

1 marble ~~fountain~~ *Cestern*

1 paire of back-Gamon tables

2 paire of brass enameled Andirons w^th. fire shovle & tongs Ditto

an Iron back

10 whole length pictures and 4 half lengths over the Doors

1 Eight cornered Tea- table with 8 blew and white Tea-cups and saucers

1 large Bason and a brown Tea- pott

an indian cover the table

the Dutchess of Norfolk's head in alablaster *on a marble Pedestal*

8 white silk window curtains lined w^th. white stuff

a fine Book of the Mordannt family

N^o. 22 In the King's bed-chamber

1 fine chince Bed compleat

4 chares and a Settee of the same

1 fine indian needle-work quilt

2 Dutch chaires

1 yellow and black velvet chaire

2 paire of white Damask window curtains & valens

1 paire of Brass enameled Andirons w^th. fire shovle & tongs of D^o.

an Iron Back and a paire Bellows

a Marble chimney piece and Slab w^th. the Lord Holland's picture over the chimney

3 pieces of Tapestry Hangings

1 picture of S^t. Barbarah over the Door

1 Bugle fire-skreen in a gilt frame & 1 fine inlaid stone cabinet w^th. 1 blew and gold jarr and 2 blew and white Rullwagons upon it

1 Oval loocking glass in a carved gilt frame

2 Stands and a table of the same

2 Hand Tea- bords one of them w^th. 3 coffee cups, and the other w^th. a china Standish & a sand box upon it

6 chocolate cups & fifteen other pieces of china upon the chimney peice

N^o. 23 In the Antichamber adjoyning on the same flore

2 pieces of Tapestry Hangings *forest work*

1 large picture of the Dutchess of Richmond over y^e chimney

3 pictures over the Doors

6 cane chaires w^th. .workt cusheons

2 green lutstring wind. curtains & valens lined w^th. green Stuff

1 oval loocking glass in a gilt frame

1 wallnut tree card table coverd w^th green velvet

a marble chimney piece and Slab w^th. 11 pieces of china upon it

2 paire of Dogs silver gilt w^th. Shovle & tongs Ditto

An Iron Back

2 glass sconces one of them broke

1 little cedar table

N^o. 24 In the Drawing Room on the same floor

4 pieces of fine Tapestry Hangings

1 fine indian cabinet with 2 blew and gold Rullwagons, & 1 blew and white jarr, w^th 12 pieces of fine china of several sorts upon it

1 fine indian Trunk upon a frame

1 fine marble Table upon a gilt fraime w^th.

2 blew & gold basons w^th. covers, & 1 blew & white bason upon it & a large square loocking glass in a black frame over it

2 Blew lutstring wind: curtains & valens lined w^th. blew stuff

a marble chimneypiece and slab, w^th. a glass over it

2 paire of Andirons lacquered w^th fire shovle & tongs of Ditto

an Iron Back

8 fine wallnut tree chaires w^th. gold workt seats

3 pictures

1 indian fire skreen

a Little India Jewel box with flowers in it that Augustus Earl of Berkeley gave me it had been my Grandmother Berkeleys

N^o. 25 In my Lady's Bedchamber

a fine needlework Bed compleat lined w^th. yellow flowered Damask w^th a counterpane of Ditto

4 Black Elbow chaires w^th. Seats and backs of Ditto

3 pieces of fine Tapestry Hangings

1 fine carved table and 2 Stands of the same

a large glass in a wallnut tree frame over y^e Table with 2 blew and white flowre pots upon it

1 little jappan Tea table with

6 blew & white and brown Tea cups & 6 saucers of Ditto

a silk cover for the table

a marble chimney & Slab w^th. a glass over it

a Stove grate w^th. fire shovle and Tongs

1 little indian cane Trunk upon a red frame

3 pictures

2 blew lutstring wind. curtains & valens lined w^th. blew stuff

1 pillow with a fine chince cover for the Dog

N^o. 26 In my Lady's Dressing Room

4 pieces of *green CaVoy* ~~indian hangings in black frames~~ *and one small slip of it*

a Marble chimney piece and Slab w^th. a glass over it

1 paire of Andirons w^th. fire shovle and Tongs

1 paire of bellows all tipt w^th. brass

an Iron back

4 pictures

~~2 pieces of Nun's work covered w^th glass~~

1 Dressing table

1 little Square ~~ender~~ *flap* table

~~2 cane chaires & 1 Dutch chaire~~ *two Dutch chairs*

~~1 square stool of Irish Stitch~~

2 Round workt Stools in the water closet

2 long Trunks **Lin'd with Sweets**

2 ~~Strong~~ Boxes one of them for strong waters

~~1 black stand with a blew & White flowre pot upon it~~

1 indian Basket for clothes

wind. curtains and valens ~~ye same as the hangings~~ *of white* ~~Damask~~ *Indian taffety*

4 Guilt fram'd stools w^th Green Caffoy Seats

N^o. 27 In the water closet

2 glass cupbords

5 prints in black frames

little shelves fastened to the wall

the closet hung w^th. Red & white calico

N^o. 28 In S^r. John's bed-chamber

a fine chince bed compleat lined w^th. yellow workt taby

a counterpane of the same

3 pieces of workt taby hangings paned w^th. hair coloured mohair

1 paire of chince wind. curtains & valens lined w^th. yellow stuff

1 chest of Drawrs w^th. a glass over it

3 pictures

2 black Elbow chaires covered w^th. blew & white flowred Silk

2 cane chaires one of them an Elbow chaire

2 Dressing tables

1 Black Trunk to put the carved Dressing boxes in a marble chimney piece & slab with 10 pieces of china upon of several sorts

a Herth to burn wood

1 paire of Dogs

a fire shovle, Tongs and fender & an Iron back

1 Dutch chaire

N^o. 29 In the chappel-room

13 Indian pictures

4 other Square pictures

2 little ones over the Door

6 other pictures 5 covered with glass, ~~5 of ym wth ye glass-es broke~~

1 scriptore

1 cupbord
1 old cedar table
1 little square table with ledges to it
1 great box for the chappel books
8 cane chaires
in yᵉ closet a speaking Trumpet

Nᵒ. 30 Upon the Brown Staire-case

29 pictures
1 square glass sconce

In the Lobby at the Staire's foot

3 cane couches
1 table Bedstead
7 cane chaires
13 pictures of several sorts

Nᵒ. 31 In the brown parlour

4 paire of crimson Damask window curtains and valens
 line with crimson stuff
18 wallnut tree chaires, wᵗʰ. seats of the same Damask
1 fine 6 leafed indian skreen
1 workt fire skreen in a black frame
1 inlaid wallnut tree card table
2 pictures over the Doors with 9 pieces of fine china over
 each door
2 blew and white great china jarrs
1 blew and white china flower pot
1 large marble like chimney piece and slab with 22 pieces
 of fine china upon it
1 large marble like sidebord table upon a wallnut tree
 frame with 1 great blew and white punch bowl upon it
1 old Iron grate
2 paire of brass Dogs & fender with a fire shovle and
 Tongs of the same

Nᵒ. 32 In the drawing room on yᵉ same floor & line

2 pieces of fine Tapestry hangings
2 paire of crimson Damask window curtains and valens
 lined wᵗʰ. crimson stuff
8 chaires, and 2 of them elbow chaires covered wᵗʰ. Ditto
 damᵏ
2 Square Stools covered with the same Damask
a marble chimney piece and slab wᵗʰ. a painted loocking
 glass over it, & a paire of glass sconces
an Iron herth and back & 2 paire of Dogs
a fire Shovle and Tongs
4 pictures
7 pieces of china over the Door
1 large loocking glass in a glass frame garnished with
 silver, & a table, & 2 stands garnished ditto
1 Small jappan box
2 china flower potts in cases

1 cane tea table with 6 blew and white old china tea cups
 and saucers and 1 Dish for the teapot to Stand in, wᵗʰ. a
 Slop bason
1 sugar Dish of old china & a red tea pot
an indian cover for the table
1 jappan Stand for the tea kettle
1 hand tea bord
1 fine india coffee table with 6 handle cups and saucers, &
 a sugʳ· Dish, all old china
an indian cover for the table

Nᵒ. 33 In the Bedchambʳ. on the same floore & line

4 pieces of fine Tapestry hangings
a fine workt Bed compleat paned with green velvet and
 lined wᵗʰ. yellow taby wᵗʰ. a counterpane of the same
6 Elbow chaires and a Settee of the same as the Bed
2 window curtains and valens, and 2 stools of green
 Damask
1 very fine jappan cabinet upon a gilt frame
2 large china jarrs & covers, & 1 little jarr
12 pieces of fine china upon the cabinet and 11 pieces of
 china over the door
1 fine jappan Trunk, wᵗʰ a table and 2 Stands of the same,
 & a glass in a frame of Ditto
4 pictures
a marble chimney piece and a Slab, wᵗʰ. a glass over it
an Iron herth and back
2 paire of Dogs, wᵗʰ fire shovle, & Tongs & a pʳ. of
 bellows
1 easy chaire of blew and gold velvet

Nᵒ. 34 In the closet on the right hand of the same floor

1 corner Shelfe with 66 pieces of fine china upon it
1 paire of window curtains and a door curtains and valens
 of flowred indian silk
4 Stools of the same with calico covers to them
2 glass cupbords with books in them
10 pannels of jappan indian wainscot round the closet
1 Small jappan trunk upon a frame *in the middle floor closet*
1 Small jappan table and 2 stands
1 black card table covered wᵗʰ. green velvet

The white Tea pot on the third Shelf has a Gilt Spout
*The Mug on the Fifth Shelf has a Gilt Trim to the cover, & so
 has the Milk jug on the Sixth Shelf*
*The Number of peices of China as they Stood in the Closet in the
 Brown Floor upon the Shelves in the Corner the Year 1740,
 being 8 Shelves*
*First Shelf, One Blue Peice Two Coloured Beakers, 2 Blue & wht
 Bottles a White Sugar Dish & Stand, 2 Small Blue & Wht
 Pieces with Covers*

Second Shelf one blue Piece 2 Coloured babies 2 Blue & wht
 Beakers, a Rice Tea Pot, a Mustard Pot, two Saffron Pots, & 2
 Small Blue & wht Bottles
3rd Shelf one Blue piece, 2 Blue & wht Beakers, a wht Tea Pot,
 2 Blue & wht Cups 2 Salt Sellars Brown & Buf.
4th. Shelf One Blue Piece, 2 Ewers Blue & wht, one fine Blue &
 wht Bason 2 Small Coloured Cups, 2 Green Parrots
5th. Shelf One pretty large Blue & Wht Mug with a Cover, 2
 Small Blue & wht Jarrs, 2 Blue & wht Cups upon them, one
 Small wht Cup
6th. Shelf, a Blue & wht Milk Jugg with a Cover, 2 Small Blue &
 wht Bottles Two Blue & wht Cups, one Besty Sugar Dish Blue
 & white
7th. Shelf a Blue & wht Tea pot 2 Small long Blue & wht Bottles
 one Small Coloured Cup
8th. a Large Blue & Wht Mug, Two Blue & wht Cups Shaped
 like a Drinking Glass a Blue & Wht Salt Sellar

No. 35 In the closet on the left hand of the same floor and line

3 pieces of hangings and 2 paire of window curtains and
 valens of green, white, and red Irish stuff
2 pictures
a Marble chimney piece and slab, wth. a glass over it
2 very fine heads
1 table bedstead
1 inlaid wallnut tree table
6 Dutch chaires
1 wainscot close stool

In the passage by the pantry Door

2 Cane couches
2 glass sconces

No. 36 In the great Hall

7 whole length pictures
6 pictures over the Doors
16 cane chaires wth 14 leather cusheons
4 glass sconces
1 large marble table upon a wallnut tree frame
a fine marble chimney piece and slab
a large Stove grate and fender wth. fire shovle tongs &
 poker
1 large clock

No. 37 In the Billiard room

4 pieces of Tapestry Hangings
16 Turkey work chairs
3 pictures
a Billiard table compleat
a map of the park and gardens
an indian umbrella

a copper Scollopt Shell in the chimney
a paire of brass andirons with a fire shovle and tongs

No. 38 In the boffett room

3 marble tables wth. wallnut tree frames
2 marble neeches with 2 marble cisterns in them

No. 39 In the green Drawing Room on the right hand

9 pictures of several Sorts
2 large peer glasses in glass frames
1 large french Beaurow wth. a leather case
2 paire of crimson mohare window curtains and valens
8 wallnut tree chaires wth. ye seats of ye same as the
 curtains
1 couch with 3 pillows and a cusheon of the same
 mohaire
2 inlaid writing tables
1 weather glass
1 Small inlaid celler for Bottles
a marble chimney piece & slab wth. a glass over it
a grate & fender, wth. fire shovle, tongs and poker
a brush and a paire of Bellows
6 wooden Arms wth. brass sockets about the glasses
a very large Turkey carpet to cover the floor
1 Indian Tea Table Box upon a Black Frame

No. 40 In the Dining on the left hand

12 wallnut tree chaires wth. girting bottoms
1 large oval wainscot table and 1 of a smaller size
2 paire of white Stichd window curtains bordered wth. red
 and white callico
an Iron harth and back wth. fire Shovle Tongs & a pr. of
 bellows
a marble chimney piece and slab
1 large carpet to dine upon
3 Pictures

In the narrow passage by the great Hall Door

3 Ombre tables and 2 Square tables
1 oval dining table
1 oval leaf for the same purpose

No. 41 In the Servants Hall

1 long table
5 long Benches

No. 42 In the Steward's Hall

2 large oval tables and
2 square tables of lesser size
18 ~~old cane chairs~~ Rusia leather chairs bought in 1730
1 paire of Backgamon tables compleat

Nᵒ. 43 In the Store Room

3 chests

2 tables

4 Shelves

7 old cane chaires

the descent of Henry Earl of Peterborugh in and old black frame

Nᵒ. 44 In the ~~spangle~~ Antichambʳ. belonging to the Spangled Room

2 pieces of gilt leather Hangings

7 green Damask chaires

1 paire of white Stuff window curtains and valens

a table Bedstead

1 Dutch tea table with *in the Spangle Room now*

~~1 blew china dish for the tea pott~~

~~1 earthen tea pott~~

6 blew and white china cups & saucers and most of ym broke

a chince cover for the table

Nᵒ. 45 In the Spangled Room

the Room hung wᵗʰ. purple cloth and embroidered wᵗʰ. Spangles and gilt leather

a bed compleat of the same as the hangings

lined with red and yellow stript silk

a counterpan of the same as the lining

8 chaires and

4 stools and

2 tables, all covered wᵗʰ. the same as the hangings

1 chest of Drawrs

1 table Bedstead

1 table

1 loocking glass in a black frame

1 Six leafed indian Skreen

2 gilt hanging Shelves *one of these in my Dressingroom*

an Iron herth and back

1 paire of brass Andirons wᵗʰ. fire shovle and tongs

Nᵒ. 46 In the Bedchambʳ. over against the spangle room

A green and gold colour brockodile Bed lined wᵗʰ. changable Silk

a green Silk quilt

5 green Damask chaires

1 chest of Drawers

2 Stands

1 Dutch table

1 other table

1 paire of Red Stuff window curtains

an Iron Back

2 paire of brass Dogs

a long glass in a gilt frame over the chimney

13 pictures in black frames

Nᵒ. 47 In the first of the three Rooms in the gallery opposite

to the spangle appartment

a green printed Stuff Bed compleat

1 Rug

1 table

Nᵒ. 48 In the second room upon the same floor

a green printed Stuff Bed compleat

1 old coverlid

Nᵒ. 49 In the third room upon the same floor

a green printed Stuff Bed compleat

1 red rug

1 chest of Drawrs and 1 table

Nᵒ. 50 In the wardrobe Room

13 Stuffed chaires and 2 frames unstuffed

2 paire of carved wooden candlesticks

1 cane couch

6 sash frames

1 yellow Damask Bed compleat and

yellow covers for the chaires } *carried to London*

4 tin fenders

6 lacquered sconces

Lady Bettys side-sadle w wᵗʰ. green velvet cape trimed with silver lace

5 tin candlesticks for Rush lights

Nᵒ. 51 In Mr. Farmer's Room

5 pieces of Tapestry hangings

a chince Bed compleat lined w wᵗʰ. white Dimitty

a stitched indian counterpane

2 paire of window curtains of the same as the Bed

6 Elbow cane chairs

2 pictures

1 chest of Draw'rs

1 paire of iron dogs

Nᵒ. 52 In the Room over against Mʳ. Farmer's Room at the bottom of the Laundry Staires

a Blew stuff bed compleat

1 fine chince quilt

1 table, and 1 Shelfe, and 1 press, and 1 cupbord

1 Dutch chaire

Nᵒ. 53 In the Landry

Nº. 54 In the first Room in the new Tower

a Large bed wth. a red rug
1 table, 2 stools and 1 chaire

Nº. 55 In the third room in the same Tower

Nº. 56 In the 3^d room in the sam Tower

Nº. 57 In the fourth Room in the same Tower

Nº. 58 In the fifth Room in the same Tower

Stuff Bed with a red rug & 1 chaire

Nº. 59 In the sixth Room in the same Tower

an old Stuff Bed wth. a red Rug

Nº. 60 In the Seventh Room in the same Tower

a Stuff bed, and 2 old rugs

Nº. 61 In the Eighth Room in the Same Tower

a Stuff Bed wth a brown Rug

Nº. 62 In the first of the maids Rooms

1 chest of Drawrs, & 1 great box, & 1 press
1 bedstead and a coverlid and a Rug

Nº. 63 In the Second of the maids Rooms

2 Bedsteads, and 2 Rugs, and 1 old chest

Nº. 64 In the Housekeeper's Room

a coloured linnen bed, wth hangings & counterpane of
 Ditto
1 chest of Drawrs & a press & 1 leather trunk
2 wallnut tree chests & 1 other chest
3 chaires, 2 serge window curtaines

Nº. 65 In the cooks room

a blew and white bed wth. calico quilt
1 old Stoll and an old chaire

Nº. 66 In the Steward's Room

a green and white Kettermaster bed compleat
1 coverlid of the same
4 old chairs & 1 chest of Drawrs
a fire shovle tongs and fender a Shelf & a press
the Room hung, & the window curtains of y^e same as the
 bed

In the passage by the Steward's Room

1 new press

Nº. 67 In the Room over the Lodge

the Room hung wth. Stript Kettermaster
a red Serge bed and a yellow rug
1 chest of Drawrs, 3 chaires

Nº. 68 In Mr. Humston's Room

a red serge bed and a red rug & 2 chaires

Nº. 69 In the Lodge

1 bedstead & an old rug, 1 table, 2 chaires

Nº. 70 In the chamber maid's Room

a Damask bed compleat and a calico quilt
1 chest of Drawrs, 3 Turky chaires & 1 cane chaire

Nº. 71 In my Lady's woman's Room

3 pieces of Tapestry Hangings
a cambled bed compleat line wth. indian flowred persian
a couterpane of the same
1 chest of Drawrs
5 Turky chaires a picture over the chimney
1 press
1 paire of brass dogs and a paire of tongs
2 Stands
1 paire of window curtains of old cambled

Nº. 72 In the Jerusalem Room

5 pieces of old tapestry hangings
3 pictures
an old grate and a paire of tongs
A Fire Engine
12 Fire Buckets mark'd 26 & 5 old ones

Nº. 73 In the Bedchamber within the Jerusalem Room

yellow Stuff hangings
a white Stript Dimitty Bed lined wth flowred calico with a
 counterpane of the same
1 paire of cambled window curtains
1 chest of draw'rs, 1 dressing table
6 cane chairs, & 1 Turky chaire
1 paire of tongs

Upon the Staires by the Jerusalem Door

1 square glass sconce

Nº. 74 In the windmill Room

a Stuff bed compleat and the Room hung with Stript Stuff
2 old Rugs 1 chest of Drawr's
4 chaires and a stand
1 old fashion Shelfe

**Nº. 75 In the rooms over then Couch houses
In the first**

Nº. 76 In the second alias the Coachman's Room

a red large bed compleat, wᵗʰ. a red rug
1 old cupbord, 1 old table, and 2 old chaires

Nº. 77 In the third alias the postillian's Room

2 old bedsteads and 2 old rugs & 1 old table

Nº. 78 In the under buttler's Room within the pantry

1 table bedstead, 1 old rug and 2 old chaires

**Nº. 79 In the little Room within the bed chamber
In the Banquetting house**

1 little bedstead
1 cane chaire
3 shelves

Nº. 80 In the Bed chamber within the Banqueting house

a chince bed compleat lined wᵗʰ. a flowred indian Silk
a white Sattin quilt
4 pieces of Tapestry hangings
3 pictures
1 fine inlaid table with 2 red china basons upon it and a glass over it in an inlaid frame
4 fine white and red indian Silk chaires
1 couch wᵗʰ. a white Sattin cusheon and 2 pillows of the same
1 paire of red Silk window curtains and valens
an old Stone grate
a marble like chimney piece and Slab wᵗʰ. 19 pieces of the fine old china upon it

Nº. 81 In the Antichamber in the Banqueting house

5 pieces of Tapestry hangings
4 cane couches
2 chests of Draw'rs with 2 alablaster heads upon them and 2 loocking glasses over them in carved and gilt frames
2 pictures
1 paire of red Silk window curtains and valens

Nº. 82 In the Chappel Gallary

1 large persian carpet to cover the floor
4 pieces of Fine Tapestry hangings with Sʳ. John, and Lady Betty, Germain's Armes, in a lossinge
4 Seats under them covered wᵗʰ. Crimson velvet to sitt on
5 Stools and 6 Cusheons to kneel upon covered wᵗʰ. Ditto
a Carpet of 11 breadths 2½ yᵈˢ. long of Ditto to hang over the peripet

2 large Bibles and 1 ditto in 2 parts
3 large Common prayer books all in Leather =covers, with purple Ribons & gold fringe to them

Nº. 82 In the Chappel below Stairs

a Large Marble Table covered wᵗʰ. crimson velvet of 7 breadths & 2 yards long, wᵗʰ. 2 velvet Cusheons, and 2 fine carved Candle-sticks gilt with gold upon it
2 Desks covered wᵗʰ. crimson velvet with one Bible and one Common prayer book upon one of them being the same with those in the Gallary
a fine Carved Rales before the alter
a Fine Carved Alter-piece wᵗʰ. a pannel of Crimson velvet over the Alter
12 large common Prayer Books in yᵉ Upper servants seats with yᵉ same Arms as yᵉ Hangings
4 of these Books carried up in to yᵉ Chappell Gallary.
A mettle Bason & Eure Gilt upon yᵉ Comunion Table

	Beds	Bolsters	Matts	Blankᵗˢ
Nº. 45 In the Spangle Room	1	1	2	3
Nº. 46 In the Room over agt. yᵉ Spangle Room	1	1	1	3
Nº. 47 In ye first of yᵉ 3 Rooms in the gallery	1	1	1 old	2
Nº. 48 In the Second ditto gallᵉʸ	1	1	1	3
Nº. 49 In the third ditto	1	1	1	2
Nº. 50 In the ward-Robe-Room	3 small	2	3	4
Nº. 51 In Mʳ. Farmer's Room	1	1	2	3
Nº. 52 In yᵉ Room over agt Mʳ. Farmer's Room	1	1	1	3
Nº. 54 In yᵉ first Room in the New Tower	1	1	1	3
Nº. 55 In the second in ditto	1	1	1 old	2

	Beds	Bolsters	Matts	Blankts
No. 58				
In the fifth in ditto	1	1	0	3 old
No. 59				
In the Sixth in ditto	1	1	0	2
No. 60				
In the Seventh in ditto	1	1	0	1
No. 61				
In the Eigth in ditto	1	1	0	0
No. 62				
In ye first of the maids Room	1	1	1 old	0
No. 63				
In the second ditto	3	2	1	2
No. 64				
In the Housekeeper's Room	1	1	1	2
No. 65				
In the Cook's Room	1	1	2	2
No. 66				
In the Steward's Room	1	1	0	3
No. 67				
Over the Lodge	1	1	1	2
No. 68				
In Mr. Humston's Room	1	2	1	2
No. 69				
In the Lodge	1	1	1	0
No. 70				
In the chamber-maid's Room	1	1	0	3
No. 71				
In my Lady's woman's Room	1	1	1	3
No. 73				
In ye Room within ye Jerusalem	1	1	1	3
No. 74				
In the windmill-Room	1	1	1	1
In the Stable	1	1	1	0
No. 76				
In the Coachman's Room	3	2	0	2 old

	Beds	Bolsters	Matts	Blankts
No. 77				
In the postillian's Room	2	2	0	2 old
	36	34	26	61
No. 33				
In the Red-chambr in ye brown Floor	1	1	2	0
No. 22				
In the Kings bed-chamber	1	1	2	3
No. 25				
In my Ladys bed-chamber	1	1	3	3
No. 17				
In the bedchamber in ye middle Floor	1	1	3	0
No. 16				
In the Closett in ditto Floor	1	1	1	2
No. 5				
In the bed chambr in ye upper Floor	1	1	2	3
No. 8				
In the Dutchess of Dorset's bed chamber	1	1	2	3
No. 12				
In Mrs. Maxfield's Room	1	1	1	3
No. 1				
In the bedchambr in ye long gallery	1	1	1	3
No. 28				
In Sr. John's Bed chamber	1	1	1	3
No. 80				
In the Banqueting-house	1	1	1	1
No. 78				
In the under Buttler's Room	1	1	1	2
brought over	12	12	20	26
	36	34	26	61
in all	48	46	46	87

pillows belonging to the beds in all 30

The Ditchley Inventories

Ditchley, Oxfordshire
1743 and 1772

Ditchley, Oxfordshire, 1743 and 1772

The Lee family acquired Ditchley Park in the sixteenth century. Sir Henry Lee (1533–1611) was Queen's Champion to Elizabeth I. In 1677 his descendant Edward Henry Lee (1633–1716) married Lady Charlotte Fitzroy, the illegitimate daughter of Charles II, and was created 1st Earl of Lichfield. Rebuilt to the designs of James Gibbs from 1720 under the supervision of Francis Smith of Warwick, Ditchley was the early eighteenth-century home of George Henry Lee, 2nd Earl of Lichfield (1691–1742). Both Henry Flitcroft and William Kent were involved in the decoration of the interior. The 1743 inventory was taken at the time of the 2nd Earl's death. His daughter Lady Charlotte married in the following year Henry, 11th Viscount Dillon, and the archives relating to the history of the house have descended in the Dillon family.

The location of the rooms is interesting with the 'Lord's Study' adjacent to the principal bedrooms on the Middle Storey. The Billiard Room is hung with sets of prints including Hogarth's *Harlot's Progress*. The great Ditchley portrait of Elizabeth I now in the National Portrait Gallery, London, hung in the Caffoy Bedchamber.

The list of plate is a fascinating record of the range of fashionable silver which the 2nd Earl of Lichfield built up during his lifetime. His surviving accounts record payments to leading suppliers including Daniel Chenevix and regular payments to Paul de Lamerie from 1729. The 1743 inventory was compiled by William Bradshaw and Edward Cullen. Bradshaw was a London upholsterer who probably supplied some of the seating furniture for Ditchley. Edward Cullen may be connected to James Cullen, upholsterer and cabinet-maker, who like Bradshaw worked from the 1750s in Greek Street, Soho.

Ditchley was inherited by the 2nd Earl's eldest son, also named George Henry, 3rd Earl (1718–1772). The inventory compiled after the latter's death includes interesting new acquisitions. 'A curious French dressing table, inlaid in Brass' was evidently a Boulle *bureau mazarin*, often used as a dressing table in England at this date.

These documents have descended through the Dillon family.

TESSA MURDOCH

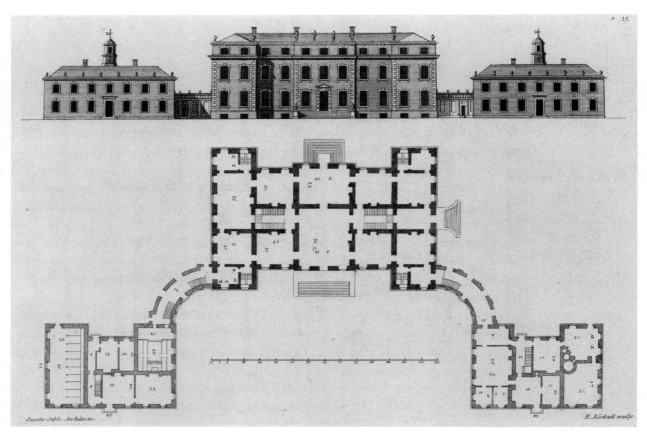

(Fig. 12) Plan and elevation of Ditchley, from James Gibbs, *A New Book of Architecture. Victoria and Albert Museum*

An Inventory of the Household furniture belonging to the R^t. Hon^ble. the Earle of Litchfeild at Ditchley in Oxford. Shire 1 June 1743

Nursery

I

2 four post bedsteads wrought dimity furniture 2 fea^r. beds, 2^o. bolsters, 2^o. Pillows, 7 Blankets, 2^o. printed linnen quilt, and 2^o. Old Matresses, a Table bedstead a Walnut chest of Drawers, an Old Chest and 2^o. Old Tables, five chair's, a stool, and a Dressing glass, a square stove, shovel, Tongs, poker, and fender

6:10

II

2^o. four post bedstids a striped camblet, and a plad furnitu^re. 2 fea^r. beds, 2 bolsters, 2^o. Old Matresses, 6^o. blanketts, a Linnen and Calicoe quilt, 2^o. Red & yellow printed, linsey wind^o. Cur^ts. an Old wainscot Table, and Six Chair's, a brass fram'd dressing glass, and a picture a square stove, poker, Tongs, shovel, and fender, Gilt leather hanging

5:10

M^r. Lees Room

III

A Bedstid with Chinee furniture, lined with sprig'd calicoe, a fea^r. bed, bolster, and pillow, 2^o. matresses, 4 blank^ts. and a Calicoe quilt, a yellow serge wind^o. Curt^n., an Old carved-cloaths-chest, 4^o. chair's, a Close stool and Earthen pan a brass fram'd dressing-glass, a p^r. of Dogs, shovel, & Tongs

6:10

IV

A bedstid with yellow silk Damask furniture and counter=pan, fea^r. bed, bolster, pillow, and four blankets, 2^o. pairs of yelow china wind^o. Curt^s. and Hangings 5^o. Elboe and 2^o. Other chair's, yelow Dam^k covers. A half lenth picture over the Chimney, A p^r. of steel Dogs shovel, and Tongs, a wainscot Dressing table, a peir glass, 25^o. ½. by 32.½ top 16^o. by 20^o. in a black frame An Old pair of walnut Stands one of D^o. broak

4:10

£23:0:0

Brought Over 23

Stuarts Room

V

A bedstid with blue china furniture, a fea^r. bed, bolster, and pillow, 4^o. blankets and a China Counterpan.

2^o. blue China wind^o. Curtains and Hangings, 6^o. Matted chair's, 3 Eboe and 2^o. other chair's, a square wainscot, and a round Dutch table on a pillor and Claw. A wainscot close stool and pewter pan. a small Dressing glass, a p^r. of Dogs, w^th. brass knobs, shovel, and Tongs

3:10

Ladys-Womans Room

VI

A wainscot four post bedstid, w^th. green lincey furniture A fea^r. bed, bolster, and pillow, 3 blankets, a printed linnen quilt, Old hair coulred hangings. of Mohair, paned with clouded sattin, 2^o. Old fashioned chamber chests carved fronts, an Old walnut & a Dail chest of Drawers, a square wainscot Table, and small Dressing glass 3^o. Old chair's and a stand,

3:5

Blue Room

VII

A bedstid with blue camblet furniture, and counterpan. a fea^r. bed, bolster and pillow, a Matress, & 3^o. blanketts 2^o. p^r. of blue camblet wind^o. curt^s. and hangings, A walnut dressing Table and brass fram'd glass, an Old Double headed=couch, six matted chair's, a picture of Abraham Sacri=fiseing Isaac, 2 small heads in Gilt frames, a p^r. of Dogs of Copper, Shovel and Tongs

10:0:0

Maids Room

VIII

4^o. Stumpt bedsteads 4^o. fea^r. beds and bolsters, 13^o. blankets, and three old Ruggs An Old walnut square Table and 2^o. Old chair's a small Dressing glass in a walnut frame

3:5

43:0:0

Brought Over 43

M^r. Wentworths Room

IX

A four post bedstid strip'd Harateen furniture, a fea^r. bed boulster, and pillow a matrass, 3^o. blankets and printed=linnen quilt a wainscot square table, and a round Dutch table on a Claw, An Old cabinet frame, a large old wainscot cloaths press, one Elboe & 2 other cane chair's a p^r. of square oak stools strip'd case's, a p^r. of Iron Dogs shovel, and Tongs, an Old Strip'd Harateen wind^o. Cur^tn.

4:10

Capn. Lees Roome

X

A bedstid with blue cloath furniture lined with yellow India persion, A fear. bed, bolster, pillow, and Matrass 3o. blankets, and a yelow India persian quilt, 8o. back stools, and setee in yellow silk Damask and yellow serge long case's, an old square Rose wood Table a brass fram'd old fasioned Dressing glass, 2o pr. of blue china window curtains, 4o. piece's of Irish stich hangings 2o. heads and a half lenth picture in Old Gilt frames 2o. Copper Dogs, shovel, and Tongs,

7:15

Lady Charlots Bed Chamber

XI

A four post bedstead Yellow Silk Damask furniture a fear. bed bolster and pillow, a Matrass 3 blankets and a white silk quilted counterpan, yellow silk Damask hangings, 2o. linnen window Curtains, 6o. Matted chair's one Elboe Do. covered with yellow silk Damask a walnut chest upon chest and an Old fashion'd cloaths=chest with carved front, An Old walnut Dressing Table a Chimney glass 35 by 15. Ends 10½. 15 in black frame

a pr. of steel Dogs, shovel, and Tongs, an Iron back, bellows and Brush

7:10

£62:15–0

Brought Over 62:15:0

Ladys Charlots closet

XII

a four post bedstead with green Linsey furniture a fear. bed, bolster, pillow, Matrass, 3 blankets, and an Old printed linnen quilt, a Dail chest of Drawers on a frame Table and a Caine chair

2

Uper lobby

XIII

14. Old Pictures

Middle Story

Blue-Mohair-Bed-Chamber

XIV

A bedstid with raised Tester blue Mohair furniture and counterpan, a fear. bed bolster, two Matrasses, 4o. blankets, two pillows, and a white India peeling quilt, 2o. do. Mohair windo. Curts. lined with China, 6o. Walnut back stools, covered with cross stich and blue cheny case's A walnut horse fire screen cover'd

with needlework and a blue Lutestring case, a Walnut chamber chest with Drawers a Peer Glass 28o. by 41o. secd. plate 19o. 28 top 18o. high, Chimney glass 35 by 19 Ends 19o. by 11 both gilt frames a Mahogoney Night table close stool and white pan a steel harth and Dogs, iron back, shovel, Tongs, and hearth brush 2o. heads, and a half lenth in Gilt frames, a Mahogoney Beaurough bedstead, fear. bed, bolster, and 3o. blankets, three peices of Tapestry hangings

51:3

Yellow Bed chamber

XV

a feild bedstead yellow silk Damask furniture trim'd wth. silver lace and counterpan do. a fear. bed, bolster, 2 Matrass's and a pillow four blankets 6o. Matted chair's yellow Calimancoe quilted backs and seats 2 pr. of yellow window Curts. and 25o. bredths of hangings Do. 9o. 10 long, a walnut Elboe chair Neeedlework cover Yellow calimancoe case a walnut Dressing chair cover'd with calimancoe a Do. Chamber chest with Drawers a Do. Beaurough, and Reading Desk on a Claw a Chimney glass 39o.½ by 22.½ ends 10o. wide in Gilt frames. a mahogoney breakfast Table on a Claw a steel hearth Iron back, Dogs, shovel, and Tongs, Ornamented with brass, brass fender Bellows and Brush, 3 heads and 2o. family pictures in Gilt frames

34:7

£150:5:0

Brought Over 150:5:

Waiteing Room

XVI

4 Chair's with Needlework seats and green case's, an Iron back and a pr. of Dogs Ornamented with Brass a Japan'd Corner Cupbd.

2o. heads and a picture of a Child in Gilt frames, a Chimney glass 34o. by 19o. Ends 8 in a black frame

2:5

Lords Study

XVII no 21 in 1772

a Red Morocco lear. Easy chair walnut frame
six walnut banister back chair's Mated bottoms
a Do. Dressing Table with a Recess and Drawers
a Dressing glass 21o. by 17 in a walnut frame
a Chimney glass 35o. by 22 Ends 12½ in a Gilt frame
2 pr. of scarlet Camblet windo. Curts., a green baise
 Door Curtn.
a Close stool chair on the back stairs
a Round Mahogoney breakfast table on a Claw
a steel-hearth, back, Dogs, shovel, tongs, belows, and
 brush

2º. large wainscot book presses

2º. prints of Homer and Julius Cesar, a Map & print

a Weather glass in a walnut frame

a whole lenth, a half lenth, and 4º. ¾ pictures in Gilt frames

40:14

Green Damask Bedchamber

XVIII no 20 in 1772

a 4º. post bedstid w^th. green silk Damask furniture and Counterpan, green shaloon case curt^s. a fea^r. bed bolster, 2 matrass's and 2 pillows, 4º. large fine Blankets 2 p^r. of green Lutestring wind^o Curt^s. a walnut Easy Chair 6º. banister back Chair's, covered with green Silk Damask and green serge Case's, A walnut chamber chest with Drawers, A peer glass, 34 by 24 brass frame & glass borders a black dressing table Ornam^ted. with Glass and Brass 3º. peices of Tapestry a steel Hearth Iron back and Dogs, shovel, and Tongs, Ornam^ted. with brass a Bellows, and Brush a p^r. of Glass slips, with brass Arms 3º. ¾ Pictures in Gilt frames, 2 Mohogoney Night Tables

26:6

£219:10:0

Brought Over 219:10:0

Lady's Dressing Room

No. 19 in 1772

a Walnut Couch with fea^r. Squab and three pillows 6º. Dressing Chair's cover'd w^th. Chinee & Red Cheque Case's

a Black Stone cabinet the front in figuers and Ornamented with brass on a Gilt frame 2º. pair of blue Lutestring wind^o Curt^s. 5º. peice^s. of paned Chinee hang^s. a Needlework fire screen on a walnut claw, a Glass screen

D^o. on a Mahogoney claw a wainscot Dressing Table, with a blue quilted peeling toilate and a p^r. of Walnut Stands a small mohogoney square Table Inlaid Top a Dressing glass 18º. by 14º. in a walnut frame a steel Hearth and Dogs, Shovel Tongs, and Iron Back, bellow Brush and two India handscreens a small walnut Desk on a frame a Chimney Glass 33½ by 23½ Ends 10 in a Gilt frame a whole lenth a ? Picture and 2º. Nuns in Gilt frame's

34:6

Billiard Room

XX

a wainscot Billiard Table compleat six banister back chair's pin cushin seats cov^d. w^th. Needle Work 2 Elboe and one Other Chair D^o. Lea^r. Seats 25º prints of the

Luxinburg Gallery, 6º. D^o. of harlots progress and 4º. Other prints in Pear tree frames w^th. Gilt Edges a whole lenth of Queen Elizab^th. in a Gilt frame. a steel Hearth and Dogs, shovel and Tongs

17:11

Yellow DamaskBedchamber

XXI No 17 in 1772

A Bedstid with raised Tester Yellow Silk Dam^k furniture w^th. Counterpan fea^r bed, Bolster, 2 Matrass's, 2 pillows, four Blankets and a white India peeling quilt 2 p^r. of yellow Damask window Curtains line'd w^th. Chena 14º. bredths of yellow India Damask hangings 19º.:10: 8º. Walnut backstools and an Easy Chair cover'd w^th. Dam^sk D^o and yellow shaloone case's a walnut Cloaths chest with Drawers, a Mohog^y Night table a Chimney glass 33½ by 17 Ends 10º: ¼ in a Gilt frame a Steel hearth, Iron back and Dogs, shovel, and Tongs, ormam^ted. with brass, and brass fender, a bellows and Brush a Fruit peice, a whole lenth, and three family peices in Oval all Gilt frames a Dressing glass 14º. ½ by 12º. in a Mohogoney frame

47:13:6

£319:0:6

Brought Over 319.0.6

Closet

XXII

2º. p^r. of yellow Taffity wind^o. Curt^s. 2 Walnut stools stufd yellow India Damask and yellow shaloon case's, one D^o. with a quilted serge Cushion, Amohogony round Table on a Claw, a p^r. of Iron Dogs, shovel, and Tongs, ornam^ted. with brass

1:5

Waiteing Room

no 16 in 1775 XXIII

3º. Walnut banister back chair's leather seats, 3 black fram'd D^o. Needlework bottoms A walnut beaurogh bedstead A fea^r bed, bolster, and 3 blankets, A Mohogoney Bason Stand three whole lenth Pictures without frames

4

Coffoy Bedchamber

XXIV No. 15 in 1775

a four post bedstead crimson Coffoy with yellow ground furniture line'd with yellow lutestring a fea^r. bed, bolster, 2º. Matrasses, 2º. pillows, 4º. blankets, 4º. blankets, and a yellow lutestring quilt 8º. back stools Japand frames cover'd w^th. Crimson and yellow Coffoy and red serge case's, two stools 2º. yellow Lutestring

wind⁰· Curtains A Mohogoney chamber chest a
Chimney glass 34⁰. by 19⁰. Ends 10⁰. ½ frame gilt in
parts Red flock work hangings on Canvas and gold
ground a steel hearth and back, Dogs, shovel, and
Tongs, ornam^ted. with brass, and brass fender, bellows,
and brush two heads and a whole lenth queen Eliz^th. in
Gilt frames

38:7

Closet

2 Walnut Dresing chair's cover'd with Needlework and
yellow serge case's, A square Mohogoney Table on a Claw,
a p^r. of brass Dogs shovel and Tongs

1:5:0

£363:17:6

Brought Over 363:17:6

Crimson Damask bed chamber

XXVI No 24 in 1772

A Bedstid with Crimson Suff Damask furniture and
counterpan, a fea^r bed, bolster, 2⁰. Matrasses,
2⁰. pillows, 4⁰. blank^ts. 2⁰. p^r. of stuff Damask wind⁰.
Curt^s. D⁰. 24⁰. bredths of hangings D⁰. six walnut
chair's with Damask cushions A Mohogoney Night
Table, a Cornor D⁰. a large Commode Table A
Chimney glass 35⁰. ½ by 20 Ends 10 a Whole Lenth of
Queen Eliz^th. a picture of 2⁰. half lenths in a Gilt frame,
the Countess of Litchfeild in an Oval frame a steel
hearth, back and dogs, Tongs and shovel ornamented
with brass a brass fender, belouse and brush a small
Dressing glass in a walnut frame a wainscot close stool
and a Pewter pan

37:15

Great Hall

XXVII

Six Rich carved benches gilt in parts a Rich Slab frame
D⁰. with a Dove coulord Marble Slab on it 5⁰. by 2⁰.:6⁰.
4⁰. Carved and gilt compass side lantrons, a large
steel=hearth, back and sides a Grate-shovel, Tongs,
Poker and fender, a plaster Statue 2 History paintings,
and one family picture

46:12

Dineing Parlour

XXVIII

12⁰. Walnut banister back chair's leather seats 2⁰. Elboe
D⁰. one of D⁰. Cover'd with Needlework, two Marble
slabs, 2:3 and 2:6: wide by 5:4: long on walnut frames
2⁰. Crimson Stuff Damask window Curt^s. an India
paper ^fire screen on a Walnut claw a round black stand
for a Cistern

a steel Hearth square grate shovel Tongs, and poker
ornamented with brass and brass fender 2⁰. Sconces in
Gilt frames and plain brass arms a p^r. of brass armes
over the Chimney, bellouse, and brush a picture of the
Duke and Dutches of york, y^e. princess Mary and Ann
in a Gilt frame 3⁰. half lenth family pictures D⁰. Lord &
Lady Tenhams & Capt. Lee 2⁰. Curtisans whole lenths
D⁰
2 heads, in Oval fram's D⁰. L^d. and Lady Litchfeild
A large hunting piece

44:14:6

£492:19:0

Brought Over 492:19

Lobby

XXIX

A large Mohogoney table with a leafe to add 3
Mohogoney ^oval Dineing Tables one wainscot breakfast
Table on a Claw a Mohogony square side lanthron

6:10

Drawing Room

XXX

2 pair of Green Mohair window Curt^s. lined with D⁰.
China 9⁰. Walnut banister back chair's pincushion
seats, and a settee cover'd with green Mohair, one Elbo
Chair D⁰. Cover'd with Needle work, and green
Shaloon case's a large Marble slab on a walnut frame
one canvass and one India paper fire screen a p^r. of
Mohogoney stands
a Chimney glass 37⁰. by 21⁰. ½ Ends 10⁰. ½ in a walnut
frame a p^r. of single brass arms 3⁰. peices of gilt leather
hangings a steel hearth, Iron back, Dogs, shovel, and
tongs, ornam^ted. w^th. Brass a Harpsicord a half lenth
picture of King Jam^s. the Second two whole lenths
2 half lenths, family pictur's gilt frames

37:10

Closset

XXXI

2 p^r. green Mohair wind⁰. Curt^s. lined with green
cheney 4⁰. walnut Stools coverd with green Mohair,
a Mohogoney Dumb waiter on Castors, a D⁰. breakfast
Table on a Claw an Eight leaf'd Screen gilt leather,
a Chimney glass 40 by 22⁰. black frame, a p^r of plain
brass Arms, a p^r. of Steel Dogs, shovel, and Tongs,

8:8

Breakfast Room

XXXII

Six walnut Smoking chair's leather bottoms, a D⁰.
Whisk and Umbar Table, cover'd with green cloath,

a Japan'd Tea Table on a Claw, and Tea Kettle Stand
D⁰. a 3.ᶠᵗ. mohʸ ovil Table a brass-compass-stove,
Shovel, Tongs, and poker. a Chimney glass, 33⁰ ? by
18⁰. Ends 10⁰. ? black frame 1⁰. Prince Artʳ· whole
lenth and 7⁰. half lenths old family Pictu=r's in black
frames gilt Edges, 8 prints of the raekes progress and
two others in black frames and gilt Edges a History
peice over the Door

<div align="right">10:16</div>
<div align="right">£556:3:0</div>
<div align="right">Brought Over 556:3:0</div>

Crimson Damask bedchamber

XXXIII Inner Library 1890

A crimson Silk damask raise Tester bed and
Counterpan with crimson lutestring caseᶜᵘʳᵗˢ. a feaʳ.
bed, boulster 2⁰. Matras's, 3 pillows, 4 fine blankets,
two pair crimson Lutestring wind⁰. Curtˢ. lined wᵗʰ.
crimson stuff Six walnut back stools and an Easy chair,
covᵈ with crimson silk Damask and Shaloon Case's 4⁰.
peices of Tapestry hangings a peir glass 51. ½ by 32:
½ glass border frame a whole lenth of King Henery 8ᵗʰ.
& 3⁰. hunting peices all gilt frames a Coulord Marble
slab on a gilt frame, a steel hearth and back, a pʳ. of
Dogs, shovel, Tongs, ornamᵗᵉᵈ. wᵗʰ. brass d⁰. fender

<div align="right">137:5</div>

Closet

XXXIV

2 pʳ. of Crimson Lutestring wind⁰. Curtˢ. lined wᵗʰ.
Crimson Stuff 3⁰. Walnut dressing chairs crimson silk
damask bottoms and shaloon case's a walnut dressing
table and small glass 4⁰. peices of Tapestry hangings
a pʳ. of Dogs, shovel and Tongs

<div align="right">17:</div>

Drawing Room

1ˢᵗ Library, 1890 XXXV

2⁰. pʳ. of crimson lutestring wind⁰. curtˢ. lined wᵗʰ. D⁰.
Stuff 8⁰. back stools gilt frames, a half Settee covᵈ. wᵗʰ.
crimson Silk Damᵏ. and shaloon case's 3⁰. peices of
fine Tapestry hangings a large Japan'd chamber chest,
a black and yellow slab on a Rich carved and gilt frame
a glass 60⁰. by 30⁰. in a tabernacle frame gilt, a pʳ. of
Gilt bracketts for candlesticks, a large square brass
grate shovel Tongs & fender, a Brass harth and steel
back a whole lenth of Charles 1ˢᵗ. in a gilt frame, the
Countess of Lindsey, Rochester, and Sʳ. ffrancis Lee,
3⁰. half lenths in Gilt frames,

<div align="right">143.13</div>
<div align="right">£854:1:0</div>
<div align="right">Brought Over 854:1:0</div>

Saloon

Billiard Room 1890 XXXVI

2⁰. Marble Slabs on plain walnut frames, 12⁰. walnutt
banister back chair's black leather seats, a steel hearth,
back, wood pan, shovel, Tongs, poker, & fender

<div align="right">10</div>

Drawing Room

XXXVII Green Drawing Room 1890

Six Tapestry chair's and two Settees A Marble Table
on carv'd frame a large oval glass and picture over the
Chimny a D⁰. of Lady Litchfeild in her robes by
Vanderbanck. a steel hearth, stove, and furniture.

<div align="right">64:14</div>

Great Room

XXXVIII White drawing room 1890

2⁰. fine marble tables on Rich frames
2⁰. Glasses D⁰: 60⁰. by 34⁰. sight
2⁰. large gilt stands with leaʳ. case's
10⁰. Mohogoney carved Chair's red Morocco leaʳ. seats
4⁰. Elboe Chair's D⁰. and Case's, a needlework screen
 and a Canvas D⁰.
4⁰. whole lenth pictures
a steel hearth, grate, and furniture,
3⁰. Spring umbereloes and rod
a Landskip over the Chimney
a Large Turkey Carpet

<div align="right">195:10:6</div>

Closet

XXXIX

a Card Table, a Tea Table, a steel hearth, & Dogs,
shovel, Tongs a pʳ. of bellows and brush

<div align="right">2</div>

Bedchamber

Velvet room 1890 XL

an Indian Cabinet on a frame
a picture of Ruins over yᵉ Chimney, a steel hearth

<div align="right">17:17</div>

Drawing Room

Tapestry room 1890 XLI

Aa large peir glass in a gilt frame
a steel hearth, a Marble Slab
a sett of Brussels Tapestry 2⁰. peices 85⁰: Ells

<div align="right">93:15</div>
<div align="right">£1237:17:6</div>
<div align="right">Brought Over 1237:17:6</div>

Smoaking Room

6o. winds or chair's a wainscot Dineing Table, An Old square stove, Tongs, and poker, a parcel of old broaken Tapestry and a broaken Carpet, a floor hair cloath

2:10

Cellars

6o. stillens and 24 Casks, 27o. Casks, 5o. large stillens

5:15

Stuards Room

12o. Wainscot Hall chair's and an Oval Dineing Table Do. a pr. of Dogs, and Iron back, shovel, Tongs, & poker 2o. fowling peices, a blunderbus a bullet gunn and a pair of pistols, a pr. of Backgamon Tables, boxes, dice, and men,

3:10

Servants Hall

3o. long Oak Tables and 2o. benches

1:1

Butlers Pantry

a bedstid old Cloath furniture, fear. bed, bolster, three blanketts, and a quilt, 2 garden chairs, and wainscot, Do. 2o. Dail Treas, 2 Copper Cisterns, 3o. old chair's, 2 stools, 2o. Square Tables, 3o. Iron hoop's, a knifebord, 4 Mohogoy. bottle stands, a brass plate warmer,

5:10

Still Room

a copper still with Pewter worm and Tubb, a pewter Limbeek or cold still, 4o. Copper preserving pans & 2o. Covers, a stue pan, a large sauce pan, and Tea Kettle, 4 pudding pans and covers, 3o. pillor 7 flat brass candle-sticks, 2 brass skillets, and old broaken pan, a Copper Tea Kitchen compleat, a brass scales and one pd. weight, a Coffee mill an Old brass sconce, a Marble Mortor with wooden pestel a Glass stand for a Desart (Crack'd), a wainscot safe, two wainscot Tables, one of Do. Round, 4o. small hair sives & and one old Silk Do, a Tinn Candle box, 4o. flat Tinn Do. 2 Copper warming pans,

8:13

£1264:16:6

Brought Over 1264:16:6

House keepers Room

7o. old cane Chairs and one Elbow Do. 4 wainscot Tables, and 2o. Do. in the closet, a large wainscot press wth. shelves a wainscot Nest of Drawers or spice box, a pr. of Iron Dogs, and back, shovel, Tongs, bellows, brush and stake Tongs, an Old square Table on the back stairs,

one Mohogoney Round Tea bord and one Japan'd Do. 2o. plate baskets a pull up Clock

2:5

Linnen

6o. pair of fine new Dutch linnen sheets, 13o. pr. Do. coarse and woren
22o. pr. of flaxen sheets and 32o. pr. of hempen Do.
33o. fine pillow cases and ten coarse Do.
30o. Diaper and Huckaback Towels
7o. fine Damask Table Cloaths, 7o. Dozn. of Do. Napkins
6 New Damask Table Cloaths Corser, 6o. Dozn. of Napkins Do.
12o. Diaper Table cloaths,
12o. Dozn. of Napkins
6o. huckaback Table cloaths, 6o. Dozn. of Napkins
6o. Old Diaper Table cloaths, 8o. flaxen Table cloaths

82:1

China

15o. Coulred Dishes
2o. Dozn. of Do. plates
4 scolop'd Dishes Enambled
2 Stands Do.
4 Coulred old China basons
1 large Enambled Dish
9 Coulred small octagon dishes
1 large Coulred Soop Dish
1o. large blue & white octagon Dish
12 small octagon Do. blue and white
18 blue & white plates
8 blue & white 2 odd Dishes
2 odd coulred Dishes
2 large Coulred Jarrs a large bowl &
4 white figures in Ladys Dressing room
34 bottles and peices of Ornamental China
1o. blue and white punch bowl
9 Coulred soop plates
10 water plates
2o. Dozn. 10o. blue & white water plates

19:17:6

£1369:0:0

Brought Over 1369:0:0

China continued

2 Dozn. 9o. blue and white Table plates
a blue and white Slop bowl and broaken Sallet dish

Kitchen

a smoak Jack, 4 spits, 2 large Racks, a large Iron back, 2 cranes, and hooks, a large rainge and cheeks, a shovel Tongs, poker, a large fork, 2o. grid Irons, a salamander

2º. Clevers, 2 Choping knives, 2 lark spits, 6 scuers, six stove trevets, one large trevet, a pigg Iron, 2º. beef forks, 3º. Leaded scewers, and Iron frame for Dishing mate on, two pair of stake Tongs, Iron scale beam on a Tree angle, tns 0:qrs. 3: lb o of brass and 20··0··0 lead weights

8:10

Copper

3º. poridge pots, two soope pots, and covers, 3 copper fish Kettles, and Covers, and one plate, 7º. stew pans and one Cover, 2 Cullinders, 2 frying pans, a pasty-pan, 3 brass and two Copper patty pans, a Mellon and Turks cap, 5º. sauce pans and two Covers, a brass Drudging box, and Copper Drinking pot, a large Old Driping pan

6:13

Pewter

35 Pewter Dishes and 5 fish plates, 9º. Dozⁿ. 10º. plates six Dish Covers a stewpot and cover, a brass Mortar and Iron, pestel,

10

1394:3:0

Sculery

a large Double Copper sett and two Covers ~~thre~~ two soope ladels, a scummer a brass spoon, 2 slices, 2 brass dish Kettles, and a Dish kettle sett, 2 plate racks, 2 stools and 2 Tubbs

Brought Over 1394:3:0

Sculery Continued

a long Kitchen Table and four benches, a Choping block, a flour Tub, and salt Tub on Roulers, a large fire screen a Marble Morter and wooden pestel, a Coal Tub a salt box and an Old chair, 4º. Water pails,

6

Larder

a powdering Tub lined with lead, and 2 Choping blocks,

2:10

Bake house

a bolting mill a Trough two blocks, a flower Tub, an Iron and a wooden peel, a large old range and two cranes, a large Iron scale beam and chains, wooden Scales

Brew house

2º coppers sett compleat, 2º. Mash Tubs, 2 coolers, 2º. guile Tubs, and leaden under bank, a Malt mill 2 Lea=ding Tubs, six small Tubs, some old casks, a screen, a sive, and a parsel of Iron hoop's,

40

Mens Room over the Kitchen

5º. bedsteads 3 old furnitur's all to peices, 5 feaʳ. beds, bolsters, 15º. blankets, five old Ruggs, all in raggs

5

Chappel

a Large Marble Slab on a gilt frame, a picture of a Dead Christ over Dº

10

Dairy

5 leaden milk Treas, a large bacon Trough lined wᵗʰ. lead, 4 Milking pails and butter scales, 3 Churns & a Cheese press, 12º. Cheese fatts and Six Tubs

3:5

Wash house

a Drying Horse and a Table and 2 Ironing boards a Copper fixt and Iron work and 2º. brass Kettles, a renching Tub and 8º. washing Tubbs, 2º. Stools, a wett horse and ashe's Tub, an Iron Rake, a pair of Tongs, and fork,

Landry

a Mangle, a grate fendʳ. tongs, poker, shovel, a box & 8 flatt Irons, 2 stands, and a hanging Iron

6:10

£1467:8:0

Brought Over

Room over the Dairy

a 4º. post bedstid blue Mohair furniture lined with yellow silk, a feaʳ. bed, bolster, 3 blanketts a yellow silk quilt, a wainscot Dressing Table, 5 banister back=chairs matted bottoms, 4 peices of old Tapestry hang=ings, a pʳ. of Dogs Shovel and Tongs,

6:15

Room over yᵉ. Landry

a 4 post bedstead old striped camblet furniture a feaʳ. bed, bolster, a Matress, 3 blankets, and an old quilt a square wainscot table and chair

2:2

Huntsmans Room

a stump bedstead feaʳ. bed, bolster, 3 blankets and an old Cover Lid, an Old Chair and stool, a bench bed a feaʳ. bed, bolster, 3 blankets and an old Rugg for his boy

2:5

Rooms over the Hack Stables

Nᵒ. 2 a wainscot stump bedstead, and old Rugg

 3. a bedstead, Dᵒ. a feaʳ. bed, bolster, 2ᵒ. blankets and a Rugg an old Table and a Chair

 4. a bedstead and bedding as the last, an old Elbow Chair

 5. a stump bedstead, a feaʳ. bed, bolster, 2 blankets, and a Rugg an Old Umbar Table

 6. a stump bedstid and beding as the last, 2 old Chairs

 7. a stump bedstid, feaʳ. bed, bolster, 3 blankets, and an old Rugg, a Table, and 3 old Chairs

Coach Mans Room

a stump bedstead, a feaʳ. bed, bolster, 3 blankets a Rugg all in raggs an Old Elbow Chair and stool

Gardners Room

a bedstead with brown serge furniture, feaʳ. bed, and bolster, 3 blankets, and a Rugg an old wainscot Table

Coach horse Stable

a bench bed feather bed, bolster and an old Rugg

	10:15
	£1489:5:0

All the within named Goods are valued & Appraised to the sum of Fourteen Hundred Eighty Nine pounds five shilling the date above mentiond by us

 Wᵐ. Bradshaw.
 Edwᵈ. Cullen

Plate. Taken march 7ᵗʰ. 1743

20 dishes of different sizes, & one oval Dᵒ.	934.5.0
5 dozplates Dᵒ	1092.5.0
1 dozsoop Dᵒ	230.15.0
1 large Gilt dish	154.5.0
a Turreen & Cover	148.10.0
4 plain sauce Boates	80.2.0
4 Cases with 12 Knives each about 2 oz. ½ each	120..0.0
4 doz. Forks, & 4 doz. spoons Dᵒ	215.0.0
a case of Desart with 10 Knives, Forks & spoons Silver Blades / a case Dᵒ with 6 Knives, spoons & Forks, steel Blades	66.5
A pʳ. of 2 light Gerrandoles, chased, snuffers and dish / a pʳ. of large Candlesticks to match Dᵒ	208..15.0
a pʳ. plain Candlesticks, a snuff dish and 2 steel Snuffers	214.8.0
6 Wrought Salts, 6 plain Dᵒ. & 4 old fashion'd & 6. salt spoons	92.5.0

3 old fashiond salvers, 4 small salvers & 2 small square waiters	117..0.0
a Wain-Waiter plated over	about 25.0.0
6 Scollopd Shells & a Chamberpott	61.18.0
An old fashiond Carvd Cup & cover Gilt, an old Salver	55.4.0
4 large soop spoons, a marrow spoon, 3 lark spits and a Silver Bell	43.0.0
a Spirit Lamp, a Cheese plate, a Tea Kettle Lamp and stand	115..0.0
a punch Ladle, and strainer, and a smoaking Candlestick	9.0.0
a Carvd Cream pott, sugar, & dish & cover	26.5.0
2 Coffee potts & a Chocolate pott	65.0.0
a Bread Baskett	82.12.0
a Cup and Cover with a Coronett	89.10.0
a large tea water, Carvd & engraved	90..17.0
a Crewit frame, with 3 castors, 2 Crewit tops, and a small pepper Castor	52.5.0
a Mazareen or Fish plate	34.10.0
4 large Carvd Sconces, with single Branches	291.5.0
2 small Mugs & 6 Bottle ticketts	15.17.0
a chased stand for a dish & Lamp	43.10.0
a Cirtute Compleat	478.15.0
	oz. 5253.3.0
@ 5/8 }	1488.7.9

All the above mentioned Plate is valued and appraizd to the summ of one Thousand four hundred and eighty eight Pounds, seven shillings and Ninepence
By us

 Wᵐ. Bradshaw.
 Edwᵈ. Cullen

An Inventory of the Furniture, Paintings, Linnen, China, and Books, of the late George Henry Earl of Litchfield, Deceased, at Ditchley, in the County of Oxford; Taken the 28th: of: October, 1772. and 4 following days, by Richard Way and James Way of Thame Oxon.

Nº. 1. In Mr. Burr's Chamber & Closet, Attic Story, North.

Two pair of old blue Cheney Window Curtains & Rods.
An old yellow silk Quilt & 2 Blankets.
An old White Mattress, & a Bolster.
A faneered Walnutree Buroe Bedsted
Shovel, Tongs, and Dogs
2 old Claw Tables
An old Turkey Carpet
An old Deal Chest Drawers
A little old faneered Desk, a pair of Steps, & an old Sword
An old Painting of a Child, & a Do. of a Lady.

Nº. 2. In the Chamber opposite, & Closet

A Bedsted wth. yellow Harrateen Curtains, & 2 pair of Do. Window Curtains & Rods
A Check Mattress
A feather Bed, Bolster & 2 Pillows
A flowered Quilt & 4 Blankets
A faneered Buroe
A Cloths Chest & Stand
A deal Chest Drawers, & a Glass
4 old black Chairs
An old Chest, and old Claw Table and a Stand
An old Painting of a Child
A Turning Lave and Apparatus
A Ventilator, in a Glass frame
Some old Packing Boxes
3 old Paintings.

Nº. 3. In the Red Chamber, S.E. Front

A Bedsted with red Callimanco furniture,
a do. Counterpane, & 2 pair of Do. Window Curtains & Rods
2 old White Mattresses
A feather Bed, Bolster, & Pillow
A flowered Quilt & 4 Blankets
Shovel, Tongs, Dogs, Bellows & Brush
An Oak Dressing Table
A Mahogany low Chest of Drawers

2 Elbow Chairs, 4 others & 2 Stools, wth. red Stuffed Seats
2 Bedside Carpets & a Night Stool
A Pier Glass, in a White frame

Nº. 4. In the Maids Room, next

4 Stump Bedsteds
4 feather Beds & 4 Bolsters
4 old Quilts & 16 old Blankets
An old Press Bedsted, feather Bed Bolster & two Blankets
An old Oak Chest Drawers and a Chair
An old Painting

Nº. 5. In Mr Beard's Room, next

A Bedsted, wth. Yellow Curtains
2 old White Mattresses
A feather Bed, Bolster & Pillow
A flowered Quilt, and 4 Blankets
An old Writing Desk
Shovel, Tongs, Dogs & Brush
A Couch, 2 Cane Chairs, a pr. of Green Window Curtains & a Glass (broke)
A large old Oak Press

Nº. 6. In Admiral Lee's Room, next

A Bedsted, wth. green Moreen furniture & 2 pr. Do. Window Curtains & Rods
An old Mattress
A White Hair Do
A fine feather Bed, Bolster & Pillow
A flowered Quilt & 3 Blankets
A Carpet round the Bed
Shovel, Tongs, Dogs, Bellows & Brush
6 Walnutree Chairs & 2 Stools, wth "Worked Seats
A Mahogy low Chest Drawers
An old faneered Dressing table & a Night Stool
A Pier Glass, in a Gilt frame, & brass Arms
19 Hogarth's Prints of Marriage a la Mode,
the Harlots Progress, &c. and 4 others
3 old Paintings of Gentlemen.

Nº. 7. In the flowered Room, next, South Corner

A Bedsted, wth. old Chintz Curtains
A Check Hair Mattress
A White flock Do
A feather Bed, Bolster, & Pillow

Nº. 7.
A flowered Quilt & 3 Blankets
Shovel, Tongs, Dogs, & Brush
6 old black Stuffed Chairs, with Red Check Covers
2 pr. Linnen Window Curtains and Rods
A Deal Dressing Table, & old Glass
An old Chest

Nᵒ. 8. In the Closet, next

A Bedsted, wᵗʰ. blue Serge Curtains
An old White Mattress
A feather Bed, Bolster & Pillow
A Quilt & 3 Blankets
2 old Chairs

Nᵒ. 9. In the Nursery & Closet, West Corner

A Bedsted, wᵗʰ. worked Dimity Curtains & 2 pʳ. Dᵒ.
 Window Curtains & Rods
An old White Mattress
An old feather Bed, Bolster & Pillow
An old fringed Quilt & 4 Blankets
A little Bedsted, wᵗʰ. green Curtains
A Check Mattress
A feather Bed, Bolster & Pillow
An old green Silk Counterpane & 5 Blankets
Shovel, Tongs, Dogs, fender & Brush
4 black Chairs wᵗʰ. Yellow Stuffed backs & seats,
 & 2 Matted Chairs
An old Table & Chest, & 2 Door Mats
6 large Tin Fenders
A large Deal Box
A Drum Night Stool
An 8 leaved Gilt Screen
A Bird Cage & 2 Lamp frames
4 brass Curtain Rods
7 Prints of Views
3 large Paintings of Queens, in Gilt frames, and 20 other
 old Family &c. Paintings.

Nᵒ. 10. In the next Blue Room

A Bedsted, wᵗʰ. blue Coffoy furniture
A White Mattress
A Check Dᵒ
A fine large feather Bed, Bolster, & 2 Pillows
A White Cotton Counterpane & 4 Blankets
Shovel, Tongs, Dogs, Bellows & Brush
A Couch & 6 Stuffed Coffoy Chairs wᵗʰ. Check Covers
A Mahogʸ. Night Stool & Pewter Pan
A Dᵒ. low Chest of Drawers
An old Table & 2 pʳ. of blue Window Curtains & Rods
A Chimney Glass
A large Leather Chair & Check Cover.

Nᵒ. 11. In the blue Wainscotted Room, next.

An old Bedsted wᵗʰ. blue Curtains
2 old Mattresses
A feather Bed, Bolster, & Pillow
A flowered Quilt & 3 Blankets
An Iron Hearth, Shovel, Tongs, Dogs, & Brush
4 old black Chairs & a Couch

An old Chest Drawers & Yellow Window Curtains
 & Rods
An Antique Dressing Table and Glass, wᵗʰ. Brass
 Ornaments
An old Painting of a Lady.

Nᵒ. 12. In the Chapel Room, next

A Bedsted, wᵗʰ. flowered Linnen furniture, lined
An old Mattress
A feather Bed, Bolster & 2 Pillows
A Chintz Counterpane
A White Quilt & 4 Blankets
Shovel, Tongs, Dogs & Brush
A Night Chair
2 Elbow Walnutree Chairs, & 5 others, wᵗʰ. Leather Seats
A faneered Walnutree double Chest Drawers
A Dressing Table & Chimney Glass
A Map, 15 Views of Stow, and 2 Glazed Prints
A Painting of Mʳ. Warner, by Carpentier. }
 gave to his Grandson by Mʳ. Dillon

Nᵒ. 13. In the Gilt Leather Room, next

A Bedsted wᵗʰ. Orange Callimanco furni=ture, & 2 pʳ. Dᵒ.
 Window Curtains & Rods
A White Mattress
A feather Bed, Bolster & Pillow
4 Blankets
Shovel, Tongs, & Dogs
An old Settee & Cushion
6 Chairs, a Night Stool & Pewter Pan
An old Dressing Table
An old Pier Glass
A Mahogʸ. low Chest Drawers
An old Painting, of a Lady.

Nᵒ. 14. Long Gallery, Attic Story.

An Oak Chest, & 3 old furniture Chests
A large Dining Parlor Matt, a long Matt, & a hair Cloth ✗
~~Old Chintz furniture, for a Bed~~ ✗ R.W. ✓Lady
 Dowager Litchfield's
An old Velvet Pall
Green Velvet furniture, for a Lady's Saddle
2 Linnen festoon Window Curtains.

**Nᵒ. 15. In the Coffoy Bedchamber and Dressing
Room South Corner, 2ᵈ. Story.**

A Bedsted wᵗʰ. Scarlet & Yellow Coffoy furniture, lined
A Check Hair Mattress
A White dᵒ
A fine feather Bed, Bolster, & 2 Pillows
A White Quilt & 4 Blankets
A Carpet round the Bed
Shovel, Tongs, Dogs, brass fender, Bellows & Brush

A Mahog^y. Airing Screen
A pair of D^o. Night Tables
A D^o. Cloths Chest, w^th. Drawers
A D^o. Square Table
6 Jappan Chairs, & 2 Stools, with Stuffed Coffey backs &
 Seats
A Deal Dressing Table, Pettycoat & Toilet
A Dressing Glass & Curtain, 7 Dressing Boxes, 2 Brushes
 & 2 Trays
2 Candle Stands
A Chimney Glass in a Gilt frame
A p^r. of Yellow Lutestring festoon Window Curtains
A Moreen D^o
A Mahog^y. Shaving Stand
A faneered Walnutree Dressing Table, a p^r. small Dogs,
 & an Elbow Chair
2 little old Carpets & a Cushion
A Painting of a Lady, in a Gilt frame.

N^o. 16. In the Anti-Chamber, next

A Mahog^y Buroe Bedsted
A D^o. Cloths Chest *1905 wc passage*
An old blue Coffoy Settee & 2 Chairs w^th. Check Covers
8 Hogarths Prints of y^e Prodigal Son
5 pair of French Plate Candlesticks
6 old Tin Night Candlesticks
4 jointed Tin fenders
3 China Bottles & 3 Basins
14 D^o. Chamber Pots
4 Glass Water Decanters, 7 small D^o, & 6 Tumblers
2 China Candlesticks

N^o. 17. In the Yellow Damask Chamber and Dressing Room, next West Corner.

A Bedsted w^th. Yellow Silk Damask furniture, & 2 D^o.
 festoon Window Curtains
A large Check Hair Mattress
A White flock D^o
A fine large feather Bed, Bolster, and 2 Pillows
A Decker Worked Counterpane
A White Sattin Quilt & 4 Blankets
2 Bedside Carpets
Shovel, Tongs, Dogs, Bellows, Brush, Chimney Screen &
 Paper fire screen
An Easy Chair & Cushion, Eight others & 2 Stools, w^th.
 Yellow Stuffed Damask backs and Seats, & Check
 Covers
A Jappan Chest & Stand
2 little Jappan Trunks & Stands
A Deal Dressing Table, 2 Silk Pettycoats, 3 Toilets,
 & 2 Glass Curtains
A Dressing Glass & 14 Jappan Boxes
2 English China Cups & Covers, & Saucers

A large Pier Glass, in a Glass & Gilt frame
A Chimney Glass & Painting, in a Gilt frame
A p^r. Gilt Candle Branches
Shovel, Poker, and Dogs
A faneered Card Table
A Square Deal Table and a Night Stool
A Painting, in a Gilt frame
A Yellow Moreen festoon Window Curtain

N^o. 18. In the blue Chamber, next, N.W. front

A Bedsted w^th. blue Silk & Worsted Damask furniture
A White Dimity Mattress
A White Holland d^o
A fine feather Bed Bolster & 2 Pillows
A White Quilt & 3 Blankets
2 Bedside Carpets, & a blue Dressing Carpet
An Iron Hearth, Shovel, Tongs, Dogs, Bellows, &
 Chimney Screen
6 Stuffed Chairs, w^th. Check Covers
A Walnutree Cloths Chest, w^th. Drawers
A Deal Dressing Table, old Pettycoat & Toilet,
 & 2 Candle Stands
A Dressing Glass & Veil, & 15 odd Dressing Boxes
A p^r. of old blue Moreen festoon Window Curtains
A Night Stool & old Jappan Night Table
A Chimney Glass & Painting of Dutch Gamesters, in a
 Gilt frame
A fruit Piece
A Painting of a Young Prince
5 Pieces in Crayons, framed & Glazed Viz^t The late L^d.
 Litchfield, Present D^o,
2 Dukes of Beaufort,, & S^r. W. W^m. Wynne, by Hoare.

N^o. 19. In Lady Litchfield's Dressing Room & Closets, next

Shovel, Tongs, Dogs, Bellows & Brush
A Couch & Squab & 3 Pillows w^th. Check Covers & 8 d^o.
 Armed Chairs
A White Sattin Quilt
A Mahog^y. Claw Table & Airing Screen and a little ffan.
 screen
A Walnutree Cloths Chest, w^th. Drawers
A Mahog^y. Writing Desk
A little Strong box, w^th. brass furniture
A p^r. Mahog^y. China Shelves & 3 Brackets
A little Square Mahog^y. Table, inlaid
A D^o. Washing Stand
A Dress^g. Table, Pettycoat, Toilet, & Veil
A blue Dressing Carpet
A p^r. old blue Silk festoon Window Curtains
A Jappan Trunk & Stand
A Chimney Glass & Painting of the late Lord
 Litchfield *George*

Two Drawings of the late Lord Litchfield& his Lady, in
Oval frames, Glazed

N⁰. 19. *Continued.* In the Closets.

Shovel, Tongs, Dogs, & 2 hand Screens
A Mahog^y. Card Table
A p^r. Mahog^y. BookCases, w^th. Glass Doors
A Mahog^y. Claw Table
A Pedestal Dress^g. Glass
2 India Prints
2 old Cotton Counterpanes
An Oak Cloths Chest & Stand
2 Mahog^y. Night Stools
3 Bird Cages
A Jappaned Night Lamp, and Mahog^y. Stand.

N⁰. 20. In Lord Litchfield's Chamber

A Bedsted w^th. green Silk and Worsted Damask
furniture
A Check Hair Mattress
A White flock d^o.
A fine large feather Bed, Bolster, & 2 Pillows
2 Bedside Carpets, & little fire Screen
Shovel, Tongs, Dogs, Bellows, Brush & Tin Fender
A p^r. Mahog^y. Night Tables
An Easy Chair & Cushion, w^th. Decker Worked Cover
5 Armed Chairs, w^th. Check Covers
A p^r. green festoon Window Curtains lined
A Glass Lamp, & p^r. Brackets
A fine large Cabinet, with a curious inlaid Marble front
4 small Marble figures
A Chimney Glass, in a Gilt frame
{A Painting in a Gilt frame, of Henry Frederick Prince of
Wales, Elder Brother to King Charles 1^st. in Library
1880 in red drs

N⁰. 21. In Lord Litchfield's Dressing Room

Shovel, Tongs, Dogs, Brush, and Tin fender
A Mahog^y. Shaving Stand & Airing Screen
A Repeating Chime Clock, by Delander
A Mahog^y. Writing Table
A D^o. Dressing Window Table
A Dressing Glass
A Walnutree Dressing Chest, w^th. Drawers
2 p^r. old Red Camlet Window Curtains & Rods
6 Matted Chairs & an old Carpet
A large Wainscot Cloths Press, Glazed
A D^o. Bookcase
A p^r. Stilliards & Mahog^y. Scale
A Reading Candlestick
A large Painting of Henry Lord Ireland
A D^o. of Queen Elizabeth
A small D^o. of Lord North & Grey

A D^o. of Lord Le Despencer
A D^o. of M^r. Neville
A D^o. of Lady B. Lee
A D^o. of – Wilkins
A Drawing of D^r. Skeener, 3 Glazed Prints, & 3 Mapps^th.

N⁰. 22. In the Library & Closets.

Shovel, Tongs, Brass Dogs, fender, Bellows and Brush
An Easy Chair & Check Cover
A Red Leather Elbow Chair, 4 others, & a pair of old
Library Stool Steps
A Neat Mahog^y. Invalid's Chair
A large Mahog^y. Library Table & an Ink Stand
A Mahog^y. Writing Desk
Three d^o. Reading Stands
An India Chest and Stand
An old Carpet
A Library Ladder
A Chimney Glass, in a Gilt frame
A Single Harpsichord, by Mahoon
A little old Spinnet
A Bass Viol & Case
A Violin, Bow, & Case
18 Plaister of Paris Busts of Poets &^c.,
2 Canns, & 5 other figures
A Painting of a Queen
D^o. of the Mustard Woman
A Painting over the Chimney

All the Books, as p. the Library Catalogue.

N⁰. 22. Library Closets *Continued*

Apparatus for Printing & BookBinding
A little Strong Box & a Waywise
A Neat fowling Piece, by Harman , Silver
Mounted, & a short Barrel to D^o.
A Riffled Barrel Gun
2 Brass Blunderbusses
One Steel D^o, a Brace of Pistols, 3 Swords a Hanger,
& 2 Powder Flasks
A Shagreen Writing Box, & a Gouty Stool
9 Enamelled Bottle Labels
A Cuckoo Clock & Picture frame
A Horse Standard & a 10ft. Staff

N⁰. 23. In the blue Chamber, next, S.E.

{ A Bedsted w^th. old blue Mohair furniture
 Blue Bed Room
 a D^o. Counterpane, & 2 d^o. festoon Wind^w. Curtains
Two flock Mattresses
A feather Bed, Bolster, & 2 Pillows
A White India Quilt & 4 Blankets
2 Bedside Carpets

An Iron Hearth, Shovel, Tongs, Dogs, Bellows & Brush
2 Worked Elbow Chairs, 6 others, & a Worked fire screen
A Neat Mahog^y. Commode Chest Drawers
A p^r. Gilt Brackets & 2 Candlestands
A Pier Glass, in a Gilt frame
A Chimney D^o., in D^o.
A Walnutree Cloths Chest, w^th. Drawers
A Mahog^y. Claw Table
A Painting over the Chimney, & 2 others over the Doors

N^o. 24. In the Red Chamber.

A Bedsted w^th. Crimson Worsted Damask furniture,
 & 2 d^o. festoon Window Curtains
A Check Hair Mattress
A White flock D^o.
A feather Bed, Bolster, & 2 Pillows
A White Quilt & 4 Blankets
2 Bedside Carpets & an Oak Table
Shovel, Tongs, Dogs, brass fender, Bellows and Brush.
6 Webbed Chairs, w^th. Red Cushions
A Mahog^y. Card Table
A Walnutree Cloths Chest, w^th. Drawers
A Dressing Glass & 6 Boxes
A Chimney Glass, in a Party Coloured frame
✕ A Painting of Sir Tho^s. Pennyston and Sir Tho^s. Pope
A Painting of Nursing **Now in the west WC Passage**
A D^o. of Lady Charlotte Fitzroy

N^o. 25. In the Velvet Chamber & Dressing Room, South.

A Bedsted with Mahog^y. Posts & Rich figured Genoa
 Velvet furniture, 2 D^o. festoon Window Curtains,
 & D^o. hangings of the Room
A Check Mattress
A White D^o
A fine large feather Bed, Bolster & 2 Pillows
A White Sattin Quilt
A blue Check Counterpane, & 4 fine large Blankets
5 Carved Mahog^y. Armed Chairs & 2 Stools covered w^th.
 Genoa Velvet, & blue Check Cases
A curious French Dressing Table, inlaid with Brass
A fine large Oval Pier Glass, in a White Carved frame
A Steel Grate, Shovel, Tongs, & Poker
A Painting of a Ruin, in a White Carved frame, over the
 Chimney
A Dressing Box, w^th. Gilt Brass Ornaments, on a Gilt
 Stand
A Chimney Glass, in a Gilt frame
A large Jappan China Jarr (C | racked)
A Yellow Silk Damask Window Curtain, & 3 green Silk
 Window Blinds
A Painting over y^e Dress^g. Room Chimney
D^o. over y^e. Door.

N^o. 26. In the Gilt Drawing Room.

A Steel Grate Shovel, Tongs, Poker, and fender
A large Carved & Gilt Elbow Chair, & 8 others, w^th.
 Stuffed Crimson Silk Damask Backs & Seats
Six New Cabriole Armed Chairs, w^th Stuffed Crimson Silk
 Damask Back & Seats
Two fine Egyptian Marble Tables, on Rich Carved & Gilt
 Stands
A pair of fine large Pier Glasses, in elegant Carved & Gilt
 frames
3 Crimson Silk festoon Window Curtains
A fine large Ackminster Carpet
A p^r. of Gilt Candle Branches
Shovel Tongs, Dogs, & 2 old Jappan Tables
A Mahog^y. Claw Table, & D^o. Tea board
A full length Portrait of Charles 2^d. & the Dutchess of
 Cleveland, by Lely..
D^o. of the Duke of Grafton..
D^o. of Lady Charlotte Fitzroy, by Kneller .
A Landscape over y^e Chimney, by Wooton

N^o. 27. In the Green Damask Drawing Room.

A Grate, Shovel, Tongs, Poker, & Fender
A fire Screen, in a Neat Gilt and Carved frame, & Claw
 Stand
A Rose-Wood Sopha, w^th. a Squab & 2 Pillows, & 6 D^o.
 Armed Chairs, covered w^th. Green Silk Damask, w^th.
 stuffed Backs & Seats, & blue Check Covers
A fine large Carpet
2 pair green Silk Window Curtains & Rods, & 2 D^o. Blinds
A large Pier Glass, in an Elegant Carved and Gilt frame
A curious Italian Marble Slab, on a Rich Carved & Gilt
 Stand
A pair of Rich Carved & Gilt Candle Stands & Branches
A fine Jappan Cabinet & Stand
A large old Jappan China Jarr
2 blue China Beakers, & a small Cup & Cover
3 White Roman Charities & 20 other pieces of White
 Ornamental China
A fine cut Glass Chandeliere
A curious small figure of a Chinese Porter w^th. 2 Chests of
 Tea, & a Glass Cover
Two Italian pieces of Rocks, Ruins, & Cascades, over the
 Doors
A Landscape, by Wooton, over y^e Chimney
A Painting of S^r. Walter Rawleigh, by S^r. Anth^y Moore
D^o. of a Madona, by Mignard
D^o. of Archbishop Warehame, by Hans Holben
D^o. of a Moor & a Child, by Lely
D^o. of the Labourers in the Vineyard, by Van Molder
D^o. of a Lady, by Lely
Two small Oval Landscapes, by Bokenes

Nᵒ. 28. In the Saloon.

An Iron Hearth & Back, Shovel, Tongs, Poker, Dogs & Fender
A Chimney Glass
4 Windsor Chairs
8 Mahogʸ. Chairs, wᵗʰ. Leather Seats
A pair Marble Tables
A fine Toned Single Harpsichord, by Mahoon, & a Mahogʸ. Stool
An Antique of the Goddess Health, on a Carved Mahogʸ. Pedestal
An Antique Medallion of yᵉ Sailing Cupid, 12 ins. Diameter
A Bust of Dʳ. Sharp, by Risbrack
A Mahogʸ. Measuring Wheel, by Heath
A Brass Dᵒ, by Dᵒ.
A double Level, by Dᵒ,. & Stand
4 Glass Lamps

Nᵒ. 29. In the Tapestry Drawing Room, next

Shovel, Tongs, large Brass Dogs, and fender
A Mahogʸ. Sopha, Squab, & Pillow, with Red Check Cases
A Walnutree Dᵒ. & Dᵒ, and 2 Dᵒ. long Stools
6 Mahogʸ. Armed Chairs, wᵗʰ. Leather Seats & red Check Cases 1ˢᵗ Library 1890
A Mahogʸ. Claw Table
A Dᵒ Writing Desk & Book Shelf
A large Jappan Chest, on a Stand
A black Veined Marble Slab, on a large Carved & Gilt Stand
A Chamber Repeating Clock, by Delander, on a Carved Mahogʸ. Pedestal
A large Pier Glass, in a Gilt frame
2 Crimson Silk Festoon Window Curtains, & 2 green Silk Blinds
A large Wilton Carpet
A pʳ. Gilt Brackets, & 2 China Beakers
2 China Candle Branches, & 2 small fire Screens
Two Paintings of the Countess of Rochester & Lindesay, by Sʳ. P. Lely.
Sʳ. Fraˢ. Harry Lee, by Vandyke
Sʳ. Harry Lee, full length, by Johnson.

Nᵒ. 30. In the Damask Chamber, next, and Dressing Room.

A Bedsted with Crimson Silk Damask furniture, & a Dᵒ. Counterpane
A large White Mattress
A Check Hair Dᵒ.
A fine large feather Bed, Bolster and 2 Pillows
A Check Counterpane, and four large Blankets
 Library 1890

A Walnutree Easy Chair & Cushion & 6 others, with Stuffed Crimson silk Damask Backs & Seats, and Camlet Covers
4 Crimson Silk festoon Window Curtains, lined
A Jasper, Marble Slab, on a Gilt Stand (broke)
A large Pier Glass in a Neat Carved & Gilt frame
A Brass Grate, Shovel, Tongs, Poker, fender, Bellows & Brush
A Chimney Glass
3 Walnutree Armed Chairs
Shovel, Tongs, & Dogs
A Painting of George Henry Lord Quarendon
Dᵒ. of the Queen of Bohemia, by Kneller
Dᵒ. of Admiral Lee, by Seeman.
Dᵒ. of Sʳ. Wᵐ. Wynne, by Doll.
An Oval Dᵒ. of Lady Grandison
Dᵒ. of Villers Lord Grandison, by Vandyke
A Coloured Print of George 3ᵈ. in a Gilt frame.

Nᵒ. 31. In the Dining Room, next.

A Grate, Shovel, Tongs, Poker, & brass Fender
12 Mahogʸ. Chairs wᵗʰ. Leather Seats
A Mahogʸ. flap Table
A Dᵒ. Dumb Waiter
A large Dᵒ. Side board Table, on a Carved frame
A large black Veined Marble Table, on a Carved frame
A Mahogʸ. Wine Cistern & Bucket
A little Claw Dᵒ. & a Liquor Chest
A Dᵒ. Voider, wᵗʰ. Brass Hoops, & Stand
A large Turkey Carpet
A fire Screen in a Mahogʸ. frame, & a Scotch Side.board Carpet
A Diagonal Barometer, by Wells
A pair of Carved Candle Branches
A Chimney Glass
A blue Cut Glass Cup & Cover
A Cut Glass Cup & Cover with a Silver Cock, on a Gilt Stand
3 green Mohair festoon Window Curtains, & a Blind
A full length Portrait of Henry 8ᵗʰ. by Hans Holbeins
A Dᵒ. of Charles 1ˢᵗ. with Charles 2ᵈ. at his Knee, by Vandyke
Sʳ. Henry Lee & his Mastiff, by Johnson
Lord & Lady Litchfield, by Richardson & Vanderbank
Duke of Monmouth & his Mother
Prince Arthur, by Johnson.
Sir Charles Rich
Sir Christopher Hatton
Four Portraits of Sʳ. Henry Lee's Brothers, by Johnson.

Nᵒ. 32. In the next Closet, & Bathing Room,

A Marble Table WC
A Dᵒ. Cistern

A Glass Lamp
Two Maps
A Bathing Tub & Spout
A Beda, & Delph Cistern
A little old Grate
An Iron furnace & Grate

Nᵒ. 33. In the Music Room, next

Shovel, Tongs, Dogs, Fender, Bellows & Brush
2 Armed Chairs, wᵗʰ. red Check Covers
A Worked Walnutree Settee, a Dᵒ. Armed Chair
 & 6 others

Breakfast Room 1890
A Mahog^y. flap Table
A Dᵒ. little Claw Table
A Marble Table (broke) on a Walnutree frame
2 Candle Stands
A Pier Glass & brass Arms
A pʳ. Crimson Worsted Damask festoon Window
 Curtains, & 2 green Blinds
A Chimney Glass
A Turkey Carpet
A Mahog^y. Camera Obscura, by Cole
A German Flute, by Stanesby, & 2 small Music Stands
A Portrait of the Earl of Litchfields
Grandfather & Grandmother
Rubens & family, Hunting
Two Venetian Courtezans
A Landscape, by Wooton
3 Hunting Pieces, by Worsdell

Nᵒ. 34. In the Hall & Passages.

A large Grate, Shovel, Tongs, Poker, & fender
Six Carved & Gilt Seats
A Marble Slab, on a Carved & Gilt Stand
4 Glass Lamps, in Gilt frames
Two Paintings of Æneas & Venus, by Kent,
A Painting of Lord Litchfield, by Akerman
Six Plaister Figures of the Sciences & 9 Busts of
 Poets &ᶜ.
A Statue of Venus de Medecis
An Antique Bronze Bust
A curious Model of yᵉ. Radclivian Library
3 Umbrella's
A Mahog^y. Dumb Waiter
2 Square Mahog^y. flap Tables
An Oval Dᵒ. and a small Dᵒ
A Dutch Tea Kettle & Lamp, & Mahogany Stand
A Glass Lamp
A Mahog^y. Card Table.
A Bagammon & Card Table, Men & Dice.
A Mahog^y. Horse-Shoe Dining Table
A Marble Slab, on a large Carved and Gilt frame

A Glass Lamp
An Eight day Clock, by Mace
A Dove Coloured Marble Slab

Nᵒ. 35. In the next Tapestry Room

A Grate, Shovel, Tongs, Poker and fender.
2 Carved Walnutree Settes & 6 Dᵒ. Armed Chairs, wᵗʰ.
 curious Tapestry seats, & blue Check Covers
A fine Needle Worked Carpet
A Dᵒ. fire Screen, in a Carved Mahogany frame
A curious Mosaic Table, on a Carved & Gilt frame
A large Elegant Pier Glass, in Rich Carved & Gilt frame
A curious small Chinese figure of a Lady
A pair of Girandoles, with two India figures
Two blue silk festoon Window Curtains and 2 green
 Blinds
A large Picture of the Duke and Dutchess of York & the
 Princesses Mary & Anne, by Sʳ. Peter Lely, over the
 Chimney
Two Masterly Landscapes, over the Doors

Nᵒ. 36. In the Housekeepers Room & Pantry Ground Floor.

Shovel, Tongs, Dogs, fender, Bellows Brush & fire Screen
A Mahog^y. flap Table
8 Leather bottom Chairs
A Square Oak Table, an old Glass, an old Turkey Carpet,
 & old leather Screen
A large Deal Linnen Press, Dresser & Shelves
An old 8 day Clock, by East
2 old Paintings
An Oak flap Table, & 2 old Square Tables
A Wired Safe
A Dresser, Shelves & Plate Rack
An old Chest
A curious hand Water Engine & Pipes

Communion Plate

{ A Gilt Silver Cup & Cover
A Dᵒ. Salver & Cover
A Dᵒ. Plate

Six Elbow Chairs, with Leather Seats, in the Chapel

Linnen

56 pair of Coarse Servants Sheets some much worn
1789
 One pʳ Markᵈ 6 sent to Lillies Bucks for yᵉ use of yᵉ Steward
 1 pʳ for dᵒ. marked
✗ 37 pair of 2ᵈ. Sheets, some much Worn
13 pair of Holland Sheets, all much worn
A pair of small Sheets, marked Q
2 pair of Irish Sheets

Linnen Continued

3 pair of fine homespun Do

A pair of large Russia Sheets

2 pair of large new homespun Do

22 fine Holland Pillow Cases

6 very old Do

1 pillow case

marked 7 sent to Lillies for the above use

✕ 19 New Upper. Servants Pillow Cases

12 old Do.

8 homespun Do

2 very old small Do.

A large fine New Damask Table Cloth and 12 Napkins, Marked L No. 13.

A Do. & Do., Flower-Pot Pattern

Two large Irish Table Cloths, two Overlayers & 24 Napkins—Mosaic Pattern

A large old Damask Table Cloth & 12 Napkins, worn out

A large old Do. & 11 Napkins, w$^{th.}$ the Litchfield Arms Pattern

2 small TableCloths, Kings Arms Pattern

7 very old fine Huccaback TableCloths & 7 Dozn. & 2 Napkins, much worn

6 Sprigged Damask Table Cloths, & 5 Dozn. & 8 Napkins (of Rochesters Linnen) much worn

A Damask Table Cloth & 12 Napkins Oak Leaf Pattern

A Do. and Do Star-Pattern

Two Damask Table Cloths & 25 Napkins marked L [with coronet above] No. 4&5

A Table Cloth & 12 Napkins, marked L.

An old Table Cloth & 11 Napkins, Apostle Pattern, worn out

Three old Table Cloths & 36 Napkins Mosaic Pattern, worn out

4 old Irish Table Cloths, Mosaic Pattern

3 Strong Damask Do.

5 small Damask Breakfast Cloths, No. 4.5.6.7.8.

2 old Do. worn out

12 fine Damask Breakfast Napkins

21 Do. of another sort

20 Huccaback Hand Towels, Marked 26.

12 Diaper Towels

24 Course Do. marked 24.

23 fine Huccaback Do Marked L.

32 new Huccaback Towels marked 32.

6 odd old Napkins

12 New Diaper Towels, L.

24 New Do. Napkins ~~read Towels~~

17 Huccaback Stewards Room Table Cloths, some very much worn.

6 New Do. Breakfast Cloths

4 very small old Do.

2 old Damask Breakfast Cloths & 5 Napkins

7 Diaper Breakfast Napkins

4 Dresser Cloths, marked D.

3 Still Room round Towels

10 Venison Cloths

4 old Coachmans round Towels

5 footmens long Towels

24 Doylys

18 Glass Cloths

10 New Plate Cloths

8 old Oyster Cloths

15 Knife Cloths

10 Stewards Room Do.

14 Servants Hall Table Cloths (4 new)

5 Kitchen Dresser Cloths (very old.)

9 round Towels

14 New Rubbers.

1785 Delivered to Mrs. Mallet 23 Huckaback Towels marked L

China & Glass

A large old blue Octagon Dish

12 round Dishes, with a blue & Gold flower Pot Border, & 24 Do. Plates

7 old large round green Enamelled China Dishes

5 less Scolloped Do

5 less Do

4 odd Do

9 fine old Jappan China fruit Dishes

17 Do. Scolloped Plates

2 round Do

2 Scolloped Do

6 Oblong Scolloped coloured fruit Dishes

A fine old Punch Bowl

12 coloured Imaged Soop Plates

4 coloured Sallad Dishes

6 small coloured Plates

4 round blue Dishes & 24 Plates

2 Baking Do

2 Do. Water Plates

A Soop Dish & 16 Plates

A blue Tureen & Dish, 10 Oblong Dishes, 5 odd Plates, & 2 small Plates

2 blue Scolloped Sallad Dishes

7 blue Sauce-boats

28 blue Breakfast Plates

4 half Pint Dragon Cups & 8 Saucers

4 blue handled English Cups & Saucers

A Sugar Dish & 3 Pint Basons

Six Red & White oblong Chelsea Dishes and 8 Do. Plates

4 Octagon Basons & Saucers

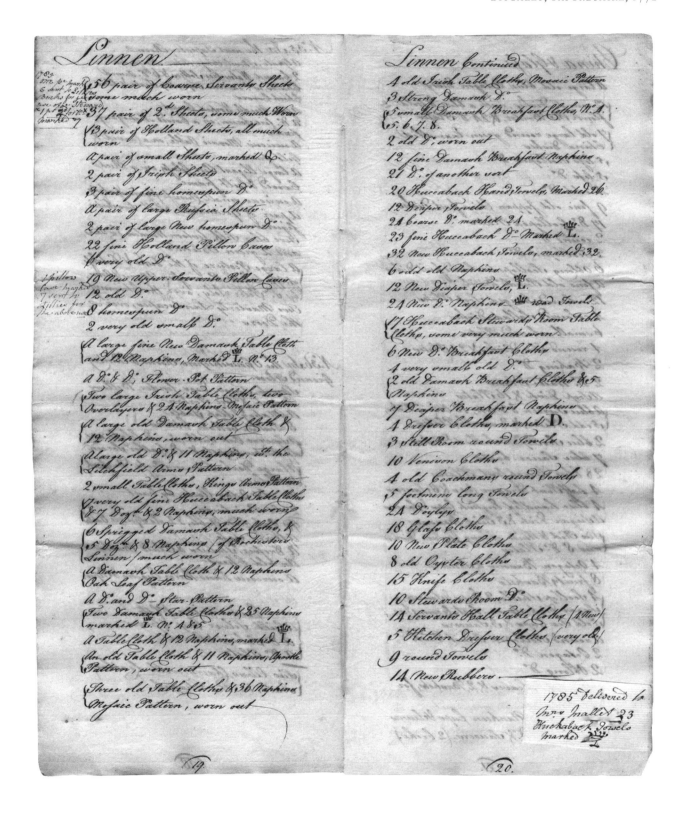

(Fig. 13) Inventory of Ditchley, Oxfordshire, 1772, 'Linnen', folios 19–20. *Pelican and Coronet Company*

China & Glass Continued

8 fruit Baskets

4 Scollop Shells, 2 Cups & Saucers, a Sugar Dish,
 Spoon-boat, Cream Jug, 5 old Tea Cups & 3 Saucers

A round Scolloped Fruit Dish

2 Octagon D°.

2 Oblong D°

6 Dishes & Leaves & 2 Baskets, for a Desert

6 Scolloped Nankeen Cups & Saucers

6 handled D°. & Saucers (2 broke)

5 Green & White Ribbed Cups & 3 odd Saucers

17 odd blue Tea Cups & 20 Saucers

A White Pint, half Pint, 2 Saucers & a Tea Pot

3 Chelsea China Lemons & 3 Melons

2 little Baking Dishes & 5 Pickle Plates

Glass Salvers, Dishes, Baskets, & other Desert Glasses

3 Jappan Tea boards

A Square D°

A Set of English Coloured & Gold Tea China, containing,
 A Tea Pot (broke) & Stand, 12 Teacups & 12 Saucers,
 6 Coffee Cups, 6 Chocolate Cups & Saucers, a Coffee
 Pot, Cream Jug, Tea Cannister Sugar Dish & Cover,
 Spoon, boat, Slop Bason & Plate.

A Set of Dresden Pattern D°. containing a Tea Pot (wth.
 a Silver Gilt Spout) and stand, 12 handled Tea Cups &
 Saucers, 4 Chocolate Cups & Saucers, Sugar Dish &
 Cover, & Slop Bason

2 old Burnt.in Basons & Covers

A D° Sugar Dish & Cover & a Saucer

A Tea Pot & Stand & an odd Chocolate Cup

6 coloured Chocolate Cups & Saucers

D°.

6 couloured handled Coffee Cups

8 coloured Scolloped Tea Cups & Saucers

3 old coloured fruit Stands

12 French China Desert Dishes & 24 Plates

A Set of Green & White French Table Delph, containing a
 Tureen & Dish (mended) 14 oblong Dishes, 2 round
 d°, 54 Plates, and 4 Sauce Boats & Covers.

3 frames & Glasses belonging to the Desert, & 13 small
 China figures

N°. 37. In the Smoking Room

An old Grate, Corn Binn, & Steps

2 Braziers

A Mahogy. Chamber- Pot-Cupboard

A large Marble Bust.

N°. 38. In the Still Room

Shovel, Tongs, Dogs, Crane, 3 hooks, a Gridiron,
 footman, Bellows, & Salt Box

A Copper Still & Worm Tub

A pr. Stilliards, Lock Iron & Pads

An Oak flap Table

2 old Chairs, a Stool, Steps, little Table, little Tub &
 2 Buckets

2 Oak Presses & a Painted Cupboard

A Marble Mortar & a Coffee Mill

2 Candle Chests

A Dutch Urn, & D°. Tea Kettle & Lamp

A Shagreen Tea Chest, wth. Glass Tea Cannisters

A pr. Copper Scales & 4 lb. brass Weights

A Copper Water Boiler

4 Copper Preserving Pans & a Stew Pan

A Copper Cheese Toaster, Chocolate Pot, Coffee Pot,
 & 2 Saucepans

Two Tea Kettles

A D°. Cannister

Some Queen's Ware & Pickle Pots

22 flat brass Candlesticks & 8 high D°.

N°. 39. In the Cellars.
Ale Cellar.

18 Iron bound Pipes

2 Hogsheads

6 Oak Stands

7 East Tubs and a Brass Cock

Small Beer Cellar, opposite.

2 Pipes

18 Hogsheads & 3 Cyder Casks

7 Stands & a Brass Cock.

Strong Beer Cellars.

11 Iron bound Pipes

5 Stands & Brass Cock.

N°. 40. In the Butlers, Pantry's

A Bedsted wth. blue Camlet Curtains

An old Mattresss

A feather Bed, Bolster, & Pillow

A Quilt & 3 Blankets

A Square Table & 2 Wood Chairs

2 Mahogy. Dinner Treas

2 old Tables & 2 Plate Baskets

5 Dozn. of Wine &c. Glasses & 12 Decanters

12 old Common Knives & forks

N°. 41. In the Stewards Room

Shovel, Tongs, Dogs & Iron bar

A large Square Oak Dining Table

A small flap D°. & an old Turkey Carpet

12 Oak Chairs

An old Landscape, & 2 Glass Sconces

Nᵒ. 42. In Mʳ. Burr's Office

Shovel, Tongs, Dogs, Bellows & Brush
An Oak flap Table & 2 Windsor Chairs
A Barometer
A Dressing Glass
Three Guns

Nᵒ. 43. In the Servants Hall

3 old long Tables & 6 foarms
A Gridiron & ffire Rake
A small flap Table & Bucket
4 Copper Warming Pans
A small ffire Engine, and 24 Leather Buckets.

Nᵒ. 44. In the Kitchen & Scullery, &c.

A large Grate, Shovel, Poker, Spit Racks, 2 Trivets,
 Pig Iron, Salamander & Cast Iron back
A smoke jack, complete
A long Kitchen Table
A large Copper Soup Pot & Cover
4 less Dᵒ
A Brasing Pan
2 Copper Fish Ketles, Covers & Plates
A Turbot Pan & Cover
18 Stew Pans & Covers
3 frying Pans
A Melon, 6 Baking Pans, & 2 Pudding Pans
A Pasty Pan
16 Saucepans
2 Cullenders
A Copper Pot & Cover, 2 Skimmers, 3 Ladles, 2 Slices
 & 3 Spoons
45 Pewter Dishes, 6 Cheese Plates
170 Plates, 4 Water Plates
A Tureen & Cover, & 6 Sauce Boats
6 Spits & an Iron Dripping Pan
3 Gridirons & 2 Cleavers
9 Stove Trivets
A little Furnace, in yᵉ Scullary, hung
A double Boiler & Cocks
A large Plate Rack
2 Rincing Tubs, 3 Pails, & a Wash Tub
2 Salt Tubs, & a little Plate Rack
A Marble Mortar
A Bell Metal Dᵒ.
2 little old Tables & 2 Chopping Blocks
A large Beam & Scales & 311ˡᵇ Lead & Brass Weights
A Hand-barrow, Chicken-Pen, Sledge & Tub
Some Tin, Earth & WoodWare

Nᵒ. 45. In the Cooks Chamber

A Bedsted wᵗʰ. blue Curtains, and an old Mattress
A feather Bed, Bolster & Pillow
A Quilt & 3 Blankets
An old Table & 2 old Chairs

Nᵒ. 46. In the Larder

2 Leaded Salting Troughs
A Chopping Block & pair of Steps
Dressers & Shelves

Nᵒ. 47. Over the Larder

A Bedsted wᵗʰ. Striped homespun furniture
A feather Bed, Bolster, & 2 Pillows
A Quilt & 3 Blankets
A Bedsted wᵗʰ. Yellow Curtains
A feather Bed & Bolster
A Rug & 3 Blankets
An old Night Stool & Pewter Pan
2 Pewter Chamber Pots & an old Table

Nᵒ. 48. In the footmen's Room

4 Stump Bedsteds
5 feather Beds, 4 Bolsters & 2 Pillows
4 Rugs & 13 Blankets
A Painted Table & an old Table
4 Pewter Chamber Pots

Nᵒ. 49. Over the Kitchen

A Bedsted wᵗʰ. green Curtains & an old Mattress
A feather Bed Bolster & Pillow
A Quilt & 3 Blankets
Afaneered Walnutree Buroe
A Desert Table & Curtains
An Oak Table, Glass, & 3 old Chairs
2 pʳ. old Damask Window Curtains
Shovel, Tongs, Dogs, fender, Bellows and Brush
A Drum Night Stool.

Nᵒ. 50. In the Cistern Room

2 old Tables, an old Bedsted, 2 old Chairs, Wig Blocks,
 & some Feathers
A Turret Clock, & 2 Bells.

Nᵒ. 51. In the Bakehouses

A Brass furnace, Lead & Iron work
A Bolting Mill,
A Dough Kiver & Moulding Boards
A Stell Malt Mill
A pair of high Steps
A Bedsted, old feather Bed, Bolster, and a Blanket.

Nᵒ. 52. In the Brewhouse

A large Brewing Copper, Lead & Iron work, & large Cock
A Wort-Pump & Spout
A large Marsh Tub
A Leaded Underback
A large Cooler, Leaded
A less Dᵒ
A Working Tub
2 Carrying Tubs, a Hop Seive and 3 Spouts.

No. 53. In the Dairy

Shovel, Tongs, Bellows & hanger
3 old Chairs, a Stool, & little Table
A Cheese Press.
2 Tubs, 2 Buckets & a Salt Box
2 little Brass Kettles
A Bacon Rack & Pully
5 Milk Leads & Stands
A Tumbrel
4 Milking Buckets & 2 Yokes
A Cheese Tub & 2 Kivers
Butter Scales & 12 Cheese boards
Earth Pots & Pans.

Nᵒ. 54. In the Washouse

A Washing Furnace, Leaded
A Buck Tub
10 Washing Tubs
A Wet Horse, foarm, Bucket, Bowl & 2 Piggons
A Brass Kettle & Starch Saucepan.

Nᵒ. 55. In the Landry.

A Grate & Cheeks, Shovel, Tongs, Poker fender
hanging Iron, Trivet, & Tea Kettle
An Ironing Stove
18 flat Irons, a Box Iron & Pad
A Mangle, complete
An Ironing board & 7 Stools
A Claw Table
An old Square Table, & 4 Window Curtains & Rods
A hanging Drying Horse, Jack and Lines
Two Wood Horses, 13 flaskets, & an Ironing Blanket.

Nᵒ. 56. Over the Washouse

A Bedsted wᵗʰ. Striped Curtain
A feather Bed Bolster & Pillow
A Rug & 3 Blankets
A Deal Table

Nᵒ. 57. In the next Room

A Bedsted with old worked Curtains
An old Mattress

A feather Bed and Bolster
A Rug & 3 old Blankets
A Night Stool & Pewter Pan, & an old Chamber Pot
2 old Tables, 2 Chairs, and a Window Curtain
An old Painting

Nᵒ. 58. Over the Landry, next

5 Spinning Wheels & a Reel
2 Leather Portmanteaus
An Oak Chest
12 old Chicken Coops
Some old Tapestry
An old Painting & Picture frames.

Nᵒ. 59. In the Cheese Chamber.

A large Cheese Rack
A pair of Steps, an old Box, and a Grate
8 old Paintings.

Nᵒ. 60. In the next Room, over yᵉ Dairy

A Bedsted with green Curtains & 2 pair of Window
 Curtains
A feather Bed Bolster & Pillow
A Quilt & 3 Blankets
An Oak Table, a Glass, and 6 Matted Chairs
Shovel, Tongs, Dogs, Bellows, & a Pewter Chamber
 Pot
2 old Paintings.

Nᵒ. 61. In the Carpenters Room & Shop

A Stump Bedsted & Mattress
A feather Bed Bolster & Pillow
A green Rug & 3 old Blankets
An old Tent
An old Weather Screen
A pair of Steps & a Window Machine
An Oak Bedsted
A Travelling Bedsted
A Step Ladder.

Nᵒ. 62. At the Stables, &ᶜ.

In the 1ˢᵗ. Room
A Stump Bedsted
An old feather Bed & Bolster
A Rug & 3 old Blankets
A small old Iron Chest
A Screw Hoop
An old Table, Trunk & Boxes.

2ⁿᵈ. Room
A Stump Bedsted
An old feather Bed & Bolster
A Rug & 3 old Blankets

3rd. Room

A Stump Bedsted
A feather Bed & Bolster
A Rug & 3 old Blankets

5th. Room

A Stump Bedsted
A feather Bed & Bolster
An old Rug & 3 Blankets

6th. Room

A Stump Bedsted
A feather Bed, Bolster & Pillow
A Rug & 3 Blankets

7th. Room

A Sparred Bedsted
An old Table

9th. Room

A Bedsted with Striped Linnen furniture
A feather Bed & Bolster
A Rug, 3 old Blankets, and an old Table

10th. Room

A Stump Bedsted
A feather Bed & Bolster
A Rug & 4 Blankets
A Deal Table

Nº. 63. In the Garden House

A Stump Bedsted & an old Blanket
A feather Bed, Bolster & Pillow
An old Chair and a Pewter Chamber Pot
A Nest of Seed Drawers.

The forgoing Inventory Taken the Days and year beforementioned

p Rich^d: Way
James Way.

The Norfolk Inventories

Houghton, Norfolk, 1745 and 1792

Holkham, Norfolk
and Thanet House, London
1760

Houghton, 1745 and 1792

Rebuilt on the site of two earlier houses for Sir Robert Walpole (1676–1745), Britain's first prime minister. Building commenced in 1722 to the designs of architects James Gibbs (1682–1754) and Colen Campbell (1676–1729). The interiors were masterminded by William Kent but incorporated some of the furnishings from the earlier house on the site, including a remarkable set of Mortlake tapestries with royal Stuart portraits.

Sir Robert assembled one of the most important art collections but the paintings were sold after his death in 1778–9 by his grandson George, 3rd Earl of Orford (1717–1791), to Catherine the Great and now belong to the State Hermitage Museum. Much of the sculpture listed still remains at Houghton and the smaller pieces were originally supported on marble tables which acted as plinths. The 1745 inventory indicates clearly which rooms were hung with old master paintings. The paintings listed in the 1792 inventory are mainly family portraits. In 1745, the Cabinet Room, Wrought Bedchamber and Velvet Drawing Room are all provided with brass mortise locks, a new form providing enhanced security, only introduced in the 1730s.

The 1792 inventory throws light on the earlier one. The annotations were made by Horace Walpole, Sir Robert's younger son. Thus No. 38 India Silk Taffetta Bed Chamber bears the comment 'this was Sr Robert's own Bedchamber' and No. 46 the Principal Bed Chamber with a superb state Bed with raised tester is annotated 'This bed cost £2000'. As most of Sir Robert Walpole's bills were destroyed in order to conceal the true costs of furnishing Houghton, such comments provide fascinating insight into the original circumstances. Recently discovered documents relating to Sir Robert Walpole's estate in the National Archives include an assessment of furniture at Houghton and Stanhoe Manor House as £7,150. The contents of the rooms on the principal floor at Houghton are valued at £2,051 9s 6d, of which the Green Velvet State Bedchamber, the most richly furnished, totalled £487 19s. The 1792 inventory lists recent acquisitions, for example the 'Elegant Chandelier with 12 Lights' in the Stone Hall which was acquired by Lord Orford from the sale of the contents of Lord Cholmondeley's London house in 1748. There is greater evidence for the practical equipment needed to run the house like the silver lighting equipment in the Butler's Pantry and the Chinese export porcelain decorated with the Orford arms. Measurements are given for the pier glasses and marble tables. The Hall and its contents were inherited by Horace Walpole and on his death in 1797 the house passed to his great nephew George, 4th Earl and 1st Marquess of Cholmondeley.

These documents belong to the Marquess of Cholmondeley and remain at Houghton Hall, Norfolk. The 1745 inventory is in a hardbound book which was used to press flowers. The 1792 inventory is in a green hardbound book supplied by the stationer and bookbinder William Grace of Long Acre, London.

TESSA MURDOCH

Inventory of Houghton, May the xxv, MDCCXLV

The Main House

Basement Story

The Little Parlor

Two Tables
Thirteen Chairs
One Looking Glass
One Night Box
One Buroe
One Clock
One Weather Glass
One Grate, fire pan, tongs, poker & fender,
One floor Cloth
Two Brass Locks to Doors
Nine Pictures
One Wire Window shade

Suppin Parlor

Three Tables
Eighteen Chairs
Two Pair of Blue window Curtains
One floor Cloth
One Grate, fire pan, tongs, poker & fender

Two Brass Locks to doors
Eleven Pictures

Hunting Hall

Four Tables
Seventeen Chairs
One Grate, fire pan, tongs, poker & fender
One floor Cloth
Six Brass Locks to doors
Two Pictures
Two Maps

Alcade

Twenty four Chairs
Nine Lanthorns
One Large floor Cloth
Two Large Settees
Ten Brass Locks to Doors
Four Black Fenders
Two Poker's
Two Fire Engine's of M^r: Newsham's with Leather pipes,
 and four Dozen of Leather Buckets to D^o:

Coffee Room

Seven Tables
Twenty two Chair's
One Pier Glass
One Settee
Four Stands

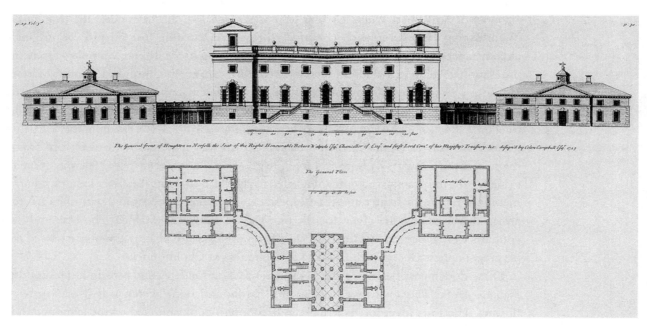

(Fig. 14) Plan and elevation of Houghton, Norfolk, from Colen Campbell, *Vitruvius Britannicus*, vol. III, 1725. *Victoria and Albert Museum*

One Thermometer
Four Brass Sconces
Two Glass D°:
One Grate, fire pan, tongs, poker & fender
Two Pair of Blue window Curtains
Six Brass Locks
Five Pictures

Plad Room

One Bed, Bedstead and Plad Hangings
One Matterass
Three Blankets
One White Quilt
One Bolster
One Pillow
One Counterpane
Two Looking Glasses
One Pair of Plad window Curtains
One Chest of Draws
One Table
One Stand
Thirteen Chairs
One Grate, fire pan, tongs, poker & fender
Two Brass Locks
One Picture

Blue Room, North

One Bed, Bedstead & Blue Hangings
One Matterass
Three Blankets

One White Quilt
One Bolster
One Pillow
One Counter Pane
One Small Buroe
One Table
One Stand
One Looking Glass
Six Chair's
One Grate, fire pan, tongs, poker & fender
Two Brass Locks to Door's

Yellow Room, North

One Bed Bedstead & Yellow Hanging
One Matterass
One Bolster
One Pillow
Three Blankets
Two Quilts
One Looking Glass
One Pair of Window Curtains
One Table
One Stand
Six Covered Chair's
One Grate, fire pan, tongs, poker & fender
Two Brass Locks to Doors

Bath Room

Not Furnished
Two Brass Locks to doors

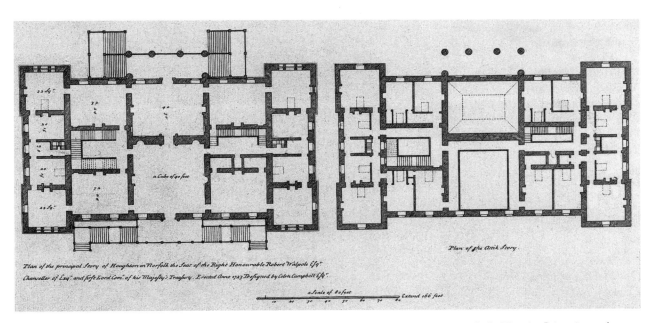

(Fig. 15) Plan of the principal storey and attic storey of Houghton in Norfolk, from Colen Campbell, *Vitruvius Britannicus*, vol. III, 1725. *Victoria and Albert Museum*

Second Stair's North Passage

Two Brass Locks to Door's

Stewards Parlor

Three Tables
One Large Leaf for Do:
Twenty two Chair's
One fire skreen, fender, poker & Crane,
Two Iron Rim'd Lock's to Door's

Pantry

One Table
Three Chair's
One Iron Rim'd Lock to Door

Inner Pantry

One Table
Two Chair's
One Poker
One Iron Rim'd Lock to Door

Grand Story

Lord Orfords Bed Chamber

One Bed, Bedstead and painted Taffity Hanging
Two Matterasses
One Bolster
Two Pillow's
One White Quilt
Three Blankets
One Settee
Four Chair's and one Stool
Two Pictures
One Hearth Iron
Two Pair of Andirons
One fire pan, tongs Bellows & Brush
One Table & one Looking glass
One Pair of Window Curtains
Two Brass Lock's

In Closit's

One Chair and one Stool
Two Brass Latches to door's

In Study

Two Tables with Draws
One Mahogony Oval Table
Eleven Chair's
One Hearth Iron
One Grate, fire pan, tongs, poker
Bellows and Brush

One Brass Wire fender
Two Brass Locks to doors
One Picture
One Silver Ink stand
One Do: stand, Pair of Candle sticks and Bell, with Iron
 Snuffer's
Two Telescopes
One Reading Skreen

Common Parlor or dining room

Six Tables
Twenty four Chair's
One Pier Glass
One Hearth Iron, with a Grate, fire pan tongs, poker,
 fender, Bellow's & Brush
One Large Chandelier
Twenty seven Pictures, with festoon's of Carving over the
 Chimney
Four Brass Locks to Door's

Hall

One Large Lanthorn
Two large marble Tables, with one Busto one Copper
 Vause, and one copper figure on Each
One Large Figure of Laocoon
Six Settee's
Four Terms at Corners with Bust's on Each
Two Terms with Bust's on Do: in Nitches
Eight Trusses with Bust's on Do: and Festoon's
 over Do:
One Bust over Chimney of Late Lord Orford
four Doors with Pediments and two figures over Each
Two Large Figures over Great Door
One Hearth Iron, with a Coal Grate, fire pan, tongs,
 poker and fender
One Brass Lock to Great Door
Two Brass Mortice Locks to Stair cases and Shams
 to Do:
Two Brass Latches to Dining Room and Common
 Parlor

Marble Parlor

or Great Dining Room

One Marble Table
One Settee
Twelve Arm Chair's
One Large Pier Glass with Sconses
One Hearth Iron, one Grate two Pokers
one fire pan, tongs, and fender
Six Pictures
Two Brass Locks and two sham's

In side Board

Two Marble Tables
One Large Marble Bason
Two Silver Cocks, under the Tables
One Brass Lock and one sham

Cabinett

One Table
Two Settee's
Fiveteen Chair's
Two Glass Oval Sconces with three Branches Each
One Hearth Iron, one Grate, poker, firepan, Tongs,
 Fender, Bellows & Brush
Fifty one Pictures
Two Brass Mortice Locks and one Sham

Cov'd or Wrought Bedchamber

One Bed, Bedstead & Wrought Hangings
Three Matterasses
One Bolster
Three Blankets
One Green Quilt
One Wrought Quilt like the Bed
Green, Case Curtains to the Bed
One Pair of Green silk window Curtains
One Table
Two Stands
One India Chest
One Looking Glass
Eight Chair's
One Hearth Iron, Grate, Pair of Andiron's, fire pan,
 Tongs, Brass Wire, fender, Bellows and Brush
Three Pictures
Two Brass, Mortice Locks to doors

Anti Room North Front

One Table
One Chair
One India Skreen
One Brass Lock

Vandyke Dressing Room

One Glass Table
One India Cabinett
One Silver Filligreen Cabinett
Ten Chair's
One Hearth Iron, Grate, Pair of Andirons, fire pan, tongs,
 fender, Bellows, & Brush
One Pair of Green, Velvett window Curtain's
Three Pictures
Two Brass Mortice Lock to Doors
Tapestry Hanging of the Stuart Family

Green Velvett Bedchamber

One Bed, Bedstead and Green Velvett Hangings
Two Matterasse's
Green Silk Case Curtains to the Bed
One Bolster
Three Blankets
One Green Quilt
One Green Velvett, Counter Pane
One Table
One India Chest
One India Cabinett and Skreen
Eleven Chair's
One Pair of Green Velvett window Curtains
One Hearth Iron, Grate, fire pan, tongs, Brass Wire
 fender, two pair of Andirons and Brush
Three Pictures
Two Brass Locks to Doors
Tapestry Hanging of Venus & Adonius

Velvet Drawing Room

One Fineared Table of Lapis Lazulli
One Large Pier Glass
Two Settee's
Twelve Chair's
Four Stools
One Brass Chandelier with Eight Branches
Four Large Silver Sconces with two Branches Each
Twenty seven Pictures
One Hearth Iron, Grate, two poker's, fire pan, tongs,
 fender, and Brush
Three Brass Mortice Locks to doors
One Sham Dº:

Salone

One Large Marble Table with a Copper figure on Dº:
Two Lesser Marble Tables, with an Oriental Agate Urn
 on Each
Two Terms by Dº:
Two Settee's
Twelve Chair's
Four Stools
Two Tea Tables with Cups Saucers &c on Dº:
Two Festoon's by Chimney with four Branches Each
Two Large Pier Glasses
One Busto over the Chimney
One Busto over the Great door West Front
Fourteen Pictures
One Hearth Iron, Grate, fire pan, tongs, poker, Fender,
 and Brush
Four Brass Mortice Locks to Doors
Two Sham Dº:
Two Brass Chandelier's with Eight Branches Each

Yellow Drawing Room

One Marble Table
One Large Pier Glass
One Couch and three Pillows to Do:
Two Settees
Twelve Chairs
One Card Table
Two Pair of Window Curtains
One Busto over the Chimney
Fiveteen pictures
One Brass Chandelier with Eight Branches
One Hearth Iron, Grate, fire pan, tongs
poker, fender, Bellows and Brush
Three Brass Locks to Doors

Blue Bedchamber

One Bed, Bedstead and Blue Hanging
Case Curtain's to the Bed, Blue
Two Mattrasses
One Pair of Window Curtains
One Bolster
Three Blankets
Two Pillows
One White Quilt
One Blue Counter Pane
One Table
Two Stands
One Looking Glass
One India Chest
One Inlaid Cabinett
One Settee
Ten Chairs and one stool
One Hearth Iron, Grate, fire pan, tongs, poker, Brass
 Wire fender and Bellows
Three Pictures
Three Brass Locks to Doors

Closit to Bedchamber

One Stool and one Stand
A Field Bed, with three Blankets, one Bolster, and two
 pillows
Two Brass Locks to the Closit
Tapestry Hanging to the Bedchamber of the Seasons

Blue Dressing Room

One Field Bed, Bedstead and Hangings
One Matterass
One Bolster
Three Blankets
One White Quilt
One Pair of Window Curtains
One Table
One Looking Glass

One Settee
Six Chairs
Two Pair of Andirons, fire pan, tongs, Fender, Bellows,
 and Brush
One Picture over Chimney
Two Brass Locks to Door's

Anti Room South front

One Brass Lock to the Door

In Great Stair's

A Large Gladiator of Brass
Six Globular, Glass Lamps in Angles

Mensaneen Story

North Stairs

One Bed, Bedstead, and Yellow Hanging
Three Blankets
One Coverlid
One Bolster
One Pillow
One Chair
One Table
One Iron Rim'd Lock to door
One Lanthorn in Stair's

South Stairs

Two Beds and Bedsteads
Six Blankets
One Rug, one Counter pane
Two Bolster's
One Table and three Chairs
One Latch to Door

Two Beds and Bedsteads
Six Blankets
Two Counter panes
Three Bolsters
Two Chairs
One Lanthorn on Stairs

Attic Story

Red Mohair Room

One Bed, Bedstead, and Red Hanging
One Matterass
Three Blankets
One White Quilt
One Bolster
One Pillow
One Counter pane

One Pair of window Curtains
One Table
One Looking Glass
One Buroe
Nine Chair's and one Stool
One Hearth Iron, Grate, fire pan, tong's
poker, fender, Bellow's, and Brush
Two Brass Lock's to Door's

Little Yellow Room

One Bed, Bedstead, and Yellow Hanging
Three Blankets
One Quilt
One Bolster
One Pillow
One Table
Two Chair's
One fire pan, tongs and poker
One Brass Lock to Door

Little Green Room

One Bed, Bedstead, and Green Hanging
Two Blanket's
One Quilt
One Bolster
One Pillow
One Table
One Looking Glass
One Chest of Draws
Two Chair's
One Pair of Window Curtain's
Two Brass Locks to door's

South East Corner Room

One Bed, Bedstead, and work't Chint's Hanging
Case Curtain's to the Bed of Red Shaloon
One Pair of Window Curtain's
Two Matterasses
Three Blanket's
One White Quilt
One Counter pane
One Bolster
One Pillow
One India Chest of Draws
One India Bookcase, with a Marble Ure on D°:
Two Tables
One Buroe
One Looking Glass
One Stand
Two Settees
Eight Chair's two Stool's and one Close Stool Chair
One Coal Grate, fire pan, tong's, poker, fender, Bellow's
 and Brush

four Picture's
Two Brass Locks to Doors
One Reading Skreen

Callicoe Room South front

One Bed, Bedstead and Callicoe hanging
One Pair of Window Curtain's
Two Matterasses
Three Blankets
One White Quilt
One Counter pane
One Bolster
One Pillow
One Table
One Looking Glass
One Stand
One Chest of Draws
Six Chair's
One Coal Grate, fire pan, tongs, poker
fender, Bellows and Brush
One Picture over Chimney
One Brass Lock to Door

One Lanthorn in Passage

Red Room South front

One Bed, Bedstead, and Red Hanging
One Pair of Window Curtain's
One Matterass
Three Blankets
One White Quilt
One Counter pane
One Bolster
One Pillow
One Table
One Looking Glass
One Stand
Six Chair's and one Stool
One Coal Grate, fire pan, tongs, poker, fender, Bellows
 and Brush
One Picture over Chimney
Two Brass Locks to door's

Closit to Ditto

A Field Bed, Bedstead and Blue hanging
A Pair of yellow window Curtain's
One Matterass
Four Blankets
One Bolster
Three Pillows
One Quilt
One Table
One Looking Glass

South West Corner Room

One Bed, Bedstead and Yellow Damask Hanging
Case Curtains to the Bed, Yellow
One Pair of Window Curtain's
Three Matterasses
Three Blankets
One White Quilt
One Counter pane
One Bolster
One Pillow
One India Chest
One India Skreen
Two Settee's
Eight Chairs
Two Table's
One Chimney Glass
One Looking Glass
Five Picture's
One Coal Grate, fire pan, tongs, poker, fender, Bellows
 and Brush
Two Brass Locks to doors
Tapestry Hanging to the Room

One Stool in Closit

White work't India Bed West Front

One Bed, Bedstead, and work't Hanging
Case Curtain's to the Bed, Yellow
One Pair of window Curtain's work't
Two Matterasses
Three Blankets
One White Quilt
One Counter pane
One Bolster
One Pillow
One Table and one Card Table
One Looking Glass
One Buroe
One Night stool
Seven Chairs and one Arm Chair
One Stool
One Hearth Iron, Coal Grate, fire pan, tong's, poker,
 fender, Bellows, and Brush
Two Pictures
One Brass Lock to Door
Tapestry Hanging to the Room

Little Blue Room West front

One Bed, Bedstead and Blue Hanging
Two Matterasses
Three Blankets
One Quilt
One Bolster

One Pillow
One Table
One Chest of Draws
Two Chairs
One Looking Glass
One firepan, tongs, poker, fender, Bellows and Brush
One Brass Lock to door

Little Room by Great Stairs

A Bed and Bolster two Blankets and a Quilt
A Pair of Blue Curtains to the Bed
One Chest of Draws
One Brass Lock to the Door

White work't Bed East front

One Bed, Bedstead and work't Hanging
Case Curtain's to the Bed, Green
One Pair of White Quilted window Curtains
Two Matterasses
Three Blankets
One White Quilt
One Bolster
One Pillow
Two Tables
One Looking Glass
One Chest of Draws
Seven Chairs
One Hearth Iron, Coal Grate, firepan, tongs, poker,
 fender, Bellows and Brush
Two Brass Locks to Door's

Little Red Room East front

One Bed, Bedstead and Red Hanging
One Pair of Window Curtains
One Matterass
Three Blankets
One White Quilt
One Bolster
One Pillow
One Table
One Looking Glass
Six Chairs
One Coal Grate, fire pan, tongs, poker
and fender
Two Brass Locks to Doors

Little Blue Room

One Bed, Bedstead and Blue Hanging
Two Pair of Window Curtains
Two Blankets
One White Counter pane
One Bolster
One Pillow

One Table
Two Chair's
One Looking Glass
One Coal Grate, fire pan, tongs, poker and fender
One Brass Lock to Door

Painted Taffaty or North East Corner Room

One Bed, Bedstead, and Taffaty hanging
Case Curtain's to the Bed, Green
One Pair of Window Curtain's
Two Matterasses
Three Blankets
One White Quilt
One Counter pane
One Bolster
One Pillow
One India Chest
One India Skreen
Two Tables
One Looking Glass
Two Settee's
Eight Chairs
One Coal Grate, fire pan, tongs, poker fender and Brush
Four Pictures
Two Brass Locks to Doors

One Stool in Closit

Blue Room North front

One Bed, Bedstead and Blue Hanging
One Pair of Window Curtains
One Matterass
Three Blankets
One White Quilt
One Counter pane
One Bolster
One Pillow
One Table
One Looking Glass
One Stand
Six Chairs
One Coal Grate, fire pan, tongs, poker, fender, Bellow's
 and Brush
One Picture over the Chimney
One Brass Lock to Door

One Lanthorn in Passage

Callicoe Room North front

One Bed, Bedstead and Callicoe hanging
One Pair of Window Curtains
One Matterass
Three Blankets
One White Quilt

One Counter pane
One Bolster
One Pillow
One Table
One Looking Glass
One Stand
Seven Chairs
One Coal Grate, fire pan, tongs, poker
fender and Brush
One Picture over the Chimney
Two Brass Locks to Door's

Closit to Ditto

A Field Bed. Bedstead and Yellow Hanging
Three Blankets
One Bolster
One Pillow
One Blue Rug

North West Corner Room

One Bed, Bedstead and Chints hanging
Case Curtain's to the Bed Blue
One Pair of Chints window Curtains
Three Matterasses
Three Blankets
One White Quilt
One Blue Silk Counter pane
One Bolster
One Pillow
Two Tables
One Looking Glass
One India Chest
Two Settee's
Eight Chairs
One Coal Grate, fire pan, tongs, poker, fender Bellows
 and Brush
Four Picture's
Two Brass Locks to Door's
Tapestry Hanging to the Room

One Stool in the Closit

Red Damask Room West Front

One Bed, Bedstead, and Red Damask Hanging
Red Silk Case Curtain's to the Bed
One Pair of Red Damask window Curtain's
Two Matterasses
Three Blankets
One White Quilt
One Damask Counter pane
One Bolster
One Pillow
Two Tables

One Looking Glass
Nine Chairs
One Hearth Iron, Coal Grate, firepan, tongs, poker,
 fender, Bellows and Brush
One Brass Lock to the Door
Painted Dimothy Hanging to the room

Little Blue Room West front

One Bed, Bedstead, and Blue Hanging
One Matterass
Three Blankets
One Quilt
One Bolster
One Pillow
One Table
One Looking Glass
One Chair
One fire pan, tongs, poker and fender
One Brass Lock to Door

Little Room by North stair's

One Bed
Three Blankets
One Quilt
One Bolster
One Pillow
One Pair of Blue Curtain's
One Brass Lock to Door

Salone Garretts

The Three Bed Room South

Three Bed's, three Bedsteads
Four Blankets, three Bolsters
One Rug: one Quilt; one Counter pane
One Large Mahogany Table in four parts

Blue Room Left hand of passage

One Bed, Bedstead, and Blue hanging
Three Blankets, one Quilt
One Bolster; one Table, one Stand
Three Chairs, one Looking Glass
One fire pan, one poker, & two pair of tongs
One Iron Rim'd Lock to door

In Closit

One Bed & Bedstead, two Blankets, one Counter pane

Blue Room Right hand of passage

One Bed, Bedstead and Blue hanging
One Matterass, three Blankets
One Quilt, one Bolster

One Table, three Chairs
One Iron Rim'd Lock to door

Green Room Right hand of passage

One Bed, Bedstead and Green hanging
One Matterass, three Blankets
One Quilt, one Bolster
One Chair, one Table, one Stand
One Iron Rim'd Lock to Door

Green Room Left hand of passage

One Bed, Bedstead, and Green hanging
Three Blankets one Quilt
One Bolster one Pillow
One Table, one Stand, four Chairs
One Iron Rim'd Lock to Door

In Closit

One Bed, Bedstead, and Bolster

Three Bed Room North

Three Feather Beds, one Flock Bed and three
 Bedsteads
Eight Blankets, two Rugs, and one Counter pane
Three Bolster's and one Pillow
A Thumb Latch to the Door

South West Terrett

Two Beds, Bedsteads and hanging
Six Blankets
One Matterass
Two Bolsters
Two Pillows
Two White Quilts
One Table
One Looking Glass, Six Chair's
One fire pan, tongs, poker and Brush
One Iron Rim'd Lock to outer Door

South East Terrett

Two Beds, Bedsteads, and Orange Coloured Hanging
Six Covered Chair's
Four Blankets, Two Quilts
Two Bolster's, three pillows, one Table,
One fire pan, tongs, poker, and Brush
One Iron Rim'd Lock & one Latch to door
Two Iron Rim'd Lock's to Closits
One Close Stool

Four Bed Garrett South

Four Beds, Bedsteads, and blue hanging
Six Blankets, four Bolster's
Two Rugs and two Counter panes

Two Bed Garrett South

Two Beds and Bedsteads
Five Blankets, one Bolster
Two Quilts and one Rug

Four Bed Garrett North

Four Beds and Bedsteads, two Red and two Green
 hanging
Twelve Blankets, four Bolsters
Three Rugs, one Quilt
Three old Chairs
One Stock Lock to door

Two Bed Garrett North

Two Beds and Bedsteads
Five Blankets, two Bolsters, two Coverlids
One old Wooden Chair

Store Room Terrett North East

Four Sconces that came from the Salone
Three Large Dressing Glasses
Four Guilded Globes
One Gout Chair
One Large Marble Dish in a Case Broke
One Large Looking Glass and Glass frame
Two Large Chimney Glasses
Six Feather Beds and Seven Matterasses
Six Bolsters, two pillows, two Quilts, two Counter panes,
 and Twenty two Blankets
One Pair of Red Damask, Bed Curtain's Vallans &c with
 Bedsteads
One Pair of Red China Do: Bedsteads &c to Do:
One Pair of Green Serge Do: &c
One Pair of Olive Green Do: &c a half head
One Pair of Green China Do: &c
One Pair of old Blue silk Damask Do: with Six Chairs of
 the same
One Pale Blue China Do: ⎫
One Printed Linnen Do: ⎬ In a Box
Two Green Velvet Vallans ⎭
One Blue Tartan hanging to a Bed
Four small peices of old Tapestry
Twenty six yards and severall odd peices of Red Caffoy
Some small Remnants of old Red silk damask
About Fiveteen yards of Yellow Caffoy and some old
 pieces
Two pair of Mahogony doors, and two old Picture
 frames
One piece of Painted floor Cloth
Twelve old Blankets

North West Terrett

One Bedstead, and Blue China hanging
Five Cane Chairs

Passage to North Terretts

Six Brassears
Eleven Tin Fender's
Two Skreens

Waiting Room or Passage to Picture Gallary

Four Plymouth Marble Terms with Busto's on Each
One Table
Eleven Chair's
Two Mortice Latches, and one Brass Lock to Doors
One Mortice Lock and one Latch in Circular Passage
Five Iron Rim'd Locks in Circular passage
Two Italian Marble Terms, with Busto's on Each

Vestibule

Six Italian Marble Vausses in Nitches
Two Tables
Six Chairs
Two Mortice Locks to Door's

Picture Gallary

Fifty one Pictures
Five Tables
Twenty four Arm Chair's
Twelve India Chair's
One Couch and three Pillows to Do:
Three India Skreen's
Two Hearth Irons
Two Coal Grates
Two Fire pan's
Two pair of Tongs
Two Poker's
Two Brushes
Two Large Iron Fenders with Brass Wire
One Brass Mortice Lock to the Door

Ten Large Carpetts to the Room's
Fifteen Small Do:
Two old India Skreen's
Eight Small Paper Do:

North Office

Infirmary

Two Beds, Bedsteads, and Hanging
Four Blankets, two Bolster's, two Rugs
One Table, two Chairs and one stool
Two Mahogony Chest's in Passage

Little Yellow Room

One Bed, Bedstead and Yellow hanging
One Matterass, three Blankets
One Rug: one Bolster and two Pillows
One Table and two Chairs
One Iron Rim'd Lock to Door

Blue Room over Washhouse

Three Beds, Bedsteads, and Hanging
One Matterass, Nine Blankets
One Counter Pane, One Quilt
Three Bolsters, two Pillows
One Large Looking Glass, one Table, five chair's
One fire pan, tongs, and Fender
Two Pair of Window Curtains
One Iron Rim'd Lock to door

Green Room over Laundry

Two Beds, Bedsteads, and Green Hanging
Six Blankets, two Bolsters, two Pillow's
Two Quilts, Three pair of window Curtain's
One Table, Six Chairs, one looking Glass
One fire pan, tongs, poker and fender
One Iron Rim'd Lock to the Door

Yellow Room over Laundry

One Bed, Bedstead, and Yellow Hanging
One Pair of Window Curtains
One Matterass, Three Blankets
One Quilt, One Counter pane
One Bolster, one Pillow,
One Table, one Looking Glass, six Chair's
One firepan, tongs, fender and Brush
One Iron Rim'd Lock to the door

Dairy

Three Marble Milk Trays
Three Lead Milk Trays
Six Milk Bowls, four Cream Tubs
One Butter Killer, two Butter hands
Three Milk Pails, one Pair of Scales
Two hand Churns, one half Barrell Churn
One Iron Rim'd Lock to door

Wash House

Fourteen Wash Tub's three Washing stools
Two Large Portland Stone Cisterns
Two Copper's, one Large Drainer
Two Horse's
A Thumb Latch to the Door

Laundry

Two Large Horses in Ceiling
Four other Horses for Linnen
Two Large Grates, one Iron Blower, two fenders, and two horses for the Iron's
Twenty Hand Iron's and four Rester's
Two Box Iron's and four Heater's
Ten Draws to Dresser with Locks
Two old Tables and one old Case
One Portland Stone Cistern
One Large Sauce pan for Starch
One Iron Rim'd Lock, and Thumb latch to the door

Mangleing Room

One Mangle, and four Roles
Two Tables, one large Portland stone Cistern
One Cheese Press, and Eight Cheese fatts
One Plate Rack, one Copper, and one Kittle
Four two Ear'd Tubs & four Ice pails

Room over the Malt Mill

Two Beds, and two Bedsteads
Four Blankets, and two Rugs
Two Bolsters and one Bed Matt

Brewhouse

One Large Copper
One Large Marsh Tub, & Lead Pump to the Copper
One Beck over the Copper
One Beck under the Marsh Tub
Four Coolers with Shoots to Ditto
Two Large working Fatts
Two Large, and two Lesser Oar's to Marsh Tub
One Iron Coal Rake, Poker, and Fork

Lesser Copper

One Lesser Copper
One Marsh Tub, and a Wood Pump to Do:
One Beck over the Copper
One Beck under the Marsh Tub

South Office

Closit to Nursary

One Bed, and three Blankets,
One Quilt one Pillow
One Bolster, one Table
One Chest of Draws, one Chair

Nursary

One Bed and Blue China Hanging
One Matterass, one Quilt,

Three, Blankets, one Bolster, two Pillows
One Pair of window Curtain's
Two Tables, one Glass, Six Chair's
One Fire pan, tongs, and Poker

Outer Nursery

One Large Looking Glass
Two Tables, Eight Chair's
One Buroe, Eighteen Pictures
One fire pan, tongs, and Poker
Four Iron Rim'd Lock's to doors

House Keeper's Room

One Matterass, one Bed
Three Blankets, one Quilt
One Bolster, Three Pillows
One Table, one Looking Glass, five Chair's
One fire pan, tongs, poker, and fender

Closit to Ditto

One Buroe, and two Chest of Draws
Two Lock's to the Door's

M^{rs}: Hamond's Appartment
In the Closit

Three Chair's, two stools, & two Iron Rim'd lock's

Bedchamber

One Matterass, one Bed
Three Blankets, and one White Quilt
One Counter pane, one Bolster
Three Pillow's two looking Glasse's
Three Table's, Six Chair's, one stool
Two Pair of Window Curtain's
One Picture
One Coal Grate, fire pan, tong's, poker
fender, Bellows and Brush
Two Brass Locks to door's

Anti Room to Bedchamber

One Bed, and three Blankets
One Quilt, one Bolster
One Pair of window Curtain's
One Table, and four Chair's
One Coal Grate, fire pan, and tongs
Three Brass Lock's to Door's

M^{rs}: Hoste's Room

One Bed, and three Blankets
One Quilt, one Matterass, one Bolster
One Pair of Window Curtain's
Six Chair's, one stool and one Close stool
One Table, one Chest of Draw's

One Looking Glass
One Coal Grate, fire pan, tongs, poker, and fender
One Brass Lock to the Door

Closit to Ditto

Six Pillow's, one Rug, one Chair, one Table
Twelve Tin Rush Light Candle Stick's
One Brass Lock to Door

M^r: Paine's Room

One Matterass, one Bed, three Blankets
One Counter pane, one Bolster, one Pillow
Five Chairs, one Looking Glass, one Table
One fire pan, tong's, and Poker
One Close stool in Closit
Three Brass Lock's to Door's

Closit to Ditto

One Bed, two Blankets, one Bolster, one Rug
One Brass Lock to the Door
In a Box in the Closit a Sattin Suit of Bed Curtain's
 wrought with Gold and Coloured Silk's and one white
 stitch't Marsela Quilt

Lord Walpole's Room

Two Matterasse's one Bed & four Blankets
One White Quilt, and one Silk Quilt
One Bolster, and two Pillow's
One Pair of Window Curtain's
One Chest of Draws, one Table
One Looking Glass, Six Chair's
One Picture over Chimney
One Coal Grate, fire pan, tongs, poker
fender Bellows and Brush
One Brass Lock to Door

losit to Ditto

One Bed, two Blankets
One Quilt, one Bolster, one Pillow
One Close Stool
One Iron Rim'd Lock to Door

Five Bed Room

Five Beds, and Bedsteads
Fiveteen Blankets, five Rugs
Five Bolsters, two Pillow's, two old Chair's
One Iron Lock and Latch to Door

M^r: Couture's Room

One Bed, and Bedstead
Three Blanket's one Quilt
One Pillow, one Bolster

Turn up Bed
One Matterass, one Bed
Two Blankets, one Quilt, one Bolster
Three Chair's one Table
One Pair of window Curtain's, one looking glass
One Iron Rim'd Lock to the Door

M^r: Tho: Jones's Room

One Bed, three Blankets, one Quilt
One Bolster, one Pillow
One Table, one looking Glass, five Chair's
One Pair of window Curtains
One fire pan, tongs, poker, and fender
One Brass, and one Iron Rim'd lock to Door's

House Maid's Room

Two Beds, and Bedsteads
Six Blankets, two Quilts
Two Bolsters, four Pillows
One Pair of Window Curtain's
One Table, one Chest of Draw's
Six Chair's two Looking Glasses
One fire pan, tongs, poker, and fender
One Iron Rim'd Lock & two latches to door

The Maids Long Room

Seven Beds, and Bedsteads
Twenty one Blankets, Eight Bolsters
Six Pillow's Seven Counter panes
One Chest of Draw's, one looking Glass
One Iron Rim'd Lock to Closit door
One Thumb Latch to outer Door

Room in Roof by the Clock

One Bed, and Bedstead
Two Blankets, one Table

Servants Hall

One Large Oake Table and one Firr Ditto
Nine Form's, and one Sink of Portland stone,
Two Iron Rim'd Lock's, and one Stock Lock
One Large Poker

Still Room

One Dresser with Eight Draw's and Locks to Six of Ditto
One Lesser Dresser
Two Still's, three stoves, & three Trivets to D^o:
Two Pair of Wafer Tongs, one Pair of Bellow's
Four Copper Preserving Pan's, two D^o: sauce pan's, and one Little Kittle
Three Pewter Measure's
One Pair of Copper, and one Pair of Brass Scales, and Brass, weights to D^o:

One Table, and three Stools
One Large Iron fender
One Marble Mortar in a Stock, and Wood Pestall to D^o:
One Iron Rim'd Lock to the Door

Confectionary

Two Mahogony Dresser's, with Draws, and Cupbords, Six Locks to Ditto
Forty Two Mahogony Shelves, with Glasses China &c on Ditto
Six Glass Lamp's, Twelve Corner shelves
Three Brass Locks, and hinges to doors
One Table, four Chair's, and one Stool
One Fire pan, tongs, poker, and Large Iron fender

Store Room

Three Tables, and Six Chair's
One fire pan, tongs, poker, and fender

Closit to Ditto

One Sett of Spice draws, and two stools
Two Iron Rim'd Locks to Door's

The Maid's Room

Two Dresser's two Tables and Six Chair's
One Broken Looking glass
One fire pan, tongs, poker, and fender
Two Iron Rim'd Locks to door's
A Press for Linnen

M^r: Paine's Counting Room

One Writing Desk, and four Chair's
One firepan, tongs, poker, and fender
Forty Eight Carbines
Twelve Muskettoon's, Seven of them Riffled Barrells
One Large Blunderbuss the Barrell 2^f. 3 ⁱⁿ long
Two Ditto 16 Inches long in the Barrell
Two old D^o: Brass Barrells
Two old D^o: Iron Barrells
Two new short Guns 18 Inches in the Barrell
Two Ditto … 16 Inches in the Barrell
One Iron Rim'd Lock to the Door

The outer Larder

A Dresser, with Cupbords under D^o: and Shelves over D^o:
Eight Locks to Cupbords, one Wire safe
A Meat Rack, with Tenter hooks to D^o:
A Bing for Dryed Bacon, and a Bing for Oatemeal Pease &c
One Iron Rim'd Lock to the door

Inner Larder

A Dresser with Shelves over Do:
A Wire Safe
Two Iron Rim'd Lock's

Cook's Eating Room

One Table and two form's
One Chest

Larder to Pastry

Two Dresser's and shelves, one Wire safe
One Iron Rim'd Lock, and one latch to door's

Pastry

One Boulting Mill, two Kneeding Trough's
One Flour Bing, and one Bran Bing
Two Dresser's, and three shelves
One Ladder, Two Cupbord's
Three Iron Rim'd Lock's

Bakehouse

Three Oven's with Iron Doors
Nine Wooden Peels, two Iron Do:
One Coal Rake, one Iron Rod to stir the coal's
One Fire fork, two Dresser's, one Iron Raspe

Scullary

Two Plate Rack's, one Dish Kittle
Two Boyling Copper's
Two Dresser's and Shelves
Three Portland stone Cistern's
Eight Wood Bowle's and two Trays for meat
One Poker, and one Pott hook

Kitchin

Two Large Jack's with Chain's, Pullys, Weights &c to
 Ditto
Ten Spits
Two Large Grates, with two Spit Racks, and Cheeks to
 Each
Three Cranes with Pott Hooks to Each
One Salamandar, one Poker, two Pigg Iron's
Twelve Stoves, Twenty two Trivets, one Brandlet Twelve
 spit Iron's
Four Choping Knives, three Lark spits
Twelve Iron Skewers, Six Lesser Do:
Two Dresser's, two Tables, two Choping blocks
One Copper, one Meat Lead, one stone sink
One Large Portland stone, Morter, one Marble Do: and
 Wood Pesstall
Three Cliver's, one Toasting Iron, two Bread Grater's

One Hand Bell, one small Bell Mettle Morter, and Iron
 Pesstall
One Iron Broiling Hearth, three Gridiron's
One Large Fire Skreen
One Pepper Mill

Lower Larder

Three Dressers
Two Portland Stone Meat Troughs
Two Salting Leads, four Powdering Tubs
One Shelf & two Meat Racks with hook's
One Rack to bring the Meat from the Slaughter House
One Greese Tub
One Iron Rim'd Lock to the Door

Poultry

One Dresser with two Draws
Nine Shelves
One Rack for Rabbits Fowles &c
One Feather Bing
One Portland Stone Cistern
A Chicken Coope
Two old Chair's & one stool
One Iron Rim'd Lock to the Door

Chicken Yard

Two Ranges of Coopes

Pewter Copper &c

In Store Room, Larder &c

Forty six Dozen and half of Pewter plates,
Ten Dozen of Soupe Plates
Ten Dozen of Pewter Dishes
Two Terreens, one Pewter Rim Dish
Eight Pewter Rings, and two fish plates
One Copper Friture Syringe
Three Dozen Cheese Cake Rings
Four Pewter Butter Boats
Two Dozen Copper Patty pan's
Three Dozen Tin Tart Do:
Twenty one Flat Brass Candle Sticks
Eleven High Do:
Ten Tinn Do:
Eight Pair of steel Snuffers
Fourteen Boylers, two Copper Driping pan's
Fiveteen Copper & Brass, Baking pan's
One Large Long Fish Kittle and Cover
Four Cullender's, three frying pan's, six scumer's
Twenty Eight Stewpan's, Thirty Eight Cover's
Five Round sauce pan's two Cheese Toaster's
Two Basting Ladles, Seven Fish pan's

One Copper Apple Roaster
Two Large Tea Kittles with Cock's two small
D^o: and one Brass D^o:
Two Lark spits, Three Beef Fork's
Three Soope Ladles, four Gravy spoon's
Two Chocolate Pott's

Beding at the Stable's, Kennell's &c

M^r: Collett':s Room

One Feather Bed, one Bolster
Two Blankets, one Rug
One Counter pane, one Cane Chair

M^r: Stroud's Room

One Feather Bed, one Bolster
Three Blankets, one Rug
One Rush Bottom Chair

Store Room

Seventeen Feather Bed's two flock Beds
Fiveteen Bolster's, three Pillow's
Twenty three Blankets, fourteen Rugs
Two Counter panes

Mack Georges Room

One Bed, one Bolster, Two Blankets & one Rug

John Scrape's Room

Two Beds, two Bolster's, Six Blankets, two Rugs,

Lancaster Rickard's Room

One Bed, one bolster, three blankets, one rug and one
 Table

Tho: Perry's Room

Two Beds, two Bolster's, three Blankets
One Rug, and one Table

Rob^t: Garnham's Room

Two Beds, three Bolster's, four Blankets, three Rugs

Sam: Purchase's Room

One Bed, two Bolster's, one Blanket & two Rugs

Fox Hound Kennell

One Bed, two Blankets, two Bolster's
One Counter pane, one Rug, one Table

Beagle Kennell

One Bed, one Bolster, four Blankets, one Pillow and one
 Rug

John Bradborn's House

Three Beds, four Bolster's
Six Blankets, and three Rugs

Utensils in the Garden's, taken May the 4th: 1745

Six new Sythe's, six old D^o: and six Rubstone's
Five Iron Rakes, some want mending
Six Hand Fork's
Two Garden Reels, and lines, one Reel Broke
Four New Hammer's, Two old D^o:
Two Hatchets, and two Pruning Saw's
An Hundred Matts, most old, half worn out
Twenty Baskets of Different Size
Ten New Water Potts, two small D^o: old
Nine old Hoe's
Seeds Enough for the Season
Forty Bell Glasses
Twenty three old Netts, two Grub Axes

N^o: of Lights to Garden frames
15 New Leaded
34 Indifferent good but want, two or three Dozen
 Squares to be stopt in
10 That want new Leading
41 Glasses, and Lights worn out
100 In all

Four Pair of Garden Sheer's
A Moveing Scaffold in the Pleasure Grounds
One Garden Ingine with Leather pipes to D^o:
One Large Iron Rake
Two Hand D^o, one Stone D^o:
One old Grinding Stone, and frame
Two Ladders Eight foot Long
Two Pair of Steps
One Standing Step Ladder
Three Water Barrow's, and three Tubs to D^o:
Six Wheel Barrow's, one Hand Barrow.
Two, one Horse Carts
One Wire Skreen

M^r: Harold's Utensil's, Taken May the 9th: 1745

One Little Cart, and Water Tub on D^o:
Two Water Pott's
One Wheel Barrow
Two Saw's for Pruning and Six Chissels
One Hoe, and two Skuffle's
Three Pick's, and four Grub Axes
One Crab Apple Press for Verjuice
One foot Plough

An Inventory of the Elegant Household Furniture Fixtures Marble Statues, Bustos capital Bronzes Pictures Tapestry Hangings Linen, China, Glass and numerous other Effects the Property of the Rt. Honble. The Earl of Orford deceased taken at Houghton Hall in Norfolk June 17th. 1792 & following days

Nᵒ. 1 North East Turrett

A Grate fixed & a shovel
Eight walnut tree Chairs stuffed seats
Five Chairs cane seats
a large deal table
Four Cedar doors
a large railed frame on support,
Four large gilt illuminating frames & sockets
Three glass Globes
An Eight light Chandelier
Fourteen tin barrels for blinds
a Chimney Glass in 3 plates one 40 by 28 one 30 by 28 &
 one 21 by 28 in a black frame
a Plate of Glass 50 by 48
a glass bordered frame
Two large cedar pannell doors & some moulding
A Measuring Wheel & compass
23 feet of gilt moulding
a curious antique marble desk (broke)
Four iron rods & some glass borders in the press

Nᵒ. 3 Right hand Room adjoining

a half teaster Bedstead linsey furniture
a Goose feather Bed
a half teaster Bedstead linsey furniture
a Goose feather Bed & bolster
a half teaster Bedstead linsey furniture
a Goose feather Bed & pillow
a half teaster Bedstead linsey furniture
a Goose feather Bed
a 6 leaf Japanned Screen
Seven Chairs various some damaged
Four Travelling Cases lined with baize
Two old Chairs on the landing

Nᵒ. 3 Small Room on the Landing

An old Bedstead
five tin fenders

Nᵒ. 4 North West Turrett

A Grate, a board
Seven old Chairs, a blind
a folding bedstead
Part of a Bedstead & a chair
a large plate glass Hall Lantern brass frame
a Quantity of damaged plate Glass

Nᵒ. 5 Attics on the same wing

a stump Bedstead
2 tin fenders. 2 packing boxes

Nᵒ. 6 Right hand Room

a Grate fixed & poker
a half teaster Bedstead & green linsey furne.
a Goose feather Bed & 2 bolsters
a check mattrass. 2 blankets & 2 quilt
a stump Bedstead
2 Goose feather Beds
a deal table. 3 Chairs & a boot Jack
The Linsey hangings to the Room

Nᵒ. 7 Room opposite

a Grate fendir & poker
a half teaster Bedstead & linsey furniture
a feather Bed & bolster
a Easy Chair, 2 others
The Linsey hangings of the Room

Nᵒ. 8 Room adjoining

A Grate & chimney board
a half teaster Bedstead blue linsey furne.
a Goose feather Bed & bolster
2 Blankets a quilt
a deal table 4 Chairs
The Linsey hangings to the Room

Nᵒ. 9 Room opposite

A Grate & poker
a half teaster Bedstead blue linsey furniture
a Goose feather Bed & bolster
a head board some laths, an Easy Chair
Two others The Linsey hangings to Room

Nᵒ. 10 Room next the Stairs

Three stump Bedsteads
2 tin fenders

Two pair of Stairs

Nᵒ. 11 Small Rooms next the Gallery & Stairs

A Bedstead 2 linsey Curtains
a feather Bed bolster & pillow

2 blankets a quilt
a Candle stand, a Chair
a chamber utensil bason bottle & tumbler
a four post Bedstead with blue furniture
a feather Bed & 2 bolsters
2 blankets. a quilt
a walnut tree table a chair
a Grate fixed shovel tongs poker fender
Chimney board & brush
a bottle bason & a tumbler
a Chamber utensil
The blue hangings to Room

Nº. 12 Crimson damask Bed Chamber

A Lofty Bedstead with crimson silk damask hangings with
 bases &c compleat
a large rod with two crimson silk Lutestring Curtains to
 draw round the Bedstead
A large Goose Bed bordered tick bolster & 2 down
 pillows
a check mattrass, a white holland ditto
Three large fine blankets, a white quilt
a crimson silk damask Counterpane
Two crimson silk damask hang down
 Window Curtains lined & rods
Eight Back stool Chairs covered with crimson silk damask
 & crimson serge Cases
Two mahogany dressing tables
a hanging Glass
a wainscot Night stool
a Stove iron hearth & back steel fender
 shovel tongs poker & bellows
a bottle bason tumbler & a Chamber utensil
a curtain hook
The tapestry hangings to Room

on the landing place

a pair of steps
five copper Coalhods
Three ditto Pails
a Coal shovel, 2 baskets & 2 tins
a night lantern
a shovel, 2 brushes & a broome

Nº. 13 Chintz Bed Chamber

A Lofty Bedstead with raised teaster & beautiful Chintz
 furniture lined with blue silk
Two blue Curtains & rod to inclose the Bed
a large bordered Goose Bed bolster & pillow
2 white holland Mattrasses
a check mattrass
Three large fine blankets a white quilt

a blue silk Quilt
Two chintz hang down Window Curtains
lined valens & rod to match the Bed
Eight Chamber Chairs covered with Chintz & blue serge
 Cases
2 dº. confidantes covered with dº & blue serge Cases
An india japanned Cloaths Chest with 3 drawers on a
 frame leather cover
a plate of Glass 48 by 46½ in a black frame
2 mahogny. dressing tables & a hanging glass
a steel Stove fender shovel tongs poker and brush
a mahogany Night stool in the Closet
a wainscot dº.

Nº. 14 Chintz Bed Chamber & Closet adjoining

a whole teaster Bedstead with raised teaster & flowered
 Chintz furniture lined
a Goose feather Bed bolster & 3 pillows
a white mattrass
Three blankets a white quilt
2 Chintz, hang down Window Curtains Valens & rod
Seven Chamber Chairs chintz Cases
a mahogany dressing table
a hanging glass
a wainscot night stool, a candle stand
The chintz hangings of the Room
2 bottles, 2 basons, a tumbler & a chamber utensil
a field Bedstead with yellow furniture
a feather Bed & bolster
3 Blankets a Coverlid
a Stove fender shovel tongs poker fender & brush
a Lantern in the passage

Nº. 15 Blue Serge Chamber

A whole teaster Bedstead & blue serge furniture
a Goose feather Bed, bolster & pillow
a feather Bed
a mattrass. 3 blankets
a white quilt, a blue serge Counterpane
2 blue hang down Window Curtains valence & rods
a mahogany dressing table
a hanging glass a candle stand
a walnut tree night Chair & 5 others
a bottle bason, tumbler & chamber utensil
a stove fender shovel tongs poker & brush
The blue serge hangings of the Room

Nº. 16 India silk Taffeta Bedchamber

A Lofty Bedstead with raised teaster and india silk taffety
 furniture lined with green silk persian fringed cornices
 &c compleat
Two blue Curtains & rod to draw round dº

An Excellent Goose Bed bolster & 2 down pillows
a check mattrass, a white quilt
a white mattrass. 3 large fine blankets
a green silk quilt
2 india silk hang down Window Curtains lined with green,
 cornice rod & valens
Eight Chamber Chairs in Canvas, india silk & blue serge
 cases
2 Confidantes in Canvas, blue serge Cases
2 mahogy. dressing tables a hanging Glass
a wainscot night stool
a four leaf india japanned black & gold screen
a Japanned Linen Chest with drawers lined with baize on a
 frame
a bottle, 2 tumblers a soap dish, a bason and a chamber
 utensil
a Stove iron back fender, shovel tongs poker brush &
 bellows
The india silk hangings to the Room

Nº. 17 Blue Bedchamber

A four post Bedstead blue furniture
2 feather Beds one bolster & 1 pillows
2 blankets a quilt
a deal table. a glass, a candle stand
a boot jack. five Chairs
a Stove fender shovel poker & brush
Two nests of mahogany Shelves
The blue hangings of the Room
2 bottles. 2 basons. 2 tumblers & 2 Chamber utensils

Nº. 18 Scarlet Bed Chamber

A four post Bedstead with scarlet furniture
A Goose feather Bed bolster & pillow
a white mattrass
3 blankets a white cotton Counterpane
2 Crimson hang down Curtains rods & valens
a mahogany dressing table a hanging Glass
Three walnut tree Chairs
a Stove fender shovel tongs poker & brush
a boot jack
The hangings of the Room

Nº. 19 Needlework Bed Chamber

a Lofty four post Bedstead with needle work furniture
 lined & ornamented with a neat coloured border
a Goose feather Bed & bolster
a check mattrass
a white do
four blankets & a white quilt
Two hang down needle work Window
 Curtains with coloured border rods &c

Four green Curtains & rod to draw round the Bed
A walnut tree night Chair
Six Chamber Chairs needle work seats and blue serge
 Cases
a mahogany Chest of drawers
a do dressing table
a bottle & bason. a chamber utensil
2 tumblers & a soap dish
a wilton Carpet
a hanging Glass
A candle stand
a Stove with iron hearth and back fender
shovel tongs and poker, brush & bellows

Nº. 20 South West Turrett

a four post Bedstead & furniture lined with green
a feather Bed & 2 bolsters
3 Blankets & a quilt
a Grate poker chimney board
4 Chairs 2 tin fenders & a boot jack
a four post Bedstead & furniture lined with green
a feather Bed & bolster
3 Blankets & a Quilt

Nº. 21 South East Turrett

a four post Bedstead & scarlet furniture
a feather Bed & bolster
3 blankets & two quilts
a four post Bedstead & scarlet furniture
a feather Bed & bolster
3 Blankets & a quilt
6 Chairs various
a Grate a chimney board & 2 tin fenders
2 wash hand basons & a boot Jack

Nº. 22 Room adjoining

a half teaster Bedstead with blue linsey furniture
a feather Bed & bolster
3 Blankets & a Coverlid
a half teaster Bedstead green linsey furniture
a feather Bed & bolster
3 Blankets & a Coverlid
2 wainscot Chairs & a boot jack
2 Chamber utensils
Two half teaster Bedsteads green linsey furniture
2 feather Beds 3 bolsters
4 blankets 2 Coverlids

Nº. 23 Room at Stair head

Two stump Bedsteads
a feather Bed and bolster
3 Blankets & a Coverlid

Nᵒ. 24 Needlework Bed Chamber facing the Stairs

A Lofty whole teaster Bedstead with needle work
 furniture lined with yellow silk
4 Yellow Curtains & rods to draw round dᵒ.
a bordered Goose feather Bed bolster & 2 pillows. 2 white
 mattrasses
Three large blankets
a needle work Counterpane
2 needle work hang down Window Curtains & rod lined
 with yellow silk
a mahogʸ dressing table a hanging Glass
a walnut tree folding table
~~a hanging glass~~
a mahogany Bureau
A walnut tree Night Chair
6 walnut tree Chairs yellow seats
a Stove iron hearth & back fender shovel tongs poker &
 brush
a Curtain hook
a Yellow bason bottle chamber utensil & tumbler
a Wilton Carpet & 3 bedsides

Nᵒ. 25 Small Room adjoining

A Stove fender shovel ~~tongs~~ poker & chimney board
a mahogany dressing table
a walnut tree Cabinet with plate glass doors
2 walnut tree Chairs
The blue hangings to the Room

Nᵒ. 26 Small Room next the Stairs

a Stump Bedstead & blue furniture
a feather Bed & bolster
a feather Bed & bolster
2 Blankets & a Coverlid
a matted Chair. a bottle & bason
a chamber utensil

Nᵒ. 27 Yellow Damask Bed Chamber

A Lofty bedstead with raised teaster and yellow silk
 damask furniture
Four yellow Curtains & rod to draw round dᵒ.
a large Goose Bed bolster & 2 down pillows
Two white Mattrasses
Three large fine blankets a white Quilt
a yellow silk damask Counterpane
Two yellow silk hang down Window Curtains rod &
 valens
Eight Chamber Chairs stuffed & covered with Yellow silk
 damask & serge Cases
Two ditto confidants to match
a mahogany dressing Table
a walnut tree dᵒ

a dressing Glass
a four leaf japanned screen
An india japanned Linen Chest with 3 drawers on a frame
a Bottle bason. 2 tumblers. a chamber utensil & a boot
 Jack
a Stove and iron back fender shovel tongs poker bellows
 & brush
a Chimney Glass in 3 plates middle plate 43 by 18
a wainscot night stool
a persia Carpet

Nᵒ. 28 Crimson stuff damask Bed Chamber

a Lofty four post Bedstead with crimson damask furniture
a Goose feather Bed bolster & 2 pillows
a white mattrass, 3 blankets
a white quilt
2 Crimson damask Window Curtains rod & valens
a mahogany dressing table a dᵒ candle stand
a hanging glass
Five walnut tree Chair damask seats
a walnut tree night Table
a Stove fender shovel tongs poker bellows & brush. a boot
 jack
a bottle, bason, tumbler Chamber utensil & a soap dish

Closet

a field Bedstead with blue furniture
a feather bed & bolster
2 blankets & a damask Counterpane
2 Yellow hang down Window Curtains & rods
a walnut tree table
a stool. a yellow bason. chamber utensil
bottle & soap stand
The Crimson damask Hangings to the Room
a chair seat. 3 blind barrells &c sundry pulls
a Lantern in the passage
2 Night Lamps & a pair of bellows

Nᵒ. 29 Yellow Serge Bedchamber

a four post Bedstead with yellow serge furniture
a Goose Bed bolster & pillow
2 white Mattrasses
Three blankets. a white quilt
a mahogany Chest of drawers
a mahogany dressing Table
a dressing Glass, a candle stand
a walnut tree night Chair
Five Chairs covered with yellow Caffey
a Stove fender shovel tongs poker & brush
a boot jack. a yellow bason & a chamber utensil. bottle
 tumbler & soap dish
The Yellow Caffey hangings to the Room

Nº. 30 Best Needle work Bedchamber

a Lofty Bedstead with raised teaster & beautiful needle work furniture lined with pink silk
Four crimson Curtains & rod to draw round dº:
An Excellent Goose Bed bolster & 2 down pillows
two white mattrasses a check dº
3 large blankets a white quilt
a Pink silk Quilt
Two hang down Window Curtains lined with silk rod & Valence
Eight chamber Chairs in canvas with needle work & pink serge Cases
Two Confidantes in Canvas & Serge Cases
a mahogany Bureau
a dº sliding Screen
a mahogany night stool
2 walnut tree dressing Tables
a dressing stand. a candle stand
An india japanned Linen Chest with 6 drawers lined with baize on a frame
a neat upright Japanned Cabinet on a frame
a bottle & bason 2 chamber utensils 2 tumblers. soap dish & a boot jack
a Stove iron back fender shovel tongs poker bellows & brush
The Needle work hangings to the Room to match the Bed & lining
a Wilton Carpet

Nº. 31 Small Bed Chamber adjoining

A four post Bedstead with blue furniture
a Goose feather Bed bolster & pillow
3 blankets. a quilt
a mahogany dressing table
a dressing Glass
2 blue hang down Window Curtains & rods
two Chairs
The hangings of the Room
a Chamber utensil. bolster bason & tumbler

Nº. 32 Small Yellow Room

a four post Bedstead with yellow furniture
2 feather Beds a bolster & one pillow
2 Blankets & a Coverlid
a mahogany dressing table 2 Chairs
a bottle, bason & chamber utensil
a Grate. a chimney board shovel tongs & poker
The hangings of the Room

Nº. 33 Crimson Silk Mohair Bed Chamber

A lofty four post Bedstead with crimson silk mohair furniture

a Goose Bed. bolster & one pillow
2 white Mattrasses, four large blankets
a white Cotton Counterpane
a crimson silk mohair Counterpane
2 Crimson silk mohair hang down Window Curtains & rod
Eight Chamber Chairs with crimson silk mohair seats & Cases
a mahogany Bureau
a dº Night stool
a walnut tree dressing Table
a candle stand. a dressing Glass
a wash hand bason, bottle. 2 tumblers
a chamber utensil & a Soap dish
a Stove iron hearth & back fender shovel tongs poker & brush

Nº. 34 Small Rooms on the South West Stair Case

a half teaster Bedstead
Two feather Beds & 1 bolster
3 Blankets & a Coverlid
a half teaster Bedstead
Two feather Beds & 1 bolster
Three blankets & a Coverlid
2 Chairs a deal table
A stump Bedstead
2 feather Beds & one bolster
3 blankets a Coverlid
A stump Bedstead
a feather Bed & bolster
3 Blankets & a Coverlid
2 Chairs, a box, a Case, some blind ~~some~~ pulls with hook
three pieces of Canvas containing 55 yards & 2 remnants
a Lantern on the Stair Case

Nº. 35 Rooms on the North Stair case

a half teaster Bedstead with yellow serge furniture
a feather Bed & 2 bolsters
three blankets & a quilt
a deal table, a chair
a chamber utensil & a bottle

Nº. 36 Principal floor

~~Sir Robt. Walpoles~~ Family Bed Chamber
a Lofty Bed with raised teaster and blue silk damask furniture
Four blue Curtains & rods to draw round the Bed
A large Goose Bed bolster & 1 pillow
a thick white Mattrass in a fustian case
Two dº in linen Cases
Three large blankets
a fine Marseilles Quilt

a rich blue silk damask Counterpane

Two blue silk hang down Window Curtains valens rod & hooks

Six Chamber Chairs covered with blue silk damask & serge Cases

a d⁰· confidante with blue silk & serge Cases

An india japanned black & gold Linen Chest with 2 drawers on a frame & leather Cover

a Writing Table

a dressing Glass

a green painted blind

a mahog^y pot cupboard

a Yellow Ewer & bason, 2 chamber utensils, 2 tumblers, a water glass & a soap dish

a mahog^y Night stool

a Night Chair, 2 others, a pair of steps & a boot jack

2 Curtain hooks & a curtain

A Steel Stove iron hearth & back

a brass framed wire fender, shovel tongs poker & brush

Two Turkey Carpets

N⁰. 37 Chintz Bed Chamber adjoining

A four post Bedstead chintz cotton furniture lined

a Goose feather Bed & bolster

a check mattrass a white d⁰

Three blankets. a white quilt

2 blue silk damask hang down Window Curtains rod valens & hooks

a confidante. 2 Chair covered with blue silk serge Cases. & a stool

a mahogany dressing Table

a green painted blind

The blue silk damask hangings of the Room

a dressing Glass

2 pair of steel dogs, shovel tongs & iron back & a brass frame fender

Closet

The wainscot Book shelves & uprights

a Japanned Claw ~~for a~~ Tea table

2 Candle stands

2 bolsters 1 pillow

3 india paper folding screens 1 damaged

a barrel for a blind

6 Curtain hooks, a Curtain

Two mahogany desks

a Yellow Ewer & bason, a chamber utensil. 2 tumblers, Goblet and a water glass

Closet in the passage

a Green painted blind

2 Lead rubbers some brushes & brooms

a night lantern & 2 Chamber utensils

N⁰. 38 India Silk Taffeta Bed Chamber

This was S^r Robert's own bedchamber.

A four post Bedstead with india silk

taffeta furniture lined with green silk & fringed cornice &c. compleat

a Goose Bed bolster & 1 pillow

a check mattrass, a white d⁰

three large blankets, a fine white quilt

Two india silk taffeta hang down Window Curtains lined valens rod and hooks

a mahogany Writing Table

A dressing Glass

a green painted blind

An Easy Chair & blue Case & cushion

Two walnut tree Chairs

a mahogany Settee carved back & feet

a mahogany Night Chair

a mahogany bason stand

a china bottle and bason

2 chamber utensils & 2 tumblers

An Orrery & with compass &c by Rowley in a wainscot case lined with baize

a Bay with a frame

a mahogany Stool

a Sliding Screen faced with silk & balances

a walnut tree Chair, a boot jack

a Telescope

Two mahogany drawers

Seven pair of bellows

2 pair of dogs, a steel hearth, shovel tongs poker & brush

a stool with green Cover

The Silk hanging to Room

a Wilton Carpet About 30yds of Passage Cloth

N⁰. 39 Library

a Steel Stove and hearth

a brass frame wire fender shovel tongs poker & brush

An Excellent mahogany Writing Table with 14 drawers green cloth top & leather cover

a d⁰. with 14 drawers carved frame

a Box ~~of~~ with a model of Gibraltar mountain with references &c

Six walnut tree Chairs & 2 Elbows blue damask seats & serge Cases

a Telescope by Nairne & Blunt on a

brass stand & mahogany Case

Two painted blinds

a Persia Carpet 23 feet long

N⁰. 40 Dining Parlour

A Large Steel Stove (back broke) iron hearth steel fender shovel tongs poker & brush

a Pier Glass 55 by 36 in a white & gold frame

a Large Marble Slab 6 feet 10 long 3 feet 3 wide on a
 mahogany frame

a large mahogy oval dining table

a smaller ditto

a square mahogy dining table

2 Square Tables

15 Walnut tree Chairs leather seats

a french Elbow Chair covered with crimson silk damask

a Screen & 2 blinds

a Turkey Carpet 26 feet long 15$^{ft.}$ 6 wide

No. 41 Grand Marble Hall

a large Steel Stove with iron hearth back & cheeks steel
 fender shovel tongs poker & brush

A pair of handsome marble Tables 6 feet 9 in long 4 feet
 wide on a carved frame

a Pair of mahogany two flap Dining Tables to join

Six mahogany Settees carved & ornamd.

An Elegant Chandelier with 12 lights richly carved &
 finished in burnished gold & a variety of ornaments
 chairs & hook

A Turkey Carpet fine Colours 30 feet long 18 feet wide

No. 42 Marble Parlour or Sitting Room

A large steel Stove with iron hearth steel fender shovel
 tongs & poker

A Pier Glass 72 by 39 in a gilt ornamented frame &
 2 sconces

A Marble Pier Table 4 feet 9 long gilt ornamented frame &
 leather Cover

a pair of handsome marble Tables 6 feet 10 long on
 marble frames with silver cocks to each

Twelve Elbow Chairs stuffed & covered with rich green
 silk damask carved & gilt frames & serge Cases

A Sopha finished to correspond

2 blinds

a Six light gilt Chandelier line & hook

a Turkey Carpet 18 feet long & 16$^{ft.}$ 6 wide

No. 43 Cabinet Room

A steel stove iron hearth shovel tongs poker & brush & a
 fender

a walnut tree pier Table

Twelve walnut tree Chairs stuffed & covd. with green
 velvet gilt frames & blue tammy Cases

A pair of Sophas finished to correspond

a walnut tree stool a green painted blind

a Silk Carpet. 22 $^{ft.}$ 6 long by 13 feet wide

The burnished Gold Mouldings round the Room

No. 44 Bedchamber adjoining

A magnificent state Bed with raised teaster and beautiful
 india needle work furniture fine colours ornamented
 with the Orford Arms

Cornice 14 feet high lined with green silk and fringes

Four green Curtains & rod to draw round the Bed

A check mattrass. Two white ditto

An Excellent down Bed. bolster & 1 pillow

Three large fine blankets

a Green silk Quilt

a very beautiful Needle work Counterpane with
 ornamented Centre lined & fringed with green silk

Two green silk hang down Window Curtains lined &
 fringed valens rod & hooks

a green painted blind

a curious antique Trunk inlaid on a gilt frame leather cover

a walnut tree dressing table

A mahogany tray & stand

An Easy Chair walnut tree & gilt frame and cushion
 covered with rich green velvet & serge Cases

Six Chamber Chairs stuffed & covered with ditto to
 correspond & serge Cases

A Stove with iron hearth back & pr. of dogs

a brass framed wire fender shovel tongs poker & brush

a persia Carpet & 2 bedsides

Closets

a mahogany night Chair

2 bason stands, a pair of bellows

a Curtain hook & sundries

a mahogy dressing Table

a walnut tree stool & Cover

a green painted blind

2 wash hand basons, 2 ewers, 2 chamber utensils with
 green festoons 2 tumblers & a soap stand

2 blue wash hand basons 2 Ewers

2 chamber utensils with borders, two tumblers & a soap
 stand

18 feet of gilt Moulding & a Lantern Rope

No. 45 Dressing Room adjoining

A steel hearth 2 pair of dogs an iron hearth & back steel
 fender shovel tongs poker & brush

a Japanned Cabinet with drawers on a frame

A handsome Pier Table with looking glass reflecting Top
 ornamented with a Cypher gilt frame & leather cover

Two rich green Velvet hang down Window Curtains lined
 with green silk and trimmed with gold lace valens
 fringed. rod & hook,

Six Chairs & 2 Elbow ditto stuffed and covered with rich
 green velvet trimmed with gold lace carved & gilt
 frames & green serge cases

a green painted blind

a persia Carpet

Nº. 46 Principal Bed Chamber *This Bed cost 2000£.·*

A superb state Bed with raised teaster and cornice, rich
green velvet furniture lined with green silk laced with
gold & trimmed with broad gold fringe, the head teaster
& cornice elegantly ornamented, the whole made up in
a very expensive Stile

Four green silk Lutestring hang down Curtains with gilt
rod to enclose yᵉ Bed

A large down Bed in a bordered tick bolster & pillow

Two white Mattrasses

Three large fine blankets, a green silk quilt

A Rich Velvet Counterpane the centre ornamented with
gold, a broad laced border & bound with gold lace

Two rich green Velvet hang down Window Curtains lined
with green silk trimmed with a broad gold border &
bound with gold lace

An Easy Chair & cushion stuffed & covered with rich
green velvet, trimmed with lace gilt frame & green serge
Cases

Twelve Chamber Chairs stuffed & covered with green
velvet trimmed with gold lace gilt frames & serge Cases
to correspond

A set of 12 Green Serge chair Cases & 2 Sopha dº to
Cabinet Room

A Japanned Linen Chest on a frame with 3 drawers lined
with baize

a Japanned Cabinet with drawers on a frame

a large Curtain hook, a green painted blind

a walnut tree dressing table

a dressing Glass, a mahogʸ. stool tray

A Stove with iron hearth & back

a pair of dogs wire brass frame fender shovel tongs poker
& brush

a Persia Carpet

Nº. 47 Green Drawing Room

A Steel Stove iron hearth steel fender shovel tongs poker
& brush

a brass Chandelier line & pulley

a Pier Glass 86 by 43½ in a carved and gilt ornamented
frame

Twelve Chairs stuffed & covered with green velvet gilt
frames & serge Cases

Two Sophas finished to correspond

Four Stools in suite

2 green painted blinds

The Green striped Silk hangings & gilt Mouldings to
Room

Nº. 48 Saloon or Principal Drawing Room

A large Steel Stove, iron hearth steel fender shovel tongs
poker & brush

a pair of ornamented brass Chandelier 8 lights each lines
tassells & pullies

a pair of Pier Glasses 87 by 44 in rich gilt and ornamented
frames

a pair of beautiful marble pier Tables gilt frames & leather
covers

a pair of Candelabras ornamented carved & gilt & marble
tops to dº

a large & beautiful marble Pier Table carved & gilt frame
& leather cover

a Japanned Table with a set of imaged Tea & Coffee China
41 pieces

6 black and gold japanned Chairs

Twelve Elbow Chairs stuffed & covered with rich crimson
cut Velvet. the frames superbly carved & gilt & crimson
serge Cases

Two Sophas finished to correspond

Four Stools in suite

A pair of gilt Girandoles

The rich crimson cut velvet hangings to the Room

Two Persia Carpets each 34 ᶠᵉᵉᵗ 6 by 12 feet

Nº. 49 Rose Coloured Drawing Room

A Steel Stove iron hearth, steel fender shovel tongs poker
& brush

An 8 light brass Chandelier balance weight lines &
pullies

A Pier Glass 65 by 42 in a gilt ornamented frame

A marble Pier Table on a carved and gilt ornamented
frame

A mahogany Card Table

a walnut tree Table

a maho: oval dining Table

Three black & gold Japanned Chairs

Twelve walnut tree Chairs stuffed and covered with yellow
caffey and pink tammy Cases

Two mahogany Stools to form a Sopha stuffed in canvas
& pink tammy Cases

a Persia Carpet, 31 feet long 9 ᶠᵗ. 9 wide

The Rose Coloured silk hangings of the Room

The gilt bordering round the Room

Two window blinds

Two lengths of painted floor cloth ¾ wide about 42 yards

Nº. 50 Grand Stair Case

Six Globe Lamps with gilt supports & burners

Two mahogany dining Tables with circular ends to join
those in the Hall 8 ft long

A square mahogʸ: Table

a Backgammon Table boxes & men & a drawer with chess
 men
a mahogany Card Table
a mahogany Dining Table

Passage

5 Yards of Cloth

Ground Story

Nº. 51 Arcade Hall

a fixed Grate fender & poker
a fixed Grate & iron fender
a fixed Grate & iron fender
a fixed Grate & iron fender
a tin fender
Nine Lanterns with chains & hooks
Four Staggs heads
Two mahogany Settees 8 ft. 6 long
Twenty four rail back mahogany Elbow Chairs
A Pair of Scales iron beam, wood planks & ropes chain &
 hook
A Missisippi Table
Two green painted Lattices

Nº. 52 Hunting or Sportsman's Hall

A Grate fender shovel & poker
a Staggs head
a large mahogany oval dining Table
2 japanned frames with tray tops
a marble table on a mahogy. frame
a deal Table
An Easy Chair covered with leather
Thirteen Chairs with leather seats
a painted floor cloth 25 feet long
a window blind
a Map of the County of Norfolk

Nº. 53 Supping Room adjoining

A Steel Stove fender shovel tongs poker & brush
a marble Slab on a japanned frame
a pewter ink stand
4 blue damask hang down Window Curtains 2 rods
a walnut tree Claw table
a mahogany oval dining Table
a Screen
Twelve walnut tree Chairs with leather seats
a french Elbow Chair cover with damask
a Large Carpet cut in the middle & joined

Nº. 54 Breakfast Parlour

A Stove fender shovel tongs poker & brush
a Barometer
a mahogany Wardrobe with drawers at bottom shelves &
 doors
a mahogany oval dining Table
an eight day Clock in a walnut tree Case
an elbow Chair covered with leather
Eight Walnut tree chairs leather seats
a mahogany dressing Table
a mahogy. Pot cupboard chamber utensil & bason
a pier Glass 30 by 23 walnut tree frame
a pair of Gun racks
a painted floor Cloth
a Gentlemans Travelling Case with apparatus for writing
 & dressing and leather case

Nº. 55 Stewards Parlour

a Grate, crane, fender & poker
a music stand
a wainscot Bureau
a deal table a square deal table
3 wainscot oval dining Tables
a Screen. a square Table
Eighteen leather bottom Chairs
a large folding table top
a curious Air Gun
Sundries in the Closet

Nº. 56 Butlers Pantry

a Grate fender, tongs poker & Crane
a gridiron, frying pan. Boiler
a tea kettle, 2 weights. a tin Can
a wainscot table. a footman
Three bronzed Tea Kitchens
a plate warmer, a tray. small Glass, 4 Copper warming
 pans
6 pair of Candlesticks with treble branches chased
 & gilt
one pair of double dº
1 pair of branches &c 6 hooks
22 pair of silvered Candlesticks
13 pair of double branches
12 flat brass Candlesticks
4 Silvered snuffer stands
2 dº. & 2 pair of Snuffers with silver boxes
6 flat tin Candlesticks
2 pewter inkstands
a japanned bottle Cistern
a mahogany Octagon Case
two dº Knife trays
Eight wainscot knife trays

3 Dozen & one Table Knives
4 Doz. & 9 forks: 9 Oyster Knives
2 wainscot dinner tray & 2 baskets
a Grate fender shovel tongs
a walnut tree Chest of drawers
a Table 2 chairs, a nett, 5 plate chests & boxes
 1 Doz & 7 Knives 3 Doz & 2 forks
The fittings up of the Cupboards

Nº. 57 Bath Room

a four post Bedstead blue silk damask furniture
a feather Bed & bolster 2 blankets a Quilt
a blue silk Window Curtain
a pair of mahogany oval shaped dining Tables to join &c a
 square dº
Nine Chairs leather seats & one matted dº.
a walnut tree table
a Grate fixed chimney board tongs & poker
a deal table
two Stoves. an old Chair
a Drum in the closet

Nº. 58 Yellow Bed Room

a Stove fender shovel tongs poker & brush
a whole teaster Bedstead yellow silk damask furniture
a white Mattrass , a feather bed: box pillow
Three blankets a white quilt
Two yellow serge Window Curtains & rod
a mahogʸ dressing table, a swing glass
a candle stand, 6 back stool Chairs
crimson Cases a french Elbow ditto
a bottle & bason. boot Jack. soap dish tumbler a chamber
 utensil The front of a deal Press

Nº. 59 Blue Room

a Grate fender shovel tongs poker & brush
a four post Bedstead blue serge furniture
a Goose Bed bolster and pillow
Two Mattrasses, Three blankets
a white quilt a serge Counterpane
a walnut tree Bureau
a mahogany dressing Table
a dressing Glass a candle stand
Three walnut Chairs leather seats
a french Elbow Chairs covered with damask
a boot Jack
a bottle & bason, tumbler & soap dish
a Night lantern & a chamber utensil
The front of a deal Press

Nº. 60 Plaid Bed Chamber

Where George D Orford died.

A four post Bedstead plaid furniture
a Goose Bed bolster & one pillow
a check hair mattrass, a white dº.
Three blankets. a white quilt
a plaid Counterpane
2 plaid hang down Window Curtains and rod
a Mahogany Settee with squab & 3 Cushions covered with
 crimson damask and crimson serge Cases
a mahogany night stool
five Chairs covered with leather
Two french Elbow dº covered with damask
a mahogany dressing table
a dressing Glass, a candle stand
a Settee & Cushion green Case
a mahogany chest of drawers
The front of a deal Press with Shelves
Ten Cushions
a Chimney Glass two plates & frame
a Stove fender shovel tongs poker & brush
a Boot Jack, a night lantern, a bottle bason tumbler soap
 dish & a chamber utensil

Nº. 61 Coffee Room

A Stove fender shovel, tongs & poker
a large Map
a model of a Ship & stand & a boat
a Barometer & Thermometer
Sixteen mahogany french Elbow Chairs on castors stuffed
 & covered with crimson damask brass nailed and serge
 cases
Four blue damask hang down Window Curtains & rods
a wainscot table
Two Candle stands looking glass back
a Pier Glass 2 plates bottom 42½ by 27 top plate damaged
a marble Slab on a mahogʸ frame
a smaller dº
4 Sconces
a backgammon Table

Nº. 62 Busts Room leading to the Gallery

Two mahogany Dining Tables
Eight Chairs leather seats
a Chimney blind

Nº. 63 In the Passage on the North side

Eleven lead weights
Two step ladders, one short dº & a pair of Steps
a turks head broom, an old grate
a spade & some odd articles
a Stove, a billet hod & a tin fender

A six leaf screen, a 5 leaf do
6 pails. a basket
Mops brooms & brushes
2 Braziers with Covers
2 Smaller do & Cover
2 large do & 1 cover
a Quantity of Sockets
a packing Case Some torches
a Spear some iron Candlesticks & Sundries
An iron hook 2 tin fenders
a Coal shovel, a bucket a nail box
a pair of bellows & a dust shovel

No. 64 Passage on the South side

Two Lanterns by the Ground Stairs
Three ditto. 1 damaged
a square lantern & chair
a Table with tray top
2 mahogany tea boards
3 Smoking basons

Under the Stairs

2 Japanned bottle Cisterns
a Lantern 3 Tables, a tray
a Dulcimer in a Case damaged
a Leather travelling Case
a piece of painted floor Cloth
a large Cup
Some Stone Bottles
Sundries

No. 65 Small Beer Cellar

A Quantity of Stillion
4 Hogsheads
2 bell shaped Casks 4 barrells
An iron bound Hogshead. a tap tub
Some Stillion. 2 bell shaped Casks
The Stillion in the old Ale Cellar
The Stillion in the Wine Cellar
a beer stand

Further Ale Cellar

a bell shaped Cask. 5 barrells
Some Stillion. a tub & some beer bottles
The Stillion in the further Cellar
Do in the opposite Cellar
The Stillion in the middle Cellar
a truck. 2 iron bound tubs
a pair of Slings. 2 dogs a stand
2 washing tubs a bearing tub
a pail, a deal table
2 New Casks a form a knife board

113 Dozen of Wine Bottles
20 Dozen various in the different Cellars

No. 66 In the North Wing

A Copper fixt in brick iron work & lead curb
a Large Stage on Castors
a do …
2 Coppers fixt in brick & iron work & a Grate
an iron bound tub & a pail
4 Grates a heater Stove
2 Grates & part of the iron work for a Copper
49 Dozen of Champagne Bottles
23 Dozen of Scotch pints
The Racks in the Bottle House
A Large Copper & iron work
Iron for the small Copper
28 Dozen of Beer Bottles
10 Dozen of Pint Bottles
2 iron hearths in the Gallery

In the Colonnade

A Dove House 2 wood blocks
a large seat
4 Apple Stages

Passage leading to the South Wing & Powdering Room

A small Cistern
a Binn & Chair
a wig block 2 troughs & a stand
40 leathern buckets 2 lanterns

No. 67 South Wing further Rt. hand Room

Seven Bedsteads & sundry hangings
Seven feather Beds three Coverlids & three bolsters
a Chest of drawers
a pair of Steps a chest. 3 Stools & a door

No. 68 Room adjoining

A Grate fender poker & Chimney board
a whole teaster Bedstead & blue furniture
2 feather Beds one bolster
2 Blankets & a Coverlid
a half teaster Bedstead blue furniture
2 feather Beds & 1 bolster
2 Blankets a Coverlid
a Glass 27 by 23 in a walnut tree frame
a Chest of drawers
2 Chairs and a Desk
The hangings of the Room

Nº. 69 Yellow Room

A Stove fender poker & Chimney board
a whole teaster Bedstead ~~blue~~ yellow serge furniture
2 feather Beds 1 bolster & a pillow
2 blankets a quilt
a walnut tree bureau
2 Curtains & a rod
Three Chairs a Glass
a Chintz Counterpane
Bottle & bason: Chamber utensil
Soap stand & boot Jack

Nº. 70 Blue Room

a half teaster Bedstead blue furniture
Two feather Beds bolster & one pillow
Three blankets & a quilt
a table. a glass 2 Curtains
4 Chairs a chamber utensil
bottle & bason
The hangings of the Room

Nº 71 Tapestry Room

a Range fixed
a stump Bedstead
2 feather Beds & 1 bolster, 2 blankets a Coverlid
a stump Bedstead
a feather Bed & bolster , 2 blankets & Coverlid
a stump Bedstead
2 feather Beds & 1 bolster
2 blankets & a Coverlid
a deal table a Chair a boot Jack
The hangings of the Room

Nº. 72 Damask Bed chamber Left hand next the Stairs

A Grate, fender shovel tongs & poker
a four post Bedstead with green silk damask furniture
a feather Bed bolster & 1 pillow
2 Mattrasses. 3 blankets, 2 quilt
a walnut tree Chest of drawers
a dressing table, a dressing glass
a bason stand
a walnut tree table & 5 Chairs
2 Window Curtains
the tapestry hangings
A Coach Gun by Griffin & Tow
a brass barrelled blunderbuss
a steel ditto
a bottle & bason & chamber utensil
3 half teaster rods
The Green Cloth dressing for the Pulpit in Church
a Green cloth Church Cushion

a Green Velvet Cushion trimmed with gold lace & 4 Tassells
a folio bible

Nº. 73 Green Room adjoining

A Stove fender poker shovel chimney board
a four post Bedstead green furniture
Two feather Beds bolster & 2 pillows
Three blankets & a Quilt
a wainscot Chest of drawers
a Glass. a deal table
Two deal Chests of drawers
Four Chairs cane seats
Two pieces of Carpets
The Tapestry hangings
a chamber utensil bottle & bason
a wainscot table in the passage

Nº. 74 Blue Room

a whole teaster Bedstead blue furniture
a feather Bed bolster & 2 pillows
2 white Mattrasses
Four Blankets a white quilt
Two blue Window Curtains
a mahogany Chest of drawers
a deal table. a glass,
a wainscot night stool
two Chairs
a pair of dogs shovel tongs & Chimney board
a boot jack. bottle & bason. a chamber utensil & tumbler

Nº. 75 Room adjoining

A shovel tongs & Chimney board
The hangings of the Room
a flap table
a Bedstead
a feather Bed bolster & 1 pillow
a Mattrass
2 Blankets 2 Quilts
a Scarlet Jacket & a hat

Nº. 76 Green Room & Closet

A Stove fender shovel tongs poker & brush
a whole teaster Bedstead and green serge furniture
a feather Bed bolster & 2 pillows
a feather Bed
a Mattrass 4 Blankets a white quilt
a mahogany dressing table
a walnut tree chest of drawers & Cabinet
Four serge Window Curtains & rods
Four chairs

A large Glass in 3 plates
The serge hangings of the Room
a boot Jack. bottle & bason. soap dish. tumbler &
 Chamber utensil

Closet

A painted Chest of drawers 2 Chairs night stool
A most beautiful white sattin Counterpane
bolster Case & 4 Cushions Cases richly worked with gold
 & lined with white silk
*I believe this & the following article were made for the
 Christening of George D Orford, George 2ᵈ & Qn Caroline
 standing in person as his sureties with his Grandfather Sᵣ
 Robert.*
Needle work furniture for a Bedstead richly worked with
 gold on white sattin the Colour of the Silk very
 beautiful
A Counterpane to correspond

Nᵒ. 77 Double Bed Room by the Stair head

A whole teaster Bedstead with green furniture
A Goose bed bolster & 2 pillows
a check mattrass, 3 blankets a white quilt
a Green stuff back Quilt
2 Window Curtains
a Table. a swing Glass 5 Chairs & print
a Grate fender shovel tongs & night lantern
2 mahogany Shelves
The hangings of the Room
a Chamber utensil bottle & bason
a blanket & 2 Slips of Cloth
a wainscot Chest of drawers & Cabinet
a walnut tree dᵒ. & a Night Stool

Nᵒ. 78 Nursery

a Grate chimney board tongs poker & brush
a pair of oval Glasses 30 by 24 in gilt frames with sconces
a large Pier Glass 59½ by 34½ bordered frame
Two six leaf japaned Screens
a form and 2 cane chairs
a Settee covered with yellow Caffoy & Case
a dᵒ Couch with squab covered with dᵒ
3 Cushions & serge Cases
a sliding Screen
Four walnut tree back stool Chairs covered with green
 velvet & serge Cases
a deal table.
3 bows & an arrow Case

Nᵒ. 79 Further Nursery

a half teaster Bedstead yellow serge furniture
a feather Bed bolster & pillow
a mattrass, 4 blankets & a Counterpane

a Settee & serge Cases
Four Chairs a table & a Glass
Two Window Curtains
a Grate fender tongs & poker
5 Lanterns
Twelve Chairs (some damaged)
A large Press with drawers in the Closet

Nᵒ. 80 Cooks Room

a Grate fender & blower
Two deal Presses & a deal bookcase with drawers
Some Blue chintz Bed furniture bases &c
Some Sash line & cord
Twelve Gun racks
2 hand bowls
Some pieces of Carpet
a deal table 5 Chairs various
a pair of Steps. 2 airing horses
a 6 leaf Japanned Screen
2 pails a stone bottle,
a tin Cann in the Closet
a Green Cloth Cushion & dress for the Pulpit
a Sheet of Black Cloth for Interment

Nᵒ. 81 Maids Room

a Grate fender shovel tongs poker & blower & brush
a mahogany oval table
a wainscot table
Six Chairs leather seats & a stool
a Glass 3 tea boards & a knife tray
The rincing Cistern as fixed in Window
Two deal presses a cupboard at one end
a painted floor cloth
2 waiters a Jack mounted with silver & 2 beer Jugs
a Glass stand & sundry Castors Crewets mustard pots &c
a bed Chair
a Sun dial at the Window
8 brass Candlesticks. 2 iron dᵒ
3 tea Kettles
2 sets of fire irons & a shovel

In the Closet

a Copper tea Kettle
a pestle & mortar
a pair of copper scales a pile of weights
a box with a pair of brass scales & weights
3 hand lanterns
a Seive, a pewter plate. Cheese toaster & a lock.
11 flat irons a stand
a mill. 2 jugs
a Wainscot deal press & a nest of seed drawers
a Chair a hanging iron & poker
a boot jack

Nᵒ. 82 Housekeepers Room

A Grate fender shovel tongs poker Chimney board &
 hooks

a pier Glass gilt frame & brass arms 32 by 18½

a mahogany Sideboard

a Claw Table

a pole fire screen

Six walnut tree Chairs & one Elbow dᵒ covered with
 Caffey

a stool

a scotch Carpet

Two deal Presses as fixed

a wainscot chest of drawers & press

an inlaid tea Caddy

a Sword with silver grip gilt, and velvet scabbard & belt
 hilt

This shd be mine, as belonging to the Robes

Nᵒ. 83 China Room

a Grate fender & chimney board

Two Stoves as fixt in stone

an inlaid tea board & 3 waiters

2 tin graters 2 yellow beer jugs

a large pan & blind

2 large glass bottles

4 Chairs

The mahogany Presses with drawers and Shelves on both
 sides of the Room

a Patent Lamp

13 Yellow dishes 4 baking dishes a tureen

45 meat plates 26 dessert plates

a Quantity of Paper about 50 Quire

Nᵒ. 84 Still Room

a Grate fixed. fender board & hooks

2 pots as fixt with iron work in stone and copper covers

The rincing Cistern in the Window

2 stools. 3 beer stands & 3 Casks

2 Copper Stills with cocks 1 stand & frame

a Copper Kettle. 3 stove trivots

Three Stewing Stoves in stone & wood Cover

2 pewter measures

a small copper pail, 2 tin pails & some moulds

a small crane 4 yellow dishes 2 plates & five jugs

Nine pewter ice moulds & some weights

a marble mortar wood pestle & stand

a tin funnell. a slip of Glass & sundries

a dish. sundry tins & moulds

a box with brass work hold fasts and other articles

Sundry stone Jars & bottles

Nᵒ. 85 Servants Hall

A Shuffle board Table 29 feet long

a large deal table, 5 forms

10 ~~Leather~~ Lantern heads

an iron fork

A deal press with small Cupboard inside

Four leather pitchers 4 Candlesticks

5 horns. 2 stone bottles. 3 salts

a box with sundries

a pitch Kettle

a large horse 2 baskets

a washing Machine

a rincing Machine

an old table & a rubber

Nᵒ. 86 Stewards office

a Grate fender shovel tongs poker blower coal tub &
 brush

a wainscot bookcase with plate glass doors

a Japanned Writing Table with drawers

a Deal Chest of drawers

a walnut tree table

2 deal nests of drawers over the press & bookcase

a pewter inkstand

a mahogany Claw Table

5 Chairs leather seats

a large iron Chest

Two deal Presses with drawers on each side of the fire
 place

a Sun Dial

a Sconce Glass 3 medallions

Five Locks

a brass Joint for an Engine

a ~~Telescope~~ Theodolite with compass by Rowley in a case.
 stand wanting

2 Ammunition Bags

2 Map Cards

a Blunderbuss with rifle barrel

three Coach Guns

Twenty Fire locks & 43 Cases

a Gilt Ball for a Lantern

an old sword

a bottle bason & chamber utensil

Nᵒ. 87 Kitchen

A Range as fixed cheeks & iron back

Two cranes & 4 long hooks

a pair of standing racks

a fender, tongs poker & 2 trivots

a Jack as fixed weights lines pullies and Case

a Cradle spit & 9 large spits various

a Range as fixed and cheeks

a large Crane

a pair of standing racks

a large iron stand

three gridirons a salamander

3 pig irons, a hanging iron, a fender

2 old gridirons & sundries in the Grate

a Jack as fixt & Case

Five Stewing Stoves in stone and iron work and 6 trivots

a Dinner Bell (cracked)

a Small Wood Cistern lined with lead

Seven Stewing Stoves in stone & iron work and 11 stove trivots

3 Lamps

6 ladles & 2 slices

a spade a pestle & mortar

a candlestick & some ᵗⁱⁿ coffee pots

10 small skewers & frame

2 cookholds, a flesh fork, pair of steak tongs & 8 Skewers

a mill fixed

an iron stand 2 cleavers 3 choppers

4 balance skewers, 2 tin meat covers a drudger. dutch oven

2 brass pails. 2 wood dᵒ. & 2 graters

a large stone Mortar, pestle cover & stand

Two stout Elm Tables on supports

2 pair of steps a deal Cupboard

a meat screen lined with tin

a wafer iron

a form. a table, a chair, a stool

2 Chopping blocks a coal hod & tub

5 wood trays. 5 copper moulds and Sundry tin ditto

Nᵒ. 88 Washhouse

A copper boiling pot & cover

Three Kettles & covers

5 smaller dᵒ & covers

a large fish kettle & cover a dᵒ. & cover

2 cullenders 1 strainer

4 large Copper dishes 3 preserving pans

14 Stewpans 6 covers

10 smaller dᵒ. 8 covers 1 brass dᵒ & cover

a cheese toaster an ice pot

6 Saucepans & covers

5 Dishes 1 brass dᵒ & 4 plates

4 brass Kettles. a pair of brass scales

3 iron frying pans a ladle

Two Coppers fixt in brick & iron work lead curbs a copper & a wood cover

a large Kettle iron frame

2 plate racks

a block, a washing tub 2 trays 6 pails

a Barrel Churn & frame

an iron bound tub

a spade a fork

a copper dripping pan

3 Seives a ladle & spoons

a pair of iron dogs

2 bowls 2 trays & sundry trenchers

4 pewter dishes 7 plates

24 Yellow plates

a form, a stool

Sundry pieces of brown Ware

Nᵒ. 89 Bakehouse

a half hundred lead weights

a meat safe wire door

36 copper patties & some tin dᵒ

a salting trough & 2 trays

a large Chest & 2 kneading troughs

a flour tub, a pie board & 2 large tubs

a Binn & a Bolting Machine

a Safe. 2 small Churns

a stand. a rolling pin, a table, a spit a drawer

11 Rat traps, & sundries

An Elm Table a pie peal a rake

a poker a fork & 3 plates

a Quantity of Lead

a deal table 10 feet long

three pie boards

Nᵒ. 90 Larder & Pantry

a deal table. a guard iron

a large bacon chest

a horse. 2 tressells & a bowl

The front of 2 meat safes with canvas doors

a wainscot oval table a pair of steps

2 baskets some Jars

2 frying pans & a binn

a pillion

16 papers of french Wax Candles 6 lbs in each

a Quantity of Tallow Candles

Nᵒ. 91 Closet in passage

Three brass Locks the keys wanting

Seven pair of brass hinges

Two boxes containing sundry brass hooks

holdfasts. pullies. plates & useful articles

a brass barr with bolt

2 large iron locks. keys wanting

Eight iron Balls for Ballustrades

a Lantern

In the press in the Maids Room

49 round Pewter dishes

18 round ditto

6 round pye dishes

2 oval shape dishes

4 old round dishes

4 fish plates & a stand

2 tureens & Covers. 5 Rincers

10 Dozen & 9 Soup Plates

36 Doz & 9 Meat Plates

a pewter bed pan

an inkstand

2 copper coffee pots. a mug. a funnell

a lamp

1 Doz & 9 tin pots

5 tin Cannesters

5 locks some keys

a set of money scales & weights

Plate

6 Table spoons

2 pair of sugar tongs

1 Doz & 8 tea spoons

a Cup & Cover

Nº. 92 In the Press

a Crimson silk line & 2 tassells

a Green dº

4 Yards of rose coloured silk Tabaret

21 Yards of striped green sattin

23 Yards of india paper 3 Yards long

4 Sheets of blue & silver dº

2 silk partridge Netts

2 twine dº

7 Yellow serge chair Cases

Sundry Rimnants of cut Velvet Caffoy &c.

a green baize Table Cover

a green serge curtain

Nº. 93 In the Stone Closet by the Maids Room

4 new hair broom 14 mops

6 hair broom heads

19 New Scrubbing brushes

2 large flat dº.

1 handle brush

1 iron & 4 brass rods

6 tin rims, sundry small dº and some patties

2 hearth brushes, 2 small brushes

a stone bottle, a Jug, 3 door mats

a pewter inkstand

a Lock, a pair of steps

Some iron hooks & brass hooks &c.

a folding stool a bracket dust shovel

a music stand & a stool pan

Nº. 94 Dairy

Two double Milk leads & frames

a Salting tray lined with lead

a Barrel Churn

a hand barrow

2 lead shifters

a half hundred lead weights & a small weight

a stove salting binn lined with lead & wood cover

Nº. 95 Yard & Fowl house

a Range of Hen Coops with rail front

an iron bound tub some hoops

some old iron

Some Stones & tiles

a long Binn & Cover

a hen coop & stand

a Stone trough & lead weight

a Coal Shovel

Nº. 96 Glaziers Shop

a large Work board

a Grate

an iron key. an old milk lead

a Casement & a quantity of old iron

14 brass ~~ser~~ pullies with iron screw hooks

an iron T with Screw

3 large brass Cocks

5 brass locks 5 iron dº

Sundry iron lead & brass

A Table with some paint pots &c

a Box with plate Glass

New and old lead

Some Cullett

2 iron Kettles

a Seat of some boards in front of the house

Nº. 97 Wood House

A Large Copper with Cock & boss

a dº with cock & boss

2 posts with scroll irons

a Saw a horse 3 beetles 5 wedges

a Quantity of Billet Wood

Nº. 98 Butchers Shop

Two large Blocks

a Tackle & ropes with windlass & lever to dº

a pole axe, pair of wood planks & ropes

iron beams

2 half hundred lead weights 2 iron dº

one quarter one 14lb. 10 & one 7lb weight

a pair of Slops a hand barrow

a Quantity of lead & iron

a strong new Rope and one pitch dº
a Stone trough & a spade
2 large iron fenders, 2 iron bars
a box with useful iron
a Quantity of Slates & Tyles

Nº. 99 Room over Stables

a half teaster Bedstead blue furniture
a feather Bed & bolster
2 Blankets & a Coverlid
2 deal tables & a Corn Binn
Sundry Bedsteads
a Stove Grate
Some Bottles
a Corn Binn & stool
a Stump Bedstead
2 feather Beds 2 bolsters
4 Blankets & a Coverlid
2 Cages. a leather Muzzle

Nº. 100 Fruit Room

Two blocks pullies & ropes
A large fruit Stage
Two dº on the sides of the Room & round the ends
a Ladder
a wire sieve a seed tray
Some baskets a pair of Steps

Nº. 101 Stables & Coach house

A Family Coach, the body painted a Lead Colour lined
 with light coloured cloth. spring blinds
A Cannon on a Carriage with iron shod wheels four
 Ammunition Chests
Spunge & hook
a fish Machine with shod wheels &c
a Coach Sitter. 2 Rammers
an iron bound Cask
a Park Phaeton with plated harness for one horse
a Deer machine & sundry harness
27 Hare traps
A Spring Machine for the carriage of Hares
a Spaniel Cart
a weed scythe
Two fire Engines with branch pipes
a Quantity of Poles & Wood &c
a Hare Cart & Shelter

Nº. 102 Brewhouse at the Farm

A Copper fixt in brick iron work & lead curb
a shovel. a peal
2 Bell shape Butts
1 Hogshead
3 barrels & one half dº

2 iron bound tubs
a tar barrell
3 marble milk trays
An iron Roller 3 ft. 6 at Birchalls

Nº. 103 Garden

a Lead Cistern
a dº
an iron Roller
An iron Roller in Jarvis's Garden near Town

Nº. 104 Dog Kinnells

An iron Boiler
Dº
a Quantity of Tyles
a large deal Table
a Binn for Meat

Nº. 105 Mill houses

a Horse Wheel 10 feet diameter
with tumbling shafts wheel &c

Nº. 106 Venison House

Two Safes canvas sides
a Table
a hand barrow
a half hundred lead weight
a Board
a Lantern weight
a water Cask
a Stone Cistern
a feeding trough
a feeding trough
a small truck
6 Bowls a Jack
a Quantity of Netting
The Turrett Clock

106 rooms & outhouses compleatly furnished. At Sᵣ Robert's death no part was left unfinished, but the Chapel, the Church being so near to the House.

China and Glass

26 round fine old coloured dishes with the Orford Arms
9 Doz & 4 meat plates to match
3 Ice pots & covers to match
2 square fine old fruit dishes & 9 handle composed to
 match 1 of the handles damaged
2 old sallad dishes damaged
an imaged fruit dish
a Scarce old tea pot cover & stand
a Coloured bowl a blue & white dº

a bason & 3 delf handle pot & stands
5 fruit leaves
6 blue and white round meat dishes & a baking dish
An antique pot & Cover & 6 Custard Cups
7 blue & white Coffee Cups
2 pair of Sauceboats the Landscape pattern
6 round blue & white dishes some damaged
2 blue & white bowls
a fine scarce old Green Ground Dish
12 blue and white round Dishes
a pair of old blue & white pudding dishes
2 small delf meat plates
9 Chocolate Cups
5 blue & white Cups 9 Sauces & a bason
4 white and gold Compotiers & 3 plates
Four glass Machines for the making of Mineral Waters –
 with various Apparatus
16 pair of glass decanters one odd decanter
4 Dozen of Wine Glasses various
11 Beer Rummers
an octagon cut dish & stand
Six oblong d⁰. & stands and one smaller d⁰.
one Basket and stand
4 desert baskets & stands
Nine dishes and a bason
an ice pot Cover & stand
a 5 tier Jelly stand with centre
12 plates
2 handle Cups & 16 pieces various
a 5 tier Jelly stand with centre
4 Cups & Covers
2 handle cups 2 baskets
30 plates
50 Pieces
A 5 tier Jelly stand with centre
a Vase pot and stand
2 handle cups & stands
3 plates 2 stands & basons
22 pieces of various
a 5 tier Jelly stand with centre
4 plates
a pot Cover & stand a 5 tier Jelly stand
2 cups & covers 2 d⁰ & stands 2 plates 2 cups & 40 pieces
 various
2 baskets & stands
2 handle Cups
About 40 pieces
a 2 tier Jelly stand
6 Glass shades
5 plates
4 pails
7 handle Cups
2 Cups Covers & stands

About 50 pieces
a Crewet with silver top
a pair of glass decanters
3 water bottles
3 pair of Salts
5 pair of Decanters
4 tumblers, 1 Goblet
1 Dozen & 9 fluted wines
11 fluted Ale Glasses
2 Dozen of plain wines
a funnel
9 Sweet wine Glasses
12 fluted finger Glasses
12 plain finger d⁰
Some odd stoppers
a Mug mounted with silver
a Glass tray
1 Doz & 10 plain Wine Glasses
36 Sweet Wine Glasses
10 Gilt & Ale Glasses
8 Salts
a waiter
a fine old bowl damaged
2 tea pots 6 coffee cups
5 saucers 5 coffee cups
5 Chocolate cups 5 Saucers
a tea pot & cover
6 small tea cups. 6 saucers
a tea Jar. sugar bason & cover
Slop bason & cream Ewer.
2 Yellow Jugs. 2 green fruit dishes
2 Glasses & some odd pieces
2 Queens metal tea pots
3 others 1 with silver spout
a brown Coffee pot
7 blue and white pint basons
12 half pint basons & 12 saucers
12 Chocolate Cups
10 Coffee Cups & 2 cream Ewers

Linen

Four pair of fine Holland Sheets
Three pair of d⁰
Four pair of d⁰ indifferent
Four pair of d⁰
Four pair of d⁰
Four pair of d⁰
Four pair of d⁰. Bad
Four pair of d⁰
Four pair of d⁰
Four pair of d⁰
Two pair d⁰

Three pair of coarse sheets
Nine pair of strong coarse sheets
Ten pair of indifferent d⁰
6 pair of pillow cases
5 pair & one d⁰.
Six new damask Table Cloths 5 yds long
Six diaper ¾ Table Cloths
Two diaper Table Cloths
Six diaper ¾ Table Cloths
Fourteen Smaller d⁰
6 large diaper Table Cloths 6 yards long
2 white diaper Table Cloths
10 diaper table Cloths
12 damask & diaper d⁰ bad
12 Doz & 6 diaper Napkins
3 Doz & 11 New D'oyleys
1 Doz & 11 Napkins
4 Doz & 9 d⁰ indifferent
10 Doz & 8 Towels
4 hand towels
8 small breakfast d⁰
3 Dozen old D'oyleys
22 old Napkins
Four table Cloths
4 Stewards large Cloths
3 Servants Hall Cloths
16 Glass Cloths
15 Knife Cloths
2 plate Cloths
8 round towels
4 Meat Cloths
2 towels
3 pudding cloths & 2 rubbers
20 yards of coarse cloth
21¼ Yards of fine d⁰
2 Remnants about 14 Yards

An Inventory of the Statues Marble Bustos Bronzes &c at Houghton Hall Norfolk

Marble Hall
over the Great door
Two female figures emblematical in white stone

over the four lesser doors
Eight Boys emblematical in white stone
all by Rysbrack

Marble Busts & Heads on Therms & Consoles round the Hall
Marcus Aurilius & Trajan, Antiques
Septimus Severus & Commodus d⁰..

a Busto of Sir Rob.ᵗ Walpole by Rysbrack
a Young Hercules Antique
Baccio Bandinelli by himself *valuable*
Faustina Senior … Antique
a Young Commodus … do
Homer Modern
Hesiod d⁰

Antique Heads
a Jupiter a Philosopher
Adrian & Pollux

The Bass Relievos over the doors and one over Chimney all in white Stone from the Antique by Rysbrack

Marbles on the Table
A Female Busto **from the** Antique
a Roman Empress d⁰
A Venus laying on a Couch by Loccatelli very highly
 finished
a Busto of Vulcan by d⁰. in composition

Bronzes on the Tables
A pair of figures representing The Nile and the Tiber from
 the Antiques in the Capital at Rome *valuable*
a Group of the Rape of a Sabine by I:da Boulogne
 very precious
a Pair of Vases from the Antique in the Villas Medici &
 Borghesse at Rome *valuable*

Before a Nich opposite the Chimney
The Group of the Laacoon & Sons. a cast in bronze
 from the Antique finished by Girardon
 extremely valuable

The Saloon
A pair of oriental alabaster Vases and two antique female
 Busts in marble

The Marble Parlour
Over the chimney
A fine Alto Relievo from the Antique by Rysbrack
A Large Cistern of the Gray Granite
Two Statues one a Mercury
 the other a Player of the Olympic Games by Loccatelli
 in Composition

The Drawing Room
over the chimney
A small Head of a Madona ~~from Fiamingo by Rysbrack~~
 by Camillo Rusconi

The Green Drawing Room

A beautiful large Slab table inlaid with Lapis Lauzulla
 valuable

The Passage Room

Four Bustos modern copied from the Antique in Statuary
 marble on veriegated dº. Pedestals
Two Heads Antiques on marble pedestals
a Statue of Ceres in Composition by Loccatelli

The Coffee Room

On a Table foot a most beautiful & highly polished
 Granite Slab with or molu border
At the bottom of the Great Staircase on 4 Doric pillars
 stands raised
"A fine Cast in Bronze of the Glaudiator finished by Joⁿ.
 of Boulogne" from the Antique **very fine**

Pictures

In the Saloon

A whole length Portrait of The Empress of Russia by
 Brompton in a rich gilt frame
Cipriani. A Large capital Picture of Oddipus Colenus
dº Custor & Pollux
dº. Philoctities in Lemnos
Cipriani. The Rape of Orithgia
Two large Pictures from Birds in the Leveranium Museum
 by Renigail
A Bull & Goats of Sierra Leona by Gerard & figures by
 Opie

over the Chimney

Ariadna by Cipriani
Parrots & other foreign Birds by Renigail
Thodore's Visions from Dryden's fables by Fuseli a very
 large picture
The Fortune Teller by Opie
Birds by Renigail

Green Velvet Chamber

A Subject of a dream from Shakespear's Plays by Fuseli
The Brussells Tapestry Representing the Love of Venus &
 Adonis **after Albano beautifull**
a picture of African Sheep belonging to the late Lord
 Orford by Renigail

The Dressing Room

Tapestry representing portraits from Vandyck at full
 length of James the first with his Queen Charles the
 first with his Queen. & Christian King of Denmark and
 ovals of the Royal Children **unique**

Library
over the chimney

a Portrait a whole length of King George the first by
 Sir G Kneller

Sir Robert Walpole's Bed Chamber

A Lady's Portrait by Dahl } *Sir Robert's Two Wives*
a dº half length by Van Loos }
a Landscape over the Chimney Wotton
& 3 door pieces dº
Lady Orford's Portrait a half length

In the Closet

a Portrait of the Old Surveyor ~~as~~ who planned & laid out
 the Park **no I believe ... is Harold, Roberts gardiner**
The four Seasons in Ancient Tapestry
a Curious old Cabinet inlaid with ornaments of Silver
 engraved

The Coffee Room
over the chimney

A Landscape by ~~Claude~~ Swanivelt,
Two Portraits, **the black colonel Horatio Walpole, Uncle of Sr
 Robert &**
Captain Galfridus, Sr Robert's youngest Brother.

The Embroidered Bed Chamber

The Tapestry.

Cabinet Chamber
over the chimney

a figure of Sedious by Fuseli
a Portrait of the Marchioness of Warton by Sir P Lely
 valuable

The Breakfast Parlour

Three Portraits of the Sons of Sir Rob Walpole by Rosalba
 in Crayons,
Lady Malpas by Jervas
~~Two by Bond Miss Walpole~~ & Lady
Mary Churchill **by Pond**
Two Portraits of Gentlemen
An Arabian Horse & a Dogs head
Twelve Portraits. half length & heads of the Family of Sir
 Rob Walpole
a View of the Camp at Readham by Renigail
Two Flamingos india birds by Dº
a Picture of Dogs from life
2 Landscapes after Claude
3 of fruit
1 of live fowls

The Housekeepers Room in the Wing

A Pair of Landscapes after Poussin in Water Colours
a Pair of circular d°. in oil by Fillilli

Nursery

The Marchioness of Warton Sir P Lely
Sir Robert Walpole in his Robes as Chancellor of the
 Exchequer and his Lady
a Head of Sir Robert with a Cap on
The Earl of Orford Son of Sir Robert
Lady Orford a whole length
Ditto the Lady's Mother M^rs. Rolles d°
a Head of Lady Orford

over the Chimney

a Landscape the finding of Moses by Romanelli

Attic Story

Two whole length portraits, one of which is Col Rolles
a Battle Piece by Borgonione
Lady Orford three quarters after Dahl
a Landscape & figures Romanelli
a Picture of Hawks & Cranes
A Portrait of a Falconer on a Horse

Yellow Damask Chamber

A Cartoon Drawing by Rysbrack
a Philosophers Head by Rembrandt
qu .if not See Vandervelde in black &white. these w.. anone
a Portrait of Dobson Zaur by himself *very good*
Boys with fruit. two pictures Italian
The Tapestry hanging from the designs of Teniers

Crimson Mohair Chamber

The Tapestry hangings

Dressing Room

a Portrait in a Landscape or a Park
 back ground of Sir Rob^t. Walpole with his horse &
 groom small figures by Wootton
15 pictures, various subjects, small
Luca Giordano: Diana & Endymion
The interior of a dutch Caberett
The Tapestry hangings representing the four Seasons

The White Room

Two pieces of Tapestry the subject Hero & Leander

The Painted Taffeta Room

a Portrait by Seb.^n Bourdon
2 Landscapes by Wotton

2 d° by another hand **by J. Van Huysum**
2 flower pieces & a fruit piece
a Sea piece in black & white **by Vandevelde, fine**
The Marriage of S^t. Catharine a fine old Copy after but in
 the school of Vandyck
The Tapestry Hangings

January 14^th 1794
Brigg Price Fountaine
E Rolfe
Anth^y Hamond
R Macknell *Orford*

We think the Appraisment and Valuation of The
Furniture, Pictures, Statues and other things at Houghton
Hall in the County of Norfolk mentioned in the Inventory
taken thereof at the Sum of £10,070 and also the Books
appraised & valued at £830 making together the Sum of
£10900 ought to be paid to the Executors of the late Earl
of Orford for the Same without any Deduction or
allowance to be made therout on any account whatsoever,
Witness our hands this 27^th Day of June 1793

Tho. Dyke
for T. Skinner Hills
James Christie

Holkham, Norfolk and Thanet House, London, 1760

William Kent's design of Holkham Hall was inspired by Thomas Coke's six-year grand tour of Italy and was created to hold his collection of paintings, sculptures, books and manuscripts. Begun in 1734, the house was not completed until twelve years after Kent's death and two years after Thomas Coke, created Earl of Leicester in 1744, had died. The 1760 inventory shows that some of the rooms were still unfurnished and there were still pictures to hang. The Mr Brettingham mentioned in the inventory is Matthew Brettingham (1699–1769), an architect from Norwich who oversaw the building process. His room contained drawings of the house. Holkham Hall was completed by Brettingham after the Earl's death under the supervision of his widow, Lady Margaret Tufton.

The inventory records the location of the paintings. The Landscape Room was named after the landscape paintings by Claude Lorrain and Nicolas Poussin which still hang there today. The classical sculpture recorded in the Gallery was collected by Coke over forty years.

Thomas Coke's only son predeceased him and the Hall and its contents passed to his nephew Wenman Roberts, who changed his name to Coke in 1750. The Hall eventually passed to his son Thomas William Coke in 1776.

Thanet House, Great Russell Street was altered for Thomas Coke by the architect James Gibbs (1682–1754) in 1718 to 1719. The inventory demonstrates that the furnishings of the London house were as grand as those of Holkham Hall. The main rooms of parade were hung with Italian old masters and adorned with classical sculpture. Religious and mythological paintings were hung side by side with portraits and landscapes. These rooms were furnished with gilt framed seating and extravagant textiles.

The contents of the servants' quarters provides a sharp contrast to the richness of those rooms used for formal entertainment. The inventory provides an interesting social commentary on life both upstairs and downstairs in a great London house.

The manuscript, in a notebook, with a marbled paper cover, remains at Holkham Hall in the collection of the present Earl of Leicester.

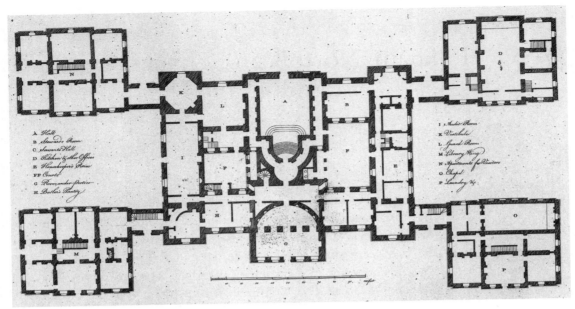

(Fig. 16) Plan of the ground floor of Holkham in Norfolk, from John Woolfe and James Gandon, *Vitruvius Britannicus*, vol. v, 1771. *Victoria and Albert Museum*

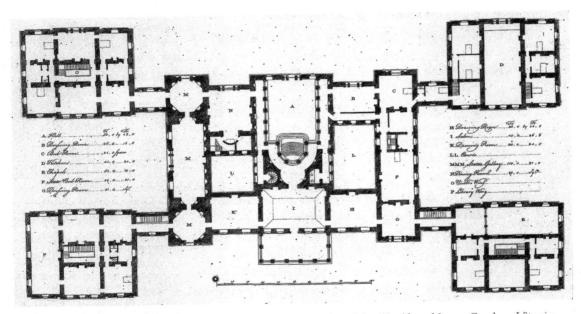

(Fig. 17) Plan of the principal floor of Holkham Hall in Norfolk, from John Woolfe and James Gandon, *Vitruvius Britannicus*, vol. v, 1771. *Victoria and Albert Museum*

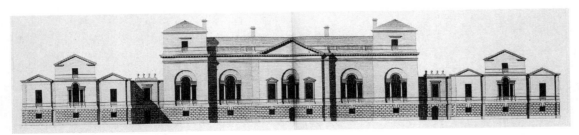

(Fig. 18) North front of Holkham Hall in Norfolk, from John Woolfe and James Gandon, *Vitruvius Britannicus*, vol. v, 1771. *Victoria and Albert Museum*

An Inventory of the Furniture, Household Goods, Pictures, Statues and Bustoes at Holkham House in the county of Norfolk, late belonging to the Right Honourable Thomas Earl of Leicester deceased

Lord Leicesters Apartment.

Passage from the Corridore

1 Cypress Chest
1. Indian Deal Chest
1. Chest of Drawers
3. Windsor chairs compass back'd
1. small windsor chair
1. mahogany stool
1. Lanthorn
Barrs set in Bricks, fireshovel, tongs, poker, fender, Hearth Broom, Chimney board.

Housemaids room

1. Press Bed
1. Feather bed, Bolster, 2 Pillows, 4 blankets
1. chest of Drawers
1. Looking Glass
1. Table
1. Larum clock
3. Rush bottomd Chairs
4. fix'd Ironbarrs, fireshovell, Tongs, Poker, fender and Hearth Broom.

Ladies Womans room

An oak four post Bedstead, red and white furniture cotton, feather bed, Bolster
2 pillows, a matrass & 4 Blanketts
1 Cotton Counterpaine
1. wainscot press
1. walnuttree Cabinett
1. Indian deal Chest
1. Chest of Drawers
1. Looking Glass
1. oak Buroe
1 mahogany hanging shelf
1. mahogany stand for airing Linnen
1. Canvas Fire screen
1. Mahogany table on a Claw
1. writing box
1. oak celler
1. Mahogany Cellar
1. Carpett

1. pewter water Candlestick
4. new Comb Trays
1. Easy chair cover'd with check
5. Rush bottom'd chairs
1. Stool
1. Iron stove, fireshovell, tongs, Poker, Fender, Bellows and Broom

Footmans room

A four post Bedstead, blue and white Linnen furniture, counterpaine of the same.
1. Feather bed, Bolster, 2 pillows, & 4 blankets
1 Windsor chair compass back
2. smaller
1. writing table with drawers
1. Chest of drawers
1. small table
1. Looking glass
Iron stove, fireshovel, tongs, fender, poker and Broom.
3 maps in frames

Passage.

2 Compass back'd windsor chairs
2. Glass Lanthorns and shades

Bathroom

The Bath lined w^th. lead a mahogany case.
1. mahogany Bathing tub
1. Biddeau
1. pair of steps
2. Ladders
1. windsor chair

Next Passage

1. old Inlaid chest
4. Compass back'd Windsor chairs
1. Stove, fireshovel, tongs, poker & fender.

Valet de chambres room

1. four post Bedstead check'd blue & white furniture and counterpain
1. featherbed, Bolster, 1 pillow, 1 matress
4. Blanketts
1. oak chest of Drawers, 2 of Indian Deal
1. Table for writing, 1 old Deal table
1. Dressing Glass
7. maps
1. Compass back'd windsor chair
2. Small windsor Chairs
A Stove Grate, fireshovell, tongs, poker, fender, Bellows and Broom

Lord Leicesters Apartment [continued]

Secretarys room

1 Highback'd Windsor chair, 2 lower backs, 1 small
1. large oakpress
1. wainscot chest of drawers
1. wainscot table, 1 Glass
1. writing table cover'd with black leather
1. stool
Iron barrs, fireshovel, tongs, poker, fender, Bellows and
 Broom.
5 maps in black frames
1. on a Roll, post roads of England
1. of Norfolk
4. leather boxes for Writings

Rustick Diningroom

9 Rush bottom'd Chairs
1. mahogany Diningtable
1. Octagon Dining table
1. mahogany Breakfast table & board
1 mahogany Chess table
1 manchinel table in two parts
1. mahogany Dumb waiter
1. Stand for a Tea Kettle
3. Crimson stuff and silk damask window Curtains
2. Glasses in Gilt frames
1 large Canvas Screen
1 Map Screen 3 leaves
1 small fire screen
1 Brass stove Grate
Fire shovel, tongs, poker, fender, bellows and Broom
A painted floor cloth
A Stand for a Tea Kettle
A Plate Warmer
2 Brass Vases on the Chimneypiece

Staircase

1 Glass Lanthorn Ironchain
a weather Glass

Anti chamber

6 chairs mahogany frames, black leather seats.
1. Crimson stuff window Curtain
1. mahogany chest of Drawers
1 mahogany Breakfast table w^(th.) a board.
1 mahogany Coffeetable on a claw
1. Card table
1. Grate, Fire shovel, Tongs, Poker, Fender, Bellows and
 Broom
4. stands intended for the Gallery Gilt

Lord Leicesters dressingroom

3 Crimson stuff damask window Curtains
2. Easy chairs cover'd w^(th.) leather
6. less chairs cover'd with black leather
1. Compass back'd chair Rush bottom'd
2. mahogany tables
1. mahogany dressing table
2. pier Glasses in Gilt frames
A. Japan Chest, a leather cover
a. Canvas Screen
a. Painted floorcloth
a. Window Blind
a. Grate, Fireshovel, Tongs, Poker, Fender, Bellows and
 Broom

Library

1 large Settee cover'd with black leather Bolster and
 Pillow
6 large arm'd chairs cover'd w^(th.) black leather
3. Easy chairs cover'd with black leather
1. Library Ladder chair cover'd with the same
9. Rush bottom'd Chairs
2. Stools
2. square mahogany tables with drawers
2. mahogany Reading desks on claws
2 french plate Candlesticks on stands snuffers and
 Extinguishers
2. mahogany stands for Books
1. mahogany writing table
1 mahogany chess table
2 Inlaid Card tables
4 mahogany stands for Candles
1 mahogany table on a Claw
1 mahogany standish
3 folding mahogany Reading desks
1. of Another wood
An English Japan writing box
2 small reflecting telescopes & 2 wooden Cases with
 magnifying Glasses
1. French inlaid clock
1 watchman inlaid case over the Chimney
2. China Candle sticks
2. firescreens
1 Grate, fire shovel, tongs, poker, fender, bellows and
 Broom
a painted floorcloth
5 window blinds

Lord Leicesters Apartment

Lady Leicesters dressingroom.

Hung with Green damask, 3 window Curtains the same lined with stuff
1. Settee and 6 Arm'd chairs coverd wth. Green Damask, gilt frames.
12. check'd false covers
2. stools mahogany frames cover'd wth. damask and check'd covers.
2. pier Glasses Gilt frames
2. mahogany tables
1. mahogany table for work, 1 work Basket
1. mahogany dressing table with drawers
2. Quilted Covers
a Dressing Glass
4 Japan Boards
a Japan chest a leather cover.
A Wilton Carpett
A clock
A screen painted on Dimithy
A screen 2 leaves mandrine paper
3 window blinds and Stick
A Grate, Fireshovell, Tongs, Poker, fender Bellows and Broom.

Bedchamber.

Hung with Tapistry 4 pieces
1 Carved mahogany Bedstead brown & Gold colour'd Genoa damask furniture
Counterpain the same (the bed & chairs very old).
2. Brown Cotton false Curtains
1 Down bed & bolster 5 pillows
1 check'd matrass, 1 white matrass, 4 blanketts
2. white Calico Quilts
2. Indian Calico work'd wth. yellow silk
1 window curtain the same as the bed
6 arm'd Chairs mahogany frames Gilt coverd wth. the same as the beds 12 check'd covers
2 Mahogany Night tables
2 Bedside Carpetts
1. French comode table inlaid a leather cover
1 water clock on a frame
1 Brass stove, fireshovel, tongs, Poker Fender, Bellows, and Broom
1 window blind and stick

Closet

An Indian Deal chest
1 Cloaths baskett and a small one
A copper Lamp

Ladies closet

Hung with Green Mohair
1 Arm'd chair and 3 stools cover'd wth. work
2 setts of false check covers
1 large chest of drawers Mahogany
1 large mahogany writing table
a window blind & stick
2 China Bottles over the Bookcases
2. Jars over the Chimney, 2 alabaster Vases
a Grate, Fireshovel , Tongs, Poker, Fender, Bellows and Broom.

Bedchamber in the Atticks

Hung with yellow damask
a four post mahogany Bedstead yellow lutestring furniture & Counterpaine
a Down Bed, 1 Bolster, 4 pillows
2 check'd matresses, 1 white Matrass, 4 blankets
2 white Calico Quilts
1 Settee cover'd wth. yellow damask Gilt frames
7 Chairs the same & yellow stuff covers to all the chairs and settee
2 lutestring window Curtains
1 mahogany chest
1 mahogany table
2 mahogany stands
1 mahogany dressing comode table
1. Dressing Glass
2. Quilted tops for the Table
a. yellow Toilett
1 night table
2. Bedside Carpetts, 1 Hearth Carpett
1. Brass wind stove, fire shovel, tongs poker, fender, Broom and Bellows

Closet

Hung with blue and yellow paper
a chair the same as the Bedchamber
a small walnutt tree writing table
mahogany shelves & pigeon Holes for paper

Closet

Hung with blue and yellow paper
Peggs for cloaths and a shelf
A Close stool.

Dressing room

Hung with Green paper
2 Green Moreene window Curtains
5. arm'd chairs
10. check'd Cases
1. Stool

2. check'd covers
1. mahogany writing table
1. Escrutore and Bookcase
1. Green toilett lutestring
a mahogany dressing table Glass in the top
a Round mahogany table on a claw
a Fire screen
an old Carpett
A Brass windstove, fire shovel, tongs poker, fender, bellows and Broom

Closet
A Mahogany chest of Drawers.

Servants room
Hung with blue and yellow paper
An oak Bed stead, crimson and white cotton furniture
a featherbed, bolster, 1 pillow, 4 Blanketts
1 matrass
1 Cotton Counterpain
1 Rush bottom'd chair
An oak chest of Drawers
A Dressing Glass
A Pewter standish
A Box under the Bed

Closet
A close stool

Belonging to this Wing are
2. Brass pails
2. Copper coal scuttles
2. warming pans
2. copper Lamps
1. Tub for washing feet
1. Baskett for wood lined w^th. Dogskin
An Iron Heater

Body of the House

North Tower room
Hung with paper
a four post Bed
Curtains and valence work'd w^th. coloured worsted on dimithy lined with cherry derry
Feather bed, bolster, 2 pillows, 2 matrasses
4 Blankets, 1 white calico Quilt
1 Easy chair, black frame cover'd with the same work as the Bed
8. Rush bottom'd chairs & 8 cushions the same work
1. mahogany Night table

1 Bed carpet, 1 Hearth Carpet
1. mahogany table
1. Glass
1. mahogany table on a Claw
a standish
a stand for a Bason
An Iron stove Grate, Fireshovel, Tongs Poker, fender, Bellows & Hearth broom.

Passage
A small wainscot Table

Closet
A Close stool

Servants room.
1. Pressbed, blue & white curtains check'd
1 Feather bed, Bolster, pillow & 3 Blanketts
1 Blue & white Calico Quilt
1. oak table
1. Glass
2. Windsor Chairs

Staircase
A Lanthorn

Tower room
Hung with paper
a four post Bed white Dimithy furniture
A feather bed, bolster, 2 pillows, 2 matrasses
4 blankets, 1 white calico Quilt, 1 Bed Carpet
1 mahogany Night table
1 Hearth Carpet
1 Easy chair cover'd w^th. white Dimithy
1 Rush bottom'd chair Quilted and cover'd with white Dimithy
8. walnuttree chairs, seats cover'd w^th. white Dimithy.
An old English Japan Chest
A mahogany Dressing table
A Dressing Glass
A stand for a Bason
A Mahogany table on a Claw
A standish
An Iron stove grate, tongs, fire shovel, poker, fender, bellows and broom

Closet
A Close stool

Staircase
A Lanthorn and chain

Body of the House [continued]

Belonging to these two Tower Rooms

1 Copper coal scuttle
1. warming pan
2. copper Lamps
1. Tin Candlestick

} all mark'd <u>Tower rooms</u>

South West Tower

Hung with paper
A Four post Bedstead
white Dimithy Curtains, Headcloth, Tester, valence Base
 & Counterpain all work'd w^th. yellow
Silk curtains lined with white Calico
Feather bed, bolster, 2 pillows, 2 matrasses
4 Blanketts, 1 tuffted white Counterpain
1. Bed Carpet
1. mahogany night table
6. large Arm'd chairs, covers work'd the same as the
 beds
1 mahogany table on a claw
1 mahogany standish
1. mahogany Dressing table
1. Dressing Glass
1. mahogany stand for a Bason
1. Hearth Carpett
1. Iron stove Grate, fireshovel, tongs, poker fender,
 bellows and Broom

Closet

A close stool

Servants room in the Tower Gallery

A Bedstead Yellow stuff curtains
Feather bed, Bolster, 3 Blankets
1 Calico Quilt
1 Compass back'd Windsor chair, & 1 less
A Table

Stone Staircase

Lanthorn and Chain

Tower room opposite

Hung with paper
1. four post bed white Dimithy curtains work'd w^th.
 yellow
worsted lined with white siletia
1 Featherbed, bolster, 2 pillows, 2 matrasses
4 blankets, 1 white Quilt
1 Bed carpet
1. mahogany night table
1 Easy chair covered w^th. the same as the bed

8. Rush bottom'd chairs
8. Cushions cover'd w^th. the same as the Bed
1. mahogany table on 3 feet
1 mahogany standish
1 mahogany dressing table
1 Dressing Glass
1 stand for a Bason
1. Hearth Carpett
1 Brass stove Grate, Fireshovel, Tongs, Poker, fender,
 Bellows and Broom.

Closets

A close stool
A coal scuttle
A warming pan
2 Lamps
2. tin Candlesticks

} marked <u>Tower Rooms</u>

Servants room

2 Press beds check'd curtains
2. feather beds, 2 bolsters, 6 blankets
2 check'd Quilts the same as the Curtains
1. oak table
1. looking Glass

Staircase

Lanthorn and Chain

Tower Galleries

2. Cypress Chests
1. Indian Deal
4. Braziers
2. Bed Airers

Closets

2. Japan Cabinets and leather covers
An Inlaid top of a table

Attick

Hung with Green and white paper
a four post Bedstead Cloath colour'd stuff damask
 furniture Counterpane the same
1. feather bed, bolster, 2 pillows, 2 matrasses
4. blankets, 1 white tuffted Quilt
2 Bed Carpitts
1. Mahogany Night table
1 Easy chair cover'd w^th. blue & white check
5 Chairs walnuttree frames seats cover'd with the same as
 the beds
1 chest of Drawers
1. writing table on a claw
1. mahogany Dressing table

Body of the House [continued]

1. Dressing Glass
1. Stand for a Bason
1. Hearth Carpett
A Stove Grate, fireshovel, tongs, poker, fender, bellows, and Broom

Closet

A Close Stool
A Lamp

Servants room

A Bedstead Bed stuff curtains
Feather bed, bolster, 3 blankets
1 Calico Quilt
1 mahogany table 3 drawers
1 Looking Glass
1 Rush bottom'd chair

Next Attick

A four post Bed, old Green damask furniture
A feather bed, Bolster, 1 pillow, 1 matrass,
3 blanketts, a sprigg'd Quilt
A Bedside carpet
4 Rush bottom'd chairs
1 Compass back'd chair, leather seat & stool
A Black table with a drawer
A Dressing Glass
A two leaf'd table
An Iron stove Grate, fire shovel, Tongs Poker, bellows and Broom
A Lamp.

Mr. Jeffries Bedchamber

Hung with paper
A four post Bed, printed Linnen furniture curtains lined with silesia Lawn.
A Feather bed, Bolster, 1 pillow
2. matrasses
4. Blankets
1. white Calico Quilt
3. Chinese chairs, seats cover'd with the same as the Bed
1 Mahogany table 2 leafs
1 Mahogany night table
a small Turkey Carpett
a Brass Stove, fire shovel, tongs, Poker, fender, Bellows and Broom

Closet

A Close stool
A Lamp

Mr. Jeffries dressingroom

Hung with the same paper as the Bed chamber
1 Chinese Arm'd chair cover'd with the same as the Bed
1. without arms the seat cover'd with the same
a walnuttree Bookcase, Glass door, Desk and Drawers
1 mahogany Table 2 leaves
a Stand for a Bason
a Brass stove, fireshovel, tongs, poker, fender and Broom

Best Attick

Hung with paper
a four post Canopy bed
printed cotton furniture lined wth. Silesia Lawn
1 Feather bed, Bolster, 2 pillows, 2 mattrasses
4 Blanketts, 1 white Calico Quilt
2. Bedside Carpetts
2. night tables
1 Easy chair cover'd wth. blue and white check
3. Chinese chairs, bottom cover'd with the same as the Bed
1 Chest of Drawers
1. Mahogany table with a Drawer
a Dressing Glass
a Brass stove Grate, Fireshovel, Tongs Poker, Fender Bellows and Broom

Closett

A Mahogany close stool
A Lamp

Dressingroom to the Best Attick

Hung with the same paper as the Bedchamber
2 chinese chairs wth. arms } bottoms cover'd wth. the
1 without } same as the Bedchamber
1 couch, bed, red & white check'd covering
Feather bed, 3 pillows
A matrass
3 Blankets } kept in a chest in the check'd Attick
a white Quilt
A mahogany Comode table
A Dressing Glass
A Blue Toilett
A stand for a Bason
A mahogany table 2 leaves
1 Standish
1. Carpett
1. Firescreen
A Brass stove, fire shovel, Tongs, poker, Fender, Bellows and Broom

Body of the House [*continued*]

Closet

A Close stool
A Lamp

Servants Attick

1. four post bed, blue imbos'd stuff furniture
feather bed, bolster, 1 pillow, 3 blankets
1 Calico Quilt, 1 Bedside Carpett
1 mahogany table 3 drawers
1. Dressing Glass
3. Rush bottom'd chairs
Barrs set in bricks
Fireshovell, Tongs, Poker, Fender Bellows and Broom
2. Back Lanthorns in the passage

Coal closet

2. Warming pans and Heaters
2. Copper coal scuttles

Servants room to Servants Attick

A Bedstead Green stuff curtains
Featherbed, Bolster, 3 blanketts
1 Calico Quilt
1 mahogany table 3 drawers
1. Dressing Glass
3. Rush bottom'd chairs

Passage

An oak chest

Next Attick

A Fourpost Bedstead check'd red & white furniture and
 Counterpaine
A Featherbed, bolster and 2 pillows
2 matrasses, 1 Tufted Quilt, 4 Blankets
1 Bedside Carpett
1 Compass back'd chair leather seat & pan
6 Rush bottom'd chairs
1. Dressing table with Drawers
a Dressing Glass
a chest of Drawers
a large chest
A mahogany table and Claw
A Hearth Carpett
A Stove Grate, Fire shovel, Tongs, Poker, Fender,
 Bellows and Broom
A couch bed blue & white check'd furniture
1 feather bed, 3 pillows
1 matrass.
3. Blanketts
1. white Quilt

Corridore from Lord Leicesters Apartm^t.

Part of a mahogany Dining table Green cover
A small Mahogany Table 2 leaves

South Octagon

A white damask window Curtain
6. wooden back'd chairs, carv'd bottoms, stuffd cover'd
 with Crimson, worstead lace stuff false covers
1. mahogany writing table
steps under it to reach Books
A Chrystal Lustre 18 branches for Candles the chain
 Gilt
4 Gilt and carved Cases for Books
A Crimson stuff Bagg

Gallery

2. Large Settees cover'd w^th. blue Turkey leather Bolsters,
 mahogany frames Gilt and blue stuff false covers.
10. arm'd chairs cover'd with the same, frames alike stuff
 covers.
3. white damask window Curtains lined with stuff
2. Preerelli marble tables, Gilt frames and leather covers.
1. large mahogany table, shelves for Books, Gilt and wier
 doors, leather cover.
2. mahogany tables 2 leaves
2. mahogany Reading desks on claws
1. map screen
A Grate, fireshovell, Tongs, Poker, Fender, Bellows and
 Broom

North Octagon

1 white Damask window Curtain
5 chairs carved wooden backs stuff'd seats cover'd w^th.
 crimson lace red false covers.
A Chrystal Lustre 18 branches for Candles Gilt chain
a Crimson stuff bagg

North Diningroom

14 Chairs cover'd seats and backs w^th. Red morroco
 leather, mahogany gilt and Red stuff cases
3 Crimson lute string window curtains lined with stuff.
A painted floorcloth
1 mahogany Dining table for 10
2 parts of a large Mahogany Diningtable
2 Grates, 2 fireshovels, 2 pokers, 2 fenders. 2 pair of
 Tongs, 2 pair of bellows, 2 brooms
1 marble table of the Asbestoes and Porphiry frame Gilt &
 brass ornam^ts. a sideboard.
2. mahogany Dumbwaiters
1. small mahogany table
1. Canvas screen, 3 leaves
1. of the same Canvas less

Body of the House [continued]

Room behind the Beaufett

1 mahogany table in two parts to set out Deserts
1 Chair
2. plate Warmers
1 mahogany Cistern for Botles and frame
1 pail for washing glasses and frame
1 night table
1 oak Cupboard
a Lead Pump

Antyroom

Hung with Crimson Velvit flower'd
2 large Sopha's cover'd with Crimson velvit Gilt frames.
8. large arm'd chairs cover'd with the same Gilt frames.
Red stuff curtains to them all and leather covers under them and Crimson scarves of Lutestring
2 Crimson Lutestring window curtains lined with stuff
1 Large Turkey Carpett
2. Chairs laced bottoms, wooden backs carved stuff cases.
2. Indian paper screens, 2 leaves
1 marble Table on a Gilt frame, leather cover.
2. Inlaid Card Tables
1 Grate, Fireshovel, Tongs, Poker, fender, Bellows and Broom.
2. window Blinds, 1 stick
1 frame for a very large pier Glass Gilt

Saloon

Hung with Crimson Coffoy
4 half sophas cover'd with the same, red Lutestring scarves, red covers, Gilt frames
6 chairs cover'd with the same, Lutestring scarves, Gilt frames and Red stuff covers.
5. Crimson lutestring window Curtains lined with stuff
5 false stuff curtains to keep off the sun
2 large mosaic tables in Gilt frames
2 Grates
2 pirced fenders
2 setts of fire shovells, tongs & pokers.

Portico

6 Compass back'd Windsor Chairs

Drawing room

A Mosack Table
A Grate
A Peircd fender
Fireshovel, Tongs and Poker

Landscaperoom

Hung with Crimson damask
2. large settees cover'd with the same
Damask, Gilt frames, leather covers, and Red stuff covers.
5. Chairs cover'd with the same damask
Gilt frames, leather covers & red stuff covers
3. Crimson Lutestring window Curtains lined with stuff
3. false stuff curtains

State Bedchamber.

No furniture putt in when Lord Leicester died.

Lord Chamberlains Bedchamber

No furniture in it

Dressingroom

13 Large chair frames
4 less

Closet

No furniture in it

Servants room

No furniture in it.

Memorandum of pattern chairs in this Apartment

3 very large Elbow chairs – paid for
1 laced bottom, mahogany back cover'd & Gilt
1. old one the same sort brought from London
8. large Arm'd Mahogany chairs red & white check'd covers
1 morocco Red leather chair carved frame the same as those in the Eatingroom, but not Gilt a stuff cover.

Coridore from Lord Leices^rs. Apartm^t.

2 large Marble tables
2. small Inlaid, different colours
1. Black marble painted
2. old Carpets
A Mahogany table for 10 a leather cover
7. boards for chimneys when swept
a square Glass mahogany lanthorn

Passage next the Audit room

A mahogany table 2 leaves under the window

Audit Room

A Settee cover'd with black leather, bolster and Pillow
14. Chairs mahogany backs covered with black leather
1. mahogany Dining table in 3 parts
2. marble slabs on painted frames

Body of the House [*continued*]

a map screen two leaves

a wooden screen

An Iron Grate, fire shovel, tongs, poker, fender and
Hearth broom.

Beefstake room

1. Standing press
1. Mahogany table 2 leaves
6. windsor chairs, 3 Compass back'd 3 small
A stove fireshovel, tongs, poker, fender & broom.
1. plate warmer
1 pair of high brass Candlesticks marked
1. Oak dumb Waiter, 1 copper tray for knives
12. knives & forks iron handles
1 Stand for oil & Vinegar
2. old french plate waiters
a Mahogany stand for Cheese

Footmans Bed

Turnup bedstead, feather bed, Bolster
3. blankets
1 Calico Quilt
a Box to go under the Bed

Pantry

Barrs set in bricks
Fireshovel, tongs, poker, fender, broom
1 large press for plate lined with Bays
1 for Glasses
1 Bread Bing
1. Dresser
1. old oak table
1. fix'd Candle bing
2. wooden chairs
1 mahogany Cistern for bottles bound with brass and
 frame
1 pail of mahogany to wash Glasses & frame
1 mahogany tray for knives
3 mahogany trays for Glasses
1. old oak
4 mahogany sliders with wheels for Ice pails
10. mahogany sliders for bottles
2. Tobacco stands
1 mahogany case w^th. tin partitions to sett Bottles in Ice, a
 frame.
1 wheel barrow with partitions to carry bread, bottles &c
 to the Garden
4. Ice pails staffordshire ware
3 China Punch bowls
6 Earthen ones
2 Bagammon tables, boxes and dice

A Pope Joan
5 doz & 4 mother of Pearl Counters
2 doz & 8 fish
2 boxes of Ivory Counters
2 wooden chess boards
4. Japan saucers for Counters
2. chessboards for travelling
3 setts of Chesmen in Green bags
17. S^t. Clou' knives, 12 forks

Butlers Bedchamber

1 Four post bedstead, yellow stuff furniture
1. Featherbed, bolster, pillow, 3 blankets
a Coloured Calico Quilt
1 Bed Carpet
1. Windsor Chair compass back'd 1 less
a chest for Cloaths, drawers under it
1 Looking Glass
A Stove fireshovel, Tongs, poker, fender and Broom
A Pewter water Candlestick

Pantry Court

A Large Bottle Rack
A Lead pump and Cistern

Long passage

2 of Durno's stoves and 2 fenders

Room called M^r. Brettingham's

Hung with purple and white furniture
A four post bed, purple & white cotton furniture
A feather bed, bolster, pillow, 3 blanket's
2 matrasses
1 white tufted Quilt
A stand for a Bason }
A Night Table } wainscot
A mahogany table with a drawer
A Looking Glass
An Easy chair cover'd with Green serge
4 Rush bottomd chairs
A Grate, fireshovell, tongs, poker, fender and Broom

Closet

A Close stool

Next room

Hung with blue red & white paper
a four post bedstead, red, white & blue printed linnen
 furniture, counterpane the same. very old
2. feather beds, bolster, 1 pillow, 1 matrass
3. blankets
1 Rush bottomd chair, 1 windsor chair

Body of the House [continued]

1 Mahogany table with a Drawer
a Looking Glass
a wainscot stand for a Bason
a night table the same
a chest of drawers
a Grate, Fireshovel, Tongs, Poker, Fender, Bellows and
 Broom.

Housekeepers Bedchamber

Hung with purple and white paper
a four post Bed, white dimithy furniture
a feather bed, bolster, 1 pillow
1 matrass. 4 blankets, a white Counterpaine
3. Rush bottom'd chairs
2. chests of Drawers
a mahogany table with a drawer
a Dressing Glass with a drawer
a cloathes press
3 white curtains against the lights to the passage
A hanging shelf
An old Carpett
A Hand bell
A water clock on a frame
A large press with drawers under it for Households
A wind Brass stove, Fireshovel, Tongs, Poker, Fender and
 Broom.
A warming pan

Closet

A Bing for foul Linnen
Nests of Drawers for Druggs
A pair of steps

Passage

A Press
2 Lanthorns

Disert room

1 Large Press for china & Disert
1 small for dryed sweet meats
1 Hanging oak shelf
8. fix'd shelves
1 marble Morter, wooden pestal & stand
1. Coffee Mill
1 small brass Morter and Pestal
1. pair of wafer Irons
1. Toasting fork
1 Chafing dish
6. Dutch Tea Ketles and Lamps
3 Dutch coffee pots and Lamps
4. Copper Coffee pots

2. Jocolot pots
1. Iron stand
a stove fixed, fire shovel, Tongs, Poker, Fender and
 Broom
1 Hanging Copper Kettle
2. Small Tea Kettles
1 oak table in two parts to sett out Diserts
1. Deal table
1. windsor chair
1 less
1. Spice box
4. Tin boxes for Biscuits
8. Tin Covers
A Machine for orange Butter

Breakfast room

A Walnutt tree Buroe
A Mahogany table one leaf
A Breakfast table 2 leaves and a board
A Coffee table on a foot
A Walnutt tree card table
A Corner cupboard
A Looking Glass in a black frame
10. Rush bottom'd chairs
A Durno Stove
Fireshovel, Tongs, Poker, Fender, Broom and Bellows
2. old paper screens
An old painted floor cloth
1 pair of high brass Candlesticks

House Stewards Bedchamber

Hung with Blue Red & white paper,
a four post Bed, Blue and white check'd furniture.
Counterpaine the same
feather bed, Bolster, 2 pillows
1 matrass
3. blankets
a colour'd calico Quilt
a compass back'd chair
a Rush bottom'd chair
1. chest of Drawers
1. chest for cloths
1 Buroe
1 mahogany table with a drawer
a small dressing glass
an Iron Grate, Fireshovel, Tongs, Poker, Fender and
 Broom

Store room

1. Press with drawers for Spices and shelves for Books
1 writing table cover'd with black leather and a Drawer.
1 stool cover'd with Green
2. Rush bottom'd chairs

Body of the House *[continued]*

1. Pewter Ink stand
1. Stove Grate, fireshovel, tongs, poker, and fender

Stewards Diningroom.

17. Rush bottom'd chairs
1. mahogany Dining table in 2 parts
3. loose leaves set in a closett
1. square oak table
2. mahogany Dumbwaiters
1. mahogany Tray
1. stand for oil and Vinegar
1. marble slab for the side board
1. pair of High brass Candlesticks
1 old wicker basket for fruit
Barrs set in Bricks, fireshovel, Tongs Poker, fender,
 Bellows and Broom

Closets to the Stewards rooms

Shelves
A Deal Table
1 Chair
in one a Lead Cistern and cock
a Cupboard
a Table
a chair

Passage

one clock
An old Table
2 Lanthorns
a Hand bell

Gaurd room

1 Large table 2 leaves
1. less
13. windsor chairs
Iron Grate and Fender
41 muskets
36 Bayonetts
36. Pouches
12.Halberts
6. Pikes
1. Drum
2. Fire Engines

Porters room

A Bedstead to turn up blue curtains
A fatherbed, Bolster, 3 blanketts
A Calico Quilt
An old wainscot Chest of Drawers
1 old Deal table

1. old Japan table
1. Compass back'd chair
2 old leather chairs
1 pewter water Candlestick
a stove and fender
a large deal chest

Passage leading to the Stairs to the Dining room

A stove

House Stewards Cellar

A Dresser
Racks for cheese

Outward Celler to the Housekeepers Distilling room

A Large old press trough for salting pork.

Celler for distilling & preserving

2 worms and Tubbs
An Iron pot set in bricks
An Almbeck
2 Pewter stills
Bars set in bricks, fireshovell & tongs
4. Copper preserving pans
1 Bell metal & cover
5 Sauce pans, 2 Covers
1. Small copper boiling pott
1. Copper Apple Roaster
6. Copper plates for baking
2 Trevetts for stoves
8. large pewter Ice moulds
4. small
2. moulds for cheese
3. for pine apples
6. for fruit
1 pint measure and one half pint
1 wooden morter & pestall for Ice
1. pail
1. Tubb
1. standing deal press
1. chair old
a stand for a Jelly bag
1 salt box

Closetts within

Shelves and Dressers

Ale Celler

28 Lying Butts for Ale
4. Upright ditto
2 upright double Butts

Body of the House [*continued*]

Ale stools for all the casks

14 half Hogsheads used to send Ale and Beer in to London

Small Beer cellers

20 Lying Butts

9. Upright ditto

2. Lying Hogsheads

2. Upright ditto

Chapell Wing

North room in the Atticks

3. four post beds, blue imbosed, stuff curtains and Valence

3. Feather beds

3. Bolsters

12. Blankets

3. blue and white check'd Quilts

4. Rush bottom'd chairs

1. Standing press

2. chests of Drawers

1. Mahogany table with 3 drawers

1 Looking Glass

Bars set in bricks

A Fender, Fireshovel, Poker & Hearth broom

South room

2. four post beds, blue imbos'd furniture

2. feather beds, 2 Bolsters

6. Blankets

2. Blue and white check'd Quilts

3. Rush bottom'd chairs

1. arm'd chair

1. mahogany table

1. Dressing Glass

1. standing press

1. Chest of Drawers

Bars set in bricks

A Fireshovel, Poker, Fender & Broom

Bedchamber in the Midlefloor

Hung with Tapistry

1. four post bed, chince furniture lined with crimson Sarsnet, counterpain chince

1 feather bed, bolster, 2 pillows

2. matrasses

4. Blankets

1. white Calico Quilt

2. Bedside Carpets

2. Night tables

1. window Curtain Crimson sarsnet

1 Easy Chair and 4 less and 1 stool all cover'd with Chince, Red and white cotton covers.

A mahogany chest

A mahogany table with a Drawer

A Looking Glass

A Mahogany table on a claw

A stove Grate, Fireshovel, Tongs, Poker Fender bellows and Broom

1 Window blind and stick

Closet

A Close stool

A Lamp.

Dressing Room

Hung with Tapistry

A Couch bed, crimson and white check'd cotton furniture

Feather bed, bolster, matrass, 1 Pillow

3. Blankets

1. white Quilt

1 Crimson sarsnet window Curtain

2. chairs and a stool cover'd w^th. chince red and white check'd covers

1. mahogany back'd chair, seat cover'd with black leather

1. mahogany comode table with drawers

a. Dressing Glass

1. Crimson sarsnet Toilett

1. mahogany reading desk w^th. a standish

1. Turkey Carpet

1. Fire screen cover'd with work

1. Stove Grate, Fireshovel, tongs, poker Fender, bellows and broom

Closet

A close stool

Passage

A Mahogany breakfast table & board

Bedchamber

Hung with red and yellow paper

a four post Bedstead yellow stuff damask furniture and Counterpain

Feather bed bolster, 2 pillows

2. matrasses

4 blankets

1. white Calico Quilt

2. bedside Carpets

2. night tables

Chapel Wing [continued]

1 yellow stuff damask window curtain

1 arm'd chair cover'd with blue and yellow velvit

4. walnutt tree chairs, the bottoms covered with yellow stuff damask

1 stool the same

1 walnut tree comode table with drawers

a Dressing Glass

a yellow Toilett

A mahogany table 2 flaps

A Grate, fireshovel, tongs, poker, fender bellows and broom

Closet

A close stool

A Lamp.

Dressing room

Hung with red & yellow paper

1 yellow stuff window Curtain

3. walnutt tree chairs, bottoms cover'd with yellow stuff damask

1 shaving chair black leather seat

1 walnutt tree chest

1 Inlaid table with a drawer

A Dressing Glass

A mahogany table 2 flaps

A Mahogany standish

A Turkey Carpet

A Grate, fireshovel, tongs, fender, bellows, and broom.

A coal scutle }

A warming pan } to these two Apartments

Passage in the Rustick floor

A Clock

A Lanthorn

Cheesechamber

Racks for Cheese &c

2. deal tables

Looking Glasses

Passage to the Bedchamber

A press.

Bedchamber

Hung with lead colour & white paper

1. four post Bed, Red and Blue stuff sattin furniture

1 feather bed, bolster, 1 pillow

2. matrasses, 4 blankets

1. white Quilt

1 Grate, Fireshovel, tongs, poker, fender, bellows and broom

next room

A Grate, fireshovel, tongs, poker fender and bellows

Passage beyond to Disertroom

A Table to Dine on in the Garden

A Press.

Laundry

A large Grate, Trivett, fire shovel & tongs

A hanging Iron

A stove w^th. a flew to heat irons

13 Cast irons

3. Iron hands

2. Brass Candlesticks & snuffers

1. Sauce pan

1. Tea Kettle

1. Hanging Horse

2. standing Horses

1 form for folding Napkins, 1 less

2. Dressers for Ironing

2 wooden stools

Wash House

1 fix'd Copper

1 Rinsing Tub

1. Bucking Tub

8. small washing tubs

2. Piggons

2. Pails

1 Horse for wet Linnen

1. Hand Bowl

Mangle room

1. fix'd Copper

An Iron stove to bake muffins

A Mangle

A Table to fold Linnen

Outward Dairy

A Copper fixed

Bars set in Bricks

A Poker, a Fender

1. pair of scales

5. cheese fatts

2. churns

1. Barrell churn

2. tables

2. forms

2. chairs

Chapel Wing [continued]

1. pair of bellows and broom
2. pails
2. piggons
1 Bowl for Butter
1 wooden Leys to strain milk
2. cheese presses
1 Cheese tub
10. Butter potts
1 Sauce pan
1. Candlestick

Inward Dairy

2 leads set in alablaster
2 Tables.

Kitchen Wing

Cooks room

A four post Bed, Green Harrateen Curtains
Feather bed, bolster, pillow, 3 blankets
a coloured calico Quilt
a Large press
2. Rush bottom'd chairs
1. Compass back'd chairs
1. small mahogany table
1. small Looking glass
Bars set in bricks
Fender, Tongs, Poker and shovel.

Under Cooks room.

A Bed stead Green Harreteen furniture
A Feather bed, bolster and pillow
4 blankets, a coloured calico Quilt
A press
A Compass back'd chair
A Leather bottom'd chair
A small mahogany table
A small Looking Glass
Bars set in bricks, fender shovel & poker.

Footmans room

A four post Bedstead blue and white check'd furniture
Feather Bed, Bolster, 1 Pillow.
4 blankets, a Calico Quilt cover'd
a wainscot tree chest of Drawers
a Looking Glass
8. Rush bottom'd chairs

Next room

Bedstead & furniture as the last room
Feather bed, bolster, 3 blankets
a colour'd calico Quilt
a small mahogany table
2 Rush bottom'd chairs

Gallery

2. deal presses
1. old black table
1. mahogany table
4. Rush bottom'd chairs
2. Octagon Looking Glasses
a small Grate, fireshovel, poker, fender, broom

Next room

2. four post beds, blue and white furniture check'd
2. feather beds, 2 bolsters. 7 blankets
2. colour'd calico Quilts
2 Rush bottom'd chairs

Next Room

one Bedstead and furniture as above
Featherbed, bolster, 1 pillow, 3 blankets
A Coloured Calico Quilt
A mahogany table
A Compass back'd chair
2 Small Rush bottom'd chairs

Next room

A Bedstead & furniture as above
Feather bed, bolster, 2 pillows, 3 blankets
1 Colour'd Calico Quilt
A mahogany table
2. Rush bottom'd chairs

5. Iron Locks 2 keys

Mr. Pickfords Room

A four post bedstead white dimithy furniture
A Feather bed, bolster and pillow
1. check'd matrass
4. Blankets
1. white Quilt
1. Bedside Carpet
a mahogany table
a Dressing Glass
a Compass back'd chair
4 Rush bottom'd chairs
a Brass stove, fireshovel, Tongs Poker, fender and Broom
Brass Lock and Key

Kitchen Wing [continued]

Closet

A Close stool

Mr. Brettingham's room

A Fourpost bedstead blue Harreteen furniture
Feather Bed Bolster, 1 pillow
a check'd matrass
4 Blankets
a white Quilt
a mahogany table
a Dressing Glass
a walnutt tree chest of drawers
a compass back'd chair
2 Rush bottom'd chairs
An Iron stove, fender, Tongs, shovel Poker and
 broom.
Brass Lock and Key

Mr. Clark's room

A four post bed, Green and white stuff damask
 furniture
Feather bed, bolster, 1 pillow
1 check'd matrass
4. Blankets
1. white Quilt
1. mahogany table
an old table
a Dressing Glass
a compass back'd chair
3. Rush bottom'd chairs
1 Brass stove, Fireshovel, Tongs Poker Fender and
 Broom
A Brass Lock & Key

Servants Hall

4 Tables
1. Round table
9. Long Forms
Stove Poker & Fender
coal box
2 Leather Jacks
2. less
the Moon Lanthorn
a Lead Cistern & cock in the Closet

Passage

A Press
27 Buckets
2. Cupboards 1 for bran under the windows

Boultingroom

A Mill
2. Boulting cloths
1. Floor Bing
1. pair of steps
1. Tin scutle
1. wicker basket

Kitchen

A Large Kitchen Dresser with two Drawers
1 Ditto with three Drawers
2 Dressers with places below them for Candles &c
 shelves above them for coppers, pewter &c
2 Cases of Shelves for sauce pans each side the Great
 door
2 pair of shelves over the sink
a choping block
marble morter, wooden pestal & stand
A wooden screen lined with Tin
2 mahogany Trays
a pair of steps
1 wooden chair
Two stools
Camp Kitchen compleat in a box
2 dozen and 10 plates
A large case for Bacon

Pastryroom

A Large dresser with drawers
1 Ditto with cupboards under and shelves above
A wainscot table and drawers
A chair and stool
A salt box
A Pease Tubb
A Floor Tubb
A mix fix'd for spice
An old Box
2 Plate baskets

Scullery

A Large Copper set in bricks
1 Iron pot
3. Iron frying pans
An Ash Dresser with shelves above it
A Deal Dresser, a Dish Rack over it
2. Large plate Racks
4. Tubbs, 1 Piggon, 1 pail
1. stool
2. wooden trays for meat
Dresser and shelves
Grease Box
A Large wooden case for coals

Kitchen Wing [continued]

Upper Larder.

1 Large Dresser
1 Ditto with shelves over it
a wainscot table with a Drawer
3 wooden Bowls
a Hanging shelf
An Iron Hoop to hang meat on

Lower Larder

1 Dresser
1. Ditto with shelves
A wooden Block
2 Leaden trays to salt meat on
6 Tubbs for salt meat

Lower Scullery

2 Long Dressers
1 shelf
2. Tubbs
A stand for the Tubs
A Large tubb to carry away the wash

Coppers

3 Long 2 round fish ketles with drainers
9 pots & 1 oleo pot, 9 covers to the pots
2. Gravy pans
4 Baking pans
1 Pastry pan
37 Stewpans with 37 covers thereto
6. Sauce pans 1 old large one.
8. round 4 oval dishes
1 Large one small Turks cap
9. Scollop'd shells
1 Promtirair
8. Round Tart pans
6. round & 6 oval petty pasty pans
12. small Turks cap, 12 oval ditto
12. small scollop'd shells
1. Copper funnell
1. Large, 1 small dripping pans
2. frying pans
4. large Ragout spoons
5. skimmers, 5 Ladles
4. Baking sheets
1. mutton stake Broiler
1. Copper cheese Toaster
1. Cullender
1. Spice box
6. scollop'd Patty panns

Brass

1 Pot for cockles
1. Bread Dridger, 1 Floor Ditto
1. Brass Grater
1. Basting Ladle for Larks
2. flat candlesticks

French pewter

34 Dishes (3 soop dishes included)
2. deep baking Dishes, 2 coppor dishes belonging them
6. dozen and 5 plates

Common Pewter

24 Common Dishes
1 soop Dish, 1 small one and Cover
26. old common plates
2 doz: & 9 new soop plates, 1 doz: put up
10. mazereens for Fish
6. Icepots and 5 Covers
1 Large dish for a Barbacue

Lord Cokes Pewter

18. Common plates
6. soop plates

Tinn &c

1. Tin & cover for Ice
3 funnels for Saucages
9. Tin covers for Dishes
2. large tin fish ketles with covers and Drainers to Ditto.

Iron &c

1. Large Jack compleat
7 Spitts, 1 smaller Ditto
1 Range and a machine to move the cheeks
1 pair of Racks
1 Crane with 4 hooks
1 Dutch oven fixed
2 pigg irons
1 Large poker
1 Salamander
4. Gridirons
2. oven Peels
14 Larkspits and skewers
1. shovell, 1 Ribb'd ditto for charcoal
14. Trevetts for stoves
2. Ditto for the Grate
3. cleavers
2. choping knives
1. Flesh fork

Kitchen Wing [continued]

2. High Candlesticks
1. pair of stove tongs
1 large comon Baking oven, an Iron door to ditto
Irons for Barbacuing piggs
1 Large Deal frames with hooks over the fire place for hams
Candlesticks in Constant use
23 flat brass
2 Brass pails for the Body of the House

Bakehouse

A Deal Cupboard
A Deal Dresser
A wainscot floor Bing
A Dough trough
An Iron Peal
6. wooden peals
1 Iron Baker
1. pitch fork
1. wooden stool
2. Hand Bowls
1 wier sieve
a Hare sieve
a wicker basket
a Box for Raspings
a salt Box
a Pail
a Piggon
a small Tub
a Tubb for yeast
a Pipe Bing
2. Rasps for Roles
An Iron pot and cover set in bricks coverd with Lead.

Bakers room

1. Glass
1. Slate
2. Boxes
Drawers under the windows
1 Deal Dresser
1 Chair

Kitchen Court

Slaughter House

1 Copper set in bricks wooden cover
1 Small Dresser
2 Cleavers

Cutting up house

1 Canvas Cupboard
1 oak Dresser
1 chopping Block
1 pair of Scales
 2. 4 stone
 2. 2 stone
 1. 1 stone } weights
 1–2 pound
 1–1 pound
 1 half pound

Cinder House

1 Large sieve for sifting cinders

House for fatting chickens &c

One side Coops
Blankets to cover them

Brewhouse

1 Large Copper
1 Small
1. Large Mashing Tubb
2. Large Vatts
1 Leaden Cistern
2. Socs
1. Small massh Vatt
1. Coal Bing & steps
A starting Tub
3 Carrying Tubs
5. Small Tap Tubs
1 under Beck
2. Leather pipes, 2 Ditto
1. coal rake poker and shovell
2. Lead pumps
2. Rudders
2. Stirrers

Temple

Octagon Room

8. Mahogany stools
A Durno stove
Fireshovel, Tongs, Poker, Fender, Bellows and Broom

Side Room

Hung with Crimson Damask
A Large settee 5 chairs wth. Gilt frames cover'd wth. Crimson damask, check'd covers
2 pieces of Lutestring over each window

Temple [continued]

Room opposite

4 Rush bottom'd chairs

Triumpal Arch

In the Upper room.

1 Compass back'd windsor chair
A walnutt tree card table
A Grate fix'd in bricks
An Iron fender, fireshovel, tongs & poker

Lodge

A mahogany Tea Table w$^{th.}$ a Cupboard under for Tea
 Cups
A Stove Grate, Fireshovel, Tongs, Poker Fender and
 Broom.

A Catalogue of the Pictures at Holkham

Family Apartment

Bedchamber

Over the Chimney A view of Venice	Carrialetti
Over it. Fair maid of the Inn	Rosalba
Over each Door. A Piece of Fowls	Imperiali

Ladys Dressing room

Over the Chimney Ladies Catherine and Ann Tuffton	
On one side a Madence Giving a flag	Solimeno
Under it a Madona	Nicola Renton
On the other side the Chimney a Vergin in the clouds	
	Cavidone
Under it a Head of Christ	Baroche
Over the Doors and on the side next the Library	
4 Landscapes	Lucatelli
Under them 4 small Landscape	Liviomeus
Over the Door going into the Library a Sea piece	
Over the Door going into the Library a piece of	
Architecture	Viviano
On the side the Bedchamber	Jordane
On the same side two pictures of poppies and Thistles	

Library

Over the Chimney a Landscape	Griffier

In the Cupboards

A Large blue leather case of Antique Grotesque drawings.
Several of the same rolled in Leather

5 Red Leather cases with Drawings
A small Mass book illuminated

Lords Dressing room

Lady Carnarvon Kneller
Duke of Leeds Kneller
Mr. Coke
Mr. Coke
 } whole lengths Kneller

Lady Ann Tufton Countess of
 Salisbury
Mrs. Price
 } 3 quarter lengths over the Doors

Lady Catharine Tufton Wife to Lord Sonds.
 3 q\overline{uar} length over the chimney Dant

Richard Coke
Mrs. Coke
Dutchess of Richmond
Mr. Henningham
Lady mary Henningham
Mrs. Walpole Wife to Lord
 Townshend
 } all heads on each side the chimney

Lady Margaret Tufton
 Baroness Clifford and wife
 to the Earl of Leicester } over one Door
A Lord Clifford or Cumberland on the opposite
} Heads

Ladies Closet

A Drawing over the chimney St. Ignatius's Alter piece at	
Rome	Bertoldi
4 original Drawings of Fryers prints after Dominichino	
2 Copies of a Madona	Raphael
4 Drawings of a Batle	Leander
2 Landscape drawings on each sides of the Doors	
	Gasper Ochiaco
2 Heads Gittes	Luti
2 Popes Crowns and 1 Mitre Jewels exactly measured	
	Bertoldi
2 Landscapes water colours by Dominichino from	
	Peter Cortone
Death of Cleopatra drawn by Kent from	Diminichino
Cleopatra & Ceasar by Ignatius from	Cortone
2 Drawings in water colours by Kent from	Titian
A Madona and Child	Kent
2 Landscapes by	Gasper Ochiaco
Lord Coke by	Rosealba
Mr. & Mrs. Coke Father and Mother to Earl of Leicester	
over the closet door a christ in Glory painted	
on Agate by	Rottenhammer
Under the 2 Landscapes of Dominichino a Head on	
copper of Cardinal Gavetteri	

Pictures [continued]

In the Rosewood Case

1. of Lord Leicester
 Lord Coke
 Henry Coke
 His Son
 A Madena
 A Leda
} all Enamell

A Christ
A Princess Borghese
 as a Vestall Nunn
A Diana
Duke of Leeds
Lord Leicester
M^r. Henningham
Lady Linsdown
M^r. Coke
Sir Marmaduke Wyvill
2 Men
1. Lady
} all water colours

2 Men
1. Lady } not known who

Rustick Dining room.

5 Views of the ports of Sicily in Gilt frames
4. Drawings of Holkham over the chimney

West Drawing room

Over the 4 Doors 4 Landscapes	Horriontes
on Each side the chimney Battle of Birds	
	Hounds Cotten
on One side Flight into Egypt	Reubens
opposite Duke Aremburg on Horseback	Vandyke
Over the chimney conception of the Vergin	
	Peitre de Peitris
on the Right hand Landscape	Poussin
on the Left hand Landscape	Claud Lorrain

Salloon

Scipio and the Spanish Bride	Giuseppe Chiara
Opposite Corialanus	Pietro Cortona
Over one chimney Tarquin & Lucretia	Procacinna
Over the other chimney Perseus & Andromeda	
	Giuseppe Chiara
Over the 4 Doors the Seasons	Zuccarelli

East Drawingroom

A Large picture 3 figures Abram, Hagar & Ismael	
	Andrea Sachi
opposite Joseph & Potiphers wife	Cignani
on One side a Venus	Titian
under it a Landscape	Poussin
Over the chimney Reconciliation Jacob & Esau	Cortona

on the side Rebecca & Servant	Lutti
Under it a Landscape	Poussin
over the Door a Magdalene, penitent	Carlo Moratti
opposite Youth and old Age	Land franc
over the other Door a Landscape	
opposite a Landscape	
In the pier Lady Ann Walpole & her Son Edward Coke	
	Kneller

Dressing room to State Bedchamber

Over the Chimney a large Landscape	Claud Laroin
Over it Saint John Baptist preaching	Lucar Jordane
Over the Door on the chimney 2 Landscapes	Herrionte
Under them 2 Landscapes	Poussin
on the Right hand the Door to the chaple a Landscape	
	Claud Lorain
Its Companion a Landscape	Claud Lorain
over it a prospect of Trivola Landscape	Claud Lorain
Its companion a Rock sea and nymphs	Claud Lorain
Over this a Storm	Varnett
Its companion a Landscape	Varnett
over the Door 2 Landscapes	Lorain
on the Right the Door a Landscape	Poussin
on the Left a Landscape	Poussin
Over the Door Abraham & Isaac a Landscape	
	Dominichino
On the Right hand John Baptizing a Landscape	
	Fran^o. Bolognese
On the Left a Landscape	Poussin
on the middle at top a Landscape	Salvatorosa
2 Pictures on Each side Views of Ruins & Figures	
	Lucatelli

State Bedchamber

Portrait of a Man playing on Musick	Inola
A Large Landscape	Bartholomeo
The Assumption of the Vergin	Guido Rene
over one Door A View	
opposite Lanscpe, Figures and Architecture	
over another Door Animalls	
opposite Animalls	} Dyprett
Portrait of a Duke of Richmond	
Portrait of an Earl of Warwick	} Vandyke

Closett to the State Bedchamber

Over the chimney Birds	Rubens
Under Boys	Dominichi
2 pictures of Boys and Flowers	Phippo Lauri
2 pictures of Alter pieces by Conca	
Figures	Philippo Lauri

227

Pictures [continued]

Closet to the next Apartment

Elysian Fields　　　　　　　　　　　Conca
A Saints Head　　　　　　　　　　　Guido Rene

In the Passage to the Chapell.

Lord chief Justice Coke
Dutchess Albemarle
over the Door John Coke
on one side M^rs. Newton
on the other side M^rs. Heningham　　　　} all whole
Lady Margaret Tufton Baroness　　　　　　} lengths
Clifford wife to Thomas Earl of Leicester
and her son Edward Lord Coke
Thomas Earl of Leicester
Lady Ann Osborn

Tapistry room

King James the 3^d.　　　　　　　　S^r. Peter Lillie
Over one Door Lord Leicester when a child
Over the other his Brother Edward Coke

Tapistry dressing room

Over the Chimney Lady Hungerford
　3 Quarters
Over one Door a Daughter of Lord chief
　Justice Cokes
opposite Lady Grace Pierpont
over the other Door Lady Ann Tufton

Housestewards room

The Assumption of the Madona a copy by
　Robinson of Lynn
A coloured Print
A Picture of Flowers

Mr Brettingham's room.

Drawings of Holkham House

Pictures not hung up.

Earl of Leicester
Lady Margaret Tufton
Baroness Clifford his wife
Viscount Coke
Henry Coke
Richard Coke　　　　　　　　　　} all whole lengths
Robert Coke
Lady Coke wife to)
Lord chief Justice }
M^rs. Coke wife to Henry Coke
M^rs. Coke wife to Richard Coke

Lady Mary Heningham
Lady Dover
Lady Plymouth when young
Sir Thomas Moor
A Pope
King Charles the 2^d.
General Talmarsh
Waller the Poet – S^r. Peter Lillie
A woman unknown
King James the 3^des. Queen
Dutchess of York
King William the 3^d.
Colonel Walpole
Lady Chesterfield and her Companion
Bishop Laud
a Venetian Lady

M^rs. Coke Mother to Earl of Leicester
Earl Leicester and his sister Lady Wynill when children
　very small figures.
M^rs. Roberts Sister to Earl Leicester, the same size
1. of Earl Leicesters Father when a child.
1. of the same when older
An old mans Head
one less
a very old picture of a woman
A picture of cattle
One of Joseph, Vergin and child

Pictures in the Closet Tower Gallery

A small Head of Chief Justice Coke – frame and Glass …
　water colour
David and Abigail miniature Gilt frame & Glass.　Ignatius
2 feasts of the Gods in miniature Gilt frame and Glass.
4 pictures made out of Fans
4. others water colours.

Drawings

Hanibal passing the Alps　red lead, frame and Glass
Adonis and Doggs　　　　red lead, frame and Glass
An Head　　　　　　　　red lead, frame
Diana and Nymphs　　　　black lead framed
Diana and Endymion　　　red lead, framed and Glass
Vergils Tomb　　　　　　Glass and framed
2 Views　　　　　　　　framed and Glass
3 Statues　　　　　　　red lead, framed and Glass
a Battle piece　　　　　framed and Glass
2 womens heads　　　　black lead framed and Glass
An Head　　　　　　　in oil colours
Saint John & Angells　　water colours
A Dutch woman & Parratt
A Saint in a cave
A Melon

Drawings [*continued*]

Sheep
2 men with a fire
4 Heads
Hercules, pleasure & virtue }
2 Larger pictures } all on ivory
2. small }
2 Indian figures Glass and frames
2 Heads small of A man and woman
A Print of the Dutchess of Bolton
Several pictures of Dogs, Birds &c

In the Cupboards in the statue Gallery

18. Books of Prints some loose
10. Views intended for Holkham by Zuccarelli

Pictures that came to Holkham from Italy in Novemr. 1759

Joseph & Potiphars wife by Guido Rene, a frame
Two half length Portraits of women
 by Carlo Maratti, frames
Winter } by Scylla Scholer of
Summer } both in frames Andrea Sachie

Jupiter and Juno by Mr. Hamilton framed
55 Drawings in frames and Glasses.

Statues and Bustoes as they are now placed.

Library

1 Plaister Busts one over each Door.

Lords dressing room

2 Plaister Busts one over each Door.

Antichamber

Cast of Cupid and Psychi
A Bust of }
1 of a Philosopher } marble

Vestibula over the Book cases and Doors

1 Bust of Emperor Adrian }
1 of Julia mamia }
1 of Geta }
N1 of Galenus } all marble
1 of Marcus Aurelius }
1 of Julia }

Gallery

Niches on each side on the Consoles	2 Fauns
	1 Bust of Seneca
	1 of the Elder Brutus
Gallery	1 Statue a Neptune
	2 a Pan
	3 a Meliager
Over the Chimney	4 an appollo
Over it	a Bust of Cybele
	5. a Venus
	6. a Diana
	7 a Bachus
Over the consoles	a Bust of Sylla
	a Bust of Metriodorus
Niches	a Statue of Pallas
	a Statue of Ceres
Tribune of Gallery	a Statue of Lucius Antonius
	a Statue of Emperor Lucius Verus
	a Statue of Agrippina the Elder
	a Statue of Juno
over the Doors	Festina wife of Antonius }
	Pius } Busts
	Emperor Philip }

Diningroom

Over one Chimney	Lucius Verus }	
over the other	Juno }	Busts
on the consoles	Marcus Aurelius }	
	Emperor Geta }	Busts

Drawing Room

4 plaister casts One over each Door. Busts

Saloon

A Large Bust over the Door marble

Portico

A Statue of Septimius Severus
A Faun marble

East drawing room

2 Busts on the chimney piece marble

State bedchamber

on the chimney piece A Bust of the countess
 of Leicester Marble

Under the Portico

A Colossus of Jupiter }
A statue of the Empress Faustina } all marble
A Faun }

Statues and Bustoes [continued]

9 Busts ⎫
21 Black. ⎭ Marble

18. plaister figures ⎫
A Lion. Plaister ⎬ all Casts
21 Busts plaister ⎭

2 marbles with Incriptions and ornaments
A small Brass figure of Jupiter

In the Passage back of the Hall 1775 in the Orangery.

Capital of ~~a Picture~~ Corinthian Column

In the Garden

A Large Coffin *marble*

Furniture in the Chests at Holkham not put up or in use

In a Cypress Chest

2 Tapistry chairs, backs, seats and Elbows
13. Morocco leather skins

In the Plain Deal chest

10. pieces of blue India damask 18 yards each
2. new white damask window curtains with lines & tassils
3. Tapistry screens.

In the Chest in the White Tower Room

1 piece of crimson and yellow Bellimene containing	57 yards
1 Ditto	59½
1 Ditto	60
1 Ditto	61¼
1 Ditto	60
2 Remnts. Ditto	23¾
	321½ yards in all

23 sheets of India paper for furniture

In the Deal chest in the Gallery

1 piece of varigated Velvit	32½ yards
A Remnant of the same	2¼ yards
	34¾
1 piece of crimson flower'd Velvit	56¾ yards
1 piece of ditto	61¾
1 piece of ditto	56¼
1 Remnant ditto	19½
1 Remnant ditto	10½
	204¾ yards in all

A Bundle of pieces of the same

one piece and ¾ of crimson Lutestring for window curtains
some small Remnants of Red damask
A small Remnant of crimson coffoy
4 Crimson tassills and crimson binding
one piece of crimson lace for chair seats

In the oak chest under the Stair case leading to the Check'd Attick

12 white fustian pillows
1 stripe pillow
1 Large white Calico Quilt
A Remnant of blue and white check
4 small Green and white worstead damask window curtains
2 small printed cotton window curtains
1 cotton counterpain

In a chest in the check'd Attick Bedchamber.

2 Large Blankets
2 small musketto carpetts
2 Bedside carpets
2 very small carpetts

In the cypress chest in the state Bedchamber

Seven pieces of Tapistry hangings for that room
Varagated velvit for chairs 7 Elbow and 3 small
velvit ditto for the Tester and Head cloth
velvitt ditto for the Sopha and Bolster
7¾ yards in Remnants to cover the woodwork

In the other Chest.

Three Vevit window curtains
Four Bed curtains lined wth. white Sattin the outside & inside Valence

In a cypress chest in the passage to the Wing

A parcell of crimson damask the same as the Temple hangings
4 small Looking Glasses
Red Leather skins

In the India Deal chest.

A Parcell of blue and yellow velvit
8. old work chairs
2 pieces of work for chairs and stools
2 Large work'd screens
A Tapistry picture
2. old velvit covers for tables
2 Carpets embroider'd with Gold
Half a piece of printed Linnen the same as Jeffrys bed
A Piece the same as the bed in the Rustick floor

one piece of printed Linnen the same as the bed in the
 chapel wing
And some pieces of the Lining
A Remnant of the printed cotton the same as the bed in
 the best Attick
Four embroidered Green sattin cushions
Two large Dressing Glasses

The foregoing Fifty pages of this Book do Contain a True
Inventory taken and finished in the Month of January
1760 of the Household Goods, Furniture, pictures Statues
& Busts late belonging to Thomas Earl of Leicester
deceased in Holkham House in the County of Norfolk
Viewed & Inventoried by us who have hereunto sett our
Hands the Seventeenth day of January 1760.

Paul Colombine
William Notley
Upholsters att Norwich

I doe acknowledge that the Household goods, Furniture
Pictures and all other things mentioned in the foregoing
Inventorys have been delivered to me and are now in my
Custody and Possession And I do hereby promise to
keep and preserve the same (reasonable use and wearing
thereof being allowed) according to the Direction in the
will of the Right Honourable Thomas late Earl of
Leicester deceased Witness my hand the Eighteenth day
of March 1760. *Margaret Leicester*

Witnesses to the Countess of Margaret Leicester
Leicesters signing the receipt *John Richardson*
 John Williams

I do acknowledge that the Household Goods, Furniture
Pictures and all other things mentioned in the foregoing
Inventory likewise the Household Goods, Furniture
Pictures &c. &c. mentioned in the following Inventory
to be then in the London House, and have since been
removed into Holkham House Also all the other Goods,
Velvets, Silks, Stuffs &c. &c. prepared for Furniture, and
are now made up, put up, and placed in the House &
Offices at Holkham by the late Margaret Countess
Dowager Leicester who compleatly finished & furnished
all the Rooms unfitted up at the Earl's Death, have been
delivered to me & are now in my Custody & Possession
And I do hereby promise to keep and preserve the same
(reasonable use and wearing thereof being allowed)
according to the Direction in the will of the right
Honourable Thomas late Earl of Leicester deceased.
Witness my hand the Sixth day of October 1775.

Wenman Coke

Witness *Sam Brougham*

An Inventory of the Household Goods, Furniture and Pictures in the London House

Valet de chambre's Garret

a Bedstead, blue check curtains
A check window Curtain
Feather bed, Bolster, 1 Pillow
3 blankets a Cotton coverlid
An Easy chair and check case
4 Matted chairs
a Wainscot chest of Drawers
2. old tables
Fender, shovel, Tongs, Poker
An Inkstand a cloaths chest
A Bed Wagon

Maids Garrett

Bedstead Green stuff furniture
Feather bed, bolster, a matress
3. old blanketts, a Quilt
A Deal table and a small glass
A pair of old Drawers, 4 cain chairs
A Tin fender, shovel, Tongs, Poker

Room over Lady Leicesters dressing room

A couch Bed red & white check furniture
2. Matrasses, a Bolster, 3 pillows
3. Blankets, a white Quilt
A mahogany chest
A Ditto dressing table with drawers
A Ditto with one drawer
A Large Dressing Glass
A Round Grate, shovell, tongs, poker, Fender Bellows
 and Brush
4. matted chairs, An Inkstand

Closett

An old walnutt tree cabinett
A Ditto Escrutore
A walnuttree chest of Drawers
A Deal Horse to air Linnen
A square Night stool
An old stool.

Next room

A Bed with blue and yellow stuff, damask furniture
Featherbed, boster, 2 pillows
4 blanketts, a white Quilt, a Counterpain
1 Elbow chair, 6 others cover'd ditto
2. matrasses, 2 Carpets
a Glass 17 by 29, a walnuttree chest

In the London House [continued]

A mahogany writing table
An Inlaid Ebony Cabinet
A Night table and a Ditto stool
A Round stove, Fender, Shovell, Tongs and Poker

The 2 Closetts

An Amber cabinett in a Blackcase
A walnutt tree cupboard
A sliding screen
A case with copper plates
A mahogany celler with bottles
A chess board inlaid
A chimney glass & frame ditto 19 by 38
A stand for a dressing Glass
A mahogany Bookstand
A picture frame
2 large frames for Easy chairs.
a warming pan a Bed Ditto
A blue & yellow stuff damask draw up curtain

Upper Library

1 Pier Glass 36 by 20, 5 matted chairs
A windsor chair cover'd with Green.
A pair of steps and 2 Globes.
An old walnuttree plate case w^th. drawers
A paper screen 6 leaves, a Ditto 4
A wainscott box with a Rich Gold Quilt Bolster and
 pillows

Backroom 2 pair stairs

A Bedstead blue harriteen furniture
Feather bed, Bolster, a pillow
A matrass, 3 blankets, a Quilt
2 window curtains blue stuff
a pair of old wainscot drawers
an old ditto table, 4 matted chairs
4 old blue Coffoy chairs
An old stove, fender, shovel, tongs, poker
An old deal writing desk and stool
A Dressing Glass, 2 old black tables

Housekeepers room

A Bedstead, check furniture
Feather Bolster, a Pillow
A matrass, 3 blankets
A cotton counterpain
An old dressing table, a Glass
A mahogany stand, 4 matted chairs
An old stove, fender, shovel, tongs, poker,
An old wainscott press
A walnutt tree chest of drawers

Land Stewards room

A Bedstead, blue check furniture
Feather Bed, Bolster, a Pillow
2 matrasses, 4 blankets
a white Quilt, 2 check'd window curtains
an old wainscot chest of drawers
a Writing desk
an old table and a Dressing glass
1 old small table, 4 matted chairs
a Black leather chair
an old stove, fender, shovel, tongs, poker.
an old Night stool.

Garret.

Bedstead green camblet curtains
Featherbed, bolster a pillow
3 blankets, an old Quilt
A matrass, an old table
4 broken chairs
a Tin fender, shovel, tongs, poker

Next Garret

A Bedsted blue stuff furniture
Feather bed, Bolster, a pillow
a matrass, 3 blankets a Quilt
a windsor chair, 4 old leather chairs
Tin fender, shovell, tongs, poker.

Footmans Garret

A half Tester bed, blue curtains
Feather bed, bolster & matrass
3 old blankets, an old coverlid
a windsor chair
2 matted ditto a Deal table

House stewards Garret

A Bedstead old blue curtains
Featherbed, bolster
3 old Blankets, 1 old Quilt
2. old tables, a Glass
4 old chairs, a window curtain

maids Garret.

3. Bedsteads old Green curtains
3. Featherbeds, 3 bolsters
9. old blankets 2 coverlids
1 old Quilt, a matrass
An old deal table
3. old chairs

In the London House *[continued]*

Lady Leices^{rs}. dressing room

2 Green morine curtains
2 spring window curtains
a settee cover'd with needlework
6. Elbow chairs Ditto
a Glass in a carv'd frame 26 by 39.
a small Japan'd cabinett
a mahogany standish
a Ditto round claw table
2. small paper screens
a stove Grate, wire fender, shovel, tongs, poker, Bellows
 and brush.

Closet

A check Linen draw up window curtain
a check case for a stool
a spring window curtain

Lady Leicester's Bedchamber

A crimson mix'd damask bed & counterpain
2 pair of window curtains
Featherbed bolster, 2 pillows
2 linnen matrasses
1 sattin Ditto & bolster ditto
5 blankets, 1 white silk Quilt
a carpet round the Bed
an Elbow chair cover'd the same as the Bed
5 other chairs ditto & check cases
A mahogany chest
A Large Glass 49 by 25. a Gilt table
A Glass over the chimney in 2 plates 34= 26
A stove, fender, shovell, Tongs, Poker.
a spring clock 2 mahogany stands
2 copper coal scuttles, aside Light

Closets

A Blue silk window curtain
a strong box ornamented wth. brass on a frame
a wainscot corner cupboard
Fender, shovel, tongs, poker,
2. night tables, 2 ditto stools
a copper Lamp and a warming pan

Drawing room

3 crimson lute string window curtains
2. settees cover'd wth. needlework, Gilt frames
8 chairs ditto, a long stool ditto serge cases
3. spring curtains, a Turkey carpett
2. marble tables on Gilt frames
2. pier Glasses 50 by 27. Gilt frames

a mahogany pillar and claw table
2 double arms
a large Grate, wire fender, shovel, tongs, poker
2 India screens, 2 card tables, a chesstable
a chimney glass 30 by 19. A Burning Glass

Diningroom

3 Crimson Lutestring window curtains
3 spring curtains
15 chairs mahogany carved & Gilt
2 marble tables, Gilt frames
a yellow marble table ditto
a Large Green ditto
a leafed small screen
3 oval Glasses, Gilt frames and arms
2 mahogany Tea tables
A stove Grate, wire fender, shovel, tongs, poker and
 brush.

Lord Leicesters dressing room

3 Red and white check curtains
8 walnutt tree chairs
An Elbow chair
An India Cabinet
A Walnuttree Desk and Bookcase
Glass door 42 by 18
A Large mahogany writing table
A smaller Ditto on 4 feet
An old chest
A small square table, a corner ditto
A Glass 52 by 27 A chimney Ditto 36 by 20.
A pair of small pistols, a Deal cupboard
A Reading Candlestand, & a screen Ditto
3 window blinds and frames
A small Desk
A Night stool
A Biddy & Pan
4 Coats of Arms

Library and closetts

3 crimson stuff damask curtains
8 mahogany chairs, leather seats
An Easy chair and check case
A mahogany Reading Desk
A Large Mahogany square Pillar table
A small round ditto
A square table with a drawer
3 mahogany Dining tables
a canvas firescreen, 2 pair steps
a stove Grate, wire fender, shovel, tongs, poker
a square Mahogany table
Fender, shovel, tongs and poker.

In the London House [continued]

Dining Parlour

3 Crimson stuff damask curtains
a Large 6 leaved Japann'd Screen
10 mahogany chairs cover'd with leather
A Pier Glass 50 by 28
A chimney ditto 19 by 39
2 large mahogany dining tables for 18
a square small Ditto, a Dumb waiter
a canvas screen, a paper ditto
a Floor cloth 5 breadths
Stove, wire fender, shovell, tongs & Poker.

Butlers Room

Feather Bed, Bolster, 3 blankets
A Quilt, a Deal table, a stool
A mahogany Tray, a Knife Ditto
A wainscot Tray
A Plate warmer, a Japann'd Ditto
A Back Gammon table, a chess board
A mahogany cistern and stand
Ditto for Ice.

Antichamber

A Bedstead
Feather bed, bolster, 3 blankets (old)
a Quilt, 2 wainscot tables, an oval ditto
a year clock in a wainscot case.
5 window chairs, a wainscot desk
a Blunderbush, a carbine
2 pair of Pistoles, a Large sword
1 old Grate, fender, shovel, tongs & poker.

Hall and Staircase

A clock in a Japan'd frame
2 Large Lanthorns
2. forms, 18 buckets

Stewards room.

A chest Bedstead
Feather Bed, Bolster, 3 Blankets
a coverlid 10 leather chairs
3 Tables a clock
a platewarmer, fender and Poker.

Closett

2. chairs leather seats
A wainscott table
A glass
Tin fender, shovell, tongs & Poker.

Servants Hall

2. Brass pails, 2 forms
a Long table an oval ditto
a Large chest, a press for china
a Poker and Fender
15. flat brass Candlesticks
6 high ditto, 3 pair of snuffers

Stilroom

An old mahogany Tea table
2 wainscot tables, a large Linen Press
a cupboard for sweatmeats, a Dᵒ. for china
Fender, shovell, tongs Poker
A copper kettle with a cock
5 Sauce pans, 3 covers
3 preserving pans, 2 Turkey coffeepots
3 Coffee potts, a chocolate pot.
a Tea kettle, 2 dutch ditto and Lamps
a Pewter & Tin Funnell
2 pair of Scales & weights, an apple roaster
9. moulds for Ice cream
2. Toasting forks, 2 old stills
a Trevett and stand, a pewter Inkstand
a charcoal Pan, 6 matted chairs
a marble Pestall & morter, a small Glass

Pantry

A Bedstead, Feather bed, bolster
3 blanketts, an old Rugg
2 chairs, a table, a small Glass
A Bread chest, fender, shovell, poker
An old chest in the passage

Backyard

A Fire Engine & a salting tub

Cooks room

2 Bedsteads check furniture
2. Feather beds, 2 bolsters, 1 pillow.
6. blankets, 2 old Quilts
3. old chairs, 2 old tables
Fender, shovell, Poker.

Laundry

a Large tubb & two wash Dittos
7 Baskets
a Pail and a Bowl
a mangle Compt.
a skillett
a Table
8 Flat Irons
a Tea kettle

In the London House [continued]

a chair, 2 benches
a Hanging iron, fender, poker & shovell,

Kitchen

A Jack compt. 2 Racks, 5 spits
Fender, shovell, Poker.
2 Gridirons, a Pigg iron
2. Salamanders, 6 chafing dishes
12. Trivetts, a Long Ditto
a Flesh fork, 21 Scuers
4 chopping knives, 2 cleavers
2 oven peals, 1 scraper
a charcoal shovell 2 frying pans

Copper and Brass

29 stewpans, 31 covers
2 frying pans, 2 boiling pots & covers
a Large Turbett pan and cover.
2. fish kettles, 5 drainers
2 pudding pans, a Gravy ditto
a Large flat baking pan
an olive pot, 3 crocantmolds, 2 covers
4 sauce pans, 1 cover, a dripping pan
a cullender, 3 baking plates
4 Soop Ladles, 4 large spoons
a Basting Ladle, 5 skimmers
a Bellmetal Pestal & morter
9 soop potts & covers, 22 patty pans
a Drudging box, a Funnell
2 Copper machines for Pommedours
3 copper cups, 2 molds to cut paste
a black brass pot, a Ditto Saucepan
a Drinking pot and a Hand bell
a marble Pestal & mortar.

Pewter.

6 Dishes, 2 melted, 9 old dishes, 23 plates
8. soop plates, 33 plates mark'd L, a small soop dish
4. oval covers, a tin spice box
a salting tub & cover, a Flour Ditto
2. mahogany Trays to carry dishes
2 Iron candlesticks ⎫
2 tubs and a Bowl ⎭ in the Scullory

Stables

Coachmans room. A Bedstead, old Green curtains,
 Feather bed, bolster, pillows, 3 blankets a Rugg Table
 and chair
Postilion & Helpers room, Bedstead Feather bed, 3 old
 blankets, a Rug, a Lanthorn

Pictures in the London House

Dining room

Adoration of the Magi	
Galatia	Albania
Deluge	carlendrucia
Nativity of St. Ann over the chimney	Galli
Picture betwn. the chimney & window	Bassan
under Ditto Holy family	Raphael
over the Door 2 Landscapes one by Liviomeris	
on Pedestals 2 marble Busts	
of carraccella & Marcus Aurelius	
A Busto over the Door	
A Head of Julius Ceesar	

Drawingroom

A Madona and child	Raphael
Magdelene washing christs feet.	P. Veronis
Lot and his Daughters	Dominichino
Under ditto Apollo & Daphne	Carlo Moratti
A Magdelene	Parmigirino
A Perspective view	Viviano
A Landscape over each Door	
One side Joseph & Angel in a dream	Lanfranc
Under 2 Landscapes	Poussin
Between a Polipheme	Carache,
Over the door a Madona Reading	Carlo Moratti
Over the other Door a cupid	Guido Reni
2 views of Venice on the Doors	Canalitti
A Busto of Palladia over the Door	
A Marble Busto over the Chimney	

Closett

A cartoon Madona & Christ and Saint John	Raphael
over the Door a child	Rubens
Judith & Hollifyrnes	Carlo Maratti
A Simon Magis flying	
2 Small Views	
1 over Ditto of Venice	Canalitti
An alter piece	Conca
a View	
a man on Horseback	
2 small Battle pieces	Burgoning
a view of St. Peters ⎫ bought of	
Ditto its companion ⎭ Mr. Edwin	Gasper Ochiali
A Magdalenes head	
A Landscape the Repose in Egypt	
A Ditto Its companion	
A Seapiece	
A View of Venice, The Holy family	
A sketch of camillus & the Goths	
God canapus oriental Alablaster	
A Plaister Bustoe	

Pictures in the London House [continued]

Bedchamber

Numa giving Laws to Rome.	Broccochina
A Large Landscape	
Sʳ. Timothy Talmish half length.	Peter Lillie
A Lady supposed the Dutchess of Leeds over the Door	
A Naked Venus over the Chimney	

Bedchamber closet

over the chimney Deborah & Barach	Solimene
over the Door Herods Daughter with Saint John's Head	} copy
4 Views in water colours copy'd by	Goupy.
a view of caprioli small	Ochiala
2 views of Venice	
2 views of Naples	
Madona, Joseph & child	Albanio
A Landscape	Ph: Laura
A Large picture of Nymps & Cupids.	Albanio

Dressingroom.

Copy of a Battle of Constantine	after Raphael
Sophonisbe receiving poison	Procochina
Tinanatus saluted Dictator	Ditto
Fruit piece with a Macco' over the Door	
A moonlight piece	
View of the collisium	Ochiali
View of Castle of Saint Angelo	Ditto
View of the Great Canal at Venice	Ditto
View of the small view of Naples	Ditto
A Woman head over the closet door	Titian

Closet 2 pair stairs

3 views of the Ports of Sicily	
A Picture of Lord Leicesters	Trovisano
A Head in plaister.	

Eating room below Stairs

A Picture over the Door Diana & Nymphs
A Markett
a piece of Fowls

Library closet

A small picture of Sᵗ. John on copper	Ph: Laura

Lords dressingroom

chiaro scuro by	Mich. Angelo
2 Drawings of the marriage	Aldrobandino
a view of old Rome.	

Library closet

A statue of Isis dressed
A Basso Relievo of the River Nile.

Above Stairs

A Bustoe of Black Marble.

The foregoing Eight pages of this Book from 52 to 59 inclusive do contain a True Inventory of the Household Goods, Furniture & Pictures late belonging to Thomas Earl of Leicester deceased in the House in Great Russell street London, viewed and examined by us the Eighteenth day of March 1760. Witness our hands *John Bladwell*
Robert Judd

I do acknowledge that the Household Goods, Furniture, Pictures and all other things mentioned in the foregoing Inventory (consisting of Eight pages) have been delivered to me and are now in my Cutsody and possession And I do hereby promise to keep and preserve the same (Reasonable use and Wearing thereof being allowed) according to the Direction in the will of the Rt Honourable Thomas late Earl of Leicester. Witness my Hand the Eighteenth day of March 1760

Margaret Leicester

Witnesses to the Countess of Margaret Leicester
Leicesters signing this receipt *John Richardson*
John Williams

[written on a small note attached to the manuscript]

bound books sent in Aprill 1760 by Sea
the M:S: by land in May 1760.
All the Pictures, Statues Busts, &
other valuable things at Holkham in June 1760
Also the Goods & furniture all except what
what was given. to Mr. Coke in London
was at Holkham in June & July 1760
Inventories were taken of all particulars before
any thing removed vizt. in the winter 1759– &60

[end of note]

I Do Acknowledge that the Household Goods, Furniture, Pictures, and all other Things mentioned in the first of the foregoing Inventorys from folio 1 to folio 51. Likewise the Household goods Furniture, Pictures &c. &c. mentioned in the latter of the foregoing Inventorys from folio 51 to 60 and which were in the London House, but have been removed to Holkam House, And all the other Goods Velvetts, Silk, Stuffs &c. &c. which were prepared for Furniture, and which were made up, put up, and placed in

the House and Offices at Holkam by ~~late~~ the late Margaret Countess Dowager of Leicester (who compleatly finished and furnished all the Rooms unfitted up at the Earls Death) have been delivered to me, and are now in my Custody and Possession, And I Do hereby Promise to keep and Preserve the same (reasonable use and wearing thereof being allowed) according to the Directions in the Will of the Right honourable Thomas late Earl of Leicester deceased. Witness my Hand the 16th day of December 1779

Thos.Willm.Coke

Witness

Hen Wilmitt
Hen: Hoyle Oddie

An Inventory of the Gilt Plate late belonging to the Right Honourable Thomas Earl of Leicester deceased

	ounces	dwts
A Gilt Bason weighing	259	0
An Ewer to Ditto	89	0
A Cup and cover	70	0
Two Salvers	139	0
A Gilt Standish	85	10
Twelve Desart knives, Twelve Three prong'd forks and Twelve Spoons	59	0
Twelve Desart knives, Twelve three prong'd forks and Twelve Spoons	57	0
Total weighing	758	10

An Inventory of the Plate late belonging to the Right Honourable Thomas Earl of Leicester deceased.

	ounces	dwts
Two chased Icepails weighing	282	5
A chased High stand for a Tea Kettle	245	10
A chased Tea Kettle and Lamp	189	0
A chased Epargne	159	5
A Bread Basket	82	0
A Tea Kettle and Lamp	57	10
A Tea Kettle and Lamp smaller	28	15
A Lamp for a Tea Kettle	28	0
A Coffee pot and Lamp	27	5
A Coffee pot and lamp	29	5
A chocalate pot	39	10
A chocalate pot	29	0
A coffee pot	28	0
An Escollop'd Waiter for a coffee pott	15	0

	ounces	dwts
A Ditto	12	10
A Ditto	7	7
An Escolop Bason chased	25	19
A Cream Ewer	10	5
A Tea spoon Boat chased	5	9
Eighteen Teaspoons chased and a pair of Tongs	8	10
Thirty eight plain Teaspoons, three pair of Tea tongs & a Tea straner	21	5
Two Tea Canisters	26	15
A Sugar Box	9	10
An Orange strainer	2	4
Two Nutmeg Graters	2	18
carried forward	1372	17

[Plate continued]	*brought forward*	1372	17
A Large Terreen and cover weighing		169	0
A Lining to Ditto		25	9
A small Terreen and cover No. 1		95	15
A small Terreen and cover No. 2		98	5
A Dish the the Terreen No. 1		52	5
A Dish to the Terreen No. 2		52	5
Twelve godroon'd table plates from No. 1 to 12		204	10
Twelve Ditto from No. 12 to 24		206	10
Twelve Ditto from No. 24 to 36		210	15
Twelve Ditto from No. 36 to 48		208	15
Twelve Ditto from No. 48 to 60		212	0
Twelve Ditto from No. 60 to 72		232	10
Twelve Ditto from No. 72 to 84		204	5
Twelve Ditto from No. 84 to 96		203	15
A Fish Dish		65	14
A Mazarine to Ditto		24	5
Two large oval Dishes		219	0
Two next size oval Dishes		120	5
Two next size oval Dishes		110	10
Two next size oval Dishes		78	10
Four smallest size oval Dishes		97	5
Two large shaped round Dishes		174	0
Two next size Dishes		121	15
Four next size Dishes		120	15
Four smallest size Dishes		105	10
Four Ragout Dishes		76	10
Four covers to Ditto		62	10
	carried forward	4925	10

[Plate continued]	*brought forward*	4925	10
Six Ragout Spoons		29	5
Four Sallad Dishes		85	15
Twelve plain plates		224	0
Twelve Ditto		223	10
Twelve Ditto		225	0
On Large Round Dish		55	10

[Plate continued]	ounces	dwts
Two next size round Dishes	120	0
Two next size round Dishes	80	5
A Large round Mazarine	42	0
A Smaller round mazarine	36	0
Six ovall Dishes	214	0
Four smallest size oval Dishes	87	5
Four Sauce Boats with Godroon'd edges	98	15
Six Sauce Boats engraved edges and festoons on the Bodys	147	0
Six fluted Sauce Boats	72	0
Six Sauce spoons	18	0
Four Terreen Ladles	31	0
Two Soop Spoons	18	10
Two olive spoons	7	15
Four chased shell salts and four spoons	29	0
Six round chased salts and six spoons	50	5
Eight square salts and eight spoons	36	10
Two double salts	29	5
One Double box for pepper and musterd	18	10
Six mustard spoons	1	5
A Cyphon	12	15
A Sliding Dish stand and Lamp with two tops	59	5
A Bottle with a cup	15	0
carried forward	6992	15

[Plate continued] *brought forward*	6992	15
Four chased candlesticks and Sockets weighing	91	0
Four chased candlesticks and Sockets	107	5
Four plain shell candlesticks and Sockets	83	15
Four wrought double branches	113	5
Twenty plain candlesticks, hollow corner	290	10
Four Hand candlesticks, three Sockets and one Extinguisher	43	5
Six Godroon'd waiters	123	5
Two Round Salvers	31	5
Two wrought cups and covers with Handles	53	10
Two wrought cups and covers no Handles	40	5
Two Pierced Sugar Spoons	7	15
A Cruet frame handles and top	23	0
Nineteen Bottle Tickets	6	15
Four Fruit Baskets	40	10
A Shaving Bason, a water pot, three boxes and two botles	85	0
A Pott and cover	43	0
Two Stew Pans	59	10
A Large Sauce pan and cover	48	0
A small Saucepan and cover	24	5
A Porringer	6	5
Eleven odd Knife hafts	19	5
Twelve three prong'd forks	25	10
Thirty eight spoons one of which is broke	81	15
A Preserving spoon and Kitchen spoon	7	10

	ounces	dwts
Four Marrow Scoops	6	5
Twelve Scewers	5	5
carried forward	8459	10

[Plate continued] *brought forward*	8459	10
Seventy two Knife hafts in six cases weighing	90	0
Seventy two three prong'd forks in six cases	160	0
Seventy two spoons in six cases	167	5
Twenty four Desart hafts in two cases	12	0
Twenty four three prong'd forks in two cases	27	15
Twenty four Desart spoons in two cases	29	5
Thirty six old square hafts in three cases	63	0
Thirty six three prong'd forks in three cases	75	10
Thirty six spoons in three cases	84	15
Twelve old round hafts in a case	21	0
Twelve three prong'd forks	25	5
Twelve spoons	27	10
Eight Marrow spoons	11	5
Two carving knife and two fork hafts	17	0
	9271	0
The Gilt Plate	758	10
Total	10029	10

We Value and Adjudge all the foregoing plate taking it together to be worth Six shillings an ounce. *Thos Gilpin*
Robt Smith

The foregoing six pages of this Book from 62 to 67 inclusive do contain a True Inventory and weight of the Silver plate both Gilt and Plain late belonging to Thomas Earl of Leicester deceased Viewed Inventoried valued and weighed the Eight day of March 1760 by us who have hereunto set our Hands

Thos Gilpin Gold smith in Searle Street London
Robt Smith Gold smith Rose Street London

I do acknowledge that all the Plate both Gilt and Plain mentioned in the foregoing Inventory (consisting of Six Pages) have been delivered to me and are now in my Custody and Possession And I do hereby promise to keep and preserve the same (Reasonable use and wearing thereof being allowed) according to the directions in the will of the Right Honourable Thomas late Earl of Leicester deceased. Witness my Hand the Eighteenth day of March 1760.

Witnesses to the Countess of Leicester's
signing this receipt *Margaret Leicester*
John Richardson
John Williams

I do acknowledge that all the Plate both Gilt and Plain mentioned in the foregoing Inventory (consisting of Six Pages) have been since the Decease of the Right Honourable Margaret Countess Dowager Leicester delivered to me and are now in my Custody and Possession, And I do hereby promise to keep and preserve the same (reasonable use and wearing thereof being allowed) according to the Directions in the Will of the Right Honourable Thomas late Earl of Leicester deceased. Witness my Hand the Sixth Day of October 1775. *Winman Coke*

Witness
Sam Brougham

I Do hereby acknowledge that All the Plate both Gilt and Plain mentioned in the foregoing Inventory (consisting of Six Pages) have been since the Decease of Wenman Coke Esquire my Father, delivered to me, and are now in my Custody and Possession, And I Do hereby Promise to keep and Preserve the same (reasonable use and wearing thereof being allowed) according to the Directions in the Will of the Right Honourable Thomas late Earl of Leicester deceased. Witness my Hand the 16th day of December 1779. *Thos. Willm. Coke*

Witness
Hen: Wilmot
Hen. Hoyle Oddie

An Inventory of the Jewells and Pearls late belonging to the Right Honourable Thomas Earl of Leicester deceased

		lib	s	d
The Cross containing	85 Brillts.	250	0	0
The Runner	21 Brillts.	50	0	0
The String	26 Brillts.	70	0	0
Girdle Buckle	58 Brillts.	74	0	0
Necklace	47 Brillts.	560	0	0
One pair of Brillt. Ear Rings, Knots and Six Drops		450	0	0
One pair of single Brillt. Ear Rings and Knots		70	0	0
Two Pearl Drops to Ditto weighing about 19Kts.		150	0	0
A Pearl Necklace containing Forty four pearls weighg about 128½ Kts.		400	0	0
Total		2074	0	0

The above Inventory and Valuation was truly taken and made of the Jewells and Pearls lately belonging to Thomas Earl of Leicester decd. on the Eighteenth day of March 1760.

Timo. Yonge Jeweller in Martlet Court in Bow Street
Thos Gilpin

I do hereby acknowledge that all the Jewells and Pearls mentioned in the foregoing Inventory and valuation about written have been delivered to me and are now in my Custody and Possession And I do promise to keep and preserve the same (reasonable use and wearing there of being allowed) according to the directions in the will of the Right Honourable Thomas Earl of Leicester deceased. Witness my hand the Eighteenth day of March 1760.

Witnessed to the Countess of Leicesters
signing the receipt *Margaret Leicester*
John Richardson
John Williams

I do hereby acknowledge that the Jewells and Pearls mentioned in the Inventory & Valuation on the other Side written have been delivered to me and are now in my Custody and Possession, And I do promise to keep and preserve the same (reasonable use and wearing thereof being allowed) according to the Directions in the will of the Right Honourable Thomas late Earl of Leicester deceased – Witness my hand the Sixth day of October 1775. *Winman Coke*

Witness
Saml Brougham.

I do hereby acknowledge that the Jewells and Pearls mentioned in the Inventory and Valuation on the other Side written, have been delivered to me, and are now in my Custody and Possession, And I do Promise to keep and preserve the same (reasonable use and Wearing thereof being allowed) according to the Directions in the Will of the Right Honourable Thomas Earl of Leicester deceased. Witness my hand the 16th day of December 1779.

Thos. Willm. Coke

Witness
Henry Wilmot
Hen: Hoyle Oddie

PART V

The Inventories of the Marquess of Carmarthen

Kiveton and Thorp Salvin, Yorkshire
1727

Kiveton and Thorp Salvin, Yorkshire, 1727

Kiveton was rebuilt for Thomas Osborne, 1st Duke of Leeds (1631–1712), between 1698 and 1704. The 1698 design by William Talman with an oval vestibule opening to a forty-foot hall and a grand staircase was unexecuted. In the event the carpenter Daniel Brand of the Minories, London, contracted to build the house in March 1697–8 and his designs survive in the Yorkshire Archaeological Society.

Thomas Osborne enjoyed a meteoric careeer as a politician, reflected in his successive ennoblement as 1st Earl of Danby in 1674, following his appointment as Lord High Treasurer of England in succession to Lord Clifford, Marquess of Carmarthen in 1689 and Duke of Leeds in 1694. In the 1640s he was in Paris and became a close friend of the diarist John Evelyn. He amassed a great fortune and the furnishings at Kiveton reflect his extravagant taste. After his impeachment he spent more time in Yorkshire at Kiveton and at Hornby Castle. His son, Peregrine, 2nd Duke of Leeds (1659–1734) served as Lord Lieutenant of East Riding of Yorkshire till 1714. The 1st Duke was a zealous protestant and the presence of a private chapel reflects this, although by 1727 it was used as a store.

The 1727 inventory provides a very detailed account of the furnishings with descriptions of the frames of the looking-glasses and seating furniture matching the hangings and mouldings of the best rooms. Such accounts are particularly fascinating as Kiveton was demolished in 1811 and there is only one surviving contemporary description of the interiors by Cassandra Willoughby, who visited in 1710. She commented on the Room paved with marble between the Hall and the garden which was sometimes used for eating, and she mentioned the two very handsome adjacent Apartments, 'more for shew than conveniency'.

Originally built in 1570, the neighbouring Thorp Salvin was sold by Sir Francis Neville to Sir Edward Osborne in 1636. His son Thomas Osborne, later Earl of Danby and 1st Duke of Leeds, spent much of his childhood there. It was he who acquired Kiveton in 1674 and commissioned William Talman to redesign that larger house. By 1874 Thorp Salvin was in ruins.

This inventory is in the National Art Library, The Victoria and Albert Museum. It is bound in a reused parchment legal document which bears the misleading title London Inventory 1714 Hornby Castle 1899. NAL. 86 22 55A.

(Fig. 19) Kiveton Park, west elevation, contract drawing by Daniel Brand, 1698. *Yorkshire Archaeological Society*

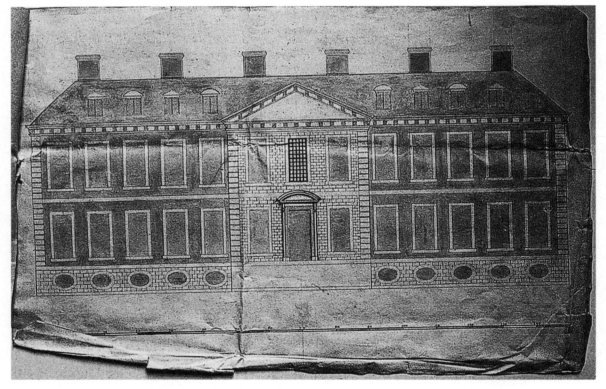

(Fig. 20) Kiveton Park, east elevation, contract drawing by Daniel Brand, 1698. *Yorkshire Archaeological Society*

(Fig. 21)
Kiveton Park,
basement plan,
contract drawing
by Daniel Brand,
1698. *Yorkshire
Archaeological
Society*

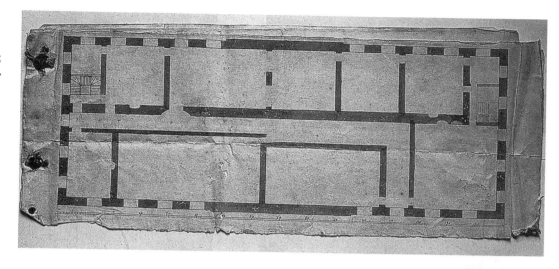

(Fig. 22)
Kiveton Park,
ground-floor
plan, contract
drawing by
Daniel Brand,
1698. *Yorkshire
Archaeological
Society*

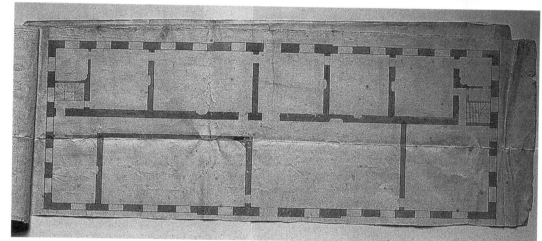

(Fig. 23)
Kiveton Park,
first-floor plan,
contract drawing
by Daniel Brand,
1698. *Yorkshire
Archaeological
Society*

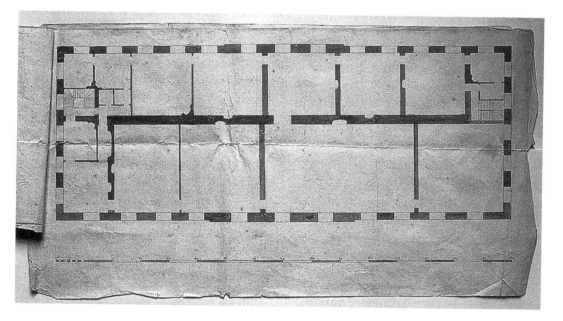

Kiveton Inventory 1727

A true and perfect Inventory of all the
Houshold Goods and Furniture at
Kiveton in the County of York belonging
to the Right Hon^{ble}. The Marquess of
Carmarthen.

The Great House

The North East Garret & Closet.

1 Fire Grate, Cast back, Fender, Shovel, Tongs and
 Poker.
 Bellows & Broom.
1 Sacking Bed Stead,
1 Black & White Callicoe Bed, trim'd with Yellow Sattin.
1 Old Holland Quilt.
1 Feather Bed & Bolster.
2 Pillows. 3 Blankets.
1 Looking Glass laid wth. Brass work.
1 Old Olive Wood Table.
3 Old pieces of Tapestry Hangings.
 The Story of Solomon.
 The rest of y^e Room Hang'd wth. green print.
5 Cane Chairs wth. Banester backs.
5 Set work Cushions.
1 Old picture of Shepherd & pipe.
1 Bell line & pulleys.
1 Cedar Close Stool & pewter pan.
1 Brass Lock & Key. 1. Spring Lock.

The 2^d. Garret South.

4 Old Chairs Cover'd with green Serge.
1 Old Square Table.
1 Iron Box Lock & Key.

3^d. Garret, or Wardrobe.

7 Old Turkey Carpets.
1 Fine persian Carpet lin'd with Silk.
4 Blue & hair Colour'd Damask Cushions.
8 Yellow Mohair Cushions.
6 Old green Damask Seats fring'd.
6 Backs fring'd and Knotted,
4 Old Green Damask Backs & Seats fring'd with Green.
 Some Old Silk fringe.
2 Green Damask Backs & Seats fring'd belonging to y^e
 Green Damask Bed in South Wing.
1 Yard & half Green Damask D^o.
1 Old Green Damask Back D^o.
2 Adder downe Quilts Crimson Silk.

2 Crimson & White Coffu hair Cushions
1 Crimson Damask pulpit Cloth, with Crimson & Gold
 fringe.
1 Altar Cloth D^o.
1 Long Cushion & Paragon Case.
2 Small D^o and Cases.
11 Pieces of fine White Sattin, Embroidered with
 Gold.
6 Blue Damask backs & Seats, 6 Cases for D^o.
~~1 Fine lac'd Suit for a Child in 11 pieces.~~
6 Morcello pillow Cases, Some fringe & black Lace
3 pieces of Blue & Yellow Strip'd Sattin Hangings, wth.
 Black & White fringe.
2 Stool Covers Ditto.
1 piece of fine Carving y^e History of Tomyris & Cyrus
 in a Wainscot Case **N. Hall**
4 White Strip'd Muslin Window Curtains.
2 White Gawse Window Curtains.
2 White Strip'd Indian Window Curtains.

Wardrobe *Continu'd.*

6 Pair of Green Damask Hangings. Embroider'd, wth.
 Small White fringe.
6 Old Small White Damask Window Curtains.
4 Little pieces of Chince Hangings border'd with
 Brocadello
12 Crimson Velvet, Cushions.
1 Piece of Tapestry y^e History of Noah's Ark.
1 Odd piece of Tapestry of Dido & Æneas.
2 Crimson Damask Window Seats & Serge Cases.
1 Piece of Crimson Damask Hangings=
 16 Feet Compass & 7 Feet 10 Inch. deep.
3 Yellow Mohair window Seats & Serge Cases.
3 Spare Window Vallants.
10 Wallnut Arm Chairs, wth. Backs & Seats, & blue
 Damask Cases trim'd wth. Buff & White Colour'd
 Fringe.
10 Curtain Rods & Pulleys.
1 Buff doublet and Sleeves.
13 Casar's Heads upon Pedestals Brunz'd
1 Chess Board, & Men.
1 Little Writing Table upon one foot.
1 Little Writing Box.
4 Breast & 4 Back pieces of Armour, and y^e
4 Arms D^o.
2 Salvers Japand upon Iron.
1 Bason. 6 Cupps D^o.
26 Old Green Serge Cases.
2 Buff Colour'd Cloth Coats.
2 Blue Colour'd Cloth Cloaks. 3 Swords.
3 Buff Belts. 2 Carbine D^o.
2 Cartridge Belts 2 pair of Boots.
1 Broad Sword wth. a Brass basket hilt.

6 Green Damask Backs & Seats trim'd wth. fringe

2 Blue Stool Covers.

Some Old Lumber.

4th. Garret or Wardrobe.

1 Large painted Skreen 5 Leaves.

2 Large Indian paper Skreens 8 Leaves each.

1 King Charles 2^d. in a Water Colour'd frame.

1 Mark Anthony & Cleopatra.

1 Dead Child wth. an Angel. ✗no <u>200</u>

1 Landskip with Ruins.

1 Coll: Culpeper Old ¾ Lengths no ___

1 Doctor ⎱

1 Prince Elector No <s>387</s> ⎰ Old ¾ lengths

1 Picture of y^e Late D: of Leeds rowl'd up.

1 D^o y^e Earl of Lindsay rowl'd up.

11 Mapps roll'd up.

2 Large Looking Glass wth. Veneer'd frames

1 Table D^o.

1 Japan Skreen Table wth. a Laquer'd frame.

1 Skreen painted on Cloth Six leaves no 16

1 Little paper Skreen 4 Leaves.

1 Drawing of a Ship.

4 Iron Doggs

10 Arm'd Chairs not finish'd.

1 Old Skreen Table wth. a draught Board on it.

1 Little Old Callicoe Quilt.

1 Old Easy Arm'd Chair.

1 Old painted Skreen Table.

1 The Wisemen's Offering at y^e Birth of our Saviour
 no <u>48</u>

The 5th. Garret.

The 6th. Garret, South.

1 Fire Grate wth. Cast back, Fender, Shovel, Tongs and
 Poker.

1 Corded Bedstead & Straw matt.

1 Very Old yellow Quilt.

1 Feather Bed & Bolster.

1 Red printed Bed.

2 pieces of Tapestry Hangings of Solomon.

1 piece of Landskip, no borders.

The rest of y^e Room Hang'd wth. green print.

5 Chairs wth green Serge Cases.

1 Looking Glass wth. a Wallnut frame.

1 Table Ditto.

1 Old picture of Dead fowls.

1 Wainscot Close Stool & pewter pan.

1 Brass Lock, 1 Box Lock on y^e Doors.

1 Stock Lock on y^e Lead's Door.

The North Back Stairs.

Feather Room.

4 Feather Beds & 4 Bolsters.

1 Stock Lock & Key on y^e door.

Little Room Eastward.

1 Old Oak press

2 Old Japan'd Stands.

1 Old painted Skreen 8 Leaves.

1 Stock Lock & Key on y^e Door.

The Long Wardrobe.

2 Iron Wheels for an Engine.

Some Cases Boxes and Lumber.

1 Stock Lock & Key on y^e Door.

Little Room East.

1 Corded Bedstead & Straw matt.

1 Sprig'd Drugget Bed.

1 Feather Bed and Bolster.

2 Blankets. 1 Coverlid.

1 Stock Lock & Key on y^e Door.

Second Floor.

The Great Dining Room.

1 Purple Marble Chimney piece.

1 Iron Cast Back.

1 Large double Fire Harth, Shovel, Tongs, Bellows and
 Broom.

1 Picture of King Charles y^e 2^d. on Horsback, no <u>66</u> in
 Carved Frame fix'd over y^e Chimney.
 a Carved ffreez pannel underneath.

4 Large pieces of Tapestry Hangings of Horses wrought
 wth. Gold & Silver.

1 Large Egyptⁿ. Marble Table upon a Wood Frame.

11 Long Banquits Wallnut Inlaid, Cover'd wth
 Crimson Velvet Trim'd with Gold nails, Red Serge
 Cases.

2 Large Easy Chairs D^o.

8 Mantua Crimson Silk Window Curtains.

4 Large freezes & Vall^{ts}. Cover'd & trim'd wth Lace

4 Rods and Silk line.

2 S^t. Sebastians in Carved frames fix'd over y^e Doors.
 no 346=347

1 Landskip fix'd D^o. no <u>100</u>

no 94 The Duke & Dutchess of Leeds & Queen Mother
 whole Lengths in Guilt frames.
 frames= painted oak

5 Marble Statues on Black pedestals, viz: Cleopatra,
 Venus, Cupid, Paris & Nero.

1 Silk Crimson Line Tassel & Vallance
 weight for a Schandeleer.
3 Large Brass Locks upon y^e Doors.

Great Drawing Room.

1 Large purple Marble Chimney piece.
1 Iron Cast Back.
1 p^r. of Large Andirons Brass, & Silver'd
1 Less pair for Doggs D^o.
 Shovel & Tongs w^th. Knobs Silver'd D^o.
 Bellows & harth Broom, 2 Steel pins.
1 Large Chimney Glass Archt.
1 Large picture of Venus & Adonius. no 112
3 Large pieces of Tapestry Hangings of Horses wrought
 w^th. Gold & Silver.
1 Large Looking Glass in a Guilt Frame.
1 Purple Marble Table on a fine Carved frame
 ✗ in Larder
 Gold and Black. A Gold Colour Serge Case.
1 Gold Colour Silk line & Tossel & Vallance w^t. for a
 Schandeleer.
14 Chairs & 2 Stools frames Black & Gold.Cover'd
 w^th fflowred Velv^t. trim'd w^th guilt Mouldings
 and Serge Cases. Library, Billard
1 Large Seat Ditto.
4 White Damask window Curtains.
2 Large ffriezes & Vall^ts. Cover'd & trimd with White
 Silk lace.
2 Large Indian Skreens, Japan'd on board, 6 Leaves
 Each,
1 Large Indian Cabinet on a Carved guilt frame.
1 Black Shelf for China.
2 Italian naked pictures fixd over y^e Doors, and Carving
 round them. ✗ tower

Great Bedchamber

1 White Marble Chimney vain'd,
1 Iron Cast back,
1 pair of Andirons Sanguid & laid w^th Brass work &
 Silverd, 1 p^r. of Doggs D^o.
 Shovel & Tongs w^th. brass Knobs Silverd.
1 Large Chimney Glass fix'd in a Carved Guilt
 frame.

Gr^t. Bedchamb^r. *Continu'd*

1 Whole Length of Q. Mary fix'd over the Chimney, &
 fine Carving round it. no 376
 Bellows & Broom.
1 Large Looking Glass in a gilt frame.
1 Table Carved and gilt. Green Serge Case D^o.
5 Pieces of Tapestry Hangings History of Æneas.
1 Large Wainscot Bedstead Leather Bottom.

1 Rich green Damask Bed Lin'd w^th. Tabby Comp^t.
 trim'd w^th. Gold, Silver, & Silk lace, fringe Lines,
 Tossels & Roses w^th. Embroid^d. Cyphers, Stars,
 & Coronetts in Gold & Silver.
4 Large Vauses Carved at y^e. Top & Japan'd.
1 Large Curtain Rod gilded.
1 Green Serge Case Curtains to y^e Bed.
1 Large Downe Bed & Bolster.
2 Pillows. 1 Holland quilt
4 Blankets. 1 Fine Holland sticht quilt.
4 Green Tabby Window Curtains.
2 Large Friezes Cover'd & Vallances trim'd as the Bed.
2 Curtain Rods & Silk Lines.
12 Large Chairs w^th. Frames Carved & Gilded, with
 Cyphers & Coronets, Covered & trim'd Same as y^e
 Bed, w^th. Green Serge Cases.
1 Large Indian Cabinet upon a Carved and Gilt frame.
1 Black Shelf for China.
no 265 The Duke of Florence and Nathaniel
no 280 Judeth & Holofernes fix'd over y^e 2 Doors and
 Carving over them.
2 Large Brass Locks on y^e Doors.

Best Dressing Room.

1 Egyptian Marble Chimney piece.
2 Dogs w^th. Brass Knobs Silver'd.
 Shovel and Tongs D^o.
1 Chimney Glass fix'd in Red & Gold Japan fra.
no 115 1 Whole Length of a Nun fix'd over Chimney.
1 Half Length of Lady Ann Walpole.
1 D^o of L^dy. Latimer ov^r. y^e Door in gilt frames.
4 Pieces of Crimson Tabby Hangings, with 8 pannels of
 Crimson & Gold Damask, with mouldings Cover'd
 & laces w^th. Crimson & Gold border'd & mouldings
 round y^e Hangings, Cover'd and Laid D^o.
6 Dressing Chairs y^e Frames Japan'd, Red and Gold
 Cover'd & trim'd same as the Hangings With Red
 Serge Cases Smoking Room
2 Window Curtains of Red Sarcenett, 1 frieze & Vallance
 Cover'd & trim'd Same as y^e Hangings.
1 Curtain Rod & Silk line.
1 Little black & Gold Japan'd Card Table Lin'd w^th. gr^n.
 Velvet.
1 Little Brass Lock, 1 Brass Ketch, 1 D^o. on passage
 D^o.
1 Little Brass Lock on y^e back Stairs.

Best Closet.

1 Plimouth Marble Chimney piece
1 Small fire Harth, Shovel and Tongs.
1 Chimney Glass fix'd in Black & Gold jap^d. frame
1 Landskip in Carv^d. frame fix'd over y^e Chimney
 Carving Over.

Best Dressing Room.

1 Egyptian Marble Chimney piece.
2 Dogs w.th Brass Knobs Silverd.
Shovel and Tongs D.o
N.o 1 Chimney Glass fix'd in Red & Gold Japan fra.
115 1 Whole Length of a Nun fix't over Chimney.
1 Half Length of Lady Ann Walpole. —
1 D.o of L.d Latimer or y.e Door in gilt frames.
4 Pieces of Crimson Tabby Hangings, with
8 pannels of Crimson & Gold Damask, with
mouldings Cover'd & laces w.th Crimson & Gold
border'd & mouldings round y.e Hangings, Cover'd
and Laid D.o
6 Dressing Chairs y.e frames Japan'd Red and
Gold, Cover'd & trim'd Same as the Hangings
with Red Serge Cases
2 Window Curtains of Red Sarcenett, 1 frieze
& Vallance Cover'd & trim'd Same as y.e Hangings.
1 Curtain Rod & Silk line.
1 Little black & Gold Japan'd Card Table lind w.th gr.n velvet.
1 Little Brass Lock, 1 Brass Ketch, 1 D.o on passage D.o
1 Little Brass Lock on y.e back Stairs.

Best Closet.

1 Plimouth Marble Chimney piece
1 Small fore Harth, Shovel and Tongs
1 Chimney Glass fix'd in Black & Gold Jap.d frame
1 Landship in Carv'd frame fix't over y.e Chimney
Carving over.
3 Pieces of Indian Sattin Hangings, w.th mouldings
round, Japan'd black & Gilt.
1 Serge Couch, 4 Large S.q Stools frames Japan'd
& black, Gold Cover'd w.th Same Indian Sattin
3 Pillows D.o Stufft w.th feathers and trim'd w.th lace
Suitable & Serge Cases. —
2 White Sarcenet window Curtains
1 frieze & Vallance Cover'd & trim'd D.o
1 Curtain Rod and Silk line
1 Landship fix'd over the Door.
1 Private Brass Lock & Key.

(Fig. 24)
Inventory of Kiveton, 1727,
'Best Dressing Room' and
'Best Closet', folio 11.
Victoria and Albert Museum

3 Pieces of Indian Sattin Hangings, w^th mouldings round, Japand black & Gilt.

1 Large Couch, 4 Large Sq^r. Stools frames Japand, & black Gold Cover'd w^th Same Indian Sattin

3 Pillows D^o. Stufft w^th. Feathers and trim'd w^th Lace Suitable & Serge Cases.

2 White Sarcenet window Curtains

1 Freeze & Vallance Cover'd & trim'd D^o.

1 Curtain Rod and Silk Line.

1 Landskip fix'd over the Door.

1 Private Brass Lock & Key.

North East Closet.

1 Chimney Glass fix'd

1 Dun Colour Marble Chimney piece.

2 Steel Andirons. Shovel & Tongs.

1 half Length of y^e Princes of Orange ¾ Over y^e Chimney.

1 Large Wallnut Book Case w^th. Glass Doors fixd.

1 Green persian draw up Window Curtain, Cornish & Vallance, trim'd w^th. fringe & Lace.

1 Oval Wallnut Card Table Covd. w^th. green Velvet.

2 Pieces of Green Damask Hangings Embroider'd w^th. Small velvet Lace.

2 Round Stools Covd. w^th. fflowred velvet, gilt frames, & Serge Cases.

1 Large Brass Lock on y^e Door.

Dressing Room.

1 Chimney Glass fixd.

1 White Marble Chimney piece. Shovel & Tongs.

1 ? Length of Lady Herbert.

3 pieces of yellow mohair Hangings trim'd w^th. Lace.

1 White Mantua Silk draw up Window Curtain Vallance & Cornish trimd w^th. Lace & Line.

2 Sq^r. Stools Cover'd D^o. w^th. Serge Cases.

1 Large Brass Lock. }
1 Less Brass Lock } on ye Doors.

Stool Room & Coal Closet.

1 Round wainscot Close Stool.

3 Black Grates to Air y^e Rooms.

11 Chimney Boards.

6 Long matts.

2 Box brass katches on y^e doors.

North East Bedchamber.

1 Chimney Glass fix'd.

1 Plimouth Marble Chimney piece.

1 Double Fire Harth, Shovel, Tongs, & Poker Bellows and Broom

2 Chimney Sconces Carved & Gilded.

2 Garters & Coronets Carved in Line tree.

1 Star & Garter D^o.

1 Little Hercules in Marble.

1 Bedsted w^th. Lath. Bottom.

1 Flowred Velvet Bed Lin'd w^th. White Sattin, wrought w^th. Needle work, & trim'd w^th fringe Compleat.

1 Compass Rod & Green Serge Case Curtain.

1 Downe Bed & Bolster. 2 Pillows. 1 Dimothy mattress.

4 Blankets. 2 Small fine Holland Sticht quilt.

10 Chairs w^th. Gilt frames, Cover'd and trimd Same as y^e. Bed, w^th. green Serge Cases.

2 Green persian draw up window Curtains, Cornishes, & Vallance, trim'd w^th Lace, fringe, & line.

1 Large Looking Glass in a Gold & Glass frame.

1 Large black & Gold Card Table Lin'd w^th Green Velvet and Leather Cover.

3 Pieces of Tapestry Hangings The Story of Circey Lin'd with Canvas.

1 Border D^o behind y^e Bed.

1 ½ Length of L^d Strafford. ✕ No 57 107

1 D^o. of Lady Strafford Lacq^d. frames. No 58

North East Drawing Room.

1 Chimney Glass fix'd.

1 Plimouth Marble Chimney piece

1 Double ffire harth, Shovel, Tongs, Poker, Bell^s. & Broom

4 Pieces of Tapestry Hangings, y^e Story of Noah's Ark, Lin'd w^th Canvas.

14 Arm Chairs black frames, Cover'd with Blue & hair Colour'd Damask, blue Serge Cases.

1 Large Looking Glass in a Glass frame.

1 Plimouth Marble Table upon a Carved black frame.

2 Japan'd Cabinets laid w^th. Mother of Pearl, upon gilt frames, & Leather Covers.

2 Cream Colour'd Indian persian draw up window Curtains, freezes & Vallance trim'd with fringe, Lace, Silk Line & Tossels

1 Whole Length of y^e Duke of Monmouth fixd over y^e Chimney. No 101

Drawing Room *Continu'd*.

1 ½ Len: of L^dy. Latimer.

1 D^o. of M^r. Peregrine Bertie.

2 Large Brass Locks & Keys on y^e Doors.

Vestuble or Picture Room.

1 Chimney Glass fixd.

1 Plimouth marble Chimney piece.

2 Brass figure Andirons Lacquer'd. Shovel & Tongs.

1 Oval Table Marble edg'd w^th wood inlaid w^th. Marble upon a Cross wood frame.

10 Wallnut Chairs Cover'd wth purple Velvet, Trim'd wth.
Lace & Blue Serge Cases.
2 Brass Sconces Silver'd.

Pictures.

King Charles y^e First.
King Charles y^e Second.
Lord Cissel no 74
An Italian Musician. no 157 } whole lengths

Earl of Arundel & his Son no 57
David & Goliah's Head. no 261
L^d. Straff^d & S^r Philip manwaring
no 270y^e } Half Lengths

Duke of Savoy. *S. S.* no 40
Admiral Howard ~~no 338~~
King Charles the First ss
D^o the Second
S^r Edward Osborn no 89
Alderman Hewyt. no 88
 Duke Hamilton. } ¾ Lengths
Earl of Lindsey. no 120
A Man in Armour.
S^t. Peter. no 106
S^t. Andrew

1 Large Festival of Rubins. no 213
1 History piece S^r. Peter Lilley.
The Royal ffamily.
A Copy of Basano no 116
Lot & his two Daughters. H.K.R.
no 274 Pilate washing his Hands. all Large pieces.
no 271 3 Orignals p Basan*o* 2 Copy's after Basan.
The Virgin holding Our Saviour.
Our Saviour and S^t John. no 268
1 Church piece upon Copper.

Vestuble *Continu'd*

1 Old Man's Head in Oval Frame.
1 King Henry 8th. & his 2 Sisters no 205
1 Small Night piece p Dore. I.D.B
1 piece of Flowers. H.K.R.
1 piece of Fruit. H.K.R.
1 Little Cupid & Deaths head fix'd to y^e Cieling.

South East Drawing Room.

1 Chimney Glass fix'd
1 White Marble Chimney piece.
1 Double Fire harth, Shovel, Tongs, & Poker. Bellows &
Broom. 1 Iron Cast Back,
1 Whole Length of K: Philip 2^d. of Spain fix'd over the
Chimney.
1 Looking Glass in a Green & Gold Glass frame
1 Japan Tea Table.

4 Green pieces of Caffie Hangings wth mouldings round
Cover'd wth y^e Same.
1 Double Seat wth black & Gold frame.
10 Chairs D^o. all Cover'd wth. green Coffie, trim'd with
Lace & Green Serge Cases.
2 Green persian draw up window Curtains Friezes &
Vallance trim'd with Lace, & Silk Lines & Tossels.
6 Glass Sconces with Brass Nossles, Silver'd.
2 ffor y^e Chimney D^o.
1 ½ Length of Lady Lansdown
1 D^o of Lady O'brion no 158
2 Large Brass Locks on y^e Doors.

South East Bedchamber.

1 Chimney Glass fix'd 1 Iron Cast back.
1 Dun Colour'd Marble Chimney piece.
1 Double Fire harth, Shovel, Tongs, Bellows and Broom.
1 Whole Len: Countess of Arundel fix'd ov^r. Chimney.
3 pieces of Brussel Tapestry Hangings y^e Story of Dido
and Æneas, lin'd wth. Canvas.
1 Wainscot Bedstead Sacking Bottom.
1 Large Yellow Damask Bed Compleat, trim'd wth.
fringe & Lace.
1 Large Feather Bed & Bolster.
1 Dimothy Mattress. 4 Large Blankets.
1 Large Sticht fine Holland Quilt.
1 Case Curtain Rod. 1 Yellow Serge Case Curtain.
8 Chairs & 2 Sq^r. Stools Cover'd & trim'd Same as y^e
Bed.
2 Yellow persian draw up window Curtains, freezes &
Vallants trim'd Same as y^e Bed, Silk Lines & Tossels.
1 Large Looking Glass in a Gold & Glass frame.
1 Philegrine Card Table Lin'd wth Green Velvet. and
Leather Cover. 2 Wallnut Stands.
no 86 1 ½ Len: of y^e Dutchess of Rutland.
no 76 1 D^o of Lady Camden, wth. Lady Plimouth.
1 Small Brass Lock.
1 Brass Katch on y^e back Door.

South Closet

1 Chimney Glass fix'd.
1 Plimouth Marble Chimney piece.
1 Little Steel Harth, Shovel & Tongs.
2 Pieces of Green & hair Colour Damask Hang^s: with
mouldings round Cover'd wth y^e Same.
4 Stools Cover'd D^o with blue Serge Cases.
1 Strip'd Dimothy Drapery window Curtain freeze, &
Vallants, trim'd with ffringe & Lace Lines & Tossels.
2 Cupboard Locks & Keys
K: Charles y^e 1st. on Horseback in Little. IDR
1 Wallnut Ov^l. Card Table Lin'd wth. green velvet.
1 Dressing Glass in a Swing frame
1 Large Brass Lock.

Serv^ts. Room on y^e South Back

Stairs & Stool Room.

1 Sacking Bedstead & Old Matress.
 Feather Bed & Bolster.
1 Pillow. 3 Blankets.
1 Red Paragon Bed and Counterpane.
1 Round Close Stool and Pan.
2 Old Dutch Matt Chairs.
1 Little Square Table.
2 pieces of Old Tapestry Hangings.
 A Bell Line & pulleys.
1 Box Lock with Brass Knobs.

The first Floor.

Great Stair Case.

1 Organ in a Case painted Olive & Gold.
2 Marble Statues, viz. Apollo & Mileager.
 matting for y^e Stair Case.
2 Brass Sconces Silver'd.
1 Oval Wallnut Card Table Lin'd with green Velvet.
1 Card Table Cover'd w^th. green Cloth and Leather
 Cover.
1 Ombro Card Table Cover'd w^th Green Cloth &
 Leather Cover.
2 Large Brass Locks on y^e Doors.
1 Less Brass Lock on y^e back door.
1 Brass Ketch.
1 Brass Knob & Escutcheon on y^e false door.
1 Large Indian Chest.
1 Large Arm'd Chair Cover'd w^th green Cloth.
 The Stair Case painted.

The Great Hall

1 Large purple Marble Chimney piece.
1 Large fire Grate w^th Cast Back, Fender, Shovel, Tongs
 & Poker, 2 Steel Andirons.
1 Large purple Marble Table upon a Carved Frame
 Burnish'd & Gilded.
12 Cane Chairs.
2 Large Brass Sconces Lacquerd.
1 Large Glass Lanthorn w^th a Crimson Silk Line &
 ballance Weight.
7 Marble Statues. Viz. Pan, Hercules, Lucretia, Diana,
 Cupid w^th. his Bow, Paris & Venus.
1 Brass knob & Escutcheon on y^e false door.
1 Iron Box Lock & Key, Bolts & Barrs on y^e Hall door.
 The Hall painted Round.

Long passage North.

2 Step Ladders. 2 Com̃on Ladders.
2 Glass Lamp Sconces.
1 Large Table Matt. 2 Side Boards D^o.
1 Little Ash flap Table. 2 Side Board Tables.
1 Five Dish Havana Table.
1 9 Dish foulding Deal Leafe.
24 Leather Buckets. 1. Large Brass Lock.
2 Less Brass Locks on y^e back doors.
1 Brass Ketch.

The Library.

1 Fire Grate w^th. Brass Knobs, Fender, Shovel, Tongs
 & Poker.
1 Wainscot Writing Desk.
2 Japan'd Chairs Cover'd w^th. yellow Damask, & Serge
 Cases.
2 Wainscot Book Cases, glaz^d. D^rs. Brass hinges &
 Locks. 1 Sm^l. Brass Lock on y^e Door.

North East Closet

1 Chimney Glass fix'd.
1 Stone Chimney piece Japan'd w^th. Marble Slab and
 Slips.
2 Andirons Shovel & Tongs.
1 White Indian Stuff draw up window Curtain freeze
 & Vall: Trim'd w^th. fringe, Line & Tossel.
1 Couch with a Black frame, and 2 Stools D^o. Cover'd
 w^th Crimson Damask trim'd with fringe, & Serge
 Cases.
3 Pillows to y^e Couch D^o.
1 Large Oval Table Black Lin'd with green Velvet and
 Leather Cover.
1 Cup^d. in y^e Wall w^th. Lock & Key.

28. Pictures Viz^t.

A Boys Oval head in Little. **H.K.R**
Oak Parlor A Lady in Little.
Jane Shore D^o. **I.D.P.**
A Woman fleaing her Dog.
Our Saviour Kissing Joseph.
A Woman w^th a bunch of Grapes & a Child. **H.K.R**
✕3✕ of This Subject The Virgin holding Our
 Saviour. 3✕
Galethea y^e Sea Goddess. *Stewards Room*
Venus w^th Cupid holding a Glass. **B.Ps Room**
The Virgin Receiving y^e Sacrament.
Our Saviour in y^e Manger. no 334
Our Saviour Dead, on Copper. **D.R.**
The Virgin w^th Our Saviour Asleep. no 287
Hagar in y^e Wilderness. All in Lacq^d. frames
Lucretia Stabbing her Self.
A woman Stabbing her Self on Copper.

Lucretia & Terquin a Rape.　no <u>379</u>

A Dutch piece.　*Teniers*　<u>H.P.</u> *Vestibule*

A woman w^th. a Child asleep.

Venus & Adonius w^th. a Cupid leading a Dog.

The offering of y^e three Kings.　no 2<u>57</u>

The 3 Shepherds under Chrystal Glass.

St. Katherine & 2 Boys.

An Old Man reading.　no 247

Our Sav^r. Raising y^e Dead.　8 Sq^r. frames.　no 341

Another History piece D^o.

2 Landskips in black frames.　<u>H.K.R</u>

6 pieces of painting upon Marble, y^e Story of Adam & Eve Black frames.　<u>Panel : Room</u>

The North East.
Drawing Room.

1 Chimney Glass fix'd

1 Plimouth Marble Chimney piece.

1 Large fire Grate, Fender, Shovel, Tongs and Poker, Bellows & Broom.

no 65　1 Whole Len: of y^e Earl of Strafford fixd　<u>65</u> Over y^e Chimney

1 ½ Len: of K: William　no 163

1 D^o. of L^d. Abingdon.

1 Whole Len: of y^e D: of Richmond in Little

3 Large Glass Sconces w^th. purple & Gold, Glass frames & double barass Sockets Silver'd.

2 Chimney Sconces D^o.

1 Looking Glass in a purple & Gold frame of Glass & Top D^o.

1 Black Table & leather Cover.

6 Pannels of purple & gilt Leath^r. Hangings fixt in mouldings.

10 Chairs w^th Cane Bottoms.

10 Purple & Gold Colour Velvet Cushions, trim'd w^th. Silk fringe & blue Serge Cases.

2 Straw Colour Indian persian draw up Window Curtains freezes & Vall^ts. trim'd with Silk fringe & Lace. Lines & Tossels.

3 Large Brass Locks on y^e Doors.

1 Brass Katch D^o.

The Dining Room

1 Chimney Glass in a gilt frame.

1 Dove Colour'd Marble Chimney piece.

1 Large fire Grate & Cast back, Fender, Shovel, Tongs, Poker, Bellows & Broom.

2 Glass Chimney Sconces.

2 Glass Sconces with double Sockets.

no 73　1 whole Len: of y^e Duke of Newburgh

no 73　fix'd over y^e Chimney.

1 Large piece of Musick.　I.D. Room

no <u>203</u>　1 Large piece y^e 4 parts of y^e World.

no <u>272</u>　4 Evangelists.

David and Nathan.　*S. Hall*

Dining Room *Continu'd*

Solomon receiving Wisdom.　*S. Hall*

All in Black & Gold Frames.

1 ½ Len: of S^r. Henry Wooton.

1 D^o of Lord Clifford.

1 Still Life.

1 Pendulum Clock in a Wallnut Case

1 6 Leav'd gilt Leath^r. Skreen Indian manner.

3 Scarlet Harateen drapery Window Curtains freezes & Vall^ts. trim'd w^th fringe & Lace, Line and Tossels

14 Large Spanish Leather Chairs trim'd with gilt nails
　gone to <u>gros cres</u> *from* <u>Billard Room</u>

2 Large Brass Locks on y^e Doors.

2 Large Marble Side Board Tables

2 Lesser D^o.

The Vestuble

1 Chimney Glass fix'd.

1 White vain'd marble Chimney piece

1 Iron Cast back.　1 Fire Grate, Fender, Shovel, Tongs and Poker.

The K: & Queen of Bohemia.　70 = 72

Earl of Pembrook & Earl of Wister　68 = 69

1 White vain'd Marble Table upon a black frame.

6 Black Chairs w^th Cane Bottoms.

✗The Marquess of Montros on Horsback✗

3 4 LandSkips painted on board and fix'd over y^e Chimney and Doors.

1 Large white vain'd Marble Bason upon a pedestal & black plint w^th a white marble shell & brass Cock gilt.

2 Brass Sconces Silver'd.

1 Large brass bolt w^th brass Knobs to the Mid: Door.

1 Iron Large Box Lock & Key, Barrs & Bolts to y^e Garden Door.

Sou: East Drawing Room.

1 Chimney Glass fix'd

1 White vain'd marble Chimney piece.

1 Fire Grate, w^th Cast back, Fender, Shovel, Tongs and Poker.

no <u>119</u>　Bellows and Broom

no <u>114</u>　1 Whole Len: of Q Dowager in gilt frame　<u>114</u>

1 ? Len: of Lady Ann Walpole.　no 79

1 D^o of Lady ~~Lancaster~~ Lansdon

1 Large Looking Glass in a Glass fra: & Top.

1 Large Japan'd Tea Table & Stand.

4 White Damask window Curtains freezes & Vall^ts. trim'd w^th. Silk fringe & Lace Lines & Tossels 2 Rods.

4 Pieces of Brussels Tapestry Hangings Lin'd with
 Canvas.
 The Story of Dido and Æneas.
6 Glass Scollopt. Sconces.
2 Do for the Chimney
1 Japan fire Skreen wth. Glass top.
12 Chairs Cover'd wth. yellow Mohair, Trim'd wth. Lace,
 wth. Serge Cases.
1 Seat Cover'd & trim'd Do. & a Serge Case
2 Large brass Locks on ye Doors.

Sou: East Bedchamber.

1 Chimney Glass fix'd. 1 Iron Cast back,
1 Purple marble Chimney piece
1 Double Fire Harth, Shovel & Tongs.
 Bellows and Broom.
1 Whole Len: of Dutchess of Beauford. no 113
1 ½ Len: of Lady Camden.
1 Do. of the Dutchess of Leeds. no 60
1 Crimson Damask Bed Compleat. trim'd wth Silk Orris
 Lace.
1 Serge Case Curtain and Rodd.
1 Large Feather Bed & Bolster. 2 Pillows
1 Dimothy matress. 4 Large Blankets.
1 Large Sticht Holland Quilt.
8 Chairs wth gilt frames.
2 Large Easy Chairs Do.
 All trim'd as ye Bed. & Serge Cases.

Sou: East Bedchamber
Continu'd

4 Window Curtains Cornish & Vallts. Same Damask &
 trim'd as ye Bed with Silk Lines & Rods.
 The Room Hang'd wth Crimson Damask, mouldings
 round Covd. wth Same Damask.
1 Large Looking Glass in a Gold frame.
1 Table Carved & gilded, & Red Serge Case
6 Large Brass Sconces Silver'd
2 For ye Chimney Do.
1 Small Brass Lock.
1 Brass Katch on Back door.

Sou: East Closet.

1 Chimney Glass fix'd.
1 Egyptian marble Chimney piece.
1 Little Fire Grate, Fender, Shovel Tongs and Pokers.
no 252 1 Picture of a Lady playing upon a Lute in Little.
 2. D.R
2 Pieces of Green Damask Hangings, Embroider'd wth
 Small Fringe round.
4 Squr. Stools Cover'd & trim'd Do.
1 Damask drapery Window Curtain & freeze all trim'd
 wth. fringe, Silk, Lines, & Lace.

1 Wallnut Oval Card Table, Lin'd with green Velvet.
1 Dressing Glass in Red Japan Swing frame.
1 Indian Chest upon a Lacquer'd frame, & Leather
 Cover. H.P.B Room
1 Large Brass Lock
2 Cupboard Locks and Keys.

The Stool Room & Closet.

1 Round wainscot Close Stool & Pan,
1 Spring Katch, & Cupbd. Lock.
2 Glass Lamp Sconces on ye back Stairs

Servts. Room over it.

1 Little fire grate and Fender.
 Brass Shovel and Tongs.
1 Old picture of Elijah ye Prophet.
1 Couch Bed wth Sacking bottom
1 Crimson Paragon Bed trim'd wth fringe.
1 Feather Bed & Bolster 1 Pillow.
3 Blankets. 1 Old Sqr. Table.
2 Sqr. Stools Cover'd wth Imbost Serge.
1 Lock wth. brass Knobs. 1 Katch
2 Cupboard Locks.

The Pantrey & Closet.

1 Fire Range fix'd, Shovel Tongs & Poker.
1 Corded Bedstead in press. 1 Straw matt.
1 Feather Bed & Bolster 1 Pillow.
3 Blankets. 1 Coverlid
 Drugget Curtains, ye Bed Lin'd Do.
1 Large deal press fix'd for plate
1 Dresser fix'd wth. Cupboards under and a Bread Bing
 in it & Drawers.
2 Deel Square Tables. 1 Less Do.
6 Old Cane Chairs. 1 Deel writing Desk.
2 Deel presses fix'd wth Locks & Keys.
1 Wood Stool 1 Copper Cistern for Bottles.
1 Lesser Do.
1 Copper Drinking pot for Small beer.
1 Brass pot to Boil Water.
1 Little Copper Sauce pan.
1 Linnen Basket.
1 Do Lin'd wth. Tin for foul plates,
1 Bath mettal Ring to warm plates.
3 Dicanters. 5 Water Bottles.

Pantrey &c. *Continu'd.*

2 Crewits. 8 Beer Glasses.
12 Strong Beer Glasses. 4 Doz: Wine Glasses.
18 Water Glasses. 1 Large German Glass.
1 Glass Punch Bowle.
1 Glass Barrel and Wood Frame.
3 Glass Candlesticks wth brass Sockets.

1 Tub for washing Plate.
1 Plate Rack. 4 Drinking horns
200 Doz: of Glass Quart Bottles.
5 Doz. of pints D⁰.
40 Butts for Strong Beer.
29 Hogsheads, & Some little Barrels
3 Old Butts for poor peoples Sm^ll. Beer.
1 Large Stock Lock & Key.
1 Iron Box Lock & Key.
2 Old Red window Curtains.

Closet under yᵉ Back Stairs

1 Dresser fixt
1 Box Lock & Key.

Servants Hall.

1 Fire Range fix'd
 Fender, Shovel, Tongs & Poker.
1 Long Oak Table upon Tress^lls. or frame.
5 Forms. 1 Deel Cup^bd., Lock & Key
1 Old Couch.
1 Large Stock Lock & Key.

In yᵉ Chappel.

2 Old wind Stove Grates broken.
1 Old Convex Lamp.
1 very Old Skreen.
1 Old twig fire Skreen.
3 Old Dutch Matt Chairs.
1 Old easy Chair cover'd w^th. Cloth.
1 Round Stool cover'd w^th. Damask.
2 old broken Stoves.
2 Door Glass Lamps.
2 Irons for D⁰.
3 old broken Stands.
6 old yellow Cushions
4 very old D⁰.
 Some Old Covers for Chairs.
1 High Childs Chair.
1 Round Glass for a Lamp to hang over a Door.
1 Old Screen Table
1 Old Iron Box Lock & Key on yᵉ Door.

Sotts Hall & Long passage.

1 Fire Range fix'd, Shovel Tongs & Poker.
1 Large Deel Table
3 Forms.
1 Old Couch & Cupboard
3 Glass Lamps
4 Locks & Keys on yᵉ Doors & out Doors.

Stewards Hall and Closet.

1 Fire Grate w^th. Cast back, Fender, Shovel, Tongs & Poker.
1 Large foulding Wainscot Table.
1 Deel Side board Table.
1 piece of Hammond & Mordecai.
1 Prospective of Portsmouth
1 Little piece of Stone heads.
1 Prospective of yᵉ Tower of London.
1 Gilt Leather Skreen 4 Leaves.
1 Sketch of yᵉ window side of a Stair Case.
1 picture of Constantinople.
1 D⁰. of Tangier.
1 D⁰. of Dog & an Ox head.
18 Chairs with Leather Seats.
1 Square Deel Table.
1 Cup^bd. fix'd in yᵉ Wall Lock & Key.
1 pendulum Clock in a black Case.
1 Copper pot for Beer.
1 Copper Cistern. 1 Iron plate Stand.
5 Drinking Mugs. 18 Glasses.
2 Doz: Knives and Forks.
1 Basket Lin'd w^th Tin for plates.
3 Pewter Casters. 2 Glass Crewits.
1 Pewter Ring. 1 D⁰ Flaggon.
1 Water Pail. 6 Brass Candlesticks.
1 p^r. of Snuffers & Pan.
3 Stock Locks & Keys.
1 Five Dish wainscot Table.

The Right Wing.

First Garret South East.

1 perriwig Block & Box.
2 Old Sq^r. Tables. 1 Old Chair
1 Rail of pins.
1 Spring Lock & Key.

The 2^d. Garret.

1 Sacking Bed stead & Straw Matt.
1 Gray Serge Bed Lin'd w^th Callico.
1 Feather Bed & Bolster.
2 Pillows. 3 Blankets.
1 Stained Callico Quilt
2 Old Set work Chairs.
1 Old Square Table
1 Rail of pins and Shelf.
1 Little Bell Line & pulley.
1 Spring Lock, 1 Cupboard Lock.

The 3d. Garret & Closet.

1 Fire Range fix'd, Fender, Shovel, Tongs, Poker & Broom.
1 Corded Bed Stead & Straw matt.
1 Sprig'd Drugget Bed trim'd wth. fringe
1 Feather Bed & Bolster.
1 Pillow. 3 Blankets
1 Stain'd Callicoe Quilt.
5 Old Set work Chairs
1 Square Deel Table wth. Drawers.
1 Writing Desk Do.
 The Room Hung wth green print.
3 Large Deel presses Locks & Keys.
1 Old Mans head. 1 Apostles head.
1 Iron Box Lock & Key.
1 Do with Brass Knobs.
1 Inlaid Chest of Drawers.

The 4th. Garret West.

1 Corded Bed Stead & Straw Matt.
1 Wrought Dimothy Bed & Counterpane.
1 Feather Bed & Bolster.
2 Pillows. 4 Blankets
1 Range Fix'd, Fendr. Shovel, Tongs & Poker.
3 Pieces of Old Tapestry.
 Rest of ye Room hung wth. Green print.
1 Looking Glass in black Frame 1 Black Table.
4 Dutch Mat. Chairs. 1 Landskip in Lacqd. frame.
1 Spring Lock & Key.

The 5th. Garret West.

1 Corded Bed Stead matt & mattres.
1 Red Serge Bed. 1 Feather Bed & Bolster.
1 Pillow. 3 Blankets. 1 Rugg.
2 Set work Chairs
1 Deel Table 1 Rale of pins
1 Box Lock & Key.

The 6th Garret West.

1 Old fire grate fix'd, Fender Shovl. Tongs & poker.
1 Old Lankskip picture
1 Sacking Bedstead
1 Red paragon Bed & Counterpane.
1 Dimothy matts. 1 Feather Bed & Bolster.
1 Pillow. 4 Blankets.
1 Square Table. 2 Red Stands.
1 Deel press, Lock & Key. 4 Dutch matt Chairs
2 pieces of Old Tapestry.
 Rest of ye Room hung wth. green Print.
1 Iron Box Lock & Key

The 7th Garret West.

1 Old fire grate fix'd, Fendr. Shovl. Tongs, & Poker.
1 Corded Bedstead & Brown print Bed Old.
1 Feather Bed & Bolster.
1 Pillow. 3 Blanktt. 1 Stain'd Callicoe Quilt.
1 Looking Glass in Carv'd Lacquer'd frame. Old.
1 Old Square Table.
3 pieces of Old Tapestry. The Rest of ye Room hung wth green print.
1 Old easy Chair Cover'd wth. Setwork & a Blue Serge Case.
4 old Chairs, green Serge Cases.
1 Landskip Lacquer'd frame
2 Old Apostles Heads
1 Box Lock wth. Brass knobs & Key.

The 8th. Garret West.

1 Corded Bedstead and Matt.
1 Old Green Serge Bed Lac'd.
1 Feather Bed & Bolster.
1 Pillow. 4 Blankets 1 Rugg.
4 Old green Chairs. 1 Close Stool & Pan.
1 Old Deal Table
1 Spring Lock & key.

The 9th. Garret West.

1 Old grate, Fender, Shovl. Tongs & Poker.
2 Corded BedSteads & Matts.
1 Serge Blue print Bed.
2 Feather Beds & 2 Bolsters.
6 Blankets. 2 Coverlids. 5 Old Stools
1 Old Table.
1 Small Dressing Glass in a white frame.
1 Deal Close press.
1 Spring Lock & Key.

The 10th. Garret South.

1 Fire grate wth. Cast back Fender, Shovel, Tongs & Poker.
1 Sacking Bed Stead
1 Yellow Mohair Bed Lin'd wth Sarcenet.
1 Feathr. Bed & Bolster 1 Pillow. 3 Blankets.
1 Staind Callicoe Quilt.
5 Pieces of Old Tapestry. Rest of ye Room Hung wth Yellow Print.
1 Looking Glass in a Wallnut frame.
2 Old Stands. 1 Old Wallnut Table.
2 Cibell heads. 1 pictr. of Figures & Fruite
5 Cane Chairs & Setwork Cushions Do.
1 Little Cane Couch wth. an Imbost Serge, Mattres Bolster & Pillow.
1 Spring Lock & Key.

The 11th. Garret South.

1 Corded Bedstead and Matt.
1 Old Brown print Bed
1 Feather Bed & Bolster
2 Blankets. 1 Rugg. 2 Old Red Chairs
1 Old Oak Table.
1 Deal Close Press
1 Spring Lock and Key.

The Second Floor.

The 2 Closets South East.

The Bedchamber.

1 Brass wind Stow grate & Cast back.
 Fender, Shovel Tongs poker & Broom.
1 Chimney Glass fixd.
1 Landskip in a Black frame.
1 Drawing of a Ship. S^t. Inatius. <u>H.K.R</u>
1 Weather Glass for wet and Dry.
2 Little bells with Springs.
2 pieces of Tapestry of Eliga.
1 Wallnut Cabinet upon a frame
1 Skreen Table, 1 Wainscot Bed Table.
1 Boarded Bedstead.
1 Chince Bed Lin'd wth. blue thread Sattin and trim'd wth
 Lace Compleat.
1 Fine Holland Quilt.
1 Cherry Silk Quilt.
1 Downe Bed & Bolster.
3 pillows 1 Little pillow.
1 Holland Quilt. 4 Blankets.
2 Window Curtains same wth. Bed, trim'd & Lin'd D^o.
 Cornish & Vall^{ts}.
1 Rod Line & pulleys.
6 matt Chairs, wth 6 Indⁿ. Strip'd Sattin Cushions.
1 Green Veneer'd Table Box. lin'd wth yellow Silk
1 Brass lock & Bolt
2 Brass Ketches.

The Dressing Room & Closet.

1 Brass Wind Stow Grate & Cast back, Fender, Shovel,
 Tongs & Poker.
1 Chimney Glass fix'd.
2 Glass Arm Sconces wth. Brass Sockets.
1 picture of y^e Roman Charity
1 Large Looking Glass in a Glass frame.
1 Large wainscot Dressing Table wth a Large Drawer
 underneath.
1 Fine Beauro or Indian Cabinet.
2 White Mantua Silk draw up window Curtains, Cornish
 & Vallants trim'd wth Lace. and Silk Lines

Dressing Room & Closet, *Continu'd.*

1 Easy Chair Cover'd wth. black & Gold Silk,
1 Blue Serge Case.
1 Old green Damask Couch.
1 Bolster. 1 Pillow & green Serge Case.
1 Writing wth. Drawer & Brass wheels.
1 Harpsical.
1 Table Clock upon a Black pedestal.
1 Green Damask Square Stool.
1 Crimson Velvet Square Stool.
4 Green & Gold Leather Chairs.
1 Little black Card Table lin'd wth green Velv^t.
3 Prints of Greenwich Hospital
2 Prints of Ships.

More prints in black Frames

4 Genealogies of y^e English Kings
2 D^o. of France.
2 D^o. of Germany.
2 D^o. of Spain.
2 D^o of y^e Turks.
4 Prints of Badminston
1 D^o of Chelsea House. <u>B.N.W.</u>
1 Tea Table. 1 Deal Table & Drawer.
2 paper fire Skreens upon Rods.
1 Hand Tea Table.
1 Brass Lock. 1 Ketch.

The Stool Room.

1 Round Wainscot Close Stool
1 Brass Katch.

The Lady's Woman's Room & Closet.

1 Brass wind Stow Grate & Cast back Fender, Shovel,
 Tongs, poker & Broom.
1 picture of Lady Lemster unfinish'd
1 Looking Glass in a black frame.
1 Dressing Glass D^o.
1 Olive wood Dressing Table Box lin'd with Red Silk.
1 Wainscot Flap Table.
1 Inlaid Chest of Drawers.
1 Old Chest of Drawers plum-tree.
3 Old Tammy wind^w. Curt^s. Vall^s. & Rod.
1 Sacking Bed Stead.
1 Red Cloth Bed Embroid^d. wth black & lin'd wth yellow
 Silk. 1 Stain'd Callico Quilt D^o Comp^t.
1 Feather Bed & Bolster
2 pillows. 4 Blankets.
4 Chairs Same as y^e Bed.
2 Dutch matt Chairs 1 Writing Box.
1 Brass Lock & Key
1 Box Lock wth Brass knobs & Key.

1 Closet Lock & Key.
1 Little Bell Line & pulley
1 Little Dutch matt Chair.

The green Damask Room.

1 Brass wind fire Stow & Cast back.
 Fender, Shovel, Tongs, & poker.
1 Picture of a man & woman naked in a black frame.
 P.O. Parlor
1 Chimney Glass fix'd.
no 121 1 ¾ Len: of ye Late Lady Carmarthen
1 D⁰. of a Lady.
no 82 1 D⁰ of mr. Charles Bertie.
1 D⁰ of Sr Edward Osborn.
1 D⁰ of ye. old Duke of Norfolk. no 111
1 Inlaid writing Box Lock & Key.

Green Damask Room *Continu'd*

2 pieces of Tapestry of Eliga.
1 Boarded Bedstead.
1 Large green Damask Bed trim'd wth. fringe
 Compleat.
1 Large Feather Bed & Bolster.
1 Dimothy mattres 2. pillows. 4 Blankets.
6 Chairs Cover'd & trim'd Same wth ye Bed, & green
 Serge Cases.
4 Green Damask window Curtains, Cornish, & Vallants
 trim'd as ye. Bed.
1 Large Looking Glass.
1 Inlaid Table. 1 Brass Lock & Key.

Closet & Stool Room.

The Closet hang'd round wth green Damask trim'd
 with Lace.
2 Window Curtains Same Damask, and Cornish & Valls.
 D⁰ trim'd
4 Stools Cover'd & trim'd D⁰.
1 Olive wood Scrutore upon a frame.
1 Inlaid Table.
 no 197 1 Old Mans head ? Length I.D.R.
1 Round Wainscot Close Stool.
1 Brass Lock & Key. 1 Spring Lock & Key.
1 Chair Bed, Callicoe Curtains & Seat.

The wrought Bedchamber.

1 Brass wind Stow Grate.
 Fender, Shovel, Tongs & Poker.
 * 1 ? Len: of Lady Latimer unfinish'd*
1 Large Cabt. Inlaid wth Ston & Marble. Pillars.
1 Large Looking Glass in a black frame.
1 Black Japan'd Table. 1 Landskip.
 no 258 1 Old man's head ¾ Length 2 .. D .. Room
1 Fortification of Nearn.

1 Large wainscot Chest Lin'd wth. white Sattin upon a
 frame wth Glass Door & wax Child.

Wrought Bedchmr. Continu'd.

3 pieces of Landskip Tapestry.
1 Sacking Bed Stead
1 Large Dimothy wrot. Bed trim'd with fringe Compleat.
 Lin'd wth. green Sarcenet.
2 Pillows. 4 Blankets.
8 Chairs Cover'd & trim'd Same as ye Bed.
4 White Strip'd India window Curtains, Cornish,
 Vallants & Rod.
1 Large Brass Lock & Key.
1 Large Feather Bed & Bolster.
1 Large matts. wth a Leather Bottom.

The 2 Closets.

1 Closet Hung wth green mohair pain'd with Brocadel.
1 Green Veneerd Card Table lin'd wth green Velvt.
2 Locks & Keys.

The Stool Room.

Mohair Hangings pain'd wth. Brocadel.
1 Close Stool. 1 Katch on ye Door.

North West Closet.

1 Red Damask Camp Bed.
1 Feather Bed & Bolster.
1 Pillow. 3 Blankets 1 Little mattres
1 Stain'd Callicoe Quilt.
1 Flap Table. Shelf & pins
2 Blue window Curtains
1 Little Old Chair, green Sattin Cover fring'd.

The Red Damask Bedchamber.

1 Fire Grate & Cast Back. Fender, Shovel, Tongs &
 poker. Bellows & Broom
2 × 1 picture of ye Golden Shower 188
1 Sacking Bedstead. one in St E Tower
1 Crimson Damask Bed trim'd wth. fringe.
1 Old Crimson persian Counterpane
1 Feather Bed & Bolster.
1 pillow. 4 Blankets.
6 Crimson Damask Chairs trim'd as ye Bed, with Paragon
 Cases.
2 Red paragon window Curtains Cornish Vallence &
 Rod.
1 Looking Glass in a green veneer'd Frame.
2 Pieces of Rale & Bannr. Tapestry.
1 Black Table 1 Brass Lock & Key.

The Closet.

3 Pieces of Imbost Serge Hangings.

1 yell^w. paragon draw up wind^w. Curtⁿ. & vall^s.

2 Stools Cover'd with Brocadel.

1 Dressing Glass in a Swing frame.

1 Wainscot Chest of Drawers.

1 Little Brass Lock and Key.

1 Box Lock & Key.

L^d. Danby's Room.

1 Fire Grate wth Cast back Fender, Shovel, Tongs & poker. Bellows & Broom.

1 picture of L^d. Latimer in Little *

1 Sacking Bedstead

1 Strip'd Cloth Bed Lin'd wth. Red Silk.

1 Feather Bed and Bolster.

L^d. Danby's Room *Continu'd.*

1 Holland Quilt.

2 Pillows. 4 Blankets.

1 Stain'd Callicoe Quilt.

2 pieces of Strip'd Cloth Hangings

4 Strip't Camlet window Curtains Cornish, Vallants & Rods.

6 Dutch Matt Chairs.

1 Large Cabinet upon a Silver gilt frame.

1 Looking Glass in a Lacquer'd frame.

1 Inlaid Table. 1 Little Table Bedstead.

1 Feather Bed & Bolster

1 Pillow. 3 Blankets.

1 Brass Lock & Key.

1 Swing Glass in a wainscot Frame.

The Closet South W.

2 pieces of Harateen blue Hangings

4 Stools Cover'd D^o.

1 picture of a Child Old black frame.

1 Little wainscot Table. 1 Skreen Table.

1 Round Close Stool & Pan.

1 Box Lock & Key.

1 Blue Chair Bed & Cushion.

The Closet South East.

1 Little fire grate, wth. Cast back, Fender Shovel, Tongs, poker, Bellows & Broom.

1 picture of S^t. Katherine. **no 186**

2 White India Stuff window Curtains, Vallants & Rod.

2 Brocadel Stools.

The 2 passages, & back Stairs & Closet under.

2 Cane Chairs Bannister Backs

8 Glass Lamp Sconces.

2 Long Matts in y^e passage.

1 Pendulum Clock in a wallnut Case.

1 Round Flap Table.

1 Little Side Board.

 One Dish Wainscot Table.

1 7 Dish Deal Leaf.

1 2 Dish D^o.

1 Round Table painted Oil Cloth.

4 matt hooks.

1 Reading Desk & round Cushion

12 Flowred Blue shagg Cushions

1 Bible. 2 Large Comon Prayer Books.

2 Less D^o. 2 Turkey Cushions

1 Red paragon D^o.

4 Sketches of painting for a Stair Case.

1 Whole Len: of M^r. Tonstall

1 D^o of M^r Lambert.

42 Maps of y^e County's of England.

1 print of Loo.

 Diana & her Nymphs.

1 Piece of Fruite & Flowers. H.K.R.

 David and Beersheba

no 213 The Garden of Love Eden. Rubens I-DR

2 Large Maps of England.

1 D^o. of Westminster.

1 D^o of Middlesex.

2 Cupboard Locks & Keys

1 Large Bachonella or Drinking piece.

The First Floor.

The 2 Closets South East.

no 257 M^r. Claver in a gilt Frame.

3 India Kings bringing y^r Offring to O^r. Sav^r. DR

1 Large wainscot press for papers with 2 Locks & Keys

1 Old press D^o. of Oak.

1 Cupboard, fixed in y^e Wall.

1 Small Brass Lock & Key

1 plain Brass Lock

The Drawing Room.

1 Double fire Harth, Fender, Shovel, Tongs, Bellows & Broom.

2 Strip'd Dimothy Window Curtains Vallants Cornish & Rod.

1 Large Old Looking Glass in Glass frame.

1 Japan Table.

10 Japan'd Chairs Covd. wth yellow Damask, and Serge Cases.

2 Brass Chimney Sconces Silver'd.

1 Red Japan Cabinet upon a Gold Lacq^r. frame Carved.

Pictures.

<u>no 165</u> 1 ½ ¾ Len: The Princess of Orange.
Lady Katherine Herbert Dᵒ.
Lady Lemstler Dᵒ.
1 Lady Oval Frame. 1 Little Landskip
½ Len: of Lady Ann Walpole.
Mʳ. Walmsley ⎫
4 Lady's ⎬ ¾ Lengths.
 ⎭
1 Flower piece
1 Horse & Groom in Little H. Passage
1 Brass Lock.

The Dining Room

1 Steel wind Stow & Cast back.
Fender, Shovel, Tongs & Poker.
2 Brass Chimney Sconces Silver'd
1 2 Dish Wainscot Table
2 Scarlet Harateen draw up window Curtains Vallants &
 Silk Line.
12 Red Morocco Leather Chairs
1 5 Dish wainscot Table.
1 White vain'd Marb: Table upon a black fra:
1 Basket fire Skreen.

pictures

1 ½ Length The Lady Sunderland 157
Lady Newport Dᵒ.
An Old Man Dᵒ.
Lady Plimouth Dᵒ.
A Little flower piece. S Hall
Bolsover Castle.
½ Len: Lady Cunstable
Lady Sᵗ. John's Dᵒ.
Lady Ann Walpole young Dᵒ. 56
Dutchess of Richmond Dᵒ. 28
no 307 Duke of Burgundy Dᵒ. 35
Mʳ. Peregrine Bertie ? Len:
1 Cane Chair with a round back.
1 Brass Lock.

Green Room.

1 Fire Grate wᵗʰ. Cast back.
Fender, Shovel, Tongs poker & Broom
1 Litt: black Marb: Table on a black frame.
1 Round foulding Wainscot Table.
1 Sqʳ. flap Table of Cedar.
10 Cane Chairs Banʳ. Backs.
1 pair of playing Tables & Men.
2 Ivory Boxes, & 2 Dice.
7 Stagg heads fix'd.
2 press Locks & Keys.
1 Box Lock wᵗʰ Brass knobs & Key.

The Closet

1 Vise board fix'd & a Drawer
1 Sqʳ. Wainscot Table & Drawer.
1 Step Ladder.
1 Cane Chair Bannʳ. Back
1 Box Lock wᵗʰ. Brass knobs & Key.

The next Room West & Closet.

2 Corded Bedsteads & Matts
2 Sprig'd Druget Beds.
2 Feather Beds & Bolsters.
6 Blankets. 1 Old yellʷ. quilt. 1 Coverlid.
1 Sqʳ. Oak Table. 2 Old Chairs.
1 Large Clock Bell.
1 Egyptian Marble Table.
1 white pedestal.
4 pewter Close Stool pans
1 pewter Bed pan. 1 Long Deal Table on fra:
2 Locks & Keys.

Mʳ. Twamlon's Room or Wardrobe

1 Fire Range fix'd & 2 Cheeks.
Fender, Shovel Tongs & poker
1 Round Oak Foulding Table.
4 Old Cane Chairs.
1 Old Stool, Shelves fix'd in yᵉ Room.
1 Dressing Glass
2 Large Close presses, Locks & Keys.
1 Lesser Dᵒ. 1 Foulding Ladder.
1 Chest of Drawʳˢ. 1 Large Deal press Bed,
 Feather Bed & Bolster.
1 Pillow. 4 Blankets.
1 Stain'd Callicoe Quilt
1 Little Old Bible.
4 Little Downe Pillows
1 Litt: Marb: Figure in a black frame.
1 Litt: Stone Round frame Dᵒ.

Wardrobe Continu'd

1 Wire Sieve. 1 Old Oval Carved frame.
5 pʳ. of Brass Sconces Silver'd.
20 pʳ. of Brass Candlesticks
10 Snuff pans, & 2 pʳ. of Snuffers Dᵒ.
3 Tinder Box Candlesticks
1 Hand Candlestick
2 Litt: Bells wᵗʰ. Blocks.
1 pʳ. of playing Tables wᵗʰ. men & Boxes of Box.
1 Iron Box Lock & Key.
Some Old Lumber.
2 pʳ. of Litt: Bath Mettˡ. Candlestᵏˢ. Silvd. over.

The Closet.

1 Deal Writing board wth Drawers.
 & Desk Cover'd wth green Bayes.
 Shelves & holes for paper fix'd
3 Brass Ketches. 1 Sett of Troy Weights.
 Box Lock & Key on ye Door.

Housemans Room.

1 Corded Bedstead & Matt.
 Feather Bed & Bolster.
1 Pillow. 2 Blankets. 1 Coverlid.
 Old blue print Curtains.
1 Old Chair. Long Cupbd. Lock & Key.
1 Long Oak Table.
1 Litt: Deal Table.
 Lock & Key on ye Door.

The Porters Room.

1 Corded Bedstead & Straw Matt.
 Old Serge Curtains Lin'd.
 Feather Bed & Bolster.
1 pillow. 3 Blankets.
1 Coverlid & Rugg
1 Red Cushion. 1 Old Table.
3 Old Chairs. 1 Spring Lock & Key.

The Linen Room.

1 Large fire Range fix'd. Shovel, Tongs poker
 & Bellows
1 Old Table. 2 Old Chairs.
1 Large Deal press for Linen.
1 Steel Mill fix'd for Coffey.
1 Old Linen Trunk.
6 Deal Linen Chests.
1 Brass water Cock & Lead pipe.
1 Deal Cupboard fix'd.
1 Stock Lock & Key.

The Housekeepers Room.

1 Large fire Range fix'd. Shovel, Tongs, poker, &
 Bellows.
1 Large Foulding Oak Table.
1 Deal Side Board Table.
6 Old Cane Chairs.
1 Long Dressr. fix'd wth. Cupbd. under
1 Large Linen Trunk.
1 Wainscot Sweet Stow, Lock & Key.
1 Tin Apple Roaster.
1 Set of Troy Weights.
1 Box Lock wth. Brass knobs
1 Stone Mortar Wooden pestal.

Continu'd. The Housekeepers Room & ye 2 Closets South &c.

1 Oak Stow for Sweet meats,
1 Press Do. and Cupboards.
1 Large Deal press Lock & Key.
1 Do. fixed in the Wall.
1 Deal Dresser fix'd Cupbds. under.
2 Tea Tables.
1 Wainscot Spice Box on a frame.
1 Tea Table & Stand
6 Hand Tea Tables.
6 Chests wth. Square Glass Bottles.
2 Pr. of Brass Scales Iron beams.
6 Brass weights. 1 Basket.
1 Copper Tea pot wth Chafing Dish on a high foot
1 Iron Stow, 1 Coppr Lamp & Cover.
1 Coffy Mill for ye Hand.
1 Litt: Brass pot & Lidd.
1 Brass preserving pan & Cover.
4 Sauce pans Do.
5 Copper preserving pans.
1 Do. Tinn'd
1 Grt. Coppr. Boiler for Tea Water wth. Cock & Covr.
1 Iron Trevit. 2 flat Brass Candlesticks.
1 pr. of Snuffers.
1 Litt: Brass Mortar & pestal.
1 Litt: Hammer Hathet for Sugar.
1 Copper Chocolate pot & Mill.
1 Copper water Kettle for Tea.
1 Brass Tea Kettle & Frame.
1 Toasting Iron.
2 Wafer Irons
1 pewter pint.
1 Large Copper Tea Kettle & Cover.
2 Chests wth. Square Bottles.
1 Wood pump & Brass Cock.
1 Wood Cistern Lin'd wth. Lead.
6 Iron bound pails.
1 Bathing Tub.
1 Stock Lock & Key.
1 Iron Box Lock & Key.
1 Old Bible.
1 Comon Prayer Book.

The Left Wing.

The 1st. Garret North West.

1 Old Corded Bedstead.

The 2d. Garret.

1 Old Range fix'd
 Shovel, Tongs & poker.

2 Corded Bedsteads & Matts.
1 Brown. & 1 Green print Curtains
2 Feather Beds, & Bolsters D°.
6 Blankets. 1 Rug. 1 Coverlid.
1 Old Table. 1 Old Stool. 1 Form.
1 Stock Lock & Key.

The 3^d. Garret East.

1 Old Grate fix'd.
1 Old Close Stool & pan.
2 Corded Bedsteads & Matts.
1 Blue, & 1 Strip'd print Curtains.
2 Feather Beds & Bolsters D°.
6 Blankets. 2 Coverlids.
4 Old Chairs. 1 Form
 Stock Lock & Key.

The 4th. Garret E: & 2 Closets.

1 Sacking Bedstead.
1 Blue paragⁿ. Bed Comp^t. trim'd wth Lace.
1 Feather Bed & Bolster.
1 pillow. 4 Blankets. 1 Holl^d. Quilt.
1 Dressing Glass.

4th. Garret E: & Closets *Continu'd*

1 Fire Range fix'd Fender, Shovel, Tongs & poker.
3 pieces of Old Tapestry, y^e rest of the Room hung wth.
 green print.
6 Dutch Matt Chairs.
1 Oak Square Table y^e Floor Matted.
2 Closet Locks.
1 Iron Box Lock wth Brass knobs & Key.

The 5th. Garret East.

1 Grate fix'd, Shovel Tongs & poker.
1 Corded Bedstead & Matt.
1 Green Serge Bed.
1 Feather Bed & Bolster.
1 pillow. 3 Blankets. 1 Rug.
1 Old Table. 2 Old Chairs.
1 Stock Lock & Key.

The 6. Garret East.

1 Corded Bedstead & matt.
1 Blue print Bed.
1 Feather Bed & Bolster
2 Blankets. 1 Coverlid.
3 Old Chairs. Stock Lock & Key.

The 7th. Garret East.

1 Range fix'd, Fender, Shovel, Tongs & poker.
1 Corded Bedstead & Matt.
1 Strip'd Stuff Bed.

1 Feather Bed & Bolster.
2 Blankets. 1 Coverlid.
1 Old Oak Table. 5 Old Chairs.
1 Stock Lock & Key.

The 8th. Garret East.

1 Coarded Bedstead & matt.
1 Feather Bed & Bolster.
4 Very Old Blankets.
 Stock Lock & Key.

The 9th. Garret East.

1 Grate fix'd, Fender, Shovel, Tongs & poker.
1 Dressing Glass.
6 Cane Chairs. 1 piece of Old Tapestry. y^e rest of y^e
 Room hung wth blue print.
1 Sacking Bed-Stead.
1 Blue paragon Bed, 1 Holland Quilt.
1 Feather Bed & Bolster.
1 pillow. 4 Blankets.
1 Large Deal Close press.
1 Deal Square Table wth. a Drawer.
1 Old Landskip Lacquer'd frame.
2 Drawings of Ships black frames.
1 Old wainscot Chest of Drawers.
1 Box Lock wth Brass knobs & Key.

The Closet.

1 Deal Writing Desk wth Drawers. and Shelves fix'd
1 Box Lock and Key

The 10th. Garret.

Shelves for Apples.
Stock Lock & Key.

The Cooks Room.

1 Press Bed Lin'd wth. Brown print.
1 Blue paragon Wind^w. Curtⁿ. & Rod.
1 Large Deal Close press.
1 Small Deal Table.
1 Old Chair.
1 Box Lock wth. Brass knobs & Key.

The Cook-maids Room.

1 Corded Bedstead & Matt.
1 Blue paragon Bed.
1 Feather Bed & Bolster.
3 Blankets 1 Rug
1 Blue Window Curtain & Rod.
 Stock Lock & Key.

Mr. Carters Room.

1 Fire Range fix'd
 Fender, Shovel, Tongs & poker.
1 Sacking Bedstead.
1 Old mohair Yellow Bed Lin'd with Sarcenet,
 & Counterpane.
1 Feather Bed & Bolster. 2 pillows
5 Blankets. 1 Holland Quilt.
1 print of Comr. St. Loo:
2 pieces of Old Tapestry
1 Deal writing Desk,
1 Setwork Chair, 1 Old Stool
2 Cane Chairs. 1 Old Oak Table.
1 Dressing Glass.
2 Large Deal Close presses.
1 Large Deal Chest. 2 Sibel Heads.
 Michael & ye Angels a print.
1 Stock Lock & Key.
2 Old red window Curtains.

Do. 2. out Rooms & Closet

1 Fire Range fix'd
 Shovel, Tongs, & poker.
1 Setwork Chair 3 Old Chairs
1 Press. 3 Old Tables.
1 Litt: Bedstead & matt.
1 Feather Bed & Bolster.
3 Blankets. 1 Old Rug.
1 Closet Lock.
2 Stock Locks & Keys.
1 Lamp Sconce on ye Stairs.

The Course Laundery & Closet

1 Corded Bedstead & straw matt.
 Drugget Curts. Feather Bed & Bolster.
4 Blankets. 1 Old Quilt.
1 Large Fire Range fix'd.
 Shovel, Tongs, & poker.
1 Hanging Plate for Irons.
12 Smoothing Irons. 3 Iron frames.
3 Drying horses.
1 Napkin press.
1 Swan Skin Ironing Cloth
1 Large Deal Dressr. 1 Litt. Sqr. Table.
1 Form. 2 Iron Candlesticks. 1 Sauce pan.
2 Stock Locks & Keys.

The Fine Laundery

1 Corded Bedstead & matt. 1 Stuff Bed.
1 Feather Bed & Bolster.
4 Blankets. 1 Coverlid
1 Old Table. 1 Old Deal Cupboard.

1 Oak Close Stool & pan.
1 Large fire Range fix'd.
 Shovel Tongs & poker.
1 Hang Iron plate for Heaters.
2 Box Smoothing Irons.
4 Plane Irons. 2 Frames to Set'em on.
1 Long Oak Table upon Tressels.
1 Deal Dresser.
1 Swanskin Ironing Cloth.
2 Close Baskets.
1 Sauce pan & Ladle.
1 Brass Candlestick
1 Iron Do.
1 Stock Lock & Key.

The Wash-house

1 Fire Range fix'd.
1 Copper fixed wth a Brass Cock.
1 Lead pipe wth. 2 Brass Cocks.
2 Old Dressers.
2 Horses for wet Linen.
7 Wash Tubs. 2 Rinching Tubs.
1 Scalding Tub.
1 Soe. 1 Lading piggen.
 Stock Lock & Key.

The Distilling Room.

1 Fire Range fix'd
1 pr of Tongs.
1 Copper fix'd. 1 Pot hook.
1 Large Tub: for Elderberries.
2 Hanging Shelves
2 Old Stows.
1 Copper Limbeck with a worm Tub.
3 Pewter Stills Compleat.
3 Pewter Tops Do.
1 Stock Lock & Key.

The 2 Daries.

 Dressers fix'd round both
6 Shelves for Cheeses. 1 Ladder.
2 Churns. 1 pign. 4 Chese fatts.
2 Kits. 2 Strainers
2 Sciming Dishes. 1 Butter Bowle
2 Cream potts. 8 Milk pans.
 Stock Lock & Key.

The Coach-horse Stable.

1 Pallet Bed
 Feather Bed & Bolster.
3 Old Blankets. 2 Coverlids.
2 Stock Locks & Keys

The Great Stable.

1 Pallet Bed.
1 Boiling Copper fix'd in ye Closet.
4 Stock Locks & Keys.

The Middle Stable.

1 Pallet Bed
 Feather Bed & Bolster.
3 Old Blankets. 1 Rug.
1 Stock Lock & Key.

The Huntrs. Stable & Chambr.

1 fire Grate
1 Corded Bedstead & matt.
1 Blue print Bed.
 Feather Bed & Bolster.
3 Blankets. 1 Old Rug.
2 Wood Chairs. 1 Deal Cupboard
1 Litt: pallet Bed.
 Feather Bed & Bolster.
2 Old Blankets. 1 Old Rug.
3 Stock Locks & Keys.

The 3 Horse Stable.

The Husbandms. Room.

1 Fire Range fix'd 1 pr. of Tongs.
1 Corded Bed Stead & Straw matt.
 Feather Bed & Bolster.
3 Old Blankets. 1 Rug.
1 Deal Table. 1 Old Stool
1 Stock Lock & Key.

The next Room.

1 Corded Bedstead & matt.
1 Blue print Bed.
1 Feather Bed & Bolster.
3 Blankets. 1 Old Rug.
1 Stock Lock & Key.

The Poultry House.

1 Fire Range fix'd
 Fender. Shovel & Tongs.
1 Corded Bedstead & matt.
 Old Camlet Curtains.
1 Feather Bed & Bolster.
1 pillow. 4 Blankets. 1 Coverlid.
1 Little Deal Table.
1 Old Chair. 5 Hen Coops.
1 Corn binge. Several troughs.
1 Tray for past.
1 Turkey Coops. 1 Kitt.
1 Brass pot. 2 Piggons

2 Locks & Keys.
3 Do to ye yard

The Catt House, or Gardiners Room.

1 Fire Grate fix'd Shovel & Tongs.
1 Coarded Bedstead & Matt.
1 Sprig'd Drugget Bed.
1 Square flap Table.
1 Feather Bed & Bolster.
1 pillow. 4 Blankets.
1 Stain'd Callicoe quilt.
3 Wood Chairs.
1 Litt: Dressing Glass.
1 Close press. 1 Table.
2 Cases of Drawrs. for seeds Stock Lock & Key.

The Dog Kennel.

1 Old Corded Bedstead.
1 Feather Bed & Bolster.
3 Old Blankets. 1 Old Rug.

Bacon Room.

1 Oak Chest to lay Bacon in.
1 Salting Bench.
1 Ladder.
1 Large Iron Stove to heat ye Room.
 Some Old Hamprs. Baskets & Lumber.
1 Large Copper Lying by.

The Brewhouse & Chamber.

1 Corded Bedstead & Matt
1 Brown print Bed.
2 Feather Beds & Bolster.
4 Blankets. 1 Coverlid
 A pallet Bed
1 Large Copper fix'd wth. Large brass Cock and a
 Damper.
1 Lessr. Do. fix'd & a brass Cock.
1 Lead pump.
1 Underbeck Lin'd wth Lead.
2 Large Mash Tubs upon a frame.
1 Cooler upon a fra:
2 Large working Tubs on Stands.
2 Covers for Do.
1 Steel matt Quern fix'd.
2 Wooden Scoups.
3 Kitts. 2 Lading piggons
2 Tunnels. 3 Soes. 2 Stroums
1 Coal rake. 1 Iron Fork.
3 Troughs. 1 Wooden Dish
2 Iron Slings. 1 Oak form.
5 Steps.
3 Large Tubs.

8 Large Tap Tubs.
1 Large Hop Basket.
1 Leaden Cistern & pipe to Tun: y^e Drink
1 Stock Lock & Key.
2 Iron Dogs to Carry Hogsheads.

The Bakehouse.

1 Wainscot Cupboard.
2 Iron pokers. 1 peal. 1 Coal Rake.
1 Old Cask for Brann.
1 Deal Dresser. 1 Bread knife
2 Large Iron Brantheries
1 Deal Board for paste.
1 Brass pot to Boil Water.
1 Sauce pan.
2 Iron Oven Lidds
1 Stock Lock & Key.

The Bolting-house.

1 Large Bolting Chest & Lid
2 Meal Tubs.
1 Wainscot Dresser
3 Old Serges for Flower.
1 Old Hair Sieve D^o.

2 Bread Rasps. 1 Dough Scraper.
1 Kneading trough.
1 Salt Box. 1 wood Bowl.
1 Peck Measure. an ½ peck D^o.
1 Chest for Flower. 1 Old form.
4 Sacks. 1 Coal Rake.
1 Bolting Mill Compleat.
3 Cloths for D^o. Stock Lock & Key.

At Harthill Church.

2 Long Velvet Cushions
6 Other Long Cushions
3 Red paragon Cushions. 1 Long D^o.
12 Comon Prayer Books Sev^l. Sizes
8 Turkey Cushions.

Necessary House in y^e South Court.

1 Large Long Lead Trough.
2 Leaden pipes
1 Very Large Brass Cock.
 Room Wainscoted round & Seats.
1 Leaden Cistern on y^e House top, and Small Brass Cock
1 Iron Box Lock & Key on y^e Door.

A True and perfect Inventory of all the Household goods and Furniture at Thorp Salvin in ye County of York. Belonging to ye Right Honble. The Marquis of Carmarthen

The North W: Bedchamber, Two pair of Stairs.

1 Fire Grate wth Cast back, Fender Shovel, Tongs, poker, turn'd Bellows & Broom.

2 Glass Chimney Sconces.

1 Sacking bottom Bedstead & Comps. Rod.

1 Culgee Bed & Counterpane Lin'd with white Sarcenet trim'd wth Silk fringe.

1 Feather Bed & Bolster.

2 pillows 4 Large Blankets.

4 pieces of Rale & Banr. Tapestry Hangings.

2 pr. of paragon Crimson Window Curtains Cornish & Vallants Covd. & trim'd wth. Lace, Lines & Tossels. 2 Curtn. Rods wth pulleys

8 Wallnut Arm'd Cane Chairs, wth Crimson & white Coffy Cushions, Stufft wth. Feathers trim'd wth. Silk fringe, & red paragon Cases.

1 Looking Glass in a Maple veneer'd frame.

1 Table wth a Drawer Do.

½ Len: of Mr. Peregrine Bertie
Do Mr Bertie
¾ Len: of Mr. Richd. Bertie } Lacqd. frames.

2 Iron Box Locks wth Brass knobs & Keys.

The Closet Do.

Hung wth. Imbost Serge border'd wth Crimsn. paragn.

2 Paragan Window Curts. Vallts. & Rod.

1 Black Japan'd Card Table.

1 Dutch Matted Chair.

1 Little Brass Lock & Key.

The Room Adjacent

1 Row of pins.

South E: Bedchamber & Closet:

Fire Shovel, Tongs & poker.

4 Red Serge window Curtains.

2 Vallants & Rods Do.

The Room wainscotted round.

Shelves fix'd in ye Closet

1 Spring Lock & Key on ye Door.

1 Iron Box Lock wth Brass knobs.

Gallery & Closets.

4 Small Iron Bolts

2 Iron Latchets

Green Bedchamber

1 Fire Harth 2 Doggs. Shovel Tongs & poker.

2 Black Brackets.

1 Sacking bottom Bedstead & Comps. rod.

1 Stain'd Callicoe Bed Lin'd wth. Green Sarcenet. Counterpane Do. all trim'd wth gimp Worsted fringe.

1 Feather Bed & Bolster.

1 pillow. 3 Blankets.

1 Looking Glass wth a black frame Laid wth Glass & Brass work.

1 Table. 2 Stands Do.

1 piece of Rale & Banr. Tapestry Hangings

6 Duth matted Chairs.

1 ¾ Len: of Ldy. Latimer on Board.*

1 Flower piece in a black frame.

1 Litt: piece of ye woman taken in Adultery

4 Blue paragon window Curtains

2 Cornishes & Valls. Covd. & trim'd wth Lace Do.

2 Rods & pulleys wth Lines
The Room wainscotted.

1 Iron Box Lock & Key on back Door.

Closet

Hung wth. Stain'd Linen & Shelves fix'd

1 Iron Box Lock & Key.

1 Do to the Room Door, wth Brass knobs

South East Blue Bedchamber.

1 Litt: Small grate, Fendr. Shovl. Tongs & poker.

2 Black Brackets.

1 Landskip in a black fra: over Chimney.

2 Flower pieces Do.

1 Looking Glass in a wallnut frame.

1 Inlaid Table wth a Drawer Do.

2 Old Broken Stands Do.

1 Sacking Bedstead & Compass Rod.

1 Blue paragon Bed with Counterpane trim'd with Lace.

1 Feather Bed & Bolster.

1 Pillow. 2 Blankets.
Room hung wth Blue paragon & black moulding.

4 Blue paragon Windw. Curts. Cornish & Vallants all trim'd wth. Lace.

2 Rods wth Pulleys & Lines.

6 Old Chairs bottoms Stuft wth Feathers & blue Serge Cases.

Closet & Stool Room.

Closet hung wth Stain'd Linen. Shelves fix'd, with Drawers.

1 Old Dutch matt: Chair.

2 Box Locks & Keys on Closet D^{rs}.

1 D^o to y^e Room Door wth Brass knobs.

2 Closets over y^e Stairs

1 Large Coal Box.

South East
Brown Wainscot Room. One p^r. of Stairs.

1 Old Grate, Fender, Shovel, Tongs & poker.

1 Sacking Bedstead & Compass Rod.

1 Holland mattres.

1 Culgee Bed Lin'd wth yellow thread Sattin. & Counterpane all trim'd wth fringe & Lace.

1 Feather Bed & Bolster.

2 pillows. 3 Blankets.

6 Chairs Cov^d. wth imbost Serge trim'd wth Lace.

1 Inlaid Table. 2 Stands D^o.

4 Red paragon window Curtains Cornish & Vall^s. all trimd with Lace.

2 Curtain Rods.

1 Old History piece of our Saviour, in a foulding frame.

1 woman's head in Litt. Hagar in y^e Wildern^s.
Room wainscotted round.

Closet & Stool Room.

Closet Hung wth. Red & Yellow Brocadel.
Shelves fix'd wth Drawers.

1 Plate Lock on y^e Door.

1 Box Lock & Key.

1 Litt: Brass bolt on y^e back door.

1 Iron Box Lock wth Brass knobs on Room d^r.

Next Room West & Closet.

Room hung wth. blue & Gold gilt Leather

1 wainscot press wth Shelves fix'd

1 Lock & Key.

1 Spring Lock & Key.

1 Cupboard wth Shelves fix'd in Closet.

1 Spanish Table. 1 Dutch matt. Chair.
Closet Wainscoted.

1 Small Iron bolt & Latch to Room door.

Servants Room West or Nursery.

1 Old Grate, Fender Shovel Tongs & poker.

2 Corded Bedsteads wth. 6 Rods. 2 Straw matts.

2 Blue paragon Beds trim'd wth fringe.

2 Feather Beds. 2 Bolsters. 2 Blankets.

2 Blue Counterpanes.

4 Old Ch^{rs}. Feath^r bott^s. & blue Serge Cases.

1 Litt: Venus & Cupid

1 Dutchess of Portsmouth in Little.

1 Oak Livery Cupboard

1 Old Sq^r. Table
Great Room Wainscotted round.

2 Spring Locks on y^e Doors.

Dressing Room.

Fender, Shovel, Tongs, & poker.

2 black Brackets.

3 pieces of Bruss^{ls}. Tapestry Hangings

1 Landskip in a black frame.

1 Oval Landskip in Lacq^d. frame.

4 Blue paragon Window Curt^s. Cornish & Vallants, trim'd wth Lace. 2 Rods D^o.

1 Round Wainscot 1 Dish Table.

6 Dutch matt Chairs. blue Cushions D^o. Mantua Silk trim'd wth White Lace & blue Serge Cases.

1 Olive wood Dressing Box upon a frame Lin'd wth Quilted yellow persian
Room most part Wainscot.

Closet & Stool Room.

Closet hung wth Green & White Brocadel.

1 Old Arm Chair Green Serge Case.

2 Blue paragon Wind^w. Curt^s. Vall^s. & Rod.

1 plate Lock & Key on Closet D^r.

1 Box Lock & Key to Stool Room

1 D^o wth Brass knobs to Room Door.

Balcony Room.

2 pieces of Gilt Leather Hangings wth. Figures & Mouldings round D^o.

1 Brass Lock on y^e Door.

Servants Room West.

1 Corded Bed Stead & Straw matt.

1 Blue print Bed trim'd wth fringe.

1 Feather Bed & Bolster.

3 Blankets. 1 Rug. 1 Old Chair

1 Spainish oak Table.
Spring Lock & Key.

White wrought Bedchamber.

1 Old Grate, Shovel, Tongs & poker.

1 Sacking Bedstead.

1 Wrought Dimothy Bed Lin'd wth white Callico, trim'd wth. fringe. Black Moulding.

1 Spotted Linen Counterpane
Feather Bed & Bolster.

1 pillow. 3 Blankets.

1 Old Looking Glass in a black frame.

1 Table D^o.

3 Old Chairs Stufft wth. Feathers & Green Serge Cases.

1 Livery Cupboard. 1 Sq^r. Oak Table.
Wainscot round y^e Room.

1 Spr. Lock & bolt to back Stairs
1 D⁰ to yᵉ Door.

Stewards Hall.

1 Old fire Grate, Shovel. Tongs & poker.
11 Turkey Chairs.
8 Lacquer'd Sconces, wᵗʰ Sockets D⁰.
1 Long Wainscot Table.
1 Large Square Table D⁰.
1 Deal 5 Dish Leafe.
1 picture of Daphne over yᵉ Chimney.
1 Stock Lock & Key on Out Dʳ. towᵈˢ. Kitchin
1 Small Bolt & Latch to inʳ. door.

Dining Room.

1 Fire Grate wᵗʰ. Cast back, Fendʳ. Shovel, Tongs &
 poker.
1 Landskip fix'd over yᵉ Chimney.
2 D⁰. in black frames over yᵉ Doors.
10 Cane Banister Backs.
6 Crimson paragon window Curtains
3 Rods, Cornishˢ. & Vallˢ. all trim'd wᵗʰ. Red Lace Lines
 & Tossels.
2 Six Leav'd paper Skreens.
2 Litt: Marb: Side boards on 4 Iron brackets.
 Room wainscot round.
1 Iron Box Lock, brass knobs. 2 bolts D⁰.

Drawing Room.

1 Fire Grate wᵗʰ Cast back, Fender, Shovel, Tongs
 poker. Bellows & Broom.
1 piece of Ruins fix'd over yᵉ Chimney.
1 piece of Fowls.
1 ½ Len: of an Old man **D.R.**
1 D⁰ yᵉ Earl of Arundˡ. *no **54** } all Lacqᵈ. frames.
1 Large Looking Glass in a black fra:
1 Sqʳ. Table wᵗʰ a Drawer D⁰.
12 Dutch matt: Chairs
2 Yell: paragⁿ. Windʷ. Curtˢ. Cornˢʰ. Vallˢ. trim'd wᵗʰ
 Lace. 1 Rod. Room wainscot.
2 Litt: Brass Katches.

Three Stair Cases. & Closets.

1 New Iron Latch & Ketch
2 Glass Lamps. 1 Round hair Broom
1 Flatt D⁰. 2 Handbrushes D⁰. 1 Whisk.
1 Dry Rubbing Brush wᵗʰ Lead.
1 Wet Scouring D⁰. 1 Iron bound pail.
 Bolts & fastnings to all yᵉ Doors.
1 Large St: Lock & Key on fore Court Dʳ.
3 Locks. 2 Keys, 2 bolts on Gardⁿ. Door.

Servants Hall.

1 Fire Range fix'd
1 Long Oak Table on Tressels
2 Forms fix'd. 1 D⁰ Loose.
1 Bread Bing.
1 Large Stock Lock & Key. 1 Latch.
2 Bolts on yᵉ Out Door.

Pantrey

1 Old press Bed, Corded Bedstead
 Straw matt, Feather Bed & Bolster.
2 Blankets. 1 Old wainscot Table.
 Cupboard & Shelves fix'd.
1 Old Stool Stuft wᵗʰ. Feathers.
1 Litt: Oak Table upon a Foot.
 Stock Lock & Key.

3 Cellars & Bottle Room.

4 Beer Stills. 1 Filter
4 Butts. 1 Bottle Rack.
3 Stock Locks & Keys to yᵉ Doors.

Wet Larder.

1 Deal leaf upon tressels
1 Dresser fix'd
1 Larg Tub lin'd wᵗʰ. Lead to Salt meat in
1 Beam Cross yᵉ Room wᵗʰ. hooks for meat.
1 Old Safe. 1 Large Iron Beam for weights

Kitchen & dry Larder

1 Large fire Range, & 2 Cheeks, 2 Cranes & hooks, Large
 fire shovel Tongs & poker.
1 Large Roasting Jack wᵗʰ. Lines, & pulleys & lead
 weights.
2 Jack Chains, 2 Large Iron racks.
3 Spits. 1 Wood wheel, 2 Iron hooks for D⁰.
1 Boiling Copper fix'd.
3 Stove with Iron hoops fix'd.
3 Iron Trevits
1 Iron Dripping pan, & Iron fra: D⁰.
1 Idle back for Frying pan.
1 Lead Cistern for water, & lead pipe wᵗʰ. Brass Cock.
2 Dressers & 4 Shelves fix'd.
1 Loose Dresser & 2 Forms D⁰.
3 Dressers: 3 Shelves fix'd in pastry.
 One Brass pot Copper Cover.
 One Brass Kettle. 1 Brass Cast mortar wᵗʰ. Iron pestal.
 1 Large Gridiron.
 One Copper Boat pan & Cover.
 One Large Stew pan D⁰. 1 Cullendʳ. & Slice D⁰.
 Four large petty pans D⁰. 1 Lesser D⁰.
 Two Brass petty pans.

One Litt: Bell mettal pot & Hooks.
Two Old Copper flatt Sauce pans.
Three Old Brass deep Sauce pans.
One Large Brass frying pan.
5 Old pewter Dishes Sevl. Sizes. 6 Plates Do.
1 Copper Cistern, 4 very Old tin Covs. for Dishes.
1 Large Salt Tub & Cover.
1 Old Oak Cupbd. 1 Litt. Sqr. Deal Table.
1 Oak joynt Stool. 2. Old Chairs
1 Brass Blunderbush, & a Carbine.
1 Large Stock Lock on ye Door.
1 Lesser Do on Larder Door.
1 Do on Stair foot Door.

Bake-house & Bolting Do.

2 Ovens. 1 Iron Lidd.
2 Dressers fix'd. 1 Loose Do.
2 Stock Locks & Keys.

Brewhouse

1 Large Boiling, Coper wth Lead top, fix'd.
1 Less: Lead Cover'd on ye Brick work Do.
1 Underbeck Lin'd wth Lead.
1 Cooler lin'd with Lead.
1 Large Mash Tub upon a frame.
2 Large working Tubs Do.
1 Wood pump for ye Underbeck.
2 Deal Spouts. 1 Lading piggen
2 Strouns & Stirrer.
1 Little Stair to ye Querns frame
Stock Lock & Key.

Old Wash-house & Dary

1 Gallabalk 2 hooks for Do.
1 Litt: Lead wth Iron Door.
1 Old Stock Lock

New Wash-house.

1 Large Range. 2 Hooks for a Gallabalk.
3 Dressers fix'd
1 Old Form to Set Tubs on.
2 Stock Locks & Keys.

Husbandmans Room.

4 Small Loose Barrs for fire grate
1 Corded Bedstead & Straw Matt.
Old blue paragon Curtains wth 3 Rods.
1 Feather Bed & Bolster.
2 Blankets. 1 Coverlid.
1 Old Squr Deal Table.
1 Old Chair.
1 Loose Range & Bottom
3 Iron frames for Casements.

In ye Yard.

1 Large pump. 2 Stone Troughs.
1 Litt: Brass Sun Dial on Court wall.
1 Large double Stock Lock & Key on ye fore Court Gate.
3 Bolts Do.
1 Stock Lock & Key for ye Gateway.
3 Plate Locks on ye Garden Gates & Drs. & Bolts Do.

28 may 1727
I Accnoulids this to be a trew Copey
of the goods at Kiveton and Thorp

p me William Mills

PART VI
The Marlborough Inventories

Blenheim Palace, Oxfordshire, and
Marlborough House, London
1740

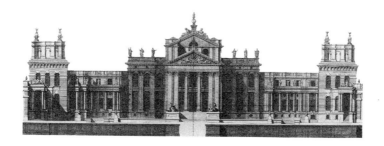

Blenheim Palace, Oxfordshire, and Marlborough House, London
1740

Blenheim Palace was built between 1705 and 1722 with a grant of £240,000 from Queen Anne. The palace was finished during the reign of George I at the expense of the Duke and Duchess of Marlborough. Originally built to the designs of Sir John Vanbrugh (1664–1726) in 1716, Sarah, Duchess of Marlborough, who had taken charge after her husband had suffered a stroke, dismissed Vanbrugh and appointed her cabinet-maker James Moore as surveyor in his stead.

The furnishings reflect the taste of the duke as well as the duchess. The series of tapestries listed at the opening of the 1740 inventory was commissioned by the duke from the designer de Hondt and the Brussels weaver Judocus de Vos. Tapestries illustrating the battles of Alexander the Great adorned the family rooms. Those illustrating the duke's own military campaigns hung in the State Rooms.

The inventory is interspersed with comments indicating where the duchess claimed to have paid for the works listed and the origin of some of the items. These give a clear idea of her particular interest in portraits and textiles and occasionally indicate how they were acquired. As the concluding paragraph reveals, this inventory was drawn up by the duchess herself who evidently dictated its contents.

Sarah, Duchess of Marlborough, secured the lease of the site of Marlborough House, adjacent to the royal Palace of St James's and chose Sir Christopher Wren (1632–1723) as her architect. The foundation stone was laid in 1709 and the house was finished by 1711. The duchess eventually died there in 1744.

The ground floor rooms are hung with paintings and important royal and family portraits, including in pride of place in the Great Room, the French king, Louis XIV, with an Apollo-headed chimney-piece below. In the duchess's bedroom on the first floor, the crimson damask bed and window curtains, supplied in 1711 and now 'Dirty and worn out', were replaced by blue damask furnishings. The original chairs were moved to the Drawing Room. The level of wear and tear on textiles was clearly higher in London than in the country. These inventories were compiled by the duchess in connection with the Chancery suit between herself and her grandson, Charles, 3rd Duke of Marlborough, in order to distinguish between the property of the 1st Duke's trustees and her personal property.

The manuscript is in the British Library and is bound in a marbled cover with a 20th-century label: 'Inventory of Blenheim & Marlborough House, signed by S. Duchess – 1740'.

TESSA MURDOCH

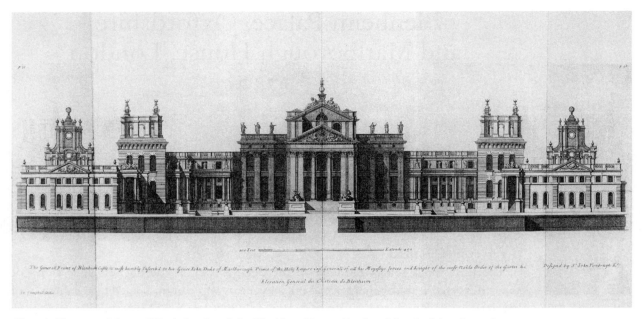

(Fig. 25) The general front of Blenheim, from John Woolfe and James Gandon, *Vitruvius Britannicus*, vol. v, 1771.
Victoria and Albert Museum

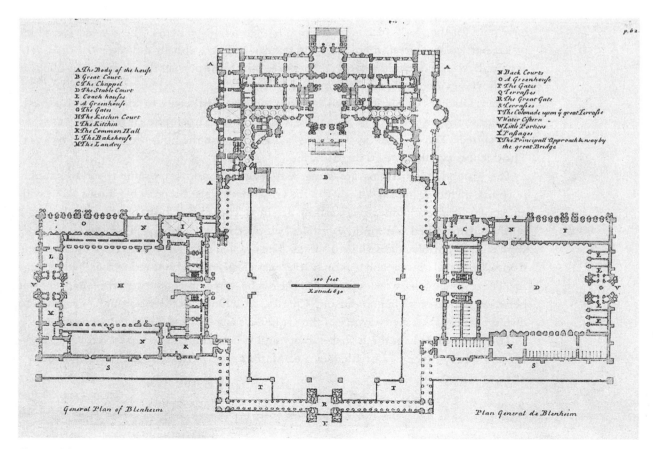

(Fig. 26) The general plan of Blenheim, from John Woolfe and James Gandon, *Vitruvius Britannicus*, vol. v, 1771.
Victoria and Albert Museum

An **Account** of the Furniture belonging to the Executors of the late Duke of Marlborough at Blenheim house in 1740

A List of the Tapestry Hangings that are at Blenheim.

In the Dutchess of Marlborough's Bed Chamber a very fine Suit, I don't know the Story

In the Bow Window Room Tapestry Hangings of Alexanders Battles

In the Dukes Dressing Room a Suit of Alexanders Battles

In the Dukes Bed Chamber Tapestry Hangings Alexanders Battles

In the Grand Bed Chamber Tapestry Hangings of Battles

In the Great Room beyond that Tapestry Hangings of Battles

In the Appartment next the Salon West two very fine Suits of Tapestry Hangings of Battles and Seiges

Eight Suits of the fine Hangings on that Floor all as fresh as New.

A List of the Pictures.

In the long Closet.

A Madonna of Raphael very fine which Cost Six hundred Pistoles

One of the same Size over the Chimney very fine

Lesser Pictures of different Sizes One hundred and twenty Six all of Great Masters and Gold Frames. There is a Printed Book which tells who are the Masters that Painted all these pictures.

In the Dutchess of Marlboroughs BedChamber over the Doors two Madonnas one of Reubens and the other of Van Dyke over the Chimney the Duke of Marlboroughs Picture at length done by Sir Godfrey Kneller. I am in some doubt whether I did not pay for it that myself.

In the Room just before that Bed Chamber.

A Madonna over the Chimney with our Saviour and Joseph done by Rubens.

Pictures in the Bow Window Room.

Over the Chimney and three Doors four, two of them Rubens one the Woman taken in Adultry the other a Lady in a Ruff

In the Duke of Marlboroughs Dressing Room.

One of Rubens of the Holy Family Lord Strafford with his Secretary & two Ladys both Vandykes

In my Lord Dukes Bed Chamber.

Three Pictures one of Rubens of the Holy Family two of Ladys in Ruffs

In the Dutchess of Marlboroughs Dressing Room

Over the Chimney a Madonna in an Eight Square Frame which she bought of Lord Banbury and is therefore hers.

In the Grand Cabinet

The Head of a Man in Black with a Small White Ruff and a Book in his hand, is the Dutchess of Marlboroughs.

Venus and Adonis by Rubens

Lot and his Family leaving Sodom by Rubens

Rubens and his Wife and his Child by Rubens

Rubens. Wife in an Arch Dutchess Dress by Rubens

The Wise Men Offering by Rubens

The Head of Paracelsus in a Furr Cap by Rubens

A Madonna with a Child and two more figures with Cattle and a Landskip.

The Burning of Troy

The Story of Esther

A Madonna with an Old Man & a Child by a very good hand.

A Picture of the Gods and Godesses at Table with Festoons of

Fruit and Flowers by Brughel.

A Peice of Architecture in perspective very good with Figures and

Statues in a Colonnade.

A Small dark Battle peice.

An Italian Entertainment with Singing and Musick.

A Small picture of the Baptising of Christ.

Mars and Venus Surprized by Vulcan upon Copper by Rottenhammer

The Gods and Godesses at a feast upon Copper by Rottenhammer

A Madonna with 5 other figures upon Copper by Rottenhammer

A Madonna and 4 figures by Rottenhammer

A Head of a Woman with a Child and a Bird, the Shades exceeding Dark

Another of the same Size by the same Hand and the same Subject

A Small picture well painted of a Madonna & Christ in her Arms

St. Francis and a Nun Adoring on her left hand & a Benedictine Monk on her Right, with Kings & Queens kneeling below and making rich offerings

A Womans head in a round Gilt Frame

A Small Square Picture of Cows

Another with Several Figures carrying a Dead Man to be buried on a Sheet.

Two Angels and the Virgin Mary with Christ in her Arms appearing to a Monk praying.

A Mans head in black with one hand, Indifferent

A Small Madona with a Child in a Gilt Eight Square Frame is the Dutchess of Marlboroughs and likewise the Murder of the Innocents and the Madona over the Chimney at length with Angels peircing the Serpent is hers bought of my Lord Banbury.

In the ~~Appartment~~ West of the Salon

Jacobs blessing a very fine Picture

A Carpet with a Basket of Fruit by Maltere

Another with Armour upon it by the same both very good

Greyhounds Coursing a Hind.

a peice of the same Size of Goats and Sheep and Dogs

A Fruit peice

A Spanish Sea Port.

Fyshes Picture at length over the Chimney done by Seeman is the Dutchess of Marlboroughs

In the State Bed Chamber.

A Family Picture of Dobson's the picture of the present Lord Godolphin with a Blackamoor in it and that of Rubens Family with our Saviour in it, are the Dutchess of Marlboroughs.

In the Room next the little Bed Chamber.

Three Pictures One Paul Veronese, One of Gypsies the other a Bassan

In the Room next the Salon

Three pictures, two of Battles of Woovermans & the other a Musick peice

In the Gallery

Seven large Titian Pictures, King Charles the first on Horseback upon the Dun Horse, A large picture called taking time by the foretop. the Roman Charity bought at my Lord Portlands Auction And Cost five hundred Guineas a Picture called the Graces, these pictures are all of great Masters & of great Value.

In the Yellow Bed Chamber

Three Pictures over the Doors belonging to this list, I don't know what the figures are, But the other two the Dutchess of Portsmouth and the Dutchess of Marlborough only an Oval head are both hers.

Time Clipping Cupids Wings by a great Master.

A Bachanal etc done by Vandyke

Two pictures of Beggar Boys a Good hand.

A large Picture of Goddesses Bathing themselves

Queen Anns picture at length over the Chimney bought by the Dutchess of Marlborough of One Lilly a Painter in York Buildings

Statues

The Duke of Marlborough's Busto done by a famous Man at Antwerp

A Statue of Bacchus and another of Ceres by the same Man

Six others

A Busto of Lewis the 14th by Bernini, upon the front of the house four brass Statues Copyed from the Duke of Tuscanys by Soldani Benzi very fine.

A List of the Furniture on the principal Floor.

In the long Cabinet the goes out upon the Colonade.

The Hangings White Damask

Two Window Curtains of White Damask

A black Laquered Table of Mr. Moores

A Walnut tree Cabinet very large

All the furniture of the Chimneys upon the whole Floor belongs to the Trust and therefore need not be described in particular there being only Andirons Tongs Fire Shovells Brooms and Bellows & likewise all the Marble Chimney peices Slabs and Glasses over the Chimneys throughout the whole house belong to the Exceutors

Two Gilt Stands for candles by the Chimney

A looking Glass in one all over the Chimney

One Settee

One long Stool

One easy Chair

Seven Square Stools

The frames only belonging to the Trust and the upper Cases but the Covers that are Rich Gold Embroidered upon Blew are the Dutchess of Marlbro's own furniture.

In the Dressing Room the next Room to the Closet

The Furniture yellow Damask and Indian Stuff and likewise the Couch covered with blue and Gold, Except the frame, is the Dutchess of Marlboroughs and the Window Curtains

The Covering of the Chairs and Stools in that Room are the Dutchess of Marlboroughs the Cases and Frames are the Trusts.

A large Looking Glass with a right Indian Japann'd Table under it.

An Indian Screen of coloured Lacquer with Six leaves.

In the Water Closet

A Walnut tree Cabinet
A Walnut tree Chest for the Sheets
Two Dutch Chairs
A Dressing Glass
A Walnut tree folding Dressing Table
Two Wainscot Stands
A Wainscot ffolding Table for Tea things

In the Room next the Dressing Room

All the Furniture of Hangings and Window Curtains and
 Covers
for the Stools and Chairs are the Dutchess of
 Marlboroughs but the Frames belong to the Trust
A large Looking Glass
A Marble Table with a Gold Frame
Four Gilt Arms to hold Candles upon a little Fire Screen
 upon a Walnut tree Strand
Two Walnut tree Stands

In the Dutchess of Marlboroughs Bed Chamber.

The furniture of blue Damask lined with Indian
 Embroidery a Couch
nine Arm Chairs and Six Stools belong all to the Trust
 Except a very deep Valence on the outside of the Bed
 of a very Rich Embroidery which was made of the
 Dutchess of Marlboroughs Cloaths
Bedding belongs to the Trust
Six blue Serge Covers for Stools
A Walnut tree Table with drawers upon it
A large looking Glass
Two Gold Arms for Candlesticks
An Indian Japan Cabinet with a Gilt Frame very fine and
 much larger than the Common Size

In the Bow Window Room.

Two Looking Glasses.
Two White Marble Tables under them with Brown &
 Gold Frames
an easy Chair covered with blue and Gold Wheat Sheaves
 the Frames is the Trusts and the Embroidery the
 Dutchess of Marlboroughs.
A large White Marble Table the same sort of Frame as
 those under the Glass
Two White Marble high Stands the Frames the same as the
 Tables
A Crimson Damask Foot Stool
A Silver Branch in the Middle of the Room
Fourteen Chairs Cover'd with Dutch Machett a thing like
 Caffoy with a White Ground and coloured Flowers.
Three Crimson Lutestring Window Curtains
An Indian Fire Screen upon a Walnuttree Stand

Two Indian Screens of four leaves each
An Ombre Table three Corner'd
A little Stand for the Tea Kettle.

In the Duke of Marlboroughs Dressing Room.

A Large looking Glass A White Marble Table and Stand,
 with Brown and Gold Frames
Two Crimson Lutestring Window Curtains
Two Crimson Damask Stools
Eleven Chairs Quilted with Indian Red Damask
The Frame of the Couch and the pillows belong to the
 Trust but the Gold Wheat Sheaves that Cover them are
 the Dutchess of Marlboroughs.
The Crimson Taffita Covers of the Chairs are the Trusts
A Silver Branch in the Middle of the Room.

In the Dukes Bed Chamber.

A Scarlet Velvet Bed
One Great Easy Chair
Eight Arm Chairs and two Stools
The Rich Gold Stuff the binds this furniture is the
 Dutchess of Marlboroughs and likewise the Tester
 which is Work and Gold stuff is hers
Covers of Red Serge to the Chairs
All the Usual Bedding of that Bed is the Trusts
One large Walnut tree Cabinet with Drawers & Looking
 Glass Doors.
One large Looking Glass in a Gilt Frame and two Gilt
 Stands for the Candles.
A Walnut tree Table with Drawers upon the top of it.
A Walnut tree round Table for play
Two Velvet Window Curtains and Valence of the same as
 the Bed lin'd with Taffita.

In the Grand Cabinet.

The Hangings Crimson Damask and six Window Curtains
One Settee
Six Chairs
Twelve Stools all Gilt Frames they belong to the Trust,
 but the rich Persian Stuff that covers them and the
 Stools is the Dutchess of Marlboroughs
Cases of Crimson Lustring for them all
Two large looking Glasses
One over the Chimney
Two White Marble Tables with Gilt Frames.
A Silver Branch in the Middle of the Room, All the
 Branches thō they are called Silver are only Gilt to look
 like Silver.
The Covering of the long Stools is the Dutchess of
 Marlborough's if they are done with the rich Persian
 Silk

In the State Bed Chamber

Crimson Damask Bed Six Chairs and four Stools Gilt frames, the Gold Galoon that trims that Furniture was bought & paid for by the Dutchess of Marlborough all except the Gold Fringe round the Valence

Two Window Curtains of Crimson Damask Laced with the Dutchess of Marlboroughs Galoon.

A Counterpain to the Bed laced likewise with Gold Galoon

And all the Bedding is Compleat and the Trusts

Table and Stands Carved and Gilt

A Japann'd Indian Cabinet with a Gilt Frame of an Extraordinary large Size and very fine.

In the next Room to the State Bed Chamber.

Two large looking Glasses

Two White Marble Tables & four Stands all with Gold Frames

The Frames of the Chairs in that Room and the Cases to the furniture belong to the Trust.

The Window Curtains and Covers of the Chairs & Stools Embroidered with Silver are the Dutchess of Marlboroughs

A very fine Indian Cabinet of the largest Size

Two Square Stools with blue and Gold Indian Embroidery the same as the Dutchess of Marlboroughs BedChamber

In the Room next the Salon

Nine Arm Chairs

Seven other Chairs all covered with Green Damask

The Frames of the two Settees cover'd with Silver Embroidery upon Green Padusoy are the Trusts but the Covers with Embroidery are the Dutchess of Marlbro's

Three Green Lustring Window Curtains and Valence

Cases for the Chairs of Serge are the Trusts

Two White Marble Tables and four Stands with Brown and Gold Frames.

Two looking Glasses in the Piers

In the Salon

Two White Marble Tables and Four Stands with Browne and Gold Frames

Two Settees Covered with Indian Matt the Matt the Dutchess of Marlboroughs…of no great Consequence

One great Chairs of Crimson Damask

Twenty Chairs cover'd with Dutch Maquelt

Seven Cushions for prayers four of them Mohair, three Gold Stuff.

In the Hall

Four Settees cover'd with Indian Matt

Twenty five Walnut tree Chairs in the Hall & Passages with Seats of Indian Matt, The Matt the Dutchess of Marlboroughs

Twelve high Stands in the Hall and passages of Walnut tree

A Marble Bason for the Beaufet

Two Black Marble Tables with Walnut tree Frames

Eight Glass branches for Candles in the Passages

One black Marble Table more in the Hall with a Walnut tree Frame

In the Chappell

Furniture for the Closet Crimson Velvet with very fine Gold Stuff

For the Altar and Pulpit purple Velvet with Gold Stuff

A great many Common prayer Books

One Large Bible

In the Bed Chamber that looks into the Area.

A Crimson Damask Suit of Hangings Striped and Bordered with Yellow and Crimson Damask

Two Window Curtains with Valence of the same Damask

One Settee and Eight Chairs of the same Damask

A Damask Bed and Counterpaine of the same and Bedding & Quilts to it

A large looking Glass with a Walnut tree frame edged with Gold

A Walnut tree Table with Stands to it Two Walnut tree Stands for candles by the Chimney

Serge Covers for the Chairs and Settees.

In the Waiting Room to this Bed Chamber

One Crimson Damask Window Curtain with Valence Strip'd & Border'd with yellow and Crimson Damask

A Wainscot folding Table

Two Dutch Chairs

A pair of Stands for Candles by the Chimney

Over these Rooms are two Beds & furniture with Conveniences for Servants

In the three Corner'd Room fronting the Court next the Yellow Bed Chamber

A Folding Walnut tree Table

A Pair of Stands

Two White Dimity Window Curtains and Valence

Four Chairs with yellow Leather.

In the Little Round Room before the three Cornered Room.

Two Chairs of Walnut tree with Seats of Coffay with colour'd flowers

Two Arms to hold Candles.

In the Bed Chamber next to the Round Closet.

Yellow Damask Hangings
One Yellow Damask Window Curtain and Valence
Six Arm Chairs Covered with yellow Damask
A yellow Damask bed and Counterpane & Bedding
 belonging to it
Six Yellow Serge Cases for the Chairs
Two Gilt Arms for Candles
A folding black Lacquer'd Table of M^r. Moores.

A Little Room within this Bed Chamber with Bed and
every thing necessary for a Servant.

In the Rooms over this Appartment A Blew Damask Field
Bed that wǎs the Dukes trim'd with Gold Galoon.

A Room by it for a Servant with a Bed and everything
Convenient

In the two first Rooms on the Right Hand of the Salon

Four Settees
Twelve Arm Chairs
Twenty Seven Chairs } Covered with Scarlet Damask
One Dressing Chair } & Cases to them all.
Six White Damask Window Curtains in those two Rooms.

In the first Room two Agate Tables and four Stands the
 frames to the Tables are the Dutchess of Marlboroughs
A large Walnut tree Chest in some of the Waiting Rooms
 behind y^e State Bed Chamber
There is a fourth of those large India Cabinets I don't
 know where it stands now

These Rooms and the Gallery were not finished nor
furnished 'till years after the Duke of Marlboroughs death
And there is nothing in them Except the Pictures and
those things already put down that were not bought and
paid for with the Dutchess of Marlboroughs own money.

All the Great Glass Lanthorns upon the principal Floor &
likewise all the others that light the Stairs belong to the
Trust All the Orange Trees and the Greens in the Green
house are the Dutchess of Marlboroughs sent by her from
S^t. Albans long after the Dukes Death.

In the Dining Room

Hangings of Lead Colour and Gold Leather
Three Scarlet Cloth Window Curtains
Two Marble Cisterns
Two Walnut tree folding Tables
Four Walnut tree Stands
An Arm Chair of Caffoy
Two Velvet Chairs
Twelve Yellow Leather Chairs

An India Fire Screen with two Leaves
A Wainscot Table to Set the Side board plate upon
Marble Shelves in the Beaufet

In the Room where the Women Wait

Tables & Chairs and all things necessary for that use.

In the Round Room where the Desert used to Stand

Tables and Chairs and all things Convenient for that use.

There are four little Rooms to Attend the Rooms of
State below Stairs with all things Convenient for Servants
to Wait in And there is four Rooms over them taken
out of the height that are furnished with Beds and things
necessary for Servants to lye in.

In the little Round Room that goes into the Gallery next the Chappel

Two Gilt Arms for Candles
Four Chairs of Scarlet Sattin Embroidered with Colours
 Indian Work
A Folding Walnut tree Table four Square lined with Green
 Cloth
A Wainscot folding Table for dressing
A Dressing Glass
Four Yellow Serge Covers for the Chairs
This Closet is Wainscotted and has no Hangings.
The Window Curtains belong to the Dutchess of
 Marlborough.

In the Principal Floor there is a Cupboard of Books not
 of any Great Value but they are all the Dutchess of
 Marlboroughs.
Looking Glasses paid for in Mr. Goodisons Bill by the
 Dutchess of Marlborough and Gilt Frames
Thirteen Glasses in Gold & Glass Frames and two
 Glasses in Walnut tree frames.
These things were paid for by the Dutchess long after the
 Dukes Death

A List of the Furniture in the Attick Story

In the Appartment called My Lady Pembrokes
In the First Room

Caffoy Hangings White Ground with Red and Green
 Flowers
A Window Curtain of White Indian Gauze which is the
 Dutchess of Marlboroughs
Nine Chairs Covered with the Same Caffoy
A White Marble Table
A Walnut tree Stand to Set a Tea Kettle on
Two Arms for Candlesticks
Ten Prints which are the Dutchess of Marlboroughs

In the Bed Chamber.

A Bed of Indian Quilting Bordered with ^{very} fine Indian Callico which I bought of my Lady Pembroke & paid for it my self & is mine.

The Hangings of this Room belong to the Trust and five Chairs covered with the same being made out of the Furniture that was the Duke of Marlboroughs used in the Campaigns

One Glass for the Chimney and two Arms for Candlesticks

One Black Lacquered Table

In the Servants Room within the BedChamber

All things necessary for that use

In the Appartment over the Dukes Bed Chamber. In the Closet

One Sopha with two Cushions covered with Crimson Damask and Ten Chairs with Scarlet Sattin Embroidered Covers

One black Lacquered folding Table

In the Bed Chamber next the Closet

One Suit of Red and White Callico Hangings

A Bed of the same very fine

Every thing belonging to it & Window Curtains of Red & White Burdet

Ten Chairs of the same Callico

One Wainscot folding Table

Two Walnut tree Stands

A large looking Glass

One Glass over the Chimney

One large picture over the Chimney I don't know what the Subject is

Two Walnut tree Arms for Candlesticks

In the Room before this Bed Chamber

A Suit of Hangings and Window Curtains of the same arched Red & White Callico

One large Walnut tree folding Table

Two Walnut tree Stands

One large looking Glass

Two Arms for Candlesticks

One large Picture over the Chimney I don't remember the subject

Eight Dutch Chairs and two Stools

In the Servants Room to this Appartment.

A Bed and all Conveniences proper for that use

In the Dutchess of Bedfords Dressing Room.

A Walnut tree Cabinet

Yellow Serge Hangings

A large Picture of a Landskip over the Chimney

Two Arms for Candlesticks

One Wainscot folding Table

One Table to Stand by a Bedside

One Dressing Glass

One Couch and three pillows covered with blue Damask

One Dressing Chair Covered with Red and White ^{flowered} velvet

Two large Stools with ^{out} Coverings

Two Chairs Covered with yellow Leather

The Bed Chamber next to it ^{is} furnished with blue Velvet Bed and Hangings sent from Marlbrō house I don't know how many Chairs, but it is compleatly furnished.

And the Nursery Maids Room has Bed and every thing proper for that use

In ~~the~~ Lady ^{Anne} Batemans Appartment In the Closet

A Suit of Hangings of Sprigged India Callicoe & Window Curtains

Two Callico Stools

One Rose Coloured Damask Stool

In the Bed Chamber

Scarlet Cloth Bed Hangings & two Window Curtains of the same trimd with Gold Colour'd Silk Galoon

Six Chairs of the same and all things belonging to the Bed

One large Looking Glass

One large Walnut tree folding Table

Two Walnut tree Stands

One Wainscot folding Table

One Dressing Glass

A Glass over the Chimney

Two Arms for Candlesticks

In her Womans Room

A yellow Serge Bed and all things Convenient and proper for that Room

And also for another ^{little} Waiting Room

In the Appartm^t. that looks into the Area over against the Arched Callico Appartment

A Striped Window Curtain ffringed

A Red and Yellow Damask Stool

Two Chairs Covered with Dimity fringed

Two Arms for Candlesticks

In the Bed Chamber

A White Indian Stitched Bed made with fringe which
 is the Dutchess of Marlboroughs All things belonging
 to that Furniture the Trusts but all the fringe is
 the Dutchess of Marlbro's own Work & therefore is
 hers
A Wainscot folding Table
A Dressing Glass
Five Chairs with Fringe

In the Room before this Bed Chamber.

Thirty five Prints which are the Dutchess of
 Marlboroughs.
Six Chairs cover'd with yellow Leather
A Little Room furnished for a Servant of blue Serge with
 all things Convenient for it

In the Appartmt. that is over the Dining Room
In the Closet

Two Window Curtains and Valence
Two Arm Chairs Covered with Caffoy Red Flowers
Two Chairs Covered with the same Caffoy
Three Stools Indian Callico
One Suit of Hangings Fillemot & White in Pannells
 These Hangings
were bought by the Dutchess of Marlborough
One Fire Screen
A black Folding Table

In the Bed Chamber where Lady Delawar lay

Yellow Damask Bed lined with White Sattin Embroider'd
 and a very old Suit of Tapestry Hangings which the
 Queen gave me to furnish part of my Lodgings at
 Windsor Castle which afterwards I sent to St. Albans &
 afterwards to Blenheim from thence to Save buying
 furniture for that Room
One looking Glass and Table Inlaid and two Walnut tree
 Stands
One two leaved Indian Screen
Two Arms for Candlesticks

In the Waiting Room next the Bed Chamber

Hangings of Fillemot Sprigged Indian Callico pannell'd
 with Indian Silk
Those are the Dutchess of Marlboroughs
Two Caffoy Chairs with White Ground & Red and Green
 flowers
One Wainscot folding Table
Two Arms for Candlesticks
One fire Screen

In the Appartmt. that fronts the grand Parterre
In the Closet

White Mohair Hangings Border'd with blue Mohair
Four Chairs and two Stools of the same
A Glass over the Chimney
One pair of Walnut tree Arms for Candlesticks

In the Servants Room within that Closet.

A Yellow Bed & all things Convenient for a Servant

In the Bed Chamber

A Suit of White Mohair Hangings all borderd and
 pannelled with Scarlet Sattin Embroidered Window
 Curtains and fourteen Chairs all the same Embroidery
 and a Couch and three pillows
One fire Screen two leaves of Indian paper
A Glass over the Chimney
Another large Glass in the Room
A Picture of my Lady Pembroke copied by Seeman and
 paid for by the Dutchess of Marlborough

In the Waiting Room between the two Appartmts.

White Mohair Embroidered with the same Scarlet Sattin
 as is in the BedChamber
Five Chairs with the same Embroidery and Cases of
 Cream Colour'd Sarcenet
One Stand for a Tea Kettle
Nine Prints by the best Hand which are the Dutchess of
 Marlboroughs

In the Bed Chamber on the Left hand

Hangings of Burdet
Nine Chairs Cover'd with the same
A Bed of the same and two Window Curtains
A Counterpane Stitched upon Callico with Gold Colour'd
 Silk that is the Dutchess of Marlboroughs
Two Arms for Candlesticks
One large picture over the Chimney with Shephards &
 Sheep.
One large Looking Glass with an Ebony frame inlaid with
 Silver
A Table and two Stands of the same
Leather Cases for them & Cream Colour'd Sarsnet Cases
 for the Chairs

In the Closet within it

The same Furniture
One Black folding Table
Two Arms for candlesticks
A Glass over the Chimney
Three Chairs the same Burdet
Cases of Cream Colour'd Sarsnet

One Couch of White Sattin richly Embroidered with
Several Colours
three pillows of the same and Cases of Taffaty to them
Those are the Dutchess of Marlbro's

In the Room called the State Room.

A Crimson Damask Bed The Teaster & head Cloth made
of two States one King W^ms. Arms the other Queen
Anns This Bed is Bound with Rich Gold Stuff Galoon
that was the Dutchess of Marlboroughs but Except that
& the triming of the Chairs in that Room that furniture
belongs to the Trust. The picture over the Chimney at
length is the Earl of Godolphin Treasurer of England.
The Closet within it is furnished with blue Camblet Chairs
and everything belonging to it is the Dutchess of
Marlbro's being Embroider'd with Gold Stuff but the
doing the Embroidery not coming home till after the
Duke dyed was paid for by the Executors and was
about Eighteen pounds.

A Room for a Servant and Closet with a Bed and all things
proper for that use.

In the Bed Chamber at the End of the Stone Gallery above Stairs.

Hung with White Dimity Chairs of the same & Window
Curtains all trim'd with Fringe of the Dutchess of
Marlbro's working
A Bed of White Quilting with knotted fringe all the fringe
is the Dutchess's and that Bed but the rest of the
Furniture belongs to the Trust as do's likewise the
Conveniences for the Servants belonging to that
Chamber.
Over against the BedChamber there is another, The first
Room has only Conveniency's for a Servant and a
Waiting Room The BedChamber and Closet within that
is furnished with very fine Scotch plad given the
Dutchess by the Duke of Athol
There is another Little Appartment upon the same floor
furnished with Strong Turkish Callico Bed and
Hangings that belong to the Dutchess of Marlbro but
as she cannot remember exactly what they are they shall
go as belonging to the Trust.

Belonging to the Appartm^t. with Arched Callico Furniture.
In the Room next to the Dressing Room.

Fourteen Arm Chairs cover'd with Caffoy Yellow Ground
& Crimson flowers
One Window Curtain of Gold Colour'd & White Striped
Burdet.
Nineteen prints of the best hands which are the Dutchess
of Marlbro's

In M^r. Spencers Appartm^t. in the first Room.

Blue Camblet Hangings
A press Bed like a Cabinet
A large Wainscot Stand
Two Coffoy Chairs

In the Bed Chamber

A Blue Bed and Hangings
A Wainscot Table two Stands
Six Walnut Tree Chairs with blue Camblet Seats
Twenty three prints that are the Dutchess of Marlbro's

In the Closet

Blue Camblet Hangings
Four Walnut tree Chairs with Camblet Quilted
A Walnut tree Chest of Drawers
Two Dimity Window Curtains
A Dressing Glass
Fifteen prints which are the Dutchess of Marlboroughs

In the White Bed Chamber at the End of the Stone Gallery

Nine Walnut tree Chairs covered with the same as the
hangings
a Walnut tree Chest of Drawers with an Escrutoire at the
top of it
A Wainscot Table
Two Extream fine high lacquered Screens each Six leaves.

An Account of the Linnen at Blenheim.

Damask and Diaper Napkins Sixty Seven Dozen and five
Table Cloths of the best Sort Ninety three
Stewards Table Cloths Twenty
Fine Sheets Eighteen pair
Servants Sheets Forty five pair
Three Dozen of Damask Towells marked N^o6
Round and Square pillow beers forty two
Two Holland Bolster Cases
Eleven Round Towells
Four Dimity Blanketts
Linnen for the Kitchen House Maid Butler &
Housekeeper
the particulars not worth putting down
The China both usefull and not usefull not much but is all
the Dutchess of Marlboroughs
All the things in the Kitchen and Offices are Compleat
and to be sure I must have bought a great many of them in
Eighteen Years But, as many of those things are Ordinary
& would Swell this Account to a vast bigness and as I am
determined not to take any of them away I don't think it
necessary to do more than mention them but there are
several Marble Tubs in the Garden (I don't know how

many) which some of the Orange Trees are put in that I Sent from the Lodge at Windsor and are Mine. The Reason that I distinguish what is mine at Blenheim is because the House is now Compleat And to take them away would lessen the Beauty of it which I have no mind to do For Perhaps I may Alter my Mind and leave the things at my death that are Indisputably my own. I think it is proper to insert here the Gold plate which the Electress of Hanover made present of to me with a Suit of Hangings part of which are in the following Account Claimed by me as my own, The Electress having Writ to me that She sent those Hangings and direction to Mons[r]. Schutz to lay out such a Sum in whatever I Chose to go with the Hangings This she say'd was in return of the Picture I had sent her of Queen Ann upon which I desired him to lay out the Money in Gold plate and that he would be pleased to put the Electreesses Arms upon it. This Money produced Twenty four Table plates twenty four spoons twenty four forks and twenty four knives All this Gold plate I desired the Duke of Marlborough would Settle in his Will after my Death in Succession upon the Family which he did but not the Hangings And there are Several Clauses in the Will by which he Gives me all that ever was mine to dispose of And therefore I have made the Claim in the following Account of part of those Hangings which are now up in Marlbourough House The rest of them being in another of my own houses I need not mention them as they are my own property The Pictures & Tapestry Hangings at Blenheims are of great Value And they are described in a very particular manner And so is every thing that is of any Consequence.

The above is an Inventory of the Goods and Furniture at Blenheim in which I have Specified and distinguished what belongs to the Trust Estate and what is my own property and belongs to me In Witness whereof I have hereunto Set my hand this twenty Second day of October 1740

S. Marlborough

Witness hereto
J: Stephens

Dec: 20 1740
I Do hereby Own and Acknowledge to have in my Custody & possession All the Pictures Glasses Hangings Beds & other Household Goods & Furniture Mentioned in the above Inventory to belong to the late Duke of Marlborough att the time of his Death att Blenheim House and also the said late Duke's Gold Plate with the Elector of Hanover's Arms Engraved thereon And Do promise that I will Carefully preserve and leave the Same either att Blenheim House or Marlborough House att my Death in as good Plight and Condition as they are now in Reasonable use wearing & Inevitable Accidents by Fire or Otherwise Excepted

S: Marlborough

Witness
J: Stephens

An Account of the Furniture belonging to the Executors of the late Duke of Marlborough in Marlborough house in the Year 1740.

In the Hall

Four Pictures out of Bord & two of the same at the
 House where my Lord Clancarty lives
A Woman and ᵃ Boy with a Baskett of Fruit
Queen Ann of Denmark with Dogs in a Hunting
 Dress
A Landskip and four Silver'd Sconces
Four Walnut tree Stands to hold Candles
Eleven Leather Chairs
A Grate Compleat and furniture to the Chimney

In the Great Room

The Rape of the Sabines
Two Pictures over the Doors of Kings called Vandykes
Our Saviour taken from the Cross
The Holy Family
A Dutch Fair
Lewis the fourteenth over the Chimney

Lot and his Daughters by Rubens
A Madonna, in a black frame, of Rubens
Queen Mother
The Rape of Proserpine
The last Judgment
The Marriage at Canaan
King Charles by Vandyke
A Venus
A Woman with a Wild Boar by Rubens
Four Settees with Walnut tree frames
Ten Chairs of the same All Cover'd with Red
Three long forms India Damask
Four Window Curtains of the same
A Grate Compleat
Two Silverd Sconces that is Chandeleirs
An Extream large Glass much bigger than ~~than~~ the
 Ordinary Size and
Two lesser
Three Marble Tables
Two high Stands

In the next Room

A very large Glass
A Marble Table with a Brown and Gold Frame

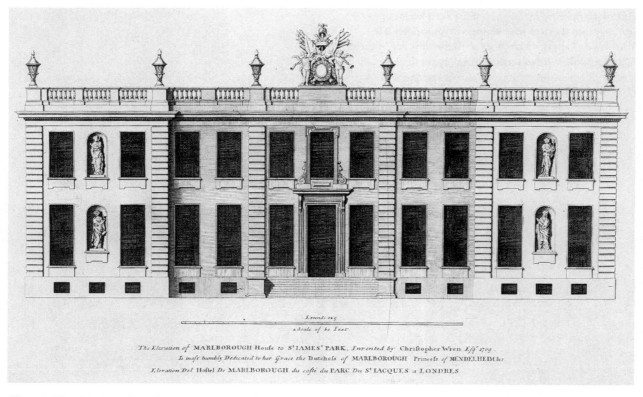

(Fig. 27) 'The elevation of Marlborough House to Sᵗ. James's Park', from John Woolfe and James Gandon, *Vitruvius Britannicus*, vol. v, 1771. *Victoria and Albert Museum*

Duke of Bridgwater the Dutchess of NewCastle Lord
 Blandford the
Lord Brackley and Lady Jersey over the Doors
A Glass over the Chimney
A Landskip a Sea peice and Antwerp
A Walnut tree Cabinet
Five walnut tree Chairs Cover'd with Green Damask &
 Hangings of the same

In Mʳˢ. Ridleys Chamber

A Picture over the Chimney
A Glass over the Chimney
A Blue Damask Bed Hangings and Chairs of Yellow
 Worsted
Damask proper for the Room

In my Lady Dutchess's Bed Chamber
On the first Floor.

There was a Crimson Damask Bed and Window Curtains
 Sett up when the House was first built & Tapestry
 Hangings twelve Chairs & two Arm Chairs of the same,
 The Bed and Hangings were Dirty and worn out and
 there is put instead of them a new Blue Damask Bed
 and Window Curtains for the Trust by the Dutchess of
 Marlborough and the Chairs being Clean are moved to
 the Drawing Room the Suit of Tapestry Hangings were
 sent to Blenheim and the Tapestry Hangings in the
 place of them are the Dutchess of Marlbro's
A Looking Glass in a Glass and Gilt Frame
No other furniture in that Room belong to the Executors
 for it was all bought by the Dutchess of Marlborough
 long after the Dukes Death

In the Salon

Andromeda by a good hand
Prince Philip by a good hand at length
A very fine Landskip, by a Great Master, over the
 Chimney
A Looking Glass over the Chimney
Two large Glass Sconces
Four Arms for Candles
A Marble Table and Stands
Eight Walnut tree Chairs with Gilt Leather the Leather is
 the Dutchess of Marlboroughs but no matter to
 Seperate it
Three Crimson Tafata Window Curtains
A Stove Grate and furniture for the Chimney

In the Room next the Salon

A Sett of Fine Tapestry of the Duke of Marlboroughs
 Battles
Fifteen Walnut tree Chairs of Red Damask Quilted
Two White Damask Window Curtains

A very fine Landskip by a great Master over the
 Chimney
Queen Anns picture in the Coronation dress by Sʳ.
 Godfrey Kneller
A Picture of the Dutchess of Richmond with a Dwarf a
 very fine Vandyke
A pretty large looking Glass
A Glass over the Chimney all in one peice
part of the fine Tapestry Hangings given by the Electress of
 Hanover are the Dutchess of Marlboroughs

In the Drawing Room

An Extream large looking Glass
A Walnut tree table and two Stands
Over three Doors Lady Sunderland Francis Earl of
 Godolphin and
Mʳˢ. Dunch
A large Picture of the Duke & Dutchess of Marlbrō & five
 Children
Over the Chimney Peice the Countess of Bridgewater
The Wise Mens offering } both by a
The Star appearing to the Shepherds } great Master
The Birth of our Saviour } both by a
A large picture with many figures } great Master
 thought to be Timon of Athens
Twelve Crimson Damask Chairs
And two Elbow Chairs of the same
A large Chandelier Silver'd
A large Glass for the Chimney all in One
Two Gilt Sconces for Candles ᵗᵒ for the Chimney and two
 to the Glass
Two high Japanned Screens Six Leaves each
The Hangings that were in this Room were put to
 Ordinary Uses being Old.

In the Closet next the Garden

A Naked Woman over the Chimney
A whole Looking Glass over the Chimney
Two Gilt Stands
Silk Indian Tapestry Hangings
Four Stools of the same
A Gold Fire Screen four Leaves

In the Waiting Room

Over Doors my Lord Holland Lord Neᵂport & Villars
 Duke of Bucks
Over the Chimney the Duke of Montagu at Length
A Looking Glass over the Chimney
A Looking Glass in the peice
A Naked Man over it
A Marble Table and two Walnut tree Stands & an Ombre
 Table
A Cedar Dining Table

When the Gilt Leather Hangings were put up the
 Hangings of this Room were carryed to Blenheim and
 are in that Account
A Grate and Furniture for the Chimney

In the Dining Room

A Picture of the King of Prussia over the Chimney
King William over a Door
A Chimney Glass and a Marble frame
A Vandyke of the Duke of Buckingham and his Family
A Bachanalian Piece very Fine by Rubens
A Madonna by Rubens very fine
An Oval of Lady Chesterfield by Vandyke
A Woman in a Ruff by a good hand
Sidney Lord Godolphin is the Dutchess of Marlboroughs
King Charles the Second
Prince Eugene
A Landskip
A Little head
A Landskip
A Picture with many small figures
A Woman and a Child
The Virgin Mary our Saviour and S^t. John
An Oval of the Queen Mother by Vandyke
Another Picture of Small figures
A Glass between the Peirs
Three Marble Tables and two Stands
Two Marble Basons for the Side board
Two Tables for Dining

In the Lobby next the Dining Room.

Two pictures at length over the Doors a Man and a
 Woman
A Glass over the Chimney and two high Stands
Nothing else on this floor but Old Tables &c not worth
 the putting down

In the Attick Story the first Room

A Glass over the Chimney and two Arms for Candles

In the next Room on the Right Hand

A Glass over the Chimney and two Arms for Candles
Two large pictures by indifferent hands

In the Closet

A Glass over the Chimney
A Woman at length
An Iron Chest with Several Keys for the Trustess to keep
 the Writings in
Two Walnut tree Stands

In the Bed Chamber

A Glass over the Chimney in One peice
Two Glasses in the Peirs

In the next Room

A Glass over the Chimney and two Arms for Candles

In the next Room

A Glass over the Chimney and two Gilt Arms
King George the Second George the first and Queen
 Caroline
Two Walnut tree Chairs with Velvet Covers

In the Closet

A Man at length and a Glass over the Chimney

In the next Room to that

a glass over the Chimney and a glass in the peir
Two arms for Candles

In the next Room over the Dining Room

A Glass over the Chimney
Seven Quilted Chairs covered with Green Damask

In the Closet

A Glass over the Chimney and two Arms for Candles
A Woman at length over the Chimney
Hangings of no Value

In the Upper Servants Rooms

M^r. Stephens
M^rs. Ridley
M^r. Lofft
The Housekeeper
M^rs. Lofft
M^rs. Patten
The Butler M^r. Griffiths
The Groom of the Chambers M^r. Lewis

All these Rooms are properly furnished And also for all
the Under Servants Men and Women And as the House
was built many Years ago that sort of furniture has been
renewed with some Old worn out things in the Great
house And an Addition of New that I paid for to put it in
Order But as I dont intend to remove any of it 'tis not
Worth distinguishing what is mine and what the Trusts
nor to put down the Particulars of all the Usefull things in
Kitchen and Offices thô there must be severall things of
my own having been a Widow near Eighteen Years But I
will leave them All at my Death as they are and such
Ordinary things are not worth my distinguishing in any
other manner

An Account of the Linnen at Marlbrough house

Eight pair of Fine Sheets Twenty two pair of Second
 Sheets twenty four pair Common Sheets fine Napkins
 fourteen Dozen, Courser

Napkins twelve Dozen fourteen fine Table Cloths
 fourteen lesser

Table Cloths fourteen Stewards Table Cloths four
 Footmens

Table Cloths The particulars of House Maids and Kitchen
Linnen are not Worth putting down.

The Reason the Account of Goods at Marlborough
House is no more is because the best pictures were sent to
Blenheim and all the fine Hangings Except One Suit
which is mentioned in this Account were carried thither
And as the Attick Story was not used after his death and
the furniture Worn out it was put to Ordinary Uses

The above is an Inventory of the Goods and Furniture
at Marlborough house In which I have Specified and
distinguished what belongs to the Trust Estate And what
is my own property and belongs to me

In Witness where of I have hereunto Set my hand this
22d.day of October 1740

<div align="right">S. Marlborough</div>

Witness hereto
J Stephens

Dec: 20 1740
I Do hereby Own and Acknowledge to have in my
Custody and possession All the Pictures glasses Hangings
Beds and other Household goods and Furniture

Mentioned in the above Inventory to belong to the late
Duke of Marlborough att the time of his Death att
Marlborough House And Do promise that I will Carefully
preserve and leave the Same either in Marlborough House
or Blenheim House att my Death in as good Plight and
Condition as they are now in Reasonable use wearing and
Inevitable Accidents by Fire or Otherwise Excepted

<div align="right">S: Marlborough</div>

Witnes: *J:Stephens*

Dutchess of Marlborough agt Duke of Marlborough.

This is a true Copy of the Inventories of the Testator the
Late Duke of Marlborough's Pictures glasses Hangings &
Beds and of all other the Testators Household Goods and
Furniture in Blenheim and Marlborough House and of the
Receipts Signed and Sealed by the Dutchess of
Marlborough which I have Examined with the Originall
Inventorys and Receipts which are Deposited with me for
the Equall Benefitt of all parties Interested therein as
directed by the Order made on hearing of this Cause
Dated the 20th June 1740 and to which my Report of this
Date doth referr.

<div align="right">12th. Feb: 1740 Robt: Holford.</div>

Accot of Inventories
Belonging to the Duke of
Marlbroh hairs at
Blenheim
See here an Accot. Of the
Gold plate fo: 20.

Glossary and Concordance

Items are listed in alphabetical order with their modern spelling (where applicable) in roman and unusual names or spelling variations are shown in italic. Definitions are given where appropriate. Some are taken from the fourth edition of Nathan Bailey's *Dictionary* published in 1728 or from Samuel Johnson's *Dictionary* of 1755.

adder downe (*see* eider down)

alarm clock *larum clock*

alembic *almbeck; lanbeck; limbeck; limbeek*
'… a Still, a Chymical Vessel for Distilling' (N. Bailey).

alto relievo
Raised ornament that projects from a background surface.

andirons (*see* fire-dogs)

ante-chamber *antichamber; antychamber*
A waiting room to a principal room or bedroom.

Axminster carpet *Ackminster carpet*
Knotted pile carpet made at the Axminster, Devon factory established in 1755 by Thomas Whitty. By the 1790s the term Axminster meant English knotted pile carpets in general.

bacchanal *bachonella*

backgammon table *backgamon table; bagammon table; back-Gamon table*
A games table or board for the game of backgammon.

baize *base; bass; bays*
A heavy woollen cloth, raised and napped on both sides. Commonly used as a table or carpet covering, for linings and occasionally for cushions and seat upholstery.

Barbary matt
Rush matting imported from the western part of North Africa, once known as Barbary.

basin *bason; baison*

basso relievo
Shallow raised ornament often employed in moulding or carving.

bear *beer; beire*
A pillow case.

beck *back*
A vessel used for storing at various stages of brewing.

bed carpet
Either a rug or small carpet placed on one side of the bed, or a carpet, made of three relatively narrow strips, which is placed on three sides of the bed.

bed furniture *furniture; furnture*
Collective term for the fabric fittings (including valances) on a bed.

bedstead
The frame of a bed upon which a mattress is placed.

bell-metal *bell metal*
An alloy of around four parts copper to one of tin.

Bengal *Bengall; Ben Gall*
Any of a variety of textiles exported from Bengal. Sometimes a thin material made of a mixture of silk and cotton, usually striped. Commonly known as Bengal stripe. Often used in curtains and wall hangings.

bidet *beda; biddeau; biddy*

billet *billet wood*
A small thick piece of wood cut for fuel.

bin *bing*

bird's eye
Indicates any fabric woven in a design consisting of a small diamond with a centre dot.

blunderbuss *blunderbus; blunderbush*

boarded picture
A painting on a panel of wood.

bolt *boult*
Sieve to separate meal from bran.

boot jack
A device for pulling off a boot.

boudoir *budore*

boy (*see* putto)

branch (*see* chandelier)

brandreth *brandlet*
A tripod to support a pot or kettle above embers.

brazier *brassear*
A pan on a footed base for braising or broiling.

Brazil
A hard wood from the West Indies of the *Cæsalpinia* family.

brilliants *brillts* [abbrev.]

brocade *brocado; brockado*
A woven patterned fabric whose design is produced with supplementary wefts. Usually silk. Sometimes with metal thread for dress but rare for furnishing.

brocatelle *broachadille; brocadel; brocadell; brocadello; broccodel; brockadello; brockadilla; brockadillo; brockedello; brockodel; brockodile*
A woven patterned fabric with contrasting warps and wefts, often in different fibres, especially linen and silk. Often with a large foliate pattern, the surface with a relief or *repoussé* effect. It is used for both upholstery and hangings.

buck *buckin*
Washing tub.

buckram *bukarome*
A coarse fabric of hemp or linen stiffened with gum and calendered before being dyed in a variety of colours. Used for

linings in curtains, bed valances and wall hangings.

buffet *beaufet; beauffett; beaufort*

burdet *burdett*
Kind of cotton fabric.

bureau *buroo; beaurow; beaurough; beaurogh; buroe; beauro*

bust *busto; bustoe*

cabaret *caberett*
Drinking shop.

caffoy *caffey; caffie; caffoy; coffu*
A patterned woollen fabric with a pile. Used in seat upholstery, bed and wall hangings, and wallpaper.

calamanco *calimancoe; calimanco; callimanco*
A wool or wool and silk cloth with a glossy surface and a twilled weave on the right side only. Plain and also patterned in stripes or flowers. Used for wall and bed hangings, window curtains and chair covers.

calico *calicoe; callico; callicoe*
A cotton plain weave cloth which was printed, coloured, and dyed. First made in India and later in the West. Commonly used in clothing and for window curtains, bed hangings, linings and chair covers.

camblet; camlet *camlet; camblett; cambled; camblot*
A plain weave worsted cloth of silk or wool, or of mixtures of these, sometimes with goat's hair. It may be watered to give a glossy surface or pressed under rollers to give a waved pattern. Used for bed hangings, window curtains, chair covers and dress.

camera obscura
A darkened box or enclosure with an aperture for projecting an image of external objects on a screen placed at the focus of the lens.

camp chairs and stools
Lightweight folding portable furniture. Usually with X frame stretchers and a wooden or leather seat.

cane *cain; caine*
A hollow, jointed woody stem of particular reeds and grasses such as bamboo used for seating.

cantine bag
A bag for a soldier's flask.

cantonnière (French term) *cantoon; canttoon*
Narrow curtains at the corners of a bed that closed the gaps between the main curtains.

caparison
An ornamented covering for a horse's saddle or harness.

card table *carde table*

cartouche box *cartouch box*
A cartridge box for storing ammunition or cartouches.

cases
Protective case curtains to hang around a four-poster bed or loose covers for furniture and upholstered furniture.

catch *ketch; katch*

cedar *ceadar; ceder; seader*
An aromatic, reddish-brown softwood used for furniture and panelling; a natural insect repellent.

chafing dish *chaffing dish*
A portable grate that is filled with burning charcoal for heating food in a dining room.

chandelier *branch*
The word branch was often used to describe a chandelier. It was also used to describe the arm used to support a candle, extending from the mirror frame, the mirror serving to magnify illumination.

chandelier *schandeleer; chandeleir*

check[ed]; checker[ed]; chequer[ed] *check'd; checkt; checkerd; checker'd; checkquered; chequer'd*
A fabric made of any fibre of plain weave, with coloured warp and weft stripes intersecting at right angles to form squares. Checks may also be printed.

Chelsea
Soft-paste porcelain manufactured at the Chelsea porcelain factory between 1748 and 1770.

chest of drawers *Chester drawers*

cheyney; china *chena; cheney; cheny; chinee*
A fairly humble plain weave worsted cloth, sometimes watered, used mainly for bed hangings but also for window curtains, wall hangings and chair covers.

chimney board
A board to block the fireplace opening during the summer months.

chimney glass
A mantel mirror.

china (*see also* cheyney) *chiney*
Chinese export ceramic ware.

chintz *chince; chints*
A cotton fabric which is painted or block printed in colours with generally large-scale pattern, often floral. First imported into England by the East India Company and later manufactured in England. An extremely fashionable material used for bed hangings and window curtains.

chocolate pot *jocolot pot; chocalate pot*

churn *chorme*

cistern *cestern; cisterne; cistron; cistion*
A large vessel for water or other liquids. Also a container filled with ice to cool wine bottles.

close stool
A chair with a hinged padded or wooden seat over an elliptical hole, concealing a shelf with a chamber pot.

cloth
Plain-wove woollen fabric.

coal-hod *coalhod*
Pail-shaped coal-scuttle.

cock
A tapped spout with a valve for controlling the flow of liquids.

commode *comode*
A French furniture form. A decorative, heavy-bodied chest, with three or more tiers of drawers, set on four short legs. Found both in bedrooms and drawing rooms.

compass back
A general term to describe a chair with a curved seat and back.

confidante
Seating furniture to accommodate two or more sitters at close quarters.

cornice *cornish*
A moulded architectural trim.

counterpane *counterpain; counterpan; counterpin; coverpain*
An elaborately decorated bed cover, usually embroidered or decorated with applied trimmings. Often shaped to fit around the posts at the foot end and over the bolsters at the head.

counterpoint (*see* counterpane) *counterpoynt; counterpoynte*

cover
Loose cover for chairs, stools, settees.

covered with
Term used to describe attached upholstery materials.

coverlet *coverlid*

crockadillo (*see* brocatelle)

cruets *crewets*

crupper
Strap to stop a horse saddle from slipping forwards.

culgee
A rich figured silk that was originally worn as a turban or sash, hence known as a figured Indian silk. Western imitations were made in England in the 18th century from both silk and wool with the pattern printed on both sides of the fabric, thereby making it reversible.

cullet *cullett*
Fragments of raw or broken glass melted down with the new ingredients of a batch to act as a flux to reduce the time required to make glass.

damask *damaske*
A woven fabric with patterns created in satin weave. Of different fibres including silk, wool and linen. Used for bed hangings, wall hangings and seat upholstery as well as for table cloths and napkins.

deal *deel; dail*
A sawn board cut from European pine and fir.

decker work
A type of floral embroidery probably derived from Indian patterns; a design based on this also found printed on cotton.

Delft *Delph*
Blue and white tin-glazed earthenware first produced in the Dutch town of Delft.

Derry (see Londonderry)

dessert *disert; desert; desart*

diaper *dyaper*
A linen fabric, woven with lines crossing to form diamonds with the spaces filled with a motif. Used mostly for table linens.

dimity *dimitty; dimothy; dimithy*
A woven cotton cloth, of different qualities, sometimes corded or patterned or embroidered. Most examples are white. Used mainly for bed hangings but also for window curtains, chair covers and clothing.

dogg (*see* fire-dog)

doyly; doily *doyley; d'oyley*
A small decorative mat of paper or cloth often placed under food.

Dresden
Hard-paste porcelain, produced at the Meissen factory near Dresden.

drugget *druget*
A thin, tough cloth of wool or wool and linen, used for wall and bed hangings in the early 18th century. By 1800 it had come to mean a coarse wool and linen cloth for protecting table tops and carpets.

dumb-waiter *dumb waiter*
Stand of two or more circular tiers with central post support on three or four short legs; used as a serving table in the dining room.

dun
A brownish-black colour.

Dutch chair
A ladder-back chair with a rush or leather seat.

Dutch oven *Dutch oven/stove*
Broiling or gridiron.

eider down *adder downe; otter down*
Soft feathers from the breast of an eider duck.

ell
A standard of measure of length employed for textiles. Approximately 45 inches.

embroidered *imbrordered; imbroidered*

épergne *epargne*
A tiered, ornate centrepiece for the table, usually of silver.

escritoire *escrutoire; escrucore; scrutoir; scrutore;, screwtore; scruitore*

A desk, writing cabinet or writing box.

ewer *ure*

faneer (*see* veneer)

felleys

Logs used for fuel.

field bed

A bed, usually with a shaped top, designed to be easily dismantled and portable. Often used when travelling. Some had elaborate hangings while others were used by servants.

filemorte *fillemot*

'... a Colour like that of a faded Leaf' (N. Bailey).

filigree *filligreen; philegrine*

Openwork decoration.

fire board (*see* chimney board)

fire-dogs *doggs*

flagon *flaggon*

flap table (*see* gate-leg table)

flasket *flaskett*

'... a sort of great basket' (N. Bailey).

flock

Wool or cotton waste used for stuffing.

footman

Stand to support kettle or cooking vessel.

form *forme; foarme*

A bench or long stool with a plain oak, walnut, cane or upholstered seat.

French

Either imported from France or made using French techniques and design.

frieze *freeze*

[curtains]

fusee *ffuzzee*

fustian *ffustian; fustion*

A twill-weave cloth with linen warp and cotton weft, later all cotton, which could be printed or embroidered. Used for bed hangings and chair covers.

gadrooned *godroon'd; godroned*

Inverted fluting or beading on furniture, metalwork and textiles. Also known as knurling and nulling.

galloon *gallome; galloom; galoon; galoome*

A decorative braid, frequently woven of gold or silver thread and used to form patterns when applied on bed hangings, counterpanes and window pelmets.

gate-leg table *flap table*

Genoa damask *Jeneva damask*

Genoa-velvet *ginoway; jeneva*

Silk velvet, usually with a large-scale floral design on a plain weave or satin ground. Originally imported from Italy.

gilt *guilt*

A technique for ornamenting wood, metal, glass and ceramics with gold leaf.

Includes honey gilding, lacquer gilding, mercury gilding, ormolu, party gilt and size gilding.

girandole *gerrandole*

A carved wall sconce intended to hold a candle.

halberd *halbert*

harateen *harrateen; harreteen*

A worsted fabric, available either plain, watered or with a waved pattern. Used for bed hangings and window curtains, occasionally for chair covers, and for linings.

harpsichord *harpsical*

hogshead *hhᵈ*

A measure of liquid containing 63 gallons. Also used generally to describe any large barrel.

holland *hooland*

A fine quality linen cloth, imported from Holland, which could be white or brown and occasionally patterned. Used for spring curtains, blinds and bed sheets.

huckaback *huccaback*

Highly absorbent linen towelling with raised figures.

inamil (*see* enamel)

India; Indian

Imported from Asia, notably from India, China or Japan, through the East India Company, or made in imitation of such imports.

Indian cabinet

A cabinet veneered with oriental lacquer or japanned in imitation of lacquer.

Irish stitch

An embroidery stitch with upright stitches worked in zigzag lines, often shaded, on a canvas ground. Used for carpets, hangings, table covers, hand fire screens, and upholstery.

jack *jack*

"An engine which turns the spit" (Samuel Johnson). Also a large leather jug.

japanned *jappan; japan; jappaned; japan'd; jappaned; japannd*

A European imitation of oriental lacquer, used to decorate furniture, boxes and wall-panelling.

jasmin *jessimies*

jib *gibb*

A concealed door.

ketch, katch (*see* catch)

Kidderminster *Kiddermister; Kittermaster*

A worsted cloth, sometimes with a woven geometric or striped pattern, named after the town of Kidderminster, a centre of worsted spinning and weaving. Used for wall and bed hangings and for window curtains. Also a floor covering of flat woven reversible double cloth like Scotch carpet.

lacquer

Asian varnish often used as finish on Chinese and Japanese furniture.

ladder *lather*

lanbeck (*see* alambic)

landscape *landskip*

lantern *lanthorn; lantron; lanthron*

larum clock (*see* alarm clock)

lathe *lave*

limbeck (*see* alembic)

linsey-woolsey *lincey; linsey*

A plain-weave cloth made of linen and wool. Used particularly for bed hangings in servants' rooms.

Londonderry *Derry*

A reference to Irish linen.

lustre

A glass pendant used to ornament a chandelier.

lutestring *lustring; lutstring; lute string*

A silk taffeta with a special glossy finish achieved by applying gum to the fabric and heating it. Mostly plain and used for curtains, linings, and covers for toilet tables.

mahogany *mahogʸ; mahog'y; mohougemy*

manchineel (*Hippomane mancinella*)

West Indian hardwood.

Mantua silk

A silk of plain weave that is heavier than taffeta. Used for linings, toilet-table covers and occasionally for window curtains.

marrow scoop

A spoon designed for scooping out bone marrow.

Marseilles quilt *Marsela quilt; Marseilles quilt; morcelleo*

A bed cover made of layers of fabric sewn together with an all-over embroidered pattern, named after the French city of Marseilles which specialised in such quilting. Subsequently developed as a machine-woven technique.

mash tub *marsh tub*

For mashing the hops in brewing beer.

mazarine *mazarineto; mazereen; mazerreen*

A flat pierced plate, fitting into a larger dish to accommodate liquids, often used in serving fish.

mentioned *menconed*

mezzanine *mensaneen*

Mississippi table

A table for playing the game Mississippi (like bagatelle).

mohair *mohaire*

Highly durable and expensive cloth made from the wool of the Angora goat, and also a mixture of Angora goat wool and silk. Originally imported from the Levant

but later manufactured in England, using coarse English wool.

money plant *money plan*

monteith *montath*
A punchbowl with a removable scalloped rim for suspending stemmed glasses.

moquette; mockado, moketto *machett; maquelt; musketto; musketue*
A robust type of velvet with a woollen pile. Made of linen and wool and available plain, figured or with patterns stamped after weaving. Often used in wall hangings and wallpapers.

moreen *moreene; morine*
A worsted cloth with a watered finish, created by pressing under rollers, and then glazed. Used for seat upholstery, bed and wall hangings and window curtains.

mosaic *mosack*

musketoon
A short gun with a bell nozzle.

muslin *muslyne; musling*
A fine transparent cotton textile imported originally from India. Produced in England after 1779.

nankeen *nankin*
A cotton cloth of plain weave, originally imported from China and woven in Manchester from the 1750s. Used particularly for costume.

oleo
A highly spiced stew of meats and vegetables of Spanish and Portuguese origin.

ombre
'A game of cards played by three' (Samuel Johnson).

orrery
A mechanical model of the solar system, invented by Charles Boyle, 4th Earl of Orrery.

orris
Braid used in clothing and upholstery, sometimes woven in gold or silver thread.

otter downe (see eider down)

pallet *pallat; pallett*
A straw bed or mattress; a mean bed; 'a little low bed' (N. Bailey).

paned *pained; payned; poin'd*
Alternate panels of different fabrics of contrasting colour and/or texture.

paragon *paragan; parag".*
A fine worsted cloth. Plain and embroidered. Used in curtains, hangings, upholstery, and seldom in clothing.

parquet *perkentine*

pastry *patty; pasty*

pattern chair
A sample chair. Cabinet-makers often produced a single chair as a sample for their customers' approval prior to producing an entire set.

peel
A broad thin board with a long handle for putting bread in and out of the oven.

peeling *peiling*
A kind of silk satin made in China and first imported by the Dutch, and from the 1680s by the English East India Company. In the late 17th century imitations were made at Haarlem.

periwig block (see wig stand)

perkentine (see parquet)

Persian *persion*
A thin plain silk, principally used for the linings in coats, petticoats, and gowns. Silks from Persia were highly esteemed, and the name Persian may first have been given to English imitations to promote sales. Used for curtains, linings and toilet-table covers.

petticoat (for table) *pettycoat*
Floor-length drapery on a toilet table.

pillow beers *pillow beires; pillow bears*
A linen case or slip used to cover and protect a pillow.

pier *peer; peire*
A wall between two openings or windows.

pier glass *peire glass*
A looking-glass hung on a pier wall between two windows, often elaborately framed.

piggin *piggen; piggin; piggon; pigging*
A small pail with an extended arm to serve as a handle.

pillow beers *pillow beires; pillow bears*
A linen case or slip used to cover and protect a pillow.

pincushion chair
A chair with a drop-in seat. The seat is domed in shape and similar in appearance to a pincushion.

pistole
A European gold coin dating from the 17th and 18th centuries.

Plymouth marble *Plimouth marble*
Marble quarried at Plymouth, Devon: 'ground is dark brown, the veining red and blue' (William Gilpin, *Observations on the western parts of England relating chiefly to picturesque beauty*, 1792).

polishing cloth *rubber*

pomade *pomatums*
A scented ointment for the skin and hair made with apples.

pomander *pommedours*
A perfumed ball or powder for placing in drawers and wardrobes to scent clothing.

Pope Joan table
A table used for the card game Pope Joan, with eight compartments for holding stakes.

*popetoniere (*poupetonnière) (see* stewing pan)

portmanteau *portmantau; portmantua; portmantle*
A chest, trunk or bag for transporting clothes. A suitcase.

press
A simple cupboard, two-tiered with hinged doors.

pressbed
Fold-down bed in the form of a press.

putto, *pl.* putti *boy*

quadrille table
A table used for the card game quadrille.

queen's metal
A kind of Britannia metal.

quilt
A bed cover consisting of two pieces of fabric, stuffed with a layer of wool or down, joined together with stitches or lines of stitches. Can be decorative or plain.

ragout
'a highly-seasoned dish of meat' (N. Bailey).

rullwagon *rulwagon*
Chinese hard-paste porcelain vessel with a cylindrical body and a waisted neck.

rummer
'... a broad mouth'd large drinking Vessel' (N. Bailey).

rush light
A cheaper form of lighting using a rush.

Russia [linen] *Russia sheets*
Hemp linen woven in Russia.

Russia leather *Rusia leather*
Named after country of origin. Calf- or cowhide, tanned and dressed so that it resists water and deters insects. Used for chair covers.

sacking bottom *sacken bottom*
A cloth of either flax or hemp that is stretched across the frame of a bed to support a mattress.

sad colour
'... a deep or dark colour' (N. Bailey).

Saint-Cloud *Saint Clou'*
Saint-Cloud porcelain factory, France.

salad *sallet*

salamander *salamandar*
A culinary browning iron with a long handle.

sarcenet *sarsnet; sasnet; sasnett;*
A fine thin woven silk and dyed in a range of colours, including black. Used for curtains, linings and as quilt covers.

291

satin *satten; sattin*
'A kind of silken stuff, very smooth and shining, the warp whereof is very fine and stands out, the woof coarser and lies underneath' (*Chambers Encyclopedia*, 1892).

sattee (*see* settee)

save-all *saveall*
A small pan inserted into a candlestick to save melted wax and the ends of candles.

scagliola
Paste imitations of marbles and other semi-precious stones made from a hard vitreous substance used as a form of decoration.

scalloped *escolop; escollop'd*

schandeleer (*see* chandelier)

Scotch carpet
A flat woven reversible double cloth floor covering, produced in various centres in Scotland.

scullery *scullary; scullory*

seader (*see* cedar)

serge *sarge*
A twilled cloth with worsted warp and woollen weft, middleweight, inexpensive and durable, ranging in quality.

settee *sattee; satteé*
Seating furniture with arms to accommodate two or more people.

setwork (*see* Turkey work)

shag *shog; shogg*
Cloth with long nap on one side, of worsted or sometimes of silk.

shagreen
Made from the skins of the shark, ray or dogfish, often dyed green. May also be ass's skin.

shalloon *shallone; shalloone; shaloone; shaloon*
An inexpensive, twilled lightweight worsted.

Silesia lawn *siletia*
Thin, slight, twilled coarse linen cloth, dyed into various colours and sometimes patterned. Used for blinds.

skewer *scewer; scuer; squer*

spangle
A small, thin piece of glittering metal, usually round and pierced in the centre for sewing as ornamentation on fabric.

Spanish table
A table with folding iron legs.

spinet *spinnet*

sprig
Adorn with designs of sprigs of blooms.

squab
A cushion shaped like a mattress for a chair or day bed.

Staffordshire ware
Lead-glazed or salt-glazed earthenware from Staffordshire.

standish
A stand for ink, pens, sand and other writing materials.

steelyard *stilliard; stilyard*

stew-pan *popetoniere*
N. Bailey's *Dictionary* describes a poupeton as a: 'Ragoo of Bacon, Pigeon, Quails, &c. dressed in a stew-pan'.

stroum, strom
'… an Instrument to keep the Malt in the Fat [vat]' (N. Bailey).

stuff
A general term for worsted cloths.

stump bedstead
A bed without tester or posts, sometimes with a very low headboard.

sumpter cloth
A cloth used to cover luggage carried by a horse or mule.

sunshade *umbrello; umbereloe; umbrelloe; umbrellow*
A sunshade fixed above a window.

surtout (epergne) *cirtute; sartood*
A tiered ornate centrepiece for the table usually of silver.

swanskin
A fine thick type of flannel used for blankets and for powdering carpets.

syllabub *sillibub*

syringe *serringe*

tabaret
In the late 18th century the term was used for a stout striped silk.

tabby *taby, tabbey*
A plain substantial silk with a watered finish, very occasionally brocaded. Use for bed and wall hangings and for window curtains.

taffeta *tafata; taffaty; taffety; taffita; taffity*
A thin silk, patterned, painted or plain, used for bed and window curtains, or for linings.

tammy
A strong lightweight worsted fabric of an open weave that is often glazed. Used for curtains, linings and chair backs.

tartan *tarteen*
A woollen cloth woven in stripes of various colours and crossing at right angles so as to form a regular pattern.

tassel *tosse; tossel; tossell; tossil*

tea table
Small table or tray designed primarily for a tea service.

tester *teaster*
The horizontal upper section of a bed, sitting on the posts, and usually made of carved wood, or of wood covered with a fabric.

tick, ticking *ticken; tickin; tycken*
A strong, close woven linen in a variety of colours and stripes. Used for feather beds, mattresses, bolsters, pillows and some men's clothing such as waistcoats and breeches.

tissue *tishure*
A rich silk, often woven with silver and gold thread.

toilet *toilate;toilett; toilight; toylight; twilight; twillet; twillett*
Dressing-table drapery.

trammel
An adjustable rack from which pots were hung above the fire.

trestle *trussel; trussell*

trivet *trivett; trevot; trevett*
A three-legged stand for utensils before a fire or fastened to the front of the fire grate.

tumbrel
A farm cart that can be tipped to empty the contents.

Tunbridge ware
A form of inlay, consisting of minute squares cut from strips or rods of different coloured woods, assembled to create a design similar to a mosaic. Named after Tunbridge, Kent.

tureen *terrean; terreen*
A deep vessel with a lid, usually oval. Placed upon a matching stand and used for serving soup.

Turk's cap *Turkscap; Turks cap*
Small round cake tins shaped like tulips.

Turk's head *Turk's head broom*
A round long-handled broom.

Turkey work *Turky*
A knotted woollen pile fabric made in England in imitation of Turkish carpets, for use as upholstery and table and floor carpets. It is particularly well suited for seat furniture as it is extremely durable and hard wearing. Decorated in floral patterns with bright and colourful fringe trimming.

twilight (*see* toilet)

twillet (*see* toilet)

underbeck; under bank (*see* beck)

ure (*see* ewer)

valance *valion; vallans; valins; vallens; vallance; vallonds; vallond; valond; vallons; valands; vanse*
A strip of fabric, suspended below the tester of a bed to conceal the curtain rod and below the frame of the bed stock to conceal the gap underneath, or hung above a window to conceal the curtain rod.

valise *vallees; vallise*

vat *fatt*
A large vessel or cask for storing liquids.

velour(s) *valear; valeur; vallure; valure*
The French term velours indicates a type of pile fabric similar to velvet.

veneer[ed] *faneered; fineared*

voider
'… a Table-basket for Plates, Knives, &c. a wooden painted Vessel to hold Services of Sweet-Meats' (N. Bailey).

volary
'… a great Bird Cage, so large that the Birds have room to fly up and down in it' (N. Bailey).

wadding [?] *wadden*

wainscot *wainscott*
High-quality oak, often imported from the Baltic region.

waiter
A salver or small tray.

walnut *walnutt tree* (also *wallnuttree*

water candlestick
A candlestick that stood in a bowl of water serving as a safety device.

whist *whisk*

wig block (*see* wig stand)

wig stand *perriwig block; perriwigg block; wig block*

Windsor chair
A wooden chair with a saddle seat and a bent spindle back, produced in a variety of styles.

worsted *worstead*
Wool cloth that has been combed to remove all the short fibres, with a tightly twisted yarn, giving a smooth, hard surface.

wort-pump
Pump used in brewing to force the wort (new ale) from the drainer to the cooler.

wrenching tub *renching tub*
A laundry tub for wringing water out of clothes.

wrought
A decorative finishing technique. In textiles, especially silk, decorated as with needlework, embellished or embroidered. In metals, beaten out or shaped by hammering or handwork.

yeast *east*

ym ym; y^m
Them: vestigial use of the old letter thorn Þ, here represented by the letter y; also used often with e to represent 'the'.

Further Reading

John Cornforth (1937–2004), 'A Memoir and Bibliography', *Furniture History*, XLII, 2006, pp. 206–47

John Cornforth's writings which drew on the inventories in this book

BLENHEIM, OXFORDSHIRE
Early Georgian Interiors, Yale University Press, 2005, pp. 275–9

BOUGHTON HOUSE, NORTHAMPTONSHIRE
Country Life, CXLVIII, 3 September 1970, pp. 564–8; 10 September 1970, pp. 624–8; 17 September 1970, pp. 684–7; CXLIX, 25 February 1971, pp. 420–3; 4 March 1971, pp. 476–80; 11 March 1971, pp. 536–9
'Boughton: Impressions and People', in T. Murdoch (ed.), *Boughton House: The English Versailles*, 1992, pp. 12–31
Early Georgian Interiors, Yale University Press, 2005, pp. 119–20

DITCHLEY, OXFORDSHIRE
Country Life, CLXXXII, 17 November 1988, pp. 100–5; 24 November 1988, pp. 82–85
Early Georgian Interiors, Yale University Press, 2005, pp. 291–5

HOLKHAM, NORFOLK
With Leo Schmidt, *Country Life*, CLXVII, 24 January 1980, pp. 214–7; 31 January 1980, pp. 298–301; 7 February 1980, pp. 359–362; 14 February 1980, pp. 427–31
Early Georgian Interiors, Yale University Press, 2005, pp. 313–24

HOUGHTON, NORFOLK
Country Life, CLXXXI, 30 April 1987, pp. 124–9; 7 May 1987, pp. 104–8; CXC, 28 March 1996, pp. 52–9; CXCVI, 26 September 2002, pp. 94–9
Early Georgian Interiors, Yale University Press, 2005, pp. 20–23, 89–91, 131–2, 150–168, 258–9

KIVETON AND THORP SALVIN, YORKSHIRE
Early Georgian Interiors, Yale University Press, 2005, pp. 43–4, 77–8

MARLBOROUGH HOUSE, ST JAMES'S, LONDON
Early Georgian Interiors, Yale University Press, 2005, pp. 134, 275

MONTAGU HOUSE, BLOOMSBURY, LONDON
Early Georgian Interiors, Yale University Press, 2005, pp. 116, 185

Credits

Index

The inventories have not been footnoted so the index is an essential tool to access efficiently the raw historical data.

For proper nouns the modern spelling is given, but where nicknames occur in the inventories or highly divergent versions of names are used, cross-references are given. Dates are given for artists, designers and craftsmen where known. Attributions are those given in the inventories and may not reflect current scholarship.

For the names of objects modern spelling is also given; many eighteenth-century spellings are glossed in the glossary/concordance. This is not an exhaustive index. However, many items for which specific characteristics are given in the inventories are listed: it is useful, for example, to show the incidence of woods or furnishing materials used. Furnishing fabrics are grouped under the entry 'furnishing materials' while the entry 'woods' provides the main access for furniture, listing items by the kind of wood specified in the inventories. Many unusual items and some identifiable objects known to be still extant are listed.

Salone

One Large Marble Table with a Copper
figure on D.º - - - - - - - - - - - - - -
Two Lesser Marble Tables, with an Orient
Agate Urn on Each - - - - - - - - - - - -
Two Terms by D.º - - - - - - - - - - - - -
Two Settee's - - - - - - - - - - - - - - -
Twelve Chairs - - - - - - - - - - - - - -
Four Stools - - - - - - - - - - - - - - - -
Two Tea Tables with Cups Saucers &c on
Two Festoon's by Chimney with four Bra
Each - - - - - - - - - - - - - - - - - - -
Two Large Pier Glasses - - - - - - - - - -
One Busto over the Chimney - - - - - - - -
One Busto over the Great door West fro
Fourteen Pictures - - - - - - - - - - - - -
One Hearth Iron, Grate, fire pan, ton
poker, Fender, and Brush - - - - - - - -
Four Brass Mortice Locks to Doors